Introduction to Fashion Merchandising

The Delmar Fashion Series

Introduction to Fashion Merchandising

Patricia Mink Rath
Jacqueline Peterson
Phyllis Greensley
Penny Gill

Delmar
Publishers Inc.

NOTICE TO THE READER

Cover design by Nancy Gworek
Cover photos courtesy The Limited; Sam and Libby; Men's Fashion Association; Malden Mills; Health-Tex
Unit opening photos and photo essays courtesy Ellen Diamond.

Delmar Staff:
Acquisitions Editor: Mary McGarry
Project Editor: Andrea Edwards Myers
Production Coordinator: James Zayicek
Art and Design Coordinator: Karen Kunz Kemp

For information, address Delmar Publishers Inc.
3 Columbia Circle, Box 15-015
Albany, New York 12212-5015

Copyright © 1994 by Delmar Publishers Inc.

The trademark ITP is used under license.

Printed in the United States of America
Published simultaneously in Canada
by Nelson Canada,
a division of the Thomson Corporation

1 2 3 4 5 6 7 8 9 10 XXX 00 99 98 97 96 95 94

Library of Congress Cataloging-in-Publication Data

Introduction to fashion merchandising / Patricia Rath ... [et al.].
 p. cm.
 Includes index.
 ISBN 0-8273-4871-1
 1. Fashion merchandising. I. Rath, Patricia Mink.
 HD9940.A2I58 1993
 391'.0068'8—dc20 92-39192
 CIP

"Fashion is one of the greatest forces in present-day life. It pervades every field. . . . Fashion leads business and determines its direction. It has always been a factor in human life but never more forceful, never more influential and never wider in scope than in the last decade and it gives every indication of growing still more important. . . . To be out of fashion is, indeed, to be out of the world."

Paul H. Nystrom
Economics of Fashion
The Ronald Press Company, New York, 1928, p. iii.

About the Authors

Patricia Mink Rath is a consultant in marketing education in Winnetka, Illinois. She is a professor on the faculty of the International Academy of Merchandising and Design, a four-year college for fashion students, located in Chicago, where she teaches courses in fashion merchandising, buying, marketing, management, and other business subjects. In addition to her teaching duties in the Merchandising Management department, Mrs. Rath also chairs the school's curriculum committee.

Her fashion merchandising experience includes work as a retail executive in the fashion departments of specialty and department stores in the Chicago area and San Francisco. A graduate of Oberlin College, Oberlin, Ohio, Mrs. Rath holds a Master's degree in merchandising management from the Prince School of Retailing, Simmons College, Boston, Massachusetts. Additional post-master's study includes work at the University of Illinois, Champaign, and Northwestern University, Evanston.

Patricia Rath has written a wide range of educational materials for high school and college students and adults. She is co-author of five editions of *Marketing Practices and Principles,* a high school marketing test. She has held positions of supervisor for marketing education with the Illinois State Board of Vocational Education and was a high school Marketing Education coordinator. She is a member of The American Marketing Association, The League of Women Voters, and The Chicago Council on Foreign Relations. Mrs. Rath is listed in *Who's Who in the World.*

Jacqueline R. Peterson is Chairperson of the Textile Department at the International Academy of Merchandising and Design in Chicago, Illinois. She is also a Training and Development manager with The Merchandising Group. As a Certified Home Economist and private textile consultant, Ms. Peterson has given lectures and seminars throughout the Chicago area.

Ms. Peterson received a Bachelor of Science degree from Iowa State University, and a Master of Science degree from Purdue University.

As a graduate of Northern Illinois University, **Phyllis Greensley** earned a Bachelor of Science in broadcast-television journalism and a minor in political science.

Her professional background includes over eight years experience in fashion promotion and publicity as well as over four years in retail merchandising. As an instructor at the International Academy of Merchandising and Design she has taught fashion show production, introduction to fashion merchandising, and fashion promotion and publicity. She has also conducted high school fashion preview seminars and previously represented the Academy to high school and junior college students. Ms. Greensley also has been a guest speaker for career nights and presented talks on fashion design and merchandising to academic professional groups.

Currently Ms. Greensley works full-time as a department manager for the Chicago-based Crate and Barrel store and teaches at the Academy.

Penny Gill is a communications consultant and writer who has covered the retail and fashion industries for numerous publications since 1977. Since 1980, she has been a regular contributor to *Stores* magazine, published by the National Retail Federation (formerly National Retail Merchants Association), and has also written for *Apparel Industry Magazine, Accessories, Apparel Merchandising, Sportswear International,* and *The Licensing Book,* among others. She is founder and president of PWG Communications Inc., White Plains, N.Y., offering editorial, public relations, and promotional services to a wide range of clients. Ms. Gill holds a B.A. in Liberal Arts from Sarah Lawrence College.

Contents

Chapter 4

Creating and Marketing Fashion ..69

Unit Two

Producing Fashion ..*95*

Chapter 5

Primary Fashion Resources ...*96*

Chapter 6

Women's Ready-To-Wear ...*130*

Chapter 7

Accessories ..*160*

Preface

Dynamic, changing, exciting, and demanding are terms that describe the vitality of the fashion industry. Indeed, many people believe, as stated by Paul Nystrom that "to be out of fashion is to be out of this world." The interest of nearly everyone in fashion provides incentive for the industry to create and market new styles each season. With this impetus, many different kinds of fashion businesses are able to offer a variety of satisfying career opportunities for people with diverse skills and interests in fashion sales, merchandising, and promotion.

From the experience of the authors in fashion merchandising and in teaching and writing, it seemed essential that current information reach students interested in fashion careers, to enable them to arrive at realistic and informed decisions. This information should include: the scope and composition of the apparel field, its various segments, the movement of goods from producers to consumers, the global aspect of the fashion business, and career paths and suggestions on gaining entry into the field.

The result is this text, *Introduction to Fashion Merchandising,* intended for students in introductory fashion programs. The authors have worked to provide a lively, forward-looking text and set of ancillary materials that engage students' interest and involve them in the fashion field quickly through activities, cases, projects, and readings in the text and the study guide.

Organization

Introduction to Fashion Merchandising is organized into five units. Unit One, entitled The Nature of Fashion, describes the various components of the fashion field. Chapter 1, What Is Fashion?, defines fashion and its elements. Chapter 2, The Fashion Consumer, explains how consumers influence fashion and how they buy. Chapter 3, Predicting the Direction of Fashion, describes fashion trends and ways the industry tracks them. In Chapter 4, Creating and Marketing Fashion, forms of business ownership and the composition of the industry are covered. Unit Two, Producing Fashion, describes various goods that the fashion industry creates. In Chapter 5, Primary Fashion Resources, the production of fibers and fabrics, leather and fur are explained. Chapter 6, Women's Ready-to-Wear, delves into the scope, organization, and marketing practices of the women's apparel industry. The related topic of Accessories is the subject of Chapter 7, which includes a discussion of shoes, jewelry, and other accessories. Men's Wear is the title of Chapter 8, which covers the production and marketing of men's apparel. In Chapter 9, Children's Wear, the com-

position of this area is described as well as trends. Chapter 10 is devoted to intimate apparel and cosmetics, including the background, scope and recent growth of those fields. The global aspect of fashion is the subject of Unit Three, Fashion Markets Worldwide. In Chapter 11, Domestic Markets, the role of major market centers across the United States is discussed. Chapter 12, International Markets, describes major fashion centers around the world. Unit Four, Fashion Marketing, further explains the marketing of apparel and accessories. Various forms of retail organizations and trends in retailing are the topics of Chapter 13, Fashion Retailing. The promotional strategy of manufacturers, wholesalers, and retailers is covered in Chapter 14, Fashion Promotion. Chapter 15, Auxiliary Fashion Services, describes the assortment of fashion services, among them buying offices, media, and fashion consultants at work in all segments of the industry. Unit Five, Finding Your Fashion Career, covers a wide range of fashion merchandising careers and ways to break into the fashion field. Chapter 16, Careers in the Fashion Field, cites fashion merchandising occupations and career paths in retailing, wholesaling, manufacturing, and business ownership. How to start building your own career, the subject of Chapter 17, contains suggestions on developing career goals. Finally, Chapter 18, Conducting a Job Search, outlines specific steps toward entering a fashion merchandising career.

Special Features

The material is written to immediately engage students and to provide them with real-world examples. Each chapter opens with an interesting story or vignette relating to fashion. Also, every chapter contains two short features about people and businesses significant to the fashion field. A chapter's Career Portrait may be of a well-known executive in the fashion industry, such as J. C. Penney's CEO, William R. Howell, or of a designer such as Adrienne Vittadini or Alexander Julian. The Spotlight on a Firm feature focuses on a fashion organization such as Burlington Mills, The Gap, or The May Company. End-of-chapter activities reinforce the text material through a vocabulary review, questions for discussion, and two in-class projects. The end of each unit features a longer, more challenging project consolidating the topics covered in each chapter of the unit.

Four appendices are included. Appendix A, The World's Leading Fashion Designers, features thumbnail sketches of more than 50 of the world's current leading designers. Appendix B, Selected Designers and Manufacturers by Industry, identifies the major men's, women's, children's, and accessories manufacturers with addresses. Appendix C, Leading Trade Associations, lists the names and addresses of associations important in the fashion field. Appendix D, Selected Consumer and Trade Publications, gives the names and addresses of these organizations. The text also contains over 150 selected illustrations, including a color photo essay and a Glossary of Fashion Terms and Index complete the text.

A supplementary *Instructor's Guide* is available to instructors adopting the text. The guide contains alternative formats for course organization, suggestions for presenting specific topics by chapter, and keys to the end-of-chapter materials. A test bank with approximately 1000 objective and essay questions accompanies the text, and selected transparencies are available.

Ancillary Materials

Also available and unique in the field is the *Fashion Forecaster* student activity manual designed to accompany the text, *Introduction to Fashion Merchandising*. The *Fashion Forecaster* contains: an outline of each chapter, to be completed by the student; a vocabulary-reinforcing word game; new supplementary review questions; a case relevant to the chapter; an out-of-class reinforcement activity; and additional readings. These activities help students internalize the content of each chapter.

Acknowledgments

Many people offered encouragement and support to this effort, among them representatives of the publisher, the fashion industry, various colleges, and the families of the authors.

The authors are particularly grateful to Mary A. McGarry, Delmar Acquisitions Editor, for her encouragement in the development of the idea for this text and for her continuing support and enthusiasm as the work progressed. And to the many other people in the production and marketing departments whose efforts made this work possible, the authors owe their gratitude.

Among the many people in the fashion industry who provided inspiration for and interest in the text, the authors deeply appreciate the efforts of the following for providing information and, when the occasion arose, for reading portions of the manuscript: Cy Boroff of Cy Boroff and Associates; Marshall Stewart of SME, Inc.; Paulette McGuire of the Apparel Center, Chicago; Eric Johnson of Esca, Inc.; Loxly Currie of Nordstrom; Byron Rice of Allied-Signal, Inc.; Mary Jane Hoerter of Marshall Field's; Laura Anders, Becky Bailey, and Jack Mugan of Dayton Hudson Corporation; Alexandra Walsh, Hartmarx Corporation; Kelly J. Klauss, The May Department Stores Company; Lori M. Tarnoski, VF Corporation; Wendy L. Ruttenberg, Craig/Steven Development Corporation; Les Hale, Joseph Abboud, Inc.; John Quincy, American Marketing Assocation Publications Group; Cyndee Miller, *Marketing News;* Rick Gallagher and Mary Alice Elmer of *Stores;* Jules Abend, editor of Clarion News Service, and retail/apparel industry columnist; Christine J. Marquis, J. G. Hook, Inc.; Eleanor Walsh, E. I. du Pont de Nemours & Company; Don Davis, *Drug & Cosmetic Industry;* Tom Fallon of Bill Blass, Inc.; Grace Mirabella and the staff of *Mirabella;* James Mansour of James Mansour, Ltd., formerly of The Limited, Inc.; Sue Canepa, Margie Korshak Associates; Kerry Weber, Esprit, Inc.; Harold Sudakoff, Caron, Inc.; Karen LaRue of Celeste Turner; and Kelly Dorn, Lee Roski, Inc.

In the academic community, the authors owe their gratitude to the reviewers who patiently went though each chapter of the text and offered many useful suggestions for its improvement. Reviewers included: Elaine McCain, Lee College, Baytown, TX; Carolyn Jenkins, Chairperson Fashion Marketing, Bauder College, Atlanta, GA; John Graebinger, Pasadena City College, Los Angeles, CA; Pamela Naylor, Shades Valley High School, Birmingham, AL; Ellen Vaughn, State Supervisor, Marketing Education, Columbia, SC; and Susan Sharp, East High School, Cheyenne, WY.

The encouragement of the administration and faculty colleagues at The International Academy of Merchandising and Design, Ltd., Chicago Campus,

helped sustain the writing efforts. In particular, the following current and former faculty and staff offered significant assistance in providing research information, encouragement, and on-request reading of the manuscript: Carolyn Tinseth, Director of Education; Shirley Bennett, Director of Educational Resources; Mary Jane Pfister, Director of Graduate Services; and instructors Larry Mages, Dorthé Bartman, former instructor Rhonda Hardy, who is now with the University of Illinois Cooperative Extension Service; and the late Dr. Maurice Kessman.

To the Merchandising Management students of the Academy's Chicago campus, who field tested a number of the activities and projects and contributed to their refinement, the authors also express their appreciation.

Finally, this work could not have come about without the understanding and support of our families during its development. To our husbands, Philip Balsamo and Richard Peterson; our children, Eric Rath, Terrance and Kenneth Peterson, and Justin Gill; and to Phyllis' mother, Ruth Greensley—thank you for your love and patience.

Patricia Mink Rath
Jacqueline Peterson
Phyllis Greensley
Penny Gill

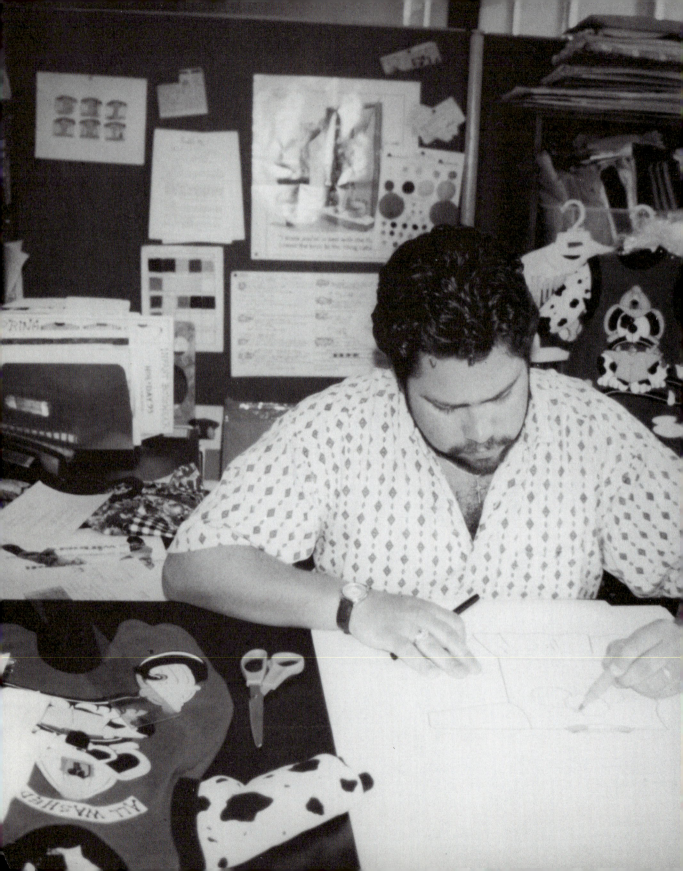

The Nature of FASHION

What is Fashion?

Objectives

After completing this chapter, you should be able to:

1. Explain the term *fashion* and state why fashion is important.

2. Describe two of the major functions of businesses in the fashion field, state the importance of the marketing concept, and define the term *fashion merchandising*.

3. Define the terms *style* and *design* and state how they relate to fashion.

4. Explain the four elements of fashion.

5. Describe the fashion life cycle and relate the importance of timeliness and the fashion seasons to fashion businesses.

When the alarm clock rang this morning, you probably shut it off quickly and with as little thought as necessary. Like most of us, you climb into the shower half-awake, only vaguely aware of the not-unpleasant fragrance of your soap as you lather up. Perhaps the bright color of your towel helps your eyes adjust to another day and the clean flavor of your toothpaste may bring you into full consciousness. But it is when you decide what to wear that you intentionally focus on fashion. You select what you feel would be appropriate for your day, adding the touches that help put you at ease in your surroundings. Traveling to school, you see a colorful billboard advertising well-known jeans. At lunch you order a sandwich that your friends are having. Back home in the evening, you thumb through the catalogs in the day's mail while watching a popular television show. Your day is filled with fashion.

Fashion Is Everywhere—Not Just in What We Wear

While most of us associate fashion first with clothing, fashion is everywhere. The alarm clock that you shut off this morning may be one you selected because of its utilitarian look—useful and inexpensive. Or it may have a sleek, attractive look, with an array of features like a radio that turns on to wake you up or a "snooze alarm" to rouse you should you fall asleep again. The fragrance of the soap you used, the flavor of the toothpaste and the color of your towel, as well as the features of your alarm clock did not appear by chance. They all evolved from research done by manufacturers to find out what qualities have appeal that would attract users and encourage them to buy. Even more true with the clothes we wear, designers and manufacturers create what they believe customers will want. Fashions exist not only in apparel and home furnishings, but in everything else as well. There are fashions in music—look at your favorite video; fashions in automobiles—watch the models change every year; fashions in foods—notice the latest additions to the menus in restaurants. There are: fashionable interiors; fashionable places to visit or vacation; and fashions in art, theater and literature. In short, fashion is all around us. What then is fashion?

Fashion Is What People Are Buying and Using

The key to fashion is acceptance. An item or a look becomes a fashion when people buy and use it.[1] When a look is no longer popular, it is no longer in fashion. An outfit that appeared so fresh and new several years ago seems out-of-date today because other looks have replaced it. A **fashion**, then, is a look or a style that is popular at a given time. Customers and consumers create fashions by buying and using new looks.[2] Although the terms *customer* and *consumer* are used interchangeably, there is a difference. A **customer** is an individual who buys goods for personal or business use. A **consumer** is one who uses (consumes) the goods purchased. For example, when you buy a gift such as a scarf for a friend, you are the customer and your friend is the consumer. When you buy a new sweater to wear to school, you are both the customer and the consumer. In business, the term *consumer* often refers to the customer as well.

The Business of Fashion

Fashion, then, is an accepted look, the prevailing style. Fashion is also a business. Creating and marketing looks targeted for acceptance is the business of fashion. A great part of the fashion business is the making and marketing of apparel, including producing fibers and fabrics, designing and making garments, and marketing them. The businesses that produce apparel, such as Levi Strauss Inc., are called **manufacturers.** The businesses offering and promoting these goods, such as retail stores, public relations agencies, and fashion consultants, are **marketers.** Marketing is the plan-

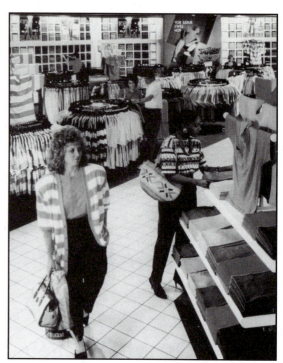

Figure 1-1. While designers and manufacturers create a garment, consumers decide if it is to be a fashion. (Courtesy Steve Neidorf/ Dayton Hudson Corporation)

ning, promoting, pricing and distribution of products, such as apparel in this instance. In its most complete definition, according to the American Marketing Association, **marketing** is "planning and executing the conception, pricing, promotion and distribution of ideas, goods and services to create exchanges that satisfy individual and organizational objectives."

The Marketing Concept

As you can tell, just creating apparel does not make it a fashion. Nor can designers or manufacturers force a certain look upon the public. Customers and consumers determine what will be fashionable when they decide what they will buy and wear.

Leading fashion businesses today, both manufacturers and marketers, know that in order to gain acceptance by customers, they must first determine what customers want. They spend effort and money to find this out. The small dress-store owner works with her customers to learn their preferences as they try on various garments. The research of the jeans manufacturer indicates customers are interested in new denim colors. These businesses must then decide what they can best offer their customers at a profit. The profit is needed to stay in business. Determining customers' needs and what the company can best provide at a profit is the **marketing concept.** While not all businesses use the marketing concept, those that do are finding that responding to customers' needs keeps them ahead in the highly competitive fashion

SPOTLIGHT ON A FIRM

DAYTON HUDSON CORPORATION

 DAYTON HUDSON CORPORATION

DAYTON Hudson Corporation, a retail organization consisting of discount and department stores, grew from a midwest base to reach almost all consumers across the country. At one time, there were two department stores— The Dayton Company in Minneapolis and the J. L. Hudson Company in Detroit—each serving similar customers. The two organizations, believing they could better and more profitably serve their customers as one organization, merged into the Dayton Hudson Corporation (DHC), with stores reaching from Ohio to Minnesota. Later, DHC brought on board the Chicago-headquartered Marshall Field's stores, further strengthening the customer base. But these department stores, accounting for about one fifth of total DHC sales, comprise the smallest portion of the total company.

Across the country in California and now in Florida, DHC operates Mervyn's, a group of more than 200 moderately priced soft-line stores emphasizing casual clothing, family apparel, and home soft goods. Mervyn's concentrates on fashionable moderately priced merchandise in an easy-to-shop environment and accounts for approximately 30 percent of total DHC sales. In the 1980s, Mervyn's experienced a slide in sales performance. By closely monitoring costs and reducing expenses, Mervyn's reported record revenues in the early 1990s, despite being hard-hit by the economic downturn in California. Mervyn's customers tend to be young, educated, active adults with families and above-average incomes. Mervyn's annual sales volume is in the neighborhood of $4 billion, twice that of the corporation's full-line department store division.

The shining star of DHC, bringing in around half of the corporation's total sales volume, or $8 billion annually, is Target, the growing chain of upscale discount stores. Almost 500 Target stores dot 32 states, ranging from Oregon and New Mexico through Michigan and Wisconsin to the Carolinas and Florida. Most are located in communities surrounding major cities. The typical Target customer is 25 to 44 years old, married with children, and part of a double-income family. The latest addition to Target are the super stores called Target Greatland, offering apparel and household goods, and providing enhanced customer services such as wider aisles, better lighting, and faster check-out. Target's fashion goods include an apparel collection labeled Merona, geared to men, women, and children. The stores are organized into four regions composed of 9 to 11 districts with 6 to 14 stores reporting to each district manager. To make deliveries to stores faster and easier, Target has seven distribution centers in strategic locations throughout the country. Merchandise is shipped by manufacturers to the distribution centers and then sent on to the stores as needed.

continued

When DHC Department Stores Division purchased Chicago's Marshall Field & Company, in 1990, it added another major company and city to its collection, and nearly doubled its retail space. With the Field's addition, DHC's department stores include around 60 full-line stores in nine states. The typical customer of these stores is married, in his or her early to mid-forties, with an average household income of nearly $50,000. Over half of them have a bachelor's degree and two thirds have managerial or professional careers. Four out of ten of these families have children living at home.

In all divisions DHC works to lower expenses and improve customer service. Improved computer-based technologies aid in the rapid distribution of merchandise. Creating a positive shopping experience is the goal of DHC's customer service. The stores' offering of broad assortments of trend merchandise accounts for some of their popularity. For example, by knowing the trends, in one recent year Target sold 5.6 million Teenage Mutant Ninja Turtles; Mervyn's sold $139 million of fashion fleece garments; and the Department Stores sold $5.5 million of one product: Giorgio's fragrance "Red."

Question for Discussion. Why is it important for a corporation such as DHC to take part in trend merchandising in all divisions?

Sources. 1. Julie L. Belcove, "At Play in the New Field's," *Women's Wear Daily,* January 1992, p. 15; 2. Penny Gill, "Macke Maps a Plan for Dayton Hudson," *Stores,* November 1991, pp. 29–34; 3. Materials supplied by the Dayton Hudson Corporation, including the 1990 *Annual Report, Investor Factbook,* and Form 10-K; 4. Discussions with Laura Anders, Manager, Public Relations, DHC, June 15 and 25, 1992.

environment. For example, K mart introduces fashionable career apparel with the Jaclyn Smith label after learning that its customers want glamorous ready-to-wear at discount prices. Or Donna Karan, recognizing the busy life styles and demanding work schedules of her customers, responds by offering them stylish yet versatile apparel.

Fashion Merchandising

Meeting customers' needs by showing appealing goods in adequate assortments is the work of fashion **retailers,** the marketing organizations that ultimately offer goods to consumers. Retailers achieve their goals through effective fashion merchandising. Merchandising, according to the American Marketing Association, is "the planning involved in marketing the right merchandise at the right place at the right quantities at the right price." This definition of merchandising applies to **fashion merchandising** as well.

The most successful fashion merchandisers apply the marketing concept by following through on meeting their customers' needs. For example, a few years ago, The Limited stores catered to a younger crowd. As this group matured and its needs changed, The Limited changed too, offering instead a wide assortment of career clothing and providing casual wear for younger customers in its Express stores.

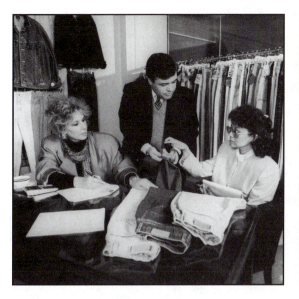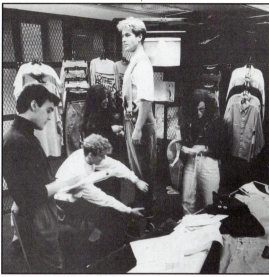

Figures 1-2a and b. When apparel manufacturers consider ways they can best meet the needs of customers, they are using the marketing concept. (Courtesy VF Corporation)

Fashion Is Important

A girl named Maria stood in a New York dress shop. She had recently arrived from Puerto Rico and had found work as a seamstress. It was after hours, and a few other young sewers were still there. Maria gathered up a lovely new gown, held it in front of her at a mirror, and sang out to everyone, "I feel pretty, oh so pretty!" Certainly, Maria had many reasons to feel good about herself: she was young, anticipating her new surroundings, and ready to fall in love. The gown, however, added a final touch to her joy, enough perhaps to cause her to sing—with a little help from Leonard Bernstein.

Providing Ways for Self-Expression

A major reason fashion is important is that it can add to our feelings of well-being by giving us a way to express ourselves, perhaps even help us feel special like Maria in the scene just described from *West Side Story*.[3] You have undoubtedly experienced good feelings knowing you are appropriately dressed for an important occasion, such as a job interview or a special social event. "Getting dressed and looking great is like going on vacation," says designer Norma Kamali. "It's an uplift. And fashion can do that for people psychologically."[4]

Fashions were not always so readily available to almost everyone as they are now. For centuries, only nobility and other elites could don fashionable apparel. In fact, throughout history fashion has been used to indicate social class. In ancient Egypt, for example, just the most important people could wear sandals. Later, in Europe only royalty could wear furs. Societies created **sumptuary laws,** that is, laws regulating what

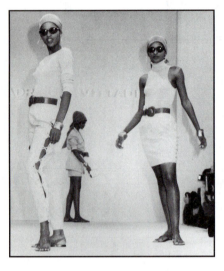
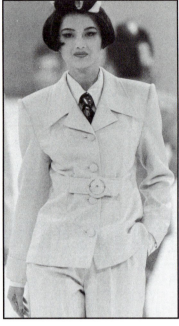
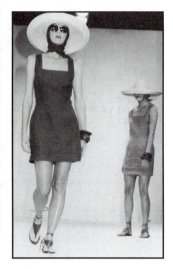

Figure 1-3. Some high fashion looks become widely popular volume fashions. (Courtesy a. Adriene Vittadini b. Cadeau Co. Ltd. c. Adriene Vittadini)

various groups of people could wear based on religious or moral reasons. Even in Colonial America farmers and tradespeople were warned by the Massachusetts courts not to wear lace, silk, and fine boots.[5] The effect of sumptuary laws was to keep fine apparel out of the reach of most people, even those who could afford it. In certain places, such as in some middle eastern countries, sumptuary laws exist even today.

However, through twentieth-century mass production and marketing, fashionable apparel is offered to vast numbers of people throughout the world. Most fashion goods marketed today are **volume (or mass) fashion,** styles that are popular and produced in large quantities and wide ranges of prices. Only a very few people can pay the lofty prices of **high fashion,** that is, custom-made or couture clothes created by famous designers; its cost alone—thousands of dollars per garment—keeps high fashion garments, but not the looks, out of the reach of most people.

The Fashion Industry Contributes to the Economy

The fashion business contributes significantly to the U. S. economy. Each year Americans spend more than $213 billion for clothing and shoes.[6] The fashion industry in this country provides jobs for nearly two million women and men in the manufacturing and marketing of fashion goods.[7] Fashion, however, is a worldwide

business, with opportunities for increasing sales and job opportunities in other countries as individual organizations expand. For example, Benetton stores spread around the world, from Italy to northern Europe, to the United States and Australia.

Fashion Documents Its Times

Fashion does not occur in a vacuum, but rather reflects the times in which it appears. People use clothing to protect and adorn themselves. In fact, clothing is an inexpensive and easy way for people to express how they feel.[8] For this reason, fashion is important, since it documents the civilization and culture of every era. Say, for example, you were interested in finding out about life in the 1960s. Think of what you could learn from leafing through a few fashion magazines, or by viewing a Sandra Dee or Marlon Brando film or an episode of the popular television series, "The Partridge Family" or "The Mod Squad." You would see the bouffant hairdos,

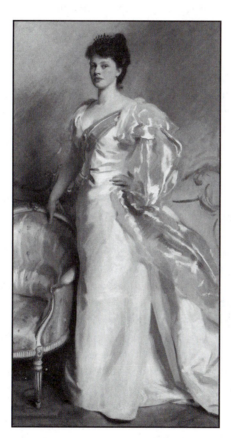

Figures 1-4a and b. This painting by Sargent reflects the opulence and the restrictions of fashions at the end of the last century, while the Calvin Klein outfit characterizes the more relaxed point of view of the 1990s. (a. © 1992 The Art Institute of Chicago. All rights reserved. b. Courtesy Calvin Klein)

the miniskirts, and boots worn by women and girls; the jeans, leather jackets, and belts popular with teens; and the fringe and peace beads of the counterculture. The concerns of that day with fashion, adventure, and peace would all be highly visible. By studying the fashions of a time, the range of social views and trends of the day reveal themselves in what people wear.

Fashion Terms Defined

If a fashion is a look popular at a given time, then what is a style? A style is a distinctive quality or appearance that is unique. There are styles of behavior, such as formal or casual; of writing, such as flowery or journalistic; of architecture, such as Roman or Georgian; of music, like baroque or jazz; and of drama, dance, and other arts. There are also styles in clothing; that is, garments with a distinctive appearance. A blazer is a style of jacket and a cardigan is a style of sweater, as is a pullover. Saddle shoes are a style of footwear; loafers are another. Knee-hi's are one style of hosiery and anklets are another. Shorts are a style of pants, as are culottes and bell-bottoms. In apparel, a **style** is a combination of features that makes an item unique and distinct. Fashions come and go but a style keeps the same characteristics. For example, the military look may or may not be in fashion but the military style (whether dress uniforms with epaulettes and braid or army fatigues) keeps its basic features. There is another use of the term *style* in the apparel market. Every garment that a manufacturer creates is given a style number, which is used in the trade to identify that item as it is produced and marketed. For example, the style number 501 on Levi's jeans identifies the button front. Manufacturers and retailers use the style number when referring to a particular garment.

Since a style is a unique combination of features, what is the difference between a style and a design? A **design** is a certain version of a style.[9] For example, Calvin Klein may determine that shirtwaist dresses for women and double-breasted blazers for men may be popular next season. The versions of the shirtwaist or the blazer that Calvin Klein creates are his designs. Or, when Adrienne Vittadini decides patterned sweaters are wanted by her customers, the versions of patterned sweaters that she does for her collection are her designs.

Some styles are in fashion for a long time; these styles are known as **classics**. Examples of classics include: jeans, blazers, pearls, gold chains, pumps, sandals, sailor looks, pleated skirts, windbreakers, and leather jackets. (See Figure 1-5.) Other fashions last just a very short time, often for a season or less. These short-term fashions are called **fads**. Fads sweep suddenly onto the fashion scene, are all the rage for a while, and then disappear as quickly as they arrived. Examples include: rhinestone-covered canvas gym shoes, neon-colored shirts or sox, and miniskirts. Sometimes fads are inspired by celebrities or popular characters, such as Madonna, whose followers copy one of her many looks, or Teenage Mutant Ninja Turtles, whose fans of all ages sport T-shirts bearing the images of Donatello, Raphael, or one of the other characters.

Figure 1-5. These classics are styles that stay popular for a long time. (Courtesy Hartmarx Corporation, Wimbledon Collection by Racquet Club, 1989)

The Elements of Fashion

What goes into a fashion? What is it about a garment that distinguishes it from others and makes it fashionable? Garments have a variety of characteristics contributing to their distinctiveness. Each characteristic can be classified as one of the four elements of fashion. These characteristics are silhouette, color, texture, and details.

Silhouette

Often the first thing we notice about a fashion is its outline or shape. The shape of a garment is its **silhouette**. Down through history there have been only three basic silhouettes. These are: the straight or tubular; the bell-shaped or bouffant; and the bustle or back-fullness.

It may seem strange, but throughout history these silhouettes have repeated themselves in cycles. At first, each cycle lasted 100 years or so, but over the last 200 years, the cycles shortened to approximately 30 years each.[10] One followed the other in a regular order. In the nineteenth century, for example, the classical flowing tubular look was followed by the bouffant dresses popular around the American Civil

Figure 1-6. The three recurring silhouettes are (1) the straight or tubular; (2) the bell-shaped or bouffant; and (3) the bustle or back fullness. (Based on Agnes Brooks Young, *Recurring Styles of Fashion,* Cooper Square Publishers, New York, 1966, pp. 14–15.)

War era, and replaced by the back-fullness of the Victorian bustle. This century, while the straight or tubular look has predominated, the others have made appearances particularly for formal wear. Today, it is possible to see examples of all three silhouettes in one fashion magazine.

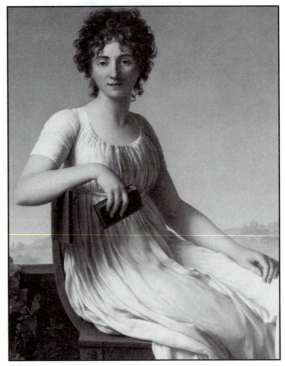

Figure 1-7. One era when the straight or tubular silhouette was popular was 200 years ago, as you can tell from this portrait by the French artist Desoria, done in 1797. (© 1992, The Art Institute of Chicago. All rights reserved.)

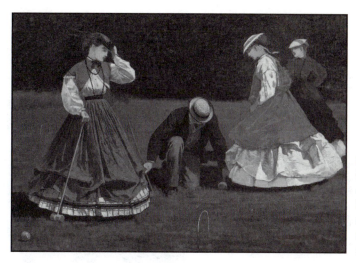

Figure 1-8. The bouffant look was worn even to play croquet in the middle of the last century. (© 1992 The Art Institute of Chicago. All rights reserved.)

The *straight* or *tubular silhouette* is the most ancient and probably the most popular. (See Figure 1-7.) It is the shape of a column from the shoulders to the hem of the garment at whatever length. The waist may be defined, or not, anywhere along the torso. The garments of ancient Persia, Egypt, and Greece were all straight silhouettes. Some medieval gowns and those of the early nineteenth century were tubular in shape. Many looks of this century, the flapper of the 1920s, the severe styles appearing during World War II, and the long-over-short looks of the 1990s are all straight silhouettes. The classic Chanel look is a straight silhouette. Even the tent dress is a straight silhouette, with fullness flaring from the shoulders.

The *bell-shaped* or *bouffant silhouette* has been an important look at various times in the past. The bell-shaped look is simply that: a fitted waist with fullness all around in the skirt. (See Figure 1-8.) The ornate and heavy dresses of Queen Elizabeth I in sixteenth-century England; the elaborate and luxurious garments of the French court in the eighteenth century; and the popular hooped skirts of the Civil War period in this country are all outstanding examples of the bell-shaped silhouette. In this century the look was popularized by Christian Dior's "new look," appearing in the 1940s as a reaction to the austerity of wartime apparel. The bouffant look was also popular among couture designers such as Balmain and Charles James for formal ball gowns. Even today, this look is frequently seen in the imaginatively outlandish collections of Christian Lacroix.

The *back-fullness* or *bustle silhouette* looks as the name indicates: the fullness of the bouffant look is pulled toward the back. (See Figure 1-9.) This look was popular in ancient Crete, at the end of the eighteenth century in Europe, and again towards the end of the nineteenth century in Europe and the United States. It has also been used in this century by designers such as Balançiaga, Dior, and Ungaro for dramatic evening wear.

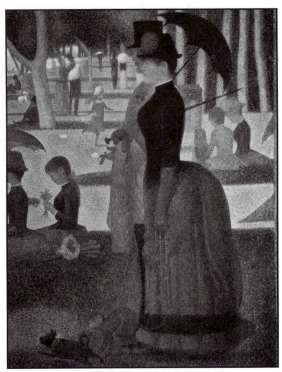

Figure 1-9. The importance of back-fullness to 19th century Parisian fashion is wonderfully portrayed in this detail of Sunday afternoon by the river bank by Seurat. (© 1992 The Art Institute of Chicago. All rights reserved.)

Color

Sometimes the first thing we notice about a fashion is its color, particularly a bright gold and red or another warm color combination that catches our eye. In each society, colors have their own meaning. In our society, for example, white stands for purity and black for mourning or sophistication. Red is associated with passions from love to anger, and blue with loyalty (true blue) or sadness (feeling blue). In other societies, colors have different meanings; for example, in India the color of mourning is white. Some colors are warm and seem to advance toward us, such as yellow and orange; other colors are cool and seem to recede from us, such as blue and green.

Today, fashion producers have a wide palette of colors from which to choose, thanks to companies known as color forecasters, devoted just to researching color and offering their color-trend analyses to the apparel and other industries. Thus, each season's color selection moves forward from the previous season, providing manufacturers and stores with fresh new looks for customers. The planning for a new season's colors starts two years ahead of the time the finished garments are seen in the stores.

Texture

The **texture** of a garment is the way it feels, due to the fiber or the method used in constructing the fabric. A wide range of textures is available for fashion apparel,

Going
TO
MARKET

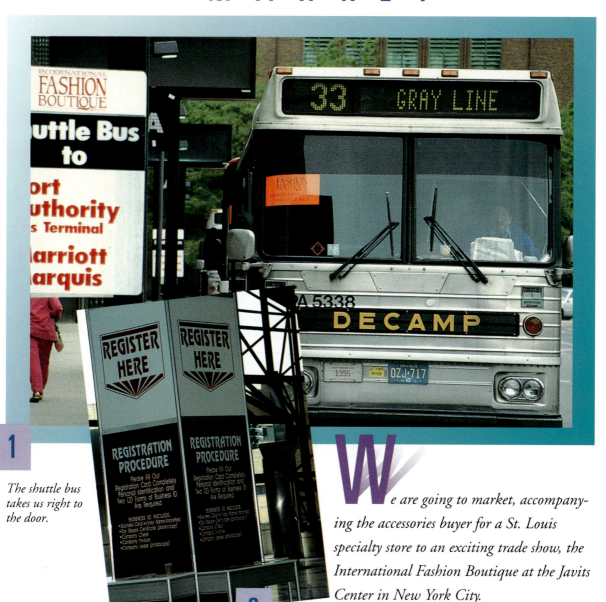

1

The shuttle bus takes us right to the door.

2

Registration this way.

We are going to market, accompanying the accessories buyer for a St. Louis specialty store to an exciting trade show, the International Fashion Boutique at the Javits Center in New York City.

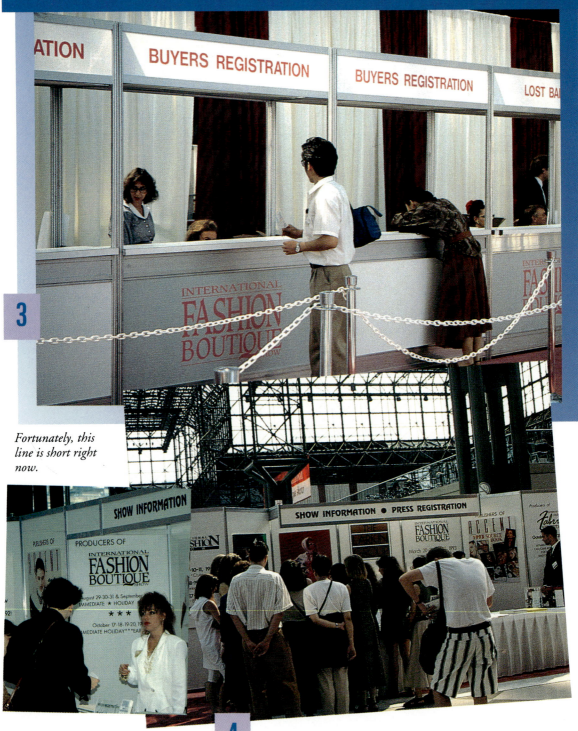

3

Fortunately, this line is short right now.

4 Next, we line up to get information about the vendors we want to see. But what have we done with the ticket?

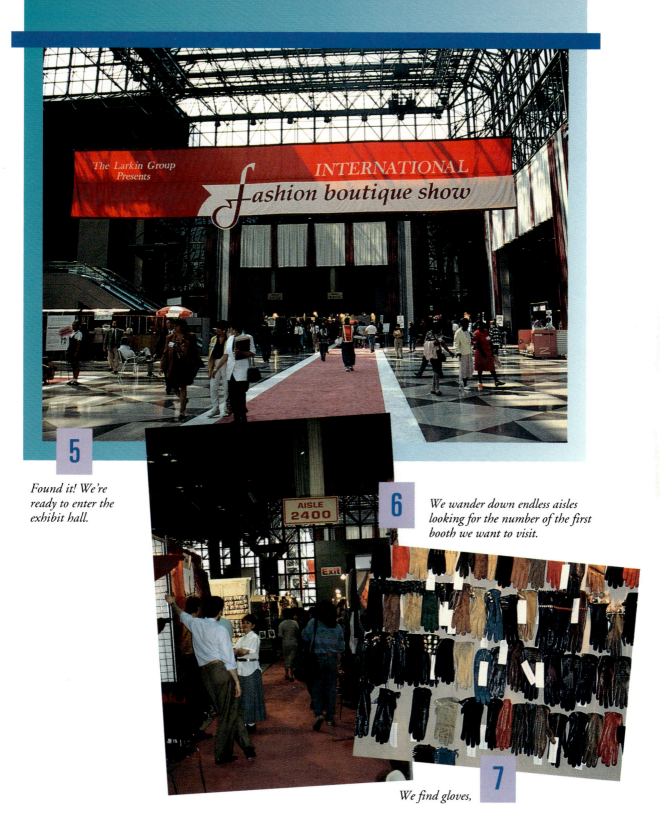

5

Found it! We're ready to enter the exhibit hall.

6

We wander down endless aisles looking for the number of the first booth we want to visit.

7

We find gloves,

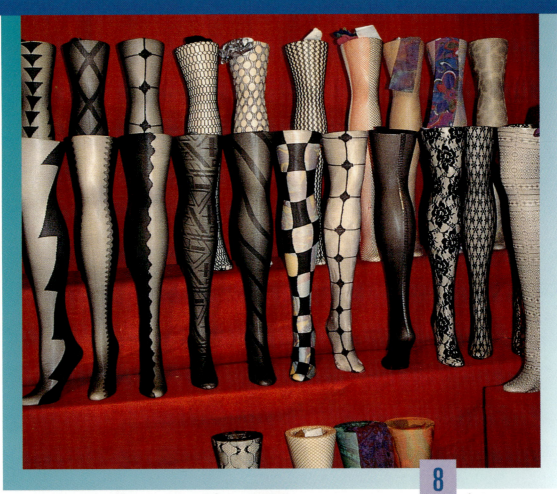

hosiery,

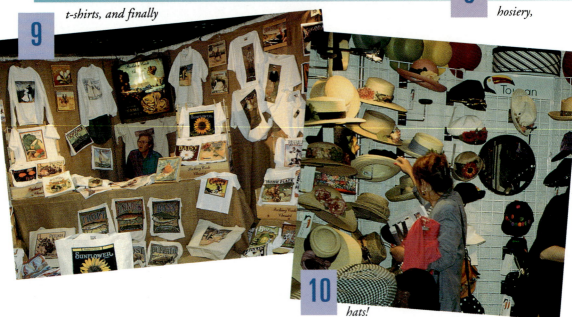

t-shirts, and finally

hats!

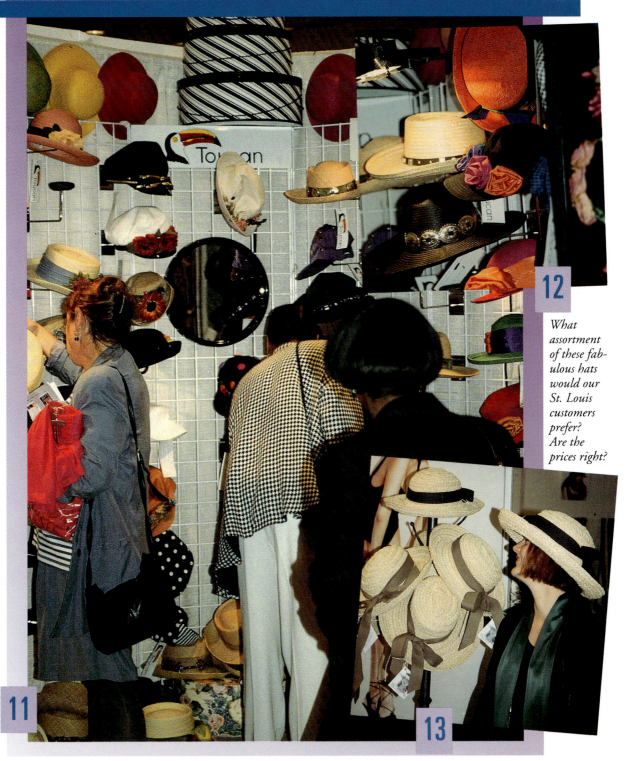

12

What assortment of these fabulous hats would our St. Louis customers prefer? Are the prices right?

11

13

Other buyers are already crowding this millinery booth. We join them.

After agonizing over many great styles, we finally settle on THE ones.

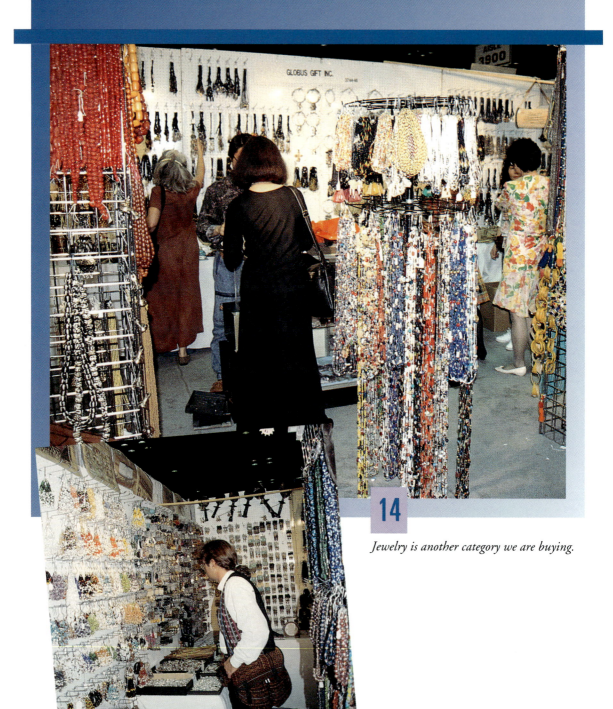

14

Jewelry is another category we are buying.

15

The number of booths is amazing.

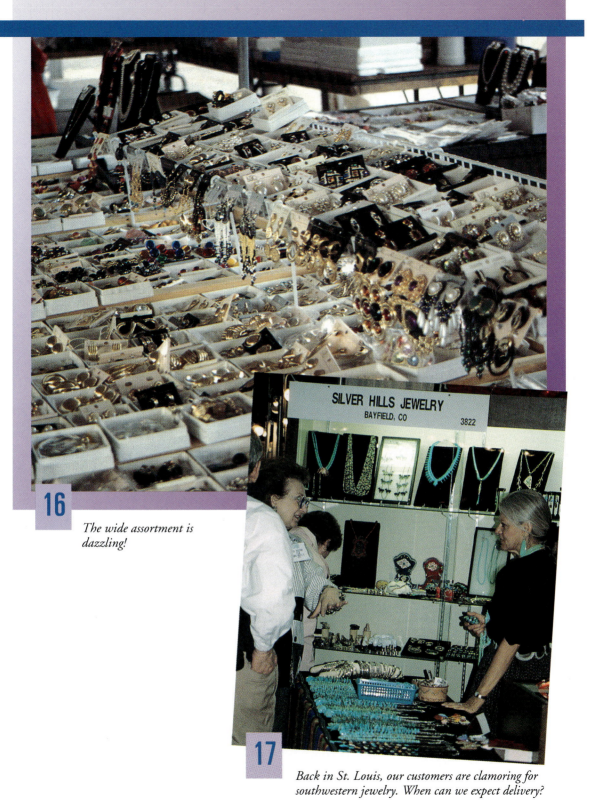

16

The wide assortment is dazzling!

SILVER HILLS JEWELRY
BAYFIELD, CO 3822

17

Back in St. Louis, our customers are clamoring for southwestern jewelry. When can we expect delivery?

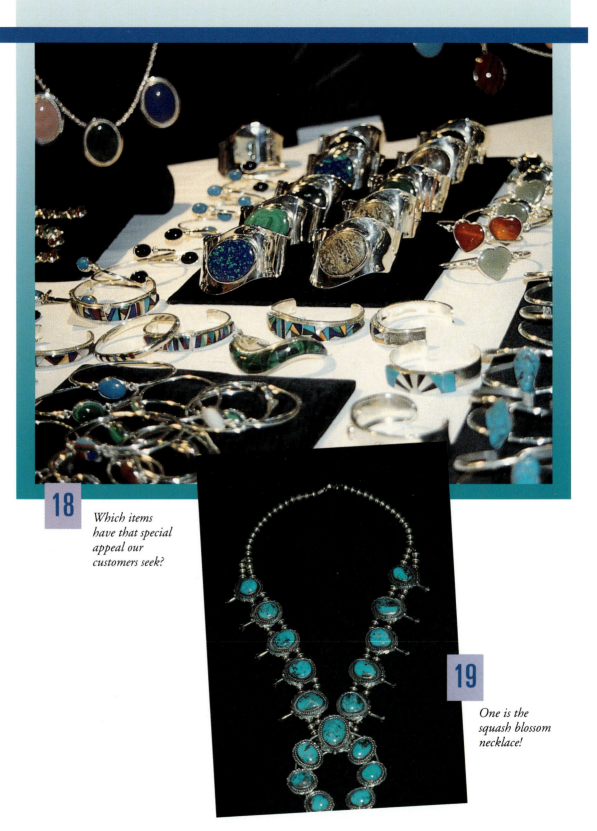

18 *Which items have that special appeal our customers seek?*

19 *One is the squash blossom necklace!*

including: smooth sueded silks, flowing chiffons, soft cashmeres, rough tweeds, and nubby linens. The texture of a garment creates a distinct look on the wearer. For example, a linen suit has a crisp appearance, whereas a denim one has a sturdy look and a wool gabardine appears smooth and durable. Textures also influence color. For example, sapphire blue velvet, because of its pile, looks richer than a similar blue in chiffon. Fiber manufacturers and textile mills offer a varied selection of textures each season for designers to turn into garments featuring a particular look.

Details

Details include the finished characteristics of the garment, such as the type of neckline, sleeve treatment, length and width of sleeves, skirt or pants, and trimmings. Trimmings are embellishments of any kind, such as buttons, braid, embroidery, zippers, lace, art work, and sequins. Details are important because they are an easy way to alter a garment and make noticeable differences. A slight change in details can propel a successful look into a new season. For example, changing the neckline or sleeve length of a sweater or blouse, or adding braid or embroidery to a suit or dress can create a freshness that appeals to customers.

The four elements of fashion in apparel thus combine to permit manufacturers and marketers to describe precisely each garment. (See Figure 1-10.)

Change and Obsolescence—Inherent Fashion Components

Some say there are two certainties about life: death and taxes. But there is a third: changes in fashion. Although we do not like to think about it, some day we will all die; until then we all pay various kinds of taxes; and we know for sure that next season's fashions will differ from those that are popular now. Fashions change because peoples' ideas about social behavior, political events, and leisure activities—among other things—change. For example, over the past several decades women in vast numbers are

Figure 1-10. The elements of fashion—silhouette, color, texture, detail—together create a unique look as seen in this style by Bill Blass. (Courtesy Bill Blass Ltd.)

participating in the economy through employment. Many are dedicated to their careers and working to advance in their fields. Generally speaking, when women began to aim for executive positions, they were entering new territory and may have felt insecure; they adopted the tailored-suit, hoping that the look would encourage male executives (their bosses) to take their work seriously. Now that many women have gained prominent status in business, they feel more secure and able to express themselves more freely; for example, by wearing the softer looks of dresses if they so choose.

Fashion changes often take place because of technology. The development of a range of fibers has made possible a variety of garments with versatile characteristics, such as non-run hosiery, washable velvets, and rainwear that repels water but lets the air circulate. Improved technology also contributes to the spread of new fashion information and speeds its acceptance. Think how easy it is to see on the televised evening news the latest outfit of a celebrity or important political figure. Or note how easy it is to learn about the newest designer creations by reading the newspaper or flipping the pages of a current fashion magazine. Computer technology in the industry helps retailers quickly reorder needed merchandise from suppliers.

The Fashion Life Cycle

Fashions, like other products, have a life cycle. (See Figure 1-11.) A **fashion life cycle** is the length of time a given look is popular. It consists of four parts:

1. introduction
2. rise
3. peak
4. decline and obsolescence.

A new fashion look may be introduced in a designer's salon or in the halls of a local school or office. A designer may come up with a new jacket and pants outfit that is an immediate success; or someone in your school may have a new way of wearing a scarf, arranging jewelry, or lacing shoes. If people like these ideas and they catch on, then a fashion is successfully introduced.

Introduction. The business of introducing new fashions is seen most readily at a designer's fashion show of new apparel for the coming season, most often at the highest prices or couture level. Some of the looks that the designer shows may gain immediate acceptance and be copied at many price levels. Others are not popular and are discarded right after their introduction. A fashion is launched successfully when people want that particular look. Successful introductory fashions are carried by exclusive stores such as Martha's in New York, Ultimo in Chicago, and MAX in Denver.

Rise. When a look is wanted and people decide to buy it, the fashion life cycle enters the rise period; that is, a time when the look is growing in popularity. In the early rise phase, the popularity of an introductory style spreads, usually first to the higher-priced specialty stores such as Saks and Neiman Marcus. At this point, the style begins to be widely copied, first at higher prices, then very rapidly at lower price levels.

The rise phase is implemented by the knock-off specialists. The industry term for copy is "knock-off." Some apparel makers are famous for their copies or "knock-

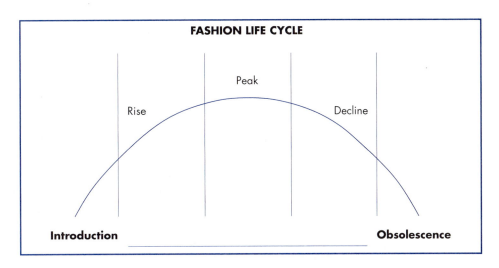

Figure 1-11. Every fashion has a life cycle. Some last for years, others only a few weeks.

offs" of high fashion apparel; one of the best known is Victor Costa of Dallas. His garments are in stores such as Bloomingdale's and Dayton Hudson at a fraction of the price of the European designers he copies. Some copies are exact duplicates of the original designer garment; these are called **line-for-line copies.** Other copies incorporate the general look of the original garment by selecting one or more features to duplicate such as a neckline or skirt treatment. Copies incorporating one or two features of the original are known as **adaptations.**

As the popularity of a style becomes more widespread, it is copied more widely and enters the late rise phase as it is seen more and more frequently in the full-price department and specialty stores such as The May Company and The Limited.

Peak. A look or fashion is at its height of popularity during the peak phase of its life cycle. At this point it is widely available in all price ranges and may be found in popularly priced department and chain stores such as J. C. Penney, Montgomery Ward, and Kohl's. At peak, it may also be found in discount stores such as Target and Venture. During the recent peak phase for the bright jacket ensemble look, bright jackets with dresses or skirts and blouses could be seen the same season at higher priced specialty stores such as Saks and Nordstrom and also in lower priced lines at Sears and K mart. A fashion look may have a short peak period such as neon-colored sweat shirts, or an extended one such as jeans and athletic shoes.

Decline and Obsolescence. A fashion or look in its decline is no longer readily available, and if it is, it is found in lower priced lines. Retailers are not interested in restocking it but rather in putting it on sale to move it out of the store. Stores offering merchandise in the rise phase of the fashion life cycle will have already turned to newer looks. At the end of the decline phase, the look is out-of-date, or obsolete, and of no immediate concern to the fashion industry, provided the supplies are gone. The

look may then be forgotten or, somewhere down the line, it may be reintroduced in a modernized version. As one example, the fashions of the early 1990s copied some of the looks of the 1960s such as the baby doll dress, but with new colors and details.

Timeliness

One of the ingredients for a successful fashion is that it must be timely; that is, appropriate and in good taste when it appears on the fashion scene. Many a fashion designer has introduced a new idea, a short skirt or full palazzo pants for example, only to learn customers were not yet ready for that look. These designers were ahead of the times. Sometimes the designers abandon the idea for the moment and return to it later when it seems more acceptable. Contrary to some beliefs, designers and manufacturers do not determine fashions; consumers do by buying and wearing certain looks, which they believe appropriate at the time.

James Laver studied the timeliness of fashions as people viewed it. The theory he developed is known as Laver's Law, a timetable of fashion. He noted how people felt about a fashion before, during, and after its time. The following is his classification list:

10 years before its time = indecent
5 years before its time = shameless
1 year before its time = daring
during its time = smart
1 year after its time = dowdy
10 years after its time = hideous
50 years after its time = quaint
100 years after its time = romantic[11]

The Seasons

What the fashion industry wants to do is to identify **fashion trends,** those looks that are timely and coming into fashion popularity. Identifying fashion trends is important to fashion businesses because they are then able to put the marketing concept to work; that is, manufacturers can create and retailers can stock goods that customers want. To do this, the industry has set up fashion seasons. A **season** is a selling period with new merchandise introduced at the beginning of each season. There are two major seasons in the fashion industry, each 26 weeks in length: February through July and August through January. Different segments of the industry have different seasons within these periods. For example, men's wear manufacturers have two seasons, fall and spring. Women's wear manufacturers may have four or five seasons, beginning with the fall, when the biggest changes occur, including: fall I (transition) and fall II; holiday; cruise or resort; spring I and spring II (summer). Organizing by season permits manufacturers to have an orderly schedule of merchandise presentation and allows store buyers the opportunity to plan their buying so that the merchandise is in the stores when the customers begin to ask for it.

RALPH LAUREN

Chairperson and CEO
Polo Ralph Lauren Corporation

Known throughout the world for his classic American fashions, Ralph Lauren oversees a business netting an estimate of over $3 billion in annual sales in designs for men, women, children, and homes. A business person by college training and retailing experience, early on Lauren sold neckties for Beau Brummel tie company. He began to realize that customers were ready for a change from the narrow neckwear they had been tied with, and he turned to designing four-inch patterned ties, which were an immediate success. He believed he could be successful in designing men's wear and he formed his own company, naming it "Polo" after the exclusive sport. Here, using superb fabrics and construction, he turned out a complete line of men's wear, including shirts, outerwear, and shoes. The timeless look of his styles was soon in great demand. Today his men's wear lines are licensed for manufacture in various countries worldwide under the "Polo" and less expensive "Chaps" labels.

In 1971, he ventured into designing women's wear, beginning with a group of tailored shirts based on designs of men's shirts. Soon he added slacks and shorts, sweaters, trench coats, and pajamas, all carefully crafted after classic men's wear. Before long Lauren's name spread even further through his costumes for films, beginning with *The Great Gatsby* and its opulent setting in the days and nights of the "roaring '20s." Customers wanted the easy yet delicate look of the pale straight dresses. In 1978 Lauren created the costumes for Woody Allen's film, *Annie Hall,* outfitting Annie in oversized men's shirts, jackets, and hats. Again, customers soon clamored for their own versions of the "Annie Hall look." Meanwhile, his women's wear line expanded to include four lifestyle groups. One of these, "Classics," concentrates on timeless American sportswear and fine men's wear looks such as tweed hacking jackets, fine pleated flannel pants, hand-knit sweaters and broadcloth cotton shirts. "Ralph Lauren Womenswear" is produced through licensing agreements in a number of countries throughout the world.

> *"There will always be a new challenge ahead, something to learn about. I love discovering new worlds. I want to perfect my craft. You can never sit back and think you've done it. There will always be room for improvement." Ralph Lauren*

continued

Ralph Lauren turned his attention to children's wear by introducing "Polo for Boys," including sportswear, blazers, shirts, and sweaters. He then followed with a line of girl's wear containing smock dresses with lace collars, pinafores, tweed jackets, and corduroy jeans. Fragrances such as Polo and Safari, swimwear, scarves, hosiery, accessories, and luggage are among the company's apparel and accessories offerings. In 1983 he added "The Ralph Lauren Home Collection," including furniture, blankets and bedding, bath and beach towels, and tableware. These items are marketed in department and specialty stores throughout the United States.

Ralph Lauren has a growing network of stores around the world that offer Polo/Ralph Lauren products exclusively. In April 1986, he opened the company's flagship store in New York City's restored Rhinelander mansion on Madison Avenue and 72nd Street. The store is a showcase for Mr. Lauren's lifestyle philosophy, where his creations—clothing, accessories, home furnishings—are presented in their own theme environments. Polo/Ralph Lauren stores are located in California, Arizona, Kansas, Oklahoma, Florida, and Washington, among other places. Countries such as Canada, Britain, France, Brazil, Argentina, Japan, and Korea are home to a few of the company's international stores.

Throughout his successful career, Ralph Lauren has received many awards, the most notable in 1992, when, after 25 years in the fashion industry, he was awarded the Council of Fashion Designers of America (CFDA) Lifetime Achievement Award. Other honors include: the Coty Hall of Fame Award for both men's wear and women's wear; the Cutty Sark Career Achievement Award; and an honorary doctorate degree from the Pratt Institute. Ralph Lauren is active in a number of cultural and charitable organizations, a major fund raiser for a new wing for the Museum of American Folk Art, and contributor to work on the behalf of needy children, and cancer and AIDS research.

Question for Discussion. In what ways are Ralph Lauren's college education in business and experience in retailing useful to him today as a designer?

Sources. 1. Lisa Lockwood, Bridget Foley et al., "Ralph Lauren at 25: Silver Threads, A Pot of Gold," *Women's Wear Daily,* Fairchild Publications, New York, January 15, 1992, pp. 1, 4–6; 2. Paul Goldberger, "25 Years of Unabashed Elitism," *The New York Times,* February 2, 1992, pp. H1, 34; 3. Press kit and publicity materials from Donald Fish, Publicity Associate, Polo Ralph Lauren Corporation, February 12, 1991; 4. Caroline Rennolds Milbank, *New York Fashion, The Evolution of American Style,* Harry N. Abrams, Inc., New York, 1989; 5. Kathleen Boyes, "Ralph Lauren Telling Stories," *Womens Wear Daily,* Fairchild Publications, New York, October 24, 1988, p. 31.

Summary

1. Fashion is what is currently popular; that is, the styles that people are buying and using now. Customers and consumers create fashions by wearing them.
2. Fashion is also a business. Fashion businesses include manufacturers of fibers, fabrics, and apparel, and marketers of apparel and fashion information. When businesses determine what customers want and how they can best provide them at a profit, they are using the marketing concept. The planning that goes into having the right goods at the right time and place in the right quantity and at the right price is called "fashion merchandising."

3. Fashion is important because it provides a means of self-expression, it contributes to the economy, and it documents the times. A style differs from a fashion in that while a fashion indicates acceptance of a look, the style is the distinctive appearance of an item that makes it unique. A design is a certain version of a style.

4. The four elements of fashion are: silhouette, color, texture, and details. The silhouette of a garment is its shape. There are three basic silhouettes: straight, bell-shaped, and bustle. Colors bring special meanings to fashion. A wide range of colors is available for apparel manufacturers, and colors change slightly each season. Texture is the way a garment feels. A variety of textures, from rough tweeds to flowing chiffons, is used in apparel. Details include the treatment of neckline, sleeves, and hems of garments and the trimmings, called "embellishments," such as buttons, braid, and embroidery.

5. Fashions change because peoples' ideas change and because of technology such as the introduction of new fabrics and the rapid dissemination of fashion information through television and other media. The length of time that a fashion is popular is called "the fashion life cycle." There are four parts to the fashion life cycle: introduction, rise, peak, and decline and obsolescence. To be successful a fashion must be timely; that is, appropriate for its times. To obtain an orderly introduction of new fashion merchandise, the industry is organized into two major seasons, spring and fall.

Fashion Vocabulary

Explain each of the following terms, then use each term in a sentence.

adaptations	fashion life cycle	marketing concept
classics	fashion merchandising	retailers
consumer	fashion trends	season
customer	high fashion	silhouette
design	line-for-line copies	style
details	manufacturers	sumptuary laws
fads	marketers	texture
fashion	marketing	volume (or mass) fashion

Fashion Review

1. Who determines fashion and how is it done?
2. What are the two major kinds of businesses in the fashion industry and why do those applying the marketing concept tend to be more successful?
3. Cite three reasons why fashion is important.

4. Explain the four elements of fashion and for each give two or more examples of what is popular today.
5. Explain the fashion life cycle and identify each of its phases; then state the importance of timeliness and the fashion seasons to the fashion industry.

Fashion Activities

1. Write a paragraph explaining how individuals use fashion as a means of self-expression. Select two or three people: celebrities, business or school acquaintances, or friends, and without identifying them as such, describe how they use fashion as a way of expressing their personalities.
2. Draw a diagram of the fashion life cycle and label each of its four phases. Identify eight or ten examples of current fashions and place them on the fashion life cycle, locating at least two for each phase. With your instructor's permission, you may illustrate your diagram with your own drawings or pictures from fashion magazines or merchandise catalogs.

Endnotes

1. Elizabeth Ewing, *History of 20th Century Fashion,* Barnes & Noble, Totowa, New Jersey, 1986, p. 3.
2. Paul Nystrom, *Fashion Merchandising,* The Ronald Press Company, New York, 1932, p. 35.
3. Leonard Bernstein, *West Side Story,* 1961.
4. Leslie Jane Nonkin, "Vogue's View: Fall Preview," Vogue, April 1991, p. 162.
5. Alison Lurie, The Language of Clothes, Random House, New York, 1981, pp. 115–16.
6. *Survey of Current Business,* United States Department of Commerce, Bureau of Economic Analysis, Vol. 71., No. 3, March 1991, Table 2.2, p. 10.
7. *United States Statistical Abstract,* 110th edition, U.S. Department of Commerce, Washington, D.C., 1990, Table 1362, p. 772.
8. Prudence Glynn, *In Fashion: Dress in the Twentieth Century,* Oxford University Press, New York, 1978, p. 14.
9. Paul H. Nystrom, *Op. cit.,* p. 33.
10. Agnes Brooks Young, *Recurring Cycles of Fashion,* Cooper Square Publishers, New York, 1966, p. 3.
11. James Laver, *Taste and Fashion,* revised, George G. Harrup & Co. Ltd., London, 1946, p. 202.

The Fashion Consumer

Objectives

After completing this chapter, you should be able to:

1. Identify the five principles of fashion and describe how consumers establish them.

2. Define *market segmentation* and describe three systems based on demographics or psychographics that are useful to fashion businesses.

3. State the effect of cultural, social, and personal influences on consumer buying behavior.

4. Describe the contributions of motivation to buying behavior.

5. Explain the six steps in the buying decision process.

*T*he wedding was in a small town about 30 miles outside of Dallas. Amazingly, everything had gone well for the bride and her bridesmaids; their gowns were ready as promised and they were spectacular. It was the mother of the bride who was experiencing some difficulty, and not just the emotional kind that can accompany a daughter's marriage.

Several months ago in anticipation of the wedding, the mother had gone to a favorite Dallas store and decided to order a designer dress. She waited anxiously for it to arrive at the store, and when it did—just a day before the ceremony—everyone could tell that although it was most appropriate, some alterations were essential.

"Oh, dear," she said disappointedly to the salesperson. "It can never be ready in time, and I have too much to do before the wedding to make the trip back to the store again."

"Don't worry," said the salesperson. *"The dress is just right for you. We will alter it and have it at your home ready to put on by three o'clock tomorrow, in plenty of time for the wedding. You can count on it."*

That afternoon and the next morning, the alterations were completed and the dress was pressed. A hired van was brought around and a line strung up in the back. The dress, freshly covered with tissue, was hung on the line. The store's assistant manager climbed into the back of the van and, watching the dress to be sure it stayed securely on the line, made the 30-mile trip to the bride's home. Once there, she helped the bride's mother prepare for the wedding, making certain that the dress fit and looked as intended. Only at that point was she satisfied that she could return to the store.

The Importance of Consumer Acceptance

As we saw in Chapter 1, in order for a style to become a fashion, people must accept and wear it. In this chapter's opening story, the bride's mother knew when she first saw the designer dress several months earlier that it was just what she wanted. For the mother and most likely for some of her friends, too, the look was a significant fashion.

The store knew that the dress would truly meet the mother's original purpose only if it were ready for the wedding. In making certain that the dress was there when she needed it, the store applied the marketing concept that you read about in Chapter 1. Understanding the customer's need, the assistant manager made certain that it was there and ready as promised. Fashion businesses are fully aware that customers and consumers determine fashions as they choose what to wear. This is the first principle of fashion.

Acceptance: The Basis for the Principles of Fashion

There are five recognized principles of fashion, all of which have developed from the idea that consumer acceptance creates fashion. The five principles are shown in Table 2-1.

1. *Consumers establish fashions as they decide what to buy and wear.* Only when groups of people are wearing a certain look does it become a fashion. Although the work of fashion businesses each season is to bring forth many fresh ideas that they hope will become fashions, the power of deciding which looks and items will turn into fashions rests solely with the customer and the consumer.

2. *Price alone does not make a fashion.* The determining factor in creating a fashion is not price but whether a group of people adopt it for themselves. A fashion is not always an expensive dress. Rather, a fashion look may begin when someone decides to wear a scarf a new way, tie a sweater around the shoulders, or, as happened in recent summers, put on a white cotton tee shirt with a summer business suit. When others also adopt the idea at whatever the price level, then it becomes a fashion.

Table 2-1 The Principles of Fashion

1. Consumers establish fashions as they decide what to buy and wear.

2. Price alone does not make a fashion.

3. Fashions evolve gradually, not suddenly.

4. Marketing and promotion cannot change the direction of a fashion.

5. All fashions end in excess.

3. *Fashions evolve gradually, not suddenly.* Each season the silhouette may change to some degree; colors and textures vary slightly from those of the past season; and details, for example skirt lengths and trimmings, will be a bit different from the past season. Most consumers are not willing to rush out and buy complete wardrobes whenever a new look appears, but will gradually add new items.

 Only once in a while do fashions change radically. One classic example occurred during the French Revolution over 200 years ago when the citizens—fed up with centuries of courtly elegance paid for by their taxes and misery—did away with the nobility and its finery. The newly empowered citizenry, severing ties with the past, quickly adopted plain apparel that reflected their own values.

4. *Marketing and promotion cannot change the direction of fashion.* Although fashion information spreads instantaneously around the globe through television and nearly as rapidly through other media, such as newspapers and magazines, marketing is not capable of altering the direction in which fashions are heading. For example, one time when fashion businesses were promoting short skirts, women did not want and would not buy them. It was not until a couple of years later that a number of women decided they were ready for shorter skirts and started buying and wearing them. For decades, the millinery industry has hoped that women would again include hats as part of a fashionable wardrobe; despite the industry's promotional efforts over the decades, only recently have some women decided to wear hats again. Only consumers determine the direction in which fashions are going.

5. *All fashions end in excess.* When a fashion is successful, it can be seen in various versions until people tire of it. Typically, the versions become more and more ornate, or the look is seen everywhere until people have had enough. Consider decorated sweaters. When they first appear, the decorations, beading, or patterns are small such as border treatments around the neckline and wrists. As the seasons progress, the decorations, beading, pearls, feathers, bits of leather, and rhinestones become more elaborate and the patterns larger, often occupying the entire front and back of the garment. Finally, decorations lose their popularity and are no longer in fashion.

Targeting Consumers by Segmenting Markets

Customers are the reason businesses exist and the goal of every business is to earn a profit. Profits enable a business to continue and grow over the years. Fashion businesses are no exception. In the highly competitive, rapidly paced apparel field, earning a profit is not easy. Nevertheless, a number of fashion businesses manage to flourish; among them, designers and manufacturers such as Liz Claiborne and the Jones Apparel Group; and retailers such as Dillard's stores, The Limited's Victoria's Secret, and Clothestime. The basis for the success of businesses such as these is that they know their customers and they apply the marketing concept. They determine what the customer wants that they can best provide at a profit.

Since the customer is the real determiner of fashion, the first responsibility of a fashion business is to identify its customers. Part of the marketing concept indicates that no business is able to serve all customers, so in order to succeed a business must first decide upon those customers it is best geared to serve. When a business aims to attract a specific type of customer, it is practicing **target marketing**.

In order to find a particular target market, businesses practice **market segmentation**; that is, dividing the total population into smaller, more similar groupings or market segments. A market, in this sense, is a group of people with money to spend and the willingness and power to spend it. It is the task of each business to determine its potentially most-profitable market segments. For example, Clothestime, a retail chain specializing in trendy apparel for juniors, decided through market segmentation that its target market is young women interested in upscale fashions at reasonable prices.

There are a number of ways to find similar groupings through market segmentation, and no business relies on one method alone. In fact, a business could make serious mistakes by using just one source of information. For example, during a recent recession when most businesses were feeling the pinch of reduced sales volume, a women's specialty store located in an affluent urban area experienced the best season in its history. Many of its customers were professional women from double-income families whose jobs were not affected by the recession. Had that store measured only the general economic climate, the buyer never would have purchased the assortment of garments responsible for the dramatic sales increase. There are a number of ways of segmenting markets and many businesses employ methods from various sources. Two popular methods of market segmentation are demographics and psychographics.

Market Segmentation Using Demographics

The term *demographics* is popular among marketers today but it has ancient origins; it means the study of people. Today's term **demographics** means the study of people based on measurable statistical information such as income, occupation, and geographic location.

Both government and private organizations develop demographics that are useful to fashion businesses. One of the most useful government studies is the census, the

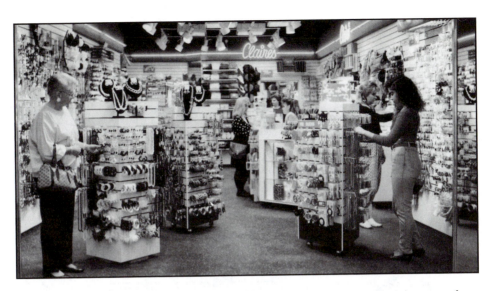

Figure 2-1. This popularly priced jewelry and accessories store targets several groups of customers through its products and visual merchandising. (Courtesy Claire's Stores)

national population count, which is taken every 10 years. Census reports yield figures on population distribution, occupations, and income among other information. Many businesses use this information to find out where their customers are living, what they are doing, and the amount of money they have to spend on fashion goods.

Private organizations conduct studies at the request of business clients who want to obtain current data on topics related to their specific needs. For example, one private organization, a New York research firm called Find/SVP recently completed a study based on demographics entitled, "Marketing to Women in the 1990s." One of its findings indicates that the concern that many women have for the environment reveals itself in the kind of apparel and cosmetics they buy.[1] Through such studies the fashion industry becomes alert to customer preferences; in this instance, for fabrics made under environmentally safe conditions and cosmetics from natural ingredients. Alert organizations respond quickly to research findings. For example, in the manufacture of some men's jeans, Levi Strauss uses Fox Fiber developed by entomologist Carol Fox, featuring cotton grown from colored seeds; color right from seeds eliminates the fabric dyeing process and accompanying pollution risk.[2] The Estée Lauder cosmetics organization launched a product line called "Origins," made from natural ingredients.

How Fashion Businesses Interpret Selected Demographics

Properly used, demographic information can help businesses put the marketing concept to work by identifying target markets and supplying information about them.

SPOTLIGHT ON A FIRM

CLAIRE'S STORES, INC.

Operating nearly 1000 stores in 47 states in the early 1990s, and intending to double that figure by mid-decade, Florida-based Claire's Stores offer costume jewelry; fashion accessories, such as hair ornaments and handbags; and trendy gifts and graphic art. Organized into three subsidiaries, Claire's Boutiques, Dara Michelle, and Decor, the company believes it is the largest chain of popularly priced fashion accessory stores in the nation. Most of the stores are in major shopping malls.

Claire's accounts for more than two-thirds of the company's stores with its "Claire's Boutiques" and "Arcadia" stores. Claire's Boutiques offer popularly priced jewelry and other fashion accessories to women ages 14 to 40. Arcadia stores sell cards, stationery items, and gifts. Dara offers higher-priced accessories in its "Dara

Michelle" and "Topkapi" stores. Decor operates a group of stores offering art posters, graphics, and lithographs.

By far the largest volume of sales is in jewelry, hair ornaments, and other fashion accessories. Dur-

ing a recent recession when apparel sales were low, women still purchased costume jewelry and accessories. According to Charlotte G. Fischer, former President of Claire's Boutiques, "Accessories such as costume jewelry, scarves, and handbags sell well because women can make an outfit that was previously worn look like a stunning, new outfit."

Claire's Stores, with bright lights, Italian tile, and displays designed to show a variety of merchandise in a small area, are planned to appeal to mall shoppers. The company defines its target market as consisting of four segments: Ms. America, age 18 and up who is seeking beads, bangles, and earrings; teenagers who are searching for fads and other "fun" jewelry and accessories; career women who want more classic jewelry and for whom Claire's Collection is designed; and infants and children up to age five, for whom a "Kids' Klub" is organized.

To obtain merchandise for the stores, Claire's employs buyers who purchase from over 1000 suppliers with sources throughout the world. All merchandise is shipped to the company's distribution center in Wood Dale, Illinois, near Chicago, where it is inspected and then for-

warded to the stores. The accessories business is highly competitive and Claire's Stores compete with discount and costume jewelry stores as well as department and women's apparel stores. Nevertheless, Claire's major plans include: expanding into the nation's leading shopping malls; modernizing its existing stores to keep in touch with its target market; and providing customers with desirable merchandise at prices representing value and encouraging repeat business.

Question for Discussion. Why is it important for Claire's Stores to target several market segments?

Sources. 1. Lisa Collins, "'Cheap and cheerful' strategy fuels Claire's explosive growth," *Crain's Chicago Business,* February 25, 1991; 2. Claire's Stores, Inc., *Annual Report 1990;* 3. Form 10-K.

For the fashion industry, some useful demographic studies yield information on the following:

- population growth
- gender
- income
- age
- race
- education
- occupation
- geographic location.

Population growth. There are some 250 million people living in the United States today, but the total population is growing more slowly than in the past.[3] Of these, approximately 125 million are employed; 68 million men and 57 million women.[4] Well over half of all women of working age are employed and the number continues to rise. By the year 2000, estimates are that 77 percent of all women between the ages of 20 and 24 will be employed.[5]

The size of the average family has declined, yet because there are a large number of women of child-bearing age, there are more children and families with children.[6] Some implications of these population trends for fashion merchandisers are obvious. For example, the total apparel market is growing slowly. It seems that men have a fairly constant need for apparel for work, although the styles are increasingly more casual. The number of employed women, however, has risen dramatically in the past half century. Women's need for career apparel becomes more evident as fashion businesses examine other information such as the growing number of women in higher echelon professional and managerial occupations. At the same time, even with smaller families, the need for children's wear is on the upswing because the total number of families with children is larger.

Gender. In the fashion industry, often one of the first ways target markets are identified is by gender. Apparel manufacturers segment markets by sex. Typically a design or manufacturing organization such as Calvin Klein or Hartmarx has separate men's wear and women's wear divisions. The apparel departments in most retail stores are organized according to whether they are for men or for women, such as men's suits or women's coats. Some businesses started out geared to one sex and then expanded

to serve both. Barneys and Brooks Brothers both began as men's stores and then expanded to offer women's wear. Donna Karan first designed for women and then added a men's line; Ralph Lauren designed first for men and then later for women also.

Income. With more women working, and more double-income families, there is a demand for some top-of-the line merchandise. Thirty percent of all working women hold professional and managerial jobs. While some women with money prefer exclusive apparel, not everyone wants or can afford high fashion. For example, around 3 percent of working women earn more than $50,000 a year. Many women still hold lower paying jobs, and in all occupations a woman earns an average of 68 cents for every dollar a man earns.[7] This kind of demographic information tells fashion businesses that, while the demand for exclusive apparel does exist, the needs of most women are for more moderately priced clothing. The manufacturers of moderate and higher priced apparel, such as Norton McNaughton and Chaus, respond by offering a wider selection of clothing in these price ranges.

Age. In the United States, the largest single age category is the former young and upwardly mobile group sometimes known as "boomers." They were born between the years of 1946 and 1964 known as the "baby boom years." The boomers, some 30 percent of the population, are now in their middle years, busy with work, travel, and leisure activities, and are spending heavily.[8] Older consumers, those over 50 years of age, however, make up the wealthiest segment of the population. The youth market is not growing as dramatically as in past years. Some implications of a mature population for fashion businesses are that styles may increasingly show the influence of the older customer and more new fashion ideas will stem from the needs of the mature segment of the population.

Race. The population of the United States is composed of many diverse racial groups and cultures. Twelve percent of the population is black, a significant market. Nearly 9 percent is of hispanic origin, the fastest growing segment, which comprised only 6 percent of the population a decade ago. Other rapidly rising groups include Asians, who make up nearly 3 percent of the total population.[9] In order to target the market of black professionals, the outdated stores in Atlanta, Georgia's venerable Greenbriar Mall underwent a complete makeover. Improvements included total refurbishing and bringing in upscale apparel that customers were requesting.[10] To reach its burgeoning Florida hispanic market, Burdine's 27 or more department stores advertise fashions in the newspapers but emphasize commercials on the state's half-dozen Spanish radio stations and two television stations.[11]

Education and Occupation. Today's consumer is better educated than ever before. Nearly a third of all working men and a quarter of all working women have a four-year college education.[12] About a third of all employed men and women are managers. A rapidly growing area for employment among both men and women is small businesses. Managerial and professional jobs can lead to higher incomes, and today

an education provides entry to these successful areas. Signs indicate that many people face a time-squeeze, which often includes working longer hours, sometimes at more than one job.[13] For many reasons, today's more educated customer is discerning and demanding, with an appreciation for style, an eye for quality and price, and less time to shop. Discerning fashion businesses recognize and respond to this range of consumer needs. For example, buyers for The Gap supervise style and quality control of the apparel it offers and management makes certain that fresh colors and styles reach the stores every eight weeks and are displayed to help make shopping easier.

Geographic Location. The fashion needs of people in one part of the country are different from those in another. People in the sunbelt states from Florida to California are not big buyers of heavy winter parkas, but people in New England and the midwest rely on them during the frigid winter cold. Men in cities, the mid-Atlantic and northeast ones in particular, make greater use of traditional business suits for work than do men in other parts of the country.

There are independent research firms that specialize in developing demographics based on geographic location. One of these is the Claritas Corporation, headquartered in Virginia. Claritas developed a system ranking the population of the United States into 40 segments based on postal zip codes. Called PRIZM (Potential Rating Index for Zip Markets), the system uses a number of variables such as stage in the life cycle, housing style, and ethnicity to create 40 distinct but flexible classifi-

Figure 2-2. This ad is an example of demographics useful to fashion businesses. What information could you gather here if you are planning to open a family apparel store? (Courtesy CMT Data Corp.)

cations. It supplies these zip code classifications with names such as "Money and Brains," "Blue Chip Blues," and "Shot Guns and Pick-ups."[14] Among the system's users were a contractor who consulted the system before locating the sites for building new shopping centers, and a fashionable department store that—after shifting its selection of designer dresses to branch stores in certain zip code categories—saw an immediate rise in sales.

Market Segmentation Using Psychographics and Other Information

The obtainable facts about our lives gathered through demographics yield fashion businesses one kind of information. People, however, are complex and have many influences on their lives and on what they buy. For this reason business researchers like to study what goes on "inside" consumers' minds, figuring out what people are thinking and feeling as well as what they are doing. This kind of study of people is known as **psychographics,** or, the study of consumers' attitudes and lifestyles. Some psychographic studies delve into peoples' activities, interests, and opinions; others are concerned with peoples' values and lifestyles.

One such psychographic system, called VALS (meaning values and life styles), sorts customers out as to whether their influences are primarily from within or stem from others. Of those motivated by others is a group called achievers, which make up around 20 percent of the population. According to VALS, "achievers" are interested in high-quality fashion goods with high-status names. Another much smaller group, more inner-directed, that is, influenced by their own feeling and opinions rather than others', is concerned with self-expression and experimentation, adopting

Figure 2-3. State-of-the-art point of sale registers permit fashion businesses to measure consumer acceptance of every product. (Courtesy Claire's Stores)

Table 2-2 The VALS System

According to the VALS system, the population may be divided into the following categories.

The Integrated

- about 2% of the population
- the elite of the customer base

The Inner-Directed

- nearly 20% of the population
- motivated from within, comprising:
 1. The I-Am-Me's—impulsive and experimental
 2. The Experientials—older innovators
 3. Societally Conscious—conserving consumers

The Outer-Directed

- almost 70% of the population
- influenced by others, including:
 1. Achievers—striving for success
 2. Emulators—"wanna be" successful
 3. Belongers—solid middle class group

The Need-Driven

- around 10% of the population
- mainly concerned with survival, including:
 1. Sustainers—eager to move up
 2. Survivors—poor, knowing hard times

fashions impulsively; they wore "punk" in its day.[15] Fashion businesses are interested in studying these groups in order to know how to appeal to them. For example, a designer's ad geared to achievers could emphasize a garment's luxurious fabric and stylish construction backed up by the designer's distinguished name.

A more recent method of market segmentation drawing on both demographics and psychographics was developed by Management Horizons of Dublin, Ohio, for its clients. Among its clients are apparel retailers, many marketing through catalogs and particularly concerned with creating special messages for specific target markets.

The Management Horizons system segments markets into six customer types based on their shopping behavior; specifically, how independent they are in reaching buying decisions, how receptive they are to change, and how impulsive they are in shopping. From this study it was determined that of the six shopper types, the three who spend most heavily on apparel are termed:

Progressive Patrons: young couples or middle-age families with higher incomes

Power Purchasers: consumers with high incomes who indulge themselves

Social Strivers: young women with lower incomes who spend a lot on clothes.

Linking up this information with other marketing research studies tells fashion businesses which customers prefer which retailers. For example, according to this system, Social Strivers are said to opt for buying their dresses at The Limited, while Progressive Patrons prefer Macy's. Armed with knowledge of the values and attitudes of particular market segments, fashion businesses are then able to closely target their advertising.[16]

Consumer Buying Influences

In buying fashions, consumers do not actively dictate what they want to designers and manufacturers. Rather, they react to each season's offerings by selecting only what they want. In this sense consumers create fashions in much the same way that society elects its officials, by voting for their choice. In making choices, there are a number of influences on customer buying behavior. These influences are cultural, social, personal, and psychological.

Cultural Influences

Cultural influences stem from our surroundings. They include the values that are passed on in our environment. For example, in American culture, along with independence and achievement, the qualities of efficiency, practicality, and comfort are among those valued. The fashion industry's appeals to these values can be seen in marketing a variety of fashion goods.

Other cultural influences grow out of our subcultures or racial and religious backgrounds. Race and religion can influence the way we dress and the choices of

Table 2-3 The Management Horizons System

From Management Horizons comes a system specifically related to fashion customers. Six shopper types are identified for use by fashion marketers:

- Social Strivers—Young women with low incomes who are into the latest styles; they buy a lot of apparel.
- Progressive Patrons—Young or mid-life couples and families with higher incomes. They buy heavily and pay top dollar for quality.
- Power Purchasers—Highest incomes and self-indulgent; they risk fashion innovations.
- Yester Years—Older women and young parents; they buy few clothes and respond to low prices.
- Dutifuls—The poorest group; they shop carefully and avoid risk. Most are mature shoppers who like low prices and guarantees.
- Fashion Foregoers—Men whose concern about their appearance is not a priority.

Of primary interest to fashion retailers are the Social Strivers, Progressive Patrons and Power Purchasers, all of whom spend extensively on clothes. Observe that the various retail organizations reach out to different target customers.

(Adapted from Management Horizons Division of Price Waterhouse, Dublin, Ohio.)

Figure 2-4. The fashion industry appeals to American culture values of efficiency, practicality, and comfort by offering sportswear to meet those needs. (Courtesy Tango by Max Raab for Boys)

specific fashion items. Fortunately, we are recognizing the importance of preserving traditions, and from time to time apparel influences from various cultures find their way into mainstream fashion. Batik patterns and African garments and jewelry are particularly popular in the summer as are the colorful prints of southern France that inspire the designer Christian Lacroix.

A third cultural influence on fashion is social class. While social classism in the United States is not rigidly inherited as in some parts of Europe and Eurasia, it does exist; but it is based more on wealth and occupation. The various social classes do have different tastes and incomes and these do influence their interest in and desire for fashions goods. (See Table 2-4 for a description of the six social classes.)

Social Influences

Social influences include those of family, friends, and co-workers. Certainly a family has a strong influence on the fashion choices of its children, particularly when they are young. Parents select the clothing for their very young children; indeed, parents are known to deny themselves a new or expensive fashion item in order to provide for their children. Or, a parent and a teenager may disagree on what is appropriate apparel for an important event. Since fashion is a form of self-expression, young people are often at odds with their parents in the matters of dress. On the other hand, many wives and husbands dress to please their spouses.

Table 2-4 Characteristics of Six Major American Social Classes

1. **Upper-Uppers** (inherited wealth and status)—People with prominent family and social backgrounds. They maintain more than one home, send their children to top schools, and contribute heavily to charity. They are customers for vacations, antiques, and jewelry. They may dress conservatively. Their buying decisions trickle down to the other classes.

2. **Lower-Uppers** (new wealth)—People who have earned high incomes from their professional or business occupations; they represent "new money." They tend to be active in social and community groups and buy status symbols such as expensive homes, yachts, and designer apparel. They want to move upward.

3. **Upper-Middles** (moderately high income)—Primarily concerned with their careers, they have achieved status as doctors, lawyers, or business executives. Strong believers in the value of education, they encourage their children to enter business management or the professions. They are civic-minded and join organizations. They are in the market for good homes, name brand apparel, and home furnishings.

4. **Lower-Middles** (traditional mainstream)—Mainly office workers, small business owners, and government workers, they aim for respectability. They adhere to the American work ethic, stay within the law, and attend a religious institution. The home is important and they are a major market for "do-it-yourself" home improvement projects. Their taste in apparel is conservative, neat, and clean rather than fashionable.

5. **Upper-Lowers** (security-minded)—The largest social class group, including blue-collar factory workers, whose main concern is security. The working-class male has an "all-male" self-image and prefers sports and the outdoors. Women hold jobs and handle household tasks as well.

6. **Lower-Lowers** (the least advantaged)—The bottom rung of society, often unskilled and poorly educated. This group is frequently unable to find work and receives some form of public assistance. They may reject middle-class morals. Their buying habits are impulsive, and they may not evaluate quality and thus pay too much.

(Adapted from Kotler, *Marketing, an Introduction*, p. 153.)

Friends can have a strong influence on buying behavior. People like to copy those they admire and look up to, and often friends copy one another's choices in fashion looks. Young people who want a sense of belonging to a group and whose individual tastes are just emerging find security in adopting fashions similar to those of their friends. People of all ages want to be comfortable with their friends and for many, similar apparel tastes may help them establish these feelings.

Co-workers influence buying behavior. Most people want to fit into the work environment and dress accordingly. They choose to adopt the look of others on the same job level (or the one above) in order to be thought of as belonging to and exemplifying that group's values.

Personal Influences

The influences on a consumer's personal life have an effect on his or her interest in fashion and ability to buy. These influences include:

- stage in life
- spending power
- personality

Stage in life. Throughout life people have different fashion needs. Infants and children need apparel frequently because they are growing. The apparel needs of young adults are centered on appropriate gear for work and social activities. Later in life, young parents need apparel for their growing children and for themselves for work and recreation. And in the retirement years, most people have fewer needs for new apparel.

Spending Power. The amount of money people have to spend is of particular interest to fashion businesses, because people with money create markets. Most people derive their ability to spend from the incomes they receive, usually earned through work. The amount of money people have left after paying taxes is known as **disposable income.** Disposable income is used to pay for life's necessities such as rent, food, transportation, and basic clothing. The amount remaining after the necessities are paid for is called **discretionary income.** Fashion businesses concern themselves with

Figure 2-5. In selecting apparel, friends influence one another. (Courtesy VF Corporation)

CALVIN KLEIN

President
Calvin Klein, Inc.

In the film *Back to the Future,* a character played by actor Michael J. Fox is called "Calvin," because that is the name he has written on his underwear. This was back in the days before designer names on all kinds of apparel was the fashion. Since then that name has appeared on hundreds of thousands of briefs, jeans, and shirts as well as classic apparel, accessories, and fragrances for men and women. Calvin Klein is renowned for his designs incorporating clean lines and quality for customers who prefer comfortable and timeless American styling.

> *". . . I was terribly determined to become successful. . . . You have to want it, and if you really want it enough, you can. . . . I think you have to make an enormous commitment to your work. You have to put that in front of a lot of other things." Calvin Klein*

Like Ralph Lauren, Calvin Klein was born in the Bronx section of New York City. His father was a grocer and his mother a homemaker with a passion for apparel. Showing an early interest in sketching, Calvin Klein attended the Art Students League and graduated from New York University's Fashion Institute of Technology. He took on a series of unrewarding jobs copying Paris designs for New York coat and suit manufacturers while also creating designs on his own. At one point, growing discouraged, he almost accepted a partnership in the grocery business of his life-long friend, Barry Schwartz. Reconsidering, he decided to stay with designing and instead borrowed enough money from Schwartz to start his own business. As a result, Barry Schwartz became and remains Calvin Klein's partner in the apparel business.

The firm's first large order came from Bonwit Teller, a prestigious women's store at the time. It happened by chance; a store executive went to Klein's showroom by mistake, but was so impressed with the collection of coats and dresses that he asked the store's president to look at them. The result: a $50,000 order. Before long, the company was approached to broaden its line to include jeans. When Brooke Shields took on the modeling of "Calvins," their popularity skyrocketed. Next, men's underwear designed for women and fragrances drew Klein's attention. All the while, there was no doubt about Calvin Klein's talent in determining the American looks his customers wanted. For three years in a row he won the fashion industry's Oscar, the Coty American Fashion Critics award.

The terms *Escape, Eternity,* and *Obsession,* all names of Calvin Klein fragrances, may well reflect his feelings

about the times when they first appeared. Obsession came out in a time when Klein was just doing too much: working hard and playing harder. His own lifestyle in those days led him to a drug and alcohol treatment center in 1988. Regaining his equanimity, marrying a second time after a divorce a decade earlier, his next fragrance, Eternity, may echo his return to more conservative values. Later, his fragrance Escape may well reflect the importance he gives to enjoying the outdoors after finishing his work. The kinds of escapes Klein and his wife, Kelly, enjoy together include riding, sailing, and skiing.

Calvin Klein designs, markets, and licenses a range of designer apparel, sportswear, and accessories under the Calvin Klein trademark. The company's businesses, accounting for over $1 billion annually in sales, are organized into three divisions: the women's collection, consisting of designer sportswear and evening wear; the sportswear division, consisting of jeans and casual sports-wear for men and women; and the licensing division, which operates internationally, placing the Calvin Klein name on a variety of apparel and accessories in countries ranging from Brazil to Japan. Plans include opening Calvin Klein stores in Europe.

Question for Discussion. What kinds of things would Calvin Klein need to know about his customers in order to design for and market to them?

Sources. 1. Andre Leon Tolley, Fashion Editor, "Riding High," *Vogue*, August 1991, pp. 230–38; 2. Calvin Klein press kits and collected articles, Calvin Klein, Inc.; 3. Bob Colacello, "You Take One at a Time: How Calvin Klein Fashions Success," *Parade Magazine*, August 26, 1984, pp. 4–6. 4. Colin McDowell, *McDowell's Directory of Twentieth Century Fashion*, Prentice Hall Press, New York, 1987.

discretionary income because people may choose to save it or to spend it in other ways: for more costly apparel, for travel or entertainment, or for a new house or car. One goal of the fashion industry is to encourage discretionary spending on apparel.

Unfortunately, while the incomes of many Americans are rising, there is also a continuing rise in prices over the years, reducing the value and the spending power of the dollar. This general rise in prices is termed **inflation** and is caused by a rise in costs or an increase in the supply of money, or both. While the federal government, through the Federal Reserve system, has ways of minimizing the effects of inflation, the rise in prices is real and continual, and fashion businesses feel the pinch of higher costs. Should there be a general slow-down of business activity, known as a **recession,** the fashion industry feels it quickly because people have less discretionary income to spend for apparel and other goods.

Inflation and recession can occur together and when they do, fashion businesses must respond even more quickly to changing customer demands. For example, during a recent recession, instead of concentrating on creating safe and conservative apparel, some manufacturers perceptively offered bright new looks that customers did not already have in their closets, for example a bright jacket to spark up an existing wardrobe.

Personality. A third influence on buying behavior is an individual's personality, that is his or her distinct characteristics such as self-confidence, sociability, and emotional stability.[17] An individual's personality has an effect on his or her behavior, including buying behavior. For example, self-confident people are more likely to rely on their

own tastes in reaching a buying decision whereas timid people rely heavily on the help and fashion advice of trained salespeople.

Consumer Buying Behavior

The way people act in the marketplace is known as **buying behavior.** A consumer's cultural, social, and personal influences have an effect on his or her buying behavior. In addition, buying behavior is influenced by the psychological factors of motivation, perception, and learning. Motivation is the topic of this section. Perception and learning are covered later in this chapter.

To set buying behavior into action there must be a **motive,** or internal need to be satisfied. For example, at the chapter's opening, the desire of the wedding party to be properly attired brought about the need or motive. A **stimulus** provides desire to fulfill that need a certain way. When the mother saw the designer dress, the stimulus, she realized that it would meet her need. Buying behavior is similar to other behavior. A stimulus activates a need and provides the buying motive or desire to act. The action the mother took, called a **response,** was to order the designer gown.

Buying Motives

People are complex and have a number of needs and so they buy to satisfy a number of motives. Most frequently, not just one but several motives combine when making a buying decision. Buying motives may have physical or psychological origins. Physical motives meet obvious physical needs: to satisfy hunger or thirst by ordering a hamburger and a soft drink; for protection from slipping on winter ice by purchasing a pair of skid-proof boots; or for comfort and convenience as in buying a sun visor at the baseball game.

Buying motives may also be psychological, most commonly for approval and affection or for recognition and prestige. A young man may wear a certain sweater because a favorite friend says she likes it, or a store manager may buy a new suit for an important meeting.

Rational and emotional motives. Buying motives may be classified as rational or emotional. Motives based on rational behavior such as logical thinking and decision making are called **rational buying motives.** A customer purchasing a raincoat may feel that its classic style and construction are durable and long-lasting and that the price represents a good value. These are all rational buying motives. Motives based on feelings and emotions that are important to the individual are called **emotional buying motives.** Another customer considering the same raincoat may be delighted with the feel of the fabric, its fashionable look and well-known name. In this instance the buying motives are emotional. Seldom do customers reach buying decisions based solely on rational or emotional buying motives, but rather a combination of each. As we have just seen, one customer's purchase may be based more on rational motives while another's stems mainly from emotional motives.

Table 2-5 Examples of Stimulus—Motives—Response

Stimulus (Need or Want)	Motive (Urge to Change)	Response (Action)
Coat is out-dated and unappealing.	You want to feel good about your appearance.	You buy a new coat.
A friend's birthday is approaching.	You want to recognize the event.	You purchase a gift T-shirt your friend admired.
A billboard features the opening of a new outlet shopping mall.	You want to go on an outing.	You travel to the mall to see the stores.
A newspaper ad describes a store's fashion show.	You need some new clothes for school.	You attend the fashion show to see the new styles.

To understand the contribution of rational and emotional buying motives to a buying decision, consider the continuum (scale) below. Buying motives on the right are rational while those on the left are emotional. If a buying decision is mostly rational it can be shown with a marker close to the rational end of the continuum:

emotional_____^_____rational

If a buying decision is mainly emotionally based, the marker is shown near that end of the continuum:

emotional____^_____rational

While not all customers are completely aware of their motivation, fashion merchandisers know that for many customers buying apparel frequently involves emotional motives. For this reason, apparel marketers often appeal to emotional buying motives in planning advertising, visual merchandising, and sales training. Consider the Ralph Lauren advertisements for apparel that emphasize the lifestyles of the models pictured in the ads: nautical outfits shown on a sleek yacht, denim jeans and patterned blanket coats worn on a western ranch. Advertisements such as these allow readers to imagine that the lifestyle shown accompanies the purchase of the apparel.

Product and Patronage motives. Customers may have motives for purchasing a certain product or patronizing a certain retailer. **Product motives** are motives for buying a certain product and stem from the qualities or image of a product, such as its materials, construction, or style. An example of product motive occurs when a customer purchases an item because of its name or reputation. A business executive, believing that a particular watch is superior in dependability and appearance (a combination of rational and emotional buying motives), who then seeks out that product by name is reacting to product motives.

Motives for buying from a certain retailer are called **patronage motives.** Often customers have a combination of product and patronage motives in buying. For

example, if the watch that the executive wants is available from several retailers, the preferred store would depend on which patronage motives are most important to the customer. Major patronage motives include the following.

Reputation and Image. Customers patronize retailers who treat them fairly and honestly. Retailers at all price levels are interested in building both reputation and image, how their customers view them. Nordstrom enhances its reputation and image through its widely recognized thoughtfulness to customers. For example, one time for an out-of-town meeting a man ordered a suit that needed alterations. The suit was forwarded to him in time and included in the package were a note from the store and a complimentary shirt and tie. Syms, an off-price apparel chain, states, "An educated consumer is our best customer," meaning that consumers who know merchandise and prices will recognize the values the store offers. By carrying out the policies expressed in their actions and sayings, retailers build reputation and image.

Merchandise Assortments. Customers buy from retailers offering the assortments they want. Included in assortments are the variety and types of styles offered, and the color, size, and price ranges. A college student may prefer a fashionable T-shirt from a trendy boutique while her older sister may choose something from J. Crew's colorful but more conservative assortment. Retailers study their target markets in order to anticipate the assortments their customers will be seeking.

Location. A saying among retailers is, "There are three important factors in the success of a retail store. They are location, location, and location!" Customers often choose a store because it is situated near work or home, or near a group of other stores where they can complete many shopping tasks. For this reason, retailers try to place their stores in locations accessible to their target markets. Retailers offering career apparel such as The Limited and Ann Taylor place their stores in urban busi-

Figure 2-6. Is this glamorous store interior designed to appeal to rational or emotional buying motives? (Courtesy James Mansour, The Limited, Inc.)

Figure 2-7. There are three important factors in the success of a retail store: They are location, location, and location! (Courtesy James Mansour, The Limited, Inc.)

ness districts and in popular shopping centers frequented by their prospective customers. Retailers offering the latest designer fashions locate their stores in exclusive shopping areas such as New York's Fifth Avenue or Beverly Hills' Rodeo Drive.

Customer Services. Customers shop in retail stores that provide services comparable to the prices they are paying. Discount stores featuring low prices, such as K mart, Target, or Venture, offer basic customer services such as free parking, merchandise return privileges, and credit. Traditional department stores such as Lazarus, Macy's, and the Broadway provide additional customer services such as gift wrapping, repair services, and alterations. It is not unusual for exclusive stores to provide special customer services as when, at the opening of this chapter, the assistant store manager personally delivered the dress to the bride's mother and made sure it fit correctly.

Price. A fundamental decision of retail organizations is determining the price levels for their target markets. Some retailers cater to customers for whom price is not a factor; these retailers emphasize fashion and exclusivity. Other retailers such as discount outlet stores emphasize price as a major appeal to customers. The task is not easy; however, for increasing numbers of customers are practicing selective discrimination; that is, patronizing stores at various price levels. Today the same customer may purchase a sweater or belt from an exclusive shop, a suit from a department store, and hosiery and underwear from an outlet store.

Shopping as Entertainment. One great American pastime is known to be shopping. The mall is often the first place many people head for to spend some leisure time. Many retailers seek to make shopping appealing by offering an attractive atmosphere. The appeal may be as simple as providing piped-in music and bright, clean stores. Or, the atmosphere may be replete with elegance as the Henri Bendel stores; an exciting bazaar as in Bloomingdale's; or adventuresome as in shopping malls with a theme such as Minnesota's Mall of America, featuring department and specialty stores surrounding a Snoopy theme park.

Figure 2-8. This calendar of events helps create an exciting shopping environment for customers. (Courtesy Nordstrom)

The Response: Reaching the Buying Decision

When reaching a buying decision, in addition to motivation, there are other psychological influences. One influence is **perception,** the way individuals accept and organize external stimuli to obtain a view of the world. Another influence is **learning;** in this instance, the way consumers acquire knowledge on which to base a buying decision. Basically, consumers perceive what they choose to see and what conforms to their view of themselves.

There are a number of theories of how people learn that contribute to fashion marketers' understanding of consumer buying behavior. One theory, based on behavior, contributes the idea that people learn by receiving repeated and restated messages. This is one reason that advertising messages for all products—among

them apparel and cosmetics—are repeated frequently and with slight variations. Another theory states that most typically the learning that people do is a kind of problem solving, based on information processing.[18]

Buying Influences Combined

The influences on consumer buying behavior could be pictured as shown in Figure 2-9. As you read earlier, influences come from outside and from within. Outside or external influences include cultural, racial, and religious backgrounds, as well as social classes. They also include the influences of a consumer's social group; that is, friends, family, and co-workers. Internal influences include the consumer's age, stage in the life cycle, and economic situation, as well as his or her individual lifestyle and personality. Finally, an individual's psychological make-up including what motivates that person and how he or she perceives and learns all have an effect on buying decisions.

Steps in the Consumer Buying Decision

Let's look at consumer decision making as a problem-solving process consisting of a series of steps. In reaching buying decisions, consumers sometimes go through these steps so rapidly they are not always conscious of them. The steps are:

- Recognizing a need
- Defining limiting factors
- Seeking information
- Evaluating information
- Deciding on a purchase
- Evaluating the purchase

Recognizing a Need. Customers recognize a need for a product and they set out to meet that need. When a new season's fashions appear, some people recognize a need to add something new to their wardrobe. Special situations can point up a need. The wedding at the opening of the chapter or a student getting ready for college are situations that call for special apparel. Or, a person realizes that a jacket or a pair of shoes is worn out and needs replacement. Need recognition can happen instantaneously as when a young woman passing a jewelry counter sees a pair of earrings that add the perfect touch to her outfit.

Defining Limiting Factors. We are not able to gratify all of our buying needs, that is purchase everything we might want. The factors that keep us from reaching a certain decision to buy are called **limiting factors.** Price is often a limiting factor. For example, while many people would like to own custom-made designer apparel, only a very few are willing or able to pay the steep prices. Other limiting factors are time and place. If Nordstrom had not promised the executive that the altered suit would reach him in time for the out-of-town meeting, he might have decided against purchasing it.

Seeking Information. Consumers actively look for information concerning potential purchases. In buying apparel, their popular information sources include: business information, friends and family, and personal experience. Business sources include fashion advertisements and articles, merchandise displays, and fashion shows. Informed salespeople also provide extensive fashion information to consumers.

These sources are the first to know about the newest fashions and their versatility. Friends and family often provide information concerning appropriateness and availability. A mother tells her eight-year-old daughter that for a cook-out a jeans outfit is more appropriate than a new velvet dress. Or, a young man admires his friend's jacket and is told where he bought it. Personal experience with a brand or a product reinforces confidence in making future decisions. For example, some people buy apparel bearing certain designer or brand names such as Liz Claiborne, Reebok, or Jockey and return to them again based on their previous satisfaction.

Evaluating Information. To arrive at a buying decision, customers then evaluate the information they have obtained. They may compare a number of factors including styles, brand names, colors, and prices. The value that customers place on each factor is an individual decision. For some, the new style of a suit is most important; for others, the label or brand name may be a deciding factor. Still others believe that a certain color is most versatile, while others find the price very attractive. To help customers reach decisions, fashion merchandisers provide thorough descriptions and accurate photographs in catalogs, show coordinated displays of current merchandise in the stores, and train salespeople in the latest fashion information.

Deciding on a Purchase. At this time, all of the influences come to bear on a buying decision. These include the cultural, social, personal, and psychological influences covered earlier. Sometimes a limiting factor, such as price or time, leads to a decision not to buy at present. A particular winter coat may just be too costly, or a young man might like a new tie for an important occasion but has no time to buy one. Decisions to purchase a particular product can stem from a number of influences. Some of these are: friends and family, informed salespeople, and one's own self-image. Friends and family can be reassuring in reaching a buying decision about

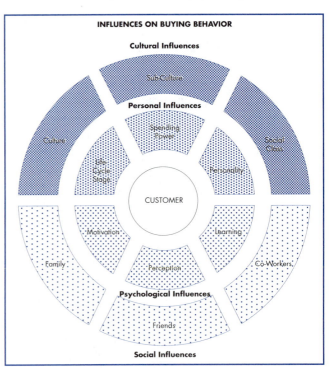

Figure 2-9. Influences on buying behavior.

appropriateness and suitability; informed salespeople are trained in helping customers select fashionable coordinated looks; and consumers' own good self-image helps them to choose the fashions they can wear comfortably.

Evaluating the Purchase. After reaching a buying decision, consumers continue to evaluate that decision, particularly of costly purchases. Frequently customers seek support for their decisions. The term **cognitive dissonance,** referring to the doubt a customer may experience after making a purchase, is also called "buyer's remorse." Cognitive dissonance may occur because a buyer has given up many attractive alternatives. For example, a customer may have purchased a very expensive jacket but now is experiencing cognitive dissonance because now a costly but needed watch is on sale and the customer cannot afford it. Fashion merchandisers work to reduce cognitive dissonance by encouraging positive feelings about their merchandise. Retail salespeople send customers notes thanking them for their purchases and offering to answer any questions; retailers plan glamorous special events, such as fashion shows, reinforcing the image of the store and its merchandise; and major designers and manufacturers place ads in prestigious magazines emphasizing the status of their products. Successful fashion merchandisers know that satisfied customers are the best customers. They also know that all customers have many influences on their buying decisions and so they study their customers and strive to please them with the products and services that best meet their needs.

Summary

1. There are five principles of fashion; all are consumer-driven. These are: consumers establish fashions; price alone does not make a fashion; fashions evolve gradually; marketing cannot change the direction of a fashion; and all fashions end in excess.

2. It is essential for fashion businesses to identify their customers. They do so by market segmentation. Two important segmenting methods make use of demographics, the study of people, using statistical measurements, and psychographics, the study of peoples' activities, interests and opinions, and lifestyles. Demographics includes information on gender, population growth, income, age, race, education, and geographic location. Demographics and psychographics useful to fashion businesses have been gathered through a number of market segmentation methods, among them are PRIZM (Potential Rating Index for Zip Markets), VALS (values and lifestyles), and the Management Horizons system.

3. There are four major influences on consumer buying: Three of these are cultural, social, and personal. Cultural influences include the values of a culture and those of race, religion, and social class. Social influences include family and friends. Personal influences include an individual's stage in life, spending power, and personality.

4. The fourth influence on consumer buying behavior is comprised of psychological factors such as motivation, perception, and learning. Buying motives may stem from a number of origins: physical and psychological; rational or emotional; or even the product and the retailer. Motives for buying from a certain retailer are called patronage motives and include: reputation and image; merchandise assortments; location; customer services; price; and shopping as entertainment.

5. In addition to motivation, psychological influences include perception, the way people organize outside stimuli to gain a view of the world; and learning, the way people acquire knowledge. In reaching a buying decision, psychological influences combine with cultural, social, and personal influences.

6. Consumer decision making is a problem-solving process consisting of a series of six steps that a customer may not always be conscious of going through. The six steps are: recognizing a need; defining the limiting factors; seeking information; evaluating the information; deciding on a purchase; and evaluating the purchase.

Fashion Vocabulary

Explain each of the following terms; then use each term in a sentence.

buying behavior	learning	psychographics
cognitive dissonance	limiting factors	rational buying motives
demographics	market segmentation	recession
discretionary income	motive	response
disposable income	patronage motives	stimulus
emotional buying motives	perception	target marketing
inflation	product motives	

Fashion Review

1. Of what importance is consumer acceptance and how does it relate to each of the five principles of fashion?
2. Why is a knowledge of consumer demographics and psychographics important to manufacturers and marketers of fashion merchandise? Cite two or three examples where demographic and psychographic studies prove useful to specific fashion businesses.
3. What are the contributions of cultural, social, and personal influences on consumer buying behavior?
4. How can the reputation of a fashion product or retailer have an effect on a consumer's buying decision? Describe three or four patronage motives that can influence a customer's decision to buy from a certain retailer.
5. In reaching a buying decision, how do fashion marketers help customers seek information and then later evaluate their purchases?

Fashion Activities

1. (a) Ordinarily customers do not consciously pay attention to the decision-making steps they follow in purchasing a product, but they can identify them if they know what to look for. Recall a significant apparel purchase you have made such as a coat or jacket or pair of shoes. Refer to the steps in the decision-making process. Write a paragraph explaining how you proceeded through each step of the process in reaching your decision to buy; or,

 (b) Select a total of six advertisements featuring merchandise from magazines and catalogs. With your instructor's permission, cut and mount your ads on separate paper. For each ad, write a paragraph describing whether the merchandise as advertised appeals mainly to rational or emotional buying motives, and to product or patronage motives. Be prepared to present your findings orally and to defend your viewpoint.

2. Select an item of fashion merchandise that is well known and involves some complex customer buying behavior, such as fine jewelry, designer apparel, or a custom-made man's suit. Then think of a consumer, using Table 2-2, the VALS system,, or Table 2-3 the Management Horizons system. Next, turning to Figure 2-9, Consumer Buying Influences, as a guide, analyze the influences that might cause the consumer to buy this product. For each major area shown, indicate at least two influences on the consumer's buying behavior.

 As a management trainee in the company marketing the item you have selected, write a memo to your supervisor entitled, "Influences on Consumer Behavior Related to Our Company's Fashion Merchandise."

Endnotes

1. Jerry Goodbody, "Marketing to Women Far-reaching," *Chicago Tribune,* June 30, 1991, Sec. 7, 7C.
2. Cyndee Miller, "Levi's, Ésprit Spin New Cotton into Eco-Friendly Clothes," *Marketing News,* April 27, 1992, p. 11.
3. *Statistical Abstract of the United States, 1991,* Volume 111, U.S. Department of Commerce, Bureau of the Census, Table No. 2, p. 7.
4. *Ibid.* Table No. 638, p. 388.
5. *Ibid.* Table No. 632, p. 384.
6. *Consumer Research Studies,* The Consumer Research Center, 845 Third Avenue, New York, NY 10022-6601, 1991.
7. Diane Crispell, "Women's Earnings Gap Is Closing Slowly," *American Demographics,* Business Reports, February 1991, p. 14.
8. Susan B. Garland, et al., "Those Aging Baby Boomers," *Business Week,* May 20, 1991, pp. 106–112.
9. Judith Waldrop and Thomas Exter, "The Legacy of the 1980's," *American Demographics,* March 1991, p. 38.
10. "Elite Black Market," Shopping Center Portfolio, *Stores,* May 1988, pp. 57–68.
11. Marita Thomas, "The Hispanic Market," Trendcheck 2, *Stores,* May 1988, pp. 53–56.
12. Diane Crispell, *Op.cit.*
13. Juliet B. Schor, *The Overworked American,* Basic Books Division of Harper Collins, New York, 1991, pp. 22–24.
14. Michael J. Weiss, *The Clustering of America,* Harper & Row, New York, 1988.
15. "The marketing maze turns out to be a model of precision," *The Chicago Tribune,* January 4, 1988, Sec. 2, p. 3.
16. Rebecca Purto, "Clothes with Attitude," *American Demographics,* October 1990, pp. 10 and 52.
17. Philip Kotler and Gary Armstrong, *Marketing: An Introduction,* Prentice-Hall Inc., Englewood Cliffs, NJ, 1987, p. 159.
18. Leon G. Schiffman and Leslie Kanuk, *Consumer Behavior,* 3rd. Edition, Prentice-Hall, Inc., Englewood Cliffs, NJ, 1987, p. 246.

Predicting the Direction of Fashion

Objectives

After completing this chapter, you should be able to:

1. Cite three reasons why people need apparel.

2. Describe the relationship of fashions to designers and to their times.

3. Explain three theories of fashion adoption.

4. Identify three contributors to speeding up fashion adoption and three to slowing it down.

5. Describe four steps in forecasting fashion trends.

John Barker was late arriving at the theater for a new musical comedy, but not too late to notice the brightly colored dressy and casual clothing worn by many of the theatergoers. He noted other late comers, among them groups of women in jewel-tone soft wools and cotton knits, some garments sparkling with gems and sequins. He walked quickly through the lobby and down the theater aisle to find his seat. Locating the right row, John squeezed past several seated patrons to settle down next to his wife just as the lights dimmed.

"Sorry I'm late, darling," he said, kissing her cheek. "It took longer to see that apparel collection than I expected." John was referring to a manufacturer's line of

merchandise he had just ordered. As the dress buyer for a group of women's specialty stores, he was planning the stores' stocks for the coming season.

"There must have been some important changes," said his wife, who was used to John's long hours when significant new buying is done. "Look at the vibrant colors on everyone here."

"I noticed," John replied. "I'm very glad not to have gone overboard on little black dresses this season," he laughed.

Why People Need Apparel

Whatever the fashion, people want to be in step with the times. Keeping up-to-date is one of the reasons people buy new clothes. Other equally obvious reasons include: protection from the weather, self-adornment, and a desire to be accepted and well regarded by others. Historically, even in the warmer climates where the earliest civilizations are known to have appeared, people took to wearing garments first as decoration and then for protection and modesty.[1] As societies wandered into colder climates, they put on animal skins and other heavier coverings to protect themselves from the elements: cold, rain, and wind. From the earliest times, however, people embellished their garments with decorations such as shells, feathers, animal horns, and skins in order to appear more attractive.[2]

Today, people choose clothing for these reasons and others, such as aesthetic appreciation or status and prestige. Sometimes customers are not totally aware of the reason or combination of reasons behind specific apparel purchases, for these reasons are often complex and subtle.

How Fashions Emerge

The process of developing and marketing apparel and accessories is similar in many ways to other forms of marketing. Manufacturers of consumer goods from soft drinks to automobiles conduct extensive research to learn the features that customers want in a product. Then, incorporating research results, they develop the product; for example, a new flavor of clear cola or anti-lock brakes for an automobile, and promote its special features to target customers. The fashion industry also conducts research, obtaining the latest information on consumer lifestyles and buying patterns and on new product developments, such as new fibers and fabrics, and new technology, like the latest uses of computers in designing and producing apparel.

Customers are a focus of fashion industry research on all levels. Changes in consumer lifestyles and buying patterns are studied. One such change with merchandising implications is the continuing trend toward a more relaxed and less formal approach to daily routine. The trend away from the stiff and formal is obvious in apparel. For several years, men have not been buying suits in quantity, opting for a more relaxed look when possible. Instead of wearing a suit to work, many men now combine a sportscoat with one of a selection of trousers, thus

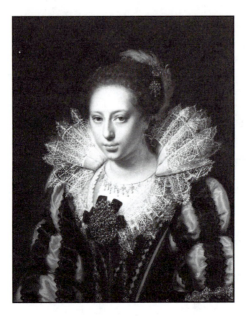

Figures 3-1a and b. Two examples of how early garments were embellished for decoration and protection. (a. © 1992 The Art Institute of Chicago, All rights reserved; b. Dover Publications Inc.)

achieving greater versatility.[3] Designers and manufacturers use this information in developing new fashion ideas, for example, creating groups of unstructured separates to be put together in a variety of ways. The effortless classic looks of apparel designers such as Giorgio Armani, Calvin Klein, and Joseph Abboud illustrate the popularity of this trend.[4]

Fashions and Designers

From research and from the inspirations of designers and manufacturers come many ideas for new fashions. The Burberry trench coat grew out of the needs of World War I army officers for warm and functional apparel. The use of costume jewelry—ropes of pearls and gold—became fashionable when shown by designer Gabrielle "Coco" Chanel in the 1920s. The miniskirts and short boots of André Courrèges were widely copied in the 1960s and again in the 1990s.

Each season, designers and manufacturers present new fashion goods that they feel are in tune with the mood of the times and their target customers. Designers and retailers, as you know, cannot guarantee that an item will become a fashion. Only customers as they decide what they will purchase are capable of creating fashions. From each season's offerings, then, customers vote for their choices among the styles presented. Those looks receiving a large number of votes (that is, purchases) become the season's fashions.

MONDAY
JANUARY 13

NATIONAL RETAIL FEDERATION'S BUSINESS & EQUIPMENT EXPOSITION

9:00AM-6:00PM MAIN SHOW ENTRANCES: HILTON 2ND FL & SHERATON LOWER LOBBY

NRF Welcomes you to their 81ST ANNUAL CONVENTION AND EXPOSITION

RETAILING 1992
Tough Challenges
New Strategies

We've added some features to help make this program...and the Convention...user friendly.

Look for:
- *S or H next to session numbers to tell you which hotel-*
S for Sheraton;
H for Hilton;
- *Squares, triangles and other icons quickly identify sessions which may interest you most. Look for the icon legend on each day's program listing.*

- *Build your own program-at-a-glance...jot in sessions you don't want to miss...on page 21.*

13H 9:00am-10:15am
● **THE ECONOMIC, CONSUMER AND RETAIL OUTLOOK**

Where's the economy heading and what do consumers think? How fiscal and monetary policy decisions affect both. By examining key retailing indicators, including employment, income, consumer confidence, and how trends will vary by merchandise category and store type, you'll gain valuable insights into key issues.

Moderator: JOSEPH E. ANTONINI, First Vice-Chairman, NRF and Chairman and Chief Executive Officer, Kmart Corporation, Troy, MI
Speakers: RICHARD CURTIN, Director, Surveys of Consumers, Institute for Social Research, University of Michigan, Ann Arbor, MI
STEPHEN S. ROACH, Principal & Senior Economist, Morgan Stanley, NY
ALLEN SINAI, President and Chief Executive Officer, The Boston Company Economic Advisors, NY
CARL E. STEIDTMANN, Vice President, Chief Economist, Management Horizons, Dublin, OH

15S 9:00am-11:45am
▼ ENHANCING CUSTOMER SERVICE

Outmaneuver your competition by improving the effectiveness of your selling staff so good service is also good selling. Enhance your service strategies, retain current customers, and bring back lost business. This session will address techniques for doing the all-important "little things right."
Discussion Leader: BRUCE R. MATZA, B.R.M. Enterprises, Inc., Grand Rapids, MI
Speaker: GERRY ROTH, Executive Vice President, Director of Stores, Younkers, Inc., Des Moines, IA

16S 9:00am-10:15am
▼ BUILDING YOUR IMAGE THROUGH VISUAL MERCHANDISING AND STORE PLANNING

Build a consistent, compelling, store image through fixturing, signage, lighting and color, display and windows, and you'll build sales. (P.S., All this on small budgets.)
Moderator and Speaker:
LAURA SCHOENE, Director of Visual Merchandising and Store Planning, Albert Steiger Inc., Springfield, MA
Speaker: ROBERT A. HOSKINS, Associate Professor, Display and Exhibit Design, Fashion Institute of Technology (SUNY), New York

Figure 3-2. The fashion industry is concerned with consumers' attitudes, as these national retailer meeting topics show. (Courtesy National Retail Federation)

Designers are not the only source of fashion inspiration. New fashions can appear anywhere: in school, at work, or on the street. Consider, for example, T-shirts, jeans, and leather jackets. These fashions first appeared among workers and then spread through the rest of society. As you recall, one of the principles of fashion is that fashion is not related to price. If some students decide to part their hair a certain way, wear only one shoelace, or tie a scarf around the neck, and the idea is accepted, then that look becomes a fashion.

Fashions and Their Era

Fashions are a product of their times. Fashions reflect peoples' values as well as their tastes. For example, the national interest in fitness has created a long-term market for active sportswear and athletic shoes of all kinds, from boating storm gear to volleyball shoes. Or, in times of crisis or war, the fashion mood turns patriotic with the colors of the flag and stars and stripes seen in apparel designs. When the crisis is over, the fashion mood moves on.

Figure 3-3. Styles adopted by certain groups of consumers become the sources of inspiration for fashion designs. (Courtesy J. Crew, Inc.)

The well-known personalities and leaders of a given period have an effect on fashion. The French courts in the seventeenth and eighteenth centuries encouraged the fashion interests of the nobility.[5] The styles of Princess Diana of Great Britain are copied widely throughout the world. Celebrities such as Liza Minelli, Oprah Winfrey, and Don Johnson, or models such as Cindy Crawford and Linda Evangalista are also copied.

How Fashions Become Popular

As you recall from Chapter 1, fashions have a life cycle. The fashion life cycle is created by customers as they decide to wear a particular style. Some people want to be innovative or daring in their apparel choices and choose to wear the newest looks from the introductory or early rise phase of the fashion cycle. Others want to copy the people they admire by wearing similar apparel and so purchase styles on the rise, that is, already accepted by leaders. Still others are not secure in their selections and choose to conform by wearing apparel similar to that of their friends and associates, often fashions at their peak.

The ways that fashions become popular are explained in three theories of fashion adoption. These are: the downward-flow (or trickle-down) theory, the horizontal adoption theory, and the upward-flow theory.

Figure 3-4. Well-known personalities have an effect on fashion. (Courtesy of International Beauty Shows)

Downward-Flow Theory

The **downward-flow** (or trickle-down) **theory** holds that new fashions are first worn by the top echelons of society: social, political, and business leaders; celebrities; and the very rich. Expensive new styles are introduced regularly by well known designers for their wealthy and famous clients.[6] The news about a new look, say a soft look with unstructured lines, spreads quickly today to the industry and to the general public through television and the fashion press. Soon people who look up to social leaders and the rich, hoping to be like them, decide to adopt the fashionable look. As the look becomes more accepted in society, others who want to conform to it begin to dress similarly. By the time the look is widely accepted, its innovators, the original purchasers, are on to another look. One major reason is that the fashion leaders do not want to be associated with fashion followers.

You can see downward-flow theory at work by studying current consumer magazines such as *Vogue* and *Town and Country* or even earlier by reading the "Eye" column of the fashion industry's trade paper, *Women's Wear Daily.* Here you will note reports of elaborate parties, often benefits for charities, and can glimpse photographs of notable celebrities and socialites in the latest looks. Fashion professionals pay great attention to downward-flow theory in their work. For example, a specialty store buyer like John

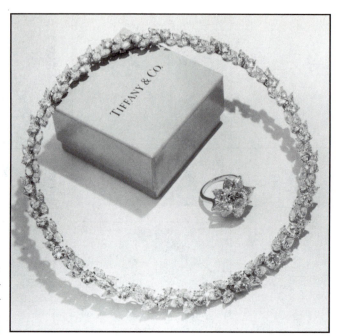

Figure 3-5. A classic Tiffany & Co. advertisement appealing to downward-flow adoption. (Courtesy Tiffany & Co.)

Barker studies the media to see the types of dresses that the fashion leaders are wearing now and the extent of their popularity. Then he determines if and when his store's customers will want them and plans his purchases accordingly. What John is looking for, of course, are the **fashion trends,** that is, the direction in which fashions are moving. John, like all good buyers, is seeking to determine what the new trends are and when his customers will be ready for them.

Horizontal Adoption Theory

The **horizontal adoption theory** states that fashions are adopted locally among similar or homogeneous groups, not necessarily in a downward-flow pattern. Similar or homogeneous groups can include a school, an office, or a community. The easiest place to see horizontal adoption theory in operation is by looking around you at school. You will note that an individual or small group can start a fashion and it may spread throughout the school. For example, a few people may decide to wear a certain kind of shoe, sweater, or hair ornament, and before long everyone is wearing that look. Horizontal adoption theory holds that fashions do not have to flow from one level of society to another but can spread within a group.

Horizontal flow theory does, however, borrow some ideas about fashion leadership from the downward-flow theory. In every social environment from the world of the very rich travelers to small isolated communities, there are fashion leaders and fashion followers. **Fashion leaders** are the people who wear and influence the direction of fashion, those people in any community keenly concerned with fashion trends. Fashion

followers include most other people, that is, those who wait to see if a fashion will be a success before adopting it. There are two types of fashion leaders: fashion innovators and fashion influencers. **Fashion innovators** include those who seek out new looks and are the first to wear a new fashion, whether in Paris, New York, or Pocatello, Idaho. **Fashion influencers** are those people in an environment who are regarded as knowledgeable about fashion and who are looked to for fashion advice.

Nationally recognized fashion innovators such as Madonna and fashion influencers such as Grace Mirabella of *Mirabella* magazine (see the Career Portrait in Chapter 14) have an effect both on the international downward flow of fashion and on the horizontal flow of fashion in their own environments. In communities around the world, there are also local fashion innovators and influencers. These local fashion leaders have an effect on the horizontal flow of fashion in their areas. Horizontal flow theory is at work in a local community, for example, when the styles worn by one member of a community are emulated by the others. Fashion businesses pay attention to horizontal flow theory by noting what local fashion leaders are wearing in order to offer merchandise to fill that need. In selecting merchandise for his store, John Barker pays strict attention to what the women in his community are wearing and gears his buying to the styles he believes his customers want and are ready to accept.

Upward-Flow Theory

The third theory, **upward-flow theory,** states that fashions can begin in the lower levels of society and move upward. The most obvious example of upward flow theory is jeans. Originally garb for miners, cowboys, and other outdoor workers, jeans are now universally worn by people everywhere, from toddlers in sandboxes to Ralph Lauren in the company boardroom. Other examples of upward-flow theory include sweat shirts, leather jackets, and steel-toed boots. Biker fashions with spandex shorts, T-shirts, scarves, and hats originated among the urban bike messengers who became real fashion influencers, wheeling their way through city traffic jams on their bikes.[7]

The fashion industry pays attention to upward-flow theory by noting what people are wearing everywhere. Designers and retailers make a practice of walking in cities such as New York, Paris, and London to absorb current fashion looks. Interest in streetwear is widespread. For example, each Sunday's edition of *The New York Times* contains a prominently featured photograph showing what people on the streets of Manhattan are wearing. Upward-flow theory also accounts for the influence of young people everywhere on fashion trends; not all new fashion ideas come from designers. The fashion industry looks around to see what people are wearing in order to spot fashion trends among their specific customers.

The three theories of fashion adoption operate continuously and simultaneously. The business of determining fashion trends demands that the fashion industry assemble a great deal of information about what is popular, not just among celebrities, socialites, and fashion models, but with people everywhere. After all, as people create the direction of fashion, the fashion industry provides the impetus.

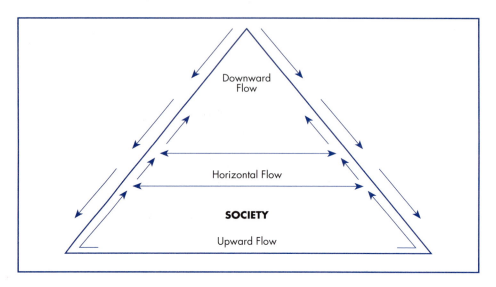

Figure 3-6. The three theories of fashion adoption operate simultaneously.

The Fashion Game

There is no doubt that fashion is strongly influenced by sex and that recognizing this fact is understanding the game of fashion.[8] The theory is that from time to time fashion draws attention to the erogenous or sexually stimulating zones of the human body. Cultures differ in their interpretation of what parts of the body are exciting; for some it is feet, for others the nape of the neck, and still for others the length and color of hair.

For western culture down through history erogenous zones are associated with the reproductive organs, and the fashion focus has shifted from chests to waists to legs and back again. From the sixteenth through the eighteenth centuries, garments featuring low-cut necklines and full skirts emphasized the bust. Toward the end of the nineteenth century, emphasis shifted to the waist and hips with the advent of the bustle followed by the Gibson Girl look. In the twentieth century, emphasis has been on the legs, and then at times it has shifted to the chest. Attention was drawn to legs in the 1920s with knee-high skirts; in the 1960s with the miniskirts and "hot pants"; and again in the 1990s with short skirts and suits featuring shorts. Attention was drawn to the bust line in the 1940s and 1950s with strapless evening gowns and peasant blouses, and again in the 1990s with the lingerie look in camisoles and the strapless look revised.

The rules of the fashion game are that only one area of the body is given attention at one time, and that when one area has been exposed long enough, attention moves on to another area. For example, in the 1980s legs on bathing suits were cut very high. After a while, people tired of that look and attention shifted to the bust line.

Contributors to Fashion Adoption

In order for fashions to have a significant influence in a given society, there must be an interest in fashion trends, money to spend, and fashion information readily accessible. These are major factors that, among others, influence the fashion adoption process. Some other factors contribute to speeding up the fashion adoption process while others slow it down. We shall next examine both kinds of influences.

Contributors to Speeding Adoption

Factors speeding up the fashion adoption process include favorable economic conditions, rising consumer income, a variety of lifestyle activities, modern communications, and new technology.

Economic Conditions. Businesses closely watch the economy to see how it is doing. In a favorable economic climate, people are employed and have money to spend, sales increase, and business is good. Businesses study economic indicators, a set of important figures including employment, housing starts, retail sales, and other information, to let them know how the economy is moving. When the economy is prospering, businesses attract customers with larger assortments of merchandise and customers are able to pay for these goods.

Figure 3-7. Designer merchandise, such as this suit by Joseph Abboud, is aimed toward consumers with significant discretionary income. (Courtesy Joseph Abboud)

Consumer Income. When an economy is doing well, people have money to spend. Businesses want to know certain things about consumer **net income,** or the money brought home in a pay check. Some businesses are interested in **disposable income,** the money left over after taxes are paid. Disposable income goes for necessities such as shelter, food, transportation, and basic apparel. Food processors and stores are interested in disposable income because these figures let them estimate the portion that consumers will use for groceries. Money left over after the necessities are met, called **discretionary income**, may be spent as one wishes. The fashion industry is particularly interested in discretionary income because it may be spent for whatever an individual might want, for example, designer apparel, vacations, or investments.

Active Lifestyles. Today, people of all ages are involved in a variety of activities, including work, school, sports, social activities, hobbies, and travel, each of which may call for distinctive fashion apparel. Increased education, wider career opportunities, and resulting higher income for many people are the foundations of their active lifestyles. Fashion professionals, alert to the demands of active lifestyles because they also participate in them, offer a wide selection of apparel to meet a broad spectrum of customer needs.

Communications. With instantaneous communications today, such as satellite transmission, the news about fashion trends spreads rapidly around the globe. Television programs and fashion newspapers and magazines present views and

Figure 3-8. Some marketers appeal directly to consumers' active lifestyles, as this advertisement from J. Crew shows. (Courtesy J. Crew, Inc.)

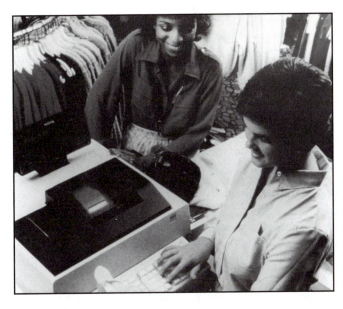

Figure 3-9. New technology beginning at the point-of-sale speeds the fashion adoption process by ensuring that merchandise is available to customers when they want it. (Courtesy Ellen Diamond)

descriptions of the latest showings of world-renowned designers as well as glimpses of world leaders, celebrities, and socialites. These all contribute to the spread of fashion information and give customers access to the latest innovations.

New Technology. Advances in technology in a number of areas contribute to speeding fashion adoption. New fabrics such as microfibers or new processes such as hyper color, when widely publicized, arouse interest in apparel incorporating new technology. Improved electronic data-information systems such as **Quick Response (QR)**, a computerized inventory system between retailers and major suppliers, enables stores to be supplied with a full range of basic merchandise.[9] Employing new technology, a retailer can be almost certain that all colors and sizes of basic stocks, such as underwear and hosiery, are always available to customers.

Contributors to Slowing Adoption

Other factors contribute to slowing the fashion adoption process. These contributors include a sluggish economy, an unsettled political environment, and habits and customs.

Slow Economy. When business is not moving along and the economy is slow or in a recession, people are not able to buy as much and, therefore, interest in fashion wanes. Manufacturers and retailers must adjust to these economic situations which are beyond their control. Those businesses able to ascertain what their customers want, even in hard economic times, are the ones most able to succeed. For example, during the recessions of the 1990s, The Gap, knowing that its customers wanted affordable and durable weekend apparel, emphasized its casual wear and managed to do well at times when other fashion businesses were experiencing mild to severe

difficulties.[10] Even smaller businesses were able to realize an increase in sales during slow periods by emphasizing apparel that customers did not have in their closets, prints, for example, to brighten up the plain colors many customers already owned.

Unsettled Political Environment. When there is a crisis or a war, public interest moves in that direction and interest in fashion tends to subside for a time. For example, during the brief period of the Persian Gulf War, national attention was focused on the Middle East. Sales in the fashion industry were flat, and interest in fashion moved slowly. After the crisis subsided, the fashion cycle picked up again and moved forward as is typical after such political activity.

Habits and Customs. Habits and customs can slow down the movement of fashion. For example, for a thousand years, during the Dark and Middle Ages in Europe, there was not much interest in fashion; out of habit, people were content with the belted tunic garment. When the renaissance began, peoples' interest in fashion perked up and, by the 1350s, changes in fashion were popular.[11] Religion, too, can slow down the adoption of fashion. In Middle Eastern countries, where religion calls for women to wear a chaddor, or head-to-toe black garment revealing only their eyes, interest in fashion trends is not widespread. Sometimes laws have halted the flow of fashion from one social level to another. For example, for years in some countries only royalty could wear silks, satins, and furs.

Forecasting Fashion Trends

Armed with information concerning the current economic and political climate, conditions in local markets, and the latest industry trends, fashion professionals begin the task of forecasting fashion. Fashion professionals analyze their target markets, their customers' tastes and preferences, the current fashion trends, and the readiness of their customers for these trends.

Identifying Target Markets

The first question a fashion-goods manufacturer or retailer asks is, "For whom are we forecasting trends? Who, exactly, is our target market?" For each fashion organization, target markets should be unique. For example, the target markets of Levi Strauss include men, women, and children and are worldwide. The target market for John Barker consists mainly of fashion conscious women in his area. As you recall from your study of the consumer in Chapter 2, businesses use many ways, among them demographics and psychographics, to find and reach the target markets they are best equipped to serve.

Analyzing Customer Tastes and Preferences

Once designers, manufacturers, or retailers have identified their target market or markets, they analyze customer tastes and preferences. For example, Donna Karan

SPOTLIGHT ON A FIRM

THE MAY COMPANY

What do Lord & Taylor in New York City, Famous-Barr in St. Louis, Foley's in Houston, and Robinson's in Los Angeles have in common? And what do these stores have in common with Payless ShoeSource and Hecht's, Kaufmann's, and Filene's? Answer: These stores and others make up the nationwide May Department Stores Company with over 3500 stores in all divisions and sales of more than $10 billion annually.

It all started in 1877, when David May opened a store in the silver mining town of Leadville, Colorado. Later, May and his brothers purchased stores in St. Louis, Missouri, and Cleveland, Ohio, and named the latter *The May Company*. As the years went by, The May Company acquired well known stores such as Kaufmann's in Pittsburgh, Penn-sylvania; the Hecht Company in Washington, D. C.; G. Fox & Co. in Hartford, Connecticut; and Meier & Frank in Portland, Oregon. In 1986, The May Company acquired a group of stores, including Lord & Taylor and Goldwater's, that had been part of the Associated Dry Goods store organization. Two years later, the company acquired Foley's stores in Texas and Filene's in Massachusetts.

The May Company prides itself on finding fashion trends and offering consumers designer and brand-name merchandise such as DKNY, Ralph Lauren, Nautica, Coach, Guess, and Girbaud in apparel and accessories for women and men. In addition, gifts for special holidays and throughout the year are emphasized with items such as china, glassware, and candy. Buying for the stores flows through steering committees composed of merchandise managers and buyers. These groups work with May Merchandising Company (MMC), the corporation's New York merchandising office, and the 14 company-owned overseas buying offices in Europe and Asia, to influence merchandise selections. A company-wide merchandise information system provides management with up-to-date information on store sales and stocks, enabling merchandise to be targeted for each retail outlet.

Customer service is important to the organization, which sponsors a Friendliness Program, training each employee in ways to better serve customers and surveying customers themselves to learn what they want. Each month the company surveys some 300,000 customers and receives around 60,000 replies, many containing suggestions the company can utilize. Amenities that

continued

customers ask for, such as gift boxes and shopping bags, chairs to sit on, three-way mirrors in various departments, and baby-changing tables, help to implement the customer service mission.

Question for Discussion. In what ways do The May Company's merchandising steering committees, worldwide buying offices, and Friendliness Program assist the fashion adoption process?

Sources. Information gathered from The May Department Stores Company, including: The May Department Stores Company Annual Reports, 1991, 1990, and 1989, and The May Department Stores Company Form 10K.

has learned that her customers want sleek fashionable apparel they can wear at work all day long and then also out to dinner.[12] OshKosh B'Gosh knows that while children—one of its target markets—like colorful overalls and playwear, their mothers, the customers, want up-to-date children's fashions that stand up to tough wear and many launderings.[13]

Retailers, too, analyze the tastes and preferences of their customers. A buyer in Denver knows that if the store's customers are not ready for a new skirt length, no matter how appealing, those skirts will be left hanging on the racks through the season. Correctly analyzing customer tastes involves risk and takes skill and practice; even the most experienced buyer is not unfailingly accurate. Those buyers most closely in tune with their customers' needs and lifestyles find that in general their selections match well, satisfying customer requirements and meeting company goals.

Recognizing Fashion Trends

Fashion thrives on change. Each season designers and manufacturers introduce changes in the elements of fashion. Some changes are shockers, often deliberately so to attract attention, such as the wild combinations of colors and silhouettes that Christian Lacroix shows at times, the daring looks of Jean Paul Gaultier, or the fantasy ball gowns of Zandra Rhodes. For the majority of styles, however, the change is usually gradual: slightly different details, or perhaps a new trim or neckline; a color palette that is brighter or lighter; or a small variation in texture or silhouette. Recognizing these trends is made easier by the auxiliary level fashion organizations

Table 3-1 Steps in Forecasting Fashion Trends

1. Identify target markets.
2. Analyze customer tastes and preferences.
3. Recognize current fashion trends.
4. Evaluate trends in terms of target customers.

JOSEPH ABBOUD

With this point of view, Joseph Abboud strives to bridge the gap between European and American styles, marketing his styles in both places. Designing apparel for both men and women, Abboud begins with fabrics, seeking out textures revealed in the light and colors that complement skin tones. He favors colors that coordinate but do not always match, unexpected fabrics together such as silk and tweed, and relaxed silhouettes with slouchy jackets and generous sweaters. His aim is an unstudied look with lasting appeal.

Born in Massachusetts, Joseph Abboud attended the University of Massachusetts, doing work in comparative literature. However, an abiding interest in design led him to study in Paris at the Sorbonne, where he saw firsthand the timelessness of European styles. On returning home, he went to work for the firm Louis of Boston, where he stayed for 12 years as buyer and coordinator of promotions. Moving on to Southwick, a men's wear manufacturer, Abboud was able to use his design talents

> *"Creating clothes isn't just about design. It's about lifestyles. Fashion needs to be flexible, versatile. My aim is to design pieces that become favorites, like that one great jacket you grab in the morning because it works with everything. That's how people buy clothes and that's how they wear them. . . ." Joseph Abboud*

to a greater degree. Shortly, he was recruited by Ralph Lauren as associate director of men's wear design, working directly with Lauren. After three years, he went with designer Barry Bricken, where he created his own collection.

In 1986, Joseph Abboud decided it was time to go out on his own. He formed Joseph Abboud Company to produce his own label. Two years later, he entered into a joint venture with GFT USA Corporation, to make his men's wear lines. GFT USA is the U. S. division of the renowned Gruppo GFT, a leading Italian manufacturer of ready-to-wear for Giorgio Armani, Emmanuel Ungaro, and other top designers. Before long Abboud signed a licensing agreement with GFT Apparel Corporation to produce his women's wear collection. Since then he has developed other licensing agreements for men's accessories and fragrances for men and women.

The fashion industry began to note and reward Abboud's accomplishments, beginning with the presti-

continued

gious Cutty Sark Award for Most Promising Menswear Designer in 1988, followed by the Woolmark Award for distinguished fashion in 1989. Next he was given the Menswear Designer of the Year Award from the Council of Fashion Designers of America for two years in a row, 1990 and 1991.

To increase interest in designer apparel among younger men, Joseph Abboud has developed a bridge line, JAII (jay-aay-two), featuring somewhat lower prices. He presents his collections in Milan, making them available throughout Europe, where they are offered by more than 70 stores. In addition, in 1990 Joseph Abboud opened his own store in Boston, where he features men's wear, women's wear, and accessories.

Question for Discussion. Which of the three theories of fashion adoption influences Joseph Abboud to the greatest degree in your opinion?

Sources. Press kit and publicity materials from Joseph Abboud, J.A. Apparel Corporation.

such as the fashion information services and buying offices that specialize in spotting trends and informing the industry. Fashion videos let industry people know what is going on without attending fashion shows.

The fashion industry looks for styles that are likely to be highly popular. Styles identified early on as destined to be widely successful in many price ranges are known as **prophetic fashions.** By pinpointing prophetic fashions early, a fashion business can be sure to offer that look to its customers as long as it is popular.

Evaluating Trends in Terms of Target Customers

The real work comes in evaluating trends in terms of target customers. Designers—from Calvin Klein to the staff at Keds—must ask themselves on perceiving a trend, "Are our customers ready for that look?" If so, then the design is produced. If not, the trend is ignored or delayed. The correct decision is not always easy to reach. For example, a designer may say that customers are ready for a casual look when many want to appear dressed up. The designer's emphasis on casual dressing for that season is out of step with what customers want, not as successful as if a more elegant look had been incorporated.

Retailers, too, need to evaluate carefully in terms of their target customers. Consider the large retailer with many branches, such as J. C. Penney, Dillard's, or Lord & Taylor. The customers at the various branches of each of these stores are very different. Some may be families with young children, others older working men and women, and still others single career people. The apparel in each branch needs to be chosen with that store's customers in mind or it will not match their needs. The retail buyers who can select accurately for their stores season after season are real fashion professionals utilizing the marketing concept.

Summary

1. There are a number of reasons why people need apparel; early reasons include decoration, protection, and modesty. Of these, the earliest reason appears to be decoration or self-adornment. Other reasons for needing fashion goods include the desire to be in step with the times, to be favorably regarded by others, and for prestige and status. The reasons for making specific apparel purchases can be many and complex.

2. While designers and manufacturers are responsible for the regular presentation of new styles, fashions can appear from many sources, among them school or work. However, fashions are always a product of their era, for they reflect peoples' values and tastes.

3. There are three theories of fashion adoption: downward-flow or trickle-down theory, horizontal adoption theory, and upward-flow theory. Downward-flow theory holds that new fashions are worn by the top echelons of society and are then adopted by the rest. Horizontal adoption theory states that fashions are adopted locally among groups, influenced by local fashion innovators and influencers. According to upward-flow theory, fashions can begin on the lower levels of society and move upward. The popularity of work clothes is an example of upward-flow theory. Fashion experts agree that all three theories are at work simultaneously.

4. Some factors contribute to speeding up the fashion adoption process while others tend to slow it down. Contributors accelerating the fashion adoption process include: rising consumer income, active lifestyles, worldwide communications, and new technology. Contributors slowing the process include: a slow economy, unsettled political conditions, and habit and customs.

5. In forecasting fashion trends, apparel manufacturers and retailers identify target markets, analyze the tastes and preferences of their specific customers, recognize new fashion trends, and evaluate these trends in terms of their customers' readiness for them.

Fashion Vocabulary

Explain each of the following terms; then use each term in a sentence.

discretionary income	fashion innovators	net income
disposable income	fashion leaders	prophetic fashions
downward-flow theory	fashion trends	Quick Response (QR)
fashion influencers	horizontal adoption theory	upward-flow theory

Fashion Review

1. Why are designers not the only source of new fashion ideas? From what other sources do new ideas arise?

2. How does the horizontal adoption theory differ from the downward-flow theory? How are they similar?
3. Identify an item of apparel or a fashion look and explain how it became popular according to upward-flow theory.
4. Explain the effect of discretionary income on speeding or slowing the fashion adoption process.
5. Describe four steps that fashion industry professionals consider in forecasting fashion trends for their customers.

Fashion Activities

1. (a) Choose an item of apparel that you or someone else in your class is wearing and, using at least two theories of fashion adoption, write a paragraph in which you identify the item and describe how it has become a fashion; or, (b) Look through fashion magazines, catalogs, and the news, society, and fashion sections of the newspaper to locate examples of the three theories of fashion adoption. Select, and if indicated by your instructor, cut out and mount on posterboard several current examples illustrating each theory. Use your selections as a guide in describing your findings to the class. (Note: Your instructor may choose to conduct this activity as a group project, dividing the class into three groups, each researching one of the three theories of fashion adoption.)
2. Your school has decided to open a small store offering selected fashion goods to students. As a member of the store's merchandise planning committee, you are asked to identify six apparel items that you believe will be fashion trends in your school. Following the steps for forecasting fashion trends (Table 3-1), select for your target market the items you believe will be popular, and for each item write and illustrate a brief advertisement to run in the school newspaper.

Endnotes

1. J.C. Flugel, *The Psychology of Clothes*, Hogarth Press, London, 1976, p. 17.
2. Ibid., Page 29.
3. Laura Zinn et al., "The Suit Market Is Coming Apart at the Seams," *Business Week*, August 12, 1991, pp. 42 and 43.
4. "Best of Italy," *Daily News Record*, Fairchild Publications, July 29, 1991, p. 17.
5. James Laver, *Costume and Fashion, A Concise History*, Thames & Hudson, Ltd., 1982, p. 127.
6. Quentin Bell, *On Human Finery*, Shocken Books, New York, 1976, p. 92.
7. "The Way We Wear," *Smithsonian World*, video, The Smithsonian Institution, Washington, D.C., 1988.
8. Flugel, *Op. cit.*, p. 25.
9. Wilmot J. Gravenslund et al., "Updating QR, New Retailing Mindset Needed," *Women's Wear Daily*, May 3, 1990, pp. 13 and 16.
10. Susan Caminiti, "How Gap Keeps Ahead of the Pack," *Fortune*, February 12, 1990, pp. 25 and 26.
11. Fernand Braudel, *The Structures of Everyday Life*, Volume I, Harper & Row Publishers, New York, 1979, p. 317.
12. Susan Caminiti, "Black Magic," *Savvy Woman*, September 1989, p. 63.
13. Julia Flynn Siler et al., "OshKosh B'Gosh May Be Risking its Upscale Image," *Business Week*, July 15, 1991, p. 140.

Creating and Marketing Fashion

Objectives

After completing this chapter, you should be able to:

1. Describe the three major forms of business ownership.

2. Name the four groups comprising the fashion industry and explain their interdependence.

3. Discuss the role of the designer in creating apparel.

4. Describe the movement of fashion from the manufacturer to the consumer.

5. Explain the function of competition in creating and marketing fashion.

T*he bright pins, necklaces, and earrings glisten on the arrangement of silk handpainted scarves in the display window, beckoning passersby to step inside the tiny shop. The jewelry—created from beads, metals, woods, and fabrics—had been imaginatively turned into items designed to offer customers something unique.*

The idea for the shop, called "Clear Cachet," belonged to Pamela Gunther, who had always wanted to own her own business. Working her way through school selling accessories part-time in a department store, Pamela enjoyed working with customers and seeing each new season's fashions. In a large store she also learned that the greatest opportunity to make decisions would be in one's own business. Pam yearned to

make her own business decisions, but she also wanted them to be correct. To minimize risks, she decided it would be wise to study fashion merchandising in college. She also decided to keep on working in the fashion field but in an area closer to her own goals.

Pam was hired by the owner of a fashion apparel and accessories store where she worked throughout college and was given many responsibilities. She stayed for several years after graduation and learned how to manage and buy for a small store. Finally, having gained both education and practical experience in fashion, and also having put aside some money to invest in a business, Pam started her own boutique, Clear Cachet. Here she began offering jewelry, scarves, and accessories created by artists and other suppliers in the surrounding area. Today her unique and interesting jewelry and accessories draw customers from many miles away. Clear Cachet is famous for its fashion looks and Pam thoroughly enjoys working with customers and interpreting their needs to local artists.

In this chapter, we will look at the choices available to Pam in selecting a form of fashion business ownership. We will then see some of the ways that businesses grow and expand. Next we will look at the various kinds of businesses that comprise the fashion field and trace the way fashion goods move from the manufacturer to the consumer. Finally, we will look at the economic environment in which fashion businesses operate and note some of the decisions they can make to enhance their ability to compete.

Forms of Business Ownership

In starting a business, the owners may choose from three major forms of business ownership. These are:

1. sole proprietorship
2. partnership
3. corporation.

There are also combinations and variations of these, such as franchises, which we shall discuss later.

Sole Proprietorship

The form of business ownership that Pamela settled on for Clear Cachet was sole proprietorship. Owned and operated by one person, sometimes in cooperation with family members, the **sole proprietorship** is easy to establish. For that reason it is by far the most popular form of business ownership in the United States. The home-owned shoe store, dress shop, or men's wear store downtown in your community may well be organized as a sole proprietorship. A major advantage most sole proprietors cite is that they work for themselves and nobody else. They make their own decisions and can take action rapidly. Also, taxes and government regulations are less stringent for sole proprietors than for more complex business organizations.

The sole proprietorship is not without disadvantages, however. Among these is the fact that the owner generally works long hours and makes the decisions alone, without additional expert advisors. Another disadvantage is that since sole propri-

etorships usually have limited funds or capital, they tend to be small and therefore may generate small incomes and profits. A major disadvantage, known as **unlimited liability,** means that if a sole proprietor is unable to meet the financial obligations of the business, such as its debts, creditors may put a claim on the personal assets of the business owner.

Partnership

Sometimes an owner does not want to shoulder the entire responsibility for the business alone. One alternative is to establish a partnership with other owners. A **partnership** is a legal agreement among two or more individuals to enter into a business arrangement as owners. While many businesses may have two or three partners, some legal and accounting firms are worldwide and have hundreds of partners. In the apparel field, Brooks Brothers men's wear store first started as a partnership, as did Sears, Roebuck and Co. Partnerships are almost as easy as sole proprietorships to formulate. In decision making the partners benefit from each others' expertise; they can increase sales and grow larger than a sole proprietorship because the partners can share the work; and they have access to more capital than do sole proprietors.

The disadvantages of a partnership can be serious. For example, partners may not always agree on a course of action; or, in extreme situations, partners have even been known to run off with company funds. A third major disadvantage to the partnership as a form of business is the concept of unlimited liability, which applies to partnerships as well as to sole proprietorships. Nevertheless, numerous partnerships operate successfully today.

Corporation

A more sophisticated form of business organization is the corporation. Organized as a separate legal being, a **corporation** is owned by its stockholders and has the rights and obligations of an individual to buy and sell property and to sue and be sued. While the largest and most powerful businesses in the United States, such as Wal-Mart—or Levi Strauss and Co., the world's largest apparel manufacturer—are corporations, most corporations are small businesses. Corporations are run by their boards of directors, elected by the stockholders. These boards hire professional managers to conduct the business of the company. The expertise of the trained professional manager can be a distinct competitive advantage for the corporation. Another major advantage of the corporation form is that of limited liability. With **limited liability,** the owners have no further financial obligation to the company beyond their original stock purchases. Unlike business partners and sole proprietors, the stockholders of a corporation are not liable for its debts.

The disadvantages of corporations are that they are expensive to form, and even more so when "going public" or preparing to sell their stock (shares of ownership) on the stock exchanges. (Publicly held corporations, such as Wal-Mart or VF Corporation, are those whose shares may be purchased by the general public. Private

corporations such as Levi Strauss and Anne Klein are owned by private investors and their stock is not offered publicly.) The government has more complex regulations for corporations and requires more paperwork from them than from a partnership or sole proprietorship. Also, the taxes on corporations are higher than on the two simpler forms of business organization.

Mergers and Acquisitions

A trend in business today is for companies to grow larger in the hope of increasing sales and profits. One way they grow is to combine or merge with another company. A **merger** is the joining of two companies to form one. A classic example of a merger in the fashion industry occurred when the J. L. Hudson department stores of Detroit and the

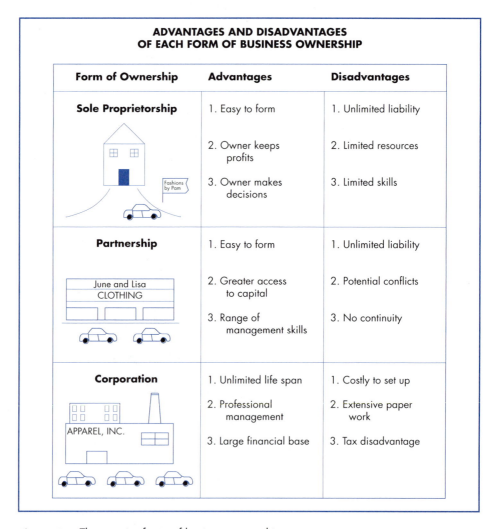

Figure 4-1. Three major forms of business ownership.

Figure 4-2. Most businesses are small, as seen in this artist's rendering for a shopping center. (Courtesy Craig/Steven Development Corporation)

Dayton Company department stores of Minneapolis, realizing they served similar customers in their respective locations, joined together to form the Dayton Hudson Company. The now more powerful organization better serves customers by securing more favorable agreements from manufacturers on styles and prices of apparel and other merchandise.

Another way companies grow is through **acquisition,** that is, by purchasing or acquiring another company. The Saks Fifth Avenue stores became an acquisition of Investcorp, a middle eastern firm, for which Investcorp handed over $1.6 billion to Saks' previous owner, BATUS.[1]

While many organizations merge with or acquire companies related to their original business, such as TJX Company does by owning TJ Maxx and Hit or Miss off-price stores as well as Chadwick's off-price apparel catalog retailer, others acquire unrelated businesses. A group of unrelated businesses in one organization is called a **conglomerate.** An example of a conglomerate is the Melville Corporation, which counts among its businesses Marshall's off-price apparel stores, Wilson's leather goods, Kay Bee toys, and CVS drug stores. Another example of a conglomerate is the Disney Company, which owns theme parks and television channels, produces films, and operates toy and clothing stores.

Composition of the Industry

In creating and moving fashion merchandise from raw materials to finished goods for customers, there are four groups of businesses that comprise the fashion industry. Three of these groups connect directly to each other; the fourth serves the other three. These groups are:

1. the primary group
2. the secondary group
3. the retail group
4. the auxiliary group

The Primary Group

Fashion goods are created from raw materials, often textiles, which are a frequent source of inspiration to fashion designers. The suppliers of the fibers, yarns, and fabrics to the fashion industry make up its primary group. These include the producers of cotton, flax, and woolen fibers, and those of manufactured fibers, such as nylon made by Du Pont. They also include the fabric manufacturers such as Burlington Industries and JP Stevens, as well as the producers of leathers and furs. Apparel designers frequent these manufacturers before thinking of their new lines in order to see what is new in the industry in the way of colors, textures, and print patterns. Production by the primary group, therefore, occurs as much as two years ahead of the time a finished garment is tried on by a customer in the store.

The Secondary Group

The secondary group consists of the manufacturers of finished garments. These include large businesses such as Levi Strauss and Co. and small organizations such as Caron Dress Company. Some of the better known are: Leslie Fay, a manufacturer with several divisions, including Leslie Fay dresses, sportswear, and children's wear; Breckenridge sportswear; and Nolan Miller/Dynasty Collection. VF Corporation makes Wrangler and Lee jeans and other apparel, and Hartmarx manufactures men's and women's suits, coats, and sportswear. These organizations buy textiles and other materials from the primary group companies, create the finished garments, and sell them to retailers. They work six months to a year ahead of the time when the fashions become available in the stores.

Figure 4-3. The designer begins work on a new line months ahead of its debut. (Courtesy Ellen Diamond)

Figure 4-4. In what ways does the apparel manufacturer depend on the primary and retail fashion groups? (Courtesy Coach)

The Retail Group

The retail group consists of the stores and other retail organizations such as catalog retailers. They purchase finished garments and other fashion goods from the manufacturers or their representatives and sell them to customers. Retail businesses are found everywhere people gather, from large urban areas such as New York and Los

Figure 4-5. Retailers place orders for merchandise months before it is needed in stores. (Courtesy Dallas Market Center Co. Ltd.)

Angeles to more remote communities such as Decatur, Georgia; Ellison Bay, Wisconsin; and North Platte, Nebraska. Retailers usually place their orders for merchandise at least six months ahead of the time that they are needed in the store so that the apparel manufacturers have time to make and ship the garments. J. C. Penney, Wal-Mart, Clothestime, Victoria's Secret, and Home Shopping Network are all examples of retail businesses.

The Auxiliary Group

While the first three groups of the fashion industry are linked directly to each other in the movement of fashion in that they buy from and sell to one another, the auxiliary group assists all of them. The auxiliary group consists of a variety of businesses, including marketing research organizations, fashion advisory services, the fashion media, and buying organizations, each of which contributes to the dissemination of fashion information and helps speed the manufacturing and marketing process.

In marketing research, the fashion industry benefits from the consumer studies of organizations such as *GQ* magazine, Grey Advertising,[2] The Claritas Corporation,[3] and others who contribute information on consumer lifestyles and buying patterns. This enables manufacturers and retailers to make and market apparel suitable to consumers' lives.

Fashion advisory services, such as The Fashion Service and The Tobé Report, let manufacturers and retailers know the latest in colors, fabrics, and fashions so that

Figures 4-6a and b. The fashion media herald the latest news on everything from what's hot in Europe to what the fashion-conscious bride is wearing. (Courtesy a. *Marketing News* b. *Brides Today*)

Table 4-1

Primary Group

Producers of yarns, fibers, and fabrics

Secondary Group

Manufacturers of apparel and accessories

Retail Group

Chain, department, and specialty stores, catalog houses and direct merchants

Customers

Auxiliary Group

Advertising and public relations agencies, consumer and trade publications, resident buying offices, fashion advisory services, professional and trade groups, and research organizations

they can choose what is most appropriate for their customers. The fashion media, including newspapers, magazines, and television, disseminate the latest fashion information to people in the fashion business through trade papers such as *Women's Wear Daily* and *Daily News Record,* and to the public through consumer publications such as *W, Vogue,* and *Ebony Man.*

Buying organizations, located in major market centers such as New York or Paris, work with retailers and manufacturers to locate and obtain the most suitable new merchandise for a store's customers.

Table 4-1 shows how the four groups of fashion businesses depend upon each other.

Fashion Designers—The Creators

New apparel and accessories grow out of the ideas of fashion designers. Each season, or from two to six times a year, designers must come up with new designs or interpretations of the goods that manufacturers then offer—known as **merchandise lines,** or simply **lines.** Each season designers must bring forth innovations and fresh inter-

pretations of last season's successes. The task is not easy. The success of the designer and of the manufacturer depends not on whether the finished items are creative or stylish, but on whether customers will accept what the designer creates and the manufacturer offers this season.

There are three types of fashion designers: fashion designers, stylist-designers, and freelance designers.

Fashion designers are at the top of the fashion business. They design their own lines and own their own businesses or have financial backing to create their own lines. The most famous are known worldwide. A few examples include Bill Blass, Donna Karan, and Geoffrey Beene, in the United States. In other parts of the world they include Karl Lagerfeld, who designs several lines, one for the house of Chanel in Paris, one for the Fendi sisters in Italy, and then a line for Chloe and his own line as well, and Giorgio Armani, who headquarters in Italy and has stores on several continents. (For other world-famous designers, see Appendix A.)

Fashion designers create new lines several times a year. These lines may be custom designs for individual clients, socialites, business and political leaders, and celebrities. For example, Bob Mackie creates show-stopping gowns for Cher's performances. In addition, they may design lines of ready-to-wear bearing their own name or label, as Donna Karan designs the DKNY line. Some designers, such as Sonia Rykiel and Kenzo, create only ready-to-wear.

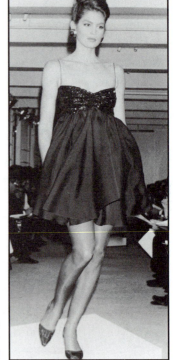

Stylist-designers are employed by manufacturers to create lines or adapt them for local production. While the names of individual stylist-designers may not be known outside the industry, the lines they create are often household words, such as Jantzen, Guess, Jockey, and Carters. These lines may be in all price ranges, from expensive Dooney & Bourke handbags to Keds canvas shoes. For example, Hartmarx, a manufacturer of men's wear and women's business wear, employs stylist-designers for its lines of men's and women's suits. The responsibility of one team of stylist-designers is to adapt certain men's suits from the Christian Dior men's wear line—which the company has purchased the right to manufacture in the United States—to a look that American men will wear. This may include changing the lapels, armholes, or the fit at the chest and waist to accommodate the

Figure 4-7. Each season, designers show their creations for customer acceptance. (Courtesy Donna Karan)

DONNA KARAN

*Designer for
the Fast Track*

Snappy, smart, and versatile are some of the terms that describe the work of Donna Karan, designer for executive fast track women and, with her less pricey DKNY secondary line, for career wanna-be's and younger affluents. Donna Karan's fashions are snapped up by customers everywhere because they are useful, packable, and interchangeable. During times when retailers hesitate to buy goods that may linger on their store racks, they are eager to secure the Donna Karan and DKNY lines because these lines sell through; that is, they need few markdowns or price reductions. In the early 1990s, the DKNY lines alone amounted to nearly $200 million in sales, each year surging upward significantly from the one before.

Designing her lines at the hectic rate of one a month, Donna Karan knows she has the ultimate responsibility for them and that the company's success is based on her work. Nevertheless, much of her life focuses on her second husband, Stephan Weiss, their children by previous marriages, and their grandchild, Mackenzi, who sometimes models in company ads. Her home, a Manhattan apartment filled with French and Italian furnishings, pillows, books, and flowers, reflects the importance of sophisticated ease, a feeling Donna Karan also emphasizes in her styles.

Karan's early life gave little indication of what was to come. Born in New York in 1948, Donna Karan did not experience a very happy childhood. Her father, a tailor, died when she was three. Donna Karan delighted in discovering, however, that she too had talent in the apparel field as a designer. She nurtured that talent by attending the Parsons School of Design, while also holding down a summer job as a designer with Anne Klein. She left school to go with the company full time. When Anne Klein died, Donna Karan and school friend Louis dell'Olio continued the designer's line, and Donna Karan started up the lower-priced highly successful Anne Klein II line.

In 1984, Donna Karan went on her own, launching the Donna Karan Company, with financial backing for half of the new company coming from the Japanese orga-

> *"I feel like I'm walking on a tightrope with every collection I do. I have fabulous people and I delegate but I do believe the buck stops here."* **Donna Karan**

continued

nization, Takihyo, Inc., which also financed Anne Klein. (Many Japanese organizations have surplus funds that they invest in potentially profitable endeavors in the United States and other parts of the world.) The other half of the Donna Karan Company is owned by the designer and her husband. Before long, in addition to her exclusive Donna Karan Collection, she started a diffusion or secondary line, DKNY (Donna Karan New York), with prices half those of the Collection. For a customer to purchase a Donna Karan outfit with Karan accessories, prices ascend from $2000, so the DKNY line, with jeans and T-shirts-in-packs-of-three at $85 each, represent prices more accessible to many women.

What accounts for the popularity of Donna Karan's designs? Many customers cite their inherent style, comfort, and ease. Built around the body suit, the sweaters, jackets, skirts, and pants can be intermixed, resulting in a smooth, uncluttered look. They pack and travel well and are suited to busy lives of her clients, among the best known Candace Bergen and Diane Sawyer. Donna Karan cuts her garments to look fashionable on women with less than perfect figures. She has won a number of awards, alone and with Louis dell'Olio. Among the most outstanding are the Coty "Winnie," the Hall of Fame Award, and the Coty Award for Womenswear. In 1990, she was named women's fashion designer of the year by the Council of Fashion Designers of America (CFDA), and in 1992 the same organization repeated the honor, this time as men's fashion designer of the year.

Along with producing her lines, Donna Karan licenses her name in the manufacturing of jewelry, hosiery, eye glasses, shoes, and furs. To accommodate its expanding divisions, the company recently built a $4.3 million Manhattan headquarters for DKNY alone, including offices and showrooms for the various DKNY divisions, among them jeans and sportswear; activewear for sports such as tennis, golf, and aerobics; accessories; men's and children's wear; retail stores; and international operations. The company does a growing amount of business overseas in stores and Donna Karan is opening her own boutiques in Asia and Europe, beginning in Hong Kong and Paris.

Donna Karan has also formed her own fragrance company and is entering into a joint venture to produce shoes.

Question for Discussion. What three or four factors do you believe contribute to Donna Karan's success in fashion design and merchandising?

Sources. 1. Genevieve Buck, "Letting Loose," *Chicago Tribune,* Section 7, October 2, 1991, pp. 5-7; 2. Constance C.R. White, "DKNY: A Home of Its Own," *WWD,* February 12, 1992, p. 2; 3. Jane Mulvagh, *A History of Twentieth Century Fashion,* Viking, London, 1988; 4. Katherine Weisman, "Designing Woman," by Katherine Weisman, *Forbes,* October 1, 1990, p. 261; 5. Barbara Rudolph, "High Style for the 9-to-5-set," *Time,* October 25, 1989, p. 70; 6. Nina Darnton, "Turning Rags into Riches," by Nina Darnton, *Newsweek,* April 24, 1989, p. 84.

current feel for style and comfort important to American men. The stylist-designer has the responsibility of seeing the garment from its initial interpretation through its changes and production until it reaches the stores.

Freelance designers are self-employed. They often work in their own studios, creating designs at the request of manufacturers. They usually specialize in certain areas such as women's sportswear, children's wear, or intimate apparel. After creating their sketches, they sell them to the manufacturer, and the designer's responsibility ends at that point.

Manufacturers

There are four categories of apparel manufacturers, based on price:

1. designer
2. bridge and better
3. moderate
4. budget

Designer Apparel Manufacturers

Designers include the world's most successful creators of fashion. Examples are Oscar de la Renta, Yves Saint Laurent, Karl Lagerfeld, Ralph Lauren, Emanuel Ungaro, and Issey Miyake and Gianfranco Ferre. Their garments are sold in selected stores and boutiques throughout the world. The ready-to-wear of these designers is often produced under contract with leading apparel manufacturers. For example, the Italian manufacturing organization Gruppo GFT produces the ready-to-wear of many French and Italian designers, among them Armani and Ungaro. Many designers, aiming to reach a greater number of customers, created merchandise lines at lower prices. These lines are known as "secondary" or "diffusion lines." An example is the Donna Karan DKNY Line, still expensive but lower in price than her higher priced Collection.

Bridge and Better Apparel Manufacturers

Bridge and better apparel manufacturers create merchandise in price ranges between designer and moderately priced apparel. The upper price range of this group is known as "bridge" apparel, serving as a bridge between the designer secondary lines and better price ranges. Some well known bridge merchandise lines include Andrea Jovine, Adrienne Vittadini, and Joan Vass. Well known names in better merchandise lines include Jones New York, I. B. Diffusion, John Meyer of Norwich, Skyr, and London Fog. A growing number of designers, among them Gordon Henderson, Marc Jacobs for Perry Ellis, Louis dell'Olio, and others, also create lines in the bridge price range. Some manufacturers, such as Esprit, offer lines in both bridge and better price ranges.

Moderate-Priced Apparel Manufacturers

Moderate-priced apparel manufacturers create clothing and accessories for most Americans. They are the producers of mass or volume fashion, such as Jordache, Levi Strauss, Ocean Pacific, Russ, and Sergio Valente. These garments are sold in department and chain stores and moderate-priced specialty stores everywhere.

Budget Manufacturers

Budget manufacturers create low-priced popular apparel that is found in chain and discount stores throughout the country. Some of the well known brands of budget apparel are Donkenny, Gitano, Keds, and Wrangler.

Fashion Marketers

As manufacturers create fashion merchandise, marketers—wholesalers and retailers—see that these goods reach the final consumer. There are several categories of fashion marketers. Three of these are wholesalers, retailers, and a form of retailing called "franchising."

Wholesalers

Fashion, like orchids, oranges, or ice cream, is perishable. Therefore, to maintain their value, fashion goods are sped on their way from the manufacturer to the customer as swiftly as possible. Few marketing steps exist between the manufacturer and the retailer. Before the beginning of a new season, retailers send their store buyers to the manufacturer to see the new lines. For example, the dress buyer for the Lazarus department stores in Cincinnati, or The Broadway stores in California, visits the showrooms of New York manufacturers, such as After Five, to see the latest in dressy evening wear. Here the **sales representative** employed by the manufacturer shows the store buyers the new line of merchandise. The buyer takes notes or leaves orders for goods to be delivered in three to six months' time. The sales representatives then follow through on the buyer's orders to see that the goods are shipped to arrive in the store as agreed.

While a trend exists for businesses to grow larger, many apparel manufacturers are small businesses that do not have their own showrooms. These manufacturers contract with an independent business organization known as a **manufacturer's agent** to sell their lines to retailers. A manufacturer's agent is not an employee of the manufacturer, but is a person in business for him- or herself. A manufacturer's agent is paid by the manufacturers a percentage of the price of the goods sold and delivered to the stores. Typically, a manufacturer's, agent carries the lines of five or six noncompeting manufacturers which are shown to retail store buyers who visit the agent's showroom at the beginning of each season. Later in the season, the manufacturer's agent visits local stores in the area or territory to see how the lines are selling, to obtain reorders, and to seek out new customers.

Retailers

The customers of the manufacturers and their representatives are retailers. Retailers include a wide assortment of chain, department, and specialty stores presenting a range of service and price levels. For example, consider the diverse offerings of Montgomery Ward, Neiman Marcus, Marshall's, and Eddie Bauer. Retailers also include other businesses that sell to consumers but not always in a store setting, for instance, catalog businesses such as Tweed's and J. Crew, vending machines, and video programs and channels such as The Fashion Channel. Increasingly, fashion is contributing more to retail sales, and retailers are looking for new ways of reaching customers in addition to traditional stores. Catalogs, television, and computers are becoming more important in marketing fashion.

Figure 4-8. In what ways is shopping made easier for customers by the construction of new shopping centers? (Courtesy Craig/Steven Development Corporation)

Franchises

An emerging form of retailing in the fashion field is franchising. A **franchise** is an agreement between an individual who wants to own a local retail business and a well known manufacturer who wants to be represented in that area. To use that manufacturer's name, the individual pays an initial fee, plus a percentage of each month's sales. While the best known franchises—such as McDonald's and Dairy Queen—are in the fast food field, franchising as a way of operating a fashion business is growing in popularity. The Polo/Ralph Lauren stores are franchises, as are some Esprit stores and all of the Benetton stores throughout the world. Franchises can give the local business owner some protection: the use of the well known name such as Benetton, a certain level of product quality, training and supervision in operating the franchise business, and possibly financial assistance in locating and fixturing the store. Not all franchises offer these advantages, however, and it is wise for people considering a franchise to consult a reliable attorney to be fully aware of the terms in a particular franchise agreement. A good franchise, however, can lessen some of the risks inherent in running any business.

How the Groups Depend Upon Each Other

Each of the four groups comprising the fashion industry depends upon the others. The primary group—creators of fibers and fabrics—depends on the secondary group—the apparel manufacturers—to purchase its output. At the same time, the

new fibers and fabrics that become available each season inspire designers to create exciting and innovative apparel. The retail store buyers, eager to buy fresh looks for their stores, seek out new interpretations from the manufacturers each season. The auxiliary group serves to make communication faster and easier among the other three groups: for example, some organizations provide research on customer preferences. Consumer and trade publications and fashion advisory services spread fashion news throughout the industry, publicizing the latest fibers, fabrics, colors, textures, and patterns, and crisp new garments. Buying offices seek out the best available goods for a store's customers and notify store buyers of items with appeal. In this way, each of the groups depends on the others and assists the others in the cycle of creating and marketing fashion apparel.

The Role of Competition

The purpose of any business is to earn a profit. A **profit** is what a business may have left from its income after paying its bills. In order to work toward earning a profit, a major right of the people in a free society is the right to compete in the marketplace. This means that within the law, individuals have the right to open a business of their own choosing and to run that business as long as they may desire. They may expand the business or move it, or close it down if they see fit.

In our society, four major competitive situations can exist:

1. monopoly 3. pure competition
2. oligopoly 4. monopolistic competition

On a scale of 1 to 10 showing competition, with pure competition being 10, monopoly ranks a 0. A **monopoly** occurs when one business dominates an industry and can then set whatever prices it chooses. For example, at one time in our history the railroads were a monopoly.[4] Because a monopoly eliminates competition, monopolies are now illegal in the United States, except for industries that are impractical to duplicate, such as utilities; however, these industries are closely regulated by the government. An **oligopoly** is the domination of an industry by a few major businesses. In the United States, breakfast cereal and light bulb manufacturers are two examples of oligopolies.

At the other end of the scale, **pure competition** exists when there are many manufacturers and many customers, and no single manufacturer is able to control the price of goods. Agriculture comes as close as possible to pure competition. Think of all of the farms selling wheat, for example, and the many customers they have. No single farmer is large enough to set the price of wheat, but price is determined in the marketplace by supply and demand; that is, by the interaction between the amount that farmers are willing to sell at a given price and the amount that the mills and other wheat customers are willing to buy.

The kind of competition common in the fashion field, including retailing, is known as monopolistic competition, an unlikely combination of monopoly and competition. In **monopolistic competition** there are many competing sellers of all

CHARACTERISTICS OF THE FOUR BASIC COMPETITIVE SITUATIONS

Characteristics	Monopoly	Oligopoly	Monopolistic Competition	Pure Competition
Number of firms in the market	One	Few	Many	Many
Control over price	Considerable	Some	Some	None
Type of product	Unique	Similar or different	Different	Similar
Ease of entry into the market	Not possible	Very difficult	Relatively easy	Very easy
Use of nonprice competition	Some: mostly public relations, advertising	Quite a lot: advertising, quality and service	Quite a lot: advertising, quality and service	None
Examples	Local water and electric service	Light bulbs, breakfast cereals, steel	Apparel and accessories manufacturers, all retailers	Agriculture

Figure 4-9. These four competitive situations can be found in the U. S. economy.

sizes, yet the product may be unique enough for each seller to have some control over its price. For example, consider Guess, Lee, and Armani A/X. Each of these jeans manufacturers works to achieve a distinct image, separate from the others. In monopolistic competition, by creating a distinct image, a fashion business may then have some control over the price it charges.

Creating an Advantage

In order to compete successfully in monopolistic competition, organizations seek to create an advantage that will bring customers to them instead of someone else. They want to stand out as unique to their customers. Businesses can do this any number of ways. They may offer special products, as do stores featuring imports or custom-made apparel and fashions. They may offer low prices and claim spectacular values, as do off-price and outlet stores or manufacturers offering a free item when two are purchased. Fashion marketers may promote their goods as rare or their services as special, as do Hermès and Nordstrom. Or, they may make their goods available in unusual ways, through catalogs, video disks, or via the computer as well as in stores, as do Footlocker and Chanel.

Establishing Perceived Difference

Whatever methods or combinations businesses choose to distinguish themselves, their goal is to set forth in actuality or in the mind of the consumer what is known as a perceived difference. A **perceived difference** is a distinguishing feature of a product or business that allows it to stand out from others, in reality or in the mind of the customer. For example, a customer sees a mounted polo player or a golden fleece embroidered on a T-shirt and feels that this T-shirt from Ralph Lauren or Brooks Brothers is significantly different from the T-shirt embroidered with a swan from Gloria Vanderbilt or a fox from J. C. Penney. In reality, all four shirts are basically similar in style and color. The perceived difference of each in the mind of the customer becomes the deciding factor in purchasing the item. One customer may want the value of the J. C. Penney shirt while another chooses the image of Brooks Brothers. Establishing a truly perceivable difference is one way for businesses to operate successfully in monopolistic competition.

Three other ways of establishing perceived difference in the eyes of the customer include licensing, private labels, and vertical integration.

Licensing. The owner of a famous name such as Michael Jordan, Hubert de Givenchy, or even Miss Piggy may grant the right to a manufacturer to produce and market a product bearing that name; granting this right is known as **licensing**. Licensing is important in the fashion industry worldwide, capitalized on by designer Pierre Cardin whose name appears worldwide on apparel, small leather goods, luggage, and many other items. Licensing is popular in manufacturing children's wear, with cartoon and television characters and sports heroes and teams showing up on children's sweaters, T-shirts, backpacks, and other items. Wrangler jeans has a licensing arrangement to have jeans produced in Belgium and Spain by manufacturers in those countries. Through licensing, the product name is made available to more people, the original company gains additional revenue through the granting of licenses, and the local company sells more than it would otherwise.

Brand Names and Private Labels. By establishing a brand name, a company sets its name above the others. This is true in all areas of marketing. Think of the pizzazz of names such as Isaac Mizrahi, Louis Vuitton, Hugo Boss, or Adrienne Vittadini. These are national and even worldwide brand names. A national **brand name** product is one that is marketed everywhere, that customers may obtain in a variety of places. Examples of national brand names include Hanes, Monet, Prince Gardner, Nike, and Arrow.

Not only does a brand name help establish perceived difference nationwide, but it is also effective locally. Retail stores establish perceived difference by offering private label merchandise. A store's **private label** belongs to that store and is placed on goods available only at that store. Examples of private labels include those with the store's own name such as Lord & Taylor or Victoria's Secret brands or special names exclusive to the store such as K mart's "B. E." (for Basic Editions) or Dayton Hudson's "Field Gear."

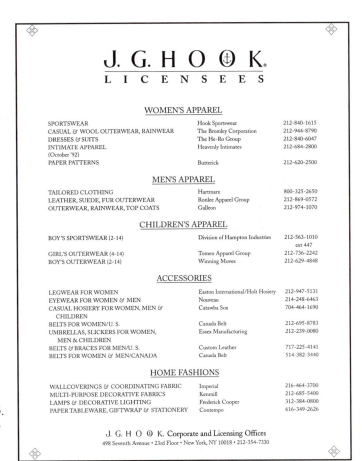

Figure 4-10. The J. G. Hook licenses may be found in many stores. (Courtesy J. G. Hook)

Vertical Integration. Another way businesses aim to obtain a distinct perceived difference is through vertical integration. **Vertical integration** is organizing a business so that it controls other levels of the manufacturing and marketing process of the product. Consider Fisher-Camuto, a shoe wholesaler headquartered in Connecticut. Fisher-Camuto owns the 9 West shoe stores around the country, as well as manufacturing facilities in Brazil. By tracking shoe sales daily in all of its stores throughout the country, counting styles, colors, sizes, widths, and even heel heights, Fisher-Camuto can inform Brazil directly about the styles and colors to replenish and those to discontinue manufacturing.[5] For customers shopping at 9 West shoe stores, the perceived difference is that rarely is the store lacking a wanted style, size, or color, and if need be, the item can be obtained quickly. Having adequate stock is a key ingredient in competing successfully and surviving in an environment of monopolistic competition.

SPOTLIGHT ON A FIRM

THE GAP, INC.

Beginning life in the late 1960s as a San Francisco jeans retailer to teenage baby boomers, The Gap, Inc. has grown into a nationwide collection of over 1000 specialty stores under four names: Gap, GapKids, babyGap, and Banana Republic. Offering casual wear for men, women, and children, these stores located in the United States, Great Britain, and Canada now ring up sales each year of billions of dollars, with a projected income of $5 billion in 1995.

When in 1969, real estate man Donald K. Fisher opened the first Gap store featuring jeans and records, he did so in part out of frustration. He had not been able to find Levi's for himself in any local stores. With a wide selection of Levi's in all sizes, the first Gap became an immediate hit among young San Franciscans. As more stores opened, Fisher made sure they were stocked with Levi's in a variety of styles and colors.

The Gap's nationwide business and high sales were not built on catering to teens alone. Early on, Donald Fisher realized that with a shrinking teenage population, it would not be long before a business depending solely on that market would shrink, too. To help build the business and change the image of The Gap, Fisher brought in Millard Drexler, who had been president of Ann Taylor and responsible for many changes in that organization.

Drexler added direction to The Gap, focusing on the profitable market of maturing "30-something," and offering simple basics with style. He redecorated the store interiors and painted the fixtures white, giving them a sparse modern look, making certain they were kept sparkling with frequent cleaning and touch-up.

Most important, Mickey Drexler added a coordinated range of fashion colors in shirts, sweaters, and socks to enhance the basic stocks of jeans. Every eight weeks the styles and colors are changed, giving the stock fresh appeal. In addition, quality is carefully monitored. The Gap maintains its own design team, people who are alert to fashion trends but are keenly aware of the tastes of Gap customers. As the sketches of Gap designers are turned into garments in the factories of some 40 countries, around 200 Gap employees work on maintaining quality control. To speed its rigidly inspected new merchandise to local stores, shipping is done from a modern distribution center such as the one in Baltimore, Maryland, which services stores in New York City every day.

The idea of reasonably priced fashionable weekend wear has caught on. The look is not limited to adults. GapKids stores, featuring Gap-style jeans and tops for children, are based on the idea that Gap customers who are parents want the same kinds of basic inexpensive apparel for their children. The newer babyGap stores are geared to an even younger consumer.

In addition, The Gap operates the Banana Republic stores, originally a safari-theme chain. When the wave of safari fashions ebbed, Gap saw the company through a

change to a more basic travel sportswear store with higher prices than those of its parent. However, not all of The Gap's ventures are successful. A group of higher priced apparel stores called Hemisphere and offering merchandise in a surrounding of muted lighting and oriental rugs was closed out after failing to capture the interest of consumers.

The success of The Gap's total image is strengthened by the company's use of branded merchandise. When Donald Fisher opened the first Gap stores, their success was based on offering substantial assortments of Levi's at a price suggested by the manufacturer. Before long, legislation no longer let manufacturers suggest prices and it became legal for retailers to cut the price of Levi's. The Gap had to lower its prices to compete, a good reason to develop its own private label. As part of changing the image of The Gap, Millard Drexler expanded The Gap label, offering jeans and tops in styles and colors different from Levi's and at lower prices. Today The Gap has phased out Levi's and offers only its own label. For The Gap, using a private label has helped create a distinct perceived difference in the minds of customers.

Another venture for The Gap is that of locating its stores as anchors in new shopping malls. Starting in Wheaton, Illinois, Donald Fisher decided to place a Gap store in a new mall as the main (or anchor) store, instead of the traditional department store such as The May Company, or chain store, such as Sears, Roebuck and Co. This kind of center is based on the idea that The Gap's 25- to 40-year-old customers want a store that is close to home and easy to reach for shopping that can be done in a limited time. Other stores in this mall include GapKids and Banana Republic and other specialty apparel and housewares stores.

How well The Gap continues to succeed can be judged in part by its imitators—as sincere a form of flattery in the fashion business as it is anywhere. A number of organizations are also aiming to reach the same target customers, ranging from traditional specialty retailers such as County Seat to Melville Corporation's Garage stores and Giorgio Armani's A/X Armani Exchange. The long-term effectiveness of The Gap depends on its skills in meeting the competition and holding on to its target customers.

Question for Discussion. In addition to its private label, what are two or three Gap practices that enable the company to establish a perceived difference in the minds of customers?

Sources. 1. Russell Mitchell, "The Gap: Can the Nation's Hottest Retailer Stay on Top?" *Business Week,* March 9, 1992, pp. 58–64; 2. Adrienne Wood, "The Gap Opens the Door to New Mall Concept," *Advertising Age,* January 21, 1991, p. 39; 3. Francine Schwadel, "Simple Success: Gap, Inc. Is Prospering Even as It Disdains Usual Holiday Hype," *The Wall Street Journal,* December 19, 1990, pp. 1 and A10; 4. Marianne Taylor, "Gap to Set Sail in Anchorless Mall," *Chicago Tribune,* October 24, 1990, Sec. 3, p. 1; 5. Nina Darnton, "From Schlock to Chic," *Newsweek,* May 15, 1989, p. 73; 6. Susan Caminiti, "How Gap Keeps Ahead of the Pack," *Fortune,* February 12, 1990, pp. 25–6; 7. *Annual Report 1990,* The Gap, Inc., San Francisco, California.

Laws Affecting Competition

Because the right to compete is essential in a free society such as ours, federal laws have been established to protect that right; among the most important are:
- The Sherman Anti-Trust Act of 1890, which outlaws monopolies and restraints in competition.

- Later, the Clayton Act of 1914 strengthened the Sherman Anti-Trust Act in the areas of price-fixing and price discrimination.
- Also, 1914 saw the establishment of the Federal Trade Commission (FTC) with the passage of the Federal Trade Commission Act. The FTC serves as a watch dog over the unfair competitive practices covered in the earlier legislation.
- The Robinson-Patman Act of 1936 was created to protect small businesses by not permitting suppliers to offer substantially lower prices to larger businesses based on their size alone.
- The Cellar-Kefauver Act of 1950 made it illegal for businesses to create a monopoly by merging.

Summary

1. In forming a fashion business, there are three major forms of business ownership: sole proprietorship, partnership, and corporation. The sole proprietorship, or one-owner business, and the partnership, two or more partners as owners, are easy to form but have the major disadvantage of unlimited liability, that is, the risk of losing personal as well as business assets to meet financial obligations. A corporation is a legal being with limited liability, owned by its stockholders and operated by professional managers. Corporations are expensive to form and are required to submit detailed information to the federal government.

2. The fashion industry is composed of four interdependent groups of businesses. These are: the primary group, the producers of fibers and fabrics; the secondary group, the manufacturers of apparel; the retail group, the stores and other retailers who sell to consumers; and the auxiliary group, those businesses providing research, fashion information and promotion, and buying services to the other three groups.

3. Fashion designers create merchandise for manufacturers who sell it to retailers through their own sales representatives or through independent businesses called "manufacturer's agents." Retailers include stores and other organizations such as catalog businesses, who sell directly to consumers.

4. The goal of business is to earn a profit. To do this, businesses compete in the marketplace. There are four competitive situations in our society:
 - monopoly, the domination of an industry by one business
 - oligopoly, the domination of an industry by a few businesses
 - pure competition, where no single business dominates and prices are set by supply and demand

- monopolistic competition, where there are many competing businesses—as in retailing and the fashion industry—and each business tries to distinguish itself from the others

5. Appearing unique and distinct from competitors creates a perceived difference. Some ways that businesses establish a perceived difference include licensing, granting others the right to manufacture and market a product with a famous name; creating national brand names and private labels; and vertical integration, acquiring businesses in the manufacturing and marketing process and creating a markedly more consumer-responsive organization.

6. The right of businesses to compete in our society is protected by Federal laws. Among the major laws are The Sherman Anti-Trust Act, The Clayton Act, The Federal Trade Commission Act, and the Robinson-Patman Act.

Fashion Vocabulary

Explain each of the following terms; then use each term in a sentence.

acquisition	merchandise lines	profit
brand name	merger	pure competition
conglomerate	monopolistic competition	sales representative
corporation	monopoly	sole proprietorship
franchise	oligopoly	unlimited liability
licensing	partnership	vertical integration
limited liability	perceived difference	
manufacturer's agent	private label	

Fashion Review

1. As a business owner, explain the advantages and disadvantages of the sole proprietorship, partnership, and corporation as forms of fashion business ownership.
2. Name the four business groups that comprise the fashion industry, give an example of each, and describe how they depend upon one another.
3. Compare three ways that fashion designers may work with apparel manufacturers.
4. Trace the movement of fashion apparel from the fiber and fabric manufacturers to the consumer.
5. Explain why fashion manufacturers and retailers seek to establish a perceived difference in their merchandise lines.

Fashion Activities

1. You want the have a fashion business, such as an apparel store of your own, but you do not know whether it would be better to start it as a sole proprietor, find a partner, or enter into a franchise agreement. On a separate paper, prepare a form like the one that follows. At the left, list the three alternative business choices. Across the top, list the advantages and disadvantages of each form of business ownership. Place your findings in the appropriate columns.

Alternative Business Choices	Advantages	Disadvantages
Starting as a sole proprietor		
Finding a business partner (or partners)		
Entering into a franchise agreement		

2. You import a line of unbranded sweaters, which you sell to stores nationwide. You are looking for ways to establish a perceived difference for your sweaters. One of your largest customers, a major department store, has asked you to sew a private label into the sweaters it buys. Determine the best course for your business to take and explain your decision. Describe and draw a suggested design for the store's private label, should you decide to take the retailer's offer. Then draw a label for your company to identify its merchandise to all of your store customers.

Endnotes

1. Bernard Baumohl, "Just Who Are Those Guys? A Reclusive Middle East Firm Buys Saks for $1.5 billion," *Time,* May 7, 1989, p. 90.
2. Penny Gill, "Who's Counting?" *Stores,* May, 1988, p. 33.
3. Michael J. Weiss, *The Clustering of America,* Harper & Row, New York, 1988.
4. Matthew Josephson, *The Robber Barrons,* Harcourt, Brace, Jovanovich, and Company, New York, 1934.
5. "MIS Lets Shoe Manufacturers Set Today's Production Schedule Based on Yesterday's Sales in its Stores," *Marketing News,* February 1, 1985, p. 27.

P r o j e c t

Analyzing a Consumer Fashion Purchase

The purpose of this project is to identify current selected fashion goods and to trace the decision-making process that customers undertake in determining potential buying action. An additional outcome is to note any relationship of the availability of certain fashion goods to a given form of retail business ownership. A final outcome is to comprehend the difference between buying for oneself and buying for others.

Using the material you have read in this unit combined with your own fashion experience, develop your project in response to the questions below. Be prepared to present your findings orally, illustrated with appropriate pictures and charts, or in writing, as indicated by your instructor.

1. Identify yourself or someone you know as a consumer according to five demographic and psychographic variables.
2. Select a significant fashion item, such as a coat, suit, or outfit, that you or your subject recently purchased or want to own this season.
3. Describe the reasons this item is a current fashion by analyzing it according to each of the four elements of fashion and locating it on the fashion life cycle.
4. Trace the decision-making process you or your subject completed or are going through in reaching the buying decision. (See Chapter 2).
5. Determine the form of ownership of the retail business where the item is offered.
6. Explain the relationship—if any—between the availability of the item and the form of ownership of the retail business. (Example: Gap jackets are offered by The Gap, a corporate chain organization. A particular jacket may be purchased at most Gap stores anywhere in the country.)
7. Would you recommend that the retailer stock this item in depth? Why or why not?

Producing FASHION

Primary Fashion Resources

Objectives

After completing this chapter, you should be able to:

1. Describe four major natural and six major manufactured fibers used for apparel.

2. Explain the major steps of textile fabric production.

3. Identify four major textile laws and cite their purpose.

4. Describe three future trends in the textile industry.

5. Summarize three recent developments in the fur and leather industries.

One day, not far into the 21st century, Angie Pearson, a college fashion design and merchandising instructor, was searching through the attic. She knew that there must be a key somewhere to a dusty old trunk. . . . Oh! There it is! She wondered what was inside. . . .

"Wow! It's my high school yearbook, I haven't seen this in quite a while," she thought. "And here's the sweater that grandmother knitted for me. . . . I don't believe it—100 percent wool with real fur and leather trim. . . . You just don't find garments like this anymore."

Her thoughts wandered back to the days of wool, silk, and cotton. "And what ever happened to real fur, suede, and leather?" she mused. "Now, of course," her train of thought continued, "these materials are found only in museums and historic costume collections, along with nylon, polyester, spandex, and acrylic. My, how times have changed."

Delving into the more recent past, Angie went on, thinking, "I guess it all started around the turn of the century, with new technological developments. First, the invention of 'hypercolor clothes' that actually change color with the wearer's body temperature. Next, the development of a new generation of super-soft micro fibers. Then came 'never iron' clothing which held a perfect crease, even after years of washing. Those were a big help and what timesavers!

"Not long after that," she recalled, "an entirely new fiber was discovered equipped with a new 'cellular intelligence.' Garments could not only change their color and size, but could communicate with one another. Separates could actually piece themselves together and coordinate with one another into a variety of outfits!

"Now," she thought, "we can change the design or color of the garment that we're wearing by pushing a button at the shoulder seam. What will they think of next?

"What's this in the bottom of the trunk? Knitting needles? My students may find these rather quaint." That reminded her that the sweater she had designed on the computer yesterday should be ready. Gathering up the needles and the hand-knitted sweater to show her students, she went to pick up her most recent computer-designed fashion. "It's amazing how times change," she reflected.

Introduction to the Primary Fashion Resources

Textiles and other materials, such as leather and fur, are the materials most widely used by the apparel industry. They often provide the original inspiration for a line and may dictate what shape the actual clothing item will take.

In the past, fashion designers basically catered to similar classes of people with stable influences and tastes. This particular market had a common religious and cultural background, a similar education in history and art, and more money to spend on clothing. The world was a lot smaller then, and people never traveled more than a few miles from home.

Today things are quite different. The American experience has expanded and international business has become a fact of life. It is not unusual for a person to

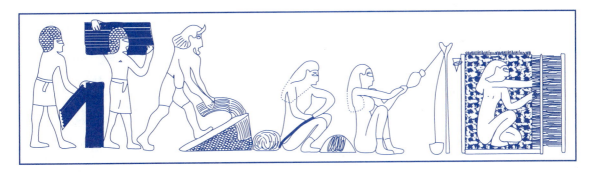

Figure 5-1. Egyptian textile production: fiber cultivation, yarn spinning, and weaving.

work, travel, and communicate across vast distances of the world within a given week with little hesitation.

As a result of these changes, the fashion business has become more multicultural. People enjoy discovering how special our many cultures are. For example, designers source the world markets and gain color and design inspiration from beautiful fabrics such as African Kente cloth, tapestries from Italy and Russia, and luxurious silks from Japan and China.

Fashion continues to be multicultural as designers look to other cultures for ideas. Their collections may feature island prints, animal motifs, and tropical florals from Africa or areas in the Pacific Rim, which have a unique character of their own. As the world becomes smaller, designers are also featuring in their collections fabrics inspired by Mexican, American Indian, and many other cultures from many lands.

The textile, fur, and leather industries are also being affected by increased cultural exchanges. The following chapter focuses on the characteristics of these industries as sources for raw and finished materials and the relationships that exist among them.

The Textile Industry

The textile industry is composed mainly of companies that develop, produce, and distribute fibers, yarns, and fabric.

Segments of the textile industry include fiber producers; yarn and fabric mills; and dyeing, printing, and finishing companies, as well as companies that style, develop, and sell fabrics. In different countries, these segments vary in technical sophistication.

The U. S. Textile Industry

The United States textile industry is long-standing and widespread, employing approximately 1.8 million people (726,000 in apparel production, 1,091,000 in textiles).[1]

Several hundred thousand are employed in support industries, including cotton growing, machinery manufacturing, and the production of dyestuffs and fabric finishes.[2]

Like other businesses, the U. S. textile industry evolved slowly over a period of time through a series of stages. Fabrics were first produced in the home, then later mass produced.

An era of technological development began in 1884 when Count Hilaire de Chardonnet, a French chemist, developed the first practical manufactured fiber, rayon.

In 1910, rayon, a fiber made of cellulose, was produced in the United States under the name *artificial silk*. Wallace H. Carothers, an American chemist, developed *nylon,* a petroleum-based fiber, in the mid-1930s. Other manufactured fibers such as **polyester** and **acrylic,** both also petroleum-based, were introduced during the 1940s and 1950s.

The last half of the twentieth century has seen many changes in manufacturing processes and in equipment technology involved in the manufacture of textile products. Weaving and knitting machines, controlled by computers, now produce fabrics

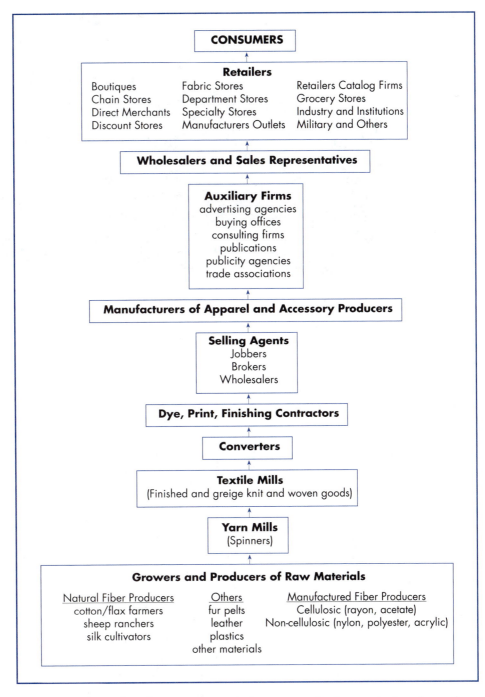

Figure 5-2. The textile industry is composed of many parts that form a pipeline of manufacturing and marketing activities.

Figure 5-3. A fabric mill, circa 1906. (Courtesy Malden Mills)

with highly complex patterns at tremendous speeds. Water or air jets carry the filling yarn through the warp at rates of up to 1000 times a minute, about four times faster than a shuttle works on a standard loom.

Today, the U. S. textile industry is at the full maturity stage of the business cycle. The industry recognizes its customers' demands for greater variety and higher quality textiles and has directed capital investments toward meeting these needs.

Major Segments of the Textile Industry

The term *textile* comes from the Latin word *texere*, which means *to weave*. A vast majority of fabrics are woven; however, today, other types of fabrics are also considered textiles including knits, braids, laces, felts, and nets.

The textile industry consists of a highly segmented production and marketing chain where fibers are made into various fabric products for sale to consumers or industrial users. This complex manufacturing process involves the conversion of fibers (e.g., cotton, wool, polyester, rayon, etc.) into finished fabrics (e.g., denim, satins, terrycloth) through a series of integrated processing steps ranging from spinning and texturizing yarns to knitting and weaving to dyeing, printing, and finishing.

Textile firms within the industry may perform a single task, such as spinning raw cotton into thread or yarn, or numerous tasks such as spinning, weaving, dyeing, and finishing. When one company is involved in a single aspect of production at only one level, it is called a horizontal operation. An example of a horizontal operation is Globe Manufacturing Co. of Fall River, Massachusetts, producer of Glospan Spandex yarns.

Figure 5-4. (a) American Savio's ESPERO Automatic Winder: This machine takes bobbins from a ring spinning frame and combines these bobbins weighing ¼ pound each and puts this yarn on larger packages weighing up to 7 pounds. During this process, the yarn is checked and all the imperfections are cut out of the yarn. The yarn is then spliced. This picture shows the free-standing winder, but it also can be linked to the the ring frame: This eliminates manual labor. (b) The Savio FRS Rotor Spinning Machine: This machine produces open-end-type yarn. (c) A loom produced by Pignone. (Courtesy American Savio Corporation)

Other firms, called "vertical operations," perform several steps of the textile manufacturing process. An example of a vertical organization is Burlington Industries, which spins its own yarn; makes fabric; dyes, prints, and finishes it; and then actually cuts and sews the finished product into such items as sheets and towels. The following discussion highlights the six individual segments of the textile industry:

1. fiber producers
2. yarn manufacturers
3. fabric producers
4. dyers
5. printers
6. finishers

Fiber Producers

The smallest visible unit of any textile product is a fiber. A **fiber** is a fine hair-like structure that can be spun into yarn and made into a textile product. Short lengths of fibers (one half to eight inches) are called "staple fibers." Longer continuous lengths are called "filaments," and are measured in yards or meters.

Textile fibers exist in nature or are created through technology. Fiber producers can be classified into two basic groups: producers of natural fibers and producers of manufactured fibers.

SPOTLIGHT ON A FIRM

BURLINGTON INDUSTRIES

Founded in 1923 in Burlington, North Carolina, Burlington Industries, Inc. is one of the world's largest and most diversified manufacturers of textiles and related products.

For most of the past 68 years, Burlington Industries' thousands of mills have produced more yardage than any other company. Once the world's largest producer of fabrics, Burlington has been fighting for its economic survival.

During the early 1980s, the company found that its outdated mills were big, expensive, and staffed with costly labor, compared with new competition from Asia. Cumbersome production schedules meant even the first, simple phase— sketching and weaving fabric samples to show prospective customers—could take an intolerable five weeks. Like other textile mills, Burlington couldn't compete with the low cost of labor in India, Sri Lanka, and Taiwan.

Burlington Industries has managed, even through the worst of times, to remain the country's second largest fabric producer. This can be attributed to its successful apparel textile production.

The company has been able to compete with inexpensively produced imports by adapting a strategy of flexible specialization rather than mass production. Flexible specialization allows companies to compete by creating new markets through the innovation of new products rather than by reducing prices and wages. It also requires quick changes in the product mix in response to changing customer demands, and requires an integrative organization in order to be successful.

In order to make quick changes, Burlington has automated many of its mills and designing facilities.

For example, personal computers have changed the core of Burlington's business—designing fabrics. Personal computers have been a welcome addition to the company's creative studio, Burlington House Fabrics in New York.

Until 1984, Burlington textile stylists drew all their patterns by hand. Quarter-inch grids denoted each stitch and coloring them in took most of a week, a very tedious and redundant task. It might take another month to obtain the fabric, set up a loom, and weave several yards of sample fabric.

> **"Personal computers have changed the core of Burlington's business—designing fabrics."**

Sometimes the finished sample was disappointing, even for the experienced stylists. If they didn't like it, they'd have to reweave it.

Today, textile designers use the CAD (Computer-Aided Design) system and other software systems. One computerized designing system, "Burlstyle," initiated in 1983, replaced the manual process of sketching a pattern and provides infinite variations of colors and patterns.

"If you've been designing for 20 years, maybe you can visualize a pattern right away. But it helps to see what it looks like on the computer," says stylist Sarah Beyer, who has been using the CAD system to draw patterns for draperies in the company's New York design studio for nearly three years. Each time a stylist designs a pattern, the person is confronted

with a mind-boggling array of nearly 10,000 combinations of color and thread. The textile stylist must precisely define every component of a finished piece of fabric from colors and threads to the frequency of a pattern's repetition and the actual weave, which determines when certain threads are shown and when they're embedded within the fabric.

Using Burlstyle, stylists can modify their initial selections by introducing alternative colors and textures with a series of keystrokes: The computer takes about five minutes to draw the new image on a high-resolution color monitor.

Some stylists show their customers printed versions of how a fabric will appear, and sometimes they work closely with buyers to customize designs by changing the width of a plaid or the tone of a stripe. Each CAD-based creation contains specifications for the loom's configuration. Designers in New York can fax printouts of their patterns to the person who sets up the loom.

Burlington is also giving more attention to teamwork and customer satisfaction, which has enabled the company to keep its head above water.

Burlington, like other textile manufacturers, is driving toward zero-defect production of quality fabrics, using a combination of technology and highly trained operators. The goal is to do away with all types of cloth inspection by using high quality monitoring systems and controls through the manufacturing process, but they still have some way to go. Darlene Ball, manager of customer support for Burlington Industries' denim division, speculated, "Maybe, someday, we'll process it, roll it up, and send it out, but I think we're a good ways from that." Burlington inspects its fabrics before it ships them to customers, by using available technology, such as color sensing devices and electronic width monitors, and through manual scanning.

Despite current efforts to create zero-defect operations, the mills hope to develop automatic clothes inspection systems for the future.

Quality assurance begins with the selecting of the raw materials and requires in-process controls and monitors throughout manufacturing. For example, Burlington gets samples of the cotton bales before ordering.

"A hunk of every bale is sent to our testing lab and we know all the significant properties that are going to affect yarn quality, and then we order specific bales by number," said Ball. Yarn preparation is a vital area for quality production.

Burlington Denim visually inspects 100 percent of its fabric and has carried the process one step further, with a program offering "security blankets" to its customers, according to Ball.

The "security blanket" is created by taking a swatch from each roll of fabric, which computers select as most suitable to the customer's specifications, and sewing them into a blanket.

"The greatest concern that we have, and our customers have is that the garment will have an even shade when it has been wet processed—stone-washed, ice-washed, etc.," Ball said. "We don't ship any rolls that don't wash down as well, or fit as well, in the customer's wet finishing as they do it the original. We do that for every customer who wants it."

Question for Discussion. In what additional ways can Burlington Industries further each of its major goals?

Sources. 1. Amy Bermar, "Designing Fabric With Custom CAD Program (Burlington Industries)" *PC Week,* December 15, 1987, p. 47–48; 2. "U.S. Mills in Drive to Zero Defects," *DNR,* March 6, 1991, p. 15; 3. Robert Haskins and Thomas Petit, "Strategies For Entrepreneurial Manufacturing," *Journal of Business Strategy,* Nov.–Dec. 1988, p. 24–29.

Natural Fibers. Fibers from animal, plant, or mineral sources are called **natural fibers** and include cotton, wool, silk, flax, glass, and ramie. Other natural fibers include jute, sisal, and hemp. The majority of natural fibers come from plants. Cotton, for example, accounts for about 95 percent of the natural fibers used in the United States. Natural fibers differ from each other, having very unique characteristics.

The agricultural resources and factories that process natural fibers are located primarily on the east and west coasts and in the southeastern portion of the United States. **Cotton,** a very soft, absorbent, and durable fiber, is grown primarily in Texas, California, Arizona, Mississippi, and Louisiana, and is processed in nearby factories. China is the world's largest producer of cotton, with the United States second in production.

GENERIC NAMES NATURAL FIBERS	FABRIC NAMES	MAJOR APPAREL USES	CHARACTERISTICS
COTTON	Denim, Corduroy, Terrycloth	Shirts, Pants, Dresses, Pajamas, Work Clothes	Cool, Comfortable, Absorbent, Durable
FLAX	Linen Suiting, Hankerchief Linen	Suits, Dresses, Blouses	Durable, Absorbent, Wrinkles Easily
SILK	Crepe de Chine, Crepe, Brocade	Dresses, Blouses, Suits, Lingerie, Scarves, Ties	Lustrous, Excellent Drape, Strong, Absorbent
WOOL	Tweed, Flannel, Gabardine, Jersey	Coats, Suits, Dresses, Sweaters, Pants	Warm, Resilient, Versatile, Requires Little Pressing

Figure 5-5. Natural fibers and their characteristics.

Other specialty fibers, such as flax and silk, have never been commercially successful in the United States and are imported from overseas.

Flax, a stiff but absorbent vegetable fiber, is imported from France, Belgium, and Holland. **Linen,** the fabric made from flax fiber, is known for its strength and beauty and is used for a wide variety of apparel and fine tablecloths, napkins, and handkerchiefs.

Silk, "the Queen of Textiles," comes from cocoons spun by silkworms, and is known for its beauty, exceptional luster, drapability, and strength. Silk is imported mostly from Japan, Thailand, and China. Workers unwind the cocoons in a process called reeling and obtain long, natural filament fibers. Silk can be dyed a wide variety of colors and is especially popular for a wide variety of apparel and accessory items.

The most popular animal fiber used for apparel is **wool,** obtained by trimming sheep, usually twice a year, in a process called "shearing." Wool comes mainly from Australia, the world's leading producer, but it is also produced in the United States. Wool is warm, comfortable, and resilient. Wool can be dyed easily making it highly suitable for dresses, coats, suits, and sweaters.

There are many different kinds of wool. Sheep supply wool, but goats, camels, llama, and vicuna also serve as sources for wool fiber. Camel hair, Angora, mohair, cashmere, llama, vicuna, and alpaca are available in limited quantities and are referred to as "specialty fibers."

Manufactured Fibers. Produced through technology, **manufactured fibers** are made from wood pulp, cotton linters, or petrochemicals. Wood pulp comes from trees and the waste products of the lumber industry. (Linters are short fibers remaining on the cottonseeds after the longer fibers have been removed through a process known as "ginning.") Petrochemicals are chemicals made from crude oil and natural gas and are used in the production of manufactured fibers. They account for more than two thirds of the fibers processed by the U. S. textile industry.

Most manufactured fibers are highly versatile; not only do they compete among each other for popularity, but they also rival natural fibers as well. Many manufactured fibers have certain qualities that are unique or superior to those of natural fibers. For example, nylon fiber is much stronger than silk fiber of the same thickness, and no natural fiber has the elasticity of spandex.

There are two main types of manufactured fibers: cellulosic and non-cellulosic. Manufactured **cellulosic fibers** contain some natural cellulose material, such as wood pulp or cotton linters, and are transformed into usable fibers by applying chemicals. Rayon and acetate are examples of cellulosic manufactured fibers.

Non-cellulosic fibers, such as nylon, are made from molecules containing various combinations of carbon, hydrogen, nitrogen, and oxygen and are derived from petroleum, natural gas, air, and water. In addition to nylon, popular non-cellulosic manufactured fibers include acrylic, polyester, and spandex. The United States is currently the leading producer of manufactured fibers in the world.

GENERIC NAMES MANUFACTURED FIBERS	FABRIC NAMES	MAJOR APPAREL USES	CHARACTERISTICS
ACETATE	Lining Twill, Taffeta, Satin	Evening Wear, Linings, Blouses, Dresses	Weak, Excellent Drape, Lustrous, Luxurious Feel
ACRYLIC	Flannel, Fleece, Jersey Knits	Sweaters, Coats, Suits, Socks, Sportswear	Wool-like Hand and Feel, Light-weight, Soft, Warm, Pills
NYLON	Tricot, Taffeta	Lingerie, Ski Wear, Dresses, Blouses	Strong, Durable, Lustrous, Supple, Resilient, Low Absorbency
OLEFIN	Jersey Knit, Interlock Knit	Ski Wear, Swimwear	Comfortable, Strong, Very Lightweight
POLYESTER	Crepe de Chine, Taffeta, Lining Twill	Dresses, Blouses, Lingerie, Fiberfill	Strong, Durable, Resilient, Low Absorbency, Pills
RAYON	Challis, Velvet, Faille, Velveteen	Blouses, Lingerie, Dresses, Pants, Shirts, Suits	Absorbent, Comfortable, Soft, Good Drapability
SPANDEX	Interlocks, Denim, Stretch Lace, Swimwear Knit	Foundation Garments, Swimwear, Ski Wear, Aerobic Wear	Excellent Elasticity, Strong, Durable, Oil Resistant
MODACRYLIC	Fur-like Fabrics, Flannel	Fake Furs, Sleepwear	Durable, Resilient, Flame-retardant, Elasticity, Drapability

Figure 5-6. Manufactured fibers and their characteristics.

Yarn Manufacturers

The next segment in textile manufacturing is yarn production. Here fibers are transformed into yarns through the process of **spinning:** that is, twisting individual fibers into one long cohesive structure. Most apparel items contain spun yarns. A yarn mill is a factory that produces yarns or sewing thread. By giving the fibers a certain amount of twist, many different kinds of yarns can be produced.

The characteristics of yarn can also be changed by varying the fiber content. For example, a tightly twisted cotton/polyester yarn used for a pair of pants has different characteristics than a loosely twisted cotton/spandex yarn used for swimwear.

Yarn mills produce simple yarns for classic fabrics like denim as well as novelty yarns for decorative sweater knits. American Savio Corporation, of Charlotte, North Carolina, is an example of a company that specializes in yarn spinning.

Primary Fabric Resources

The company that actually creates or makes the material from yarns is called a primary fabric resource. Two primary fabric resources are textile mills and converters.

Textile Mills. The yarn mills sell their products to textile mills. A textile mill is any company that owns textile machinery and produces woven, knitted, knotted, braided, felted, or any other type of fabric or cloth. Textile mills produce an incredible variety of fabrics in every color imaginable and in an infinite number of patterns. The textile mill products sector is the tenth largest industrial employer in the United States, with approximately 700,000 people and shipments totaling $50 billion annually.[3]

The majority of U. S. textile mills manufacture fabric for the garment industry, producing 25 billion square yards of fabric annually with 70 percent of this output destined for clothing and household goods.

Although textile mills are located in nearly every state, most textile mills are located in the southeastern portion of the United States, with the highest concentration in the Carolinas and Georgia.

Large textile mills, such as Burlington Industries and J. P. Stevens, have their production facilities in the South and maintain their corporate headquarters and fashion offices in New York City.

Table 5-1 Major U. S. Textile Mills		
Burlington Industries	Shaw Industries	Delta Woodside Industries
Springs Industries	JPS Textile Group	Interface
West Point Pepperel	Cone Mills	Guilford Mills

("The 500 by Industry," *Fortune 500 Magazine*, April 20, 1992, p. 284.)

The largest percentage of U.S. textile mills produce woven or knitted fabric. **Weaving** is the process of forming a fabric on a loom by interlacing the lengthwise yarns (**warp**) and the crosswise yarns (**filling** or **weft**) over and under each other. There are three basic weave types: plain, twill, and satin. There are also many other fabric constructions. (See Figures 5-7 and 5-8.)

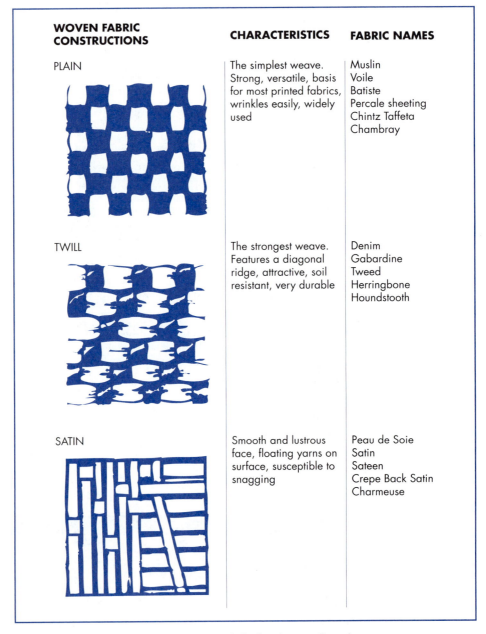

WOVEN FABRIC CONSTRUCTIONS	CHARACTERISTICS	FABRIC NAMES
PLAIN	The simplest weave. Strong, versatile, basis for most printed fabrics, wrinkles easily, widely used	Muslin Voile Batiste Percale sheeting Chintz Taffeta Chambray
TWILL	The strongest weave. Features a diagonal ridge, attractive, soil resistant, very durable	Denim Gabardine Tweed Herringbone Houndstooth
SATIN	Smooth and lustrous face, floating yarns on surface, susceptible to snagging	Peau de Soie Satin Sateen Crepe Back Satin Charmeuse

Figure 5-7. Woven fabric constructions include the plain, twill, and satin weaves.

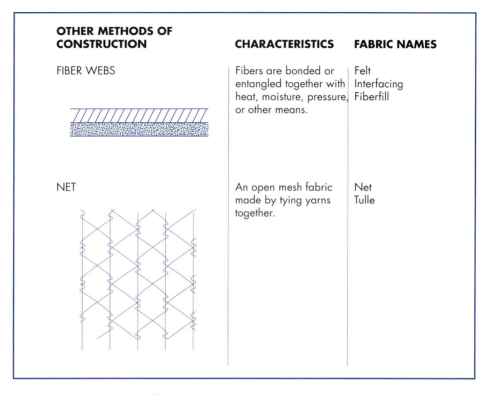

OTHER METHODS OF CONSTRUCTION	CHARACTERISTICS	FABRIC NAMES
FIBER WEBS	Fibers are bonded or entangled together with heat, moisture, pressure, or other means.	Felt Interfacing Fiberfill
NET	An open mesh fabric made by tying yarns together.	Net Tulle

Figure 5-8. Other methods of fabric construction include nets, non-woven constructions, and laces.

Knitting is constructing fabric by the interlooping of a single yarn or a set of yarns using needles. (See Figure 5-9.) Finished fabrics have crosswise rows of loops, called "courses," and lengthwise rows of loops, called "wales."

Knitted fabrics have more stretch when compared to woven goods, making them highly suitable for active sportswear, sweaters, sleepwear, and other types of comfortable apparel items.

Knitting mills specialize in four kinds of products: flat fabric, which is sold by the yard to garment manufacturers; hosiery; underwear; and outerwear such as dresses, shirts, slacks, and sweaters. A vast majority of the knitting mills specialize in making full-fashioned knits, that is, shaping sweaters, socks, or stockings during the knitting process by increasing or decreasing the number of loops or stitches.

Most mills produce unfinished fabrics called **greige goods** (pronounced "gray goods"). These fabrics come directly from a loom or knitting machine, are usually unbleached, and are not yet dyed or printed.

Textile mills produce piece goods, fabrics that are to be cut and assembled into garments. They also produce **findings,** which include all of the rest of the materials used in garments, including linings, interfacings, trims, thread, and labels.

Small textile mills sell piece goods to various customers, that is, apparel manufacturers. They also sell to converters who transform them into finished fabrics.

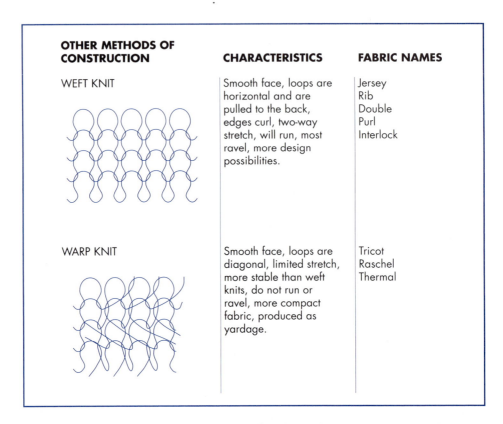

OTHER METHODS OF CONSTRUCTION	CHARACTERISTICS	FABRIC NAMES
WEFT KNIT	Smooth face, loops are horizontal and are pulled to the back, edges curl, two-way stretch, will run, most ravel, more design possibilities.	Jersey Rib Double Purl Interlock
WARP KNIT	Smooth face, loops are diagonal, limited stretch, more stable than weft knits, do not run or ravel, more compact fabric, produced as yardage.	Tricot Raschel Thermal

Figure 5-9. Knit fabric constructions include weft and warp knits.

Larger mills produce a wider selection of fabrics than smaller mills and may dye and print their own fabric. For example, Dan River of Danville, Virginia, is a large weaving mill that manufactures a wide variety of dyed and printed cotton fabrics, including gingham, sheeting, broadcloth, and shirtings.

Converters. Businesses that buy greige goods from the mills, have the fabric dyed, printed, and finished, and then sell the finished fabric are called **converters.** For example, a converter may dye the background of a fabric blue, print it with a floral pattern, give it a waterproof or stain repellent finish, and then sell it to Esprit Kids for children's jackets.

Positioned between the textile mill and the apparel manufacturer, converters play a major role by interpreting fashion and color trends and designing fabrics that will satisfy consumer wants and needs. They do this by working closely with apparel manufacturers to determine what colors, patterns, and finishes are likely to be wanted. Large converting organizations, such as Concord, Cranston, and Loomskill, are located in major apparel markets. More than 90 percent are located in New York City, where they can observe trends, anticipate demand, and quickly adjust to changes in fashion.

After dyeing the greige goods, the converter sells them to apparel and home furnishing manufacturers or to fabric retailers.

Secondary Fabric Resources

A secondary fabric resource is a company that buys cloth and then sells it without any involvement in producing the material. Any seller of fabric other than the mill and converter is considered a secondary source. Examples of major secondary fabric resources include jobbers, textile brokers, and retail stores.

Jobbers. In the textile industry, a jobber is an intermediary between the mill and various business customers. Buying large quantities of fabrics from primary sources including textile mills, converters, or apparel manufacturers, jobbers sell to smaller retailers and apparel manufacturers. Jobbers often buy discontinued colors, styles, or prints and "mill overruns," when a mill produces more fabric than ordered.

Jobbers also supply small cut-and-sew apparel operations that cannot purchase the large quantities required by mills and converters. For example, an apparel manufacturer in New Jersey may buy small quantities of brocade and velvet fabrics from jobbers in New York City and make vests or jackets for boutique stores in the New Jersey area. The jobber may have originally obtained the goods from a mill in North Carolina.

Textile Brokers. Acting as a liaison between a textile buyer and a seller, textile brokers inform buyers and sellers of textile products that each party needs. Smaller mills, which do not employ a sales force, routinely sell through a broker. For example, a broker lets the smaller mill (seller) know what the converter (buyer) wants and the price that the buyer is willing to pay. The textile broker, however, does not own the fabric at any time. Examples of textile brokerage houses include Universal Textile Brokers, Inc., Heinman & Company, and B. J. Stein, Ltd.

Retail Fabric Stores. A third secondary fabric resource is the retail fabric store, an establishment primarily engaged in over-the-counter sales. Leading fabric store chains include House of Fabrics, Inc. and Fabri-Centers of America, with some 600 stores under the names of Jo-Ann Fabrics, Best Fabrics, and House of Fine Fabrics.

Dyeing and Printing Plants

Factories that dye or print fabric are called "dye houses" or "print houses." These operations make greige goods more appealing by adding color, pattern, texture, or design. A dye house specializes in adding color to textiles through the use of dyes or pigments. Fibers, yarns, and fabrics can be dyed brilliant colors.

Print houses specialize in three chief methods: screen printing, roller printing, and heat transfer. They cater to different but overlapping markets.

Finishing Plants

Fabrics must pass through various processes to make them more attractive and suitable for their intended end uses. This procedure is called "finishing," and factories that finish goods are called "finishing plants." Finishing may change the appearance of the fabric; the way the fabric feels, called its "hand"; its serviceability; and its durability. For example, children's sleepwear is given a flame-retardant finish and rain-

coats are given water-repellent finishes to make them safer and more useful to customers. Other finishing treatments help fabrics resist bacteria, fading, mildew, moths, stains, static electricity, and shrinkage.

The Textile Industry Today

The United States textile industry consists of about 5000 companies that operate more than 7000 plants with sales that total over $450 billion a year. The textile industry is different from other industries in that many of those other companies market only one item or a narrow range of items whereas textile companies market a wide range of apparel products and home furnishings such as carpeting and upholstery fabrics.

The textile industry plays a vital role in the economy of the United States and the demand for textile products is highly influenced by overall economic conditions.

Realizing that being more responsive to customers' needs motivates people to "buy American," successful U. S. companies have designed programs that center around better communication and cooperation with their customers.

One of the most widely acclaimed and successful programs is Quick Response, a highly interrelated, technologically advanced communications program that allows the industry to make manufacturing and merchandising decisions based directly on customers' buying patterns. It involves the establishment of an electronic data interchange (EDI) system to send point-of-sale information to the supplier and, thus, requires a close working relationship between the manufacturer and the wholesaler or retailer.

For example, Milliken & Co., a leading textile mill, has shortened the amount of time required to turn raw materials into finished garments and the distance between domestic producers and retail stores.

Milliken's Quick Response program connects fiber producers, textile manufacturers, apparel makers, and retail stores through electronic networks. The program has shortened the channel between textile and apparel producers and the shelves in stores.

The program operates in the following way: Textile and garment makers agree to ship small batches of garments to retailers throughout the season. Before the textile mill sends goods to the apparel maker, the fabric is tagged with standardized bar codes that describe the type of material, the color, and other pertinent information.

The apparel manufacturer, who scans the codes as the fabric arrives, immediately puts the cloth on the proper production line. Finished garments are labeled with specific bar codes (e.g., one code identifies a misses size 8 Levi stone-washed jean) so that the retailer can track precisely which goods are being sold.

Bar codes are scanned by sales clerks when goods are sold at the retail level. The retail store then transmits data on sales back to the apparel maker, who electronically orders additional fabric from the textile mill. Retailers carefully monitor which garments are selling and reorder only those garments that are in demand.

Fabric and apparel manufacturers need to continue only producing garments that are selling. Consequently, customers get what they want, retailers avoid the nightmare of unsold stock and so save money, and the U. S. textile industry prospers.

Today, as a part of the just-in-time Quick Response programs, textile mills and converters across the nation quickly transform greige goods into high-quality apparel items like Levi jeans based upon the information that is received from electronic data in retail stores such as Nordstrom and Bloomingdale's.

Textile Laws

The U. S. Government requires the textile industry to observe certain federal laws designed to protect consumers and give them information about textiles. For example, consumers need to know if a sweater is made of a natural fiber (e.g., wool) or a manufactured fiber (e.g., acrylic), because both fibers may look and feel the same. The following laws are in effect:

- **The Wool Products Labeling Act** of 1939 provides that all garments made of wool have a label telling the percentage and kind of wool used.
- **The Textile Fiber Products Identification Act** of 1958 covers all fibers and requires that all clothing and most home furnishings have a label showing the fiber content by percentage. Fibers must be listed according to their **generic name,** which is the family name of a group of fibers having a similar chemical composition, such as nylon, acrylic, spandex, or polyester, as established by the Federal Trade Commission (FTC).
- **The Flammable Fabrics Act** of 1953 regulates the sale of highly flammable wearing apparel fabrics, specifically prohibiting the sale of exceedingly hazardous fabrics.
- **The Permanent Care Labeling Act** of 1972 administered by the FTC protects consumers from mislabeling by requiring that all clothing at the retail level be labeled with specific information regarding its care.

Market Planning for Apparel

Factors that influence the sale of textiles include fashion changes, population shifts, economic conditions, the media, and change of seasons. At any given time, these factors can affect the sale of merchandise in the industry.

In addition, the segments of the textile industry are interrelated and depend on one another. Fiber producers, spinners, fabric producers, converters, dyers, printers, and finishers must all work closely together to make sure that the garment arrives at the retail store on time. Therefore these segments of the textile industry must plan well in advance of the retail selling phase.

Market Research

Each segment of the textile industry has to respond to the wants and needs of the consumer in order to create and market its products successfully. By researching the market, the textile industry gets information that is used to project potential sales volume of a new or existing product. A mill might gather information from government agen-

cies, technical or trade associations, consumer sources, and trade publications and use it as a basis for market planning. In this way it can better anticipate customer needs.

Product Development

Research and development of a new fiber begins at least five years ahead of the selling season. As Table 5-3 shows, the textile industry has to plan well in advance of the retail selling season.

Research and development efforts can be conducted individually or cooperatively. Natural fiber producers, with smaller budgets than the synthetic fiber producers, pool their resources for cooperative research and development. Large chemical companies like Du Pont and Monsanto first conduct independent research projects.

For example, a new water-resistant fiber might be evaluated at first by a single company such as Du Pont. Next, the company produces experimental fabrics in limited quantities and sells them to manufacturers specializing in a certain product like raincoats.

Raincoats made from the water-resistant fiber are placed in certain stores say in Iowa, Illinois, and Indiana, in a sample market. If the raincoats are found to be desirable, then the fabric and garments go into full production.

Fiber producers work with fabric producers at least two years ahead of the targeted selling season. New fibers must be introduced early to allow enough lead time for the mills and converters to plan their fabric and color lines.

Several organizations help fiber and fabric producers with color predictions. The oldest organization is the Color Association of the United States (CAUS), which recommends colors for use in yarns and fabrics, and provides designers with preferences of future hues.

The International Color Authority (ICA), another color forecasting service, is geared to aid the textile mills, converters, apparel manufacturers, and retailers. The ICA meets twice a year to help dyers, spinners, weavers, and clothing manufacturers make soundly based long-term predictions.

Table 5-3 Planning Schedule for Apparel Development

Four to five years before retail selling season—Manufactured fiber producers develop new fibers.

Two years before retail selling season—Trade associations and other forecasters work with mills to research and develop new fabrics and predict colors.

Two years before the retail selling season—Primary markets begin developing new fabrics.

One year before retail selling season—New fabric lines are presented at fabric shows (e.g., Ideacomo, Interstoff). Fashion designers research new colors and fabrics at these shows.

One year to six months before retail selling season—Textile designers create and develop new prints.

Ten months to one year before retail selling season—Designers shop and place orders for fabrics so that they can sample, design, and construct their lines.

Career Portrait

ROGER MILLIKEN

*Chairman and Chief Executive
Officer
Milliken & Company*

For years Milliken & Co. has been recognized as a leader in the production of quality textile products. Milliken & Co. began in 1865 in Portland, Maine. Founded by Seth Milliken and William Deering as a woolen fabric jobbing business, the company was originally known as the Deering Milliken Company.

In 1868, Deering Milliken moved to New York City, which was at that time the heart of the American textile industry. There it prospered as a jobber and a factor for the New York textile mills. In 1884, the company moved to Pacolet, South Carolina, where it became involved in the southern textile industry.

In an effort to pursue new technology, the Deering Milliken Research Trust was founded in 1945 by six scientists. It became the most progressive and technologically advanced research center of its time. Today, known as the Milliken Research Corporation, it has grown to become the largest textile research center in the world and has achieved an impressive record of innovation and product development.

In 1976, Deering Milliken officially became Milliken & Company. Milliken & Co. is run by Chairman and Chief Executive Officer Roger Milliken.

> *"We must learn to highly value the customer and get to know him better. We must learn to delight the customer. I believe that's good for America and good for Made in the U. S. A."*
> *Roger Milliken*

Roger Milliken became president in 1947 following the death of his father, Gerrish H. Milliken. He is primarily responsible for what was once the largest, most profitable textile company in the United States. Milliken has reached estimated sales of $2.5 billion, has some of the best equipped mills in the country, and 1200 patents.

Milliken began its quest for quality in 1980 to counter both domestic and international competition abroad. Roger Milliken began a personal crusade to reinvigorate the industry. After reading quality guru Philip Crosby's book *Quality Is Free,* he encouraged 240 Milliken associates to meet with the author to discuss important manufacturing and quality issues. It was during that three-day seminar that Milliken made the first commitment to change. The company began holding monthly quality policy meetings, discussing methods for measuring the evolution and improvement of the quality process.

Realizing the need for the entire textile and apparel industry to band together to fight import issues, Roger Milliken encouraged the industry to take a different approach to quality.

continued

He soon launched another battle plan and developed a program that blended technology with the drive for quality.

As the 1989 Chairman of the textile industry's Crafted With Pride in the U.S.A. Council, he led the campaign to convince consumers, retailers, and apparel manufacturers of the value of purchasing and promoting United States-made products.

Roger Milliken realized the need for higher quality goods at every step in the manufacturing process. Knowing that quality manufacturing and quick response are synonymous, Milliken & Co. has set a goal "to provide the best quality products, customer response and service in the world, through constant improvement and innovation with a bias for action." The company remains at the forefront of the industry in applying new technology. Milliken converted its Magnolia finishing plant to computer automation in 1970. Now artificial-intelligence tools help technicians solve problems on the factory floor. In addition, computer programs that recognize verbal commands have been installed to speed up quality checks.

Milliken's efforts have paid off through the years. In 1985, 75 percent of Milliken's deliveries to customers were on time, and by 1990, 98 percent were on time. By 1990, the number of defects in goods decreased 50 percent when compared to figures from 1981. Milliken touts a "customer driven and quality focused" manufacturing philosophy. Since the early 1980s, productivity has increased 42 percent and annual sales have risen significantly to over $1 billion.

Realizing the need for active participation from associates at all ranks, Roger Milliken developed programs to get the work force more personally involved with achieving quality goals. One way he did this was by instituting an extensive program of corporate recognitions and awards. Today employees receive feedback and applause at "sharing rallies," in which associates present their contributions to their peers.

Milliken & Co. was one of two companies awarded the prestigious Malcolm Baldrige National Quality Award in 1989. The award, issued by the U. S. Commerce Department, represented the highest honor for corporate quality performance in the United States. In his acceptance speech Roger Milliken stated:

We must recognize that Total Quality Improvement is a never-ending voyage: a process, not a program. We are continually striving to provide innovative, better-quality products and services to enhance our customers' continued, long-term profitable growth by understanding and exceeding their requirements and anticipating their future expectations.

The Milliken Company continues to prosper through Roger Milliken's leadership and commitment to quality.

Today, the privately held Spartanburg, North Carolina-based company operates 56 plants at 44 locations in the U. S. and 8 operations internationally. Product offerings span from apparel fabrics to residential and contract carpeting to automotive upholstery fabrics.

Manufacturing plants and sales offices are located worldwide with plants in North Carolina, South Carolina, and Georgia. To better serve the needs of their customers, there are sales offices in New York City and branch offices throughout the United States, Western Europe, Canada, and Japan.

What challenges await Roger Milliken and his company? "We must learn to highly value the customer and get to know him better. We must learn to delight the customer. I believe that's good for America and good for Made in the U.S.A.," says Milliken.

Question for Discussion. In what two or three major ways is Roger Milliken contributing to the growth and success of the fashion industry?

Sources. 1. Elizabeth Corcoran, "Milliken & Co.," *Scientific American,* April 1990, pp. 74–76; 2. Carla Kalogeridis, "Milliken in Motion: A Pursuit of Excellence," *Textile World,* December 1990, pp. 42–48; 3. Walecia Konrad, "How Milliken's Tightly Knit Empire Could Unravel," *Business Week,* May 28, 1990, p. 27; 4. "Roger Milliken, Textile World's Leader of the Year," 1990, *Textile World,* December, 1990 p. 42; 5. From a Crafted With Pride in U.S.A. Council, Inc. brochure; 6. "Milliken & Co., Managing the Quality of a Textile Revolution," *Scientific American,* April, 1990, p. 74.

Merchandising and Promotion

It is not unusual for the cost of fabric and other materials necessary for production to equal 25 to 50 percent of the total apparel manufacturing costs. How do textile producers make potential customers aware of their products?

Promotional activities, such as advertising, publicity, and sales presentations, attract buyers. To help promote a new product, sales promotion materials, company shows, and various customer services are aimed toward manufacturers, retailers, and consumers.

Trade associations play a major role in promoting natural and manufactured fibers and are actively involved in these activities. The rapid growth of the manufactured fiber industry has caused producers of natural fibers to become more aggressive in promoting the use of cotton, wool, silk, and flax.

Trade Associations

Independent trade organizations have been formed for each natural fiber to make consumers more aware of their products. An example is Cotton Incorporated, a private corporation established in 1961, which is owned and controlled by more than 50,000 U. S. cotton producers. Cotton is promoted in the United States and abroad through the Cotton Seal, a registered trademark indicating that the fabric is made of domestic cotton.

Figure 5-10. Chemical companies market new fibers in trade publications. (Courtesy The Rowland Company, Du Pont Lycra Spandex)

Other trade organizations help promote the use of other natural fibers such as wool. The marketing of wool is done mainly through the Wool Bureau, a branch of The International Wool Secretariat (IWS). The IWS is funded by wool growers in the Southern Hemisphere and was formed to expand the use of wool through promotion, research, and development. Special advertising and marketing programs feature the "Woolmark," a symbol or logo used to identify wool products that meet various quality performance standards.

Like natural fiber producers, individual manufactured fiber producers have their own promotional activities.

Giant chemical companies like Du Pont, Monsanto, and Allied Signal have more money to spend on promotion than natural fiber producers, and therefore put on more elaborate promotional campaigns.

Table 5-4 Members of the Manufactured Fiber Producers Association

Allied-Signal, Inc. Fibers Division 1411 Broadway New York, NY 10018	Eastman Chemical Products, Inc. Kingsport, TN 37662
	Fiber Industries, Inc. 1211 Avenue of the Americas New York, NY 10036
American Cyanamid Company Fibers Division One Cyanamid Plaza Wayne, NJ 07470	Hercules Incorporated Fibers Marketing Division 3169 Holcomb Bridge Road Norcross, GA 30071
Amoco Fabrics & Fibers Company 900 Circle 75 Parkway Suite 550 Atlanta, GA 30339	Hoechst Celanese Corporation 1211 Avenue of the Americas New York, NY 10036
Avtex Fibers Inc. 1185 Avenue of the Americas New York, NY 10036	Monsanto Chemical Company Fibers Division 800 North Lindbergh Boulevard St. Louis, MO 63367
BASF Corporation Fibers Division P.O. Box Drawer "D" Williamsburg, VA 23187	North American Rayon Corporation West Elk Avenue Elizabethton, TN 37643
Courtaulds North America Inc. 104 West 40th Street New York, NY 10018	Phillips Fibers Corporation Subsidiary of Phillips 66 Company P.O. Box 66 Greenville, SC 39602
E.I. du Pont de Nemours & Company, Inc. Textile Fibers Department Wilmington, DE 19898	Tolaram Fibers, Inc. P.O. Box 436 Ansonville, NC 28007

The Manufactured Fiber Association's members include chemical companies that specialize in the production of manufactured fibers.

Source: Manufactured Fiber Producers Association, New York, New York

Chemical companies also belong to the Manufactured Fiber Producers Association, a trade organization that promotes the use of manufactured fibers. (See Table 5-4.) Other trade organizations include The Polyester Council and The Acrylic Council.

Manufactured fibers can be marketed as commodities or brand-name fibers. Commodities are fibers not identified with any specific brand name or trademark and can be sold to anyone on the open market. In addition, the purchaser has no idea of who the manufacturer is and is under no obligation to produce a product of any specific quality.

Fibers marketed as brand-name fibers are identified through the use of the trade name, such as "Lycra" spandex and "Dacron" polyester. Since the fiber manufacturer's brand name is carried on the finished product, the manufacturer has more control over the quality of that finished product. In return, a garment manufacturer can capitalize on the publicity and promotional materials distributed by the fiber manufacturer.

Trade Shows

A trade show is a selling event that gives fiber or fabric producers the opportunity to exhibit their latest products. Textile shows in Europe are held for the trade twice a year, drawing manufacturers and designers eager to buy new fabrics and gather ideas on how to use them.

Figure 5-11. The Polyester Council is a trade organization that promotes the use of manufactured fibers (microfiber polyester). (Courtesy The Polyester Council of America)

The largest international trade show for apparel fabrics is the Interstoff Fabric Exhibition, called "Interfabric," held each spring and fall in Frankfurt, West Germany. Over 25,000 textile buyers from over 70 countries attend the four-day exhibition to buy fabric and receive information on the latest international apparel fabric trends.

Textile buyers attend several shows to stay on top of the market and to keep abreast of new trends. Other trade shows and fairs include Ideacomo in Como, Italy; Texitalia, in Milan, Italy; and Premiere Vision, in Paris, France.

Trade shows held in the United States include the Bobbin Show; the Knitting Yarn Fair; the New York Fabric Show; TALA, a fabric show presented by the Textile Association of Los Angeles; and the Trimmings, Accessories, and Fabrics Expo (TAFE).

The Leather Industry

Leather is a tough, flexible material made of preserved animal hides and skins. Any animal hide or skin can be converted into leather through a chemical and industrial process known as *tanning.* Cattle hides, supplied mainly by the meat-packing industry, provide the source of most leathers, but goat-, pig-, sheep-, lamb-, and calfskin are also widely used. Other more exotic kinds of leather come from the crocodile, alligator, snake, lizard, ostrich, camel, and fish. For example, salmon, frog, sea bass, sting ray, and the skins of other sealife are manufactured into accessory items such as wallets and handbags.

History

Leather production has been recognized as one of the earliest arts. As early as 20,000 B.C., people obtained protection and warmth from the hides and skins of the animals killed for food. Leather processing remains a highly specialized and time-consuming operation. Machines have taken much of the human labor out of leather processing; however, many procedures are still done by hand. (See Figures 5-12a, 5-12b, and 5-12c.)

Organization and Operation

The leather tanning and finishing industry is composed of establishments primarily engaged in tanning, currying, and finishing raw or cured hides and skins into leather. The industry also includes leather converters and dealers who buy hides and skins and contract with tanners or finishers to process these products. Specifically, the leather industry is composed of the following businesses:

Tanneries, which convert skins and hides into leather and sell it as a finished product.

Contract tanneries, which convert skins and hides into leather for other firms (mainly converters), but are not involved in the final sale of the finished products.

Converters or **dealers,** who buy hides and skins and contract with tanners to process these products, and then sell the finished leather. In recent years, converters have been buying finished leather from both regular and contract tanneries.

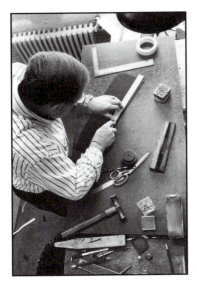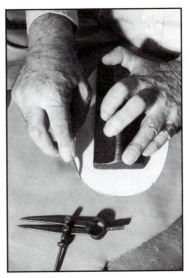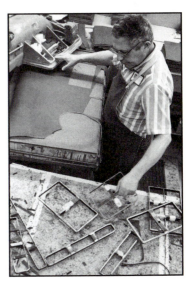

Figure 5-12. Leather goods production: (a) the tools of the trade; (b) an idea becomes a reality as the first pattern is cut; (c) a cutter uses dies to cut patterns in the leather. (Courtesy Coach)

The tanning industry has undergone mergers and consolidations in recent years. In 1870, over 4500 tanneries operated in the United States. Some 120 years later, only about 125 establishments of significant size remain.

Leather producers are mainly located in the northeast and north central states. Factories in New York, Massachusetts, Maine, California, Wisconsin, Pennsylvania, New Jersey, and Texas produce $9.2 billion worth of leather products annually. Also located in these states are the leather industries' major customers, the manufacturers of shoes, apparel, and accessories. The largest market for the tanning industry is the footwear industry, which consumes over 40 percent of all leather shipments. Like the textile industry, most leather firms have sales offices or representatives in New York City.

Types of Leather

Cattle hide is the most commonly used leather and accounts for nearly 90 percent of the total amount of leather produced. Cattle hides are by-products of the meat-packing and milk industries, and their supply depends solely on demand for these products rather than the actual leather product.

Many other varieties of leather are produced throughout the world and used in hundreds of different ways for the fashion industry. Exotic types of leather are protected under The Endangered Species Conservation Act, originally passed in 1969. The law protects the buffalo, iguana, seal, whale, deer, and some reptiles that are near extinction.

Animal skins obtained as by-products from other industries are less costly than those from animals raised just for their skins.

Manufacturing and Processing

Before animal hides can be tanned, they must undergo certain preparations. During pretanning, hides are cleaned and cured.

They are then weighed and divided into three categories. The terms "cowhide," "kidskin," and "kipskin" originate from the sizes and weights of the various leathers. In the leather industry, those animal skins that weigh 15 pounds or less are referred to as **skins.** Calves, goats, pigs, sheep, deer, and alligator fit under this category. Those weighing from 15 to 25 pounds are known as "kips" and come mainly from young horses and cattle. Since very few animals fall under this category, kip mainly refers to oversized calves, whose skins are called **kipskins.**

An animal skin weighing over 25 pounds is called a **hide.** Cattle, oxen, buffalo, walrus, and horses fall under this category.

After the hides are washed, cured, and sized, they are ready for tanning. Tanning preserves the skin and improves its natural physical properties through the application of various substances: minerals, oils, and chemicals used alone or in combination.

Final Processing

After the skins are tanned they are wrinkled, dull, and unattractive. The final processing that is carried out after tanning includes splitting, dyeing, and finishing.

Splitting involves cutting thick skins into layers. The top layer with the grain intact is called **top grain leather.** Only top grain leather may be designated as "genuine leather" and is found on high-quality shoes, handbags, and belts. All remaining layers are called "splits," which usually have a rougher, coarser appearance, and are not as durable, costing less than top grain leather. The bottom or flesh layer is often called suede leather.

For almost all leather, the process after tanning is known as "dyeing." Leather can be dyed with a number of natural wood dyes, acid dyes, and aniline dyes. Oil is usually added to soften the skin. Due to modern technology, leathers can be dyed in a wide variety of fashionable colors.

Processes that make the skins pliable and beautiful are known as "finishing processes." Finishes also give aesthetic appeal to the leather by showing the natural grain, modifying the grain, or changing the grain entirely. For example, the most highly polished leather is patent leather, which is produced by applying successive coats of heavy oil varnish at the end of the finishing process, giving the leather a high, durable gloss.

Marketing Activities

Like the textile industry, the leather industry must respond to the needs and wants of its consumers. To determine customers' preferences, leather tanners conduct research programs. They also work closely with trade associations to develop innovative uses for leather products and ways to promote leather.

Figure 5-13. The new Delancy Drawstring handbag from Coach combines a cultivatedly casual silhouette with natural grain, lightweight leather. (Courtesy Coach)

Research and Development. Due to the tremendous amount of processing time involved, fashion trends for leather goods have to be anticipated and researched well in advance of textile goods. Colors, textures, weights, and finishes are predicted two or more years before consumers will be ready to buy the goods. Dyers and finishers begin researching specific dye and finishing treatments months before other fashion industries commit themselves to colors and textures.

Merchandising and Promotion. The individual tanners and finishers are not well known because these producers do not promote their names. Instead, the entire leather industry participates in this process through its primary trade association, the Leather Industries of America (LIA). Located in New York City, the LIA offers color seminars semi-annually and a school for people involved in the buying and selling of leathers. It also publishes a weekly industry newspaper, called *Council News*.

Eighteen months to two years prior to the retail selling season, tanners introduce their leathers in several different trade shows. For example, the largest trade show, the Semaine de Cuir, is held in the fall of each year in Paris. Tanners from around the world display their tannages to international buyers and the fashion press. A more recently established trade show is the Hong Kong International Fair, held in June, which also attracts buyers and sellers from many countries, including the United States. One of the largest shows held in the United States is the Tanners' Apparel and Garment (TAG) Show held in New York City in October of each year. It attracts garment manufacturers, suppliers, and retailers from approximately 40 foreign countries.

The Fur Industry

Another important supplier of raw materials for fashion is the fur industry. **Fur** is the soft, hairy coat of mammals that can be processed into a pelt and used to make apparel or accessory items. Since prehistoric times, people have used animal fur for its warmth, protection, and beauty. Fur has long been associated with wealth and prestige; for example, ancient Egyptian priests wore fur as a status symbol. During the fourth century, an active fur market operated in Athens, Greece. Fur became a luxury during medieval times, when only kings and princes wore such expensive furs as ermine and sable to project their wealth and status. The demand for luxurious furs stimulated much of the early exploration of North America and has played a major role in the development of the fur industry. Today, the industry plays an important role in the economies of many nations.

Organization and Operation

The fur industry consists of three major groups, which also represent the three stages of manufacturing: pelt producers, fur processors, and product manufacturers.

Pelt Production. A wide variety of animals can be used for fashionable fur products. The majority of fashionable furs are made from pelts that are obtained from animals that have been raised on fur farms or ranches. Fur farming or ranching involves the breeding and rearing of furbearing animals strictly for use of their fur.

After the fur is obtained, pelt producers ship their furs to one of the great auction houses in one of the major fur-trading centers of the world. Pelts are sold at public auction directly to wholesale pelt merchants or manufacturers, or to commission brokers (who buy for merchants or manufacturers). One example of a fur-marketing agent is The Hudson's Bay Company of Canada. Major fur auction centers are New York City, Tokyo, China, Scandinavia, London, Leningrad, Toronto, and Montreal. Buyers and manufacturers examine bundles of fur pelts that are matched by quality and color and then bid on them. Pelt prices can fluctuate sharply and the fashion for a particular fur can drive up its pelt price drastically.

Fur Processing. After the pelts have been bought at fur auctions, they must be cleaned and made flexible by a process called "dressing." Fur dressers process the fur to make it soft, pliable, and more suitable for use in consumer products. Dressing involves cleaning, stretching, and finishing to preserve their natural color. After dressing, pelts may be sent out to a dyer. Fur can be dyed to improve the appearance of unattractive naturally colored furs. Major dyeing centers are in France, Belgium, London, Frankfurt, and New York City.

Fur Labeling. The Fur Products Labeling Act of 1951 requires that all furs sold in the United States be labeled at retail according to:
1. The true English name of the animal.
2. The country of origin.

3. The method of processing: dyeing, bleaching, or special finishing methods that change the natural characteristics of the fur.
4. The use of scrapped, pieced, or sectioned fur, or fur previously used by a consumer.

Marketing Activities

Like the leather industry, the fur industry relies mostly on group efforts for promotional activities. Traders, dressers, and producers work together and promote their products through trade associations. Some trade associations that promote and encourage the demand for fur include:

- The American Fur Industry Inc. (AFI)
- Eastern Mink Breeders Association (EMBA)
- The Great Lakes Mink Association (GLAMA)
- The Empress Chinchilla Breeders Cooperative
- Master Furriers, Inc.
- American Legend
- The Fur Retailers Information Council
- Fur Farm Welfare Coalition

Future Trends and Predictions

Years ago, primary fashion resources were hit with a barrage of competition from overseas. Tremendous competition still exists today and is expected to continue into the next century. Despite highly competitive international markets, the textile, fur, and leather industries have remained competitive.

For example, the textile industry has demonstrated a tremendous survival instinct. Despite the tremendous number of layoffs, plant closings, and buyouts, the industry has survived and to some degree has prospered under tremendous pressures.

Throughout the primary fashion industry, consolidation is expected to continue with growing global competition putting increased pressure on domestic producers. As a result, there will be fewer but stronger companies. These companies will have to provide a newer stronger industry for the future.

The textile industry is expected to continue to be highly fragmented, with the ten largest textile mills accounting for less than one-third of the American market.

Due to these factors the primary fashion resources are now in a period of transition, realizing that the only way to remain competitive in the 1990s and beyond is to re-examine goals and focus on some important issues, which include foreign trade and new technology.

Foreign Trade Opportunities

The long-term problem that faces the primary fashion resources is trade. The domestic textile market, for example, is generally mature and saturated.

FOCUS ON TECHNOLOGY

The sign above the shop reads:

TEXTILE QUICKPRINTING
SPECIALIZING IN HIGH-SPEED
TEXTILE PRINTING
(FAST FRIENDLY SERVICE—WHILE YOU WAIT)

Yes, some time in the very near future, print shops like this one will probably be able to produce innovative textile designs and patterns on fabric in a matter of seconds. By making a quick stop at the local print shop you may be able to get the latest fashions—fresh off the copy machine!

Time is crucial in the fashion industry and fashion fads often change before a textile printing house can produce a new pattern. For example, cartoon superheroes, popular slogans that appear on teenage clothing items, and political messages often have a shorter lifetime than the time it takes for the textile industry to design, print, and distribute the fabrics.

The textile and apparel industries could save bundles of money if they could shorten the time it takes to produce new patterns, so researchers are currently studying the possibility of using photocopying machines, similar to office copiers, to print designs on fabrics.

Since 1984, textile researchers at Georgia Institute of Technology in Atlanta have been modifying a Xerox Corporation machine, normally used for architects' blue-prints, so it can pump out patterned bolts of cloth for everything from T-shirts to pillowcases to sheets. The project uses fabric in a copy machine built to handle 36-inch wide paper and simply substitutes special pigments for the toner the machines normally use.

Photocopiers work by putting an electrostatic charge on a metal drum. Light reflected from the document being copied modifies the charge, creating an invisible, electrostatic image of the document on the drum. Particles of toner—a blend of pigment and binder—stick to the charged areas, and the whole image is transferred to paper or in this case, fabric. The pattern is fixed to the surface by heat.

Researchers have modified standard office copiers to use toners appropriate for fabric and to print continuous images onto moving sheets of material. The process is tricky because pigments that last as well as the ones now used on fabric are typically hard and coarse, making them tough to grind up into fine powder for use as toner. The pigments must also have special electrical properties if they are to stick to the fabric.

> A computer-controlled system has been developed utilizing three photocopying machines, enabling a designer to create multicolored designs and more complicated patterns.

A computer-controlled system has been developed utilizing three photocopying machines, enabling a designer to create multicolored designs and more complicated patterns. These techniques would replace existing water-based printing processes that rely on metal rollers or screens to apply the necessary colors. With xerography, trendy patterns could be produced in just days, not the usual months.

In addition, textile photocopiers would save energy in the textile industry by reducing the amount of water and energy used for processing. This would be a tremendous incentive for Southern textile mills. Textile printing uses so much water that during the South's usual summertime droughts, mills are often forced to curb production.

Xerographic textile printing will be much faster and far less expensive than conventional techniques and will definitely give a "shot in the arm" to Quick Response. The copier process is ideal for short production runs, permitting textile manufacturers to adjust more quickly to consumer demands.

With commercial application still about three years off, the first uses of the process in coming years will most likely be in textile factories. Eventually, fabric copiers may even move into retail stores for custom-printing sheets and wall coverings.

Sources. 1. "The Latest Fashions, Fresh off the Copy Machine," *Business Week,* May 16, 1988, p. 111; 2. "Quick prints for textiles," *Science News,* Vol 133, June 4, 1988, p. 364; 3. "Printing Out Bed Sheets On the Office Copier?" *Wall Street Journal,* June 23, 1988, p. 1.

In the past, the U. S. textile industry has been relatively insulated from the more dynamic international market. Future growth in demand for apparel and other textile fabrics is expected to be largely outside the United States and will have to come from exports.

Exports of fur and leather products are expected to increase in the future.

Exploration of New Technologies

Automation has arrived in the textile industry, as many companies have elected to implement computerized and automated techniques in an effort to remain competitive. By exploring new technologies, the industry realizes that their operations have to become more flexible, more accurate, and more productive. As a result, output is increased and waste and errors are reduced significantly.

In addition, new computer technology offers textile designers enhanced features for higher efficiency, greater accuracy, and more opportunities to present new design ideas for today's Quick Response environment.

One software system gives the designer the flexibility to telecommunicate full-color pictures around the world in about three or four minutes, which is very interesting to customers who do sampling and manufacturing overseas. The industry predicts that a standard-apparel textile-file format will be established by 1995. This standard would allow users of different systems to quickly exchange data among various brands of CAD systems. Swatches, weaving specifications, and color formulations will be exchanged instantly on a global scale.

Future development in the computer aided design area will focus on increased automation and speed.

Summary

1. Primary resources play an important role in the fashion industry and provide fibers, fabrics, leathers, and furs to the apparel industry.
2. The textile industry, the primary source of material for the apparel industry, provides fibers, yarns, and fabrics.
3. The smallest visible unit of textile product is a fiber. Fibers are classified as natural (e.g., cotton, wool, silk) or manufactured (e.g., polyester, rayon, acrylic).
4. The textile industry is composed of various segments, including:
 - fiber producers
 - fabric producers
 - printers
 - yarn spinners
 - dyers
 - finishers
5. Primary sources of fabric include mills and converters.
6. Secondary sources of fabrics include jobbers, textile brokers, and retail stores.
7. The leather industry is made up primarily of companies involved in the tanning and finishing of animal skins.

Fashion Vocabulary

Explain each of the following terms; then use each term in a sentence.

acrylic

cellulosic fibers

converters

cotton

fiber

filling (or weft)

The Flammable Fabrics Act

flax

generic name

greige goods

hide

kipskins

linen

manufactured fibers

natural fibers

non-cellulosic fibers

Permanent Care Labeling Act

polyester

rayon

silk

spinning

Textile Fiber Product Identification Act

warp

weaving

wool

Wool Products Labeling Act

Fashion Review

1. Discuss the economic importance of the U. S. textile industry.
2. List four major natural fibers, citing the advantages and disadvantages of each.
3. List four major manufactured fibers, highlighting the advantages and disadvantages of each.

4. Discuss the major steps in textile manufacturing.
5. List three methods of fabric construction, citing two fabric names for each method.
6. What are four major textile laws? For each law, give an example of a textile product that would be labeled accordingly.

Fashion Activities

1. Make a list of different clothing needs that you have. Using the fiber/fabric charts (Figures 5-5, 5-6, and 5-7), identify fibers and fabrics that would be best suited to your individual needs.
2. Describe and analyze a fabric product that you like. Identify the steps taken to manufacture the fabric used for that product. If the product contains more than one type of fabric, identify each.
3. Follow the same procedure stated in activity 2, but this time describe and analyze a product that you don't like. What should have been done to improve the product before it was manufactured and sold to you?

Endnotes

1. *Standard and Poors Industry Surveys,* June 14, 1991, p. 78.
2. Ibid.
3. "The Textile and Apparel Trade Act," *Congressional Digest,* p. 6.

Women's Ready-To-Wear

Objectives

After completing this chapter, you should be able to:

1. Identify major fashion trends in women's apparel throughout history and explain one or two important fashion trends during each decade of the twentieth century.

2. Name three kinds of apparel manufacturers and describe the manufacturing process for women's ready-to-wear.

3. Explain the organization of the women's apparel industry according to the types of apparel, sizes, and price ranges produced.

4. Describe three or four promotion activities that manufacturers and retailers use to reach apparel customers.

5. Cite four successful practices in the women's apparel industry that in all likelihood will be more widespread in the future.

June Driscoll, a young fashion designer, leaned over her sketch pad and added pleats to the gown she was drawing. Employed by Evening Lights, a manufacturer of formal gowns and evening wear, June was drawing what would become a garment for the manufacturer to offer to store buyers. June was impressed with the French fashions for the season: strong colors yet feminine with ruffles and pleats. The short evening dress she was designing had a young and flattering look about it. She only hoped that management would approve.

The owners of the company had made it clear to her that they felt Paris was important this year. June knew, too, that she had been hired to add a youthful look to

the merchandise of this well known and mature manufacturing organization. She hoped that this strapless dress with its pleats and ruffles, which she considered to be right on target, would be accepted by the company and by consumers.

A while later a sample dress based on her sketch had been sewn up in the company workrooms and a model had been called in to wear the dress and others for company executives and an important fashion consultant representing a group of retail stores. June waited breathlessly to hear their opinions. When the model showed the strapless dress, the room was completely silent. "Would it be accepted?" June thought. "Why are they so quiet?" Just then, the fashion consultant said, "That dress is beautiful; it will hide every fault on a woman's figure!" June knew that the dress would be a hit.

History of Women's Apparel

June is fortunate because she is carving out a successful and well paying career designing dresses for an apparel manufacturer. Throughout history women created garments for themselves and their families, not as a career but through necessity. To be sure, wealthy families assigned the work of making the family's clothing to servants trained as seamstresses and tailors, but the wealthy of any era make up only a small fraction of the total population.

In some societies women had the tasks of raising the plants such as flax for linen or animals such as sheep for wool, gathering the fibers and fleece, spinning and dyeing the yarns, and at last weaving the fabrics. Only then were they ready to start making the actual garments for every family member! Contrast these time-consuming efforts with the ease of shopping today, at the store, through the mail, over the phone, or via television.

Just within the last century have mass production and marketing made possible the development of women's ready-to-wear as opposed to **custom-tailored** apparel, that is, clothing created for individuals according to their measurements. **Ready-to-wear,** consisting of a wide selection of mass-produced garments in standardized sizes, brings a vast number of apparel choices within the reach of nearly everyone. To gain perspective, let's trace women's fashions through history, leading up to and including the development of the women's apparel industry of today.

Pre-1900

Early in history and with few exceptions, in the Middle East, Egypt, and Greece, and later in the days of the Roman Empire, garments were straight and simple. They called for draping rather than tailoring and were easy to wear in the warm climates. The Greek chiton—a simple length of cloth—was typical of these early garments. (See Figure 6-1.) More ornate were women's hair styles, particularly in Greece and Rome. Later, during the Dark Ages in middle Europe, an important factor in clothing was total body coverage, probably for warmth but also serving as an expression of the repressive times. The characteristic garment for women and men was a tunic, two lengths of cloth sewn together, slipped over the head and often gathered at the

Figure 6-1. Early Greek apparel was very simple, but the hairstyles were elaborate. (© 1992, The Art Institute of Chicago)

waist. Headdresses for noble women became elaborate with wire structures, hair, and veils intertwined.[1]

In the middle of the fourteenth century, fashions for women, at least the rich ones, became more shapely, many featuring low necklines, with an emphasis on bosoms and hips.[2] The Italian fondness for elegant fabrics and decoration began spreading north to the rest of Europe. By the sixteenth century in Britain, King Henry VIII awed his court with his crimson velvet and ermine trimmed coronation robes.[3]

Henry's daughter, Queen Elizabeth I, echoed her father's affection for richly decorated apparel and ornate trimmings. In records from 1600, a petticoat worn by Elizabeth was described as being of white satin with gold and silver threads and silken threads of various colors worked into a border pattern of pomegranates, pineapples, and other fruit, along with representations of the nine Muses (ancient Greek goddesses of the arts and sciences).[4] To contain all of this decoration, the silhouette had evolved from straight to a bouffant fullness. Supporting and worn under the wider skirts was the farthingale, a kind of hoop arrangement popular among all but the poorest women. Other fashions of the times included the ruff, a wide stiff collar. (See Figure 6-2.) The wife of Elizabeth's coachman brought the art of starching from Holland to Britain, enabling ruffs to reach new dimensions of grandeur.[5]

In the seventeenth century, the focus of fashion for western civilization shifted to France and the court of King Louis XIV. During his reign and those of his descendants Louis XV and Louis XVI, fashion flourished for women and men, reaching its decorative heights in the reign of Louis XV. Elegant silks and painted and printed linens were embellished with embroidery, lace, and ribbons. Waistlines were small and necklines low. Sleeves were trimmed with lace and bows. Skirts were

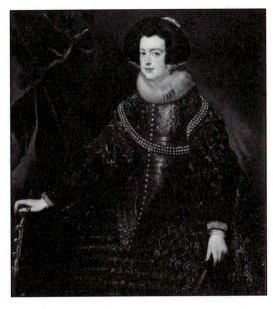

Figure 6-2. Note the ruff, jewels, and ornate fabric worn by nobles in the seventeenth century. (© 1992, The Art Institute of Chicago)

full and held out by a new kind of farthingale called a "pannier," an attachment like a pair of baskets extending out over each hip.[6] (See Figure 6-3.) Variations of this look lasted until the monarchy, and its preoccupation with style and elegance, was brought down during the French Revolution at the end of the eighteenth century. Apparel suddenly became simpler and made from sturdier fabrics, reflecting the values of the newly empowered citizenry. (See Figure 6-4.)

Figure 6-3. Fashion reached its decorative height in France during the seventeenth century. Fabrics were elaborate and embellished with lace, ribbons, and embroidery. (Courtesy Dover Publications Inc.)

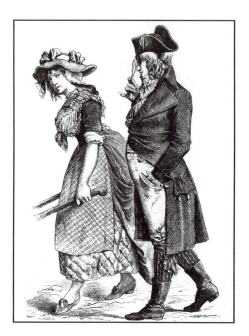

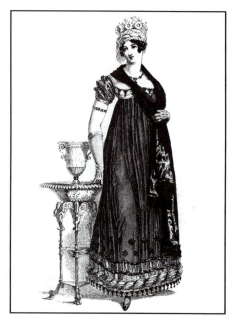

Figure 6-4. Middle-class dress after the French Revolution reflected the citizenry with simpler styles and sturdier fabrics. (Courtesy Dover Publications Inc.)

Figure 6-5. The straight, almost classical silhouette of the early nineteenth century. (Courtesy Dover Publications Inc.)

The first part of the nineteenth century saw society turn away from the ornate and head toward the classical. The silhouette was straight, patterned after those of ancient Rome. (See Figure 6-5.) Women wore long white dresses, sometimes dampened to cling to the body as classical sculpture, and thin-soled shoes, even in winter. By mid-century, the full skirt had returned, again supported by hoops. (See Figure 6-6.) Toward the last third of the century, fashion moving ever onward saw skirt fullness swept to the back, and the bustle became the rage. (See Figure 6-7.) By this time some women's clothing was made in factories, starting with simple items such as capes and cloaks, then skirts and shirtwaists—an early term for blouses—and later combining the two into dresses. At the end of the century, the Gibson Girl look, a combination of shirtwaist and long skirt over a figure corseted into an "S" shape, was widely copied.

1900 to 1930

The first decade of the twentieth century saw a predominance of the straight silhouette for women. For a while even a hobbled look was fashionable and some women tied their legs together in order to walk correctly in the very long, very straight hobble skirt. Fortunately, that restricted look was soon replaced by the relaxed silhouette

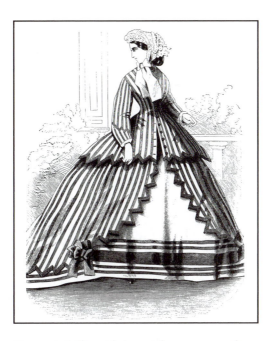

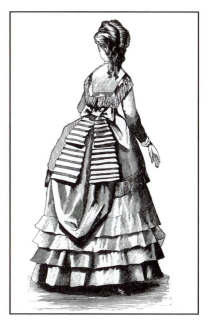

Figure 6-6. The mid-nineteenth century saw the return of the full skirt with unprecedented proportions supported by the hoop. (Courtesy Dover Publications Inc.)

Figure 6-7. Toward the end of the nineteenth century the fullness in the skirt swept to the back in the form of the bustle. (Courtesy Dover Publications Inc.)

of Paul Poiret, the highly popular French designer who also introduced the fashion show. As World War I approached, skirts shortened to mid-calf and, during the war, a simple look prevailed.

In the years that followed, called "the Roaring '20s," women experienced new freedom in their lives and in their apparel. Many took jobs, bobbed their hair, shortened their skirts above the knee, and after hours kicked their heels up to the dance craze called "the Charleston." The silhouette was straight and relaxed with the waistline often at the hips. Soft silk or wool fabrics, cardigan jackets and pleated skirts, and light colors were highly popular, reflecting a carefree and hedonistic era. These extravagances suddenly ended as the stock market crashed in 1929, heralding the Depression of the next decade.

1930 to Today

The 1930s were accompanied by hard times for many Americans. Without funding from investors in the stock market, many businesses could not keep on producing goods and paying employees. As a result, people out of work were not able to buy much of what was produced. The clothing of the day reflected general attitudes.

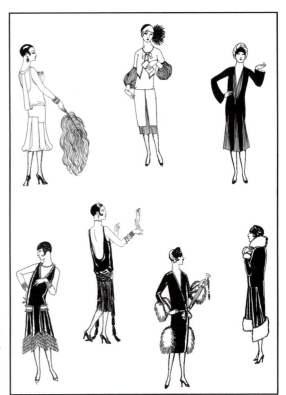

Figure 6-8. The "Roaring '20s" reflected a new freedom and lifestyle with bobbed hair, shortened skirts, and a relaxed fashion silhouette. (Courtesy Dover Publications Inc.)

Many women had to "make do" with what they had. Fashions were straight and simple with skirts at mid-calf and fabrics (cottons, wools and rayons) sturdy and comparatively inexpensive. Turning from the impoverishment of their own lives, many people delighted in the rich fantasy lives of the glamour girls as shown in the films of the day. Designers such as Madeleine Vionnet and Elsa Schiaparelli enhanced the glamour girl look creating clinging, shapely styles in velvets and satins, a look vastly different from that of the shapeless 1920s.

In the 1940s, World War II brought rationing of food and gasoline and restrictions on the amount of fabric to be used in apparel. The straight silhouette prevailed as apparel manufacturers out of necessity copied military looks offering knee-length straight skirts and boxy-jacketed suits, which minimized the amount of fabric and trimmings needed. For work at home, the popularly priced "house dress" was the fashion of the day.

After World War II, with a burst of joy, American women delighted in the full-skirted feminine "new look" created by Christian Dior, and manufacturers copied it at all price levels in the United States. (See Figure 6-10.) Also in the 1940s, sportswear—known as "separates"—became highly popular among young people. Jeans and sweaters were beginning to be seen everywhere. (See Figure 6-11.)

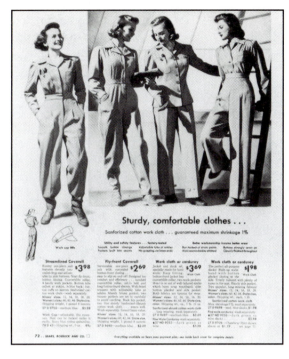

Figure 6-9. Military styles were copied as a result of World War II. (Courtesy *Everyday Fashions of the Forties as Pictured in Sears Catalogs*)

The growing interest in casual looks fostered the development of American designers in the 1940s and their tremendous popularity in the ensuing decades. While designers such as Edith Head and Irene were movie industry legends, particularly for glamorous apparel, American designers Bonnie Cashin and Claire McCardell highly influenced more casual day wear and sportswear throughout the 1950s. More fashion trends appeared such as the chemise, the empire look, and the tent or A-line. New easy-care synthetic fabrics helped increase the popularity of all kinds of sportswear and day wear.

The 1960s was a decade of great change as fashions became definitely younger, influenced by London designer Mary Quant, who introduced miniskirts and short shorts. Paris copied the youthful trend as André Courrèges brought out short tent dresses worn with white boots. For the more serious fashion-conscious, there were the influences of Hubert de Givenchy, who designed simple boat-necked shift dresses and elegant gowns for movie actress Audrey Hepburn, and Valentino and Chanel, whose classic suits and elegant sportswear worn by former First Lady Jacqueline Kennedy were copied throughout the world. For many women the 1960s were an opportunity for new cultural freedom, including freedom in dress. This freedom also expressed itself in fashion. Women rebelled against a major fashion focus—the maxi (very long) skirt, which, touted as an important change, never became a hit. However, sportswear grew in popularity and with it came an interest in ethnic looks and crafts.

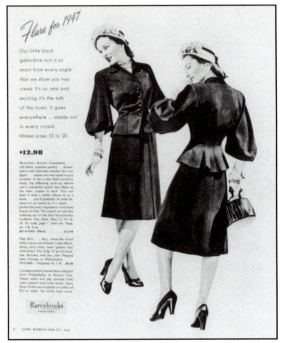

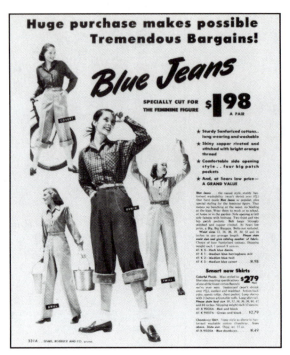

Figure 6-10. After World War II, Dior's "new look" brought a softer, more feminine feel to fashion, which was widely copied at all price levels. (Courtesy *Everyday Fashions of the Forties as Pictured in Sears Catalogs*)

Figure 6-11. The jeans craze began in the late '40s and hasn't let up since. (Courtesy *Everyday Fashions of the Forties as Pictured in Sears Catalogs*)

The pants suit for women was the accepted mode of dress in the 1970s. Pants suits were available in a range of prices and a variety of natural and synthetic fabrics. The influence of French designers waned as the domestic market for sportswear kept growing. Young American designers such as Ralph Lauren appearing in the late 1960s and Calvin Klein in the early '70s—both noting an emerging interest in classic apparel—set out to meet that need by launching lines featuring classic looks for women. They used natural fabrics, such as wool, silk, cotton, and linen, and emphasized separates and "investment dressing": classic jackets, pants, skirts, blouses, and sweaters that could be combined a number of ways.

In the 1980s fashion interest swung back again to Paris. Young French talent such as Christian Lacroix brought fresh new silhouettes and color combinations, and designers from all over the world, such as Karl Lagerfeld from Germany, Rei Kawakubo from Japan, and Giorgio Armani from Italy, began to show their collections in Paris. These designers and others also realized that while most women cannot afford custom-made apparel, many do want designer styling. They began designing ready-to-wear lines that cost appreciably less than their custom collections and could be far more widely sold.

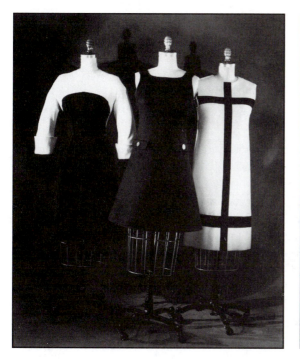

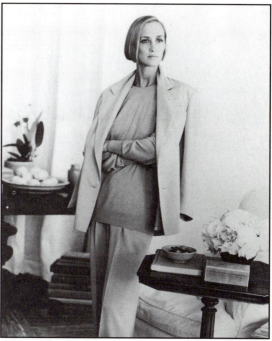

Figure 6-12. Fashions from the 1960s and 1970s. Left: Kleibacker's black/white dress of wool/dacron crepe, 1970s. Middle: Courrèges' A-line mini in heavy black wool twill, late 1960s. Right: Yves Saint Laurent's Mondrian-inspired dress of white wool jersey crossed with insets of black wool jersey, 1965–66. (Courtesy The Rowland Company)

Figure 6-13. Ralph Lauren's designs emphasize classic looks and natural fabrics. (Courtesy of Ralph Lauren)

The 1990s are seeing a continuation of several earlier trends. Some of these are a growing reluctance among many women to pay extremely high prices for custom designs; a continued interest in designer and brand names; and a desire for variety, style, and comfort in apparel. At the same time, designers are seeing rising costs throughout the industry at all levels. Many European and American designers are finding their ready-to-wear lines are satisfying customers' desires for well known names and lower prices. Consumers' desire for change combined with an interest in comfort and suitability continue to influence the fashions that women choose to wear.

Characteristics of the Women's Wear Industry

Exciting, dynamic, and *constantly changing* are a few terms that describe the women's wear industry. It is "exciting" because the industry is a continuing originator of potentially new fashion ideas. The industry is "dynamic" because it thrives on producing and promoting what it believes customers want.

"The industry is about change. The change is all about fashion dictated by lifestyle," says Marshall Stewart, a midwest manufacturer's agent with 30 years of industry experience.[7] Providing an arena for change, there are five seasons a year, permitting each season's line a shelf life of eight to ten weeks. Each season the industry brings forth new merchandise for retailers and their customers.

Economic Importance

The women's apparel field is a significant contributor to the nation's economy in terms of the volume of business it does and the number of people it employs. Consisting of large and small manufacturing and marketing organizations, these businesses make up a multi-billion-dollar industry, with 1992 retail sales of women's apparel alone amounting to over $77 billion.[8] Women's wear firms employ hundreds of thousands of people in a wide range of jobs calling for a variety of skills and abilities. Success stories in fashion production and merchandising include organizations such as Liz Claiborne, Inc., which grew in annual sales from nothing to $2 billion in just 16 years; Dillard's, Dayton Hudson, and The May Company, whose organizations together total sales of around $25 billion; Wal-Mart, the world's largest retailer; and The Limited, which counts among its holdings the highly successful Victoria's Secret and Lane Bryant stores.[9] Large organizations such as these and others—in addition to the thousands of small manufacturers and retailers throughout the nation—have positions offering exceptional opportunities for people with talent, ability, and interest in the fashion field. For further information on fashion merchandising careers, see Chapter 16.

Location

While the center of the domestic garment industry is New York City, the work of creating and marketing women's apparel goes on all over the world. At the beginning of this century, when the women's ready-to-wear industry went into full production, Seventh Avenue in Manhattan was its home. That area is still known today as the garment district and it houses the showrooms of many major women's apparel manufacturers. New York was the logical place for the garment industry to take hold because the city had access to the ingredients necessary for success. The industry needed skilled immigrants to produce apparel and at that time they were arriving almost daily by the thousands from Europe. To create apparel the industry also needed fabrics, which were readily available from the nearby textile mills of New England. Today, production and marketing of women's apparel takes place along the Atlantic seaboard and also in California, Texas, and Florida; across the borders in Canada, Mexico, and Latin America; and overseas, both in Europe and Asia. The marketing of women's ready-to-wear extends nationwide from the largest cities, throughout the suburbs, and to all but the very smallest of towns.

Kinds of Apparel Manufacturers

There are three kinds of women's apparel manufacturers:

1. manufacturers
2. jobbers
3. contractors

A single manufacturer may call on one or more of the others in producing apparel for a given season. A **manufacturer** is a business that takes responsibility for the entire manufacturing process for apparel. Joan Vass USA is an example. Apparel produced within the manufacturer's own plant is made in an **inside shop;** goods destined elsewhere for some or all of their manufacturing go to an **outside shop.**

A typical manufacturing organization employs its own designers, cutters and sewers, and sales staff. For example, the Rosemary Brantley organization in Los Angeles, California, a manufacturer of cotton knits for women, employs its own design and manufacturing staff and supervises development of its line from the very beginning to its shipment to the stores.

Jobbers do everything but the sewing. An apparel jobber may even have a design staff or may buy designs from freelance designers. The jobber then creates the patterns and cuts the fabric. Then the jobber ships the cut pieces to the contractor for sewing. **Contractors** specialize in sewing garments. They invest in high-speed industrial sewing machines and contract with manufacturers and jobbers as outside shops to sew their garments. When the sewing is completed, the garments are returned to the manufacturer or jobber for shipment to retailers. While most contractors are set up to complete and fill orders rapidly and at short notice, the manufacturer or jobber has limited control over the quality of the contractor's work.

How Apparel Is Produced

The production of women's wear begins with research. Since fashion is evolutionary, manufacturers want to know what styles are selling well now that customers will want again in next season's fabrics; they want to know what new fabric colors and textures the textile industry is offering; and they want to view the name designers' current collections in order to include fashion trends appropriate for their customers. This research is the work of the **merchandiser,** a major executive of the manufacturing organization who has the responsibility of determining the fashion direction the business will take. It is the responsibility of the merchandiser to work with the design, production, and sales departments to create and present fashion merchandise geared for the organization's customers when they want it.

Interpreting current sales results and fashion trends, the merchandiser then works with the designers to create a theme for the season, from which the designers will develop styles incorporating the looks that they and the merchandiser believe are important. For example, from the chapter opening, when June Driscoll was working on the collection of younger looking evening wear for the apparel manufacturer

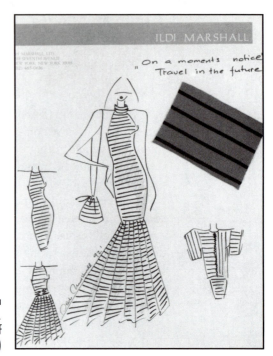

Figure 6-14. Some designers sketch a fashion idea before it is executed. (Courtesy The Polyester Council of America)

Evening Lights, she followed the recommendations of the merchandiser and the **principals,** or business owners, by looking at Paris fashions for inspiration.

Some designers create a sketch of the garment-to-be, while others begin by draping muslin on a dress form. Other designers use computer technology, called **computer-aided design (CAD),** to create designs and choose among alternatives. They study the draping of a garment and possible color combinations, and when satisfied they use the computer to create patterns. A few exclusive designers, such as Emanuel Ungaro, begin by draping fabric on live models. The completed sketch or draped muslin is then given to the **sample hand,** an expert sewer who, working from the sketch or muslin, sews a complete garment in muslin or an original sample in the actual fabric.

Management reviews the original sample and determines whether to accept or reject it, based on anticipated customer acceptance and potential profitability. To determine the wholesale price, the cost of making each style and the minimum number of orders needed to earn a profit are calculated. A production sample is made from a brown paper pattern in the company's model size, often size 8. The original pattern is then graded into the size range in which the garment will be offered, say sizes 4 to 14. Separate patterns are needed for each size to be manufactured. Pattern grading is a tedious task but now one that can be done swiftly by computer, another important application of CAD technology. The pattern pieces are then laid out on a marker, a long roll of paper that has been placed on top of many

layers of fabric. (See Figure 6-15.) An expert cutter using an electric or laser knife cuts around the pattern and the fabric underneath. Some large manufacturing organizations use computerized cutting, an example of **computer-aided manufacturing (CAM)** technology, that is, using computers to produce goods. After cutting, the parts for each garment are bundled together for sewing. The bundles then go to the factory's own sewing room or to outside contractors, where they are sewn into apparel. The newly made garments are then pressed, inspected, labeled and ticketed, and put on hangers or packed for shipping to the stores.

The Garment Workers' Union

Many of the men and women who produce women's apparel in U. S. factories are among the quarter million members of the **International Ladies' Garment Workers' Union (ILGWU)**. You have probably seen the union's television commercials and heard the song, reminding listeners to "Look for the union label."

The ILGWU has a long and illustrious history in the fast-paced garment industry, where conditions for workers were not always ideal. Early factories were crowded, unsanitary, and dimly lit. Even those workers who contracted to take work home were no better off. Picking up work to be done and later returning it finished, whole families—adults and children alike—worked in squalid apartments. It was common for workers to toil 16 hours a day seven days a week, because they were paid according to the number of garments they produced.[10]

Figure 6-15. Pattern pieces laid out on a marker. (Courtesy Ellen Diamond)

In the early days, the workers had no way of expressing their views to management, but realizing the importance of having a voice, they formed the first union in 1900. Many factory owners were becoming rich in the rapidly developing women's wear industry while the workers earned as little as $3 a week and had no protection. In 1910, however, the union staged a lengthy strike and won the right to bargain with management.

At first the general public did not concern itself with the workers' plight, but a fire the next year radically changed public opinion. On May 25, 1911, at the Triangle Shirtwaist Company in New York, 500 employees—mostly women and children—were delayed in leaving the burning building, and 146 lost their lives because major exit doors were locked. This tragedy turned public sympathy to the needs of the workers, and management began serious negotiations with the ILGWU.[11]

The decades that followed, under the 34-year leadership of David Dubinsky, a former Russian immigrant garment cutter, the ILGWU instituted a 35-hour, five-day work week; created health and pension programs; and developed housing programs and recreation centers for its members. Today, concerned about the number of industry jobs moved offshore shrinking membership to half of its nearly 500,000 peak in 1966, and concerned about nondocumented immigrants in substandard domestic factories, the ILGWU is working to encourage domestic production in unionized plants.[12]

Structure and Organization

The women's apparel industry produces a variety of new merchandise several strategic times throughout the year. Manufacturers' styles for a given season are called their "merchandise lines" or simply **lines.** A designer's line is known as a **collection;** when designers offer several price lines, the highest priced line is often called the "designer's collection." A typical line or collection may contain from 60 to 200 garments.

To provide for an orderly introduction of lines, the industry has created fashion seasons, as you will recall from Chapter 1. The seasons vary in number, depending on the type of merchandise. Manufacturers of women's wear tend to have the most seasons, from four to six, while children's wear manufacturers have four, and tailored men's wear have two seasons. Liz Claiborne has six seasons beginning with fall, where the greatest fashion changes take place. For Liz Claiborne, Inc., the seasons are fall I, fall II, holiday, cruise, spring I, and summer. Fall merchandise is shown by manufacturers in February and March for delivery to the stores in June through September. Holiday and cruise wear are shown in June for delivery in November and spring lines are shown in October and November for delivery in January and February.

The women's apparel industry is also organized by type of apparel, price, and size.

ADRIENNE VITTADINI

Energetic, hard-working, and concerned about the world around her, Adrienne Vittadini believes her customers have similar attitudes and work schedules. Her designs, such as layered looks and separates emphasizing knits, are created to appeal to women throughout the world. As head of a conglomerate with annual estimated sales of just under $200 million, and a growing global market, her work takes her frequently both to Europe and Asia.

Vittadini's background prepared her to use the world as her source of inspiration. The daughter of a sculptor of East European heritage, she graduated from Moore College of Art in Philadelphia with a degree in fine art. Traveling to Italy, she worked as a freelance knit designer and married. Her husband, Gianluigi, was a doctor involved in his family's pharmaceutical business. As a hobby, he encouraged her to start her own design business in 1979. Unexpectedly, the business, headquartered in the United States, flourished rapidly and for a while Gianluigi found himself commuting between Italy and New York. As sales grew significantly, Gianluigi decided to leave the pharmaceutical business to join Adrienne full time. The company is owned by the two of them. His ability to take over financial matters enabled Adrienne to devote her attention to designing. At first she was the only designer, but as the organization grew, a creative design team was added to carry out the themes she develops.

> *"I'm appealing to a lifestyle. There's a theme, a consistency throughout all of my lines. . . . The ecology and trend to global warming has really influenced my work." Adrienne Vittadini*

Today, the company has grown to consist of three divisions and includes some 14 licensing agreements. The three company divisions are Collection, Sport, and Dresses. Collection includes designer sportswear, career wear, and a growing segment of elegant evening clothes, of both knit and woven fabrics. The Sport line emphasizes her first interest, knit sportswear. Taking part in a trend emphasizing a young look, she is adding jeans and lowering prices. Interested also in functional sportswear, she is developing Adrienne Vittadini Active, offering tennis, golf, and other active sports apparel as well as hats, socks, and visors. The Dress line ranges in style from casual to elegant. A Vittadini Petites line is made up of selected styles translated from

continued

Sport and Dress. The licenses range from designs for swimwear to home furnishings and include handbags and scarves, lingerie and sleepwear, and girls' wear. One of the most recent licenses is for a fragrance.

Vittadini apparel is marketed to major department and specialty stores, such as Bloomingdale's, Saks Fifth Avenue, and Nordstrom, and through almost 30 Adrienne Vittadini boutiques and outlet stores. The company's retail affiliate, Vopco, owns the outlet stores and some of the boutiques; the others are franchises. The organization is expanding globally, doing business in Canada, Mexico, Great Britain, Japan, Australia, and Singapore. Plans include further expansion in Germany and Italy.

Adrienne Vittadini believes in "seasonless clothes," that is, clothing that extends beyond the traditional seasons and can be layered for warmth. She believes that knits are ideal for layering and a modern way of dressing because of their wearability, comfort, and ease of care. Her goals include not only recognition as a company for knits, but, more importantly and with the help of her licensing arrangements, being known as a lifestyle resource.

Question for Discussion. Since the ecology and the trend to global warming influence the work of Adrienne Vittadini, in what ways could they have an effect on her customers' purchasing behavior?

Sources. 1. Constance C.R. White, "Vittadini Expanding and Redefining," *Women's Wear Daily,* May 20, 1992, p. 20 and "Vittadini Eyes Strategies for Global Growth," *Women's Wear Daily,* August 28, 1991, p. 1; 2. Press kit and press releases from Adrienne Vittadini, Inc., 575 Seventh Avenue, New York 10018, June 1991; 3. Irene Daria, *The Fashion Cycle,* Simon & Shuster, New York, 1990; 4. John McGlaughlin, "Partners in Success," Men's Bazaar, *Harper's Bazaar,* March 1991, p. 104.

Types of Apparel

Manufacturers create a range of women's apparel in a number of categories. A typical manufacturer produces merchandise in one or two categories from the groups shown below. For example, Castleberry, a division of Leslie Fay, is known for colorful yet conservative suits and dresses, while Evan Picone specializes in career-oriented sportswear. The traditional women's wear categories are:

1. Outerwear—coats, suits, jackets, and rainwear.
2. Dresses—including dresses with jackets and two-piece dresses.
3. Sportswear and active sportswear—Sportswear includes separates such as sweaters, jackets, skirts, and pants; active sportswear includes bathing suits, shorts, ski and tennis wear, and other active sports apparel.
4. After-five and evening clothes—dressy apparel for special occasions.
5. Bridal and bridesmaids' attire.
6. Blouses.
7. Maternity wear.
8. Uniforms and aprons.

Size Ranges

The women's apparel industry is divided into four major size ranges. Most manufacturers specialize in one or two of these ranges, although large organizations such as the Leslie Fay Companies produce garments in just about every size. Unfortunately,

women's sizes are not highly standardized, and there seems to be little interest in creating a truly standardized size. One reason may lie with the manufacturers themselves. Typically, manufacturers use dress forms on which they drape designs to be made into samples. While dress forms come in standard sizes, manufacturers of expensive apparel are known to down-size a dress form so that the dress form supplier's size 8 becomes the apparel manufacturer's size 6. Dress forms may also be customized to manufacturers' specifications. As a result, many customers—particularly those who want to be thought of as fashionably slender—are delighted when they fit into an apparent smaller size. Perhaps it is no wonder that despite today's sophisticated technology, efforts to standardize sizes have not gone much beyond the following traditional ranges:

1. Misses—for women of average height and weight—even sizes ranging from 2 to 16. Some manufacturers also create talls in these sizes.
2. Juniors—for small-boned and slender girls and women—odd-numbered sizes ranging from 3 to 13 and sometimes 15.
3. Petites—for shorter women—garments are cut in either misses (2 to 14) or junior (1 to 13) sizes.
4. Women's and half-sizes—known as full-figure fashions, women's dress sizes run 14 to 26 and sometimes to 32, and half-sizes for shorter women with a fuller bust run from 14½ to 26½.

Price Categories

In addition to its wide assortment and choice of sizes, apparel for women is available at many price levels. Actually, manufacturers may create women's wear for one or more of five price levels. The price of a garment depends on four elements: the cost of the material used; how complex the garment is to manufacture; the expenses and profit the manufacturer requires to stay in business; and the fashion image of the designer or the manufacturer. The five price levels are:

1. Couture and designer—including the highest priced apparel created by name designers such as Bill Blass, Scaasi, Calvin Klein, Oscar de la Renta, and others. Many designers are producing **secondary lines** (sometimes called "diffusion lines"), that is, lower priced lines to reach a wider customer base. Anne Klein II is a secondary line of Anne Klein; Kors is a secondary line of Michael Kors.
2. Bridge—a bridge between designer and better merchandise, high prices but lower than designer and usually associated with a designer's name such as A Line Anne Klein, Andrea Jovine, Joan Vass, and Adrienne Vittadini.
3. Better—between moderate and bridge price lines, among them Harvé Benard, Susan Bristol, Evan Picone, Liz Claiborne, Jones New York, and Carole Little.
4. Moderate—medium-priced merchandise with well known brand names such as Levi-Strauss, Leslie Fay, Ocean Pacific, Haymaker, and Jantzen.
5. Budget—lower priced brand name or unbranded merchandise for mass marketing, such as Donkenny, Gitano, Judy Bond Blouses, Wrangler, and Oops of California.

Table 6-1 Selected Designers' Secondary Lines	
Signature Line	**Secondary Collection**
Michael Kors	Kors
Gordon Henderson	But Gordon
Bob Mackie	Bob Mackie Collection II
Ungaro	Emanuel
Perry Ellis	Perry Ellis Portfolio

(Adapted from *Women's Wear Daily*, May 15, 1991, p. 5.)

Merchandising and Marketing Activities

Like fresh roses and ripe strawberries, fashions are "perishable" and so must reach the ultimate consumer as rapidly as possible. For this reason manufacturers and their representatives deal directly with retail store buyers. To further speed the process, buyers travel to the manufacturers' headquarters or showrooms to view the latest merchandise. A **showroom** is a manufacturer's or representative's local sales office. Except for a few basic items, there are no wholesalers along the path from producer to consumer other than the manufacturers and their representatives. Few goods are stored for any length of time. More often they are sent to warehouses or distribution centers for reassembling and shipping on to local retailers and final customers.

Major manufacturers make it easy for smaller stores scattered throughout the country to see the latest lines by participating in local showings and/or establishing showrooms in the region. Manufacturers want buyers to visit their showrooms whenever convenient and invite them in particular to view the new season's lines. The ways manufacturers work with retailers is further covered in Chapter 11, Domestic Markets. To convey the latest fashion information, the industry makes great use of advertising and sales promotion.

Advertising

Apparel manufacturers want to reach two main audiences in their advertising: consumers and other fashion businesses such as retailers. In recent years apparel and accessories manufacturers have been allocating between three and six percent of annual sales to advertising.[13] This gives major manufacturers, such as Liz Claiborne or Ralph Lauren, a considerable amount of money to spend. Recent sales for the Leslie Fay Companies amounted to nearly $1 billion. Larger manufacturers are the ones who can easily afford a variety of promotional strategies to reach their two main audiences. Many choose to concentrate on print and television advertising and sales promotion.

Major manufacturers advertise to consumers through consumer publications, fashion magazines geared to the general public, specifically, fashion magazines whose readers include the manufacturer's target customers. For example, designers such as Carolina Herrera, Adrienne Vittadini, and Michael Kors tend to advertise in *Vogue, Harper's Bazaar, Elle,* and other high-fashion magazines, while manufacturers such as Guess and Cherokee place their advertisements in *Glamour, Mademoiselle, Seventeen,* and other magazines intended for a younger audience.

Both major manufacturers and smaller manufacturers advertise to the trade, that is, other businesses in the fashion field. The most popular **trade paper,** or newspaper created for the women's fashion industry, is *Women's Wear Daily,* called by its initials, *WWD* and published daily, Monday through Friday, by Fairchild Publications in New York. Major manufacturers advertise in *WWD* to keep their name fresh in their customers' minds; smaller manufacturers advertise in trade papers because the cost of an advertisement is far lower than in a consumer magazine and because trade advertising allows them to directly reach potential initial customers, that is, the store buyers.

Manufacturers of all sizes often help retailers advertise the manufacturer's merchandise carried by the store. Traditionally, these advertisements appear in local newspapers, but they are also showing up more frequently on local cable television. The costs of both of these media are far lower than for similar advertising in national consumer publications or on network television.

When a store orders a certain style or group of styles from a manufacturer, the manufacturer may share in the cost of the retailer's advertising; the agreement is known as *cooperative advertising*. For example, a local store may purchase from Haymaker a mix-and-match group of skirts, tops, jackets, and slacks, and decide to advertise the group in the local paper. The manufacturer agrees to pay for a portion—frequently half—of the advertisement. In return, the Haymaker name appears in the advertisement along with the name of the retail store. The manufacturer may even furnish the art work for the advertisement. Cooperative advertising has benefits both for the manufacturer and for the retailer. The manufacturer's name appears in a local market where customers may be enticed into buying the merchandise, the retailer promotes to local customers, and the cost to both is half of the amount that a similar advertisement would cost if done by each alone. Advertising is discussed further in Chapter 14, Fashion Promotion.

Sales Promotion

Manufacturers and marketers both use sales promotion to build enthusiasm and gain response to their products. Manufacturers aiming to build goodwill with buyers work to ease the buying effort by making the buying process as smooth as possible. Manufacturers of couture, designer, bridge, and better lines hold fashion shows enabling store buyers to view the entire new collection at once. Part of the work of the manufacturers' representatives for these lines includes retail public relations, that is going out to the stores to see how the lines are selling, seeking out reorders, or taking part in a local promotion.

SPOTLIGHT ON A FIRM

THE LESLIE FAY COMPANIES, INC.

In glancing at apparel ads in newspapers and magazines, you have probably come across the names of Leslie Fay, Albert Nipon, Nolan Miller, and Castleberry. Did you know these names and a raft of other brands all originate from one source, the Leslie Fay Companies? Leslie Fay is a major manufacturer of moderate- to designer-priced dresses, suits, sportswear, and loungewear for women of all sizes and ages, and for men, offering Albert Nipon neckwear, shirts, and ties. The Leslie Fay Companies count as their customers over 16,000 retail stores who each year buy Leslie Fay goods totaling nearly $1 billion.

Leslie Fay creates and markets apparel in three major price categories: designer, better, and moderate. (See Marketing Strategy Chart.) The designer category consists of the Albert Nipon and Nolan Miller lines of dresses, suits, and evening wear, and the bridge label *Nipon Boutique.* In addition, Albert Nipon licenses coats, fragrances, accessories, sportswear, and patterns. The better price category consists of suits, dresses, and sportswear bearing the labels *Kasper* for A. S. L., and *Castleberry.* A label new in 1993, *Theo Miles,* offers sportswear, knit separates and dresses, and evening dresses for women in a variety of age and size ranges. Earlier Leslie Fay brand names, *Outlander* basic knitwear and *Breckenridge* sportswear, are marketed now to retailers other than the company's traditional customers. The moderate price category is made up of Leslie Fay dresses and sportswear and other apparel. The sportswear division offers skirts, blouses, pants, and jackets in coordinated styles and colors for fashion-oriented career women and is available in petite, misses, and large sizes. Also in the moderate price category are Andrea Gayle careerwear and Evelyn Pearson robes and loungewear. Like Albert Nipon, Leslie Fay has a number of licenses, among them coats; cosmetics; various accessories such as scarves, handbags and belts; and patterns.

In 1990, Leslie Fay acquired both the robe and loungewear manufacturer Evelyn Pearson and Spitalnik, a leather goods and private label manufacturer. These organizations further increase the variety of fashion offerings for consumers.

Producing and marketing apparel profitably calls for research. Through research, the Leslie Fay Companies have learned that their typical customer is between the ages of 35 and 55 with an annual income ranging from $30,000 to $50,000. Computer-based research enables Leslie Fay to track the sales of products by brand, style, and price. Periodic consumer research, drawn from the companies' data base of 37,000 households, enables Leslie Fay to know what customers are

buying, by age, income, occupation, geographic location, and even size. Research information then forms the basis for the companies' marketing strategies.

As part of a strategy to become more visible, the Leslie Fay Companies are promoting the Leslie Fay trademark as a "super brand" name for moderately priced apparel, placing the name on the major dress and sportswear lines. Through the licensing agreements cited, the name *Leslie Fay* now appears on a wide range of moderately priced merchandise. Also increasing visibility, over 1000 Leslie Fay in-store shops across the country feature dresses and sportswear bearing that brand name exclusively. Another strategy is to offer higher priced bridge and designer merchandise, again supplemented through licensing agreements, with emphasis given to the Albert Nipon brand name.

The Leslie Fay Companies manufacture some lines domestically in their own plants, but for approximately 90 percent of their production they rely on independent contractors in The United States, Asia, and Europe. However, no one contractor is responsible for more than five percent of the companies products. Depending on the line, there are from four to five seasons: spring, summer, fall I, fall II, and cruise or holiday. It takes two to four months to produce garments in the United States and four to six months for imports.

Executive headquarters, major sales offices, and design facilities are located in New York. A main factory for cutting garments as well as a large distribution center are in Wilkes-Barre, Pennsylvania. Other production and distribution centers are in Georgia, Massachusetts, New Jersey, and Ohio. Foreign distribution includes Canada, Great Britain, Spain, Germany, and Scandinavia. The sales force consists of over 300 people, some of whom are independent sales representa-

continued

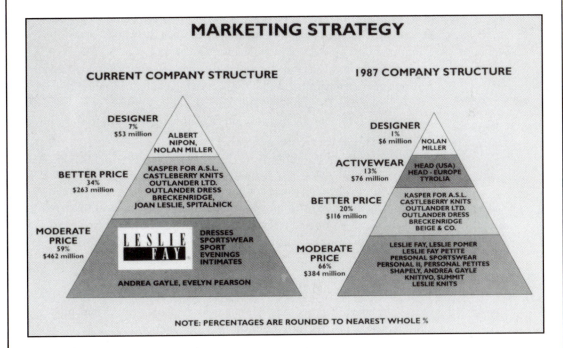

What is the advantage to Leslie Fay of creating a super brand? (Courtesy Leslie Fay)

tives located in New York and in showrooms across the country, among them Atlanta, Chicago, Kansas City, Dallas, and Los Angeles. Marketing and merchandising activities include advertising in publications such as *Harper's Bazaar, Cosmopolitan, Working Woman,* and *Women's Wear Daily.* Direct mailings and fashion shows in retail stores are examples of Leslie Fay sales promotion activities.

Question for Discussion. If the Leslie Fay Companies are extending the "super brand" idea in moderate price ranges, why are they also expanding in the higher price ranges?

Sources. 1. Lisa Lockwood, "Leslie Fay Has a Better Idea with Theo Miles," *Women's Wear Daily,* January 14, 1991, p. 10; 2. Thomas Ciampi, "Seventh Avenue Puts the Accent on Cost-Cutting," *Women's Wear Daily,* June 13, 1991, pp. 8 and 9; 3. Selected materials from The Leslie Fay Companies, including the *Annual Report* for the years 1989 through 1991, and Form 10-k.

One of the most successful local promotions is the **trunk show,** where a designer or representative of the manufacturer brings an entire line to a local store, where customers may see and buy it. The trunk show has several advantages for the manufacturer and the retailer. First, it helps to sell the line. One designer noted that when her representative participated in a local store's trunk show, sales increased by 65 percent. When she took part herself, sales went up by 135 percent. Second, a successful trunk show can increase prestige and add to the image both of the designer (or manufacturer) and of the local retail store. Third, the local store is able to have customers see and order from a designer's entire line without having first to invest money to stock the whole line.

Other promotional efforts of manufacturers include:

- In-store meetings or sales clinics where the manufacturer's representative explains new merchandise to the store's sales force, demonstrating the ways new fashions may be combined and worn.
- Seminars and tours of the manufacturer's plant or showroom to show how the line is planned, produced, and marketed.
- Tags, labels, and informative literature attached to the merchandise or given to the salespeople, describing particular features of the line, such as a new fabric. For example, when jackets and pullovers made of "polarite" were introduced, hang tags described the moisture-absorbing qualities of this new fabric.
- Display fixtures are offered to stores by manufacturers, usually when a store creates a special department, such as DKNY or Esprit, because these departments are often built to the manufacturer's specifications. Jewelry manufacturers, such as Napier and Monet, supply stores with fixtures to show earrings, chains, and other jewelry. Isotoner provides stores with fixtures to display the entire line during the fall and winter months, when gloves are in greatest demand.
- Counter cards, posters, and other advertising material, such as advertising mats, are frequently available to retailers from various manufacturers. You have probably seen a counter card for Lee jeans or a poster for Nike somewhere in a store.

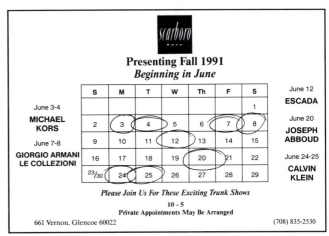

Figure 6-16. Exciting events, such as a series of trunk shows, help a retailer build business. (Courtesy Scarboro Fair)

- Recommendations are made on the appearance of the store's department and on ways the merchandise should be displayed. Some manufacturers want their merchandise to present a certain look in a store. For example, Ralph Lauren approves the appearance of many of the departments in stores offering his merchandise. Esprit asks major stores to fixture their departments and display the merchandise in a way that the manufacturer believes presents the line most appealingly.
- Videotapes are popular with manufacturers of all price lines, from Donna Karan's DKNY to Levi Strauss; however, the best ways to use them are still being explored. Some customers find them distracting or even annoying in a store, particularly if the merchandise described is not yet in stock.
- Bill enclosures are offered by manufacturers of sportswear, dresses, and intimate apparel among other women's wear producers. The advertisement, with a coupon for responding, is included with charge account statements, enabling the customer to react immediately and the store to learn the success of the promotion quickly.

Future Directions

In order to grow, the future of the women's apparel industry depends on its flexibility in meeting customer demand. The task is not easy in this fast-paced, highly competitive field operating in the face of continually rising costs. To respond to changing customer needs, the industry engages in some successful practices that will be more widespread in the coming years. These include licensing, brand names and private labels, vertical marketing systems, and global expansion.

Licensing

Over the years, customers have grown more name-conscious when buying goods including not only apparel, but also home furnishings, electronics, and automobiles. Many consumers feel more secure when they see a familiar name attached to the

suits, coats, and shoes they buy. This interest in brand-name merchandise has caused both women's wear manufacturers and marketers to identify their goods and promote their names. Today, the women's apparel field is an industry filled with highly recognizable names as well as up-and-coming ones.

The designers of exclusive apparel have been familiar names to fashion devotees since the middle of the last century, when Charles Worth opened the first salon in Paris. After World War II, however, the names of the top European, and later American, designers grew famous worldwide, due in some part to licensing. An agreement between an individual or organization with a famous name, such as fashion designer Adrienne Vittadini or the Walt Disney Company, and a manufacturer to create and market a product bearing that name (e.g., a handbag or a pair of sunglasses) is known as *licensing*. In a licensing agreement, the licensee who develops the product, say a Minnie Mouse T-shirt, pays the licensor, the owner of the name, in this case the Walt Disney Company, a royalty fee. The fee is often in the form of a percentage of the product's sales. The licensor's risks are somewhat limited in making the product, since the licensee (the manufacturer) may bear those costs. In addition, the licensor is not limited in granting licenses for other products. For example, Ralph Lauren has a number of licensing agreements, among them an agreement with Bidermann Industries to produce Ralph Lauren Women's Wear. The licensor has the degree of control over the quality of the product that is written into the licensing agreement. Licenses may be multinational. For example, Lee and Wrangler jeans have licensing agreements with factories in Spain and Belgium to produce those brands for European distribution. A trend in licensing is toward the joint venture, a cooperative effort between the licensor or brand owner and the licensee or manufacturer to share the costs and control of the licensed goods.[14]

There is no guarantee that a licensed product will sell, but many licenses are highly successful. Licensed fragrances and cosmetics are particularly popular among designers and manufacturers. Practically every designer you can think of, from Chanel to Liz Claiborne, has at least one licensed fragrance. In addition to fragrances and cosmetics, other popular licensed products include women's and men's apparel (for a discussion on men's wear licensing, see Chapter 8, Men's Wear); children's apparel (for a discussion on children's wear licensing, see Chapter 9, Children's Wear); accessories such as hosiery, jewelry, and shoes; and luggage, small leather goods, and home furnishings. The most prolific licensor of fashion goods to date is Pierre Cardin, whose name has appeared on many of the aforementioned products for women as well as on men's and children's wear, even on automobile interiors! Among the manufacturers with which Calvin Klein has licensing agreements are Joan & David for shoes, Kayser-Roth for hosiery, and Gabar for swimwear.[15] As long as the licensed name enhances the product through a perceived difference in the mind of the customer—as you recall from Chapter 4—licensing will continue to flourish as a method of manufacturing and marketing women's apparel and other fashion goods.

Brand Names and Private Labels

The area of exclusive merchandise is not the only one where names are important. Many women's wear manufacturers at all price levels, recognizing that customers want merchandise they can trust, try to distinguish their products from others and instill customer confidence, creating a perceived difference. Levi Strauss was one of the first apparel organizations to understand that by establishing a perceived difference, such as sturdy fabric riveted at stress points, and promoting that garment by name, customers will begin to ask for it. Other manufacturers followed suit, distinguishing their names and products from the competition. For example, when Esprit sportswear for women first appeared, the company promoted its colorful relaxed look and quickly became famous for it. Customers throughout the country ask for Esprit by name.

When a manufacturer creates and markets a product widely under a certain name, it is called a "brand name." Well known brand names in the women's apparel industry include Jordache, Leslie Fay, Jones New York, and J. G. Hook. Increasingly, manufacturers are promoting their brand names; for example, J H Collectibles, Catalina, and I. B. Diffusion. To offset the very high prices of designer collections, many fashion designers are developing merchandise at lower price lines carrying special designer brand names. In so doing, they hope to broaden their target markets and increase sales. Donna Karan first saw the need for lower prices and introduced her DKNY line. Anne Klein offered A-Line Anne Klein, and Michael Kors developed the secondary line with his last name, *Kors*. (For examples of other secondary lines, see Table 6-1.)

Private labels are the retailer's method of using a special name to establish perceived difference. As you recall from Chapter 4, a **private label** is a brand that belongs to one store or retail organization. Private label merchandise is available only through the retailer who offers it. For example, Saks hosiery is available only at Saks Fifth Avenue stores, or T-shirts marked *Bloomie's* are offered only by Bloomingdale's. Sometimes the private label is the same as the store name, as Eddie Bauer or Lands' End. Other times, it is originated by the retailer, such as Dayton Hudson's Field Gear label. Sometimes the private label is a name known mainly in the industry, as the Associated Merchandising Corporation's Preswick and Moore label. To obtain private label merchandise, retailers enter into agreements with manufacturers to supply merchandise bearing the private label. The merchandise is designed to compete with national brands but at a slightly lower cost, which is then passed on to the customer.

Retailers first used private labels for promotional or sale merchandise offered at lower prices than comparable national brand merchandise in the department. For example, for years Carson Pirie Scott & Company used the private label *Barbara Lee* on sweaters, hosiery, and other merchandise obtained for promotions, such as the annual fall sale.

As national brands became more prominent and available, retailers knew they needed something to encourage customers to visit their stores. They began to develop private label merchandise to compete with national brand names at a variety of price levels. For example, Henri Bendel offers a private-label T-shirt that competes with the designer

brands the store also carries. Marshall Field's Country Shop, a private label department, offers comparable styling to its neighboring Ralph Lauren department. In the future, both national brands and private labels will continue to flourish as long as they represent distinctiveness and value to the customer and offer profitability to their creators.

Vertical Marketing Systems

One way for businesses to grow is to control a greater portion of their production and marketing activities; this improves efficiency and keeps costs down. For this reason, a manufacturer decides to enter retailing, or a retailer decides to create a continuing relationship with a group of fabric suppliers and sewing contractors. For example, Liz Claiborne is opening stores in various parts of the country to offer apparel and accessories under her name; already the company has established First Issue stores, a lower price line of career wear for women, and for larger sizes there are the Elisabeth stores.[16] When businesses establish ownership or formal agreements along the product's journey from the manufacturer to the customer, they are setting up a **vertical marketing system,** which is a more efficient way of securing merchandise for customers. The form of vertical marketing system known as dual distribution (when a manufacturer sells through the company's own stores and to others as Liz Claiborne does) occurs in many parts of the apparel industry and began in the men's wear field. Dual distribution is fully described in Chapter 8, Men's Wear.

Another type of vertical marketing system occurs when a retailer establishes informal yet relatively permanent agreements with suppliers. The Banana Republic division of The Gap obtains its linens from Ireland and leathers from Italy. Using information gathered from store executives, the company's design team develops the ideas for the season's merchandise lines. After management approval, individual designs are sent to jobbers and contractors for mass production. The on-going relationship with suppliers enables Banana Republic to offer private-label merchandise styled according to the company's interpretation of customer demand. Another example is Mast Industries, a manufacturing organization owned by The Limited, which produces apparel for the various Limited organization stores. The number of fashion organizations using vertical marketing systems will increase as long as the systems are efficient and effective in delivering the apparel that customers want.

Global Expansion

The women's fashion business is truly worldwide. Designers work everywhere: Geoffrey Beene in New York, Bruce Oldfield in Britain, Emanuel Ungaro in Paris, Gianni Versace in Italy, and Hanae Mori in Japan, to mention just a few. American manufacturers continually scan the collections of leading European and Asian designers for hints of fashion trends they can produce in volume. American women enthusiastically purchase imports (goods from other countries) in all price ranges. For example, consider the popularity of names such as Laura Ashley and Burberry from Great Britain, Benetton from Italy, and Escada and Mondi women's apparel from Germany.

To participate in the wider fashion community, American fashion businesses are taking a greater part in global marketing at a variety of price levels. On the most exclusive level, American designer Oscar de la Renta shows his new lines in Paris as well as New York. Apparel in a variety of price ranges from manufacturers in the United States is offered by department stores and specialty shops worldwide. Ralph Lauren has granted franchises for Polo/Ralph Lauren stores in a number of countries, including Argentina, Brazil, Canada, France, Germany, Japan, and Mexico.[17] Liz Claiborne has stores in Canada and sells to stores in Great Britain and Spain.[18] Woolworth's Lady Footlocker stores are located in Canada and Germany as well as across the United States.[19] Calvin Klein is opening licensed freestanding boutiques in Europe and Asia.[20] These organizations are paving the way for other American women's apparel businesses to offer their goods in foreign markets as an important way of reaching a broader base of customers and thus increasing sales and profits.

Summary

1. In early history and up to the fourteenth century in the Middle East and Europe, women's garments were straight and simple. At that time, silhouettes became more shapely, first in Italy and then in northern Europe and Britain. By the eighteenth century, the center of fashion was France, where bouffant silhouettes of elegant fabrics were the style of the king's court until the revolution, when apparel became much simpler. In the nineteenth century, silhouettes moved from straight to bell-shaped to back fullness by the end of the century. The predominant shape of the twentieth century has been and continues to be straight. Today, through the mass production of ready-to-wear, a wide choice of apparel is available to almost everyone.

2. The women's wear industry contributes significantly to the economy, a multibillion dollar industry employing hundreds of thousands of people in businesses of all sizes. Much of this nation's apparel production is located in New York; however, women's wear is manufactured and marketed throughout the world.

3. There are three types of apparel manufacturers: manufacturers who have their own facilities, apparel jobbers who may design and cut garments, and contractors who specialize in sewing. When a typical garment is designed, it is made up as a sample, then reviewed by management. If approved, its cost is determined and it is added to the line for presentation to store buyers. When store orders are received, the garment is cut, sewn, and shipped to the stores.

4. The women's apparel industry is organized by type of apparel, such as outerwear, dresses, and sportswear; by sizes, such as misses and juniors; and by price categories, from designer to budget.

5. Merchandising and marketing activities of manufacturers include advertising and sales promotion. Advertising appears most often in consumer and trade

publications and with retailers in local newspapers in the form of cooperative advertising. Sales promotion activities include trunk shows, seminars, informative labels, videotapes, and bill enclosures.

6. Future directions for women's wear include continuing the successful practices of licensing well known names, emphasizing brand names and private labels, creating and using vertical marketing systems, and expanding to markets worldwide.

Fashion Vocabulary

Explain each of the following terms; then use each term in a sentence.

collection

computer-aided design (CAD)

computer-aided manufacturing (CAM)

contractors

custom-tailored

inside shop

International Ladies' Garment Workers' Union (ILGWU)

jobbers

lines

merchandiser

outside shop

principals

private label

ready-to-wear

sample hand

secondary lines

showroom

trade paper

trunk show

vertical marketing systems

Fashion Review

1. Beginning with the late 1940s, following World War II, describe the prevailing fashions in women's wear for each decade.
2. Explain the process for manufacturing women's ready-to-wear today and describe the role of the International Ladies' Garment Workers' Union (ILGWU).
3. Describe the organization of the women's apparel industry according to the types of garments manufactured and the price levels.
4. Explain three or four advertising and sales promotion activities commonly conducted by apparel manufacturers and retailers.
5. Describe four successful practices in the women's apparel field that are likely to be more prevalent in the future.

Fashion Activities

1. As a manufacturer of junior sportswear, you are responsible for developing a perceived difference in your product line. You decide to create a brand name that emphasizes the distinctiveness of your merchandise. Create a label for your brand name. Then write a memo to your retail store customers explaining your brand name and how it distinguishes your merchandise and makes your lines more recognizable to customers. Include an example of the advertising you will do to make the brand name stand out and be easier to sell.

2. Think of three local stores you know that offer women's apparel. On the form below, list the stores by name and for each store give an example of recent advertising and sales promotion activities.

| | Marketing and Merchandising Activities | |
Name of Store	Advertising	Sales Promotion
Example: K mart	Cable TV ad featuring Jaclyn Smith apparel	Store signs and counter cards showing the line

Endnotes

1. James Laver, *Costume and Fashion,* Thames and Hudson, New York, 1990, Chapters 1–3.
2. Jenni Lau, "An Early Obsession," *Women's Wear Daily,* May 30, 1991, p. 6.
3. Jane Dorner, *The Changing Shape of Fashion through the Years,* Octopus Books Limited, London, 1974, p. 16.
4. *Ibid.* p. 17.
5. *Ibid.*
6. Turner Wilcox, *The Mode in Costume,* Charles Scribner's Sons, New York, 1958, p. 178.
7. Marshall Stewart, owner, SME, Inc., Chicago, Ill., author interview, March 11, 1992.
8. Thomas Ciampi, "A $2 Billion Phenomenon," *Women's Wear Daily,* May 8, 1991, p. 1.
9. Ira P. Schneiderman, "Mass Market Report, Power Retailers Siphon Apparel Share," *Women's Wear Daily,* February 24, 1993, p. 22.
10. *A Brief History of the International Ladies' Garment Workers' Union,* ILGWU, New York.
11. *Ibid.*
12. Kevin Haynes, "ILGWU: Continuing the Battle," *WWD: 75 Years in Fashion,* Fairchild Publications, New York, 1985, p. 34.
13. *Advertising Age,* September 16, 1991, p. 32.
14. Constance C.R. White and Chuck Struensee, "Designer Licensing: No More Easy Money," *Women's Wear Daily,* May 11, 1992, pp. 4–5.
15. Lisa Lockwood. "Calvin Klein's Bold Strategy in U. S., Europe." *Women's Wear Daily,* June 19, 1991, pp. 1–8.
16. Robert Hartlein, "Liz Claiborne Plans to Test Accessory/Shoe Store in '91," *Women's Wear Daily,* May 17, 1991, p. 7.
17. "Polo/Ralph Lauren Stores," Ralph Lauren press kit, 1991, Ralph Lauren, New York.
18. Liz Claiborne, Inc. company update, *Prudential Securities,* May 20, 1991, p. 2.
19. "Major Specialty Growth," Trendcheck/Expansion, *Stores,* August, 1990, p. 24.
20. Lisa Lockwood, op. cit.

Accessories

Objectives

After completing this chapter, you should be able to:

1. Name the major categories of accessories and describe their role in the making of fashion.

2. Name several important styles in footwear in the twentieth century and explain how they related to ready-to-wear fashions of the time.

3. Describe the three major segments of the jewelry industry and explain how they differ.

4. Name three or four ready-to-wear designers who include accessories as an integral part of their clothing collections.

5. Cite three or four directions that the various accessories categories are expected to take through the 1990s.

t was Monday morning, and Susan had overslept. As she hurried to get ready for work, she remembered that she had an important client meeting at the office that day. She began searching in her closet for the suit she had planned to wear, until realizing with a start that she had forgotten to pick it up at the cleaners on Saturday, along with several of her other favorite business outfits.

Flipping quickly through her closet for alternatives, Susan passed over outfits that were either too dressy or not dressy enough for the day's agenda, and finally stopped at a simple, round-necked black rayon dress with three-quarter length sleeves, a fitted waist, and a slightly flared skirt. She slipped it on, and then began digging through her drawers and shoe boxes to find something that would brighten and "dress up" the dress.

First, she slipped on a pair of sheer black pantyhose. Next, she found a large square silk scarf in a burgundy and yellow paisley print, and arranged it artfully with one point draping her left shoulder. Over the scarf's knot, to secure and conceal it, she pinned a gold brooch with a wine-colored stone, and mirrored the jeweled pin with a matching pair of

small dangle earrings. Then she wrapped a black-banded watch around her wrist, and stepped into a pair of mid-sized heel burgundy pumps. After examining her image in the mirror, Susan went back to her closet and pulled out a thin black leather belt that she carefully adjusted around her waist. A final check in the mirror, and Susan grabbed her black shoulder-strap handbag, and headed out the door for work.

What Susan did, with a little effort, was to transform a simple black dress into an outfit that made a fashion statement and expressed her own creativity and personality. She did it with accessories, those "finishing touches" of fashion that can turn an outfit into a "look," and change an off-the-rack garment into an individual creation.

Importance of Accessories

If it is true that "clothes make the man [or woman]," then it is even more true that accessories make the clothes. Think about what happens when you add an elegant strand of pearls to a basic black dress or when you find the perfect pair of boots to complement a western-style jeans and jacket outfit. Accessories are like the "icing" on top of the fashion "cake." They can complete a look, they can change a look; they can even become the look, depending on how they are worn.

Accessories are worn on the head, on the feet, and virtually everywhere in between. And because they generally cost less than apparel, they are often used to perk up a wardrobe in between major purchases—just as a homeowner might buy new towels rather than redoing the whole bathroom. In fact, because of their mostly moderate prices, accessories are often considered **impulse items**, meaning that customers will buy them without having planned to in advance. For that reason, retailers such as department and discount stores tend to position their accessories departments in high-traffic areas, usually near an entrance, to attract the attention of customers passing by.

Because accessories play such a visible role in dressing up a wardrobe, they have to be at the cutting edge of fashion. Accessories designers must be completely in tune with the latest trends in apparel, and ready to offer accessory styles and colors to coordinate with garments when they appear. In fact, accessories are so important to today's fashions that many of the top apparel designers, including Donna Karan and Liz Claiborne, create their own accessory lines, frequently as a licensing arrangement with an accessory manufacturer, and feature them with their garments in fashion shows and advertising.

The total accessories market is somewhat fragmented, since within the broad category of accessories there are a number of different, specific types of merchandise. Among them are shoes, hosiery, jewelry, handbags, hats, gloves, scarves, hair goods, sunglasses, belts, and small leather goods. In some cases, one company may market products in more than one area. A shoe manufacturer, for instance, may also make handbags, and a jewelry firm may also offer hair accessories. In other cases, an established apparel manufacturer or design firm might license its name to another company to produce accessory items in keeping with the apparel. Levi Strauss & Co., for

Figure 7-1. Fashion accessories come in a wide variety of styles and add finishing touches to clothing outfits. (Courtesy Claire's Stores, Inc.)

instance, recently began licensing its Dockers brand name to Genesco Inc. and Royce Hosiery Mills for men's shoes and men's socks, respectively.

Over the years, categories of accessories tend to fluctuate in importance, with one type of accessory taking center stage for a time, before being replaced by another. Often, it is a specific style that becomes all the rage. For example, in the '60s, the "pillbox" hat was seen on the heads of many fashionable women, popularized by First Lady Jacqueline Kennedy. In the early '70s, the best-dressed legs were sporting fishnet and other thickly textured pantyhose. In the 1980s, scarves were draped, knotted, and wrapped in endless variations to jazz up outfits. And in the early '90s, fashionable accessorizers were taking their cue from the popular "rap" music movement, and adorning themselves with bulky gold chains and oversized medallions.

Although accessories have always played a significant role on the fashion scene, recent years have seen an even greater blossoming of the business, with annual sales estimates of all categories combined topping $66 billion. Shoes alone account for almost half of that total, with yearly sales over $30 billion, and jewelry ranks a close second, with sales that were approaching $25 billion in the early 1990s. The other categories individually remain much smaller, but the growth of the accessories business in general has led to a burgeoning in the number of retail stores specializing in this type of fashion merchandise. Claire's Boutiques, the largest of them, operates more than 1000 stores across the country, dividing the business into three price levels under three different banners: Claire's for volume-priced accessories, Topkapi for mid-priced goods, and Dara Michelle for upscale merchandise. (See Spotlight on a Firm: Claire's Stores, Inc., Chapter 2.) Other retail specialty chain operations include Afterthoughts and Carimar, owned by Woolworth Corp., which planned to open 900 stores by 1995; Cabaret, a division of U. S. Shoe; Accessory Place; Accessory Lady, a division of Melville Corp.; and The Icing.

Figure 7-2. Apparel companies such as J. G. Hook consider accessories a part of their total fashion image and often offer accessories lines to complement their ready-to-wear. (Courtesy J. G. Hook)

Shoes

Of all fashion accessories, there is no question that shoes fulfill the most functional purpose. Footwear is meant to keep our feet warm and dry in rain and snow, and protect our soles from hot pavement and sharp objects. Obviously, some types of shoes perform that role better than others, because in some cases, shoes are unquestionably designed more for fashion than function. However, even the most functional footwear contains certain elements of fashion, and makes its own statement about the person wearing it.

While the shoes manufactured today are a far cry from the pieces of animal skin early cavemen wrapped around their feet, the dramatic variety of shoes seen over the centuries actually differs more in fashion than in concept. According to William A. Rossi, a marketing counselor to the footwear industry, there are only seven basic styles of shoes, although each has a myriad of variations.[1] These basic styles are: pump, boot, oxford, sandal, mule, moccasin, and clog. The fact that most people think shoes come in many times that number of basic styles is vivid testimony to the fashion creativity of shoe designers.

History of Shoes

The earliest foot coverings our ancestors used served the single purpose of protection from the elements. But as time went on, different shoe styles began to emerge. The early Egyptians wore thong sandals more than 3000 years ago, and the Romans

developed a type of open-toed boot called the "campagus" back in the first century A.D. By the Middle Ages, one could often tell people's occupation or social status by the kind of shoes they wore. Men and women who worked in the fields, for instance, fastened simply contrived pieces of leather or wood to their feet, while the shoes of society's upper echelons became fanciful to the point of absurdity, some with long pointed toes curling up well beyond the end of the foot. (See Figure 7-3.)

The dramatic differences between the footwear of the rich and that of the poor came to an end with the French Revolution, when shoes in general became sturdier and better constructed.[2] It was not until the nineteenth century, however, and the Industrial Revolution, that the groundwork was laid for the modern manufacture and mass production of shoes as we know them today.

Up until that time, the craft of shoemaking had changed very little since ancient Egypt. Early cobblers cut out the leather parts of a shoe with a crescent-shaped knife and beat the leather on a stone until it was soft enough. Then, to make the sewing easier, they punched holes in the leather with a pointed tool called an "awl," and finally stretched the leather on a foot-shaped form called a **last**.

With the 1800s came three specific inventions that helped mechanize the shoe-making process. First, Elias Howe's invention of the sewing machine allowed shoe-makers to begin stitching the upper parts of shoes together by machine. Then in the 1850s, Lyman Reed Blake, an American shoe manufacturer, created a machine that would mechanically stitch the shoes' uppers to their soles. Finally, in 1882, Jan Matzelinger, the South American-born son of a Dutch engineer and a black slave, filed a patent for a lasting machine that would take the time and effort out of shaping

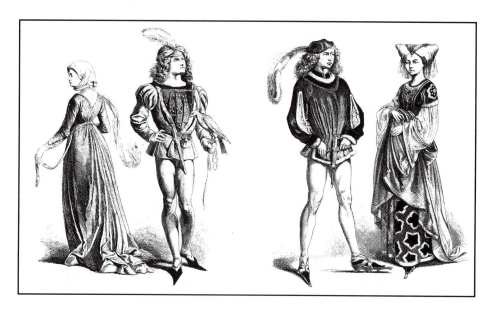

Figure 7-3. Early shoe styles were sometimes functional, sometimes frivolous, as seen in these samplings. (Courtesy Dover Publications Inc.)

leather over the last by hand. Matzelinger's machine enabled shoe factories to expand from producing between 50 and 60 pairs a day to turning out 700 pairs a day!

Of course, further advances in technology over the last 100 years have improved the efficiency and quality of shoemaking even further, allowing manufacturers to create hundreds of different shoe styles in a wide variety of sizes and widths each year. At least 5000 different lasts are used by U. S. shoe manufacturers today, designed to fit every foot size and shape. While leather remains a mainstay, new materials for the construction of footwear have been added, including plastics and fabrics such as cotton twill and brocade for the uppers, plus plastic, rubber, rope, and cork for the soles.

New technologies and materials not only improved the efficiencies of shoemaking, they opened the door for a dramatic influx of fashion in shoes in the twentieth century. As hemlines rose in the early 1900s, beautifully shod feet became more important, and the emerging role of women in society in the 1920s lent an entirely new approach to shoes as a fashion accessory. High heels, rich colors and textures, and buckles, sequins, and beadwork all heralded a new era in women's shoes. (See Figure 7-4.)

Since the 1920s, shoes have continued to undergo fashion transformations from year to year, and season to season, following the fads and fashions of ready-to-wear. The '30s, with a budding interest in active sports, saw the first forerunners of the modern tennis shoe, in the form of rubber-soled shoes with linen uppers. That decade also saw *Vogue* magazine chastising women for wearing open-toed and open-heeled shoes as streetwear—a style the fashion magazine would consider acceptable only after the end of World War II.[3]

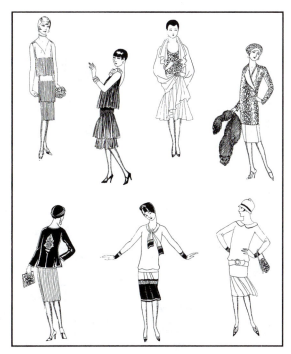

Figure 7-4. Women's shoes in the 1920s were dressy and delicate, reflecting rising hemlines and a new interest in foot fashion. (Courtesy Dover Publications Inc.)

The outrageously high and pointed stiletto heel made its first appearance in the 1950s, alongside the schoolgirlish black and white saddle shoes, but throughout the decade, women wore anything from narrow high heels to lower squat heels to "flatties," depending on the occasion and time of day. In the '60s, boots were everywhere, offsetting the expanse of leg newly visible beneath the ubiquitous miniskirts. And with the burst in popularity of a then-new British singing group, "Beatle boots" were sported by thousands of fashionable feet. Boots, in general, carried over into the 1970s, and sometimes reflected the "psychedelic" influences in society, with brightly colored designs and appliques. At the same time, platform shoes grew higher and higher, with two-inch-thick soles not uncommon by mid-decade.

By the early 1980s, platforms had given way to wedges, which in turn gave way through the rest of the decade to more comfortable flats and low-heeled pumps, not to mention the burgeoning category of athletic shoes. Whether worn for active sports, neighborhood strolls, or shopping, athletic-style shoes became the casual footwear of choice for men, women, and children. For the avid sports participants, super "high-tech" versions of athletic footwear, such as the "air bladder" or "pump" system first developed by Reebok, became a status symbol.

In the 1990s, some footwear trends began to come full circle, as an interest in nostalgia helped spawn shoe styles reminiscent of the '40s and '60s. Even platform shoes began staging a comeback, achieving a lesser degree of popularity than before because of consumers' greater interest in comfort. This comfort factor, and the continued casual lifestyle of the "Baby Boom" generation, should ensure the continued popularity of athletic and athletic-inspired casual shoes through the remainder of the decade.

Figure 7-5. Fitness activities, such as the popular "step" aerobics, as well as casual lifestyles, have kept athletic shoes in the forefront of the footwear industry. (Courtesy Nike, Inc.)

Characteristics of the Footwear Industry

Shoes are a significant fashion business in the United States, with retail sales having grown consistently since 1980, reaching $31 billion in 1990. A huge 80 percent of that footwear, however, is manufactured in countries other than the U. S. In 1990, imports accounted for 1.1 billion pairs of shoes, at a wholesale value of over $9 billion.[4] The rising wave of imports, coupled with the economic recession that hit the U. S. in the early 1990s, helped to cause a severe drop in the number of workers employed by U. S. shoe factories in recent years.

Of the manufacturing business that remains in the United States, the hub is no longer found in Massachusetts, as in the early days of American shoemaking. Over the years, manufacturing has spread to other regions of the country, so that today the leading states for shoe production are Missouri (home of Brown Group, parent company of Buster Brown, and other brand-name shoes), Maine, Pennsylvania, New York, and Massachusetts. Furthermore, many U. S. shoe companies, seeking lower costs of labor and materials, have taken their manufacturing operations offshore, often to the Far East, a fact that contributes heavily to the import statistics. In the early part of the 1990s, some companies were also looking south to Mexico and Colombia for the sourcing of their products. Wherever their production takes place, most companies, particularly those in the fashion end of the footwear business, also maintain showrooms in New York City.

In discussing the import side, many people tend to think first of Italy and Spain, due to those countries' reputations for fashionable, high-quality, leather dress shoes. Indeed, Italy and Spain do account for the highest priced shoes, on average, being sold in this country. In numbers of pairs of shoes imported to the United States, however, those countries are dwarfed by the total number of pairs being shipped from the Far East in recent years. China, in particular, profited from its newly awarded "Most Favored Nation" trading status with the United States at the end of the 1980s, by exporting a whopping 267.4 million pairs of nonrubber shoes to this country in 1990, or about 30 percent of the total from all countries.[5] Other leading footwear exporters to the United States are Taiwan, the Republic of Korea, and Brazil.

Structure and Organization

Each year footwear manufacturers and importers introduce an estimated 150,000 new shoes to retail buyers.[6] In general, the new styles debut at two major shows for the retail trade. In February, fashions for the next fall and winter are introduced, and August brings the launch of footwear for the following spring and summer. Shows are sponsored both by the Fashion Footwear Association of New York (FFANY), an organization of some 200 fashion footwear manufacturers representing 600 brands of men's, women's, and children's footwear, and the National Shoe Fair, the country's oldest and largest shoe convention. Smaller interim markets and regional shows are also held in between the major national events. In addition, athletic shoes are included in the annual trade show of the National Sporting Goods Association.

Footwear is segmented into men's, women's, and children's categories, each with a variety of types of shoes. The most common classifications are *dress shoes, athletic shoes, casual shoes,* and *boots.* Within each of these broad groupings, there are numerous subclassifications. For instance, the athletic shoe group encompasses aerobics shoes, running shoes, walking shoes, tennis shoes, and other types designed for specific sports activities. In addition, for industry classification purposes, footwear is divided into *rubber* and *nonrubber,* the latter of which is defined as containing less than 50 percent rubber in the upper part of the shoe. This segmentation is important primarily with regard to tariffs on shoe imports, and has less to do with the fashion or merchandising aspect.

In women's shoes, there is yet another subdivision within the dress shoe category, based on price levels, similar to those in women's apparel. (See Chapter 6.) These price categories include *better, bridge,* and *salon* or *designer shoes,* with the most exclusive salon styles selling for up to $600, and at the lower end of the price spectrum are *budget* and *moderate-priced* shoes.

Merchandising and Marketing Activities

To unify the industry and help support its merchandising and marketing activities, the footwear business has several active trade associations. In addition to the Fashion Footwear Association of New York, there are the Footwear Industries of America, the National Shoe Retailers Association, and the Footwear Distributors and Retailers of America. (See Appendix B for the addresses of these organizations.)

On the retail side, the U.S. footwear marketplace of the 1990s is dramatically different from that of 20 years ago, due largely to the growth of specialty retailing. (See Chapter 13, Fashion Retailing.) Once-prominent family-oriented shoe store chains, such as Kinney Shoes and Thom McAn, have taken a back seat to stores focusing on a specific segment of the business or those offering value pricing and self-service. Athletic shoe specialists, such as Foot Locker and Athlete's Foot, are examples of the former; Wal-Mart and Payless Shoe Source are examples of the latter.

Brand names are very important in the footwear business, and many of the leading companies, such as Nine West and Bandolino, keep their name exposure high through advertisements in fashion and other magazines. Many apparel companies and designers advertise their names on footwear collections, as well, including Evan Picone and Guess. Probably the biggest advertising expenditures, however, are made by the major athletic shoe companies, which devote a significant amount of their advertising budgets to national television commercials. In many cases, those ads are designed to capture viewers' attention through the appearance of well known sports figures. Nike, for instance, has used football's Bo Jackson and basketball's Michael Jordan in some of its ads; Converse has featured basketball's Larry Bird and Earvin "Magic" Johnson, among others.

Some of the footwear advertising that appears before the public is also generated by shoe retailers themselves. Often the most prominent are the stores and brands

owned by larger conglomerates or diversified firms. Like men's wear, the footwear industry involves a number of companies operating under a dual distribution system. **Dual distribution** means that a manufacturer uses several competing ways to reach target customers; in this instance, marketing its shoes in company-owned stores as well as through other retailers. The largest of these footwear companies is Brown Group, whose brands include Buster Brown for children; Naturalizer, Life Stride, and Connie, for women; and Regal for men. Another example is Melville Corp., which owns Thom McAn, Fan Club, and Foot Action.

Another recent trend in merchandising is for established footwear manufacturers not previously involved in retailing to open their own stores. Late in 1990, Nike unveiled the first Nike Town in its hometown of Portland, Oregon, featuring shoes, apparel, and accessories in a high-tech, futuristic, fun-to-shop retail format. (See Figure 7-6.) By summer of 1992, the company had opened an additional Nike Town store in Chicago, while its major competitor, Reebok, forged ahead with its own retail venture, including stores in Boston, New York, and Santa Monica, California. Similarly, Timberland, the New Hampshire-based shoe and apparel company, had opened 20 of its own stores in 1991 and planned an additional 30 by mid-decade.

Future Directions

As the country progresses through the last decade of the twentieth century, a number of trends are at work in the footwear industry. On the retail front, mass merchants and specialty stores continue to take sales away from department stores and independent shoe stores, a direction likely to continue throughout the decade. And imports will continue to erode the business of domestic shoe manufacturers, leaving some with shrinking profits and others in bankruptcy.

Figure 7-6. Nike dazzled retail watchers in the early 1990s with the opening of its first Nike Town, a fun and futuristic store selling the company's shoes, apparel, and accessories. (Courtesy Nike, Inc.)

SAM AND LIBBY EDELMAN

"**O**ne shoe, two people, three children, and a dog" is how *Footwear News* described the launch in 1987 of a brand new shoe company, Sam & Libby California. The shoe was a ballet-style flat shoe with a big bow. The two people were Sam and Libby Edelman, a husband and wife team who took a simple idea and turned it into one of the most successful footwear companies in America.

From the outset, the Edelmans had a clear vision and goal of what they wanted their company to be: "World leaders of translating social trends into lifestyle products." That principle certainly came into play in the development of their first shoe, the ballet flat that sold for a mere $20. In fact, as a typical thirty-something couple with kids, trying to make ends meet, they took the cue from their own lifestyle and needs, believing that there were surely other consumers besides themselves who can't or don't want to spend a lot of money on fashion.

Sam and Libby were not starting out cold in the shoe business, however. After college, Sam, the son of well known leather tanners, had established a company with his father that specialized in classic and equestrian footwear. Next, he held a position with the Candie's Division of manufacturer El Greco before joining what was a then start-up import footwear company called Kenneth Cole Productions. In 1983, he moved to California to become the president of Espirit's new footwear division, taking that company from zero to $55 million in sales in just four years, before leaving to launch Sam & Libby California.

Libby followed a different route up the fashion career ladder. After college, she started as an editor with *Harper's Bazaar* and later became an editor with *Seventeen* magazine. From there, she became public relations director for Calvin Klein, and after marrying Sam in 1980, moved with him to California where she, too, joined Espirit's shoe division, as vice president of marketing.

The inspiration for the ballet flat that would launch their own company came out of their travels in Europe, where they noticed everyone wearing traditional style ballet slippers with a pancake bottom and string tie. They decided to Americanize it with a big bow, and proceeded to beg and borrow every dime they could to start production. Within 18 months, more than 2 million pairs of the

> *"From the outset, the Edelmans had a clear vision and goal of what they wanted their company to be: 'World leaders of translating social trends into lifestyle products.'"*

Sam & Libby ballet flats were delivered to major retailers across the country. Women of all ages, thrilled with both the styling and the price, began snapping up the shoes—to the tune of $3.2 million in sales in 1988. That number skyrocketed to $25 million in 1989, then doubled to $50 million in 1990, and increased to $85 million in 1991!

Not content to rest on their laurels, the Edelmans, fresh from the heady success of their first shoe collections, began developing new ideas and concepts that would complement their original footwear and appeal to the same fashion-seeking yet price-conscious customer. They started by expanding the ballet flat to five different styles and dozens of different colors. Then they added new looks and shapes. For Spring 1992, for instance, the collection included "Silhouettes," with round or blunt toes, platform soles, and heels either square and blocky or shaped with hourglass curves; "Best of the '40s," featuring shoes made of denim and gingham checks, little round toe pumps on sensible heels, and a buck oxford; and "Ethnic Scene," a combination of cultures for casual wear evoking images of Africa, the Mediterranean, and Guatemala, with python printed shoes, fisherman sandals, and striped espadrilles.

In 1989, Sam & Libby took the ballet flat and other women's styles and reinterpreted them for the younger set, launching a Sam & Libby Kids division. Soon they added men's shoes, as well. For fall 1991, they unveiled their first collection of Sam & Libby Clothing for women, designed for the active lifestyle of women of the '90s. The initial collection featured such items as biker shorts, bodysuits and leggings, oversized sweatshirts and colorful short tops, stretchy blazers, and colored denims, plus dresses and skorts. Looking ahead, the couple was already envisioning Sam & Libby fragrance, Sam & Libby hosiery, Sam & Libby handbags, Sam & Libby fashion jewelry, Sam & Libby shops, and Sam & Libby "whatever" to fill a niche for their consumers.

When called upon to speak to students or aspiring young businesspeople, Sam shares his advice that they need to have a product the public wants, know how to produce it, believe in themselves, and get out there and sell. That is exactly what he and Libby do, traveling across the country and around the world to visit their offices in Brazil, Hong Kong, and Taiwan, calling on their manufacturing resources, and making personal appearances in retail stores. As overseer of the company's promotional activities, Libby plays a particularly visible role, greeting the public and listening to customer and salespeople's comments during store visits. Those comments and suggestions are taken to heart, and put into play as she and Sam prepare the next season's collections. In fact, Libby personally answers every one of the hundred-plus letters she receives from customers each week.

Despite the hectic pace of launching and running their own company, Sam & Libby Edelman always take time out to spend with their children, and that "juggling act," so typical of parents of the '90s, helps give them insight into the fashion needs of their customers. Indeed, Libby prides herself on being the perfect reflection of the company's basic customer: their concerns are her concerns; she cares about family, business, and the state of the world; and she loves fashion, but doesn't want to spend a fortune on it. Thanks to Sam & Libby, she won't have to.

Question for Discussion. In what ways are Sam and Libby Edelman achieving their goal of creating and marketing fashion goods for today's consumer lifestyles?

Sources. 1. Press kit and press releases from Sam & Libby California, Inc.; 2. Robert McAllister, "People of the Year: Sam & Libby," *Footwear News,* November 25, 1991; 3. Caryl Foster, "Casual Shoes that Set a New Pace," *Footwear News,* October 7, 1991; 4. "Get Ready for the Dazzling New Styles of the '90s," *People Weekly,* Spring 1990; 5. "Sam & Libby Planning Stock Offer for Expansion," *Footwear News,* October 28, 1991, p. 1.

As is typical in all fashion areas, footwear styles in the 1990s will continue their ongoing cycle, borrowing on fashions from the past and updating them to a current look. The leather motorcycle look, harking back to the 1950s, is one example; the modified return of platform shoes is another. Also, new materials, such as "nubuck" washable suede, and new technologies, particularly in the athletic shoe arena, will make an impact on styling and construction. The advent of "jewelry for shoes," or clip-on gemstones and bows that instantly change the look of a pair of pumps, will continue to allow consumers to update their shoe wardrobe at minimal expense.

Perhaps the most important forward trend is the continued interest of American consumers in comfortable, casual shoes. Already by 1990, women's athletic shoes had surpassed women's dress shoes in numbers of purchases,[7] and "comfort" dress shoes, such as those by Easy Spirit and Rockport, were growing in popularity. That trend was also giving rise to an entirely new casual shoe category, combining the fit and comfort of athletic shoes with the styling of fashion footwear.[8]

Jewelry

Ever since the earliest man or woman picked up a colorful pebble or rain-polished bone, attached it to a string made from bark or root, and hung it around his or her neck, people have loved jewelry. Unlike shoes that serve a functional as well as fashionable purpose, jewelry is pure adornment, worn for the simple pleasure of its sparkle and allure. Even the word *jewelry* is traced by wordsmiths to one of two French words, either of which captures the delight that wearing jewelry can bestow: *joie*, meaning *joy*, or *jeu*, meaning *game*.

History

Jewelry has been made and worn since ancient times. More than 4000 years ago, the Egyptians were adorning themselves with earrings, rings, jeweled collars, and headdresses made of gold, silver, turquoise, and other gemstones. (See Figure 7-7.) Some of the most exquisitely made jewelry in all of history was created by the Etruscans, living in northern Italy in the sixth and fifth centuries B.C. Their intricately shaped and patterned necklaces, brooches, and other jewelry pieces often looked as if fine gold powder had been sprinkled uniformly over their surfaces.[9] The early Romans, on the other hand, favored very elaborate jewelry, set with large gemstones including emeralds, pearls, and sapphires.

Throughout the Middle Ages, most jewelry was made by monks and was used as religious decoration. During the Renaissance, with its rebirth of interest in all of the arts, jewelry again became an object of beauty. It was in this era, in the fifteenth century, that gem cutters first learned to cut dull-looking raw diamonds in a way to show their brilliance and sparkle.[10] Until the start of the seventeenth century, both men and women draped themselves with jewelry of all types. It has been said that King Henry VIII of England owned 234 rings and 324 brooches![11]

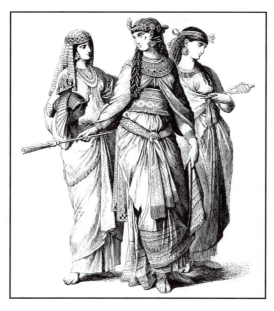

Figure 7-7. More than 4000 years ago, the ancient Egyptians wore lavish earrings, jeweled collars, and head-dresses made of gold, silver, turquoise, and other gemstones. (Courtesy Dover Publications Inc.)

The seventeenth and eighteenth centuries saw a new delicacy in jewelry, and with the long reign of Queen Victoria of England through most of the nineteenth century, jewelry became more diminutive still, often decorated with tiny figures of elegant ladies or knights in armor. But near the end of that century, appreciation of exquisite beauty returned, particularly in the work of two renowned French designers, René Lalique and Peter Carl Fabergé.

In the twentieth century, jewelry styles have become as varied as the regions and peoples from which they draw their inspiration. An interest in Native American culture and the American Southwest has spawned popular jewelry fashions incorporating sterling silver and turquoise, leather, and even feathers. Tremendous interest in and publicity about the discoveries from Egypt's King Tutankamen's tomb in the 1970s revived fascination with ancient-Egyptian–inspired jewelry, including scarab-type brooches and thick, heavy gold neckbands. The Orient also provides a consistent source of fashion infusion to the jewelry scene, with its delicate designs, natural motifs, and frequent use of jade.

Characteristics

While jewelry is created and produced all over the world, New York City is considered the world center for gems and jewelry design. Most American manufacturers of fashion jewelry maintain New York offices from which they conduct their design and marketing efforts. The majority of the actual production of jewelry in the United States, however, is done in the Providence, Rhode Island area. At the end of 1990, there were just under 5300 U. S. jewelry manufacturers.

Figure 7-8. Classical stylings of ancient Greece are the inspiration for this modern 22-karat gold jewelry. (Courtesy Cellini)

Since the 1970s, imports have had an enormous impact on the domestic jewelry market, with the wholesale value of imported jewelry reaching nearly $3 billion in 1990. Much of the imported merchandise in the lower priced jewelry segment of the industry comes from the Orient, particularly Korea, Taiwan, and Hong Kong, but for all jewelry, Italy actually accounts for by far the highest value of imports to the United States.

Structure and Organization

Jewelry comes in virtually all sizes, shapes, colors, and designs, but all fall into a roster of five main types. They are rings, bracelets, necklaces, brooches or pins, and earrings. Watches, as a type of bracelet, are also considered jewelry; additional classifications include jewelry for men, specifically tie clips and cuff links.

The jewelry business is divided into three main categories, based on a combination of price, materials used, and style. These categories are *fine* or *precious jewelry*, *bridge jewelry*, and *costume* or *fashion jewelry*. In general, **fine jewelry** is expensive, made from precious metals and gemstones, and classic in style, while **costume jewelry** is inexpensive, made from a variety of nonprecious materials, and usually trendy in style. **Bridge jewelry**, like bridge apparel and footwear, falls in between, to offer good quality at affordable prices.

Fine jewelry includes pieces made of precious metals, specifically gold, platinum, and, occasionally, sterling silver. Gold is by far the most widely used, but because pure gold is very soft, it is most often combined with another metal, such as copper, silver, or nickel, to create an alloy. The amount of gold in an alloy is measured in **karats**, each of which is equivalent to one twenty-fourth ($1/24$) of the total,

based on the fact that pure gold is 24 karats, or 24K. The most common alloys are 18K, 14K, and 12K.

In addition, fine jewelry is often set with precious stones, such as diamonds, rubies, sapphires, emeralds, and cultured pearls. Because of the high cost of both the gems and the metals, even a small ring or pin can cost hundreds, if not thousands, of dollars, and fine jewelry is frequently passed down in families from generation to generation. Retailers that create and sell fine jewelry under their own name include Tiffany and Cartier. It is also sold through jewelry specialty stores and chains, some department stores, and certain catalog showroom operations, such as Service Merchandise.

Bridge jewelry owes a large part of its popularity to the number of women entering, or re-entering, the workforce in the last few decades. These women want fashionable, quality jewelry, without having to make a major investment. Therefore, bridge jewelry generally uses some precious metals, but in lower grades than fine jewelry, and also incorporating less expensive or semiprecious stones, such as amethyst, jade, coral, and onyx.

To keep prices within the appropriate range, bridge jewelry usually contains no higher than 14K gold. Or, it may be **gold-filled**, that is, made from a process in which a less expensive base metal is coated with a heavy layer of gold. Sterling silver, the least expensive of the precious metals, is also used for bridge jewelry, as is **vermeil** (pronounced ver-may´), a composite of gold over sterling silver. What's more, bridge jewelry may take a slightly more fashion-forward approach in its design than fine

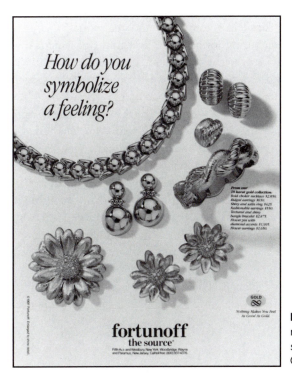

Figure 7-9. To sell fine jewelry, retailers like to appeal to customers' sentiments. (Courtesy World Gold Council)

jewelry. It is sold in jewelry stores as well as in department stores and some clothing boutiques. Designer names such as Christian Dior and Hubert de Givenchy are often found in bridge jewelry assortments.

Costume jewelry first developed in the 1920s, with the end of World War I and the resurgence of fashion in clothing. The classicism of fine jewelry could not keep pace with the rapidly changing apparel, so an inexpensive, quick-to-produce alternative was invented. Popularized by such celebrities as Coco Chanel, the look caught on and has remained at fashion's cutting edge ever since.

Costume jewelry can be made of plastic, metal, glass, shells, straw, leather, or wood, and colored with splashes of lacquer or imitation gemstones, or shaped into cute or trendy designs, such as animals, symbols, or characters. When made of metal, it is usually created by a process called **electroplating,** in which an inexpensive base metal is passed through a gold or silver "bath" with an electric current, to give it a shiny finish. While some intricately formed pieces of costume jewelry may cost hundreds of dollars, simpler pieces may be sold for less than one dollar. Because it is linked so closely to fashion trends, costume jewelry is most often sold through department stores, specialty apparel stores, discount stores, and catalog showrooms, as well as through specialty accessories chains.

Merchandising and Marketing Activities

The jewelry industry supports several trade organizations, including the Jewelry Industry Council, whose role is to promote jewelry directly to the public, most often through articles placed in newspapers and magazines. Other major associations include the Manufacturing Jewelers & Silversmiths of America, which operates out of offices in Providence; the American Gem Society; American Watchmakers Institute; Diamond Council of America; Fashion Jewelry Association of America; Jewelers of America; and Jewelry Manufacturers Association.

The newest jewelry items are shown to the retail trade at numerous shows held around the country and throughout the year. One of the largest is the Fashion Accessories Exposition, held in New York in January, May, August, and November.

Jewelry is one of the last industries in the United States to include a large number of small entrepreneurial companies. The great majority are family-owned businesses with fewer than 25 employees. Because of their small size, most of these companies do little in the way of advertising and sales promotion. On the other hand, a handful of larger firms in the fashion jewelry business are more aggressive in their merchandising and marketing, and run frequent advertisements in newspapers and magazines. Among the best known names are Monet and Trifari (both owned by Crystal Brands) and Napier. These companies also work closely with retailers, such as department stores, in creating and supplying special instore displays, store catalog offerings, and cooperative advertising.

SPOTLIGHT ON A FIRM

TIFFANY & CO.

In the movie *Breakfast at Tiffany's,* Holly Golightly (played by Audrey Hepburn) takes her neighbor for his first visit to the Fifth Avenue flagship store of Tiffany & Co. Inside the revolving glass doors the noise of the city seems to be left behind, and she asks him in a reverently hushed voice, "Do you see what I mean, how nothing bad could ever happen to you in a place like this?" Movie fiction aside, there is something magic about Tiffany's, one of the world's most respected sources of fine jewelry, timepieces, sterling silverware, china,

crystal, stationery, fragrance, and accessories.

Since the store's initial opening in 1837, Tiffany & Co. has held to a belief that good design and good taste lead to good business. The store actually originated as a retailer of stationery and "fancy goods," including umbrellas, Chinese bric-a-brac, and pottery,

launched by Charles Lewis Tiffany and his friend, John P. Young. Within 12 years, Tiffany's invento-

ry grew to include watches, clocks, silverware, and bronzes. Based on his growing reputation as one of the world's leading gem merchants, Charles Tiffany soon added gold and diamond jewelry departments, which would quickly become the cornerstone of the business.

Throughout his career as a gifted and innovative entrepreneur, Tiffany exhibited a flair for the sensational, even in keeping with his motto of good taste. He not only agreed to cater to his clients' unruly and often indiscriminate tastes, but also set out to surprise and delight them with ideas of his own. For instance, he offered souvenirs of the changing times that included four-inch sections of the Trans-Atlantic Cable laid down in 1850. That same decade, he purchased and then resold the Crown Jewels of France, as well as the

continued

famous "Girdle of Diamonds" that belonged to Marie Antoinette!

Over the years, the Tiffany name came to be associated with specific gems or styles of jewelry and accessories, including the "Tiffany Diamond," the world's largest and finest fancy yellow diamond; the six-pronged "Tiffany Setting" for diamond solitaires; and the colorful and decorative "Tiffany lamps." Throughout the store's history, the most prominent members of American society were and are frequent Tiffany customers. Financier J.P. Morgan frequently ordered gold and silver services, and "Diamond" Jim Brady dropped in regularly to purchase jewelry. Even President Abraham Lincoln, during the throes of the Civil War, found time to purchase a seed pearl necklace from Tiffany's for his wife, Mary.

Some of the world's leading designers have also created special collections for Tiffany's. The store's current collection of fine jewelry includes exclusive styles created by master designers such as Jean Schlumberger, Elsa Peretti, and Paloma Picasso. The company has also expanded its merchandise mix to include other fashion accessories, such as leather goods, scarves, and fragrances. Whatever the item, the prestige of owning a product with the Tiffany name remains unquestioned; and the proof lies in the company's sales figures, which, despite an economic recession, grew consistently from 1986 through 1990, reaching more than $455 million.

In recent years, Tiffany & Co. has significantly expanded its business in both the U. S. and internationally. As of 1990, there were 11 Tiffany stores and one boutique in the U. S., 6 company-owned stores in Europe and the Far East, and 26 boutiques located in Mitsukoshi department stores in Japan, Hong Kong, and Hawaii. A select assortment of Tiffany products is sold through approximately 200 fine jewelers and specialty stores in the U. S., and the company also markets its luxury goods through special corporate programs and catalogs.

Question for Discussion. How does Tiffany's combination of unique merchandise and service attract customers?

Sources. 1. Press kit and 1990 Annual Report from Tiffany & Co.; 2. Holly Brubach, "Birthday at Tiffany's," *Vogue,* October 1987.

Future Directions

Looking forward, the growing number of women in the workforce should continue to spur interest in the bridge jewelry category, which offers elegant, fashionable styling at affordable prices. Similarly, for those who want the look of precious gemstones without paying the price, jewelry incorporating synthetic or "faux" stones, such as cubic zirconia or "artificial diamonds," along with "laboratory-grown" emeralds, rubies, and sapphires, should continue to gain acceptance.

Platinum, or "white gold," which for decades suffered in popularity after its heyday in the early 1900s, is seeing a comeback. Use of this precious metal in jewelry jumped 67 percent between 1985 and 1990,[12] and is expected to continue its upswing, despite its hefty price tag. And, in general, fashion jewelry will remain in step with trends and fads in fashion and society, with new products like specialty sport watches that blossomed with America's love affair with fitness in the last decade.

Other Accessories

While shoes and jewelry account for a large percentage of the total accessories business, there are a number of other categories that are equally important from a fashion point of view and which contribute significantly to the accessories marketplace. Along with fine and fashion jewelry, all of these classes of merchandise receive an unveiling of their newest lines at numerous shows, such as the Fashion Accessories Exposition. The following sections give a brief overview of some of those categories.

Hosiery

Hosiery, or legwear, does a lot more than keep the feet and legs warm. Today, it is an integral part of a complete fashion look—and may have been so for longer than most of us would imagine. Five items discovered in the excavation of early Egyptian tombs were determined to have been socks, and they came in an array of brown, purple, yellow and red wool![13]

Over the last 500 years, several events have revolutionized the hosiery industry. In 1589, England's Reverend William Lee invented the frame knitting machine, which produced the first flat-knitted fabric for commercial production. Although the machine helped to mechanize hosiery's manufacture, the fabric still had to be cut

Figure 7-10. In the 1930s and 1940s, keeping the seams straight on their nylon stockings was a major concern for women. In the 1990s, back seams were back in—this time in pantyhose designed to make legs look slimmer. (Courtesy Jockey For Her Hosiery)

and sewn into the desired shape and size until the early twentieth century, with the development of circular knitting, which created a round tube of fabric. The next major event came in 1937 with the invention of nylon, which offered the sheerness of silk with a strength surpassing even cotton and wool. Stretch qualities were added to the yarn for hosiery in the 1950s, eliminating the need for socks and hose produced in numerous rigid sizes. And finally in 1965, the first pair of sheer pantyhose was produced, changing forever the way women adorn their legs.

Because cotton was such an important early material in hosiery, the American hosiery industry began migrating south, where raw cotton was plentiful, in the years following the Civil War. Today, 94 percent of U.S. hosiery manufacturing is still concentrated in six southern states, with North Carolina alone producing more than half the socks and pantyhose manufactured in the United States. While some hosiery is imported from other countries, domestic production by approximately 345 companies accounts for about 95 percent of U. S. sales. In 1990, these companies shipped more than 328 million dozens of pairs of hosiery to retailers, comprised of about 48 percent women's sheer hosiery and 52 percent socks.

In women's pantyhose, manufacturers' brand names, such as *Hanes* for department/specialty stores, and *L'Eggs* or *No Nonsense* for mass merchants, account for just over half of all sales. Many department stores feature their own private-label pantyhose, such as Bloomingdale's B-Line assortment, alongside a selection of national brands. Plus, many designers have added hosiery lines to complement their apparel; among them are Donna Karan, Liz Claiborne, Anne Klein, and Ellen Tracy. In most cases, the large manufacturers are involved at all the marketing levels, producing different product lines under different names for different kinds of retailers. Hanes, for instance, sells Hanes brand to department and specialty stores; L'Eggs to supermarkets and other mass market retailers; licensed Donna Karan hoisery to upscale retailers; plus private-label goods to individual store organizations.

The dramatic infusion of fashion into the hosiery marketplace was sparked by rising hemlines in the 1920s, but that fashionability has really exploded in the last three decades, and will continue to fire up the industry looking forward. The widespread use of basic blacks and off-whites in pantyhose was already giving rise to a new burst of color in 1991, to coordinate with brightly hued ready-to-wear. Plus, the ready-to-wear connection promises to grow even stronger in coming years, as designers such as Anne Klein create hose specifically designed to coordinate with their bridge or designer collections.[14] Even socks are receiving fashion emphasis as never before, with traditionally staid men's brown, black, and blue socks giving way to colorful styles adorned with stitched-in basketballs, fish, designer logos, and other designs, such as diamonds, checks, and plaids. Brand names began growing in importance in the 1980s, but at the beginning of the 1990s still represented less than 15 percent of the business.[15] In addition, manufacturers continue to create socks designed for different lifestyles, with special offerings made specifically for jogging, tennis, golf, bicycling, and other activities.

Figures 7-11a and b. Manufacturers today cater to women's desire for a legwear "wardrobe" by offering tights and pantyhose in a variety of colors and patterns. (Courtesy HUE Legwear © Dorothy Handelman)

Hats

Hats, or *millinery,* as a fashion accessory have been less important in recent years than throughout the rest of history. For more than 5000 years, however, they have been worn in one style or another either to protect or to decorate the head—or both. In many cases, a particular style of hat is closely associated with a particular person, society, or era. The coonskin cap, for instance, immediately calls to mind Daniel Boone and the American "Wild West," while a soft beret is instantly related to the French people. Similarly, a top hat almost always brings with it an image of Fred Astaire, and when we think of Abraham Lincoln, we tend to picture him in his signature stovepipe hat.

Over the centuries, hats have been worn for protection, either from sun and rain or from injury, such as a construction worker's hard hat; to show status, such as an army officer's dress uniform cap or a member of royalty's crown; or for religious reasons, such as the *yarmulke* of the Jewish faith. Hats worn purely for decoration have

Figure 7-12. Diana, Princess of Wales, often makes public appearances in stylish outfits topped off by a fashionable hat. (Courtesy British Information Services)

seen only minor surges in popularity in the last three decades. The decline can be attributed in part to changes in women's hair styles that often did not accommodate the wearing of a hat. More important, it can be traced to changes in lifestyle, with an emphasis on casual dressing supplanting the more formal looks of prior years.

The heyday for U.S. hat production began in the early 1800s, when the state of Connecticut alone boasted more than 50 hat factories. Today, only a handful of American companies produce hats, and are located primarily in New York City and St. Louis.[16] Imported goods come primarily from the Philippines, South Korea, and China.

Since everything in fashion works in cycles, there is every possibility that hats may enjoy a true resurgence in the years ahead. Spurts of activity in the marketplace in recent years indicate that the category is not completely gone. Any renewed interest that occurs may well be inspired by a hat-wearing celebrity, as has been the case in the past. For instance, some hat sales in the 1980s were probably stimulated by Diana, the Princess of Wales, who frequently attends social and public events sporting a chic new hat to coordinate with her outfit. The less formal baseball cap—sometimes bedecked with sequins or bows—was also enjoying popularity with women early in the 1990s, perhaps in part through its appearance on the head of actress Candace Bergen in her television series, "Murphy Brown."

Gloves

As is the case with shoes and hosiery, the first gloves were created as a means to warm and protect the hands. But again, as with those other accessories categories, in time gloves took on a fashion personality of their own. By the thirteenth century, gloves richly decorated with precious stones and gold or silver embroidery were worn by

Figure 7-13. In the 1800s, gloves were not only a fashion accessory, but a statement of etiquette. (Courtesy Dover Publications Inc.)

English kings at their coronations.[17] In the seventeenth century, they were carried as frequently as they were worn, while in the 1800s, a lady's hand was always covered, with strict rules of etiquette stating what colors, lengths, and materials could be worn for specific occasions and times of day.[18] Needless to say, the rules of glove wearing relaxed dramatically in the twentieth century, although certain customs remained in place through the first half, such as wrist-length white gloves for Sunday dress-up, and elbow-length opera gloves for the prom or formal night out. Even those traditional glove-wearing occasions fell from practice through the '60s, '70s, and '80s, but the 1990s are seeing a renewed interest in gloves for more than just cold weather wear.

As with other accessory categories, the U.S. glove industry has been hard hit by the increase in imported merchandise. Most gloves on the market today come from the Philippines, Taiwan, Korea, and Italy. The region of Gloversville, N.Y., still is home to some domestic manufacturers, but the industry has shrunk to the point that its former trade organization, the National Association of Glove Manufacturers, no longer exists. Of the U.S. companies remaining in the business, the best known is Aris, whose range of Isotoner brand gloves includes styles made of nylon spandex and knits, as well as leathers.

There are many types of specialty gloves, particularly those made for use in specific sports, such as skiing, as well as gloves (and mittens) made primarily for warmth and gloves made primarily for fashion. Although most gloves are now produced on a

small, medium, large, and extra-large sizing basis, dress gloves and some leather gloves are sized based on finger and hand length. The length of gloves themselves is measured in "buttons," tracing back to the days of Napoleon when gloves did button. Each "button" equals one inch from the base of the thumb. A two-button glove, ends at the wrist; an opera-length glove, ending at the elbow, measures 16 buttons.

At the beginning of the 1990s, gloves were receiving a new "thumbs up" as a fashion accessory for the decade, with a wide array of new styles starting to appear on the marketplace. Included have been embellishments such as fringe, studs, gemstones, and zippers; neon-bright colors such as orange and fuschia; and unusual fabrications such as plaids and metallics. Designers, including Oscar de la Renta, Anne Klein, and Geoffrey Beene, have started incorporating gloves into their ensembles at fashion shows. Plus, for fashion combined with function, manufacturers have engineered high technology into their gloves for the '90s: Grandoe's GCS Cocoon glove, for instance, is sold with a choice of three different linings, each offering a different "EPF" (Environmental Protection Factor) of warmth. Also, two manufacturers, Gates and Gordini, now offer gloves with special solar panels to absorb the heat of the sun and increase the temperature inside the glove.[19]

Figure 7-14. Classic styling that never goes out of fashion helps manufacturers like Coach meet the fashion and function needs of handbag customers. (Courtesy Coach)

Figure 7-15.
Department store Dayton's, Minneapolis, created these striking displays for headwraps in its hair accessories department. (Courtesy *Stores* magazine)

Handbags

To some women, a handbag is simply a place to stash any belonging that might come in handy during the course of the day. To others, it is the finishing fashion touch to a well planned outfit. Either way, a woman's choice of handbag says a lot about her personal style and fashion choices, and manufacturers work hard to provide a wide variety of styles, sizes, and shapes to meet every woman's taste and needs. The overwhelming majority of handbags sold in the United States today are imported, with the few domestic firms mainly headquartered in New York City, near the pulse of the fashion apparel business. While brand names are generally not of great importance in this category, a few design/manufacturing names have built a strong reputation and status image in handbags. Among them are Hermès, Coach, Louis Vuitton, and Gucci. In addition, a number of apparel designers, such as Calvin Klein and Pierre Cardin, have licensed their names to handbag manufacturers.

Most likely, there will not be any dramatic changes in the handbag industry in the future. Most "hot" fashion trends tend to impact most heavily in the lower-priced end of the business, where the latest colors and textures of the moment can be translated quickly into inexpensive shoulder bags, totes, or other carry-alls. It is also in the lower price ranges that sports-inspired styles, such as "fanny packs," worn by men and women, are seen. At the upper end of the spectrum, women who can afford them will continue to seek elegant, quality bags in classic stylings for everyday use, and for evening wear, to seek rich-looking bags and clutches designed with lavish beadwork, satins and silks, embroideries, and jewels.

Others

The balance of the accessories market consists of a variety of smaller classifications whose importance varies, depending on current influences in society and directions in ready-to-wear fashion. Sunglasses, for instance, enjoyed a surge of importance in the early 1980s, based in part on the "Miami Vice" look that swept the country when the television show premiered. Scarves continued to prove their versatility as a fashion accessory from the late 1980s into the 1990s, as women constantly experimented with new ways to tie or drape them around their heads, necks, shoulders, waists, and hips. Hair accessories, ranging from bows to headwraps, headbands, barrettes, and ponywraps, began rising in popularity in the early 1990s, as well, with some stores enhancing their presentation of those goods or even creating a whole separate department for them. Along with belts, small leather goods, handkerchiefs, umbrellas—even wigs—these and all accessories play a very important role with their contribution to the total look of fashion.

Summary

1. Because many accessories are relatively inexpensive, they are often considered impulse items. In all accessories categories except hosiery, a significant portion of merchandise sold in the United States is imported. Domestic manufacturers in each category are spread throughout the country, but because of accessories' close relationship with ready-to-wear fashions, most maintain showrooms in New York City.

2. Shoes account for about two-thirds of all accessories sales. They are divided into the major segments of men's, women's, and children's footwear. Within the women's portion, dress shoes are further divided by price, much like ready-to-wear, into *salon* or *designer, bridge, better, moderate* and *budget.*

3. The major categories of jewelry are based on a combination of price, materials used, and style, and are called *fine* or *precious jewelry, bridge jewelry,* and *costume* or *fashion jewelry.*

4. Hosiery follows fashion trends more closely today than ever before. The U.S. hosiery market, consisting of the two segments of women's sheer pantyhose and socks, is dominated by American companies manufacturing domestically. In pantyhose, brand names are very important. Socks are also becoming more fashionable, with some styles created for specific activities and lifestyles.

5. Small surges of renewed interest in hats have occurred in recent years and will continue, often because of a famous personality appearing in them. The early 1990s also saw a resurgence of interest in gloves, with ready-to-wear designers and others creating newly fashionable styles in a variety of fabrications, colors, and embellishments.

6. Handbags are considered by most women to be a necessity as much as a fashion accessory. Generally fashion trends are reflected primarily in the lower-price ranges.
7. Other accessories categories cycle up and down, based on general ready-to-wear directions as well as cultural influences. These categories include *scarves, sunglasses, hair accessories, belts, small leather goods, handkerchiefs, umbrellas,* and *wigs.*

Fashion Vocabulary

Explain each of the following terms; then use each term in a sentence:

bridge jewelry	fine jewelry	last
costume or fashion jewelry	gold-filled	millinery
dual distribution	impulse item	vermeil
electroplating	karats	

Fashion Review

1. Name the major categories of accessories and state which is the largest.
2. Explain how accessories coordinate with trends in ready-to-wear fashion, and give two examples of specific accessories that reflected the fashion or culture of their times.
3. Cite the most important development in footwear in the 1980s and explain how it is affecting footwear trends in the 1990s.
4. Name the three major segments of the jewelry business and give examples of the materials used in each.
5. Name three events or developments that revolutionized the hosiery market in the last 100 years; then describe a current trend that will influence the business in the 1990s.

Fashion Activities

1. You have joined a company in the position of accessories designer, and your first task is to create a line of accessories to coordinate with an emerging fashion trend. Pick a trend that you currently see on the market, and decide: (a) which categories of accessories would be suitable to complement the clothing; (b) how you would design the accessories in terms of shapes, colors, materials, etc.; and (c) how you would want to see them presented in stores to best show off their coordination with the ready-to-wear fashions.
2. Think of a store that you've visited recently that carries fashion accessories. Remembering the location, size, and amount of merchandise found in the accessories area, try to analyze how much importance the store places on its accessories business. Are there categories to which you would give more or

less emphasis, based on current fashion trends? Why? Does the store take full advantage of the impulse purchase nature of lower priced accessories? Why or why not? What displays would you create for the store that might further demonstrate to shoppers the relationship between accessories and ready-to-wear?

Endnotes

1. William A. Rossi, "The Seven Basic Shoe Styles," *Footwear News,* Section Two, November/December 1991, p. 33.
2. *The New Book of Knowledge,* Grolier Inc., Danbury, Conn., 1991, Vol. 17, p. 158.
3. Christina Probert, *Shoes in Vogue Since 1910,* Abbeville Press, Inc., New York, 1981, pp. 36–37.
4. Susan Raehse, "Shoe Imports Ahead 4.4% in '90," *Footwear News,* November 25, 1991, p. 44.
5. Raehse, op. cit.
6. Rossi, op. cit.
7. Dick Silverman, "Athletics Take the Lead," *Footwear News,* August 12, 1991, p. 27.
8. Dick Silverman, "Casual Commotion," *Footwear News,* Section Two, October 1991, p. 7.
9. *The New Book of Knowledge,* Vol. 10, p. 94.
10. Ibid.
11. Ibid.
12. Mary Shustack, "Jewelry Climbs the Charts Toward Platinum," *Gannett-Westchester Newspapers,* June 26, 1991, p. C3.
13. Sid Smith, "The History of Hosiery" (press release), National Association of Hosiery Manufacturers, Charlotte, N.C.
14. Susan Reda, "Head-To-Toe Fashion," *Stores,* August 1991, pp. 60–63.
15. "The American Hosiery Industry 1990 Fact Sheet," National Association of Hosiery Manufacturers, Charlotte, N.C.
16. *The New Book of Knowledge,* Vol. 8, p. 47.
17. Eldred Ellis, *Gloves and the Glove Trade,* Sir Isaac Pitman & Sons, Ltd., London, 1921.
18. Lynn Schnurnberger, *Let There Be Clothes,* Workman Publishing, New York, 1991, p. 130.
19. Barbara Nachman, "Love those Gloves," *Gannett-Westchester Newspapers,* December 14, 1991, p. B1.

Men's Wear

Objectives

After completing this chapter, you should be able to:

1. Describe the history of the men's wear industry.

2. Discuss the influence of trade unions in the men's clothing industry.

3. Identify four characteristics of the men's wear industry.

4. Name and describe the basic men's wear clothing categories.

5. Compile a list of the size categories found in men's wear.

6. Identify two major merchandising and marketing activities.

7. Describe three trends in the retailing of men's wear.

Michael is the first one to admit that he has no taste. In fact, he admits that although he's a genius and an excellent golfer, like many executive men he hates shopping for himself. Michael feels that he has a severe fashion problem. He loves flipping through the pages of GQ, but severe attacks of store anxiety result in his spending a minimum amount of time in them. For example, on a recent shopping trip he entered an Armani boutique at a blinding speed and indicated that he was shopping for a green tie. The salesperson showed him several ties in a wide variety of stylized, geometric, and abstract prints. He picked out two, paid for them, and left the store promptly. Total time elapsed: 12 minutes. It's not unusual for Michael to spend an average of $100 per minute on those very rare occasions when he shops.

Michael feels that wearing clothes is easier than buying them. He loves the compliments that he receives when he wears that "special outfit," but he hates purchasing it, whether alone or with others.

On another occasion, Michael's wife Nicole offered to buy him a new sport coat. As a definite part of their unspoken "contract," his wife naturally expects to have an editorial voice in the way Michael dresses. Realizing that the jacket represents a few

hundred dollars, and wanting to avoid owning a sport coat that he doesn't like, despite his heavy work schedule and Monday night football, he agrees to go shopping with his wife Nicole Monday evening, right after work.

As they drive toward their favorite men's specialty store, a moderately famous place on a fashionable block in a large city, Michael gets a funny feeling in his stomach as he imagines row upon row of jackets neatly displayed in the store. He likes this store, especially the extremely discreet salespeople, and he knows that Nicole will find that "special sports coat with unique buttons on each sleeve."

When they arrive at the store, he starts to perspire even though it's the middle of winter. As they venture into the store, he is immediately greeted by Alexander, a middle-aged man with a silver moustache, a polished appearance, and an unobtrusive manner. "Yes," he thinks, "this man can handle anything and anyone, including my wife. This shouldn't take long. I'll be home in time to watch Monday night football."

After indicating the purpose of their visit, Alexander directs Michael and his wife to the men's clothing area and his wife begins to pick through the racks as though cobra snakes were draped over the hangers instead of jackets.

"This one is nice," remarks Nicole, as she pulls a wool gabardine jacket from the rack. "It's made of 100 percent Australian Merino wool. Why don't you try it on?"

"It's okay, but I really wanted something with more of a sheen. How about this one?" Michael pulls a green silk jacket from the rack and tries it on. "Besides, it's less expensive."

"No, that is not a becoming style and shape for you. How about a silk and wool blend?" remarks Nicole.

As Alexander directs Michael and Nicole to the "Designer Showcase," as hard as Michael tries to hide it, it's obvious that nothing matters to him anymore. Looking at his watch, he realizes that the game has just begun and he's missed the kick-off. As he tries on a few more jackets that obviously don't work, he narrows his choices down to four: a grey glen-plaid, a navy flannel, a wool Donegal tweed, and a green silk herringbone.

As Michael parades around one last time in each of the jackets, he glances down at his watch and thinks, "Maybe I'll make it home by half-time." Besides, he's set his own world record, he's been in the store for a record-breaking 30 minutes!

Finally, with a very austere, paternal air, Alexander, a very clever salesperson, pulls one more jacket from the rack. As Michael begins to try it on he says, "Now that's a very special jacket. It's for someone who wants something very special to wear."

"I love it! It looks great on you! We'll take it!" Nicole says as she removes from Michael's body the silvery blue Douppioni silk jacket by Perry Ellis. "That will work nicely with those multi-colored abstract silk ties that you picked up from the Armani boutique. You know, the ones that you said that you were going to take back?"

A few days later, Michael walks into the office and is greeted by his friend Kenneth, "Nice outfit, Michael, very GQ."

Michael just smiles and says, "Thanks."

History of the Industry

The 1600s

The men's wear industry began in Europe during the early seventeenth century when the first ready-made apparel was manufactured and sold in London, England. Tailors constructed men's clothing by hand. Men wore knee breeches, waistcoats, flat collars, and huge curled wigs called "periwigs" around 1660.

The early settlers who came to America preferred a plainer version of this style of dress. They cut their hair short, wore high stiff hats, and dressed themselves in dark-colored breeches, doublets, and jerkins.

The 1700s

The first mass-produced garments in France were soldiers' uniforms. It was only a small transition from making uniforms to making civilian apparel, and by 1771, men's suits were custom made by hand, sold, and advertised throughout Paris.

Many Parisian designers marketed their fashions by distributing dolls dressed in fashions to be copied in England, America, and other parts of the world.

In 1789, the French Revolution interrupted France's fashion leadership, and England took the lead. British fashion soon dominated the men's wear industry and English tailoring continues to influence men's fashion up through today. Many custom tailors opposed the manufacturing of ready-to-wear but failed to stop mass production with protective trading laws.

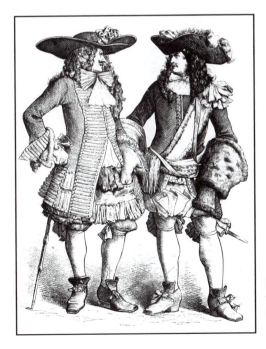

Figure 8-1. Seventeenth century men's wear (France): Note the elaborate, flamboyant styles of this period. (Courtesy Dover Publications Inc.)

During the American Revolution, around 1776, English tailoring continued to influence men's fashion. Wealthy American men continued to follow European fashions as closely as possible through publications brought over from London. Men typically dressed more flamboyantly than women, with laces and bows as well as high-heeled shoes with shiny buckles.

As America tried to shake off all of the influences of England, the colonies began discouraging the purchase of any British goods by levying fines against those who bought them. As the country changed, so did clothing styles: they became less elaborate. Men began to develop fashions made from what was available to them in America.

In the wilderness areas, they relied heavily on materials like fur and buckskin. Women made clothing for men as well as for themselves. They spun yarn from the fibers that nature produced: cotton, flax, and wool. Their work also included dyeing the yarns and weaving them into fabric called "homespun," which is still used today.

The 1800s

Prior to the nineteenth century, most clothes were hand sewn. Factory production of men's wear in the United States was nonexistent. There was little demand for ready-made clothing and two thirds of all garments in the United States were produced in the home with the remainder produced by seamstresses or in the shops of custom tailors. One of the most famous and prestigious retailers of men's apparel, Brooks Brothers, was founded in 1818 as a custom tailoring shop.

The men's wear industry got its start in the United States in the 1850s when the first ready-made suits were made by tailors in the seaport cities along the Atlantic coast. Small tailor shops produced and sold inexpensive ready-to-wear suits. In addition, they sold trousers, jackets, and shirts in rough size groupings to sailors. To meet increased demand, they hired seamstresses who worked at home to produce garments more quickly. In this way sailors could have new clothes to wear when they came on land after a strenuous sea voyage.

Unlike the careful fit or detail of custom-tailored clothes, ready-made clothes were baggy and unattractive. These low quality garments were called "slops" and the retailing establishments that sold them were called **slop shops.** Today the term "sloppy" is still used to describe dress that lacks any fashion considerations.

The men's wear industry continued to prosper in this country with the development of the first really workable continuous stitch sewing machine, which was patented by Elias Howe in 1830. All of Howe's machines were run by hand and their acceptance was not immediate since the tailors and seamstresses feared that the machine would put them out of work. By 1849, factories established in Chicago and St. Louis were outfitting the laboring slaves of the South.

In 1859, Isaac Singer developed the foot-treadle machine, which improved the quality of clothing construction and sped up garment production. Clothing manufacturers started using sewing machines around 1860. Despite new production methods, the public had a very negative view of machine-sewn clothes. Men's ready-

to-wear clothing was usually made of low quality cotton fabric and was poorly constructed by local seamstresses.

As the industry grew, production methods gradually improved but many men still preferred to have their clothes made by a tailor if they could afford it. Others continued to wear homemade garments.

The California Gold Rush in 1848 also created a market for ready-to-wear clothing. Around 1850, a 20-year-old immigrant and textile manufacturer named Levi Strauss traveled west to the gold fields. He arrived in San Francisco with a small stock of canvas, sailcloth, and duck fabrics, which he intended to sell to the gold miners for tents and covered wagons. Instead, in answer to a prospector's request for pants that would last more than a short while, Levi Strauss began manufacturing pants out of a fabric called "serge de Nîmes," a tough cotton fabric from France. Serge is the name of a twill fabric. It is easy to see how the term serge *de Nîmes* evolved into the word *denim*. Strauss had no idea that a century later this pant with double top-stitching and riveted pockets would be worn throughout the world.

Today Levi Strauss has grown to become the largest apparel manufacturer in the world. Approximately 800 million pairs of "Levis" have been sold since 1850.

In 1861, the Civil War began in America and provided experience in the mass production of garments. Factories, in their efforts to clothe soldiers during the war, began keeping track of the most common measurement combinations. The armies on both sides surveyed the height and chest measurements of more than a million recruits. With this statistical data, they soon discovered that by making uniforms in

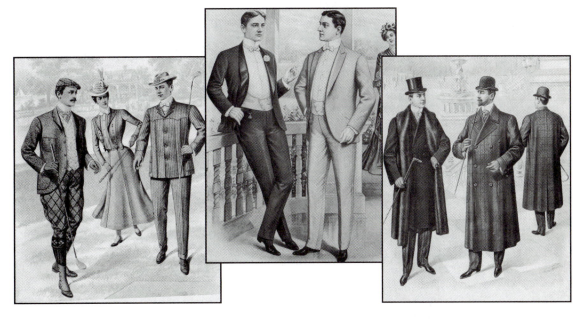

Figures 8-2a, b, and c. The men's ready-to-wear industry flourished in the late 1800s and early 1900s, offering men choices in sportswear, formal wear, and outerwear. (Courtesy Dover Publications Inc.)

different sizes, they could provide almost everybody with a fairly good fit. For example, they found that many men with a 36-inch waist had a 30-inch trouser length.

The development of **standardized sizes,** a method of matching clothing to figure types, eventually affected the entire clothing industry. Now ready-to-wear could be manufactured according to specifications to fit a variety of figure types. Despite each manufacturer's attempt to accurately fit as many people as possible, the fit of these garments was far from perfect.

Standardized sizes soon led to sized and graded patterns. In 1863, Ebenezer Butterick and his wife invented the flat, graded pattern method for making clothes and introduced paper patterns to the public in ready-made sizes. By 1871, they were distributing several million patterns, which improved the fit of ready-to-wear men's clothing items. They also published a popular fashion magazine that featured patterns and designs adapted from Parisian designs. These developments led to the increased popularity of men's ready-to-wear.

The 1900s

In the early 1900s, the men's wear industry continued its expansion and by the turn of the century the industry spread to a number of cities including Rochester, Philadelphia, and Chicago.

The work week averaged 72 hours with little time for leisure activities. **Sweat shops,** factories that employed workers under unfair, unsanitary, and oftentimes dangerous conditions, soon became quite prevalent. This situation led to the demand for better working conditions and the formation of unions. In 1910, a successful strike at the Hart, Schaffner & Marx manufacturing plant in Chicago grew to include thousands of workers elsewhere and resulted in a restructuring of working conditions to a 54-hour week and procedures for addressing grievances. In 1914, these changes led to the establishment of the Amalgamated Clothing Workers Union of America. After merging with the shoe and textile workers, the union representing the men's wear industry today is entitled **The Amalgamated Clothing and Textile Worker's Union (ACTWU).**

The 1920s to World War II

Improved manufacturing methods, such as electrically powered sewing machines, brought rapid growth to the men's wear industry and mass-produced clothing became widely available and more popular. The 1920s was a time of experimentation, with the rise and fall of "jazz" clothing, featuring extremely long tight-fitting jackets and narrow trousers.

During the Great Depression of the 1930s, 13 million people were unemployed and the demand for men's wear tumbled. More than one-third of the ready-to-wear manufacturers went out of business. Nevertheless, in 1933, *Esquire,* a new men's magazine, appeared on the scene to meet the needs of those men who could still afford fashionable apparel.

World War II

World War II resulted in a marked simplicity in dress. The men's wear industry focused its attention on manufacturing uniforms for the military. Civilian men's wear was of little importance during the war and clothing selections were limited. The average American male simply rolled up the sleeves of his shirt for weekend or vacation activities, since casual attire was unavailable. Government restrictions were placed on the amount of fabric allowed for each garment. Shirts were scarce and shoes were rationed.

With the end of the war in 1945, the men's fashion industry was on a rise again and domestic firms enjoyed a tremendous spurt of growth. Men were ready for a change in their clothing styles. Lifestyle changes were responsible for the new "American look" in men's wear. As servicemen returned home from the war the baby boom began and with it a long era of post-war prosperity. Suburbia became the new family frontier and soldiers, eager to get out of their uniforms, demanded casual everyday clothing. Men wanted casual clothes that differed from work apparel and were more suitable for weekends and vacations. American men demanded a non-English type of dress, with the shirt tails out and no neckties.

These developments were responsible for the emergence of men's designer sportswear which originated in southern California in the late 1940s. At first the demand for sportswear and casual apparel was filled by manufacturers elsewhere. Later, these organizations moved to California and started the California fashion industry, primarily based in Los Angeles and San Francisco. These manufacturers

Figure 8-3. A relaxed casual style in men's wear developed after World War II. (Courtesy *Everyday Fashions of the Forties as Pictured in Sears Catalogs*)

provided men with sports and weekend wear supplementing their business attire. Eastern men's wear designers like Calvin Klein, Bill Blass, and Oscar de la Renta, turned sunglasses, ties, and other clothing and accessory items into instant status symbols by licensing their designer names to manufacturers. Wholesale shipments of casual and sportswear apparel soon increased by about 160 percent with suit sales declining by about 40 percent between 1947 and 1961.

The 1950s

The 1950s were the age of conformity, and fashion choices during this time were limited. Young men returning from the Korean war were anxious to fit right in with "the Establishment" and the trim, natural shoulder "Ivy League" look emerged.

The 1960s

The men's wear industry changed dramatically during the '60s. Unlike the 1950s, the industry began to focus on a more youthful market (ages 25 and under), which made up over 50 percent of the population.

The '60s was the era of the **Peacock Revolution,** which started on Carnaby Street in London and featured a wide variety of new looks. The Mod look, which featured flamboyant colors, bold floral prints, jackets with wide lapels, and bell-bottom trousers, originated in English boutiques. Other new looks, which included the Edwardian suit and Nehru jacket, allowed men to wear less restrictive, more casual attire. These developments, along with the increased popularity of blue jeans, changed men's clothing styles for the first time in decades.

In addition, a youthful president, John F. Kennedy, had a strong impact on men's fashion in the United States when he popularized the elegant Ivy League look proving there were other alternatives to high style British clothing. Kennedy's wardrobe featured two-button shaped suits with natural shoulders and wider lapels.

The '60s were also a time of social unrest, riots, and civil strife, which included the assassinations of prominent people such as John F. Kennedy, Robert Kennedy, Martin Luther King, and Malcolm X. As a result of these events, African-American men became even more interested in their heritage. Ethnic fashions became increasingly popular as men wore the *dashiki,* a traditional African shirt; ceremonial robes and hats made of Kente cloth; and other African attire.

A youthful counterculture, the hippie generation, also emerged during the late '60s with rebellious attitudes against the Establishment and the traditional look of the "Peacock Generation." Their faded blue jeans, batik or tie-dyed shirts, long flowing hair, and "flower power," had a tremendous impact on every segment of society including the men's wear industry.

New to the market, synthetic fibers and fabrics reflected this more casual lifestyle. Permanent press cotton shirts, which needed little or no ironing, arrived on the fashion scene. Designers used polyester double-knit fabric instead of wool flannel for relaxed leisure suits as an alternative to business suits.

Other significant changes took place in the industry. The first designer clothes for men arrived on the scene when Pierre Cardin opened his first men's ready-to-wear department in 1961, featuring his original designer shirts and ties. Soon John Weitz, Christian Dior, Yves Saint Laurent, and other women's designers followed his example and started designing men's wear with great success.

In addition, many privately owned men's wear companies producing a single type of product went public. Giant publicly owned apparel firms emerged and grew through mergers, acquisitions, and internal expansions. In this way they were able to expand their operations (using the public's invested capital) at a much faster rate than relying mainly on accumulated profits.

The 1970s

The industry continued to grow during the 1970s. This was a time of intense fashion experimentation. Manufacturers sought to capture the one third of the buying public that was spending two thirds of the money. Many of the publicly owned conglomerates whose businesses were in widely diversified fields, started to buy apparel firms and enter the fashion arena. For example, General Foods bought Izod Ltd., and Consolidated Foods acquired Hanes Hosiery.

The 1980s

During the 1980s, men's wear manufacturers began to see public ownership as more of a liability than an asset and private ownership became more prevalent.

Levi Strauss, Blue Bell, and Palm Beach each bought back their corporation's stock during the highly competitive atmosphere of the late 1980s. By becoming private, companies could make swift and silent changes that would enable them to better respond to the needs of a changing market. A buy-back also served as a protection from the possibility of a hostile takeover in the highly competitive environment.

During the early 1980s, the dramatic rise of imported garments began. Apparel imports from low-wage countries became increasingly troublesome to the domestic men's wear industry and contributed to New York's decline as a manufacturing center. Much of the world's apparel production shifted to the Caribbean Basin and the Pacific Rim where labor costs were, and still are, much lower than in North America and Western Europe. Today only about half of the garments sold in the American market are manufactured domestically.

The Demographic Aspects of the Industry

Age Factors

The age distribution of a population plays an important role in the retailing of men's wear. The age distribution of the United States has shifted and continues to grow older.

Baby boomers, those born between 1946 and 1964, are getting older. As consumers, now in their 30s and 40s, they have different needs and lifestyles. For example, they no longer have 18-year-old bodies. Retailers also target their merchandise to meet the needs of this consumer. For example, The Gap developed Easy Fit jeans to help discreetly and fashionably beat "the battle of the bulge." Levi Strauss created men's Dockers for middle aged men who wanted a more relaxed fit than jeans give.

As baby boomers mature, many continue to fight aging every step of the way. Older men and women shop for established clothing brands that give them a sense of security and the promise of value and quality. They tend to shop for good service and knowledgeable sales personnel. With the number of older Americans expecting to increase from 28 million in 1984 to 32 million in the year 2000, the clothing industry is focusing its attention on the needs of this growing market by offering more comfortable and fashionable apparel for older customers as Levi Strauss and The Gap have done.

Men and women are also getting married at a later age, and in the interim have more discretionary income to spend on themselves. Despite the declining size of the youth population, retailers continue to focus their attention on this group because many young men and women typically are free spenders in search of trendy, upbeat

Figure 8-4. Ralph Lauren/Polo apparel and presentation reflect men's changing lifestyles and focus on family and environmental concerns. (Courtesy Ralph Lauren)

merchandise. They tend to look for fashionable assortments and designer labels at reasonable prices.

Income

There was a time when husbands "brought home the bacon" and wives "cooked it." However in the 1990s only 22 percent of married-couple households contain a male breadwinner and a female homemaker. The share of jobs enabling men to earn enough to support a family has declined, especially for younger men; therefore, less money is available for apparel purchases.

Geographic Location

About 17 percent of all Americans move each year, making the United States a very mobile society.[1]

Occupational shifts are a major cause of increased mobility. The most mobile group of Americans is in the 30- to 44-year-old age group.[2]

These statistics present a challenge to the men's wear industry. For example, a men's wear shop in a highly transient area may face a constantly changing group of customers whose store loyalties, shopping habits, and brand preferences are different from those of previous customers.

The men's wear market is divided into different geographic regions that include the Northeast, North Central, South, and the West. All are analyzed to determine purchasing patterns and intentions.

These locations provide marketing opportunities because of differences in climate, terrain, economic base, and characteristics of the people. For example, due to the concentration of government, financial, and large business occupations in the Northeast, a larger percentage of men are likely to purchase business suits there than in other parts of the country.

Men who live in urban metropolitan areas tend to buy a wider variety of clothing than do suburban consumers.

Education

Customer education levels can be used to target the various markets within the men's wear industry. High school graduates are likely to read less, spend more time watching television, and rely more on well known clothing brands when compared with college graduates. College graduates have higher quality expectations and fashion taste levels as well as stricter requirements for what they purchase. For example, as people become more aware of economic issues, they may insist on garments that are manufactured domestically and refuse to buy imported merchandise, or as people become more concerned with ecological issues, they may insist on clothing made of natural fibers rather than synthetics.

SPOTLIGHT ON A FIRM

MERRY-GO-ROUND ENTERPRISES

Emerging fashion trends are what customers find at stores operated by Merry-Go-Round Enterprises (MGRE). MGRE operates over 600 stores including Merry-Go-Round, Boogie's Diner, D.J.'S/ Dejáiz, Attivo Cignal, and Silvermans/His Place.

The Merry-Go-Round shops sell unisex merchandise with a focus on young people. While other manufacturers have abandoned this sector, it has had a payoff for MGRE.

The long-term direction for MGRE is to develop new fashion trends. An attitude of boldness not timidity is expressed by MGRE CEO and president, Michael D. Sullivan.

He states "in good times and bad retailing remains a fashion business," and "the ones that are successful are the ones that are aggressive— the ones that say I can't wait for the good economic times to come back."

Men's wear accounts for 65 percent of the chain-wide volume for Merry-Go-Round shops. According to Sullivan, "there's been less competition in the men's area." It was his idea to open the men's division.

Operations focus on customer service. To ensure the youthful salespeople expound this philosophy, an audio-visual training program was developed to help them create more sales.

Success is also attributed to the ability to retain personnel through a system of upward mobility. Pro-

moting from within for MGRE means literally taking individuals right out of the stores and into the home office. This ensures a continuous influx of new talent.

Based on figures taken from a *Stores* magazine report of the top 100 specialty chains for 1989, Merry-Go-Round had the largest year-to-year sales gain of 60 percent to $479 million, an achievement made by continually producing high sales per square foot of store space.

Plans are to double the number of stores over the next 10 years and expand the size of existing stores by capitalizing on leases due to expire at several malls built in the late '70s and early '80s.

Question for Discussion. As a store manager for Merry-Go-Round, what three or four things would you do to implement MGRE's philosophy?

Sources. 1. Joan Bergmann, "MGR Goes Ape in N.Y.," *Stores,* October 1990, pp. 72, 74; 2. Rick Gallagher, "Merry-Go-Round," *Stores,* February 1991, pp. 14, 15, 17; 3. David Schulz, "The Top Specialty Chains," *Stores,* August 1990, pp. 9, 10; 4. "Merry-Go-Round" Annual Report, 1990.

Characteristics of the Industry

Economic Importance

More than 3000 firms are engaged in the production of men's clothing and furnishings. There are over 4100 plants that are located throughout the United States.

These plants and factories employ over 200,000 people.[3] These individuals are mostly engaged in production activities such as cutting and sewing.

Consumer expenditures in the early 1990s for men's and boys' wear was just under $20 billion.[4]

Geographic Location

Men's wear manufacturers and production facilities can be found in almost every part of the United States. For example, Levi Strauss is headquartered in San Francisco, Hartmarx is headquartered in Chicago, Grief & Company and After Six are located in Philadelphia, and White Stag and Pendleton are located in Portland, Oregon. The majority of the smaller firms are still located in the mid-Atlantic states: New York, New Jersey, and Pennsylvania. Companies such as Hartmarx produce **tailored clothing,** that is, men's tailored suits, overcoats, top coats and short coats, formal wear, and slacks, with firm construction utilizing some hand-tailoring. The manufacturing of tailored clothing requires highly skilled labor, which often can be found only in large metropolitan areas such as New York City and Chicago.

A few men's wear manufacturers like Oxford Industries have always been located in the South. Others like Haggar and Farrah are located in the Southwest, Texas specifically. Recently, the number of men's wear manufacturers moving southwest has increased, since they can take advantage of cheaper land and labor costs. With a

Figure 8-5. This model is seriously suited in a three-button, ventless tailored suit by Hartmarx, Krizia collection. (Courtesy Hartmarx, Krizia collection)

trend toward increased mechanization, manufacturers can employ individuals with minimal skills and therefore depend less on highly skilled laborers.

Most firms have showrooms in New York City as well as in other major markets like Chicago and California. In these locations, each company's marketing and sales efforts are carried out by local sales representatives. In New York City, many offices are located at 1290 Avenue of the Americas, which houses over one hundred men's wear firms.

Men's clothing showrooms are also located in offices on 51st, 52nd, and 53rd Streets, between Fifth and Seventh Avenues. Men's furnishings showrooms are located farther downtown, in the Empire State Building, at 34th Street and Fifth Avenue.

Structure and Organization

At the manufacturing level, the men's wear industry is dominated by large firms. In recent years, Levi Strauss, Hartmarx, Phillips-Van Heusen, Russell, Oxford Industries, and Farrah have been the largest manufacturers of men's wear.

These companies do a larger share of their industry's total business than do the largest women's firms. Through mergers, diversification, and acquisitions, many men's wear firms have become even larger. Many have expanded their operations into other areas such as women's and children's wear. For example, Hartmarx markets the Barrie Pace line to executive women.

Figure 8-6. Most men's wear manufacturers sell their new lines to buyers at their showrooms or at major city apparel centers like the Dallas Market Center shown here. (Courtesy Dallas Market Center Co. Ltd.)

Specialization by Type of Apparel

The federal government and manufacturers usually classify men's apparel items into two main categories: men's clothing and men's furnishings.

Men's clothing generally refers to outerwear such as suits and coats, work clothing, slacks, and sportswear. The categories in full are:

1. Tailored clothing: structured or semi-structured suits, overcoats, topcoats, trenchcoats, tuxedos, furs, and separates including sports jackets and dress slacks. Hand tailoring, quality fabric, and excellent fit are found here. Manufacturers involved in uniform production are also included in this classification. Many firms produce both men's, youths', and boys' tailored clothing items.

2. Work clothing: work shirts and pants, overalls, and other loose fitting washable apparel items like jumpsuits and painter's pants.

3. Trousers and slacks: pants worn specifically for casual wear. Jeans worn for casual wear are also in this category. Other alternatives within this category include western-style twill or corduroy pants and casual pants of cotton gabardine or chino.

4. Outerwear and active sportswear: non-tailored apparel for skiing, bicycling, mountain climbing, horseback riding, swimming and surfing, aerobics, boating, etc.

5. Spectator sportswear: western wear, sweaters, casual knit and woven shirts and pants, jeans, etc.

Men's furnishings refers to all articles of clothing that are worn with men's outerwear, including the following:

1. Shirts: both knit and woven dress, casual, and sport shirts. Dress shirts are more tailored and are often worn with a tie for street, business, and semiformal wear. Sport shirts are more casual, with or without a collar, long or short- sleeved, and worn without a tie.

2. Sweaters: many cardigans and pullovers of various styles such as crew, turtle-neck, or V-neck.
3. Neckties, scarves, handkerchiefs, and accessories: items often purchased as gifts such as pocket squares, belts, suspenders, garters, cuff links, and gloves.
4. Underwear and nightwear: woven boxer shorts and knit briefs, T-shirts, thermal underwear, sleepwear, robes, and loungewear.
5. Hosiery: hose and socks for casual, work, dress, or athletic wear.
6. Hats and caps: dress and casual headwear such as baseball caps.

Men's wear fashions also feature *innovative* styles, which include very trendy, usually youthful styles. *Directional* merchandise is offered to the man who wants to project a current image. *Conservative* styles are for the man that resists change.

Apparel manufacturers often break down the men's wear market into various customer fashion types and from these have developed individual lifestyle collec-

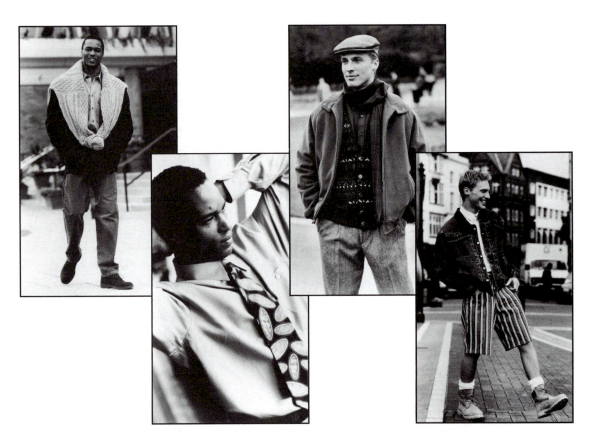

Figure 8-7. The men's wear market covers everything from accessories to outerwear and is targeted to just about every lifestyle. (Courtesy Men's Fashion Association: (a) Tempo Libero, Div. Mondo, (b) Mondo Di Marco, (c) Pendleton, (d) Marithé & François Girbaud)

tions. There are several different categories of men's tailored suits, including natural shoulder, athletic, European styling, and seven-inch drop, which refers to the difference between the waist and jacket size. For example, Hartmarx breaks down its market into seven categories:

1. business/professional
2. natural shoulder traditional
3. American fashion contemporary
4. French
5. Italian
6. British designer-inspired
7. American sportsman

The traditional collection has a relaxed cut but with a distinctive fashion edge.

Product Pricing

Like the women's wear producers, men's wear producers market their merchandise at various price levels. The various price levels are: designer/couture, bridge/better, moderate, and budget.

Designer/couture men's apparel features **custom tailoring,** clothing created for individuals according to their measurements, as well as some factory-made tailored clothing. Well known men's wear designers in the United States include Joseph Abboud, Jeffrey Banks, Jhane Barnes, Ralph Lauren, and others.

Bridge and better price ranges include some lower priced designer lines such as Joseph Abboud's J.O.E. and Colours by Alexander Julian. Other merchandise in the better price range includes nationally known names such as Hart, Schaffner & Marx suits. Below the better price range are moderate price lines which include well known names such as Levi Strauss, Arrow, and Sansabelt. The budget price range includes popularly priced brand names such as Lee, Wrangler, and Kuppenheimer, and the private brands of mass and discount retailers such as K mart's B.E. (Basic Editions) lines.

Product Sizing

Although the men's wear industry has failed to adopt a general size standard for men's apparel, sizing is much more standardized, running truer to specification than does women's wear.

Size categories cover all ages, from boys' to big and tall men's wear. Most men's wear is sized according to chest measurements. Tailored suits and sports jackets are available in a wide variety of proportions and according to height.

In general, sizing for the various categories of men's wear runs as follows:

- *tailored clothing* includes suits, jackets, and coats and comes in proportioned sizes:

 Short (36–42) Extra Long (40–48)
 Regular (36–46) Portly (39–52)
 Long (38–48) Short portly (36–50)

- *separate trousers* come in proportioned sizes also, and are measured both by the waist and the inseam. Typical waist measurements are 25–42; inseam 29–36.
- *contemporary clothing* has a relaxed construction and fit, lending itself to less structured sizing, and is identified as small, medium, large, and extra-large.

Figure 8-8. Retailers like Brooks Brothers readily offer the customer information on pricing and sizing. (Courtesy Brooks Brothers)

- *sportswear* sizing for tops and pants is less specific than the sizing for tailored clothing. Sportswear sizes are small (S), medium (M), large (L), and extra-large (XL). Big and tall sizes run 2X to 5X.
- *men's long-sleeved dress shirts* are sized by neck measurements (14"–17½"), and sleeve lengths (32"–35"), and are offered in fitted or regular cuts.

Many retailers are giving more attention to the big and tall customers. Jessie Bourneuf, president of the King Size Co., a big and tall catalog company based in Norwell, Massachusetts, believes that retailers are missing out on a golden opportunity.

According to Bourneuf, "We have an underserved customer. Larger sizes in the women's business have come into their own, but not in men's wear."[5]

Merchandising and Marketing Activities

The men's wear industry primarily uses three main types of promotion to market its items:

1. print advertising
2. broadcast advertising
3. public relations and publicity

Advertising

Large manufacturers of men's apparel, such as Levi Strauss, use both print and the broadcast media. Men's apparel producers of all sizes tend to put a lot of their advertising money into **cooperative advertising,** that is, sharing the costs of specific local retail advertisements with their retail accounts.

Retailers and manufacturers have traditionally put more of their advertising dollars into print advertising—newspapers, magazines, and catalogs—because they can reach a larger and more varied group of prospective customers at a relatively low cost per reader. Many men's wear retailers advertise in city or town papers as well as foreign language papers, schools, and independent local shopping publications. These types of publications are either mailed or hand-delivered to homes free of charge.

Men's wear retailers advertise to promote goodwill and to produce sales. Different types of advertising can be used to present goods, services, or ideas to the men's wear market. An advertisement may also serve as an educational tool.

The specific type of advertising used has to be carefully planned and executed in order to generate sales, enhance the image of the store, and conform to its policies.

In small retail stores, the owners act as the buyer and advertising manager. They usually decide what to advertise and provide all of the information concerning the merchandise to whomever prepares the advertisement. Many proprietors make up their own ads with the assistance of the vendors, newspapers, or other free or inexpensive media services.

Figure 8-9. This Paul Stuart men's wear ad has a definite message to convey about the merchandise the store sells and the customer it appeals to. (Courtesy Paul Stuart)

Larger stores have advertising departments. The buyer, who has more knowledge about the merchandise, usually works along with the merchandise manager to decide what to promote and how it is going to be promoted. The ads will usually have a consistent format intended to convey the retailer's image.

Buyers and merchandise managers may decide to advertise in a magazine rather than a newspaper. This type of print advertising is used more infrequently by retailers because it is so costly.

Specialty retailers such as Nordstrom, Saks Fifth Avenue, and Neiman Marcus feel that advertisements in high-fashion magazines give more prestige and are well worth the cost. A disadvantage to magazine advertising is that it often takes weeks to prepare a magazine for publication; thus, retailers find it difficult to advertise a particular item so far in advance.

In recent years, magazines devoted exclusively to men's fashions have gained in popularity. *Gentlemen's Quarterly (GQ), Esquire,* and ethnically oriented publications such as *Ebony Man* and *Modern Black Man* have made magazine advertising worthwhile for retailers and manufacturers. Publishers are introducing or repositioning men's magazines. These publications are targeted toward upwardly mobile professional men. Marketers hope to invigorate the market by focusing on the more fashion-sensitive consumer.

Direct-mail advertising to targeted groups is also a popular form of men's wear advertising. Some popular forms of direct mail include letters, bill enclosures, circulars, postcards, booklets, and package inserts. Both large and small stores find this type of advertising profitable because of its convenience. Customers can easily receive information about new merchandise or special sales events without leaving home.

Most retail stores put at least 20 percent or more of their advertising budget into the broadcast media. This amount has increased in recent years with the tremendous growth of cable television. Television offers men's wear fashion retailers and manufacturers the use of color, movement, realism, and sound to promote their goods.

Figure 8-10. This ad promoting Dayton's own Field Gear apparel line has a wide appeal to a large audience. (Courtesy Dayton Hudson Corporation)

Dads come in all sorts of shapes, sizes and styles. How perfect, so does Field Gear.

More Sizes.

ONLY AT DAYTON'S

Figure 8-11. The apparel styles found in many of the men's fashion magazines are geared to the upwardly mobile professional man. Shown here are a charcoal grey flannel double-breasted suit, white cotton broadcloth shirt, silk tie, silk pocket square, and silk and leather braces, all from Polo/Ralph Lauren. (Courtesy Ralph Lauren)

Although more costly than print advertising, some television advertising costs, such as cable, can be low enough to be affordable and profitable for even the small, local retailer.

Another form of broadcast advertising is radio, which reaches more people than any other media. This advertising medium has gained in popularity in recent years because many busy adults ages 18 to 49 spend more time every day with radio than with television. Radio advertising is relatively inexpensive, but unlike television, it reaches the ears, not the eyes.

Trade Associations

A major trade association for the men's wear industry is MAGIC. **Trade associations,** organizations created to serve their members' interests, play a major role in men's wear promotion.

MAGIC, which originally stood for the *Men's Apparel Group of California,* began in the late 1930s when it became an October tradition for the newly formed Men's Wear Manufacturers' Association of Los Angeles to gather at the Desert Inn for rounds of fashion shows, golf, and socializing with retailers.

The group later moved to the Riviera Hotel and, for the first time, became involved in showroom selling. Due to the increased popularity of the show, the organization expanded to include San Francisco manufacturers and changed its name to *Men's Apparel Guild of California.* A few years later, several other groups were added including Portland, Seattle, and Hawaii.

Figure 8-12. The Fashion Association of America (formerly The Men's Fashion Association of America) sends out informative press kits filled with news on the latest trends and market information. (Courtesy Men's Fashion Association)

Table 8-1. Men's Wear Trade Organizations

1. Apparel Retailers of America (formerly Menswear Retailers of America)

2. Designers' Collective

3. The Fashion Association (formerly The Men's Fashion Association of America)

4. Men's Apparel Guild of California (MAGIC)

5. Men's Clothing Manufacturers' Association

6. Men's Merchandising Association Inc.

7. National Association of Men's Sportswear Buyers (NAMSB)

The group continued to grow, and in 1950 MAGIC moved to San Diego, remaining there for five years.

In 1979 they moved to the Los Angeles Convention Center and started semi-annual shows, which were open to any men's wear manufacturer in the world that wanted to exhibit. Today, the MAGIC logo includes the word *International*.[6]

MAGIC and other trade associations sponsor market weeks, trade shows, and other promotions designed to publicize individual men's wear manufacturers or the industry as a whole. They feature distinctive viewpoints and feature rising fashion stars. This is quite different from the women's wear industry, where trade associations generally work only with their retail members. In the men's wear industry, trade associations act as a liaison between the manufacturer and retailer and are actively involved with marketing and merchandising activities.

Most trade associations provide press kits that summarize the direction of men's fashions for a particular season. Advertising managers and fashion editors can use the information word-for-word with the accompanying photographs. The Fashion Association of America (formerly The Men's Fashion Association of America), located in New York City, sends news releases and men's fashion photographs to fashion editors throughout the country.

Because information on a wide variety of merchandise is included, the editor can pick and choose items to be featured. Although most retailers do their own advertising, this type of information is also instrumental in increasing retail sales.

Other trade associations for the men's wear industry include the Men's Apparel Guild, the National Association of Men's Sportswear Buyers (NAMSB), and the Clothing Manufacturers Association (CMA), to name a few. (See Table 8-1.)

Men's wear merchants constantly need information on sales, profits, and trends. They can turn to a number of resources for facts and figures to help them analyze those products most in demand and those that are declining. Retailers can use the information gathered from trade associations as a basis for making marketing decisions.

Trade Shows

Trade associations play an important role in the marketing and merchandising of men's wear. Acting as a liaison between producers and retailers, they hold trade shows in various regions of the United States throughout the year.

Since the largest number of men's wear showrooms are located in New York City, the greatest number of trade shows are given in this large market center.

The Clothing Manufacturers Association (CMA), the oldest trade association in the men's wear field, sponsors market shows throughout the year. The CMA coordinates and publicizes two market weeks a year in New York. Fall/winter merchandise is shown in January and February, and spring/summer merchandise is shown in August and September. This is one of the largest men's wear trade shows in the world, and brings together the greatest number of men's wear producers. Merchandise is shown from various manufacturers and includes all types and styles of men's wear items. Tailored, sportswear, and contemporary apparel is shown. Buyers have the opportunity to view many different offerings from various men's wear producers at one time in one place.

Another market show is the MAGIC show sponsored by the Men's Apparel Guild, held twice a year in Los Angeles. In the early 1940s, salespeople in the men's wear industry held a trade show for West Coast producers only. Since 1979, the association has grown in importance and now sponsors a national men's apparel show in Las Vegas, with an emphasis on sportswear.

The major purpose of the MAGIC show, held shortly after Labor Day each year, is to provide vendors with three action-packed days of appointments, impromptu visits, buying group briefings, fashions shows, and exciting entertainment. An estimated 30,000 people attended the 1990 show.[7]

Regional market shows have gained in popularity in other parts of the country as well. Los Angeles, Chicago, and Dallas, for example, have grown in importance.

These shows are sponsored by fashion trade centers in the United States and around the world. For example, in Paris, European men's wear trade associations sponsor the European Menswear Show (SEHM). European manufacturers have the opportunity to show their merchandise twice a year for two major seasons—fall/winter and spring/summer. Other men's wear trade showings include:

- Pitti Como, Florence, Italy
- English Men's Wear Designers' Collection, London, England
- International Men's Fashion Week, Cologne, Germany
- Scandinavian Men's Wear Fair, Copenhagen, Denmark

Designer Labels and Licensing

Since 1970, licensing has played an important role in the men's wear industry. Through licensing, famous designers or other well known celebrities allow the use of their name on various types of clothing and furnishings. When used as a marketing tool, licenses are status symbols proven to be extremely profitable for manufacturers and retailers.

Designer apparel for men first appeared in the early 1970s, and had a very distinct and unique look. Designers like Calvin Klein, Ralph Lauren, and Perry Ellis offered merchandise bearing their names. Designer men's wear featured a different cut of suit, a more fitted shirt, and an interesting assortment of ties, and men became more fashion conscious.

Designer men's wear was easily recognized and gave consumers instant recognition and gratification. As consumers began to associate designer names with prestige and fashion, the demand for status-name clothing increased. European designers of women's apparel, Pierre Cardin, Christian Dior, and Yves Saint Laurent to name a few, found it relatively easy to break into the men's wear business.

American designers, such as Oleg Cassini, John Weitz, and Bill Blass, soon followed by displaying their talents in the men's wear area. The designer explosion of the '70s became a major merchandising thrust for specialty and department stores mid-decade and continued peaking during the 1980s.

Status labels and designer names have accounted for an estimated 25 to 35 percent of the contemporary clothing business, 20 to 25 percent of the shirt business, 40 to 50 percent of neckwear sales, and the bulk of the higher priced jeans volume.

Today, men's wear designer licensing continues to be big business for several reasons. First, the designer name pre-sells itself. Many designers, such as Donna Karan, Calvin Klein, and Liz Claiborne, are well established in the women's wear industry and are now household names for men's wear as well. A knowledgeable consumer who identifies with a particular designer is an advantage to the retailer.

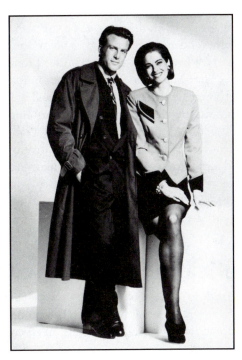

Figure 8-13. Many women's wear designers, like Pierre Cardin, successfully crossed over to the men's wear market. Shown here for him is a Pierre Cardin navy double-breasted suit. (Courtesy Polyester Council of America)

Secondly, designer names help stores promote a fashion image. The name can add luster and excitement to the assortment of merchandise. The knowledgeable retailer selects designer names that fill a particular fashion/price niche and do not conflict with other brand names in the department.

In addition, designer fashions provide an opportunity for major retailers to introduce the latest fashions quickly and easily in their branch or suburban locations.

As consumers become more concerned about quality and value, designer names offer the consumer security, credibility, and a sense of assurance about garment quality.

There are many designers vying to get into the licensing business, and now designer labels are promoted as heavily as well established brand names.

Many designers, such as Valentino, Gianni Versace, Gianfranco Ferre, Ralph Lauren, and Giorgio Armani, have their own boutiques, both in-store and freestanding. These established designers are in for the long run and have a strong commitment to men's clothing.

Some well known men's wear manufacturers carry a wide variety of licensed designer merchandise. Hartmarx, for example, leads the designer parade with a grand total of 17 designer labels and brands. These include Karl Lagerfeld, Nino Cerruti, and Krizia.

Established brands, like Hart Schaffner & Marx or Hickey-Freeman, have been known for more than a century and continue to stand for superlative quality and fine craftsmanship. These labels have a lifespan of 100 or more years while celebrity names often have shorter life cycles.

Dual Distribution

Some large men's wear manufacturers own their own chain stores and sell the same merchandise that they sell to other independent retailers. This system of selling through company-owned retailers as well as to other retailers is called **dual distribution.** For example, Hartmarx sells its Hart Schaffner & Marx suits through its own Baskin, Kuppenheimer, and Wallach's stores and also through Macy's and other retailers.

Other men's wear manufacturers involved in dual distribution include Botany Industries, Eagle Clothes, Phillips-Van Heusen, and Cluett Peabody. These manufacturer-owned stores are usually given names that do not identify them to the public as belonging to the producer concerned. Hartmarx, a billion-dollar-a-year company, owns 468 stores throughout the United States, including Wallachs, Silverwood, and Hastings, as well as Baskins. Hartmarx distributes about 80 percent of its tailored clothing apparel to other competing department and specialty stores under Hart Schaffner & Marx, Hickey-Freeman, and other labels.

Future Trends and Implications for the Industry

The men's wear industry has done a good job keeping up with changing consumers. As the American male becomes more fashionable, and as we approach the twenty-first century, the men's wear industry will need to focus on several major factors in order to maintain profitability.

Career Portrait

ALEXANDER JULIAN

Alexander Julian, outstanding men's wear designer, is renowned for his modern, artistic interpretation of color.

Born in Chapel Hill, North Carolina, his first introduction to the fashion business was at the age of six months, when he accompanied his parents to a fashion market. Alexander Julian grew up in the retail environment of his father's College Shop and oftentimes read fabric swatchbooks instead of comic books. As he grew older, he became very interested in fashion and worked for the family store every day after school. At the early age of 12, he designed his first shirts and later designed his first jackets at the age of 16.

> *"Take the retail route. Work your way up through retail. Get into buying, learn your way around, make contacts, and then try to establish a business." Alexander Julian*

Also at the age of 16, he began managing his father's clothing store. This was the beginning of a series of events that led to his career as a fashion designer.

Upon graduating from high school, despite his 18 years of retail experience, his parents forbade him to go into the fashion business and encouraged him to enroll in a pre-med program at the University of North Carolina. When his father developed health problems he had to return home

to run the family store. Known as a very presumptuous young man, at age 21 Alexander Julian used his father's money to purchase his own store, while his father was out of town.

He developed an interest in fashion design when he started designing sweaters for his own store. A good friend one day remarked, "I really think designing is your forte. You should be doing it all the time because you're good at it."

Alexander Julian wanted to get into the fashion design business but hesitated. Later, he found himself designing his first collection to bail out a friend who had sold himself to a clothing manufacturer as a creative designer, but was really more of a salesperson. After designing the no-name collection, he decided to pursue fashion design full-time.

He moved to New York City in 1975 to pursue his new career. Julian dreamed of winning the prestigious Coty Award and decided that if he didn't win it before the age of 30 he would quit and return home.

He first approached an older more established men's wear company and sold it on the beneficial effects that his

continued

designs would have on the company. Despite struggling to gain publicity for his collections, Alexander Julian knew his clothes had validity and continued to work hard toward reaching his goal.

His dream was soon realized when he was first nominated for the Coty Award after only two years in the fashion design business. In 1977, after three years in business, he won his first Coty Award. After that, Julian won a total of four Coty Awards and became the youngest designer to ever be inducted into the Coty Hall of Fame.

Alexander Julian became known as the first American clothing designer to design his own exclusive fabrics. He also designed the first women's wear collection anywhere based entirely on in-house textiles.

He worked with European mills and was the first to explore broad ranges of color. In 1980, he was the inaugural recipient of the Cutty Sark Menswear Award, the "Oscar" of the men's wear industry for fashion superstars. His second Cutty Award was earned in 1985 when once again he was voted outstanding U.S. designer of men's fashion. Other fashion design awards include the Council of Fashion Designers of America's Designer of the Year and the Woolknit Award.

He is the four-time winner of the prestigious Coty Award, and has made the best dressed list for nine years running.

At the age of 40, he was honored with the Cutty Sark Career Achievement award, and was the youngest designer to receive the honor bestowed by members of the national fashion press.

In 1981, he created "Colours by Alexander Julian," a popularly priced collection for men that reflected the artful color combinations that by then were a Julian signature. The "Colours" collection, which began with tailored clothing, quickly expanded into men's sportswear, furnishings, sleepwear, knits and hosiery, belts, footwear, and luggage. Soon his men's wear was carried in the most sophisticated stores across the country including Jerry Magnin in Los Angeles, Wilkes Bashford in San Francisco, and Perkins Shearer in Denver.

His company racked up sales of $44 million in 1981 and increased to a whopping $88 million in 1982. Saks Fifth Avenue staged a spectacular parade down Manhattan's Fifth Avenue in his honor.

In 1985, Levi Strauss moved to broaden its customer base and entered into a licensing contract with Julian for the "Colours" line and his higher-priced couture collection.

In 1991, he began a new era and bought back the rights to his licenses. In a partnership with Harvard University Venture Fund (Aeneas), he successfully bought back his two largest divisions from his licensees. Alexander Julian expressed his excitement about this business transaction when he said, "I have finally achieved my dream of combining the Couture and Colours lines under one roof, under one concept, and one set of ideals."

With this development he had total design and product control over every item with the Alexander Julian name on it.

Alexander Julian was the first fashion designer to be involved in professional sports and has designed the uniforms for the Charlotte Hornets, the Charlotte Knights, and the University of North Carolina's Tar Heels basketball team.

In 1990, he became involved in his first architectural project. He found the Charlotte Knights stadium visually exciting and designed the world's most colorful stadium interior in a striking combination of bright black and 12 colorful pinstripes.

Julian is also responsible for the world's "fastest" uniforms, having been asked on numerous occasions to design the uniform car color and crew apparel for the racing team of Mario and Michael Andretti. He also designs clothing for the famed team's co-owners, Paul Newman and Carl Haas.

Julian typically works 12 hour days, but finds time to relax in his Connecticut retreat with his wife Meagan, daughters Claire and Alystyre, and son Will. Some of his favorite pastimes include listening to vintage jazz, collecting antique cars, painting, and tennis. He also enjoys vacationing in Milan, horseback riding, fly-fishing, and sailing.

Known for his uncanny eye for odd and unusual color mixes he gets his inspiration from "everywhere."

When advising students, Julian feels that formal design training is helpful, but the most important thing is

having the right ideas. He also believes that creativity is a part of an individual's make-up, but a person can become more or less creative by his or her own particular involvement with the world.

Alexander Julian also believes that creative thinking in education should play a more significant role in the learning development for children and has formed the Alexander Julian Foundation for Aesthetic Understanding and Appreciation. The organization is involved with supporting experimental learning centers for children and encourages creative thinking. Julian hopes that these centers will some day become a national model for schools.

Alexander Julian attributes his tremendous success to his creativity, but also to his retailing experience. He encourages aspiring fashion designers to "Take the retail route. Work your way up through retail. Get into buying, learn your way around, make contacts, and then try to establish a business."

He's quoted in *Who's Who:* "To be successful in any endeavor, whether fashion or something else, an important element is to liken your endeavors to defensive driving. To reach your goal, you have to look out more for what others are doing wrong than for what you're doing right."

Question for Discussion. In what ways did Alexander Julian meet the needs of an expanding target market?

Sources. 1. Alexander Julian Press Kit—Spring, 1991; 2. Melissa Sones, *Getting Into Fashion,* Ballentine Books, 1984, pp. 3–8.

Focusing on Customers' Changing Needs and Lifestyles

Manufacturers and retailers have responded to men's apparel needs by providing ways to express individual lifestyles. Apparel manufacturers, for example, make changes in product development, marketing, and point-of-sale presentations to provide merchandise that meets the wants and needs of today's consumer.

For instance, Hartmarx manufactures three distinct collections, Pallesco di Vitale Barberis, Impressions, and Corporate Collection, which are made in America but styled in Italy.

Offshore Production

Increasingly, the men's wear industry, like the women's and children's industries, is dealing with **offshore production,** importing goods from foreign countries. Nearly one third of all the clothing purchased in the United States is made somewhere else. In high-price categories imports can exceed 50 percent. Almost one third of the American apparel industry is involved in importing.

A man's typical wardrobe of today is probably better traveled than he is. It may contain high-priced clothing items from Hong Kong with well known labels like Perry Ellis and Calvin Klein. These garments also "rub elbows" with sweaters from Uruguay, jackets from the People's Republic of China, and sport shirts from India.

A typical sport shirt by Arrow, Gant, or Van Heusen may or may not be produced domestically. It's most likely made from domestic fibers but may be cut and sewn in an east coast factory or produced in Asia.

Figure 8-14. Hartmarx International Collections feature merchandise that is made in America but designed in Italy. (Courtesy Hartmarx)

Well known labels, like Yves St. Laurent, Daniel Hechter, or J. P. Germain, are oftentimes produced in Far East cities and countries, including Hong Kong, South Korea, and Malaysia.

Eastern European nations supply basic suits and sweaters that undercut the market despite high tariffs. Many industry manufacturing and union leaders continue to demand more protective quotas, while retailers—seeking appealing prices for consumers—cry out for free trade.

The obvious incentive for non-domestic production is reduced labor costs. However, many contend that quality control is more important than cost efficiency. For example, to supervise quality control, Ralph Lauren maintains an office in Hong Kong with 14 employees, yet more than half of the 5 to 6 million Polo items produced annually are made domestically.

Many American designers insist that the Middle and Far East offer better fabric selection, greater design flexibility, and lower minimum orders, which are unavailable in the volume-oriented U.S. industry. For example, a men's wear sweater designer may want to produce a cardigan-style sweater with a unique series of pockets. An Asian manufacturer will be glad to make it. If, however, the designer goes to a U. S. mill, the management may show the designer the door; domestic mills are very large and have high minimum order requirements. These requirements offer the smaller apparel producer few alternatives.

Finding Skilled Workers

One of the challenges that the men's wear industry faces is replenishing a decreasing source of skilled laborers. Good tailors and sewers are in great demand and unfortunately supply has not kept pace with the demand.

One way that major manufacturing companies handle the labor problem is by utilizing new equipment and computer systems. In recent years, the men's wear industry has become increasingly more machine- rather than operator-oriented. Machines, however, cannot replace the hand-tailoring operation called for in creating men's tailored clothing.

Summary

1. The men's wear industry, the oldest of the apparel industries, began during the early seventeenth century and followed European fashions. Ready-made clothing was produced in seaport cities along the Atlantic coast during the early nineteenth century by slop shops. The California Gold Rush and the Civil War created a greater demand for men's apparel. Production was made possible by the development of spinning and weaving machines, sewing machines, standardized sizes, and sized and graded patterns.
2. The unions played a major role in correcting the poor working conditions in the sweat shops during the twentieth century. Today the Amalgamated Clothing and Textile Workers Union represents the men's wear industry.
3. The men's wear industry plays an important role in the economy of the United States and factories can be found in almost every area of the country. Large firms have expanded their operations to include women's and children's wear. Men's apparel is classified into two major groupings: men's clothing and men's furnishings. Although the men's wear industry has failed to adopt a general size standard, sizing is more standardized than for women's wear.
4. Trade associations play an important role in the men's apparel industry by sponsoring market weeks, trade shows, and other promotions designed to publicize the industry as a whole.
5. Some future trends in the men's wear industry include focusing on customers' changing needs and lifestyles, offshore production, and finding skilled workers.

Fashion Vocabulary

Explain each of the following terms; then use each term in a sentence.

Amalgamated Clothing and Textile Workers Union (ACTWU)

cooperative advertising

custom tailoring

dual distribution

men's clothing

men's furnishings

offshore production

Peacock Revolution

slop shops

standardized sizes

sweat shops

tailored clothing

trade associations

Fashion Review

1. List four historical developments that had an influence on the development of the men's wear industry.
2. Name four important characteristics of the men's wear industry.
3. List and describe the basic men's wear clothing and furnishings categories.
4. Identify two major merchandising and marketing activities of men's wear manufacturers.
5. Compile a list of the major men's wear trade organizations.

Fashion Activities

1. Find five advertisements that feature men's clothing items and three advertisements that feature men's furnishings. For each advertisement, indicate the designer or manufacturer, price, size, and type of apparel.
2. Analyze the men's clothing department of a store that you are familiar with and evaluate it according to the following criteria:
 a. The location in the store: Is it adjacent to another fashion department? Is it near the accessories area? Is it easily accessible to customers?
 b. Compared to other departments in the store, how large is it?
 c. How many salespeople are available?
 d. What are the product prices?
 e. What are the product sizes?

Endnotes

1. Bo Emerson, "Family For Sale," *Chicago Tribune,* Wednesday, April 17, 1991, p. 15.
2. *Statistical Abstract of the United States, 1992,* Volume 112, U.S. Department of Commerce, Washington, DC 20402-9328, Table No. 22, p.20.
3. *U. S. Industrial Outlook For Apparel and Fabricated Textile Products 1992,* p. 33-2.
4. Ira P. Schneiderman, "Men's Wear May Claim Top Billing for '92 Apparel Sales, " *Daily News Record,* Volume 23, January 11, 1993, p. 16.
5. "B & T Underserved, Says Catalog Executive," *Daily News Record,* Tuesday, March 19, 1991, p. 6.
6. "Men's Trends: How They Grow," *Stores,* September 1990, p. 13.
7. "MAGIC Time for Men's," *Stores,* September 1990, pp. 9–11.

Children's Wear

Objectives

After completing this chapter, you should be able to:

1. Describe the history of the children's wear industry.

2. Describe some of the psychological aspects of children's clothing and explain the role demographics play in the industry.

3. Name four characteristics of the children's wear industry.

4. Name and describe the basic children's wear categories.

5. Identify two industry merchandising and marketing activities and describe three trends in retailing children's wear.

t was Thursday night. Millions of viewers had tuned into NBC's "The Cosby Show," one of the most fashion-aware shows on television.

Raven-Symone appeared on the screen in a white dress with multicolored polka dots and a pair of neon colored sunglasses, which covered half of her face. She jumped up and said, "I'll show you the Michael Jackson Moonwalker dance!"

In the 1990s, splurging parents find it difficult to resist the kaleidoscopic hues of this polka-dot dress and other children's clothes from well-known designers like William and Mary Olsthoorn of Holland, who produce children's clothes under the "Oilily" label, widely used in the Cosby Show.[1]

Today, fashionable clothing for children is produced and marketed throughout the world, but it wasn't always this way.

History of the Industry

Like most industries, the children's garment industry in the United States developed over the years and has been affected by many sociological, economic, and political factors. A brief history of the development of the children's wear industry follows.

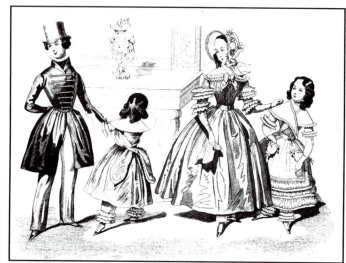

Figure 9-1. In the 1800s, children were dressed in miniature versions of adult apparel. (Courtesy Dover Publications Inc.)

Pre-1910

Before 1910 there was no real children's apparel industry. Children were expected to be "seen and not heard." Their parents dressed them up in miniature versions of adult apparel. Middle- and working-class parents made their children's clothes at home. Wealthier parents spent more money on fashionable children's clothes, purchasing them from their own dressmakers or tailors. Later they turned to manufacturers of adult apparel.

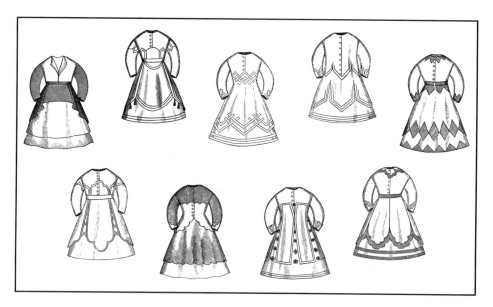

Figure 9-2. Both boys and girls wore ankle-length dresses during the 1800s. (Courtesy Dover Publications Inc.)

These manufacturers merely adapted basic styles of adult apparel and cut them smaller to fit the younger child. In those days, childhood and the needs of children were given no special attention.

Apparel makers did not consider the special needs of children. They gave little attention to proportion or fit, and clothing was poorly designed for children's activities. For example, in colonial times, little girls wore low necklines, layers of petticoats, and pantaloons.

Unlike the youth of today, children of earlier eras had no control of what they wore so they were not interested in clothing selection.

During the early 1800s, all babies wore straight, narrow, ankle-length dresses. Small children, both girls and boys, wore dresses as well. Clothes, according to today's definition of style, were drab, unattractive, and had the look of a uniform.

1900 to 1930

The children's wear industry as we know it emerged as a commercial activity during the twentieth century. In the early 1900s, a few manufacturers began to specialize in high-priced children's wear. They sold these garments primarily to wealthy families.

The mass production and distribution of stylish children's wear began after World War I. This development closely followed the emerging women's wear industry, which was significantly boosted by the carefree and relaxed era of the 1920s, and its accompanying greater freedom for women.

Figures 9-3a and b. Ads from the 1940s reflect the expanding children's wear market and the beginning of targeting this audience with clothes depicting recognizable figures, such as Roy Rogers and the Walt Disney characters. (Courtesy *Everyday Fashions of the Forties as Pictured in Sears Catalogs*)

As women grew more liberated, they stopped making their own clothes and those of their children as well, resulting in additional growth in the children's wear industry. By this time, manufacturers had also discovered ways to make factory-produced clothes sturdier than homemade fashions.

1930 to Today

In the 1930s, consumer demand led to the development of closures, snaps, and other durable techniques of clothing construction. Manufacturers began to produce more functional apparel and developed other self-help features, like zippers, so that children could dress and take care of themselves more easily.

After World War II, there was a tremendous surge in population growth. This period, known as the "Baby Boom Era" (1946–1964) produced an average of 4 million births per year. Apparel manufacturers became more interested in producing apparel for this expanding children's market. Due to increased consumer demand, they designed casual outfits that stressed comfort and easy care.

Through radio and television, children could be targeted directly by advertisers, so ads were geared toward them. Sears, Roebuck and Co. was one of the first television advertisers with its commercials for "Winnie the Pooh" children's clothing. Television especially served to promote a more sophisticated look in children's fashions.

In the 1980s, mothers dressed their daughters as they had dressed their dolls, which was seen as an expression of individual taste. Babies were often clothed in dresses with many frills and colors.

Boys and girls alike had access to comfortable, durable, colorful apparel. Children became more involved with clothing selection, and had more to say about

Figures 9-4a and b. As jeans and western wear grew in popularity for the adult market, the same trends were mirrored in children's wear. (Courtesy Wrangler)

what they would or would not wear. Through television and VCR presentations, they became more style conscious. They were deluged with advertisements for apparel, shoes, and other accessories from many companies.

Children today have definite opinions about every aspect of their lives including clothing, food, and bedroom furnishings. This liberation of children has had a direct impact on the styling of children's wear.

Today, the children's wear industry still takes its cue from the adult fashion scene. The industry incorporates some of the same fashionable trends seen in women's and men's wear. These characteristics are apparent both in children's dress-up and casual apparel. For example, for special occasions some parents buy suits, shirts, and ties for little boys, the same as those for men.

Adult fashion trends, such as jogging suits and running shoes, are also echoed in children's casual wear. The clothing found at GapKids and babyGap stores reflects the adult styles and colors found in Gap stores.

Psychological Aspects of Children's Wear

Many psychologists believe clothes play an important role in shaping and guiding a child's self-image at various stages of development.[2]

Before the age of four, most children do not pay much attention to their clothes. As they mature, however, fashion becomes an important means of self-expression.

Figure 9-5. Childrens' apparel choices reflect their desire to fit in and belong within their peer groups. (Courtesy Health-Tex, Inc.)

Figure 9-6. Parents often dress their children in the latest fashion with well-known labels. Shown here is popular clothing from the Esprit collection. (Courtesy Esprit de Corp.)

By the time children reach the age of four or so, they have established groups of friends their own age. At this point, peer group pressure becomes strong and the need to fit in and belong to the group grows increasingly important. In these situations clothing can be a tool that helps youngsters build self-confidence.

Children are typically happier when they can select something themselves rather than have it picked out for them. Selecting clothing is an important way for children to discover their own identity, learn about risk-taking, and practice making choices.

The way parents dress their children says a great deal about how the parent sees a child. Some parents see a child as a mini-adult, and they may select clothing that is a scaled-down version of their own wardrobe.

Other parents feel their children are an extension of themselves and as such are on display. As a result, they dress their children in the latest fashions, usually with well-known labels. Still others feel that children should be dressed comfortably so they can easily explore the world around them.

Today's children want to be included in the decision-making process or, more frequently, they want to make their own choices. They often accompany their parents on shopping expeditions. They know what they want and freely express their wishes.

Although many parents usually make the final selection, children today have much to say about what they prefer. After all, what parent wants to spend money for an outfit only to see it hang in a closet and never be worn?

MICHAEL SEARLES

Former President of Kids "R" Us

"When Toys 'R' Us understands the ferocity of this business, I think they'll get out." These were the words of one unidentified chief executive of a competing children's wear chain back in 1983. That year the first two branches of Kids "R" Us, the children's apparel division of giant retailer Toys "R" Us, opened for business.

Needless to say, Toys "R" Us did not get out of the specialty store kids' wear business. Instead they met the "ferocity" of the

> *"I see us doing well because of the concept and vision of the company, and its willingness, or I should say, determination to grow."*
> **Michael Searles**

business by hiring Michael Searles as president in 1984.

Searles got his first taste of retailing by managing ski shops in college. After graduation, he worked his way up through the merchandising ranks of the Steinbach department store in White Plains, New York. Later, he became president and chief operating officer.

In 1984, he was offered a position with Kids "R" Us. Ironically, as if to complete his qualifications, on the first day he reported for work, his first child was born.

Searles described himself as having been a "missionary" during the first three years that he was on board.

"Kids 'R' Us' biggest problem at the time I joined the company was getting brands. The company was new; it had gotten too much press. And even though we only had two stores on the map, the din from other retailers was just phenomenal," he explains. "A lot of manufacturers got frightened, and didn't want to risk disenfranchising their regular customers by selling to us. So my job was to wear down the manufacturers, and convince them that we'd be here for the long run," he continued. "In time, we got a stable of brands that finally reached a critical mass, at which point other manufacturers looked and decided they should be here, too."

Searles' matter-of-factness misrepresents the difficulty of the task. The company sued Federated Department Stores and two clothing manufacturers, Absorba Inc. and General Mills' Izod Ltd., alleging a conspiracy to prevent Kids "R" Us from buying the manufacturers' products. Department stores, which usually sell brand-name clothing at full price, often pressure manufacturers to refuse to

continued

supply discounters, such as Kids "R" Us, which offer the same merchandise for less.

Although both suits were dropped, Searles claimed those actions were necessary.

"It was something we didn't want to do; but we felt that if we didn't, the negative momentum would continue," he said. "The value of the suits was that people understood we felt strongly enough to go that far. But then the real key was to get off the issue quickly—after all, retailers do business through relationships, not intimidation."

Today, the chain has a very strong reputation with the big vendors with whom it does business. Some major suppliers include: Osh Kosh B'Gosh, Carter, Levi Strauss, Bugle Boy, Ocean Pacific, Nike, LA Gear, and Lee. These lines cut across a broad range of styles and prices, including major brands, fashion goods, and basics—everything but the lowest prices.

"From birth to adolescence, we have all the clothing they'll ever need," boasts Searles. The chain offers a huge selection of brand-name items at discount prices.

Michael Searles was also responsible for making the physical plant of the chain more conducive to shopping. He noted, "Kids are treated like stepchildren in most big department stores, with their clothes hidden behind the furniture department," so he changed the design of the stores.

The company's first two stores, in Paramus, New Jersey, and Brooklyn, New York, were approximately 15,000 square feet—four to five times larger than the average children's specialty store at the time, and comparable to the children's area in department stores.

There was one long aisle running down 15,000 square feet, which did not exactly represent convenience shopping. With the help of a New York design firm, Searles developed a prototype racetrack design with wider aisles and increased floor space. As a result, the chain quickly grew from 4 to 72 stores.

Today Kids "R" Us stores feature 22,000-square-foot circular layouts with each department and its sizes clearly identified by overhead signage. In addition Searles

has added department identifications, such as Babes "R" Us, Tykes "R" Us, Guys "R" Us, Gals "R" Us, and Shoes "R" Us, with color-coded signs, carpeting, and fixtures. This contributes to shopping ease: blue for boys, purple for girls, and green for infants.

Almost 10 years later, Toys "R" Us has not gotten out of the specialty kids' wear business. Unlike other companies (e.g., Sears McKids), it has successfully met the challenges of the children's retailing business.

In 1990, the chain consisted of 164 stores stretching coast to coast in 27 states with an estimated volume of $550 million. "It's a tough business to operate, and they've been a real leader," states retail analyst Robert Schweich, adding, "The chain's 1991 volume could reach $660 million."

Michael Searles agrees. "Children's wear is very competitive, yet we've seen really few signs of people willing to abdicate the business. And looking ahead, I think it will be an increasingly competitive environment, but I see us doing well because of the concept and vision of the company, and its willingness, or I should say, determination to grow.

"Granted, retailers are born optimists," he adds. "But based on the signs we see, and flavored by our own success, I see us continuing to do very well. In fact, I've already forecast us up to the 400-store mark by the late 1990s."

In 1993, Michael Searles was named Group President for the Women's Specialty Retailing Group of the United States Shoe Corporation, Cincinnati, Ohio.

Question for Discussion. What are the past successes Michael Searles has enjoyed, and in what ways did they influence the growth of Kids "R" Us?

Sources. 1. Penny Gill, "Kids "R" Us: Growing Up," *Stores,* March, 1991, pp. 20–23; 2. "On The Rise," *Fortune,* October 12, 1987, p. 192; 3. Kenneth Labich, "Toys "R" Us Moves in to Kiddie Couture," *Fortune,* November 26, 1984, p. 135; 4. Muriel J. Adams, "Kids' Specialty Retailing," *Stores,* March 1990, pp. 18–23.

Demographics of the Industry

Demographics refers to the fundamental and measurable statistics of a population. They are generally easy to identify and measure. Demographic variables such as age, income, birth rate, and geographic location, are most often used as the basis for market segmentation.

Demographics play an important role in shaping the children's wear industry, making it quite different from the other fashion industries.

Age

In children's wear, apparel needs vary tremendously with age. Many children's manufacturers have carved out a place in the market by concentrating on a specific age segment. For example, Fisher Price produces toys primarily for preschoolers. Carter's emphasis is on outfitting newborn babies. Apparel manufacturers may produce garments specifically geared toward infants, toddlers, children, or preteens. Some manufacturers target their products toward one market or several different markets.

Birth Rate

The number of available customers has an effect on any industry. The size of the children's wear industry is influenced by the **birth rate,** that is the ratio between newborns and other individuals in a given population. The birth rate tends to change in cycles.

As mentioned earlier, the aftermath of World War II brought on a baby boom and the birth rate soared. It was not uncommon for families to have three or four children until the mid-1960s.

During the 1970s, the world population grew very rapidly and people were encouraged to have fewer children. More women worked outside the home, which brought about a decline in the birth rate.

During this period, the average number of children per family decreased to 1.5 and the children's wear market tightened its belt accordingly. Then during the 1980s, the baby boomers reached childbearing age and had an average of 2.0 children resulting in an increase in the birth rate.

At the same time, the number of double-income families also grew, bringing households more discretionary income to spend on clothing and luxuries. Increased income fueled an era of conspicuous consumption; that is, many people spent money for things that are highly visible such as homes, automobiles, and expensive clothing, including children's clothing. What's more, babies and parenting became popular. Movies such as *Three Men and a Baby* and *Look Who's Talking* expressed the growing popularity of babies.

This generation of new parents not only bought more clothing items for each child, but they purchased more expensive items. At the same time, these consumers were more educated and more value conscious, demanding higher quality merchandise. They liked natural fibers, particularly cotton. Many consumers preferred pur-

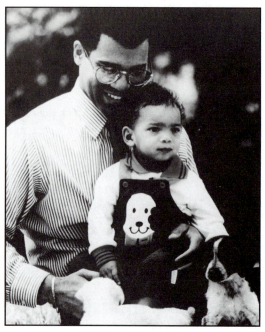

Figures 9-7a and b. The children's clothing industry boomed with the increased birth rate in the 1980s. Babies and parenting became popular, which boded well for this market. (Courtesy Health-Tex, Inc.)

chasing high-quality cotton clothing as opposed to apparel made of synthetics like polyester or nylon fabrics.

It was not unusual to find babies dressed in designer diapers, tailored overalls, and elaborate fashion styles.

One author described the middle-aged baby boom generation in this way:

> When you already own a microcomputer, Cuisinart, telephone answering machine, home video system (including camera and monitor), one or more futons, his-and-her Universal gyms, an indoor herb garden, two or more Dhurrie rugs, and a pasta machine, you feel ready for an animate object and all of the accessories that go with it.[3]

The compulsion to buy baby items was an extension of a well-established pattern of the 1980s.

Income

In recent years, consumers have spent a considerable amount of money on children's apparel. A significant part of that sum is spent by children themselves.

Many of today's children receive more money at a younger age than in previous generations, and the monies available for discretionary spending rise markedly when they enter elementary and high school.

Table 9-1 Projections of Children's Market from 1990 to 2000

	July 1, 1990	July 1, 1992	July 1, 1994	July 1, 1996	July 1, 2000
Under 5 years	**18,408**	**18,314**	**18,005**	**17,586**	**16,898**
Under 1 year	3743	3662	3573	3491	3388
1 year	3636	3587	3501	3416	3295
2 years	3627	3625	3546	3561	3322
3 years	3682	3704	3654	3566	3410
4 years	3719	3735	3731	3651	3483
5 to 9 years	**18,378**	**18,566**	**18,766**	**18,730**	**18,126**
5 years	3736	3724	3745	3694	3519
6 years	3609	3724	3739	3734	3565
7 years	3745	3813	3800	3820	3677
8 years	3612	3565	3677	3690	3605
9 years	3676	3739	3806	3791	3759
10 to 14 years	**17,284**	**18,125**	**18,658**	**18,955**	**19,208**
10 years	3688	3794	3741	3857	3865
11 years	3522	3706	3768	3834	3839
12 years	3405	3641	3742	3693	3819
13 years	3400	3538	3721	3784	3834
14 years	3270	3449	3685	3787	3851

("A Look At Children's Wear Retail Sales For Most of '89," *Stores*, March 1990, p. 17, reprinted with permission.)

In the 1990s, this new group of independent consumers is spending $700 million a year on clothing items alone, a figure which is expected to increase in years to come.[4]

As more women enter the work place on a full-time basis, most children continue to shop independently, with the average 10-year-old making five visits a week to five different stores. Table 9-1 shows that there will be an increase in children 7 to 10 years of age through the year 2000, creating a tremendous opportunity for the children's wear industry to capture this potential market.[5]

As the twenty-first century approaches, researchers predict that by July 2009, 3.5 million people will celebrate their 62nd birthday, 63 percent more than in 1990. This older population will have more disposable income and a desire for spending it on their grandchildren.[6]

Geographic Location

Dividing the market into different locations is called **geographic segmentation.** The theory behind geographic segmentation is that people who live in a similar location

SPOTLIGHT ON A FIRM

THE CHILDREN'S PLACE

The Children's Place is a company that has entered the high-tech age of the '90s. Its stores, which are located in shopping malls nationwide, reflect an appreciation for the latest in creative visual merchandising displays.

The Children's Place targets its specialty shop merchandise toward three distinct markets: girls, boys, and infants. Each of these areas reflects management's desire to make the shopping experience visually appealing. Attention to detail is reflected throughout the store in everything from the carpeting on the floors to the fixtures gracing the building to the selection of hangers holding the garments.

The Children's Place has selected an array of popular brands to feature in its stores including Gloria Vanderbilt, Too Cute For School, Gitano, and Levi Strauss.

This selection of garments reflects the company's desire to attract upscale consumers.

This high-tech state-of-the-art appeal is further reflected in the company's selection of new IBM point-of-sale computerized cash

registers. These machines have the capability of providing standard sales transactions, payroll information, electronic mail, mark-down authorization, and merchandise counts. They also have the ability to collect information from the customer regarding check information

and can retain this until the check clears.

Question for Discussion. In what ways does the Children's Place reach out to its target market?

Sources. 1. Muriel Adams, "Superstore Selling," *Stores,* March 1990, p. 15; 2. Gary Robbins, "CP Takes Technology Leap," *Stores,* March 1990, p. 16.

will have similar needs and wants. Geographic characteristics include region, city size, density of an area, and the climate. The children's wear industry is interested in the geographic location of its customers.

For example, a manufacturer of summer shirts and shorts is interested in identifying stores in the sunbelt states where the demand is greater.

Characteristics of the Industry

The children's wear industry is dynamic and economically significant. It is also concentrated in two parts of the country, as we shall see: New York and Miami.

Economic Importance

There are almost 1000 firms in the United States that produce children's wear which resulted in retail sales of around $20 billion in 1990.[7] These figures demonstrate that the industry holds an important place in our economy and has become increasingly important in recent years.

Today, aside from a few large firms such as Carter's and Health-Tex, the bulk of children's wear firms are small, privately-owned corporations or partnerships. They employ fewer that 60 employees and have annual sales volumes between $2 and $4 million.

In the 1980s, well-known women's wear firms such as Liz Claiborne, Esprit, and Ralph Lauren entered the children's apparel business. These large multi-product companies set up separate divisions for children's wear with their own design, production arrangements, and marketing departments.

Location

Most domestic children's wear manufacturers are located in the North Atlantic region of the United States and are concentrated in New York's garment district. Some factories have moved to the South to take advantage of lower labor costs. To cut down on production costs even further, much children's apparel is imported from Asian countries, Europe, and Central and South America.

In recent years, a substantial number of children's wear manufacturers have sprung up in the Miami area.

Structure and Organization of the Industry

The structure and organization of the industry are similar to those of the women's and men's wear industry. The method of operation, preparation of seasonal lines, and methods of production are quite similar to the adult industries. The children's wear industry can be classified according to price, type of apparel, style, and size.

Children's wear manufacturers usually produce for three seasons a year:
- Spring/summer
- Fall (back to school)
- Winter/holiday

Figures 9-8a, b, and c. The back-to-school fall season is an important time for the children's wear market. (Courtesy OshKosh B'Gosh)

The fall season is the most important, since many new fashion looks are introduced then. Manufacturers plan their fall lines a year ahead and have them ready to show store buyers in March, six months before the merchandise appears in retail stores. Goods that store buyers purchase in March arrive at the retailer between August and October.

Product Pricing

Children's wear is manufactured in four price ranges: boutique, better, moderate, and budget. Boutique children's wear lines include Mother and Child, Laura Ashley, and Bellini. Better-priced range children's wear labels include Pierre Cardin Boys, Plum Pudding, and Calvin Klein. Examples of moderate-priced children's wear are Flapjacks, Gear Kids, and Health-Tex. The budget-priced range includes names such as Wrangler Youthwear, Kid Duds, and Wilson Sportswear.

Product Sizing

The needs of children change constantly as they grow from infancy to adolescence. To satisfy these needs, manufacturers have developed distinct size categories for children's wear.

Infant's wear, 0 to 24 months, is intended for newborns and babies up to one year of age. Usually infant apparel runs from 0 to 3 months, 6 to 9 months, 12, 18, and 24 months. Some infant apparel is sized as newborn, small, medium, large, and extra large. These garments allow room for diapers.

Toddlers' sizes are designed for walking, running, and the other strenuous activities of two- and three-year-old children. They range in size from 2 Toddler (2T) to 4 Toddler (4T). They are also designed with less room for diapers.

Children's sizes include apparel for girls and boys, ages 3 to 6. The size ranges are 3 to 6X for girls and 4 to 7 for boys. This category is often called preschool. There is no extra room allowed for diapers.

Girls' sizes are designed for the older female child and range from size 7 to 14.

Preteen sizes provide more refined styling similar to the junior size range. These sizes range from 6 to 14.

Boys' sizes range from 8 to 20; however, sizes 14 to 20 are usually produced by the men's wear industry. More recently the terms *young men, student, teen,* or *prep* have been developed to satisfy the needs of the sizes 14 to 20 market segment.

Specialization by Type of Apparel

Several children's wear categories are produced by apparel manufacturers. They include:

Tops	Bottoms	Outfits
Blouses	Slacks	Suits
Shirts	Skirts	Dresses
Sweaters	Shorts	
Coats	Swimtrunks	
Jackets	Underwear	

Merchandising and Marketing Activities

The children's wear industry participates in a variety of merchandising and marketing activities. Two of the most important and distinctive are trade shows and licensing.

Trade Shows

There are three children's wear trade shows held in New York City each year.

During the National Kids' Fashion Show, more that 350 apparel manufacturers exhibit their lines to prospective buyers.

The Florida Children's Wear Manufacturers Guild holds an annual market show every September to promote children's spring and summer merchandise.

Licensing

As you recall from Chapter 4, *licensing* is the granting by the owner of a famous name the right to manufacture and market goods bearing that name. Licensing is important in the children's wear industry. Five forms of licensing are popular: designer, character, corporate, sports figure, and slogan licensing.

Figure 9-9. Licensing plays a major role in the children's wear industry as witnessed by a whole store devoted to merchandise tied into the Hanna-Barbara characters. (Courtesy Space Design International)

Designer licensing, the granting by a designer the right to use his or her name on apparel, has become increasingly important in the children's wear industry.

Designer-licensed children's wear features European and American designers such as Laura Ashley, Yves Saint Laurent, Ralph Lauren, and Calvin Klein.

Another popular trend is **character licensing,** the granting by the owner of certain cartoon and toy characters the right to use those names on apparel. T-shirts, sweatshirts, and other apparel items display licensed characters such as:

- Teenage Mutant Ninja Turtles
- Mickey and Minnie Mouse
- Snoopy
- Barbie and Ken
- The Flintstones and The Jetsons

Corporate licensing, the right to use a company symbol or logo on a given item, is also popular in children's wear. Many children wear clothes that advertise the products that they use. Several successful corporate licensors include Pepsi-Cola, Coca-Cola, and Lego. Nonprofit corporations such as the Smithsonian Institution, Purdue University, and the Seattle Seaquarium all offer children's clothing such as shirts and caps bearing their logos.

Large corporations, such as Nike, Reebok, and Adidas, have become involved in **sports figure licensing,** the granting of the right to use the name of a sports celebrity on apparel.

Individuals, such as Michael Jordan of the Chicago Bulls, Wayne Gretzksy of the Los Angeles Kings, and Earvin "Magic" Johnson formerly of the Los Angeles Lakers, have high visibility and enjoy instant recognition both on and off the court. Therefore, they are popular choices for sports figure licensing.

In addition, professional and school teams grant manufacturers the right to license their names on children's apparel, such as Miami Dolphins sweatshirts and Chicago Cubs T-shirts.

Children are making social and political statements on their clothing items. Apparel manufacturers have signed agreements with nonprofit organizations and foundations, known as **slogan licensing,** which allow the company to design clothes

using the group's slogan or logo. An example of this is the "Just Say No" drug prevention campaign. "Greenpeace" and "Save the Whales" are other organizations whose slogans are seen on apparel for children and adults.

Retailing Children's Wear

There are several types of children's retail outlets: specialty store retailers, general merchandise chain and department stores, boutiques, and catalogs devoted to children's wear.

Specialty Stores

Today, specialty store retailing is a rapidly growing segment of fashion merchandising.

Large chains with general audiences like Toys "R" Us have expanded into new market areas and have added Kids "R" Us stores. (See Career Portrait.)

In one shopping mall it is not unusual to find more than one specialty store catering to children, in addition to specialty department or boutiques in anchor stores.

These specialty stores include stores such as GapKids, Esprit Kids, Benetton 012, Limited Too, Laura Ashley's Mother and Child, and Talbot's Kids.

Specialty stores are increasingly more aggressive and are starting new trends in mall retailing, such as the Children's Place. (See Spotlight on a Firm.)

Many believe that specialty children's retailers are the wave of the future and that stores like Kids "R" Us will be around long after some department stores have departed the fashion scene.

General Merchandise Chain and Department Stores

Larger national general merchandise chains like J. C. Penney & Company and mass merchandisers like Montgomery Ward & Co. are developing new marketing strategies.

Because of the competition from specialty stores, many department stores and general merchandise chains are giving more attention to children's wear by expanding merchandise selections and enhancing the appearance of their children's wear departments.

Figures 9-10a and b. Kids "R" Us, the children's apparel division of giant retailer Toys "R" Us, offers a huge selection of brand-name items at discount prices. (Courtesy Kids "R" Us)

Boutiques

To satisfy the wants and needs of the baby boom generation, there has been an emergence of fashion boutiques specializing in high fashion "tot couture." These upscale, one-of-a-kind boutiques offer the latest in fashions, toys, and furniture. Chains such as Baby Guess, Bellini, Nanny, and Toys International provide trendy tots with outfits that make a definite fashion statement.

Affluent adults, both parents and grandparents, are the target market of boutiques. Boutiques provide these consumers with merchandise that satisfies their sense of style and fashions that can be worn to school, parties, or simply on the playground.

Catalogs

Once upon a time, people with rural delivery addresses (RFDs) bought their clothes from catalogs. Sears, Penney's, and Montgomery Ward dressed many generations of children.

The recent "baby boomlet," the birth of children born to the baby boom generation, has prompted a second generation of more sophisticated catalogs geared to children. According to Arnold Fishman, president of Marketing Logistics of Lincolnshire, Illinois, a direct marketing services company: "They're not more successful, necessarily, but they're higher quality and geared toward the upscale market."[8]

Popular clothes catalogs that specialize in children's wear include: Tortellini, the Wooden Soldier, Mother and Child, Talbot's Kids, and Lands' End.

Mail-order merchants like Gun and Tom Denhart have built a blockbuster catalog business by selling bright natural-fiber clothing to baby boomer parents. In just seven years, the Denharts have grown a $20 million Portland, Oregon-based company, Hanna Anderson Inc. Ms. Denhart describes her success: "We came at the right time with the right kind of product. A lot of these babies are born to parents who've postponed parenthood. They're two-income families who have a little more money to spend on their children."[9]

Catalog shopping has increased in popularity because many people no longer have time to shop nor do they enjoy it. In the 1990s, more than 12 billion catalogs were crammed in the mailboxes of suburban and city dwellers.[10]

Other firms are catering to the special needs of children. Kids At Large, a Massachusetts-based mail-order company, makes stylish clothes exclusively for large-size boys and girls. The catalog offers acid-washed jeans and funky neon-colored shorts. Owner Copie Lilien says, "It's hard enough being heavy without worrying about having the wrong clothes. We're really building self-esteem."[11]

The baby boom of 1990 has led to an explosion of specialty catalogs geared toward children. Mall-weary mothers and fathers have discovered the convenience of shopping at home. This pattern is expected to continue in the future.

Future Trends and Implications for the Industry

The children's wear industry will have to focus on some very important consumer trends to compete successfully in the twenty-first century.

Steps IN
CREATING A GARMENT

1

We enter the Saint Laurie workrooms and see a mural showing the Kozinn family with a statue of a seamstress.

In developing a new fashion look, let us follow the process used by the New York City men's wear manufacturer, Saint Laurie, in creating a sports coat.

2

Saint Laurie designer, Avery Lucas, sketches a design for a man's sport coat.

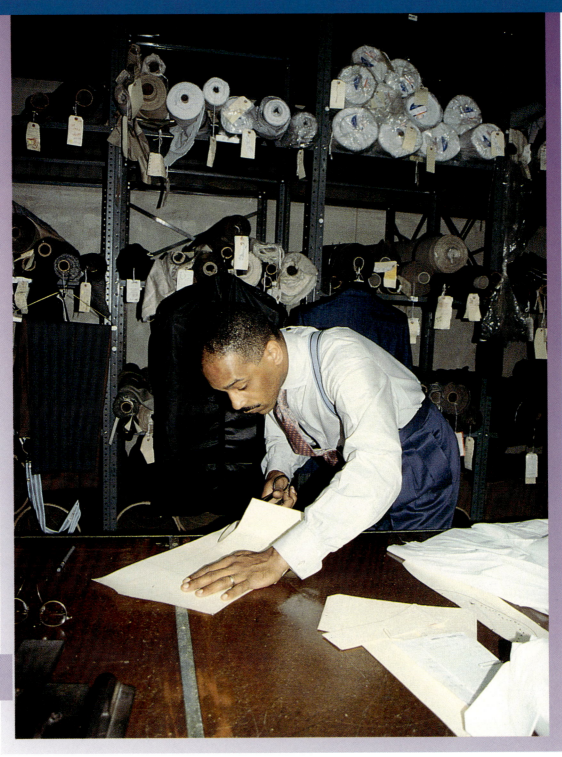

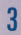3

He cuts a paper pattern.

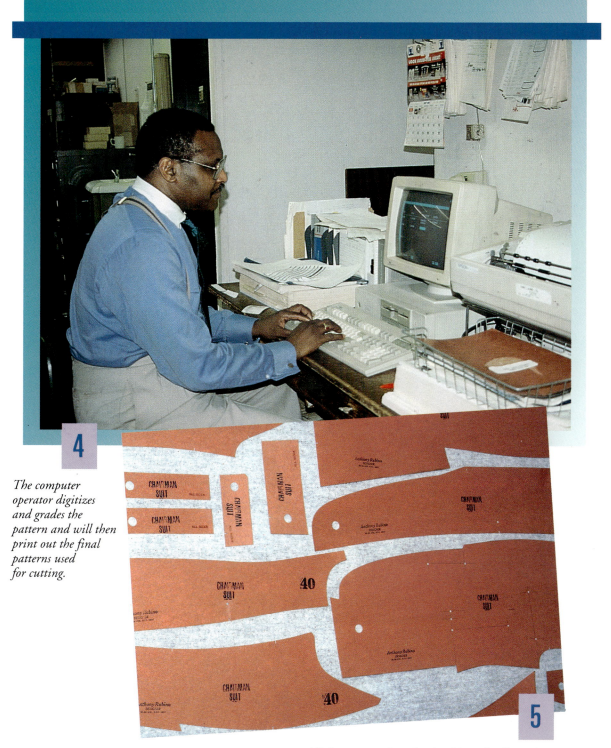

4

The computer operator digitizes and grades the pattern and will then print out the final patterns used for cutting.

5

All the pattern pieces for size 40 are finally ready to cut.

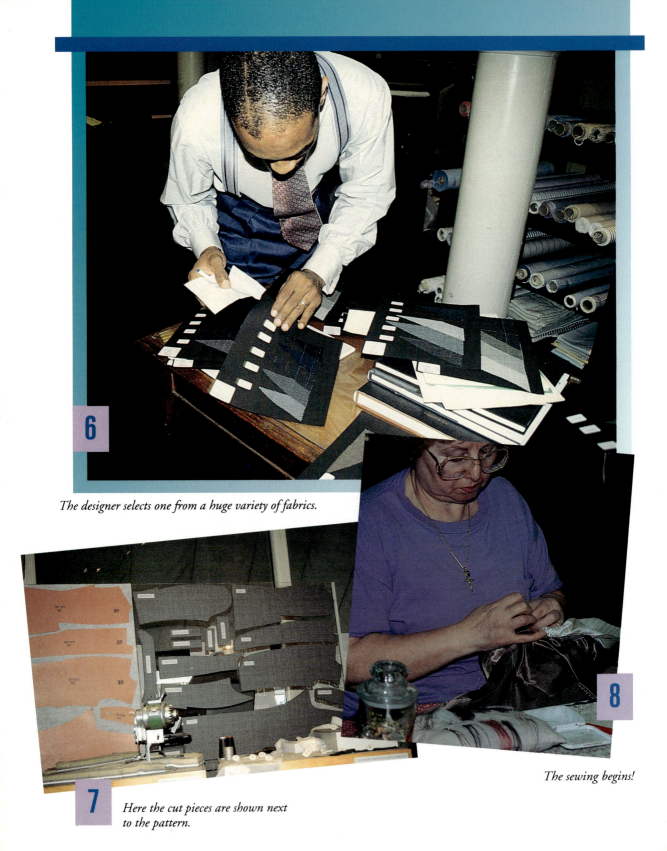

6 The designer selects one from a huge variety of fabrics.

7 Here the cut pieces are shown next to the pattern.

8 The sewing begins!

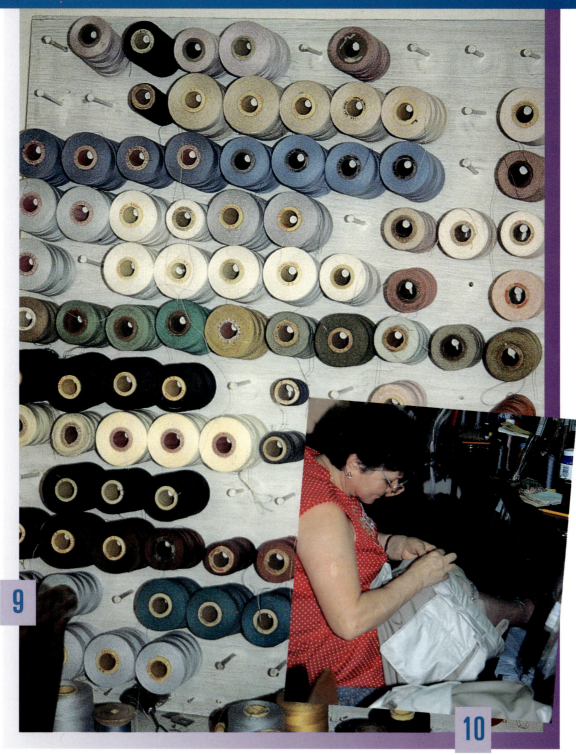

9

10

Threads...dozens of spools of thread...

The sewing continues...

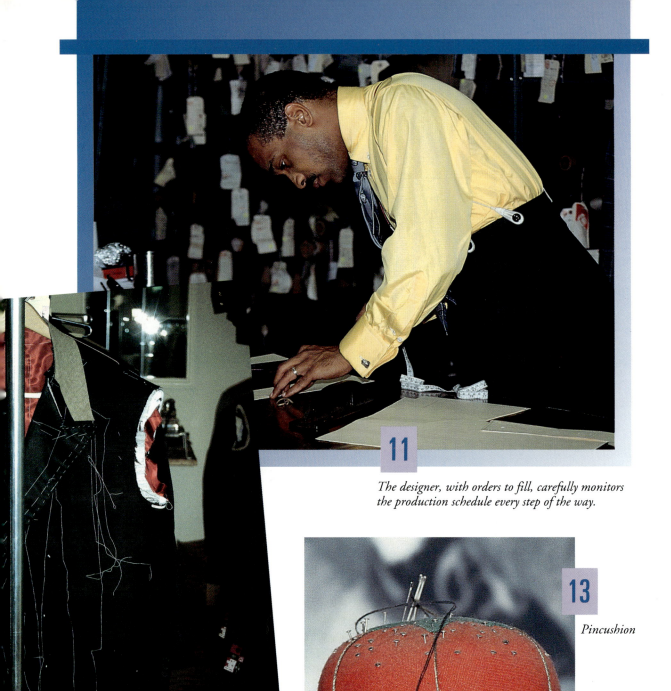

11

The designer, with orders to fill, carefully monitors the production schedule every step of the way.

13

Pincushion

12

At one point, the sports coat is covered with a bewildering number of basted threads.

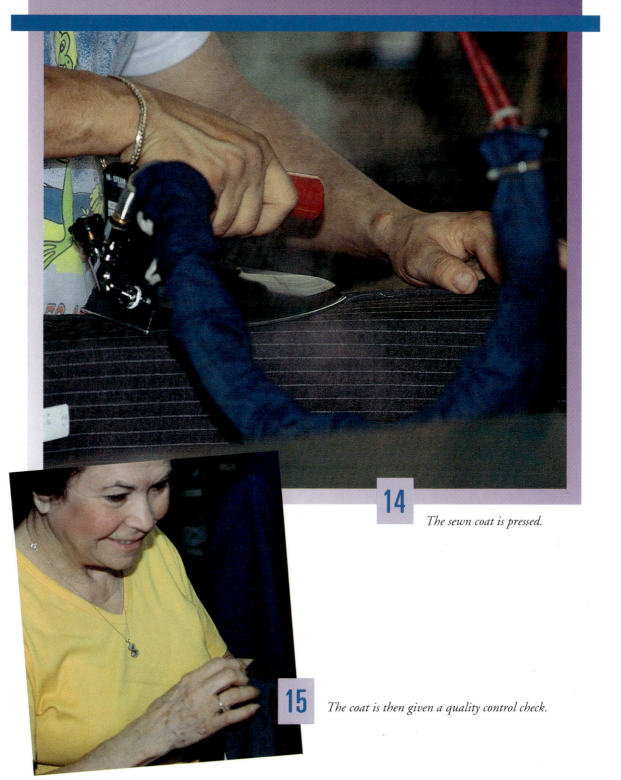

14

The sewn coat is pressed.

15

The coat is then given a quality control check.

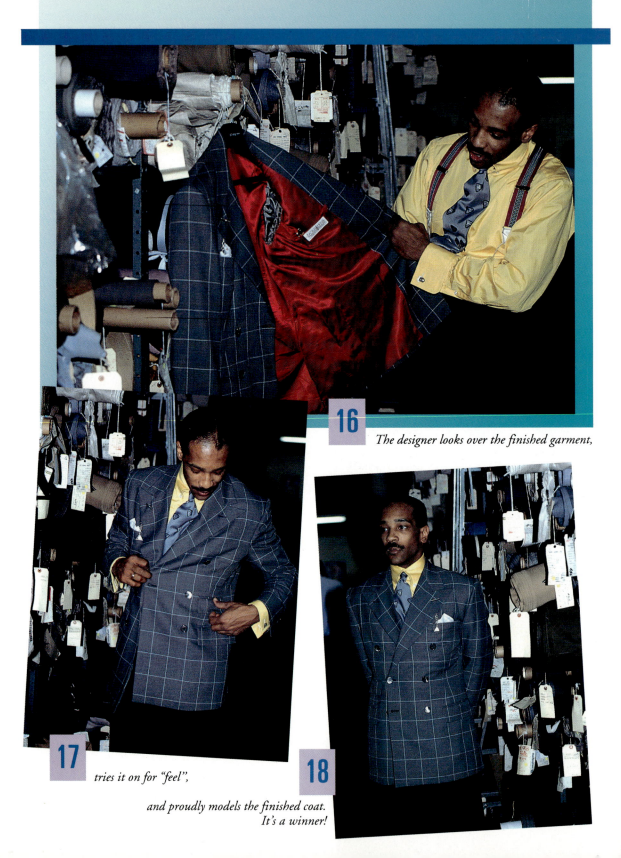

16 *The designer looks over the finished garment,*

17 *tries it on for "feel",*

18 *and proudly models the finished coat. It's a winner!*

By the year 2020, experts predict that immigration will become more important to U. S. population growth than natural increase and the population will diversify even more rapidly.

The family unit as we know it will be redefined. More than half of all children will spend part of their lives in single-parent homes. By the year 2010, about one in every three married couples with children will have a stepchild or an adopted child.

Full-time homemakers will become even rarer. Most children will never know a time when their mothers did not work outside the home. As the new century begins, more than 80 percent of women aged 25 to 54 will be in the labor force. This means that families will have less leisure time to shop and will need alternate ways to buy: catalogs, television, mail, and phone orders. Children themselves will be doing more spending for apparel.

Summary

1. The children's wear industry developed over many years. Prior to 1910, there was no real children's apparel industry. Manufacturers adapted basic styles of adult apparel to fit children. The special needs of children were not taken into consideration.
2. Commercial production and distribution of children's wear began shortly after World War I. Manufacturers developed ways to make factory-produced clothes sturdier than homemade fashions. After World War II, there was a tremendous population growth and apparel manufacturers produced more apparel for the expanding children's market. Through radio and television, children could be targeted directly by advertisers, and they became more involved with clothing selection.
3. There are almost 1000 firms in the United States that produce children's wear. Most are located in the North Atlantic region of the United States. Manufacturers usually produce three seasons a year, which include Fall, Winter, Spring/Summer. Garments are manufactured in four price ranges: boutique, better, moderate, and budget. Children's wear is divided into distinct size categories, including infants, toddlers, children's, girls, and boys.
4. Children's wear manufacturers participate in two types of merchandising and marketing activities: trade shows and licensing. Trade shows are held in New York City and Florida. Manufacturers are involved in many types of licensing: designer, character, corporate, sports figure, and slogan licensing. There are several types of children's retail outlets: Specialty stores, department stores, boutiques, and catalogs are the most popular forms.
5. The children's wear industry will have to focus on some important consumer trends during the 21st century. Immigration will become more important and the population will diversify more rapidly, and the family unit will be redefined with more than half of all children raised in single-parent homes.

Fashion Vocabulary

Explain each of the following terms; then use each term in a sentence.

birth rate demographics infants' wear

boys' sizes designer licensing preteen sizes

character licensing geographic segmentation sports figure licensing

children's sizes girls' sizes toddlers' sizes

corporate licensing

Fashion Review

1. What three factors encouraged the development of the children's wear industry?
2. Explain the role demographics play in the children's wear industry.
3. Name the three major size categories of children's wear and list three types of clothing items within each group.
4. What are the four basic price ranges in children's clothing?
5. Name and describe several forms of children's wear licensing.
6. How do manufacturers show and promote children's apparel?

Fashion Activities

1. Identify the types of licensing and categories of apparel you see today. Make a list of the licensed children's apparel you have seen recently, noting the form of license (character, corporate, designer, sports figure, or slogan) and the type of clothing item. Then develop a licensed apparel item for children and be prepared to state why you believe it would be accepted by children.
2. You want to own your own children's wear specialty store. Write a paragraph stating whether you would need to operate a branch of a well-known chain, such as Laura Ashley or Esprit, or whether you would start your own business from scratch. Explain your reasoning. (You may refer to the Chapter 4 discussion of business ownership forms and licensing.)

Endnotes

1. "Dutch Treats for Splurging Parents," *People Weekly,* Spring 1990, p. 70.
2. "Kids and Clothes," *American Baby,* February 1985, p. 34.
3. Ann Walmsley, "A Boom in the Baby Business," *Maclean's,* May 20, 1985, p. 52.
4. "Children as Customers," *American Demographics,* September 1990, pp. 36–39.
5. Ibid.
6. Ibid.
7. *U. S. Industrial Outlook,* 1990, U. S. Department of Commerce, Research Department, Washington, D. C.
8. Debra Kent, "History Lessons Pay in Reaching Kids," *Advertising Age,* October 26, 1987, p. S-13.
9. Stephen Wilkinson, "The Bold New Force in Kids' Wear," *Working Woman,* November 1989, p. 54.
10. Ibid.
11. Debra Rosenberg, "One Small Step For Bigger Kids," *Newsweek,* November 26, 1990. p. 73.

Intimate Apparel and Cosmetics

Objectives

After completing this chapter, you should be able to:

1. Describe the silhouettes achieved by intimate apparel throughout history and name several current intimate apparel looks.

2. Name the four major segments of the intimate apparel business and give examples of garments from each.

3. Describe some of the trends and fashion influences in cosmetics throughout history.

4. Name the two main segments of the cosmetics market and tell how they differ.

5. Describe several key marketing and merchandising techniques and trends in the cosmetics industry today.

The time: July 1861. The place: Charleston, South Carolina. "Ooooh," squeals 18-year-old Julia, as she tightens her grasp on the bedpost, and braces herself for the next yank at the strings of her already rib-crushing corset. Mary, her sister, secures her hold on the corset strings and readies herself for the next pull, saying, "Just hold on and suck in! I can still get it tighter!" After tying the ends to hold her sister's corset in place, Mary goes back to finish dressing herself for the neighbor's midday barbecue party. Over the bell-shaped fullness of her layers of petticoats she pulls on a low-cut, shoulder-baring dress with eyelet trim and a big red bow. At the sight of it, Julia warns, "Just keep your shawl on your shoulders— Mama will be furious if you get all freckled!" Just then, the girls' father calls impa-

tiently from downstairs saying that they are ready to leave. Taking a last look in the mirror, Julia bites her lips to redden them, then bends to retrieve her parasol from under a table where it has fallen. "Oooh," she squeals again, straightening up quickly. "My corset is so tight, I may faint before lunch!" she confesses to Mary as the sisters run out of the room.

This scenario, reminiscent of a scene involving Scarlett O'Hara in the classic film and novel *Gone With the Wind,* is sure to evoke a smile of amusement from any modern young woman imagining the ordeal endured by women in the mid-1800s when dressing for a party. Indeed, it is difficult today to relate to the beauty standards of pre-Civil War America, which necessitated the use of excruciating undergarments to create artificially miniature waists, and enormous hats and parasols to help "true ladies" protect their pale, milky-white complexions from the ravages of the sun.

Truly, the lifestyle of the late twentieth century is a far cry from that of the 1850s. In general, women are more relaxed about beauty and feel comfortable with more natural looks. As a result, the undergarments they wear are designed to follow the true shape of their bodies more closely; and the products they use to enhance their complexions are most often ones created to give a healthy, glowing, natural look to the skin. This is not to say that fashion trends do not remain an integral part of these two categories. Indeed, today's undergarments, known as body fashions or **intimate apparel,** and skin and beauty products, referred to under the banner name of **cosmetics,** reflect the styles and cultural influences of the time just as closely as the more visible fashion apparel and accessories discussed in preceding chapters.

Intimate Apparel

Just as the clothing men and women have worn through the ages reflects the prevalent tastes of the time, so does the shape of their bodies beneath those clothes. In the early 1600s, for instance, the women considered to be most attractive were "pleasingly plump," as is evidenced by the voluptuous nudes in the paintings of Flemish artist Peter Paul Rubens. In the 1920s, the exact opposite was the fashionable look, with women striving to achieve straight, slim, boyish figures. But whatever the style of the moment, women have generally been able to enlist the help of undergarments that would push, pinch, prod, or pad them into the desired shape.

History

As you recall from Chapter 6, through many centuries, women's apparel styles were simple and straight, requiring no adjustment to the figure beneath. Plus, throughout the greater part of history, standards of modesty were far different from those of today, and people perceived no particular need for covering the more private parts of their anatomy other than with their outer garments. One of the first changes to the straight sheath look came around 3000 B.C. on the Greek island of Crete. Foreshadowing our "Southern belle" Julia's ordeal, the Cretan women tightly cinched their waists with metal corsets to achieve an "hourglass" figure, while their breasts

remained bared atop cutaway bodices. That silhouette was so much the rage that boys and girls were actually soldered into metal corsets during early childhood.[1]

Still in Greece around 1500 B.C., the first precursor of the modern brassiere took the form of a "bandolette" made up of ribbons wrapped loosely around the shoulders and underneath the bosom. It was often accompanied by the wearing of a "zone," a girdle-like band of linen that women wound tightly around their waist and hips to flatten their stomachs. By 400 B.C., Greek women were taking even more interest in their bustlines, and scrunching the cloth of their robes around their bodices, creating, in effect, the first padded bras.[2] Meanwhile, in Rome during the last century B.C., some women took to wearing the "subucula," or undertunic, over briefs and a breastband, while others preferred a single piece of cloth wound around the torso, or even a wide, tight girdling garment to hold in their stomachs and hips.[3]

During the Middle Ages, corsets were still compressing the waists of fashionable women, though by now they were the kind that could be laced up, and were made of linen reinforced with whalebone or metal bands. Bosoms were flattened along with hips and waists in this era, as well, by means of a decorative pasteboard called a **stomacher,** which covered the chest and filled in the deep V-necks of medieval gowns.[4] By the mid-sixteenth century, the stomacher was gone (at least until it had a reappearance in the next century), but corsets were tighter than ever. Made of iron, leather, or canvas, with bones of wood or steel, these corsets were silk-lined and worn over a chemise, or simple slip-like undergarment. On top of the corset, noblewomen wore a petticoat and a farthingale, or wide, hooped support to hold their skirt straight out from their hips, further accentuating the tiny waist. In fact, Italy's Catherine de Medici decided that having a thick waist was "bad manners," and proclaimed 13 inches to be the perfect waist size—a width achieved by tightening the corset so much that women's ribs actually overlapped![5]

In the early 1700s, the farthingale gave way to the bustle, a rounded cage form or pad that caused the skirt to protrude only in back, and which enjoyed its real heyday toward the end of the 1800s. By the 1730s, skirts came full circle again, with the introduction in France of the "pannier," or hoop structure that rigged the skirt into a bell shape; after which new understructures were developed that allowed the skirt to lie flat in the front and back, but extend to the sides of the hips as much as eight feet, creating havoc with seating arrangements in theaters and other public places.[6]

Through the 1800s, tightly laced corsets remained the basic undergarment of choice for the bodice, joined by the **crinoline,** or full, stiff underskirt often sewn into steel-cage hoop structures in a continuation of the bell shape for women's wear. Near the turn of the century, however, the more active women abandoned their long, bulky skirts in favor of loose-fitting, knee-length trousers, which would evolve into a new style of undergarment named bloomers, after their inventor, Amelia Bloomer. And as the twentieth century ushered in a new era for women's lifestyles and fashions, even the die-hard corset ended its long reign—though it would soon be replaced by its modern counterpart, the elasticized girdle.

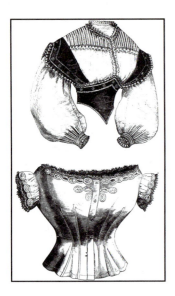
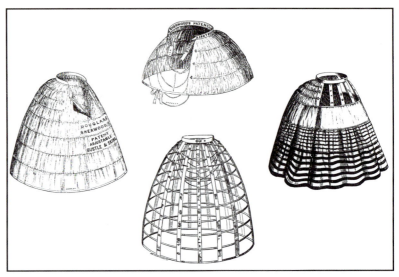

Figures 10-1a and b. Undergarments popular through the 1800s included elaborate, tightly laced corsets, full stiff underskirts, and steel-cage hoops. (Courtesy Dover Publications Inc.)

For the new century, women turned their attention away from crinoline and toward softer petticoats of satin and silk, often made with lace trim. The short, sleeveless teddy first appeared in the 1920s. Unlike its predecessor, the camisole, which was originally worn as a protective layer over a corset and under a dress, the teddy was worn by itself under the flapper's straight, slim fashion looks. Those looks were also accompanied by the first modern brassieres, although initially the simple bras were designed not to support, but to actually flatten the bust. In 1927, this began to change, when William Rosenthal, founder of Maidenform, received a patent for his "Maidenette" bra, made of lined cotton mesh with separate natural shaped cups joined by a piece of center elastic. It was not until late in the 1920s and the 1930s that manufacturers began inserting **bones,** or strips of stiff whalebone or steel, to provide shape, and producing bras with different cup sizes. Padded bras joined the selection in the 1940s; and while rebellious feminists and other liberated women made a political and societal statement by burning them in the 1960s—at the same time they were abandoning girdles in droves—brassieres returned to vogue in the '70s, with new softer styles and seamless constructions geared to a new generation of women.

The 1970s also saw the widespread donning of pants and pantsuits by women entering the workforce in record numbers; and as a result, slips and half-slips designed to be worn under skirts disappeared from many a woman's lingerie drawer. By the early 1990s, however, a new generation of slips came into vogue, many in hip-slimming and body-shaping versions, such as the HipSlip by Bodyslimmers, which was introduced in 1991. In fact, stylings of all types of intimate apparel have

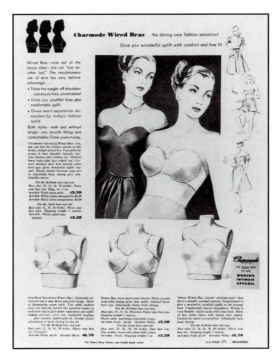

Figure 10-2. An intimate apparel ad from the 1940s emphasizing comfort, fit, and shape. (Courtesy *Everyday Fashions of the Forties as Pictured in Sears Catalogs*)

continued to evolve into the '90s, with comfort going hand-in-hand with garments created to flatter the silhouette.

Indeed, the last several years have seen something of a renaissance in intimate apparel. Some of that renewed interest is based on materials and technology that allow manufacturers to create more comfortable and functional garments. Stretch fabrics, particularly those made with spandex fibers such as Du Pont's Lycra, for instance, have ushered in a whole new era for control undergarments. Although the panty girdle, which was worn by millions of women in the 1950s and early 1960s, fell almost completely out of favor in the fitness-conscious '70s and '80s, this new generation of "shapers" is now appealing to the aging baby boomer segment of the market. These women may not need or want the uncomfortably firm control of the old girdles, but feel that even after exercising, their tummies, fannies, and thighs could use a little slimming with up-to-date control slips or toning, bike-short type undergarments.

At the same time, fashion is more important than ever before in intimate apparel, and is likely to remain so throughout the 1990s. Much of the credit can go to Victoria's Secret, the specialty store division of The Limited that brought lacy, frilly, and sensuous intimate apparel out from under wraps and into the forefront of the public eye as a full-fledged fashion category. In addition, pop celebrities—Madonna, in particular—contributed strongly to the early 1990s lingerie-look trend of women wearing "innerwear as outerwear." Even for those not daring enough to don exaggerated cone-shaped bras and the like over their clothing, items such as shoulder-

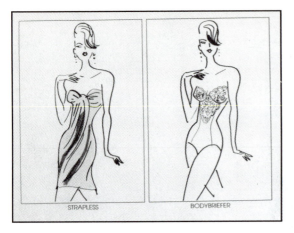
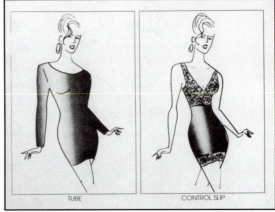

STRAPLESS BODYBRIEFER TUBE CONTROL SLIP

Figures 10-3a and b. Intimate apparel, or "innerwear," styles reflect and often enhance current silhouettes in outerwear, subtly shaping the body to achieve a particular line. (Courtesy Du Pont Company)

padded camisoles, stretchy crop tops, and lacy **bustiers,** the popular waist-length and often decorative strapless bras, were crossing the line and showing up as streetwear with jeans or under suits.

Characteristics of the Intimate Apparel Industry

During most of the 1980s, the intimate apparel market was steady but not booming. By the end of that decade and into the early 1990s, however, the "innerwear-as-outerwear" trend took hold, and both manufacturers and retailers of intimate apparel began marketing the garments more as fashion items, rather than as replacement items, as had been the traditional approach. Those trends helped to push retail sales to a record level of about $7.2 billion for the category in 1992.

Like the hosiery category, which is closely related to the intimate apparel field, by far the majority of intimate apparel sold in the United States is domestically manufactured. Also like hosiery, many American intimate apparel companies base their manufacturing operations in the southern states, although most of them also maintain showrooms in New York. Some of the largest and best known U. S. manufacturers are Maidenform, Warner's, Vanity Fair, Playtex, and Olga.

In addition, a number of leading ready-to-wear designers lend their names to collections of intimate apparel, reaffirming the strong fashion influence now prevalent in that category. In most cases, the designer merchandise is produced under a licensing agreement with an intimate apparel manufacturer. For instance, Maidenform offers an Oscar de la Renta line, Heckler Manufacturing produces both Calvin Klein and Adrienne Vittadini intimate apparel, International Bodywear Corp. sells Adolfo shapewear, and Wacoal launched a full collection of Donna Karan intimate apparel in the fall of 1992.

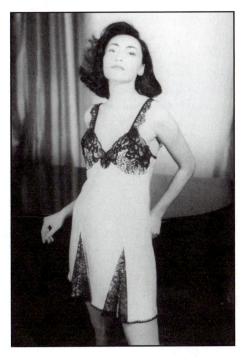

Figure 10-4. Designers such as Josie Natori have contributed greatly to the fashion influence in intimate apparel. (Courtesy Natori, Inc.)

Structure and Organization

The term *intimate apparel* may first call to mind the most basic types of underwear, such as brassieres and panties; but the industry is actually much broader than that. In fact, it is generally divided into four major segments:

- **Foundations** are intimate apparel items that either support or control. Included are classic bras designed to support the bosom, as well as all levels of shaping undergarments from underwire bustiers, to light-control panties, through full-fledged girdles.
- **Daywear** includes all other types of intimate apparel meant to be worn primarily under outer layers of clothing. In this segment falls a wide array of garments ranging from slips and half-slips, to camisoles and teddies, to soft bras and panties, and all-in-one bodysuits.
- **Sleepwear,** just as it sounds, consists of pajamas, nightgowns, and other apparel designed for sleeping. One of the newest classifications within sleepwear is the popular sleeptee, resembling an oversized T-shirt. Together, daywear and sleepwear comprise the portion of intimate apparel known as **lingerie.**
- **Robes** and **loungewear,** sometimes referred to as "leisurewear," is comprised of a variety of garments designed primarily for at-home, leisure-time comfort. Along with traditional robes are such items as leggings, fleece pants and shirts, and dusters.

Products in all four of the major classifications are offered in a huge variety of styles and at a wide range of price points, depending on the manufacturer and the type of retail outlet through which the garments are sold. New styles and collections are presented by manufacturers to retail buyers five times a year in market weeks held in Atlanta, Chicago, Dallas, Los Angeles, New York, and San Francisco. These market weeks generally coincide with fashion accessories markets, since the same retail buyers frequently buy both categories.

Merchandising and Marketing Activities

The intimate apparel business, particularly in the segments of foundations and daywear, has traditionally received strong marketing and merchandising emphasis from both manufacturers and retailers. Sales support has frequently come in the form of both print and television advertising by major manufacturers as well as newspaper advertising and catalog or sales brochure exposure by retailers. One of the most memorable advertising campaigns of recent years was a series produced by Maidenform, picturing a variety of history's more outlandish silhouettes and stating, "Women have spent the last 10 centuries conforming to their lingerie. Fortunately, lingerie has finally gotten around to conforming to women."

In addition, intimate apparel manufacturers generally work closely with retailers, department stores in particular, to conduct special sales promotions once or twice a year. These promotions are designed to inspire consumers to make multiple pur-

Figure 10-5. The increasing fashion aspect of intimate apparel has led retailers to create more appealing displays, with a greater amount of merchandise unpackaged and hanging on racks for customers to examine. (Courtesy P. A. Bergner/Boston Store)

Figure 10-6. The importance of stretch qualities to provide comfort and fit in intimate apparel is emphasized in marketing and merchandising, such as in this "Intimates with Lycra" boutique, created at Bloomingdale's in conjunction with Du Pont. (Courtesy Du Pont Company)

chases, especially of bras and panties, often by offering special pricing such as "buy two, get one free." The stores alert their customers to these limited time offers through such vehicles as newspaper ads, billing inserts, or direct mail brochures.

Within department stores themselves, the merchandising of intimate apparel has taken a stronger fashion direction in recent years, in keeping with the new array of colorful, fashionable garments being introduced by manufacturers. The tremendous success of the Victoria's Secret specialty chain, with its elegant presentations of lingerie, has led many other retailers to upgrade the visual look of their intimate apparel departments and step up their own assortments of the newest colors, prints, and fashion stylings. Some stores have even renamed their departments in an effort to emulate Victoria's Secret's image. Belk's, for instance, calls its department Marianne's Boutique and Marshall Field's identifies a section of its intimate apparel department as Amelia. Even discount stores, such as Target, have redesigned their lingerie areas to provide a softer, more feminine atmosphere for shoppers. By this strategy, and by stressing well-known brand names such as Vassarette, Playtex, and Bestform, discounters have been steadily increasing their share of the intimate apparel market in recent years.

Intimate apparel also receives heavy marketing support from key suppliers of fibers used to produce the garments, most notably Du Pont, which manufactures the stretchable Lycra along with many other fibers. In fact, in 1990 Du Pont began working with a number of major department stores, including Bloomingdale's and The Bon Marché, to create special "Intimates with Lycra" boutiques, featuring a broad array of foundations, daywear, bodywear, and loungewear all made of fabric blends that include Lycra. The giant fiber company worked closely with the stores in all aspects of the boutiques, helping decide how the shops would look and training the sales staff in how to sell the stretch qualities of the Lycra garments.

In addition, the Intimate Apparel Council, a division of the American Apparel Manufacturers Association, which is made up of intimate apparel designers, manufacturers and suppliers, recently began sponsoring a special Lingerie Week each spring. Timed to fall between Easter and Mother's Day, traditionally a slow sales period for intimate apparel, the promotion involves special events, publicity, and signing at participating stores in an effort to stimulate retail sales for the category.

Future Directions

Probably the most important direction for the intimate apparel category through the 1990s is the continuing crossover between lingerie and ready-to-wear looks. Even as the intimate apparel industry creates new stylings that are pretty and functional, either under other garments or on their own, ready-to-wear designers are incorporating lingerie looks into their outerwear collections. Garments such as camisoles, bustiers, bodysuits, bike shorts, and hipslips are crossing the line from innerwear to outerwear with increasing frequency, both in retailers' displays and on the streets. Plus, the lines between intimate apparel and hosiery are blurring as well, as companies in both categories pursue the concept of shaping and control in their garments, and hosiery manufacturers add lingerie looks, such as lace-panty tops, to their traditional lines.

Even as manufacturers create foundations and daywear in every fashion color and print imaginable, the "bread and butter" of the business is expected to remain in the basics of white, beige, and black. Even those basics, however, will continue to benefit from the innovations in fabrics and constructions progressing through the decade. The area of stretch, for instance, continues to revolutionize all segments of the intimate apparel market. In its most talked about application, new stretch technologies are behind the burgeoning new classification of control and shaping garments, which bear far more resemblance to daywear than to traditional girdle-like control garments. Stretch fabrics are also exerting an influence on other types of intimate apparel. In sleepwear, for instance, fabrics with stretch qualities are being used to create items like chemises that offer comfort for lounging or sleeping, along with the fashion look of ready-to-wear. And even padded bras are getting a more comfortable and easier fit, with stretch now built right into the padding.

In the area of marketing, the remainder of the 1990s will most likely see heightened competition among both manufacturers and retailers for customers' intimate apparel purchases, as consumers continue to control their spending. The result may be a closer attention to pricing, as illustrated by the addition of three bridge price groups in 1992 to Warnaco's Valentino Intimo designer line. Increased competition may also generate even more licensing activity, whereby intimate apparel producers seek out brand names with instant consumer recognition to embellish their lines with a "pre-sold" quality. Among the most recent names to adorn licensed intimate apparel lines are No Nonsense and Jovan, as well as *Cosmopolitan*, which the fashion magazine has licensed to manufacturer Kiki for a sleepwear collection.

JOSIE NATORI

President,
The Natori Company

If Josie Natori's lingerie appeals to the woman of the '90s, it is probably because Natori herself is a consummate woman of the '90s. As founder and president of The Natori Company, her self-stated mission is to create a way of dressing "for women like me, who believe that nine-to-five is not all of themselves." In a nutshell, Natori designs clothing for the independent woman to wear after five o'clock as well as under her career-dedicated exterior, to express her other side—the sophisticated, sensual woman who is suppressed in the work world.

> *"What we need to do is to be attuned to the lifestyle changes of the consumer. We must adjust our thinking to mirror her '90s attitudes. We have to liberate our definition of intimate apparel." Josie Natori*

There is no question that Natori understands that work world well, since, before launching her own company in 1977, she commanded a six-figure salary as an investment banker on Wall Street. It was a career she had known she wanted since she was a child; and yet, it was not her only ambition. In fact, by the age of nine, she had achieved her first goal of being a concert pianist, when she performed as a soloist in a full orchestra recital. "I didn't know how I was going to be a stockbroker and a concert pianist

at the same time, but I held onto both dreams," she says, looking back.

When she was 17 years old, the stockbroker dream took top priority, as she left her native Philippines for New York, to study economics at Manhattanville College. After graduating in 1968, she joined Bache Securities as a stockbroker, later switching to investment banking at Merrill Lynch in 1971, where she soon became a vice president. In 1972, she married Kenneth Natori who was also an investment banker; and in 1976, their son was born.

It was during her maternity leave that the idea of starting her own business took hold. While she reveled in the fast-paced, competitive world of Wall Street, she missed using her aesthetic sense—the "piano-playing" side of her nature.

Not yet clear about how to channel her artistic leanings, Natori went back to her Philippine roots. A friend there had sent her a dozen blouses that featured the embroidery of local artisans, and armed with them, she walked into Bloomingdale's—only to find that the blouse market was saturated. A Bloomingdale's buyer suggested,

continued

however, that she turn the blouse into a nightshirt, since new ideas in sleepwear were in short supply. Even though Natori was not sure what a nightshirt was, she created a new sleepwear look for the blouse; and sales of the unique garment took off, launching Natori firmly into the lingerie business. In less than three months, her living room was crowded with racks from which she sold $150,000 worth of orders to such major department stores as Saks Fifth Avenue and Neiman Marcus.

One key to Natori's immediate success was the novelty of her garments. In the 1970s, sleepwear was still a commodity business in which styles changed indiscernably from year to year. But using the delicate appliqué work and embroidery for which the Philippine islands, with their 350 years of Spanish heritage, are famous, Natori gave sleepwear buyers more than simply a feminine alternative to "Granny" gowns. What's more, in doing so, she challenged the industry's misconceptions about who bought lingerie and why, recognizing that a successful woman would buy her own $300 sleepwear sets instead of waiting for a man to give them to her.

In bringing her fresh perspective to the industry, Natori has also balked at the traditional labels of lingerie marketing, such as "sleepwear," "at home," and "leisurewear," feeling that they patronize women. "Women today don't need to be told when and where to wear what," she says. "They can figure that out for themselves." In saying this, she speaks from her own experience as a woman who balances the conflicting nature of her roles at work and at home as wife and mother; she understands instinctively a woman's desire to dress to match her mood, to convey her feelings about herself in her private life.

The style Natori has developed to cater to that woman is elegant and contemporary, and tempered by traditional details—sometimes Oriental, sometimes European, but always feminine. Not for women who want to hide themselves in shapeless nightgowns, the Natori look is luxurious and soft-edged, yet sophisticated. What's more, Natori has worked to aggressively expand her business, translating her creative vision and lush designs from the sleepwear category into a wide range of products from intimate apparel, to ready-to-wear, to home textiles.

For instance, a recent intimate apparel collection included Hollywood-style, glamorous sleepwear such as flowing gowns, smoking jackets, chiffon baby-doll shapes, and luxurious velvet tunics and pants. An assortment of camisoles, bustiers, and bodysuits were created in stretch velvet, Lycra, all-over lace, and cotton-backed satin, all designed to be worn under business and evening suits. For fall '91, Natori also launched her first full-blown collection of day and evening ready-to-wear, with looks suited for business and formal daytime occasions, as well as scintillating evening looks for which she has become famous. A highlight of that first collection was an innerwear-inspired, embroidered and jewel-encrusted waist cincher, an evolution from the bustier, meant to be slipped on over a velvet catsuit or evening trouser for dinner and dancing.

Through a licensing agreement with the Lily of France division of Bestform, Natori also entered the foundations category, expanding her viewpoint and signature appliqué and embroidery looks to products including underwire and push-up bras, demi-bras, French briefs and panties, garter belts, thongs, and bustiers. Her lingerie stylings have also been translated to the bedroom, through a collection of bed and bath ensembles produced by Revman Industries. Taking yet another step forward, in late 1991, Natori entered a licensing agreement with Trina to manufacture coordinated bath accessories, hat boxes, and room and closet organizers. And in 1992, she unveiled her first accessories line, including jewelry items and elaborate shawls.

It is a rapidly expanding business and hectic lifestyle on which Natori thrives—especially since her husband joined her full time in the business in 1985 to oversee finance, distribution, administration, and negotiation of new business. They even share a spacious office, with their desks facing one another; and to break the tension of intense business dealings, Ken often putts golf balls against the baseboard of Josie's antique desk. Of course,

the golf does not interfere with the concentrated effort of finding new ways to develop the original lingerie business. Already, Josie Natori has plans to enter the categories of swimwear, hosiery, wallpaper, china, and home fragrance! As she states, "What we need to do is to be attuned to the lifestyle changes of the consumer. We must adjust our thinking to mirror her '90s attitudes. We have to liberate our definition of intimate apparel. In fact, it's a good thing I had no idea of what the heck I was doing when I first entered the business, or I wouldn't be here today!"

Question for Discussion. How have Josie Natori's own life and lifestyle contributed to her interpretation of intimate apparel?

Sources. 1. Press kit from The Natori Company; 2. "Bra Bazaar '91," *Body Fashions/Intimate Apparel,* May 1991; 3. Michele Cohen Hollow, "Bedrooms Get Lush Looks of Josie Natori's Lingerie," *HFD,* September 16, 1991; 4. "Natori's Indulgences," *Women's Wear Daily,* July 1992; 5. Presentation by Josie Natori at the National Retail Federation Annual Convention, New York, N.Y., January 19, 1993.

Cosmetics

The quest for personal beauty is as old as mankind—and using cosmetics to enhance one's beauty has been a "trick of the trade" through virtually all of history. What many people may find surprising, in light of the customs of our current society, is that throughout the ages, men used cosmetics as much as women, and sometimes more so. For instance, back in the second century A.D., the Greek physician Galen invented cold cream, and is said to have been one of its most avid users. Even earlier, in the first century A.D., Roman men dyed their hair bright red with a special liquid soap imported from Gaul.[7] Today, there is still a healthy men's market for some types of cosmetics items, but the overwhelming focus of the industry is on products for women. This is because women are now by far the heaviest users of the three major segments of the cosmetics industry: **color cosmetics** (or make-up), skin-care products, and perfumes and fragrances.

History

Although cosmetics have generally been used for fashion and beauty, the very earliest uses of make-up and fragrance were probably religious, with bright colors being painted on the body to please the gods, and fragrant oils or incense poured on as part of religious ceremonies.[8] By 1500 B.C. in Mesopotamia, perfumes were such prized possessions that instead of cash, salaried soldiers received bottles of scent.[9] Then, in the ninth century B.C., Queen Jezebel, wife of the King of Israel, began dramatically adorning her eyes with a dark make-up preparation called **kohl**—and the term *jezebel* has been used ever since to describe a "painted woman."

Several hundred years later, the Egyptian queen Cleopatra took the cosmetics art to new heights. To make her skin softer, she took baths in milk and wore exotic perfumed oils. She dramatized her eyes by painting her eyebrows and eyelashes black, the upper part of her eyelids blue-black, and her lower eyelids green.[10] In the meantime, women in Rome were developing their own collection of beauty basics,

Figure 10-7. This scene (c. fourteenth century B.C.) shows the queen anointing the Egyptian king Tutankhamen with aromatic oils.

including red or purplish face paint called "fucus" to rouge their cheeks and lips, wood ash and saffron as black and gold eyeshadow, blue paint to outline their veins, sheep's fat to color their nails, and meal paste and lemon to bleach their freckles.[11]

Since the manufacture of scientifically formulated cosmetics did not come about until much later, in each era of history seekers of beauty experimented and made use of the variety of natural—though not always appetizing—ingredients that were available to them. For instance, one medieval beauty cream was a horrific concoction of boar's brains, crocodile glands, and wolf's blood.[12] Far more palatable was the simple use of a thick layer of white flour to achieve the smooth, pale look that was popular well into the eighteenth century. However, some women went a deadlier route, using white powders made from a base of lead, which over time was found to be poisonous!

In seventeenth-century France, beauty spots were all the rage. Made of black taffeta or thin leather, these little patches were first used to cover blemishes, but soon became a fashion statement of their own on cheeks, chin, or forehead in a variety of shapes including circles, hearts, stars, and diamonds. One marquis purportedly arrived at a fancy dress ball made up to the hilt with no fewer than 16 patches on his face.[13] At the same time, the early settlers in America were making do with less ele-

gant, homemade concoctions found in the woods and fields of their new land—scrubbing their faces with buttermilk in an effort to remove freckles and rouging their lips and cheeks with the juice of red berries.[14]

By the early nineteenth century, a few American peddlers began creating cosmetics and selling them under their own trade name to women who had been making their own cosmetics at home. In 1867, the B. Altman department store in New York introduced the first "making up" department, designed to teach fashionable ladies how to apply rouge, powder, and eyebrow pencil. The top priority was to make up discreetly, with color coming less from rouge and lipstick, and more from pinching one's cheeks and biting one's lips.[15] Yet another milestone in cosmetics history came in 1886, when David McConnell, a door-to-door book salesman, decided to give away perfume samples in order to make his sales pitch for the books. He soon discovered that women preferred the perfume to the books, and launched a whole new door-to-door sales business—which he named Avon.[16]

At the outset of the twentieth century, most women found it improper or too daring to wear either heavy perfume or visible make-up. But by the "Roaring 20s," flappers changed all that by brazenly sporting flaming red lipstick, rouge on their cheeks and earlobes, and thick liner on their eyes. Around this time some of the early cosmetics empires began to be built as well, with now-famous names like Helena Rubenstein, Elizabeth Arden, Max Factor, and Charles Revson of Revlon all becoming known for their growing beauty collections of skin creams, lotions, tonics, rouges, lipsticks, and other cosmetics merchandise.

The trend of clothing designers lending their names to perfumes also began in the early twentieth century, when French designer Paul Poiret first hired chemists to concoct Oriental-type, mysterious scents such as "Nuit de Chine" and "Le Fruit Défendu." This tradition has continued even stronger well into the 1990s, with fragrances on the market bearing the imprimatur of such current designers as Yves Saint Laurent, Christian Dior, Liz Claiborne, Halston, Jessica McClintock, and Calvin Klein, to name a few.

Figure 10-8. Bathing beauties from the 1920s sported flaming red lipstick and rouge on their cheeks. (Courtesy Malden Mills)

Over the last half century, the cosmetics business has continued to follow closely the fashion trends shaped by society and its changes. As the country became more conscious of the health and safety aspects of all products for the body, for instance, the government passed the **Food, Drug, and Cosmetics Act of 1938** to regulate the ingredients used in the manufacture of cosmetics. Over the years, this legislation has been updated several times to keep pace with both chemical and societal changes. In the '70s, the "back to nature" movement led to a raft of products with natural-sounding names and ingredients, such as cucumber facials and strawberry shampoos. In the early 1990s, that direction was taken even further, with some cosmetics makers and their customers making the case for natural ingredients by deploring the harm done to animals in traditional testing of chemical-based cosmetics.

The cosmetics industry has also been strongly influenced by looks made popular by movie stars and other celebrities. In the 1920s, for instance, women were diligently plucking their eyebrows to achieve the pencil-thin line worn by actress Clara Bow; while in the late 1970s, many women abandoned their tweezers in order to emulate actress/model Brooke Shields, whose naturally bushy eyebrows became a fashionable trademark. In between, supermodel Twiggy was probably singlehandedly responsible for skyrocketing sales of false eyelashes in the 1960s, wearing three rows of them herself.

Celebrities have recently exerted their influence on the cosmetics market in more direct ways. Through special licensing arrangements, a number of well-known names have become linked with specific products, particularly fragrances, in much the same way designers have done. In just the last decade or so, those celebrity names have included Mikhail Baryshnikov, Elizabeth Taylor, Jaclyn Smith, Priscilla Presley, and Julio Iglesias.

Characteristics of the Cosmetics Industry

Cosmetics represent a huge market in the United States, with total retail sales for cosmetics and fragrances, along with toiletries (including shampoos, antiperspirants, etc.), estimated at more than $19 billion. Reflecting the increasing international influence on all areas of fashion, a small but growing proportion of the products sold in the United States is imported primarily from France, followed by Japan. Some domestic manufacturers, such as Estée Lauder, also turn to overseas operations for the manufacture of certain portions of their lines, although this practice has decreased slightly in recent years with the decline in value of the dollar against foreign currencies.

Of all the cosmetics production taking place in the United States, the largest percentage is concentrated in New Jersey, where major pharmaceutical companies, many of which maintain or have acquired cosmetics operations, are based. However, at least 70 percent of all cosmetics companies locate their main headquarters and marketing operations in New York City. All the United States-based firms employed more than 55,000 workers in 1991, according to the U. S. Department of Commerce.[17]

A relatively small number of large manufacturers garners the major share of the market, particularly in the more expensive cosmetics lines. Estée Lauder Inc. alone,

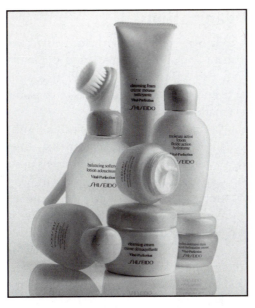

Figure 10-9. As in other segments of the fashion business, cosmetics trends are influenced by products from around the world, such as this prestige skincare line from Japan. Note that the Japanese use French terms to reinforce a high-quality fashion image. (Courtesy Vital-Perfection, Shiseido)

for instance, is estimated to control some 38 percent of the department store cosmetics business with the company's various brands that include Estée Lauder, Clinique, and Aramis. In the second position, with about 14 percent of the market is Cosmair, which is owned by the French company L'Oréal and which markets products under such brand names as Lancôme and Ralph Lauren.[18] In the less expensive, mass market cosmetics lines, sales are spread much more widely among a variety of manufacturers, although the undisputed leaders are Maybelline and Noxell.

In recent years, there has been a trend toward consolidation in the cosmetics industry, with some of the major brand names being bought, sold, and merged with other companies. As a result, many giant corporations offer multiple brands of cosmetics directed to different customers. For instance, Avon, the largest marketer of fragrances in the world, sells its own brand, as well as the upscale Giorgio Beverly Hills fragrances. Benckiser, a German company, acquired the Germain Monteil and Jovan brand names, among others; and consumer products giant Procter & Gamble now owns the Noxell/Cover Girl and Max Factor brands.

Unlike virtually every other fashion category, the cosmetics industry has no national trade shows. Some of the manufacturers whose products are aimed at the mass market do participate in retail drug shows; and there are a few regional cosmetics markets, such as one in Florida, that attract a good turnout of retailers. But by and large, new product presentations are made more individually to the stores. The total cosmetics industry is, however, represented by a non-profit trade organization called the Cosmetic, Toiletry, and Fragrance Association (CTFA), based in Washington, D.C. One of the association's main functions is to represent its members in matters of health and safety, as well as in government regulatory requirements. Over one third of the CTFA's budget is devoted to scientific programs to ensure the safety of cosmetic ingredients.

Structure and Organization

The cosmetics business today can be roughly divided into two major segments: **prestige lines,** for department and specialty stores, and the mass market cosmetics lines for discount and other lower-priced retailers. Prestige lines account for the highest volume of fragrance and skincare product sales to consumers, while the bulk of color cosmetics sales are made in the mass market.

The prestige lines—including such brands as Lancôme, Estée Lauder, Clinique, Ultima II, Princess Marcella Borghese, and Elizabeth Arden—enjoy limited distribution and exposure through a carefully controlled number of upscale stores, thereby maintaining a high-quality, exclusive image of their products. Most of these lines are given their own distinct counter space in the stores, which are serviced by specially trained and uniformly attired sales staff. Known as a *brand-line representatives*, they are hired only to sell that one particular brand.

Mass market cosmetics lines may be found in a wide variety of stores, including drug stores, discount stores, supermarkets, and variety stores. Some of the best-known mass market brand names are Cover Girl, Maybelline, Almay, Natural Wonder, and Max Factor. These lines are less expensive than the prestige lines, and are presented in informational packages so that customers can easily make their own selection, without the need for sales assistance.

While these delineations of prestige and mass market lines apply to all categories of cosmetics, in actual practice today they are more evident in the skincare and color cosmetics businesses than in fragrances. While there are still prestige fragrances that enjoy controlled distribution through only upscale department and specialty stores, many designer and other "exclusive" fragrances have gradually found their way into discount, drug, and other retail outlets through a process known as **diversion.** In some cases this means that a manufacturer sells its products to a wholesaler, who in turn sells them to any interested retailer. In other cases, the mass market retailer actually purchases the products from other retailers; and occasionally, the product

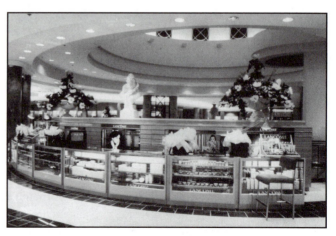

Figure 10-10. Department stores generally create elegant settings for their cosmetics and fragrance departments, as illustrated by this cosmetics counter at a Belk's store. (Courtesy Belk Department Stores)

comes directly from the manufacturer, who may wish to get rid of an excess of inventory. In general, diversion is a practice that manufacturers dislike, but one that the market finds difficult to control, since consumers are eager to purchase prestige fragrances at discounted prices.

Merchandising and Marketing Activities

As Margaret Allen states in her book, *Selling Dreams: Inside the Beauty Business,* "Clever marketing is the key to success in selling cosmetics and toiletries. As there is very little basis for choosing one brand over another it is only by successful marketing that one particular brand triumphs."[19] Indeed, the cosmetics industry is one of the fashion business' biggest spenders on advertising and sales promotion, particularly for launching new products. Back in 1978, the U. S. introduction of Yves Saint Laurent's Opium fragrance, for instance, included a $250,000 party held on a tall ship anchored at New York's South Street Seaport, complete with six bars, a disco, fireworks, and $50,000 in orchids flown in from Hawaii.[20] Elaborate and costly product events such as that, backed by multi-million dollar television and print advertising, are still the norm for major fragrance introductions.

A far less splashy approach is taken by cosmetics marketers for their ongoing lines, although advertising campaigns stressing the products' benefits or their image of a particular lifestyle may run on a regular basis in newspapers and magazines or on television. For instance, Revlon used the theme "Unforgettable Women in the World Wear Revlon" for an ongoing series of advertisements in the early 1990s; and Clinique had a long-running magazine ad that showed a toothbrush on one page and its basic skincare products on the other, noting simply for both, "Twice a Day."

While the major mass market cosmetics brands rely heavily on national advertising to reach consumers, prestige cosmetics manufacturers work much more closely with their retailers to build market awareness and image with consumers. One of the most widely practiced techniques is called **sampling,** which allows customers to try out a product before purchasing it. In some cases, a customer may sample a line of

Figure 10-11. Film star Catherine Deneuve makes an appearance at Bloomingdale's department store to promote her perfume. (Courtesy Ellen Diamond)

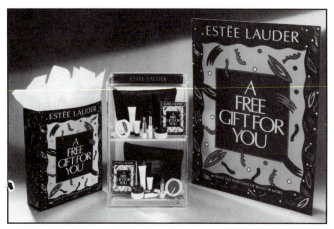

Figure 10-12. Offering customers a gift-with-purchase is one of the most popular sampling techniques among cosmetics companies. (Courtesy Dayton Hudson Corporation)

color cosmetics by getting a custom "make-over" by a trained cosmetician at a particular brand counter. With a fragrance, the store may have an employee with a sample bottle standing in a high-traffic aisle offering customers a spritz of the scent; or the salesperson at the counter may offer a tiny sample vial of a new fragrance to customers making a purchase of something else. Another method of sampling that has grown in frequency in recent years is the use of scent strips, or narrow bands of paper specially formulated to release a fragrance when pulled apart. Department stores often include scent strips within a billing enclosure to their customers; and a number of fragrance companies place the strips within their ads in consumer magazines when launching a new scent.

Two other methods of sampling that are widely used in the department store cosmetics business are called **gift-with-purchase** (gwp) and **purchase-with-purchase** (pwp). In both cases, a customer is required to make a purchase from a particular line in a certain minimum amount, and then receives a bonus, either as a gift or at a small additional cost. As a sampling technique, the bonus is usually another item or group of small-size items from within the cosmetics line. Sometimes, however, the technique is used more as a sales incentive than a sampling method, and the bonus may be a non-cosmetic item, such as an item of clothing or an umbrella. Generally, both types of promotions are announced by the store to consumers through direct mail brochures, catalog or newspaper inserts, as well as through special in-store signs.

In addition to manufacturers' and retailers' individual efforts to promote their products, the entire fragrance industry joins forces each year to promote the use of scents through a special Fragrance Week in New York. Sponsored by The Fragrance Foundation, the week-long series of special events involves marketers, retailers, and publications, and is capped by the bestowing of the FiFi Awards, the fragrance industry's version of the Oscars. FiFi Awards are presented to winners in various categories such as Best Women's Fragrance and Best Men's Fragrance, as well as for excellence in areas such as packaging and advertising.

Future Directions

The cosmetics market has enjoyed steady but only moderate growth in recent years, a trend that is expected to continue through the 1990s. Of the individual segments of the business, fragrances are actually seeing the least growth, due in part to a decrease in consumers' disposable income this decade. Skincare products, on the other hand, are expected to see increased growth through the decade, partly because the aging baby boom population is seeking ways to maintain a youthful appearance, but also because there are many new products and ingredients. Color cosmetics are also predicted to remain on an upswing, as women continue their desire to enhance and improve the appearance of their natural features.

Helping to keep the visibility of cosmetics high are a number of retail outlets that are growing in importance. Specialty cosmetics chains, such as The Body Shop (see Spotlight on a Firm) and The Limited's Bath and Body Shop, are expanding their reach to more and more shopping centers across the country. In another vein, the specialty perfume boutique concept is spreading rapidly to the United States from Europe, with chains such as Perfumania already operating more than 100 shops nationwide as of early 1992. These stores sell as many as 700 fragrance and cosmetics products, many of them prestige items priced well below normal department store prices. Plus, the use of television as a retail outlet for cosmetics has shaken up traditional marketers thanks to entrepreneur Victoria Jackson, who sells her line of "No Makeup" brand color cosmetics via cable television. A one-time Clinique saleswoman and later make-up artist for celebrities and models, Jackson demonstrates her cosmetics herself in realistic makeovers of average-looking women. The proof of her success lies in the sales figures: In just her first year of selling, she took 10,000 orders a week totaling $45 million for the year.[21]

Yet another retail trend that started taking shape in the early 1990s was the entry of ready-to-wear retailers into the cosmetics arena. For instance, Victoria's Secret specialty chain now has its own cosmetic and fragrance line; and trendy retailer Benetton also introduced its own line of Benetton Colors. The computer shopping network, Prodigy, has a Cosmetic Express service as well, giving consumers yet another way to purchase beauty products.

In specialized niches of the cosmetics field, the 1990s are expected to see even more attention paid to cosmetics formulated specifically for the skin of African Americans and other ethnic groups. For some time, ethnic cosmetics lines have been marketed by several minority-owned businesses, notably Chicago-based Johnson Products. But at the beginning of this decade, several major cosmetics marketers launched their own new ethnic lines, such as Maybelline's Shades of You, designed specifically for the skin of African-American women, Pavion's Black Radiance, Estée Lauder's Prescriptives All Skins, Clinique's Colour Deeps, and Almay's Darker Tones of Almay. These lines joined an already existing group of collections from smaller cosmetics firms, including Flori Roberts and Fashion Fair. Other major brands, such as Cover Girl and Max Factor, are expected to follow the trend, as well.[22]

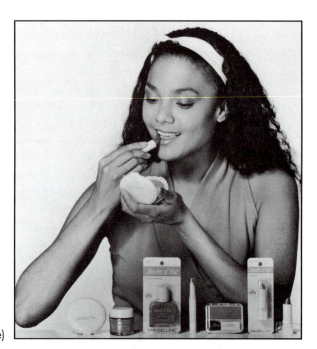

Figure 10-13. Color cosmetics and skincare lines formulated specifically for the skin of ethnic women are receiving increased attention by major marketers in the 1990s. (Courtesy Maybelline)

Another niche that is predicted to receive more marketing scrutiny in the 1990s is the men's cosmetics market, particularly in the area of fragrances. While only about half the size of the women's fragrance market, the men's business is spurred by the introduction of more than 20 new scents each year, many of them backed by advertising that is as aggressive as that for women's fragrances. Notable examples in recent years were Egoïste and Calvin Klein's Obsession for Men.

In color cosmetics, new product innovations will continue to come primarily in the form of new shades and tints—although in 1991, Elizabeth Arden launched the first new lipstick to break from the wax-and-oil formulation used since the product's invention in 1900. Perhaps the most important trend, however, will continue to come in the direction of natural ingredients and a move away from product testing on animals. By 1991, a number of major manufacturers, including Avon, Revlon, Noxell, and Mary Kay, had already eliminated animal testing from their product development.[23] Plus, the huge success of companies like The Body Shop, with its broad line of naturally based cosmetics, should continue to exert strong influence on other cosmetics marketers to explore the use of natural ingredients. Even giant Estée Lauder Inc. launched a new division in 1990 called Origins Natural Resources, consisting of special departments in department stores, as well as company-owned stores, selling naturally based cosmetics, skin treatment products, environmental fragrances, sensory-therapy products, as well as books, candles, stationery, and gift items.

SPOTLIGHT ON A FIRM

THE BODY SHOP

Imagine a cosmetics store that does no advertising, displays no photographs of glamorously made-up models, makes no promises that its products will rejuvenate or otherwise change users' lives, and whose founder and president proclaims that her concept of beauty is Mother Theresa, not "whomever by the grace of God was given a couple of high cheekbones."

Rather than having to imagine, you may have only to look as far as the nearest shopping mall—as long as that mall contains The Body Shop, an international cosmetics chain that sells only naturally based and non-animal-tested beauty and personal care products. Founded in 1976 as a single store in England by Anita Roddick, then 33 years old, The Body Shop had more than 700 shops in 39 countries by the end of 1991, with worldwide retail sales totaling more than $391 million.

The entire corporate and marketing strategy of The Body Shop could not be further removed from the traditional methods of developing and selling skincare products. While most major cosmetics companies still create products in laboratories, many testing their safety by conducting experiments on animals, The Body Shop takes a completely different route. All its products are (and have always been) made from ingredients that are either completely natural or that have already been used by humans for decades or even centuries.

And rather than sporting high-tech scientific-sounding names, The Body Shop's products sound as natural as they are, with names like Carrot Facial Oil, Peppermint Foot Lotion, and Rhassoul Mud Soap.

The naturalness of its product line is just one point of departure for the company, however. While other cosmetics firms spend millions of dollars each year to advertise their merchandise, The Body Shop does not spend a dime, depending instead on repeat business and "word-of-mouth" advertising from its customers. What's more, to help cut down on used packaging thrown into landfills, the stores feature a "Refill Bar," where customers can return their empty and cleaned plastic bottles from prior Body Shop purchases and have them refilled with more of the same product. To encourage the practice, the store even gives a 25-cent discount on the new purchase when a bottle is reused.

This concern for the environment is an obsession with Anita Roddick, who is not the least bit shy about using her stores' success and fame to get publicity and support for her favorite causes. In addition to ecological concerns, she encourages others to join her in efforts to promote human rights throughout the world, both through local volunteerism and support of global organizations such as Amnesty International. As she is quoted in the introduction to the company's mail order catalog: "The Body Shop is

continued

more than a cosmetics company. We are an emissary for social change."

Roddick's passion for causes reflects in part the social consciousness so prevalent in the 1960s, when she was in her late teens and early '20s. She never seemed to lose the less-than-conventional lifestyle of those liberal years; and in fact, she initially founded The Body Shop as a way to support herself and her two daughters while her husband Gordon took off to pursue a lifelong dream of riding horseback from Buenos Aires, Argentina, to New York. He made it as far as Bolivia; and on his return to London 10 months later, Anita had already opened a second Body Shop.

That second shop was just the "tip of the iceberg," and the Body Shop concept and stores began taking off in all directions around the globe. By 1978, the first branch opened in Belgium; the following year, stores opened in Sweden and Greece. Just 10 years after the first store was launched, there were Body Shops in 26 countries—and Roddick has not yet slowed down. A total of at least 150 new shops worldwide were planned to open each year from 1992 to 1994; and in the United States alone, the company's expansion plan called for an additional 1000 stores by the year 2000.

Most of The Body Shop's growth has come through franchising, and a full 90 percent of the company's franchisees around the world are women, underscoring Roddick's belief that not enough women hold executive positions in the beauty business. As she was quoted in The *Chicago Tribune:*

> "There is no doubt about it, [the perfumery and cosmetics industry] is controlled by men and their perception of what women want is often a little old-fashioned. They still create needs that don't exist. They still use a type of language [in describing their products] which is at best puffery and at worst a lie. . . . We don't use the word 'beauty.' We've even banned the word 'luxurious.'"

And as if to further emphasize her own perceptions and beliefs, Roddick herself most often appears with little or no make-up.

That does not mean she is not constantly seeking out new ingredients and formulations to tempt her customers. In fact, she travels almost continuously in search of ideas, such as one trek to visit the Kayapo Indians in Brazil and negotiate the purchase of Brazil nut oil for use in such products as shampoos and body scrubs. From a base of just 15 products sold in her original shop, she now offers more than 350 products. Included are a color cosmetics line called "Colourings," which was launched in 1986; a Mostly Men collection introduced that same year; and the Mamatoto line of body care products for expectant mothers and babies, which debuted in the United States in 1991. Among the new product introductions launched in 1992 were Banana Shampoo, Banana Hair Putty, Pumice Foot Scrub, Ice Cream Lip Balms, and Body Butters.

The company states its own principles, thusly: "The primary function of our products is to cleanse, polish, and protect the skin and hair. We make no dubious promises about rejuvenation. In fact, we promote health rather than beauty." This statement, as part of The Body Shop's total corporate strategy of societal awareness, has already shaken up the traditional cosmetics market, and is likely to continue doing so for a long time to come. As the company proudly notes, the following was stated in Vogue magazine: ". . . Anita Roddick has just as much knowledge as Mrs. [Estée] Lauder about how to put the genie in the bottle and hope in a jar. At the bottom of Mrs. Lauder's jar is the world of eternal youth. At the bottom of Anita's jar is the world itself."

Question for Discussion. What makes Anita Roddick's and the Body Shop's approach to cosmetics so different from that of conventional cosmetics companies?

Sources. 1. Press kit, press materials, brochures and catalogs from The Body Shop, 45 Horsehill Road, Cedar Knolls, NJ 07927, December 1991; 2. Bo Burlingham, "This Woman Has Changed Business Forever," *Inc.,* June 1990; 3. Libby Morse, "Rebel with a Cause," *The Chicago Tribune,* October 20, 1991, Section 6; 4. Pamela Street, "Body Shop: Stretching Out," *Women's Wear Daily,* December 28, 1990.

1. Throughout history, intimate apparel has gone hand-in-hand with fashion to help achieve different looks and silhouettes. In recent years, new fabrics and constructions have led to intimate apparel styles that match the body's natural shape more closely, controlling that shape, if at all, much more gently than in the past.

2. The four major categories of intimate apparel are: foundations, daywear, sleepwear, and robes and loungewear. All are benefiting from a new infusion of fashion trends into the category in recent years.

3. Cosmetics have been used since earliest history by both men and women to enhance their beauty. Trends in cosmetics have often followed the lead set by movie stars or other celebrities.

4. The two main segments of the cosmetics industry are the: prestige, or department store, lines, and mass market cosmetic lines. They apply to color cosmetics, skincare, and fragrance, although sometimes prestige fragrances are sold through the mass market.

5. The cosmetics industry spends a significant amount of money on advertising and sales promotion. Some of the most widely used marketing techniques are sampling, gift-with-purchase, and purchase-with-purchase.

Fashion Vocabulary

Explain each of the following terms; then use each term in a sentence.

bones	Food, Drug, and	mass market cosmetic
bustiers	Cosmetics Act (1938)	lines
color cosmetics	foundations	prestige lines
cosmetics	gift-with-purchase (gwp)	purchase-with-purchase
crinoline	intimate apparel	(pwp)
daywear	kohl	sampling
diversion	lingerie	sleepwear
	loungewear	stomacher

Fashion Review

1. Describe the major highlights in the evolution of intimate apparel in the twentieth century and explain how they relate to the ready-to-wear fashions of the time.

2. Name three factors influencing the increase in popularity of control or shaping undergarments in the 1990s.

3. Describe some of the fads and fashions in cosmetics use throughout history and name the most important trend affecting the business today.
4. Explain the practice of sampling and give several examples of how marketers use the technique.
5. Name two specialized niches that are getting new attention from cosmetics marketers in the 1990s.

Fashion Activities

1. Visit both a department store and a discount store, and study their intimate apparel departments. Then make a comparison list of how they are alike and how they are different. Do they carry the same basic types of merchandise? Do they offer the same basic proportions of daywear to foundations to sleepwear, for instance? How do the decor and displays differ? How do the price ranges differ? How would you describe the intimate apparel customer each is trying to target ?
2. Looking through the newspaper, find at least three examples of advertisements that involve cosmetics or fragrance gift-with-purchase or purchase-with-purchase techniques. Identify the purpose of each program (sampling or sales incentive), and analyze how effective you think each might be. Does the gift or bonus have a logical connection to the primary purchase? Does it appear to offer customers real value? If you were marketing the line, would you offer something different as a bonus? What would it be?

Endnotes

1. Lynn Schnurnberger, *Let There Be Clothes,* Workman Publishing, New York, 1991, p. 66.
2. Op. cit., p. 68.
3. Op. cit., p. 86.
4. Op. cit., p. 139.
5. Op. cit., pp. 174–175.
6. Op. cit., p. 212.
7. *The New Book of Knowledge,* Grolier Inc., Danbury, Conn., 1991, Vol. 2, p. 111.
8. Op. cit., Vol. 3, p. 553.
9. Schnurnberger, op. cit., p. 31.
10. *The New Book of Knowledge,* Vol. 3, p. 553.
11. Schnurnberger, op. cit., p. 90.
12. Op. cit., p. 125.
13. Op. cit., p. 196.
14. *The New Book of Knowledge,* Vol. 3, p. 553.
15. Schnurnberger, op. cit., p. 270.
16. Op. cit., p. 308.
17. *Cosmetic Insiders' Report,* January 13, 1992, p. 3.
18. *Cosmetic Insiders' Report,* September 16, 1991, p. 4.
19. Margaret Allen, *Selling Dreams: Inside the Beauty Business,* Simon & Schuster, New York, 1981, p. 215.
20. Op. cit., pp. 224–225.
21. Alison Deyette, "Cosmetics Queen," *Your Family,* June 1991, p. 10.
22. "Cosmetic Establishment 'Discovers' Ethnic Cosmetics," *Drug & Cosmetic Industry,* November 1991, p. 19.
23. Roberta Wilson, "Alternative Routes to Animal Testing," *Drug & Cosmetic Industry,* April 1991, p. 28.

p r o j e c t

Researching Domestic Designers and Manufacturers of Fashion Goods

The purpose of this project is to acquaint you with an American designer and/or apparel manufacturer whose goods are widely known through the company's brand labels. You may select a designer or manufacturer of women's, men's or children's apparel or accessories.

Begin your research in your local library. Determine the location of the company headquarters and write or telephone to gather information for your report. In your report, include as much of the following information as you can.

Prepare a written and/or oral report as indicated by your instructor.

1. Name and principal address of the company.
2. Purpose of the organization. Is the line more a designer or volume-priced fashion?
3. Who is the target customer of the company? Create a customer profile using at least five demographic or psychographic variables.
4. Where is the company located in addition to the headquarters? Locate manufacturing plants and sales offices.
5. Does the company have a designer or a design staff? Is the designer the owner?
6. Describe the company's manufacturing organization. Is the manufacturing considered an inside- or outside-shop operation, or both? Does the company participate in dual distribution?
7. Does the company operate its own retail organizations?
8. Identify the retail businesses that are major customers of this manufacturer.
9. Is the company privately or publicly owned?
10. What is the company's sales volume (most currently published figures or most credible estimate)?

unit THREE

Fashion
Markets
WORLDWIDE

Domestic Markets

Objectives

After completing this chapter, you should be able to:

1. Explain how apparel is marketed domestically.

2. Name and describe six major market centers in the United States.

3. Explain the purpose of market weeks and cite four advantages each for retailers and for manufacturers to participate in them.

4. Compare trade shows and market weeks at major market centers.

5. Name three current directions in which the fashion industry is moving and cite local examples.

T*he streets of New York's garment district were teeming with people and truck loads of merchandise as on any working day, but the young fashion designer seemed not to notice. He pushed a rolling rack of garments block after block, away from Seventh Avenue towards Fifth Avenue's elegant retail stores. His heart pounded as he steered the rack among the crowds, all the while holding on to the garment bags as they swung along the rack's top rod. He was almost* unaware *of the 40 or more blocks he had marched to reach the exclusive store that was his destination. Nervously he rang for the freight elevator. Would the store's executives like his collection, he wondered as the elevator climbed to his designated floor? If they liked it, would they buy it? A short while later, he emerged jubilantly from his meeting. The managers had not only liked his collection, they had placed a substantial order. As this story goes, Calvin Klein knew his career was launched!*

How Apparel Is Marketed

Not all designers personally haul their collections to the stores as some say Calvin Klein did to Bonwit Teller for that first order, but designers and apparel manufacturers are vitally concerned with learning what their customers want. While the initial

customers of designers and manufacturers are the retail stores, their final customers are the consumers who purchase and wear their goods. Manufacturers who design for the final consumer and produce what they believe these customers will want are putting the marketing concept to work, as discussed in Chapter 4; that is, they concentrate on best providing what their customers want at a profit.

Discerning what customers want and getting it to them as quickly as possible are not easy tasks. After determining customer preferences for the coming season, a risky venture in itself, it takes time to design and manufacture a line of merchandise. Fashions, like other good things, such as fresh roses or strawberries, are "perishable." After production they must move as quickly as possible to the retailer. Because of fashion's "perishability," the **channel of distribution**, or the series of businesses participating in the marketing of fashion goods from the producer to the consumer is short. New fashions tend to move directly from the manufacturer to the retailer, either through the manufacturer's own sales force or through an independent manufacturer's agent, as discussed in Chapter 4. Typically, before each new season retail store buyers visit manufacturers and their representatives (both also known as "vendors," "suppliers," and "resources") to view new merchandise and to place orders.

Market Centers

Apparel manufacturers and their representatives are located in various parts of the country, commonly in large population centers. The largest, New York City, is the traditional capital of the fashion industry in the United States for a number of reasons, as we shall soon see in this chapter.

Since the demand for fashion is widespread and diverse, major markets for fashion have grown up throughout the country in cities such as Los Angeles, Chicago, and Dallas. These cities, where fashion goods are created and marketed, are called **market centers.** The major market centers in the United States (called domestic market centers) in addition to New York are: Los Angeles, Chicago, Dallas, Miami, and Atlanta. It is in these major market centers as well as in smaller cities, such as Boston, Kansas City, and Minneapolis, where markets are found. A market is a location where manufacturers and their representatives show and sell their goods or lines to retail buyers. Now let's look at each of the major market centers.

New York

New York, the historic center of the garment industry in the United States, stands out from other market centers for a number of reasons. Although it is crowded, expensive, and inconvenient for manufacturers and buyers alike, the newest fashions and latest fashion information are to be gathered here and nowhere else to the same degree.

New York was able to grow as the center of the industry because it was here that the trained immigrants from central Europe landed in the nineteenth century, ready

HENRI BENDEL–NEW YORK
712 FIFTH AVENUE

SUSAN FALK

President
Henri Bendel

Once there was a milliner who decided to open a store in New York to be known to shoppers as "the lady's paradise." Offering designer apparel for women and children in elegant surroundings, the store grew famous for its sumptuous atmosphere and excellent service and was recognized by its logo featuring a slender, fashionable lady walking an even more slender and stylish whippet hound. New York's socialites and celebrities became its most loyal customers.

Today, the name of the store is the same, Henri Bendel (Henry Ben´-del), but it is now part of The Limited organization that also includes The Limited stores, Limited Express, Lerners New York and Lane Bryant stores, and Victoria's Secret stores and catalogs. As such, the Henri Bendel stores have multiplied, with branches in Chicago; Chestnut Hill, Massachusetts; and Columbus, Ohio—as well as new headquarters in New York and additional stores in the planning. In The Limited's crown of stores, Henri Bendel is considered a jewel.

Presiding over the opulence of Henri Bendel is Susan Falk, who brought a range of fashion experience to the job. She knew the store well because as a child she was a Bendel customer. She also knew the Limited well because she had been with the corporation for five years, moving to Bendel's presidency from her earlier responsibilities as vice president and general manager of The Limited's Express division.

Early tasks at Henri Bendel included overseeing the move of the venerable flagship store to its glamorous new headquarters at 712 Fifth Avenue. The move included the addition of a section called New Créateurs, featuring young designers with appeal for the fashion-forward Bendel customer. New Créateurs is an example of niche marketing for which the organization is famous.

> *Presiding over the opulence of Henri Bendel is Susan Falk, who brought a range of fashion experience to the job.*

Susan Falk worked in a department store while attending Arizona State University to earn a degree in marketing and business administration. After graduating, she went to work in Los Angeles at Bullocks department store. Then she was hired by The Broadway stores as an associate buyer and divisional vice president for the southern California division. In 1985, she joined The Limited. At the Henri Bendel stores, her goal is to offer cutting-edge merchandise in an environment that is personal and elegant, drawing customers from room to room in "the

to work in the emerging garment industry. In those days, the factories that now dot the East Coast and the South were concentrated in Manhattan. The factory workers were primarily immigrant women and children. The demand for apparel was here, too. More people found jobs in the growing city, had less time to make their own clothing, and became ready customers for factory-made goods. Within easy access were the textile mills in New England, a major source of fabrics.

Also, communications about fashion stir public imagination, and the publishing industry, well rooted in New York, provided a means to spread the word and picture of fashion. Today the information industry maintains its base in New York—the print media and major television networks headquarter in the city. Auxiliary fashion services, such as fashion consultants, trade associations, and buying offices centered here help strengthen New York's leadership in the manufacturing and marketing of apparel. Fashion services to the industry are covered in detail in Chapter 15, Auxiliary Fashion Services.

For fashion designers, New York's cultural setting is a constant source of inspiration. The theater and the opera, with exciting themes and settings in each season's productions, and the Metropolitan Museum of Art, with its extensive art and costume collections, are frequent sources of inspiration for designers creating a new season's line. They are also sources for retailers seeking out new ways to promote the coming fashions. Other reference points for out-of-town store executives continue to be the creative displays and merchandise arrangements found first in New York stores such as Barney's, Macy's, and the Polo/Ralph Lauren store in the refurbished Rhinelander mansion.

Visiting the New York market is not an easy task for retail buyers, nor has it ever been. There is no permanent central facility such as the apparel marts found in Dallas, Atlanta, or Portland, Oregon's Montgomery Park. Instead, retail buyers must visit the manufacturers' and wholesalers' showrooms located in the garment district. A **showroom** is a facility where buyers actually see and order a manufacturer's line. Some showrooms, usually those of a single manufacturer, show only the lines of that manufacturer; others, often those of wholesalers, carry an assortment of noncompeting lines.

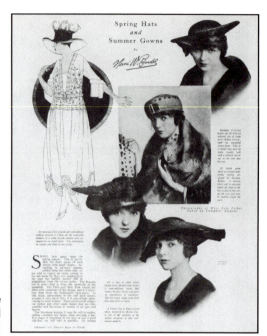

Figure 11-1. Even years ago, the fashion messages of New York reached far and wide. (Courtesy Henri Bendel)

New York's famous garment district runs along and is known as **Seventh Avenue,** frequently referred to by its initials *SA* in the trade and by fashion publications such as *Women's Wear Daily.* Bordered by 41st Street to the north and 33rd Street to the south and running a block or so east and west of Seventh Avenue, the garment district is crowded into a few blocks containing buildings with showrooms; fewer and fewer manufacturing facilities, however, are here, as the cost of rent continues to escalate over the years. Originally, manufacturers located their plants and showrooms together, but as costs have spiraled, many manufacturers moved their production out of the city or even the state to locations west and south—and overseas—where wages and

Figure 11-2. The creative merchandise displays found in New York stores capture the imagination of New Yorkers and out-of-towners alike. (Courtesy The Limited, Inc.)

Figure 11-3. Why do store buyers visit "SA" when the city is so crowded and expensive? (Courtesy Ellen Diamond)

other costs are lower. However, some manufacturers still maintain design workrooms in the garment district along with their showrooms.

Today, the showrooms are jumbled together with little planning, except for the fact that similar categories of merchandise are found in some proximity to one another. If you were a buyer of bridge or designer women's wear, you would visit showrooms mainly between Broadway and Eighth Avenues on 40th and 41st Streets. Perhaps you would stop into the building at 550 Seventh Avenue, where you could see the collections of Bill Blass, Donna Karan, and Ralph Lauren. If you were a children's wear buyer, you would go to showrooms off of Seventh Avenue on 33rd and 34th Streets. With all of the trekking around to various showrooms in all kinds of weather, how has New York managed to maintain its lead in the fashion industry? Many buyers remain convinced that in New York they will see and be able to purchase the newest and best merchandise for their customers.

Los Angeles

Across the country, Los Angeles is the center for the relaxed and casual life that typifies California style. A major center for sportswear—Levi Strauss, Guess, Esprit, and Ocean Pacific are among the brand names originating in the state—California draws attention to its unique casual look. California fashions are created for women, men, and children in moderate and better price ranges. Several designers are headquartered in California, too. Among the best known are James Galanos, a designer favored by film stars, and Bob Mackie, well known for his decorative ready-to-wear and for the imaginative costumes created for Cher's appearances.

Most California apparel production is done in the Los Angeles or San Francisco areas. Levi Strauss, for example, makes San Francisco its headquarters, but Los Angeles has a greater concentration of manufacturers. The apparel industry in Los Angeles County employs some 94,000 people and is second in employment only to

Figure 11-4. Apparel marts provide a central location where buyers may see many lines of merchandise in one visit. With areas like the Great Hall and Fashion Theatre, the Dallas Market Center has the expertise to stage big and extravagant events for thousands of buyers. (Courtesy Dallas Market Center Co. Ltd.)

the aerospace industry.[1] The drawing card of Los Angeles, in addition to its many sportswear manufacturers, is its several central buying locations, called **apparel marts,** where retail store buyers may do their purchasing. In contrast to New York, which has no permanent central apparel mart, Los Angeles has three: the CaliforniaMart, the Los Angeles Apparel Mart, and the New Mart.[2] While some Los Angeles manufacturers maintain showrooms in their factories, many opt for the central location of a mart as a convenience to their customers. Store buyers find visiting showrooms in one or two buildings physically less exhausting and often less expensive than steering to appointments that may be blocks apart.

The CaliforniaMart is a major apparel center in central Los Angeles and has recently expanded to make room for manufacturers from Dallas and New York as well as for those of California. The CaliforniaMart maintains approximately 2000 permanent showrooms containing 12,000 lines of women's, men's, and children's apparel and accessories. These showrooms are open all year long and attract nearly 100,000 store buyers from across the country and internationally. The mart also houses temporary space for manufacturers to lease during market weeks. **Market weeks** are held periodically before a new season in each market center to introduce specific categories of new merchandise such as women's, children's, bridal, or men's wear to the store buyers. The CaliforniaMart produces around 20 market weeks during a given year. Several markets, such as women's, men's, and children's wear, may be held simultaneously.[3]

Chicago

Located between New York and Los Angeles, Chicago serves the 13-state midwest area reaching to North Dakota, Kansas, Kentucky, and Michigan as well as Canada. A center of manufacturing for men's wear as well as women's wear, Chicago is the headquarters of Hartmarx, the parent of Hart Schaffner & Marx, manufacturer of

Figure 11-5. The Chicago Apparel Center is the Midwest showcase for fashion. More than 8000 lines of women's, men's, and children's apparel and accessories are represented in permanent showrooms all under one roof. (Courtesy Chicago Apparel Center)

men's and women's apparel, and the home base of designers such as Mark Heister, Peggy Martin, Richard Dayhoff, Hino and Malee, and Maria Rodriguez. The Chicago area also serves as the headquarters of two giant retail chain stores: Sears, Roebuck and Co. and Montgomery Ward. Within the 13 surrounding states are more than 75,000 apparel stores of various sizes whose total retail sales amount to more than $33 billion annually.[4]

Chicago's buying center for retailers is known as the Mart Center. It consists of the Chicago Apparel Center, the temporary exhibition area known as Expocenter, and the Holiday Inn Mart Plaza, all located in the same building, and the Merchandise Mart, across the street. The Merchandise Mart was the first mart established in the country back in 1930. In the beginning, the Merchandise Mart contained showrooms for apparel as well as home furnishings and gifts. As the volume of apparel sales grew in Chicago, a separate 25-story Apparel Center building was erected in 1977.[5]

In early 1991, the first and second floors of the Merchandise Mart were redesigned to accommodate a retail shopping center known as "The Shops at the Mart." Containing roughly 85 retail stores, such as Lerners New York, The Gap, and Topkapi, the shops and several restaurants serve the nearby growing River North area. The Mart Center is owned by the Kennedy family of Massachusetts.[6]

The Mart Center complex has well over a million buyer-visits per year. Store buyers come to its 750 showrooms to see its vast assortment of merchandise, including apparel and accessories lines for women, men, and children. The Apparel Center serves mainly small- and medium-sized stores in the area; however, larger department stores call on the showrooms for reorders.

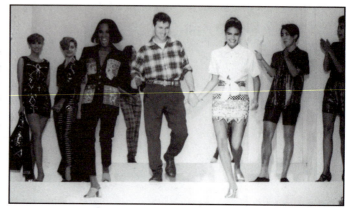

Figure 11-6. Runway fashion shows highlight seasonal fashion markets at the Dallas Market Center. Shown here is guest designer Todd Oldham with models at a Group III fashion show. (Courtesy Dallas Market Co. Ltd.)

Let's accompany one of those buyers on a visit to the Apparel Center. Maryanne Chart is a buyer for a medium-sized women's ready-to-wear store in Madison, Wisconsin. She visits New York and Los Angeles twice a year and goes to the Chicago Apparel Center during market weeks and in between to fill in her stock with new merchandise.

Sometimes Maryanne drives from Madison to Chicago, about a four-hour trip. Today, however, she has decided to take American Airlines since she is in a hurry. It is not a market week but, on reviewing current sales records and looking over the merchandise in stock, she needs to reorder some dresses and sportswear. She is also looking for new merchandise to perk up her stock. Before leaving Madison, Maryanne phoned the showrooms for appointments.

The airport bus from O'Hare Field drops her off at the Mart Center where she goes first to the Holiday Inn on the 15th floor to register and leave her luggage. She quickly hangs up her coat in her hotel room as she will not be leaving the building. If she did not know how to find the showrooms, she could obtain a **market directory,** a showroom guidebook published by each apparel mart and given to all buyers at market. The directory lists all of the representatives and showrooms and the merchandise lines they carry by size.

Chicago's Apparel Center showrooms are organized by categories of merchandise. For example, children's wear showrooms are mainly on the sixth floor. Maryanne knows where she is heading—dresses are on the twelfth and thirteenth floors—and she has been there many times. She does not need to register because her store is known at market, having met the Apparel Center's requirements, as all stores must before beginning to buy. Maryanne takes the elevator down to the first showroom. Here the sales representative greets her warmly and shows her two lines of merchandise she had not seen before. They discuss dates for delivery to her store and Maryanne leaves an order and goes to her next appointment as the afternoon is ending. At this showroom, Maryanne learns that the merchandise she wanted to reorder is not available and so she must find a substitute. The next morning she calls on two other showrooms, finds and orders some dresses she needs, and by noon is headed back to Wisconsin.

Figure 11-7. How does a buyer search through thousands of showrooms to find the right merchandise? Apparel centers publish market directories to help speed up the search. (Courtesy CaliforniaMart)

Dallas

Just as buyers from the Midwest travel to Chicago to buy, store buyers from the Southwest and beyond visit Dallas. Known for moderately priced sportswear, Dallas is a major market center. Dallas manufacturing is not limited to moderate prices, however, for higher priced apparel emphasizing the southwestern look is readily available here. Even designer apparel may be purchased at less-than-designer prices. Dallas is the home of Victor Costa, a renowned manufacturer of copies (called knock-offs) and adaptations of couture garments.

The hub of marketing activity in Dallas is the complex of seven buildings that make up the Dallas Market Center; Texans refer to it as the largest wholesale center in the world. Of the seven, two buildings are devoted to apparel: the International Apparel Mart—Dallas and a separate but connecting Menswear Mart. The six-story International Apparel Mart, totaling 1.8 million square feet, is larger than 37 football fields. The Menswear Mart brings the total of the two buildings to 2.2 million square feet. The thousands of apparel and accessories lines shown at the International Apparel Mart's five Women's and Children's markets bring in an annual estimated 100,000 store buyers from the region's 12 states and farther. Around 2000 permanent and temporary showrooms provide an assortment of merchandise. Store buyers may choose from vendors offering designer, misses, and junior dresses and sportswear; intimate apparel; and accessories and shoes. Other showrooms specialize in western wear, bridal wear, maternity, larger sizes, and children's wear.[7]

Figure 11-8. The International Apparel Mart—Dallas is part of the largest wholesale center in the world. What are the advantages for retail store buyers to buy at a mart? (Courtesy The International Apparel Mart—Dallas)

The Dallas Menswear Mart, also six stories high, contains showrooms for some 3000 men's apparel lines. It holds four men's wear markets each year where retail buyers may view items ranging from apparel, accessories, and shoes to western wear. They may even purchase new display racks, mannequins, and visual merchandising supplies for their stores.[8]

Miami

Another Sunbelt market center is Miami. The manufacturing and marketing of children's wear and sportswear has turned Miami into an increasingly important fashion center in recent years. The warm temperatures and mild climate encourage the design and production of cruise wear, swimsuits, and active wear, which are available year-round. Much of the growth of Miami's apparel manufacturing is due to Cuban immigrants who came to the United States to escape the political oppression in Cuba in the 1960s. Like the European immigrants in New York who preceded them early in this century, many Cubans entered the garment industry in Miami and over the years a number have risen in business to become owners. The Miami International Merchandise Mart contains both apparel and giftware showrooms. It contains more than 500 showrooms that are open year-round, but most of its activity occurs during trade shows, which are held periodically throughout the year.

Atlanta

The Atlanta Apparel Center was recently doubled in size and is visited by buyers from the 11 surrounding states. These buyers flock into its more than 1000 showrooms, which offer 5000 lines of merchandise ranging from men's and boy's wear to women's and children's wear. The Atlanta Apparel Center also contains a six-story theater accommodating over 1200 people for fashion shows and other market meetings.[9]

Figures 11-9a, b, and c. Apparel centers promote glamorous and informative merchandise showings as in the six-story Atlanta Apparel Center Theater shown here. (Courtesy Atlanta Apparel Mart)

Other Markets

Other markets include San Francisco, Seattle, Boston, Kansas City, Las Vegas, Charlotte, North Carolina, Denver, and Portland, Oregon. These regional markets serve stores in the surrounding states and save retailers the cost of an expensive trip to either coast, Dallas, or Chicago. Some regional markets, such as Boston and Minneapolis, maintain showrooms in general merchandise marts. While some of these showrooms may be occupied year-round, their greatest marketing activity occurs during the periodic regional market weeks when buyers are invited to see the newest merchandise. At an even greater savings in time and money to local stores are the various smaller regional markets scattered all across the country.

In the Midwest alone, periodic regional markets are held in cities such as Detroit and Southfield, Michigan; Columbus, Ohio; Indianapolis, Indiana; and Green Bay and Madison, Wisconsin. Local store owners and buyers can visit these small regional markets in a day or less, supplement their stocks between market weeks, and avoid the hassle and costs of lengthy travel.

Market Weeks

A buyer may visit a market at any time just as Maryanne Chart visited Chicago's Apparel Center. Markets are at their busiest peaks, however, during market week. A **market week** is held periodically in each market center to introduce to store buyers

Table 11-1 Major Regional Market Centers

Atlanta Market Center
Suite 2200
240 Peachtree Street, N.W.
Atlanta, GA 30303

CaliforniaMart
110 East Ninth Street
Suite A727
Los Angeles, CA 90079

Chicago Apparel Center
350 North Orleans Street
Chicago, IL 60654

Dallas Market Center
2300 Stemmons Freeway
Suite 5G51
Dallas, TX 75207

Miami Merchandise Mart
Radisson Centre
777 N.W. 72nd Avenue
Miami, FL 33126

the coming season's lines. Market weeks take place from three to six months before the merchandise reaches the stores to give the manufacturers time to make and ship the merchandise. Several markets may be held at the same time during a given market week. For example, the women's and children's fall markets may occur together during market week in March or early April. Men's and young men's holiday and spring market week comes in August.

Market Week Advantages for Retailers

Retailers attend market weeks for a number of reasons. These include: seeing the vendors' latest offerings; meeting with the managers and owners (called principals) of these businesses; finding new lines; and gaining a sense of the market.

Seeing the vendors' latest offerings gives buyers an opportunity to finalize their buying plans and provide for a balanced assortment of merchandise. They can see for themselves samples of new merchandise and either write descriptions to review and buy later, or buyers may choose to *leave paper,* the industry term for writing orders. Seeing the new season's lines enables store buyers to add a new look here and delete something else there, creating, as a result, the quantities and assortments deemed appropriate.

Meeting with the principals gives buyers a chance to hear about industry trends and discuss their special needs and concerns. For example, a buyer will learn what noncompeting stores are buying this season; or, the buyer may learn about some merchandise available to the store at a special price for a mid-season sale, then negotiate a purchase.

Finding new lines from other manufacturers is something that buyers hope to do each time they are at market. Market weeks offer special opportunities to see new lines because all of the manufacturers are showing new goods and some manufacturers who do not have permanent mart showrooms occupy temporary exhibition space. By viewing these lines, a store buyer hopes to obtain merchandise that the competition does not have and thus gain an advantage at home.

Figure 11-10. Several markets may be held simultaneously as this typical year of listing shows.

Gaining a sense of the market by being there to absorb the trends gives retailers a broad base of information for buying. Seeing many lines of merchandise, talking with sales representatives and principals, attending meetings, conferring with other buyers, and visiting market center stores all help a buyer gain an awareness of the economic conditions and fashion trends in order to make decisions with greater confidence.

Market Week Advantages for Manufacturers

Manufacturers show new merchandise during market weeks for several reasons. These include: showing the latest merchandise to a number of retailers in a short time; determining those styles that will actually be produced; learning of retailers' needs and ideas for new merchandise; and making fashion news and gaining publicity.

Showing the latest merchandise to a number of retailers in a short time can be a hectic and strenuous task but successful manufacturers manage it every season. Some designers, among them Bill Blass and Adrienne Vittadini, arrange fashion shows where many buyers may see the entire line and then write orders, or leave paper. During market week all vendors encourage buyers to make appointments to view the lines so that they may devote their full attention to the store's needs.

Determining those styles that will actually be manufactured is a task that is done during market week. In some cases, not all of the garments shown will be made up by

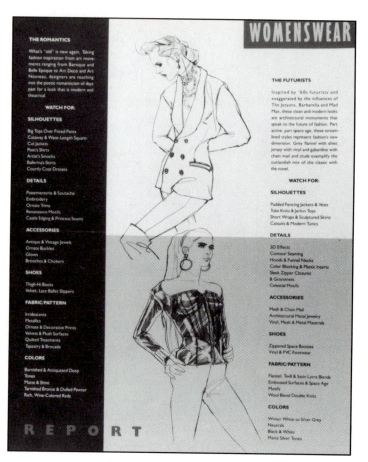

Figure 11-11. Why do apparel marts supply store buyers with fashion trend information? (Courtesy CaliforniaMart)

the manufacturer; only those that have enough store orders to make production profitable will be made. For a number of manufacturers, the decision as to which garments are most likely to be produced is reached after the buyers place their orders.

Learning of retailers' needs and ideas for new merchandise is something that manufacturers are alert to during market week. Sometimes a retailer will make suggestions about styles or request a certain style. Perhaps customers have asked for a different jacket length or a coordinating blouse, and the manufacturer will add those ideas next season.

Making fashion news and gaining publicity is a desirable by-product of market week for the manufacturer. Since the merchandise lines are new, it is hoped that they are also newsworthy and therefore the news media fashion editors are invited to industry fashion shows, called **showings**, sponsored by designers and their representatives or by the apparel mart sponsoring the market week. It is hoped that the media will favorably report the new styles.

Market Week Activities

Manufacturers and others in the market centers work hard to make market weeks successful. The apparel marts put forth effort to attract store buyers to market weeks.

Figure 11-12. Market weeks are crowded with business and social events. (Courtesy Miami Merchandise Mart)

They schedule meetings of interest to buyers such as fashion shows, workshops and seminars on topics like developing buying plans and operating profitably. For example, the Atlanta Apparel Center will hold a fashion show in its six-story auditorium. To draw buyers' attention, apparel marts send out flyers and bulletins announcing market week activities containing information on airline and hotel reservations and discounts. When buyers register, they are given the buyer's directory and are issued tickets to meetings and evening parties. To improve traffic control, security is tightened so that only those registered may enter the showrooms and meetings. Showrooms work to create a pleasant environment at this hectic time; some provide lunch for buyers viewing their lines. All of these efforts encourage buyers to attend market weeks and while there to leave paper.

Trade Shows

Market weeks are concentrated in large city market centers, but retail stores are located in cities and towns of all sizes throughout the nation. Retailers who do not frequently visit market centers, and even those who do, may choose to attend a trade show in a nearby city.

A **trade show** is a temporary exhibit usually from three to ten days (depending on the industry) whose purpose is to provide a forum for manufacturers and their representatives to show new merchandise to business customers. Trade shows are held in all industries, at various times, and in many locations. For example, New York and Chicago are among the U. S. cities holding fabric trade shows where designers, manufacturers, and other fashion professionals view and gain inspiration

from the latest fabrics. A trade show differs from a market in a major market center in that the trade show is temporary, whereas market showrooms are permanent.

Trade shows are usually sponsored by the organizations of the businesses in a given industry, known as **trade associations.** For example, the Florida Children's Wear Manufacturers Guild, a trade association of children's wear manufacturers, holds an annual trade show in Miami that draws children's wear buyers from stores across the nation. Other apparel trade associations hold trade shows in places such as Birmingham, Alabama, and Kansas City, Kansas.

Current Directions

Three major trends are apparent as apparel marketing moves into the next century. Apparel businesses at all levels are becoming larger; they are making increased use of technology, and those businesses able to identify and respond to customer needs are the ones most likely to prosper.

Apparel Businesses Are Growing

While small apparel businesses will always exist, the parts of the industry responsible for the greatest volume of sales are the larger business organizations. Many retailers and manufacturers are growing in size. Sometimes growth is due to rising sales from opening or acquiring new businesses as is true with Dillard's, Liz Claiborne, Inc.,

Figure 11-13. Trade shows, such as this fabric show, draw fashion professionals from many areas including design, manufacturing, and promotion. (Courtesy Chicago Apparel Center)

INTRODUCING

CHICAGO INTERNATIONAL FABRIC SHOW

NOW THERE'S NO NEED
TO TRAVEL BEYOND THE MIDWEST TO SHOP
A FULL SPECTRUM OF FABRIC RESOURCES

MAY 22 & 23, 1991

CHICAGO APPAREL CENTER
ExpoCenter

SPRING 1992

and Clothestime, among others. Often, however, an individual company's expansion is due to consolidation within the industry in order to survive in a climate of increasingly stiff competition. For example, the giant VF Corporation, the manufacturer of Lee and Wrangler jeans as well as Vanity Fair intimate and other apparel, recently acquired Health-Tex, a well known but struggling children's wear manufacturer.[10]

What does this kind of growth mean to people working in the business or those planning to enter it? For one thing, it means that in these larger organizations competition is fierce. The jobs are fewer and carry greater responsibility, but the work must be done and jobs and rewards exist for talented and dedicated designers and merchandisers. It also means that the small business—if it is original and unique and can satisfy customers' needs profitably—holds real career potential for those who can identify opportunity and seize it.

Technology Is Widespread

To get closer to the customer, to learn what is in fashion today, and to react to customer demand, the apparel industry makes widespread use of technology in the form of computers. Large and small retail stores use computers to determine exactly what is selling and what is not. For example, at the end of every business day, the management of The Limited stores, headquartered in Columbus, Ohio, can learn what items have sold in every Limited, Express, Victoria's Secret, Lerners New York, Lane Bryant, and Henri Bendel store throughout the country. By knowing the color, size, and price of each item sold, the buyers can swiftly reorder the best selling merchandise while the time is right. Using satellite transmission and high definition television, a supplier to these stores can also send images of the latest styles to its factories in China. Within six weeks the garments made from those images are in the stores.[11]

Computers also help fashion designers by enabling them to design directly on the computer screen, known as Computer-Aided Design, or CAD. Using CAD enables a designer to create a three-dimensional design and avoid costly mistakes by viewing early on the item designed, say a shoe or jacket, from all sides. Later, computers quickly grade garment patterns into the needed sizes, an otherwise onerous and time-consuming task.

To supply customers with the right merchandise quickly, however, retailers, manufacturers, and their suppliers make use of **Quick Response (QR)**, a computer technology that permits rapid manufacture of ordered merchandise. With Quick Response, a retailer's computer transmits store needs for say jeans to the manufacturers whose computers then send their requirements for denim to the fabric suppliers, the fabric is shipped instantly, and the jeans are manufactured. The retailer then has new jeans arriving in the store weekly instead of every six weeks or so.[12] A major advantage to keeping stocks available for customers, Quick Response is an important way of counteracting low-cost foreign-made goods with slow deliveries. Increased use of more sophisticated technology can be a way to increased profits as well as greater consumer satisfaction.

SPOTLIGHT ON A FIRM

LIZ CLAIBORNE, INC.

Today, Liz Claiborne, Inc. designs and markets women's and men's apparel and accessories and contracts for production with independent manufacturers in the

men's division with a complete line of men's wear. Liz Claiborne, Inc. also has arrangements to produce fragrances and accessories, including handbags, shoes, and jewelry.

Liz Claiborne, Inc. is the brain child of fashion designer Liz Claiborne and her husband, Arthur Ortenberg. Both are now retired, but still oversee the overall direction the company takes. A successful business in tough times for the apparel industry, many-faceted Liz Claiborne, Inc. rings up over $2 billion in sales each year. Customers enjoy the identification of a designer's name on brand merchandise at less than designer prices. Retail stores nationwide buy the lines because they sell almost effortlessly.

Liz Claiborne got her break early on because she was the first to realize that as more women were employed they needed fashionable and attractive apparel, both for work and recreation. She put the marketing concept into action by finding out what her customers needed and offering it at a price that enabled her company to earn a profit and to grow.

United States and overseas. The company, headed by Jerome Chazen, offers a variety of dresses, sportswear, and men's wear under an assortment of labels; among them the Liz Claiborne Collection, a better line of elegant and casual ready-to-wear; Lizsport, a colorful casual apparel line; Lizwear, sportswear for weekends; Liz Claiborne Dresses, apparel for day and evening wear; and Liz & Co., a line of knitwear for comfort and travel. The company also manufactures petite and larger-sized lines; the latter carries the label Elisabeth. The division that bridges between the better and designer apparel is called Dana Buchman and offers sportswear in a variety of fabrics and textures. Claiborne is the company's

Hosiery and eyewear are produced under licensing agreements.

Administration of the company's output stems from production headquarters in North Bergen, New Jersey. There, the product engineering, including pattern and sample making, takes place as well as the allocation of manufacturing worldwide and the administration of quality control. Suppliers are chosen on their ability to meet company quality and delivery standards.

In addition to selling its lines to some 3500 department and specialty stores across the country—among them Dillard's, The May Company, and R. H. Macy—Liz Claiborne, Inc. practices dual distribution by operating its own Elisabeth stores for larger women,

First Issue sportswear stores featuring moderately priced dresses and sportswear, and Liz Claiborne stores, offering assortments of women's and men's wear and accessories in selected locations in the United States, Canada, Great Britain, and western Europe. The company operates some 16 Liz Claiborne boutiques and also has just under 30 outlet stores featuring excess stock and merchandise from previous seasons.

In an effort to reach out to more middle-income customers, Liz Claiborne, Inc. purchased Russ Togs, a well known moderate- and budget-priced women's apparel manufacturer with labels that include Crazy Horse and Villager.

With some modernizing and new labels, Russ apparel will be aimed toward the mass marketing organizations such as Wal-Mart and Kmart.

Question for Discussion. Would you encourage Liz Claiborne, Inc. to expand through dual distribution domestically and overseas at the same time, or would you suggest that the organization concentrate on reaching more customers through mass marketing lower-priced apparel from Russ Togs? Cite your reasons.

Sources. 1. "An Essay: The Working Woman in America, Annual Report," 1989, Annual Reports of 1990 and 1991, Liz Claiborne, Inc.; 2. Liz Claiborne, Inc., brochure, Ibid., 1990, and other company materials; 3. Irene Daria, *The Fashion Cycle,* Simon and Shuster, New York, 1990; 4. James Lardner, Annals of Business: "The Sweater Trade—I and II," *The New Yorker,* January 11 and 18, 1988, pp. 39–76 and 57–73, respectively; 5. Liz Claiborne, Inc. Company Update, Prudential-Bache Securities, October 26, November 29 and December 17, 1990; 6. Liz Claiborne, Inc., Research Capsule, Ibid., May 16, 1990; 7. Nina Darnton, "The Joy of Polyester, Can Courting Kmart Revive Liz Claiborne?", *Newsweek,* August 3, 1992.

Successful Businesses Respond to Customer Needs

Successful businesses today are able to quickly identify and respond to customer needs. This is not an easy task in the fashion business where customers themselves do not state their needs but do know what they want to buy when they see it. Successful businesses, however, want to discern customer needs and react to them.[13] For example, Donna Karan's work stems from the idea of creating clothes for busy women who want fashion elegance and comfort, suitable to wear from work to dinner.[14] Or, the success of The Gap and its offspring GapKids and babyGap is based on management's understanding of customers' needs for fashionable and wearable weekend wear and sportswear at moderate prices. Those businesses that determine what customers want and what the business can offer at a profit are the ones that can succeed in an environment of higher costs and increased competition. One popular strategy among businesses today is known as **niche marketing,** that is, identifying and closely targeting a specific market segment and gearing operations to serve that segment. Donna Karan and Eddie Bauer are among many successful businesses applying niche marketing strategies.

Summary

1. Fashion marketing begins with determining what customers want and—when it is produced—getting it to them quickly. Since fashion is "perishable," new styles move quickly from manufacturers to retailers.

2. Apparel manufacturers are located in various parts of the country. The major cities where fashion goods are created and marketed are called market centers. The six major domestic market centers are New York, Los Angeles, Chicago, Dallas, Miami, and Atlanta. New York is the historic center of the garment industry, the headquarters of major designers and manufacturers, and many buyers believe that the widest variety of new merchandise is found there.

3. Los Angeles as a market center is known for California sportswear; a major center for buying here is the CaliforniaMart. Chicago features men's wear and women's apparel manufacturing and the area is headquarters for the major retail chains Sears, Roebuck and Co. and Montgomery Ward. Chicago's Apparel Center draws retailers from the Midwest and Canada to its showrooms. Dallas is known for southwestern wear and men's wear and Miami for children's wear. These cities and Atlanta have apparel marts open year-round.

4. Market centers hold periodic market weeks to introduce new lines to retailers. Market weeks take place three to six months before the merchandise reaches the stores to give the manufacturers time to make and ship the goods.

5. Trade shows, usually sponsored by the trade associations in an industry, run for three to ten days in temporary locations, often in medium-sized cities. Many smaller retailers do not attend all market weeks in market centers but opt instead to visit a trade show in a nearby city.

6. Three major directions for the apparel industry are: (1) the growth of individual apparel retailers and manufacturers; (2) the increased use of computers by retailers, manufacturers, and their suppliers to improve customer service and profitability; and (3) the realization that those organizations identifying and responding quickly to customer needs are the ones most likely to thrive and prosper.

Fashion Vocabulary

Explain each of the following terms; then use each term in a sentence.

apparel marts	market weeks	showings
channel of distribution	market(s)	showroom
leave paper	niche marketing	trade associations
market center(s)	Quick Response (QR)	trade show
market directory	Seventh Avenue	

Fashion Review

1. Name six major domestic market centers and explain their functions.
2. In what three or four ways does New York differ from other market centers?
3. Identify and discuss the outstanding characteristics of the other five major domestic market centers.
4. State three major advantages for retailers to attend market weeks and three major advantages for vendors to participate in them.
5. Describe three directions in which fashion marketing businesses are moving. Cite examples from your experience of each of these directions.

Fashion Activities

1. You are a buyer for a men's apparel store in the Southwest. The Dallas fall market is coming up. Create a list of things you need to do in preparation for your visit to Dallas to make the best use of your time during market week.
2. You are a manufacturer of children's swimsuits and warm-weather sportswear located in the South and you show your line regularly in Miami markets. Lately, your sales volume has been rising dramatically and you see no reason for it to let up. You are wondering if you should seek out sales representatives in other parts of the country and are wondering into which other major market centers you might expand. Write a memo to your staff citing two or three other market centers where you might offer your line and your reasons for selecting these locations.

Endnotes

1. Information from the CaliforniaMart press kit, the CaliforniaMart, 110 East Ninth Street, Suite A 727, Los Angeles, CA 90070.
2. Telephone conversation by author with the marketing department, CaliforniaMart, February 19, 1991, (213-239-9200).
3. "The CaliforniaMart's History," *Op. cit.*
4. Chicago Apparel Center bulletin and other press kit materials, The Chicago Apparel Center, Chicago, IL 60654.
5. "Merchandise Mart Facts: The Business of Design . . . and the Design of Business," Press kit background paper, the Merchandise Mart Properties, Inc., Chicago, IL 60654.
6. Press kit materials, *Ibid.*
7. "The Dallas Apparel Mart Background and History," Press kit news release, pp. 5, the Dallas Market Center Company, Dallas, TX 75258.
8. "The Menswear Mart Background and History," *Ibid.*
9. The Atlanta Apparel Mart Press Kit, the Atlanta Market Center, 240 Spring Street N.W., Atlanta, GA 30303.
10. Eben Shapiro, "Few Rags in Riches These Days," *The New York Times,*. January 5, 1991, p. L 29.
11. John Holusha, "Factory Tradition, Fashion Imperative and Foreign Competition," *Ibid.,* September 9, 1990, p. F 4.
12. Walter F. Loeb, "Managing for Success in a Recession," *Conversations for the '90's,* Harris Trust and Savings Bank, Chicago, IL 1990.
13. Cyndee Miller, "Fashion Industry Adapts to New Consumer Power," *Marketing News,* Vol. 24, No. 3, February 5, 1990, pp. 1 and 2.
14. Irene Daria, *The Fashion Cycle,* Simon and Shuster, New York, 1990.

International Markets

Objectives

After completing this chapter, you should be able to:

1. Name and describe three major foreign fashion centers each in Europe, Asia, and the Western Hemisphere.

2. Explain the purpose, composition, and major activities of the haute couture and its relationship to the Chambre Syndicale.

3. Cite the importance of international fashion trade and state the effect of free trade and protectionism on U. S. apparel manufacturers, retailers, and consumers.

4. List and describe two or three laws influencing the international apparel trade.

5. Explain three ways that U. S. manufacturers import goods and four ways retail organizations buy foreign merchandise.

6. Describe two or three exporting activities of U. S. apparel businesses.

T*he New York designer's product manager, Sybil Rochard, and her assistant sat at the rectangular table in the office of the Hong Kong factory, along with James Chang and his son, the two factory owners. Rochard had traveled from the United States for this meeting, but was used to the trip, since it occurred several times a year as production time neared for each season's lines.*

Each person at the table had a set of papers with the croquis or sketches of the coming season's designs and the specifications for each garment.

"Let's review the line and see what we have," said Rochard.

"First, we have Spring I," replied her assistant. "Let's start with the Soft Comfort group of knits, consisting of three sweater styles with matching skirts and slacks. Total quantity is 50,000."

"What retail price do you want to target?" asked the senior Chang.

"$160 for the tops and $120 for the skirts and slacks," answered Rochard.

Mr. Chang deliberated for a minute and then noted, "We can make it for that but will need to send the skirt to our other factory. The sweaters and slacks we can do here."

"Can you meet the same delivery?" Rochard's assistant wanted to know.

"It should work out just fine," replied Chang's son. "We are in daily communication with all of our factories and that keeps us together on our schedules."

In this instance, everything did work out just fine. The stateside specialty stores buying this designer's bridge line received the merchandise for early spring promotion, a feat not always easily achieved from halfway around the world.

Important Fashion Centers

Apparel is produced and marketed in industrialized and developing economies throughout the world. When apparel manufacturers in a given country make goods to sell in other countries, they are creating **exports.** For example, some Monet or Napier costume jewelry, created in Rhode Island, may be destined for export to Canada or Europe. When businesses or individuals buy goods manufactured in other countries, they are purchasing **imports.** Some of your T-shirts and sweaters may bear labels from far-away places such as Hong Kong, Korea, Israel, Greece, or Italy. The businesses in most countries both export and import goods, although not necessarily to the same degree.

There are three major types of fashion goods producers operating in other countries. These are: the couture; ready-to-wear manufacturers; and offshore contractors.

The Couture

The couture, French in origin, headquartered in Paris but not limited to French citizens, stands unique as a source of ideas to the entire fashion industry. **Haute couture** (oat koo-tour´), that is high fashion, means a business, known as a couture house or "maison de couture," whose designer creates an original collection of garments that may then be made-to-order for individual clients. Couture garments are very costly, running from around $7000 for a day dress to $100,000 for an evening gown, and even more for a bridal gown. The couture houses with the greatest worldwide impact on fashion are nearly all in France, with a few in Italy.

Ready-to-Wear

Ready-to-wear manufacturers have sprung up throughout the world. Most consumers are not in the market for couture, but rather for the more moderate prices of most ready-to-wear. Even couture designers create secondary ready-to-wear lines, called **prêt-à-porter** (pret-ah-por-tay´), at approximately 40 to 60 percent lower than

their couture prices. These are the designer garments seen in exclusive stores in the United States. In addition to Paris, ready-to-wear manufacturers are creating fashion goods successfully in many places such as Italy, Spain, Germany, Israel, Japan, and Great Britain, making these countries important global fashion centers.

Offshore Contractors

Working with independently owned foreign producers to manufacture garments is called **offshore contracting.** This is a widespread way of producing apparel by American and foreign designers, manufacturers, and retailers. Under the offshore contracting system, the designs are furnished to the foreign contractor and the goods are made to specification. One example is Patagonia, Inc., of Ventura, California. Patagonia creates its own designs in house and contracts to have its women's sportswear produced offshore in Hong Kong, Thailand, and Singapore, while outerwear is made elsewhere in the United States.[1] The Hong Kong manufacturer in this chapter's opening story is another example of an offshore contractor. Apparel manufacturing is labor intensive and can be accomplished economically in countries where the cost of labor is low. For these reasons, offshore production occurs in places such as Hong Kong, China, Taiwan, and Central and South America.

A discussion of the major market centers follows. Note the types of apparel production for which each is known.

Europe

Europe is famous for apparel and accessories found not only in the traditional cities of Paris, Milan, and London, but also throughout the continent and beyond. The Scandinavian countries of Denmark, Norway, Sweden, and Finland are renowned for woolens, silver, and furs; Austria is known for knits; and Ireland is famous for wool sweaters and tweeds. Spain and Greece produce leathers; and Israel is highly regarded for swimwear as well as knits and leathers. Many of these countries are growing as fashion centers.

The emergence of the European Community (EC), consisting of the major European nations who have lowered economic and political barriers, encourages trade in all goods including fashion merchandise. Primarily, fashion goods production is concentrated in France, Italy, Great Britain, and Germany. These countries are the topic of this section.

France

France is world-famous for its haute couture, meaning exquisitely sewn high fashion; nothing like it exists in the United States. France is also a major producer and marketer of prêt-à-porter and other ready-to-wear. A traditional center for creative fashion innovation, Paris has been a showcase of fashion for over three centuries, since the days of Louis XIV, the "Sun King." While its importance as a design center has waned in the

past, recently Paris has reinforced its position as the world's fashion leader to the extent that along with French designers, well known Italians, Japanese, and even Americans, such as Valentino, Issey Miyake, and Oscar de la Renta, show their collections in Paris.

Haute Couture. The couture was started originally not by the French but by an Englishman, Charles Frederick Worth, who opened the salon in his Paris "maison de couture" not quite 150 years ago. Operated by his descendents, the House of Worth functioned for nearly a hundred years, counting among its clients the Empress Eugènie, many nobles, and society matrons. Many of these women had their portraits painted by leading artists in the elegant dresses and beautiful ball gowns designed by Worth.

The purpose of haute couture is for designers to create the most beautiful garments from the most luxurious materials for the two or three thousand women in the world who want custom-made designer apparel and can pay its exorbitant prices. The designer is called a **couturier** (koo-tour´-ee-ay) if male, such as Yves St. Laurent or Christian Lacroix, or **couturière** (koo-tour´-ee-air) if female, such as Gabrielle "Coco" Chanel or Nina Ricci. In this text, the term couturier refers to both men and women. Couture garments call for two or three fittings, the first in toile—a muslin version of the outfit. When the garment is finished it is said to be as beautifully constructed on the inside as it is on the outside.

The Chambre Syndicale. The major couturiers are members of the Chambre Syndicale de la Couture Parisienne, the governing organization of the French fashion industry. Founded in the late 1860s, the **Chambre Syndicale** (shom´-br san-dee-kall´) concerns itself with requirements for showings, qualifications for membership, and other matters important to the industry. To be a member of the Chambre Syndicale, a couturier does not need to be French. One of the greatest couturiers of all time, Cristobal Balençiaga, was Spanish; Elsa Schiaparelli was Italian; and the originator Worth was British.

Because the costs for producing a couture collection can reach $3 million and more, the Chambre Syndicale is in the process of relaxing some of its regulations to encourage young couturiers. At the time of this writing, it is anticipated that a member couture house will meet the following requirements:

- Request in writing membership in the Chambre Syndicale.
- Locate workrooms in Paris with at least 20 employees, but couturiers need employ only 10 for the first two years.
- Show an original collection of not less than 50 garments twice a year, in January and July, on dates set by the Chambre. New couturiers may show only 35 garments the first two years.
- While formerly two or three models were employed by each couture house year-round to show the collection to customers, today the use of videos has eliminated that requirement.[2]
- Create in the workrooms only custom-made apparel—not ready-to-wear— for individual customers.

In addition, the Chambre Syndicale has decided to allow designers with studios outside of France to become associate members. These designers include Vivienne Westwood, Romeo Gigli, and others.[3]

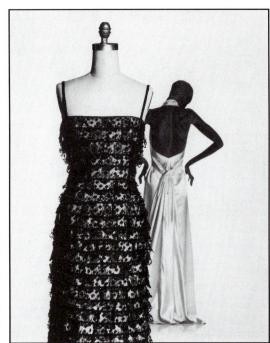

Figure 12-1. Elegantly styled haute couture garments in black and white continue to impress. Left: Balençiaga's beaded black lace cocktail dress over white organza, 1960s. Right: Jacques Griffe's white satin evening dress, 1930s. (Courtesy The Rowland Company)

The Chambre Syndicale is highly useful to the fashion industry. It sets dates for showing the new collections twice a year and it takes care of registration. It also serves the purpose of a union among its members in matters of grievances and wage and hour settlements. Finally, the Chambre registers and copyrights new fashion designs to protect them from illegal copying. There is no similar protection for fashion designs in the United States.

Currently, the French government is working with the couture, through the Chambre Syndicale and its members, to revise some of the couture rules. The purpose is to encourage young designers to participate more easily by showing, say 25 garments instead of the required 75, as a start.[4]

At the time of this writing, Pierre Bergé, head of the house of Yves Saint Laurent, pulled out of the Chambre allegedly over a dispute to move up the dates of ready-to-wear showings. Bergé, who was responsible for the restructuring of the Chambre Syndicale in the 1970s, threatened to start his own organization. He believes that the designers should have control over industry events, but too often the design houses of today are controlled by their business owners. For example, the organization Financière Agache claims ownership of the houses of Christian Lacroix, Christian Dior, and Hubert de Givenchy.[5]

Couture Showings. Normally there are around 24 couture houses and most show new collections twice a year, although costs for major showings can run to over a $1 million.[6] January collections feature spring and summer designs; July collections contain

fall and winter fashions. Couture houses may bear the name of the designer such as Pierre Cardin or Hubert de Givenchy, or the name of the originator, such as Christian Dior, but the designer's name is well-known. For example Gianfranco Ferre is the designer for Dior, Karl Lagerfeld is the designer for Chanel, and Oscar de la Renta designs for the house of Pierre Balmain. All of these designers also produce under other labels, too. Lagerfeld for instance, designs for Chloë and also under his own name.

The following types of customers may be seen at couture showings:

- Fashion press and information services who report on the latest styles.
- Individual clients who attend some showings and visit the couture houses to purchase designs to be made to order for their personal use.
- Retail trade buyers prefer to attend the couture's prêt-à-porter or ready-to-wear showings, which are held more in advance of each season. For example, fall merchandise is typically shown in March.
- Trade buyers, including apparel manufacturers, textile producers, and retailers who purchase styles to copy or adapt for ready-to-wear.
- Pattern companies who purchase designs to create patterns for their customers.

Individual customers are admitted to showings without charge, as is the press; however, members of the press must register with the Chambre Syndicale. All trade buyers must pay a fee, called a **caution** (ko-see´-on) to attend a showing. The caution may be a certain amount of money or an agreement to buy a certain number of items.

Other Couture Activities. The two or three thousand women who buy haute couture garments are not a large enough market to keep the industry profitable. For this reason, couturiers branch out into other activities such as ready-to-wear, their own boutiques, and licensing.

Figures 12-2a, b, c, and d. A designer's press kit helps promote each season's line. (Courtesy Karl Lagerfeld)

- **Ready-to-wear.** Couturiers, such as Christian Lacroix and Emanuel Ungaro among others, create ready-to-wear (which they call prêt-à-porter) at prices far lower than their couture garments and sell them to many more customers throughout the world. The couture garments you see in designer departments of exclusive stores come from their ready-to-wear collections.
- **Boutiques.** Many customers who cannot pay couture prices enjoy items from the couturier's collections. For this reason many couturiers have set aside a small shop or **boutique** (boo-teek´) featuring the designer's ready-to-wear collections and accessories. A customer who cannot afford an outfit may well splurge on a scarf, jacket, or handbag. Some boutiques offering the designer's merchandise are expanding into other countries; for instance Chanel boutiques are found around the world.
- **Licensing.** As you recall from Chapter 4, licensing is granting the right to use a famous name on a product. In designer licensing, for a fee the couturier grants the right to a manufacturer to use his or her name on a designated product or line such as apparel, accessories, small leather goods, and other items. The designer may participate in any number of noncompeting licensing agreements and may have the amount of control over the goods that she or he wishes. Developing a signature fragrance was the way most designers entered into licensing; just about every designer today has a well-known fragrance on the market. The licensing of a variety of products can be very profitable to designers and is now imitated by retailers such as Cartier, Benetton, and others.

Figure 12-3. A Patou boutique in Paris with strategically placed accessories to complement the perfect outfit. (Courtesy Patou, Paris)

Figure 12-4. A Sonia Rykiel boutique window in Paris featuring the designer's innovative ready-to-wear. (Photo courtesy Bob Colborne)

Prêt-à-Porter. The French ready-to-wear industry has two elements: designers and more moderately priced manufacturers. In addition to the couturiers who also create ready-to-wear, there is a group of innovative designers who specialize in designing ready-to-wear. Among these include Azzedine Alaïa, Dorothée Bis, Jean Charles de Castelbajac, Kenzo, Thierry Mugler, and Sonia Rykiel. To assist these ready-to-wear designers, also known as **créateurs,** the Chambre Syndicale expanded its membership and now its total membership of over 40 includes some two dozen créateurs as well as couturiers.

Under the sponsorship of the Chambre Syndicale, the couturiers show their collections twice a year in the Cour Carée of the Louvre, while the createurs show their collections twice a year in various places throughout the city. The March showings feature fall and winter apparel and the October showings feature spring and summer wear. At the same times the more moderately priced manufacturers show their ready-to-wear at the Porte de Versailles exhibition hall. A show for men's wear is also held twice a year, in February and September, and is known as SEHM, Salon de l'Habillement Masculin. Thousands of buyers from throughout the world make a point of attending these important prêt-à-porter trade shows.

An important textiles and apparel organization in France is Bidermann SA, the parent of Bidermann International, the largest men's wear manufacturer in France. Bidermann International is also the owner of Bidermann Industries USA, which manufactures among other labels Arrow, Bill Robinson and Burberry's men's shirts, Perry Ellis hosiery, and Ralph Lauren Womenswear.[7]

Italy

Although younger than French couture, Italian **alta moda**—meaning high fashion—is outstanding, surpassed only by French haute couture. Italian ready-to-wear is also one of the nation's leading industries with heavy exports to Germany, France, and the United States. Italy is known throughout the world for its beautiful fabrics, sophisticated prints, leather goods, and men's wear.

Well-known Italian designers include Giorgio Armani, Valentino, Gianfranco Ferre, Mila Schön, and Gianni Versace and the young team of Domenico Dolce and Stefano Gabbana who count Madonna and other celebrities among their clients. Italian design centers include Milan, Rome, and Florence. Like their French counterparts, Italian designers create lower-priced—although still costly—ready-to-wear: for instance, Versace designed through 1994 the Genny label along with others, and Armani has several lines in a range of prices. Some are marketed internationally through approximately 30 Armani stores and over 100 Emporio Armani boutiques in places from Florence, Italy, to Honolulu, Hawaii. Armani sells some of his other lines to department and specialty stores throughout the world.[8] Other designers have their own international boutiques, including Valentino with a boutique in New York City and one in Beverly Hills, and Romeo Gigli, with a boutique in Manhattan.[9]

Ready-To-Wear. Mass-produced ready-to-wear is made by several popular Italian companies. Consider Benetton, manufacturing and marketing sportswear for women, men, and children in shops throughout the world. This global organization grew out of the work of one family, three brothers marketing the sweaters designed and knitted by their sister. Other well-known Italian apparel and accessory firms include Basile, Ferragamo, Gucci, and Missoni.

Trade Shows. Ready-to-wear trade shows are held twice annually in Milan and Florence, just before the French prêt-à-porter shows in Paris. Both cities promote their shows extensively, with Florence emphasizing men's and children's wear and

Figure 12-5. This Fortuny gown from the 1920s is an example of Italian designers' tradition of attention to detail and exquisite fabrics. (Courtesy The Rowland Company. Collection: The Ohio State University Historic Costume and Textiles Collection. Photo courtesy Fredrik Marsh)

Milan promoting women's wear. The fall and winter collections are shown in early March and the spring and summer collections in October. This coordination minimizes the travel time and expense for store buyers and fashion editors, permitting them to see both the Italian and French collections on one trip. Men's wear is shown in Florence in February and September. Handbags, scarves, belts, and other accessories are shown at a trade fair called Mipel, held in Milan during January and June, and well-known Italian shoe manufacturers have a show in Bologna in March. One of the most important trade shows is the exciting Ideacomo, the fabric show held in early May at Lake Como. Since new fabrics and patterns are sources for new fashion ideas to designers, Ideacomo provides inspiration to fashion creators and the press.

Great Britain

Traditionally famous for men's custom apparel and for elegant ceremonial gowns, today's British fashion industry is also known for its ready-to-wear. However, a man may still visit the tailors' shops on London's Savile Row and order a "bespoke" (custom tailored) suit and shirts. Each will require at least three fittings and the suit will cost from $1500; the shirts, of which he must buy four initially, will tally up around $1000. For these sums, the customer is assured of incomparable fit and wearability. It is not uncommon for "bespoke" apparel to last for decades. Unfortunately, the elegant formal gowns needed for royal ceremonies, such as weddings and receptions, are not sufficient to support an entire couture industry.

Ready-To-Wear. British ready-to-wear is available in three price categories: designer ready-to-wear, moderate, and budget. In the 1960s the ready-to-wear industry had a revolutionary boost from a young designer named Mary Quant who realized that young women did not want to dress like their mothers. She opened a shop on King's Road and then began designing her own apparel for mass production. Quant paved the way for more "free-wheeling" designs such as those by Zandra Rhodes and Vivienne Westwood.[10]

Other successful British ready-to-wear designers include: Katherine Hamnett, whose much-copied designs are based on workwear; Ellis Flyte and Richard Ostell, whose Flyte Ostell Collection is carried by Dayton Hudson and Bergdorf Goodman; and Selina Blow, whose retail-store customers include Saks Fifth Avenue and Charivari. Among Britain's younger designers are award-winning Arabella Pollen and John Richmond.

Some other familiar names in British fashion include Liberty of London, famous for complex printed fabrics for dresses, blouses, and men's ties; Laura Ashley apparel and prints; apparel for men and women by Burberry; and rainwear by Aquascutum. Garments made of the famous tweed and woolen fabrics, as well as lambswool and cashmere sweaters from Britain and Scotland, are a British fashion mainstay throughout the world.

Trade Shows. Exporting British fashion is a $1 billion or more business promoted by the Fashion Council of Great Britain. The Fashion Council sponsors two major trade

shows, one in the spring and the other in fall. A major trade show for men's wear is the International Men's and Boy's Wear Exhibition held in London in February.

Germany

While German couturière Jil Sander is causing a stir in Paris, Germany itself is known for well-made, conservatively styled, high to moderately priced ready-to-wear for women and men. Two women's apparel firms stand out because each has its own stores in the United States. These firms are Escada and Mondi.

Ready-to-wear. Escada AG is one of the largest vertically integrated fashion organizations in Europe. As you recall from Chapter 4, a vertically integrated firm owns both its marketing and production facilities. In Escada's case, the company owns manufacturing facilities in Germany and Italy, and some of the marketing facilities for the lines its designers produce. For example, some of the publicly held company's factories are in Germany and some are in Italy and other parts of Europe.

In addition to the Escada line created and designed by Margaretha Ley, until her death in 1992, other lines include: Laurel, for career women; Crisca, for younger customers; Cerruti 1881; and Acatrini. Designer Natalie Acatrini designs the collection bearing her name as well as the Crisca line for Escada.[11] There is also a bridge line called Apriori whose advertisements are hung as art pieces on some consumers walls.[12] Larger stores offering the Escada line include Neiman Marcus, Bergdorf

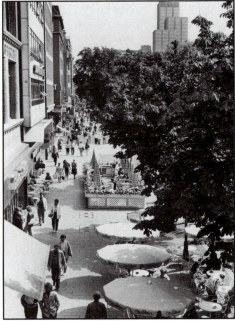

Figures 12-6a and b. A Dusseldorf fashion house and the famous fashion promenade known as the "Ko," a street for elegant shopping and strolling. (Courtesy Igedo)

Figures 12-7a and b. The thousands of elaborate vendor showrooms at the Igedo trade show in Dusseldorf draw retail buyers from all over Europe. (Courtesy Igedo)

Goodman, and Marshall Field's. Escada has over 100 stores and boutiques of its own throughout the world, among them: Escada boutiques in New York and California; an Escada and Laurel boutique in Scottsdale, Arizona; and a Crisca boutique in Houston, Texas.[13] Like Escada, Mondi has boutiques in major international cities. Other German manufacturers, such as Hugo Boss, the men's wear manufacturer with 900 stores in Germany alone, are following these two leaders, offering apparel in somewhat more moderate-priced ranges.[14]

Trade Shows. The famous women's ready-to-wear trade show in Germany—known as Igedo and held in spring and fall in Dusseldorf—features thousands of vendors. In 1991, Igedo drew some 180,000 visitors from Europe and overseas, who purchased merchandise for their store totaling $8 billion.[15] A show featuring men's wear is held twice annually in Cologne, is about one third the size of Igedo, but also attracts nearly 30,000 buyers. There are also shows for children's wear and footwear in Cologne and Dusseldorf. Some fashion professionals believe that the trade show format like Igedo's may soon replace the individual designer showings of Paris and Milan because of the skyrocketing cost of individual showings.

Another popular trade show, the famous German textile fair, Interstoff, is a source of inspiration for apparel designers and manufacturers. Held in Frankfurt in May and November, Interstoff features fabric producers from a variety of countries exhibiting their latest goods to various fabric buyers from all over the world. From the United States, Cranston Print Works brings typical American fabrics, such as calico and denim, to Interstoff and converter Symphony Fabrics offers American novelties.[16] The latest designs and technology seen here fuel the industry's imagination for new apparel. For example, fabric buyers from Anne Klein and Liz Claiborne, Inc., shop Interstoff, the French fabric show Première Vision, and Ideacomo for new fabric ideas. To boost Germany's foreign trade, the Overseas Export Fashion Fair is held in Berlin in September.

SPOTLIGHT
ON A FIRM

GIORGIO ARMANI COMPANY

Founded in 1975, Milan-based Giorgio Armani, S.p.A. (S.p.A. meaning company), has grown vastly in popularity throughout Europe and the United States. It offers apparel for men and women in an array of price lines: the couture-priced Giorgio Armani le Collezione; a prêt-à-porter Giorgio Armani Borgonuovo 21 line; a somewhat lower-priced designer ready-to-wear line, Emporio Armani; Mani, a line of men's and women's wear for the U.S. market; and Armani jeans and an assortment of swimwear, underwear, fragrances, and accessories. The higher-priced Armani lines tend to be concentrated in the company's own Armani stores in major U.S. and European cities. The other lines are sold through department and specialty stores such as Neiman Marcus, Saks, and Bloomingdale's. Other recent ventures into the U.S. market include the opening of A/X Armani Exchange departments and freestanding stores, featuring Armani jeans and other weekend wear, mostly priced under $100.

The company is based on the work of its founder who was born in Piacenza, Italy, in 1934. Giorgio Armani studied to be a physician, but after a stint in the military service, he joined the famous Milan department store La Rinascente. His first job was working with merchandise display but he then moved to the fashion department as a buyer. As his interest in men's wear grew, he went to work for the manufacturing firm of Nino Cerruti. Before long Armani struck out on his own as a fashion consultant working also with designer Emanuel Ungaro. Armed with this experience, Armani started his own firm.

He designed first for men and then for women. Armani apparel is known for its timeless look, featuring well-cut lines, expert tailoring, and casual elegance for men and women. Many designers and manufacturers seek to emulate his classic looks such as long jackets over short skirts and the unstructured blazer. One of the firm's strengths lies in Armani's ability to translate and softly tailor men's wear looks for fashion-conscious career women. Another strength is the selection of fabrics made for Armani apparel. The company owns its own textile manufacturing facilities for the Emporio Armani line, participates in more than 20 licensing agreements and in two joint ventures in Japan. Giorgio Armani fragrances include "Gio," pronounced "Joe."

Giorgio Armani boutiques and Emporio Armani stores are found in Italy, Great Britain, France, the United States, Japan, and Hong Kong, among other places. Expanding company-owned stores in locations such as Dusseldorf, Germany, and Costa Mesa, California, Giorgio Armani, S.p.A.—the organization—hopes to gain even greater popularity. Some 2000 stores sell Armani goods throughout the world, contributing to the organization's estimated $700 million in annual sales. Armani stores and boutiques in the United States are located in major affluent markets: New York, Beverly Hills, Boston, Palm Beach, and Chicago. The glamour of Hollywood adds to the designer's aura when film stars such as Michelle Pfeiffer and Julia Roberts wear Armani gowns to galas like the Oscars.

To reach a wider target market with its A/X Armani Exchange offerings, the company is reaching out to affluent young and middle-aged men and women who want a casual look with a designer name but not at couture prices. A/X Armani Exchange includes a group of departments within higher-priced specialty and department stores as well as freestanding boutiques designed in rustic light woods reminiscent of Armani's own summer home off of Sicily. The idea is to offer casual designer apparel to a wide range of customers in accessible locations (as did its namesake, the military P/X Post Exchange).

Question for Discussion. In what additional ways could a designer-based organization effectively reach an international mass market?

Sources. 1. Materials from Giorgio Armani, New York; 2. Kevin Doyle, "Armani's True Confessions," *Women's Wear Daily,* June 25, 1992, pp. 4 and 5; 3. David Moin et al., "The A/X Blitz," *WWD,* February 25, 1992, pp. 1, 4–7; 4. Jane Mulvagh, *Vogue History of 20th Century Fashion,* Viking Penguin, Inc., New York, 1988; 5. Glynis Costin, "Giorgio's New Glamour," *W,* Fairchild Publications, New York, February 18–25, 1991, pp. 113–116; 6. "Armani Will Open a Store in Florence in September," *WWD,* August 7, 1991, p. 2; 7. *Giorgio Armani Collezione Autunno Inverno 1990/91,* Giorgio Armani, S.p.A., Milan, Italy, 1990; 8. Genevieve Buck, "Take a Bow!" *Chicago Tribune Magazine,* September 9, 1990, pp. 53–60.

Asia

With the exception of Japan, wages in Asia are extremely low in comparison to the United States. Apparel production is a labor-intensive industry. Usually, it is less expensive for manufacturers in developed nations where wages are higher, such as the United States, Canada, or France, to have goods produced where wages are far lower (as in Asia). Stores, eager to supply customers with reasonably priced goods, seek out merchandise offering the best values; often they are imports. Several important Asian sources for fashion apparel include Japan, Hong Kong, Taiwan, and Korea, among others.

Japan

Once known for cheap trinkets, Japanese industries are world leaders in many areas, among them electronics, automobiles, and apparel in high- and better-priced ranges. Japanese designers rank among the world's leading creators and a number of them show in Paris. These include the early leaders such as Kenzo Takada, Hanae Mori, and

Issey Miyake, followed by Rei Kawakubo for Comme des Garçons, Yohji Yamamoto, and other more recent arrivals, among them Yuki Torii and Junko Shimada. The timeless, asymmetrical look of Japanese apparel appeared in the 1960s, and for the next decades took the fashion world by storm.

The concern of Japanese designers with color, texture, and proportion, changed the view of European and American designers whose primary focus had been on shape. Younger designers producing ready-to-wear in Japan today include Kei Mori, son of Hanae Mori, who is with Studio V; Isao Kaneko who designs for Pink House; and Yoshie Inaba who works for Bigi.

The Japanese fashion industry does well over $30 billion in sales each year. It consists of vertical operations. For example, the Jun group manufactures nearly two dozen brand names and markets them in over 500 of its own Japanese stores. The Renown manufacturing group has sales well over $1 billion through its production of almost 50 apparel lines.[17] Tokyo Fashion Week, held twice a year, is the industry's major trade show.

Hong Kong

Hong Kong has a large luxury retail market with world-famous designer goods available in many stores and boutiques. In manufacturing, Hong Kong's textile and apparel industries are among its largest. Apparel from Hong Kong is exported throughout the world. The nearly 15,000 textile and apparel producers employ over one third of Hong Kong's labor force.[18] Known at one time for inexpensive goods, Hong Kong has changed its fashion image and raised its prices. Some manufacturers contract to produce designer and brand-name garments. Pierre Cardin, Giorgio Armani, Calvin

Figure 12-8. Fashions on the runway at Hong Kong's annual fashion week show. (Courtesy Hong Kong Trade Development Council)

Klein, Liz Claiborne, and Esprit are some of the firms whose goods are made in part in Hong Kong. Other manufacturers have turned to producing the collections of Hong Kong designers; among them, Patricia Chong, Eddie Lau, and Anna Pang.

Hong Kong holds an annual fashion week, and the Hong Kong Trade Development Council promotes its designers' collections at trade shows in Germany, France, and the United States. The future of Hong Kong as a viable apparel source is uncertain. In 1997, it will revert from its present protection by the British government and become a part of mainland China. Members of the business community are concerned about whether or not Hong Kong's form of free-enterprise economy can function under the Chinese government.

Taiwan

Industrialized when the followers of Chiang Kai-shek fled the communist takeover of China in 1947, Taiwan follows the lead of Hong Kong in developing its apparel industries. Many Taiwanese factories produce under contract moderately priced sportswear made of manufactured fibers. Taiwan's textile factories are known for the production of polyester fibers. The Taiwan Textile Federation helps young designers and technicians prepare for careers in the apparel industry. Like Hong Kong, Taiwan is continually improving the quality of its textiles and apparel. This improvement not only makes goods more appealing to overseas markets but also increases their value. Businesses in the United States are major customers for apparel imports, yet to protect its own industries, the U. S. government has restricted its imports. These restrictions, described later as quotas, specify the types and number of garments that may be brought in to the United States but not their price. Therefore, the producing country benefits by creating higher-priced goods resulting in greater income.

Korea

Korea has followed the footsteps of Japan in industrializing. Its technology is outstanding in textiles and apparel. Korea is known for men's suits and shirts, knitwear, and sportswear for men, women, and children. Although much of the production is still by contracting, Korea is developing its own design and manufacturing capabilities. Maria Kim is one of Korea's best-known designers, with a business in the United States marketing knitwear.

Others

Of the other Asian nations, China has by far the greatest potential for trade and is a significant exporter of textiles and apparel. In fact, China is a leading supplier of low-priced apparel to the United States. It is true that the U. S. government differs with that of the Peoples' Republic of China on human rights and other issues, and cooled relationships after the Beijing uprising. However, in 1991 the U. S. government granted China what is known as Most Favored Nation (MFN) trade status, meaning that the United States treats China on an equal basis with other favored trading partners.

Renowned for its luxurious silks and fine embroidery, in addition to lower-priced apparel, and for being a major supplier of textiles to Hong Kong, China is sometimes an overeager participant in world apparel trade. China has been known to violate the restrictions on its textiles and apparel by **transshipping,** or sending goods through other nations to their final destination. By transshipping, the hope is that quota restrictions can be evaded and the goods then be treated as imports from the nation through which they are shipped. A nation found guilty of violating its quota restrictions must relinquish some of its quota, as has happened with China on occasion.

Other Asian countries manufacturing apparel for export, particularly in lower- and moderate-priced ranges, include Thailand, Sri Lanka, the Philippines, Indonesia, and Bangladesh.[19] For more timeless fashion influences in addition to volume-priced goods, Indonesia is known for printed cotton fabrics and sportswear; the Philippines, for embroidered shirts, blouses, jackets, and children's wear; Singapore, for shirts and sportswear; Thailand, for beautiful silks; and Malaysia and Sri Lanka for sportswear. India deserves special mention because of its tradition of colorful silks and its cotton fabrics; for example, the bright unique plaids of Madras. Dresses and blouses from Indian fabrics are popular throughout the world.

The Western Hemisphere

In addition to the United States, other significant contributors in the Western Hemisphere to the apparel industry include Canada, Mexico, and Central and South America.

Canada

The greatest trading partner of the United States in all categories is Canada. Canadian fashions are available in high- and moderate-priced ranges. There are two major fashion centers in Canada: Montreal and Toronto. The apparel industry, one of the country's top five, is promoted by the trade association Fashion Canada/Mode du Canada. This organization publicizes the work of Canadian designers and offers scholarships to design students. The Canadian International Womenswear Show held in Montreal draws exhibitors and store buyers from Europe and the United States as well as Canada. Also famous for its outerwear and furs, a large and well-attended Canadian outerwear showing is the Canadian Outerwear Fashion Fair in Winnepeg, Manitoba. Some Canadian designers include Alfred Sung, Angela Bucaro, and Bob Tan.

There is an agreement between the United States and Canada to eliminate all barriers to trading, such as taxing imports. The United States-Canada Free Trade Agreement of 1988 phases out trade barriers to a variety of products within a certain number of years. By 1998, taxes on trade in textiles and apparel are scheduled to be eliminated completely between the two countries.

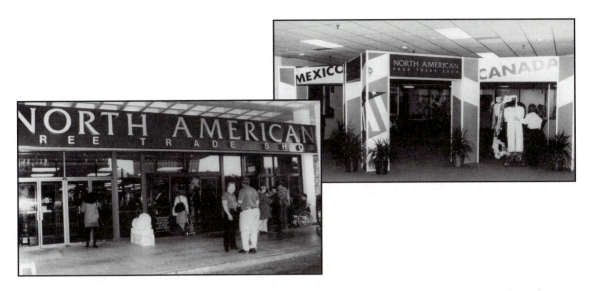

Figures 12-9a and b. Trade shows offer access to international markets. Shown here is the annual North American Free Trade Show held each October at the Dallas Market Center featuring merchandise from Mexico and Canada. (Courtesy Dallas Market Center Co. Ltd.)

Mexico

A similar agreement is in process with Mexico. Trade among the three nations amounts to more than $240 billion annually; eliminating trade barriers can dramatically increase this amount.[20] The goal of the expanded **North American Free Trade Agreement (NAFTA)** is to lower trade barriers among the United States, Mexico, and Canada, eventually creating a single North American market without trade barriers. NAFTA aims, in effect, for an economic climate similar to that of the European Community.

Apparel production for export is taking place now in Mexico, with factories owned there in part by U. S. firms such as Haggar Apparel Company, Arrow division of Cluett, Peabody, Inc., and Vanity Fair, among others.[21] It is expected that with the NAFTA, more U. S. apparel organizations will enter into larger-scale agreements in Mexico for goods to be produced at the lower Mexican wage rates. Many domestic apparel manufacturers believe that the NAFTA will open up new markets for their goods. The challenges for the United States, as expressed by the Clinton administration, are to maintain employment opportunities domestically for displaced workers; promote the human rights of workers in low-wage countries; and protect the environment from extensive pollution.

Central and South America

Along with Mexico and the Caribbean, some Central and South American countries are a source of offshore contracting for U. S. corporations. For example, Liz Claiborne, Inc. has contracted for knits to be produced in Panama. Some of these countries also

have organizations producing higher-priced fashions, and there is a growing interest in Latin American arts and crafts including ethnic apparel, jewelry, and leather goods.

Brazil is famous for leather goods and shoes. The factories that produce 9 West brand shoes and others for Connecticut-based Fisher Camuto are located in Brazil. Handbags, belts, and small leather goods are also made in Brazil. Argentina and Uruguay are well known for men's and women's apparel, particularly for fine woolens, and Peru and Ecuador are known as producers of silver jewelry.

International Trade

The fashion business is truly worldwide. Throughout history European apparel has influenced fashion trends in the United States. From the eighteenth to the twentieth century, many women looked to Paris for new fashion ideas, while men turned to Britain. After World War II, U. S. fashions, most notably jeans and other sportswear, spread to Europe and almost everywhere else. Today, fashion influences stem not only from Europe and the United States, but from all over the world as more and more nations trade with one another.

The Balance of Trade

When the value of the goods a nation exports equals or surpasses its imports, that nation's domestic industries and its economy tend to prosper. The difference between the value of a nation's exports and its imports is known as the **balance of trade.** For many years, the United States exported more goods than it brought in, creating a favorable trade balance, or trade surplus. In the mid 1980s, however, U. S. businesses began importing more than they exported, resulting in an unfavorable trade balance, or trade deficit. In 1991, the United States imported $5.2 billion in apparel while exporting under $2 billion in apparel, contributing a significant $3.2 billion to the total trade deficit.[22] While the United States is not the only nation with a trade deficit, its deficit, although declining, is still considerable in size.

Kinds of Imports and Their Importance

Nevertheless, imports are important players in the U.S. fashion scene and there are two major kinds of imports. The first kind is the import merchandise created and manufactured overseas—often the type of merchandise prized for its foreign origin such as an Emanuel Ungaro dress, Mondi suit, or a Harris tweed jacket—and ordered by retailers in the United States for their customers. The second kind is merchandise ordered by a domestic manufacturer or retailer to be manufactured overseas. This kind includes the apparel that either domestic manufacturers or retailers have created offshore to their specifications. For example, apparel organizations from Bugle Boy to Adrienne Vittadini regularly contract with overseas manufacturers to create garments from their designs. Similarly, most large retail organizations such as The Limited or The May Company have fashion goods created by offshore manufacturers from their specifications.

Figure 12-10. Fashion ideas come from the around world as seen here in this portion of an ad from J. C. Penney. (Courtesy *Marketing News*)

There are several reasons for manufacturers and retailers to offer customers imports: These include price, specialization, and exclusivity.

Price. When a manufacturer or retailer can supply customers with an imported product for a lower price than a similar domestic one, the company stands to sell more of that item and thus earn more money. As you know, apparel production is labor-intensive and the cost of producing fashion goods varies tremendously throughout the world. In the United States, apparel industry union wages average $7.75 per hour, comparable to those of other industrialized nations such as Japan and those of the European Community. However, the day's wages for some garment workers in Asian and Latin American countries may approximate the hourly earnings of U. S. workers. Some Asian workers may even be paid less than that: in the neighborhood of 25 cents per hour.

In the garment industry, manufacturing, shipping, and even paying import taxes can still make many imported goods less expensive than those produced domestically. In addition, some countries encourage exporting, providing incentives such as tax exemptions and preferential financing to exporters; such incentives for domestic industries are not practiced in the United States.

Specialization. Some nations specialize in certain aspects of fashion and are famous for them. British woolens and tweeds, Chinese silks, and Italian leathers are a few examples. These goods are renowned throughout the world and customers demand them. Also, many foreign factories are able to specialize by producing smaller orders and a wider variety of styles than are economically feasible for many large-scale

domestic manufacturers. Finally, in places where wages are lower and workers are skilled, handwork, such as hand-knitting, lace-making, and embroidery, are affordable additions to ready-to-wear styles. For example, Victoria's Secret may offer a competitively priced embroidered shirt produced in Asia.

Exclusivity. Mass production and mass marketing supply fashion goods to people everywhere, but often there is a complaint that these goods all look alike. While most people want to dress like their friends, everyone seeks out something different on occasion. Imports, which are usually not produced in such great quantities as domestic fashion goods, often provide that "special" look. An apparel manufacturer buys imported fabric because it will make up into attractive and unique men's sportshirts, or a retailer purchases a line of foreign sweaters because they are unusual and not to be found elsewhere. The ultimate in fashion exclusivity is the couture label, designating the designer's unique design ability. For these reasons, imports can bring with them an individuality not found elsewhere.

Free Trade and Protectionism

Down through history the United States has supported the rights of nations to buy and sell goods freely. In colonial days, various public demonstrations, including the Boston Tea Party, which signaled the start of American Revolution, were protests against taxing imports. The policy permitting the free exchange of goods among nations is known as **free trade.** The theory behind free trade is that each nation may specialize in producing and marketing the goods it makes best, trading them for the goods in which other countries specialize. Free trade encourages competition, for under free trade a business may create and market a new product and later discontinue that product when it is no longer profitable. In the United States, retailers and many consumers support free trade because they want the right to buy a wide range of goods from all over the world. The NAFTA negotiations with Canada and Mexico are evidence of the U. S. government's support of free trade.

On the other hand, whenever a company orders goods from overseas, these goods then are not produced domestically. Without domestic orders, jobs in domestic factories are reduced or eliminated and the factories themselves may be forced to close. The circle completes a full turn: workers who are not employed cannot purchase goods.

Domestic industries threatened with extinction seek help from our government in the form of laws and regulations. The government may respond by taking steps, known as **protectionism,** to limit or exclude competing imports. Typically, the backers of protectionist policies in a given industry are the organizations of manufacturers and the labor unions concerned with keeping the factories open and supplying jobs. For example, in the garment industry, manufacturers' campaigns featuring "Made in the U. S. A." and the ILGWU slogan, "Look for the union label," draw attention to domestically made apparel.

Regulating International Trade

Support for free trade and for the protection of domestic industries is provided for through international laws and agreements and domestic laws and regulations. International laws may be bilateral agreements negotiated between any two countries concerning their trading practices; or they may be multilateral agreements established among a group of nations. The United States has bilateral trading agreements with Japan, Taiwan, and China, among others, with the goal of reducing their exports to the United States.

International Regulation

To encourage international trade by lowering trade barriers, approximately 100 nations met nearly 50 years ago in Geneva, Switzerland, and created the multilateral **General Agreement on Tariffs and Trade,** known as **GATT.** The GATT organization and agreement were set up with the goal of negotiating trade restrictions among nations throughout the world. Since the late 1940s, the member nations of GATT have met periodically, reducing tariffs on thousands of products in a range of categories, and exploring concerns about trade barriers. An example of a trade barrier coming under GATT scrutiny was Japan's restrictions on importing U. S. agricultural products such as citrus, rice, and beef. Showing considerably more progress in improving trade among nations are the countries in the European Community (EC).

A major international law concerning the fashion industry is the Multi-Fiber and Textile Arrangement (MFA), an agreement among roughly 50 nations to provide for an orderly growth in textile imports while preserving the textile and apparel industries of developed nations such as the United States and Canada. MFA went into effect under GATT in 1974, and continues to be revised from time to time. Through MFA, imports can be negotiated with countries whose products threaten domestic industries and restrictions set through quotas, limiting the amount of goods a country can accept.

For individual apparel and textile manufacturers in the United States, MFA has not had the effect of protecting them because the limits and quotas are high. Quotas are also designated by units rather than price, encouraging exporting nations to move into higher-priced goods, siphoning off even more domestic production.

The goal of the U. S. government at the time of this writing is to do away with MFA over the next few years, as nations worldwide work together to lower trade barriers through GATT agreements.

Domestic Regulation

When a country wants to control the kind and amount of goods coming in from foreign nations, it has several choices, including taxes, quotas, and incentives to assist developing-nation trading partners.

Taxes. When the government of a country wishes to discourage competing goods from entering its country, it may tax these goods. Import taxes, known as **tariffs,** or duties, are usually a portion of the original cost of the item. Imported goods bound

for U. S. consumers—often goods also produced domestically such as apparel—are charged a duty at the port of entry. One purpose of the tariff is to eliminate any price advantage the imported item may have over the domestic one.

Import Quotas. To limit the amount of certain kinds of goods from foreign countries, a country may establish import quotas. An **import quota** sets the specific quantity of each item that may be brought into the country within a given time, usually a year. There are two types of import quotas: tariff-rate quotas and absolute quotas. Tariff-rate quotas raise the tariff on an item after a certain limit is reached. Absolute quotas ban further imports for a given time period when the limit is reached.

The United States enters into individual bilateral quota agreements with the major textile and apparel exporting nations, particularly the Asian exporters such as China, Taiwan, and Hong Kong, which compete with domestic manufacturers. At the time of this writing, China is the largest textile and apparel exporter to the United States, and Taiwan is second.[23] The U. S. Trade Representative has the responsibility of working out quota arrangements and the Customs Service watches over their implementation.

Quotas are measured by yardage (actual meters) and then translated into square meter equivalents (SMEs) in apparel items. They are then organized by fiber and garment categories. For example, category 638/639, including manufactured fiber knit shirts and blouses, is one category whose quota is negotiated with a given producing nation such as Taiwan. Usually the government of the producing country is in charge of allocating quotas to manufacturers based on the previous year's sales. If, for one reason or another, a manufacturer does not use its entire allocated quota, the quota cannot be saved for another season. The quota may be sold to another producer, though, thus saving the original manufacturer's right to receive a similar quota the next time.

As mentioned earlier, sometimes a country tries to evade quota by sending certain categories of goods through another country to the final receiving country in order to enter under the second country's quota. Shipping through another country, called transshipping, for the purpose of evading quota, is illegal. In 1992, in response to China's earlier quota circumvention, the U. S. government cut that country's apparel quota in several categories.[24]

The United States does not have quota agreements with the industrialized European Community since their goods do not underprice domestic goods and since U. S. exports to those countries are more nearly equal.

Assisting Developing Nations

To help developing nations industrialize, the United States has implemented a number of preferential programs in Asia, Africa, and the Caribbean. Two of these programs related to fashion are Section 807 of the U. S. Tariff Schedule and the Caribbean Basin Initiative.

Section 807. Sections 807 and 807A of the U. S. Tariff Schedule reduce or eliminate tariffs and quotas on goods partially produced in developing countries. Section 807 permits garments cut in the United States and sewn in certain developing countries to be taxed only on the "value added" by the sewing, not on the entire garment. For

example, if the cost price of a pair of jeans was $18.75, but the value added by sewing was $1.75, only the sewing value would be taxed, not the entire garment.

Section 807 has helped the Miami market grow recently. For example, Gitano Manufacturing Group, part of the Gitano jeans organization, has opened up a distribution center in Miami to handle Gitano's production done under Section 807.[25]

Section 807A states that the goods sent elsewhere for completion must originate in the United States. Apparel in the stores that you see with, say, the label "Assembled in Belize of U. S. components" is an example of Schedule 807A at work.

Caribbean Basin Initiative. The encouragement of the Caribbean and Latin America as developing economies has been of concern to the United States for a number of years. For this reason the Caribbean Basin Initiative (CBI) was passed in 1983, with the goals of building export industries in the Caribbean and Central America, and also protecting U. S. manufacturers. Due to expire in 1995, the CBI considers just about every kind of manufactured goods from the Caribbean and Central America exempt from U. S. quotas, provided that they meet certain requirements. Among the requirements are that the goods come directly to the United States, and that their value has increased by more than one third by the participating CBI country or countries.

Many manufacturers believe that the CBI nations must be treated similarly to Mexico under NAFTA or investment in these nations will cease. Some manufacturers are taking part in the development of all of these areas. For example, Jockey International, Inc., of Kenosha, Wisconsin, manufactures most of its knit underwear in the United States. Jockey also does manufacturing in the Caribbean and is establishing joint ventures in Mexico to make apparel for non-U. S. markets.[26]

Global Sourcing

Through international trade, fashion businesses participate extensively in the global economy. Importing goods lets manufacturers and retailers offer customers fashion selections from all over the world. Exporting fashion apparel and accessories permits manufacturers and retailers to increase the number of customers that they reach. Expanded target markets mean higher sales and greater potential profits. In the United States, many apparel businesses participate in both importing and exporting.

Importing

Today both manufacturers and retailers look throughout the world for goods for their customers. For example, an apparel manufacturer may seek an appropriate fabric for a jacket or a retailer might hunt for a patterned sweater. When businesses purchase goods from resources (producers or vendors) from around the world, it is known as **global sourcing.**

Importing by Manufacturers. Many apparel organizations import directly from overseas. I. B. Diffusion imports its knits directly from overseas manufacturers and sells them to retail stores throughout the country and in its own outlets. Other domestic apparel firms

Career Portrait

KARL LAGERFELD

Designer of couture and ready-to-wear for Chanel, as well as his own couture and KL lines, a line of furs and other garments for Fendi, and recently returning to Chloë, Karl Lagerfeld is highly talented and prolific. Born in Hamburg, Germany, in 1938, he studied in Paris in his teens and, at 17 years of age, entered a design competition which he won for his design of a coat. Another winner of that same contest with a design for a suit was a young man named Yves Saint Laurent!

> *"Wherever fashion is the topic, Lagerfeld's influence is felt."*

The couturier Pierre Balmain, one of the contest judges was impressed with Lagerfeld's design and hired him and produced the coat. After three years with Balmain, Lagerfeld went with another famous couture establishment, the House of Jean Patou, where he worked for several years. For a while Lagerfeld turned from fashion, choosing to study art history in Italy. Before long, however, he began freelance designing for firms such as Chloë and Krizia.

Lagerfeld became a consultant in 1967 to the Fendi sisters' Italian design company known for furs. Here he introduced new ideas in fur design; using unpopular skins, such as mole and squirrel, transforming them into vibrant fashionable colors and styles. His work for Fendi has expanded with recent designs including apparel such as chiffon evening gowns. Designs done for Chanel couture and ready-to-wear reinvent the couturière's timeless looks, soft suits, separates, camellias, and ropes of gold or pearls. His own signature Karl Lagerfeld and KL diffusion lines as well as a men's wear group let him express his view of styles, drawn from his extensive knowledge of history and fashion tradition. Although Lagerfeld's favorite era is the eighteenth century, his apparel is very contemporary. Returning to the Chloë line in 1993, updating print dresses, sportswear, and crepe and lace dinner gowns seems almost effortless for the designer because of his earlier work with the label where he first attracted international attention.

Wherever fashion is the topic, Lagerfeld's influence is felt. Sales for all of his lines are estimated at over $1 billion annually. The shapes, colors, fabrics, and accessories that he creates, for Chanel in particular, are swiftly copied throughout the fashion world in a wide range of prices.

To maintain his production schedule, Lagerfeld divides his time between France and Italy, sandwiching segments of time for himself in his several homes—such as his strictly modern Monaco apartment and his eighteenth century chateau in Brittany. The eighteenth century is a period he favors and salutes in various ways from the furniture he collects to the ponytail he wears.

To support his many interests, Lagerfeld relies on several sources of income in addition to his designs. His most lucrative business is an arrangement with Elizabeth Arden for a subsidiary, Parfums Lagerfeld, producing and marketing his fragrances including Chloë, Lagerfeld for Men, and KL. In his spare time, some of Karl Lagerfeld's activities have included: redecorating a famous Berlin hotel; designing stage sets and costumes for theater and films; and shooting photographs for books and magazines. Along with Yves Saint Laurent, Karl Lagerfeld has been and continues to be a major design influence in the last part of the twentieth century—he is the most copied.

Question for Discussion. Why would Karl Lagerfeld want to design lines for several different organizations? How do fashion manufacturers and retailers benefit from Lagerfeld's work with these organizations?

Sources. 1. Materials from Karl Lagerfeld, New York; 2. Godfrey Deeny and Kevin Doyle, "Karl's Back at Chloe," *Women's Wear Daily,* June 2, 1992, p. 1; 3. Margit Mayer, "King Karl," *Women's Wear Daily,* November 20, 1991, pp. 6–9; 4. Georgina O'Hara, *The Encyclopedia of Fashion,* Harry N. Abrams, Inc., New York, 1986; 5. Jane Mulvagh, *Vogue History of 20th Century Fashion,* Viking Penguin, Inc., New York, 1988; 6. Carrie Donovan, "Paris Couture," *The New York Times Magazine,* August 18, 1991, pp. 31–34; 7. "Who Rules the Roost?" *Ibid.* December 2, 1990, pp. 89–91; 8. "The Chanel Obsession," *Vogue,* September, 1991, p. 512.

contract to have their designs produced by offshore manufacturers. There are several ways that offshore production is done. One way is for the fabric to be made and cut in the United States and sewn offshore; this procedure is used by some U. S. jeans manufacturers. Another way is for the designer to supply the designs and the fabric and have the garments cut and sewn offshore. Adrienne Vittadini, among others, uses this method in the manufacture of many of her knit garments. A third way is for the designer to supply the designs and the contractor supplies the fabric and produces the finished garment from offshore. Some garments are produced offshore for Liz Claiborne using this method.

Importing by Retailers. Retailers also buy imports in a number of ways. These include:

- **Importers.** Retail buyers may talk to sales representatives and visit showrooms to buy goods from apparel firms specializing in imports. These importers may include an independent agent marketing the lines of several German men's wear manufacturers, or domestic apparel firms, such as Generra, offering goods manufactured offshore in one or more of the ways previously described.
- **Import fairs.** Import fairs bring domestic buyers in contact with groups of foreign suppliers. One of the most prestigious import fairs is the New York Prêt à Porter, held twice a year in New York City. Here, in one location and without leaving the country, buyers can see the lines of a number of smaller French apparel manufacturers not able to support a full-time showroom.

- **Company-owned buying offices.** Buyers for large organizations, such as J. C. Penney, may work with the company's buying office located in the foreign country. These companies employ full-time resident market representatives located in major market centers throughout the world, from Milan to Tokyo. It is the work of the foreign market representative to gather information on the kinds of local manufacturers whose goods would appeal to U. S. buyers, to assist the visiting buyers in working with these manufacturers, and to follow up on store orders.
- **Commissionaires.** Buyers in smaller organizations that have no company buying office may utilize the services of a commissionaire. A **commissionaire** is an independent agent in a foreign market center who helps retailers find the merchandise they want. A commissionaire will also follow up on the shipment of goods, and for these services receives a fee, usually a percentage of the cost of the merchandise.
- **Attending foreign markets.** The most glamorous but by far the most expensive and exhausting way for a retail buyer to know what is available is by attending foreign markets and visiting foreign suppliers directly. Depending on the merchandise they are seeking, buyers may attend couture showings or fashion fairs such as the famous Igedo fair in Dusseldorf, Germany, and visit foreign manufacturing facilities. The pace is exhausting.

Figure 12-11. Store buyers arrange to have manufacturers supply goods to their specifications, as in this Country Shop ad. (Courtesy Dayton Hudson Corporation)

Since many showings are planned during the market, buyers need to carefully select those goods they want to see and then remember which ones they want to order. In this way, though, they can also negotiate to buy goods created specifically for their stores.

When a store offers something not available elsewhere—giving the goods its own label, perhaps the store's name—that **private label** merchandise can be a drawing card because of its exclusivity. For example, only at Saks Fifth Avenue stores can customers buy Saks hosiery and only at Nordstrom can customers purchase their Nordstrom private label shoes. Because buyers are able to purchase private label merchandise at a lower price than many nationally known brands, it can be priced more attractively for customers and at the same time be profitable for the retailer.

When store buyers have private label merchandise created to the retailer's design and fabric requirements, this is called specification buying. For example, Beverly Miller, the buyer for Marshall Field's Country Shop, visits sweater and suit manufacturers in Britain and Scotland with her own designs and has a collection of cashmere sweaters, tweed jackets, and skirts created solely for Field's, Dayton's, and Hudson's Country Shop departments. Specification buying is often far easier to do overseas than in the United States because manufacturers there are more willing to make smaller quantities.

Exporting

Although imports exceed exports of U. S. fashion goods, apparel organizations are expanding their markets. Manufacturers participate in exporting in a number of ways. They may export goods directly to retailers overseas, just as Calvin Klein sells to stores in Spain, Germany, and other countries. They may maintain their own plants or have agreements or licensing arrangements with foreign manufacturers to make and market their lines overseas, as Jockey International does. They may enter into joint ventures as Lee has done in Spain and Australia to manufacture jeans in the overseas countries. They may own factories in other countries to produce some of their goods, as Levi Strauss does, thus operating on a truly global basis. They may have distribution centers in other countries, as Donna Karan maintains in Amsterdam, speeding her lines to stores throughout Europe.

Some manufacturers are opening up their own stores in foreign countries as well as here in the United States. For example, Liz Claiborne, Inc. has stores in Canada, Britain, and Germany. Timberland's shops feature its apparel and shoes in Paris, Milan, Tokyo, and Singapore, among other locations worldwide. Designers are also marketing internationally. Ralph Lauren has Polo/Ralph Lauren boutiques in leading cities throughout the world; Oscar de la Renta now shows in Paris with the couture; and Josie Natori, among others, participates in trade fairs in Paris, Dusseldorf, and Florence.

According to Esprit, more than two thirds of its worldwide volume comes from international sales. Headquarters for the European design, sales, and production operations are in Germany. Esprit Hong Kong is the organization's largest and first overseas production facility. Below is a partial listing of Esprit's overseas locations.

Table 12-1 Partial Listing of Esprit de Corp's International Operations

Country	Production	Wholesale	Retail
Australia	X	X	X
Austria		X	X
Belgium	X	X	X
Canada	X	X	X
Chile	X	X	X
China	X		
France		X	X
Germany	X	X	X
Holland	X	X	X
Hong Kong	X	X	X
Mexico	X	X	X
Singapore	X	X	X

Source: Esprit, Inc.

Summary

1. Fashion goods are produced and marketed throughout the world by three different types of producers including: the couture, ready-to-wear manufacturers, and contractors.

2. The center of fashion in Europe is Paris, with the haute couture representing the finest in apparel creations. Couture interests are protected by its trade association, the Chambre Syndicale. Members of the Chambre include couturiers, designers of garments custom-made for individual clients, and créateurs, designers of ready-to-wear. France also has a growing ready-to-wear industry. Among other European nations producing ready-to-wear are Italy, Great Britain, and Germany. Italy is also known for its couture, fabrics, and leathers, and Britain for its custom-made men's wear.

3. Asia is a major source for U. S. apparel imports, from unique Japanese designs to mass-produced imports from Hong Kong, Taiwan, Korea, China, and other nations. In the Western Hemisphere, Canada and Mexico are trading partners as well as Caribbean and Latin American countries. The goal of the North American Free Trade Agreement (NAFTA) is to eliminate trade barriers among the United States, Canada, and Mexico, creating a single market.

4. When a nation's exports exceed its imports, a favorable balance of trade exists. The United States imports more than it exports, resulting in a trade deficit. While the United States traditionally encourages free trade among nations, a

view many retailers and consumers support, many U. S. apparel and textile producers and unions are interested in protecting domestic industries.

5. Both free trade and protectionism receive support through international and domestic regulation. The Multi-Fiber Arrangement (MFA) is an attempt to protect domestic manufacturers by restricting the amount of certain goods that can be imported. Section 807 and the Caribbean Basin Initiative encourage apparel manufacturers in developing countries through very low tariffs on goods produced there.

6. Utilizing global sourcing, that is buying goods from throughout the world, U. S. manufacturers import directly or contract for offshore production. Retailers' global sourcing includes: buying from importers; attending domestic import fairs; using company-owned buying offices or commissionaires; and attending foreign markets. U. S. apparel organizations export by selling their products directly, through licensing, joint ventures, and opening their own retail stores.

Fashion Vocabulary

Explain each of the following terms; then use each term in a sentence.

alta moda	exports	North American Free Trade Agreement (NAFTA)
balance of trade	free trade	
boutique	General Agreement Tariffs and Trade (GATT)	offshore contracting
caution		prêt-à-porter
Chambre Syndicale	global sourcing	private label
commissionaire(s)	haute couture	protectionism
couturier, couturière	import quota	tariffs
créateurs	imports	transshipping

Fashion Review

1. Who are the two types of designers who belong to the Chambre Syndicale? How do they qualify for membership?
2. Name three or four ways a U. S. buyer may view the coming season's imports.
3. Why do some U. S. textile and apparel manufacturers, and all garment workers' unions, tend to favor protectionism, while most consumers and retailers are proponents of free trade?
4. Explain the goals of the MFA and the Caribbean Initiative. How are they similar? How do they differ?
5. As an apparel manufacturer in the United States, cite three ways that you could expand into international markets.

Fashion Activities

1. As the owner of a medium-sized apparel store for men and women, you are importing a collection of fashion clothing for the coming season. As the merchandise begins to arrive in the store, you decide to have an import promotion. To announce the promotion, create at least a quarter-page newspaper advertisement explaining the promotion, describing the goods you purchased, where they came from, and why they are particularly appealing to your customers.

2. You are an officer in a nationwide garment workers' union that is working to protect manufacturing jobs in the domestic apparel industry. Write a column for a newsletter to be sent to U. S. apparel manufacturers. In the column, state why you believe it is essential that the nation's domestic apparel manufacturers concentrate on increasing domestic production, including sewing and garment assembly.

3. You are head of an apparel manufacturing firm who sees an opportunity to produce some of your output offshore at lower cost. Write a memo to your board of directors stating why you believe investigating offshore production possibilities is a good idea.

Endnotes

1. Robert Spector, "Patagonia: Adding a Feminine Twist," *Women's Wear Daily,* special Sportswear section, October 2, 1991, p. 15.

2. Godfrey Deeny, "French Commission Announces Proposed Couture Rule Changes, " *WWD,* October 21, 1992, p. 2.

3. Godfrey Deeny, "Paris to Show Fall Couture One Week Earlier This Year, " *WWD,* March 25, 1993, p. 2.

4. Godfrey Deeny, "France Proceeds with Plan to Revise Rules for Couture," *WWD,* August 6, 1991, p. 9.

5. Amy N. Spindler, "Patterns, Revolution in the French Fashion World: A Rival to the Powerful Chambre Syndicale is Born," *New York Times,* February 9, 1993, p. A19.

6. Carrie Donovan, "Paris Couture," *The New York Times Magazine,* August 18, 1991, pp. 30–34.

7. "Biderman Sales Up 16% in Half," *WWD,* August 12, 1991, p. 2.

8. "Armani Will Open Store in Florence in September," *WWD,* August 7, 1991, p. 2.

9. Irene Daria, "Designer Boutiques," *Vis a Vis,* United Air Lines, March, 1991, pp. 39–40.

10. Colin McDowell, *McDowell's Directory of Twentieth Century Fashion,* revised, Prentice Hall Press, New York.

11. Godfrey Deeny, "Escada Sets $5.8 M to Launch Acatrini Line," *WWD,* August 7 1991, p. 31.

12. Genevieve Buck, "There's Controversy at Benetton— and It's Not Over Clothes," *The Chicago Tribune,* F.Y.I. column, Style Magazine, August 14, 1991, pp. 14–16.

13. Annette Miller and Theresa Waldrop, with Nina Darnton, "The Selling of Jil Sander," *Newsweek,* November 16, 1992, p. 62.

14. *Germany '93, WWD Export Report,* A Supplement to Women's Wear Daily, December 1992, p. 2.

15. Irene Daria, *Op. cit.,* p. 40.

16. Margaret Mazzaraco, "U. S. Fabric Buyers to Hit Road Again," *WWD,* International Trade Shows Abroad section, May 14, 1991, p. 18.

17. Colin McDowell, *Op. cit.,* pp. 178–179.

18. "The U. S. and Hong Kong," Hong Kong Trade Development Council, New York, September 1988.

19. Jim Ostroff, "The Changing Face of Hong Kong," *WWD,* November 20, 1991, pp. 13–14.

20. Gaylon White, "Run for the Border," *Express,* Federal Express magazine, Summer, 1991, pp. 10–13.

21. Joyce Barrett, "Saludos Amigos: The Push for Free Trade," *WWD,* July 17, 1991, pp. 12–13.

22. Jim Ostroff, "Shipments Hit $400 M in '91," *WWD,* March 3, 1992, pp. 22–23.

23. Jim Ostroff, "U. S., Taiwan to Discuss Quota Fraud," *WWD,* August 14, 1991, p. 24.

24. "U. S. Hits China with Chargebacks," *Ibid.*

25. George Lee, "The Big Lure: 807," *WWD,* June 22, 1992, pp. 15–16.

26. Jim Ostroff, "U. S. Makers Fear NAFTA Will Cause Sun to Set Over Caribbean," *WWD,* June 11, 1992, pp. 10–11.

UNIT Three

Project

Identifying Fashion Goods Manufacturers Worldwide

The purpose of this project is to acquaint you with the fashion goods of designers and manufacturers in other parts of the world. For this project, select a major foreign location, such as Milan, Hong Kong, or Germany, and determine the contribution to the fashion industry of a selected designer or manufacturer in that area. You may choose a designer or manufacturer of men's or women's apparel or accessories.

Prepare your report as indicated by your instructor. This project may be an individual or a group effort, with a team of students selecting a given location, for example, London, and reporting on various designers and manufacturers there.

1. For what types of fashion goods is this area famous? What geographic, historic, social, and economic factors contribute to the success of the fashion goods from this location?
2. Identify the apparel or accessories designer or manufacturer you have selected and state the company name and address.
3. Describe the worldwide target customer of the company, using four demographic and psychographic variables.
4. Cite the unique characteristics of the goods of this company that cause them to appeal to the particular target customer you have identified.
5. Explain the organization's manufacturing setup. If there are licensing agreements, how and where are these goods manufactured?
6. Identify the major retail organizations that are customers of this manufacturer. Does the company also maintain its own retail outlets? If so, are they company-owned or franchised?
7. Is the company privately or publicly owned?
8. What is the company's most recent estimated or actual annual sales volume?

unit FOUR

Fashion
MARKETING

Fashion Retailing

CHAPTER 13

Objectives

After completing this chapter, you should be able to:

1. Explain how retailing in America has evolved in the last 100 years and what factors in society have influenced that evolution.

2. Identify and define the major factors in a retailer's merchandising policy.

3. Name the different types of store retailers and explain how they differ.

4. Identify different kinds of non-store retailing and the trends taking place in that segment of the business.

5. Explain the major trends that are affecting the future of fashion retailing.

It was a typical Saturday morning at the Smith house. Bob and Janet and their two teenage children were all flying in different directions, trying to get themselves organized for the various errands and tasks they needed to accomplish that day. Bob's first priority was to buy a couple of new suits for work, to replace some older ones that were looking a little worn and dated. Janet was interested in filling some "holes" in her summer wardrobe before vacation time, and also wanted to pick out some lingerie for her cousin's upcoming bridal shower. Sixteen-year-old Carla, who had recently gotten her ears pierced, was eager to get out and find some new earrings to wear to the big dance at school the following week. And 14-year-old Brian, who had just made the basketball team, needed a new pair of high-top athletic shoes and some workout sweat suits.

By 10 o'clock, Bob and the kids had jumped in the car and were off to fulfill their missions at the shopping mall three miles away from their suburban home. After agreeing to meet at noon at the food court to grab a bite of lunch, the family separated, each on his or her own quest. Bob headed straight for the big department store at the end of the mall, where he knew there would be a good selection of well-made suits in different styles and colors in his size. Carla made a beeline for a small boutique that specialized in fashion jewelry, hair goods, and other accessories, and where she knew she would find hundreds of pairs of earrings from which to choose. And Brian

found his way to a shop that sold nothing but athletic shoes and apparel, with a number of styles for virtually every sport in stock.

Meanwhile, back at home, Janet sat at the kitchen table with a second cup of coffee and a stack of catalogs that had come in the mail. One was from a mail-order company that specialized in pretty lingerie; and Janet began comparing its selection of merchandise with that found in another catalog—one sent by a local department store, which was offering selected styles of lingerie at reduced prices. Next, she started browsing through a larger catalog from the catalog division of a national chain store, which featured a full array of apparel, accessories and more for the whole family. After a few minutes of flipping through at random to see what caught her eye, she zeroed in on the misses' casual sportswear section, and began seriously shopping for shorts, tops, and skirts that she'd like to take along on the family's summer vacation in six weeks.

While the Smiths are a fictional family, their Saturday is representative of the myriad of ways today's consumers are able to shop for clothing and other fashion merchandise. There are probably more places and opportunities for Americans to shop for fashion in the 1990s than at any other time in history, whatever their tastes or their budget. Just as the realm of fashion ranges from inexpensive, trendy T-shirts all the way up to sophisticated and pricey haute couture, the types of retailers selling fashion merchandise to consumers run the gamut from discount operations offering mass-produced commodities to exclusive salons featuring designer originals—and everything in between.

History of Retailing

While no one knows exactly who was the first to exchange a piece of merchandise for money, the concept of **retailing**, or selling goods to the final consumer, is surely almost as old as mankind. From ancient Greece with its open-air marketplace called the *agora*, to medieval fairs noisy with merchants hawking everything from silks to spices, the business of buying and selling has always been a popular one. Yet retailing in the United States as we know it today really began evolving only in the middle to late 1800s.

While the eastern seaboard cities that were first settled in Colonial America replicated their European counterparts with shops reminiscent of those found in the colonists' homelands, the situation across the vast frontier was far different. Settlers venturing their way westward were, for the most part, self-sufficient, growing their own food and making their own clothes. But as the population grew, and settlements became more permanent, industrious sellers of goods found a willing and open market for their wares.

Among the first of these were peddlers, who purchased manufactured goods in the cities and traveled to remote farms and villages to supply farmers and homesteaders with necessities, as well as some niceties. For customers living closer to a town, the general store was the key source of merchandise. Offering a wide range of basic products, from fabrics to saddles to flour, the general store not only supplied its customers with important commodities, but also became a gathering place for exchanging news and gossip.

General stores' monopoly on the rural, small town customer began to erode, however, in 1872. That was the year that a new company named Montgomery Ward started printing catalogs encompassing a broad variety of merchandise, enabling customers to place their orders by mail. Montgomery Ward was soon followed by Sears, Roebuck and Co., which at its inception in 1886 sold only watches by mail. By 1895, however, the company's catalog had grown to 532 pages featuring hundreds of additional items—and exceeding $750,000 in sales![1]

Meanwhile, back in the cities, enterprising merchants got the idea of taking a number of different categories of merchandise sold in small shops and putting them conveniently together under one roof. In doing so, they created the first department stores, where customers could do "one-stop shopping" for all types of apparel and accessories, as well as home goods. Among the first of these retailers were Lord & Taylor in New York City, Marshall Field in Chicago, John Wanamaker in Philadelphia, and Jordan Marsh in Boston—all of which are still successfully in business today. A bit later, around the turn of the century, variety stores were springing up around the country, as well, selling a range of inexpensive goods. These were the first "five-and-dime" stores, including such names as Woolworth and S. S. Kresge (later to become K mart).

As the country progressed into the twentieth century, retailing continued to keep pace with the movements, trends, and needs of the American consumer. As more and more people increased their mobility thanks to the automobile in the 1920s and 1930s, mail-order retailers Montgomery Ward and Sears, Roebuck and Co. began supplementing their catalog sales by opening stores in towns across the

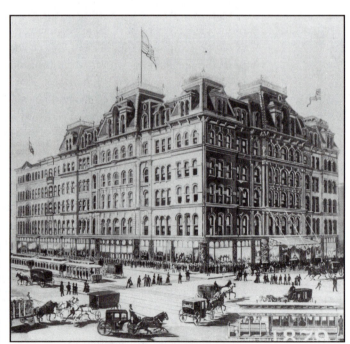

Figure 13-1. Marshall Field's flagship State Street store has been a Chicago landmark for nearly 150 years. (Courtesy Dayton Hudson Corporation)

country. Before long, those two retailers—along with J. C. Penney, the third of what were known until recently as the "Big Three" national general merchandise chains—were operating hundreds of stores nationwide, all coordinated from one central headquarters office.

Later, in the 1950s, as Americans by the thousands moved out of the cities and into the suburbs, retailers and real estate developers followed them and created suburban shopping centers, giving customers convenient access to the many types of stores found in the city. These centers were created initially as single-level, open-air groupings or strips of stores, featuring ample parking for shoppers. Before long, the concept evolved into that of the enclosed shopping mall, containing one or often several levels of small shops specializing in specific categories of merchandise and usually "anchored" by two or three major department or chain stores. Most today also incorporate restaurants or food stands for the convenience of hungry shoppers and may also feature service and entertainment outlets such as banks and movie theaters. Both shopping centers and malls continued to spring up in record numbers throughout the 1970s and 1980s, not only in suburban locations, but often at downtown urban sites, such as New York City's Herald Center and Chicago's Water Tower Place; and—especially with teenagers—they have become almost as important a social gathering spot as the country store was some 150 years ago. In fact, the 25,000 shopping malls across America today are where 50 to 60 percent of the nation's total retail sales take place![2]

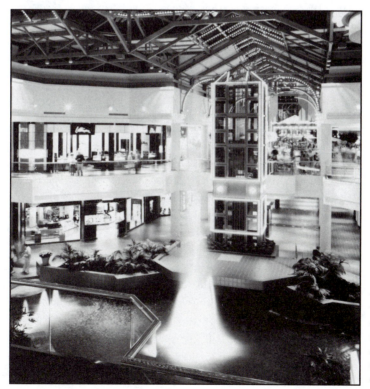

Figure 13-2. The modern shopping mall offers consumers a wide array of stores, all in an attractive setting and under one roof. Most also feature services and amenities such as restaurants or food courts. (Photo courtesy Frederick Charles)

SPOTLIGHT ON A FIRM

NEIMAN MARCUS

When the first Neiman Marcus store opened in Dallas in 1907, its advertisement promised simply "wider variety and more exclusive styles . . . than any other store in the South." Today, consumers around the world associate the name Neiman Marcus with much more—particularly high-fashion apparel, world famous designers, flamboyant, fun-filled gifts, and Texas wealth. Obviously, a lot has changed since the launch of that first store, a luxury shop selling only ladies' outer garments and millinery. But its original concept of offering the finest, most carefully selected merchandise in the world has not changed.

Founded by Herbert Marcus, Sr., his sister Carrie Marcus Neiman, and her husband, A. L. Neiman, Neiman Marcus remained a family-run business for many years. In fact, all four of Herbert

Marcus' sons joined the company, most notably Stanley Marcus, who served as President and Chief Executive Officer from 1950 to 1975—and who is generally considered to have been one of America's most astute merchants.

From the beginning, the Neiman Marcus objective was to bring the finest merchandise available from the markets of the world to the discerning customer. To meet this objective, many additional categories of merchandise were added over the years to the original mix of women's outerwear and hats. Accessories were first, followed by infant's, children's, and junior apparel; active sportswear and bridal apparel; men's and boys' apparel; cosmetics; gourmet foods; and more. In fact, Neiman Marcus stores today also feature a wide range of fine jewelry and furs, glassware, linens, silver, gifts, as well as objects of art for the home.

It is in the apparel area, however, that the retailer truly stands out from the crowd, with its exceptional roster of designer names featured in the stores. Even as the country faced debilitating economic woes in the early 1990s, Neiman Marcus kept its long-term focus in the designer arena, strengthening even further its bridge business, which is estimated to represent 60 percent of the retailer's women's apparel sales. This commitment to the upper-end fashion business is what Neiman Marcus customers have expected from the retailer through most of its history. In fact since 1938, the company has presented an annual Neiman Marcus Award for Distinguished Service in the Field of Fashion to those the retailer feels have made a distinctive contribution to the world of fashion, whether by designing it, publicizing it, or wearing it in a way that

has influenced the public. Among the winners since the award's inception have been Bill Blass, "Coco" Chanel, James Galanos, Gloria Swanson, Estée Lauder, Perry Ellis, Richard Avedon, Princess Grace of Monaco, Mary McFadden, and Elsa Schiaparelli.

Yet another program that has contributed greatly to the worldwide renown of Neiman Marcus is its famed Christmas Book. More than just a catalog, the Christmas Book is eagerly awaited each year, not only for its selection of interesting and unusual gift ideas, but for its acclaimed "His and Her" gifts—a tradition begun in 1960. Always outlandish and outrageously expensive, these gifts over the years have included such extravagances as His and Her Beechcraft airplanes, His and Her ermine bathrobes, His and Her camels, His and Her mummy cases, His and Her robots, His and Her diamonds—and in 1991, following on the heels of the Persian Gulf war, His and Her civilian versions of the "Hummer" military all-terrain vehicle.

It is not only through the Christmas Book that Neiman Marcus has made unusual merchandise sales. Anecdotes in abundance fill the company's history, such as

the story of the Texas oilman during the Depression who was searching for a gift for his wife. Assisted personally by Stanley Marcus, the customer kept rejecting suggestions on the basis that he had already given his wife something similar. Finally, in desperation, Marcus showed the man a window filled with a variety of gifts, ranging from lingerie to a white ermine evening wrap. The oilman accepted—the entire window—which Neiman Marcus replicated in the customer's playroom on Christmas Eve.

That kind of innovative merchandising reflects the basic Neiman Marcus philosophy of customer service: to exceed the customer's expectations. This entails doing whatever it takes to satisfy the customer and harks back to the original principle of business expressed by Herbert Marcus, Sr., that "There is never a good sale for Neiman Marcus unless it's a good buy for the customer." Clearly, customers have been very satisfied with shopping Neiman Marcus, judging by the company's annual sales, which total more than $1.2 billion for the retailer's 27 stores.

In 1968, Neiman Marcus merged with Carter Hawley Hale Stores Inc., a relationship that

enabled the retailer to expand by 20 new stores over the next 17 years, and to enter new markets in Florida, Georgia, Missouri, Illinois, Washington, D. C., California, New York, Nevada, and Massachusetts. Then, in 1987, Carter Hawley Hale reorganized its department and specialty store divisions into two separate companies, with the specialty store division becoming The Neiman Marcus Group Inc., a publicly owned independent company including Neiman Marcus, Bergdorf Goodman, and Contempo Casuals. Today, Neiman Marcus is expanding again, with plans to add 10 to 12 new stores by the mid-1990s, including one in Honolulu, Hawaii—enabling even more consumers to sample the company's unique brand of fashion merchandising.

Question for Discussion. In what ways does Neiman Marcus strive to exceed its customers' expectations?

Sources. 1. Press materials and catalog from Neiman Marcus, 1618 Main Street, Dallas, TX 75201; 2. "Fashion Focus at NM Could Make It Tops," *Women's Wear Daily*, March 5, 1992, p. 1.

Merchandising Policies

Today in the United States, retailing is a $1.9 trillion industry, employing nearly 20 million Americans, or full 18 percent of the nation's workforce.[3] Because of the vast number of retailers in operation, competition among individual stores for customers' shopping dollars can be fierce. For this reason, each retailer works hard to develop its own unique identity that will draw customers. To do so, the retailer must first identify its **target customer base,** or the type of people it wants to attract. Usually, this is based on factors such as customers' income level, age, geographic location, and lifestyle. (See Chapter 2, The Fashion Consumer.)

Once a retailer specifies who its target customer is, the management must make sure that everything in the store (or catalog) works together to appeal to that customer. Central to that goal is the establishment of a **merchandising policy,** or set of guidelines that help determine what merchandise the retailer will carry. Every retailer has its own specific merchandising policy, but all take into consideration six basic elements: fashion cycle emphasis, quality, price ranges, depth and breadth of assortment, brand policies, and exclusivity.

Fashion Cycle Emphasis

In determining its own fashion cycle emphasis, a retailer must decide whether to present fashion goods to its customers earlier or later in the rise or peak of their cycle. Generally, the more prestigious the retailer, and the more it targets affluent and fashion-conscious customers, the earlier in the cycle it will present fashion goods. For instance, prestige stores such as Neiman Marcus or Bergdorf Goodman emphasize fashion early in its cycle; while discount stores such as Target or Caldor emphasize fashion styles much later in their cycle.

Quality and Price Ranges

The quality of the merchandise and the price ranges follow a similar pattern, with upscale retailers offering only the highest quality goods at upper-moderate to high prices, and stores appealing to a wider customer base offering generally lower prices combined with merchandise of serviceable, but not necessarily top quality. Of course, the quality of the merchandise has a large influence on the **wholesale cost,** or how much retailers must pay manufacturers for the goods, and in turn, how much they can charge consumers. In addition, the final price to consumers is determined by the retailers' **mark-up,** or the percentage added to the wholesale cost to establish the retail price. The standard, or "keystone," mark-up is considered to be 50 percent of the retail price. The majority of today's volume retailers tend to take less than a keystone mark-up, at least on certain categories of merchandise, while high-priced fashion retailers take more than a keystone mark-up to help defray their expenses for such amenities as personalized service and elegant decor. Some discount retailers also choose to sell "seconds" or "irregular" merchandise, or goods with minor flaws, which they can offer to consumers even more inexpensively.

Depth and Breadth of Assortment

Depth and breadth of assortment refers to the number of different styles (breadth) and how many pieces of each style (depth) are carried by the retailer at any given time. For most retailers, the assortment is either narrow and deep, or broad and shallow. In a **narrow and deep assortment,** a limited number of different styles are available to customers, but they are available in many sizes and/or colors. The Gap is an example of a store offering a narrow and deep assortment. With a **broad and shallow assortment,** a much larger selection of different styles is displayed, but each may be available in only limited colors or sizes. Many discount stores and stores selling at off-price, such as Marshall's or T. J. Maxx, offer broad and shallow assortments because they may not be able to buy all sizes in all colors. In addition, high-priced specialty stores and boutiques offer a broad and shallow assortment, stocking styles in a limited number of sizes and colors partly in order to convey to their fashion-forward customers a sense that they will not see a dozen other people walking down the street in the same outfit.

Brand Policies and Exclusivity

Regarding brand policies, retailers must decide whether to emphasize designer names, national brand names, imports, or their own private label merchandise—or some combination of those four—and in what proportions. Their decision in this area will be based in part on what degree of **exclusivity** they want to achieve; that is, how much of their assortment they want customers to be able to find only at their store, and not at another retailer down the street or across town. While exclusivity is often associated with status or prestige names, as in high-priced fashions found only at a Bergdorf Goodman or Henri Bendel, it is a merchandising policy that applies

Figure 13-3. Merchandising policies for The Avenue, a specialty store chain selling apparel for plus-size women, include an extensive use of private labels and moderate prices for its assortment of sportswear and career apparel. (Courtesy *Stores*)

equally to retailers at all levels of the price scale. Some retailers, such as The Gap and Victoria's Secret, maintain virtually 100 percent exclusivity by featuring only merchandise of their own design and label. Others, such as K mart with its Jaclyn Smith and B. E. (Basic Editions) fashions, develop exclusive labels to fill a niche within an assortment that also includes a variety of other brands.

Most retailers constantly re-evaluate all of these different elements of their merchandising policy and make minor—or sometimes major—adjustments in their focus, based on changes in the marketplace, in their customer base, or in their own merchandising and marketing goals. One of the most striking examples of how dramatically a merchandising policy can change may be seen at J. C. Penney, which during the 1980s and into the 1990s repositioned itself from its traditional status as a general merchandise chain to a national department store. In the process, all aspects of its merchandising policy were revised significantly, most visibly in the increased number of brand and designer names offered, earlier fashion cycle emphasis, and higher quality and prices. (See following Career Portrait.)

Store Retailing

Although there are increasing opportunities for consumers to shop without ever leaving their homes, there is no question that the greatest percentage of retail sales still takes place in a store setting. What's more, the number of stores and different types of stores doing business in the United States today is greater than ever before. For those selling fashion merchandise, most fall into one of the following categories.

General Merchandise Organizations

A store that sells merchandise from a variety of different product categories, usually including a mix of hard lines (non-textile products) and soft goods (including apparel), is considered to be a **general merchandise retailer.** A wide range of retail companies fall under this broad heading, selling fashion merchandise at virtually every price point.

Department Stores. By current industry definition, a **department store** is a retailer with a fashion orientation and full mark-up policy, which carries nationally branded merchandise, and operates in stores large enough to be shopping center anchors.[4] At one time, department stores were identified by the wide assortment of all kinds of merchandise they carried. One hundred years ago, they offered one-stop shopping for all their customers' needs, from apparel to hardware to furniture and housewares. Even 25 years ago, many still had departments for categories such as books, records, toys, and fabrics. Today, however, most department stores have either eliminated or drastically scaled back their selection of hard lines, including categories such as furniture, major appliances, and consumer electronics. As a result, fashion merchandise, including apparel and accessories, and other soft goods, such as home textiles, has become a much larger proportion of the department store mix. In fact, the combined categories of women's, men's, and children's apparel and accessories, including

WILLIAM R. HOWELL

When James Cash Penney opened his first cash-only dry goods store back in 1902 in the mining town of Kemmerer, Wyoming, he surely could not have dreamed that his venture would evolve into what is now by far the largest department store company in the country. And indeed, J. C. Penney might not be in that enviable position today if it had not benefited from the leadership abilities of William R. Howell.

In a business world where it has become normal for employees and rising executives to jump from firm to firm, Howell is the antithesis, having spent his entire career with J. C. Penney. In fact, his father before him was a J. C. Penney store manager in their home town of Claremore, Oklahoma, where Howell, as a young high school student, had the thrill of meeting James Cash Penney himself for the first time. Later, after graduating at the top of his class from the University of Oklahoma in 1958, Howell interviewed for numerous other retail jobs, but decided in the end to join up with Penney's, feeling that the retailer's philosophies and ways of doing business were the best he had seen.

> *"It appears that J. C. Penney . . . will be the country's leading department store chain for some time to come. And to a large degree, it has William R. Howell to thank."*

Starting as a management trainee, Howell applied himself diligently to his work, and that effort paid off. Within 10 years, he became the manager of his own branch store, and a year later, was promoted to District Manager. In 1971, the company transferred him to New York headquarters, where he took the title of Small Stores Coordinator in the regional operations department; and in 1973, he was named Director of Domestic Development. Proving himself capable through all of these promotions, Howell continued to climb the J. C. Penney corporate ladder, becoming Western Regional Vice President in 1976, Senior Vice President and Director of Merchandise, Marketing, and Catalog in 1979, Executive Vice President and Company Director in 1981, Vice Chairman of the Board in 1982, and Chairman of the Board in 1983.

Over the course of the years he spent with J. C. Penney, Howell saw and experienced many changes in the company and in retailing in general. For instance, the 1960s and 1970s marked the tremendous proliferation of suburban shopping centers and malls; and to meet the one-stop shop-

continued

ping needs of its customers, J. C. Penney began expanding the size of its stores to accommodate additional merchandise. Departments for categories such as automotive goods, paint and hardware, and major appliances were all instituted. And during those years, Penney went head-to-head with Sears and Montgomery Ward, all known at the time as the "Big Three" national general merchandise chains.

In the early 1980s, however, J. C. Penney began to re-evaluate its merchandising policies and directions. Largely under the guidance of Howell, the company carefully studied the sales performance of many of the merchandise categories it had added in previous years. Addressing the question of whether American consumers truly expected to find and shop for those lines of merchandise at J. C. Penney stores, the company concluded that the answer was "no," and therefore proceeded to completely and dramatically redefine its own image, charting a totally new course toward the 1990s and beyond.

With Howell as a key "architect," in 1982 J. C. Penney issued a Stores Positioning Statement, which, in essence, would begin the conversion of the company from a general merchandise chain to a department store chain. Within three years, businesses within the stores that had accounted for a whopping $1.5 billion in annual sales—including automotive and major appliances—were dropped, in order to make more room for the businesses the retailer had decided to pursue aggressively: women's, men's, and children's apparel and accessories, and home furnishings. By 1990, reflecting the success of the company's repositioning, J. C. Penney was added for the first time to *Stores* magazine's annual listing of the top 100 department stores—and took the number one spot!

Of course, it was not simply a matter of changing the merchandise mix. Under Howell's leadership, the compa-

ny initially spent more than $1 billion over five years to modernize the look and layout of its stores. It also allotted a significant budget toward advertising, to make sure that customers would understand that the J. C. Penney stores had changed to keep pace with the times and with customers' needs and wants. And Howell intends to make sure the company continues to change as necessary: adjusting its merchandise to maintain the right balance of fashion, quality and price; refurbishing its stores to keep them fresh, attractive, and easy to shop; and opening new stores in shopping centers or markets where the customer demographics and opportunities are right.

Although Howell prefers to credit the entire management team for the success the company has enjoyed with its repositioning, most retail observers believe that he personally can take great pride in the direction J. C. Penney has taken during his tenure. Even his widely debated decision to move the company's headquarters from the fashion capital of New York to Dallas in the late 1980s has proved to be an increasingly sound one, and one that has resulted in tremendous cost savings for the company. With more than 1300 stores nationwide and a catalog division that accounts for more than $3 billion, it appears that J. C. Penney—fast approaching $15 billion in annual sales—will be the country's leading department store chain for some time to come. And to a large degree, it has William R. Howell to thank.

Question for Discussion. What were some of the actions William Howell initiated in order to reposition J. C. Penney as a national department store?

Sources. 1. Press releases and background material from J. C. Penney Co., Inc.; 2. Penny Gill, "NRF Honors William R. Howell," *Stores,* January 1992, pp. 36–77.

shoes, currently accounts for more than two thirds of department stores' net sales.[5] Plus, because of the evolving industry definition of a department store, retailers that had traditionally been classified as "departmentalized specialty stores," such as Saks Fifth Avenue and Nordstrom, are now sometimes included in the broad category of department stores.

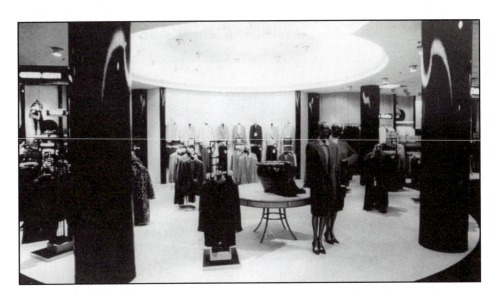

Figure 13-4. Department stores maintain an upscale fashion image by showcasing designer collections in elegant settings, such as Dayton's Oval Room department. (Courtesy Dayton Hudson Corporation)

While all department stores offer to a large degree the same basic types of merchandise, they are far from being all alike. Because of individual merchandising policies, each department store company has a distinct store image and customer base. Some target the higher-income, fashion-forward customer, with apparel on the cutting edge of fashion and merchandise from leading designers in prominent focus. Bloomingdale's, for instance, is one retailer that has cultivated just such a reputation for being at the forefront of fashion trends. Other department stores may aim to reach more of middle America, or consumers with average incomes who want their apparel to be in fashion and affordable. Mervyn's and Kohl's are examples of two department stores that cater to a broader, middle-income customer base.

While there are some single, local department stores in towns across the country, most of the department stores people think of first are part of chains, or groups of stores operating under the same name and the same merchandising policies. Usually each chain has a **flagship** or main store, which is often the largest and where its executive offices are located; the other stores are called **branch stores.** Nordstrom, for example, has its flagship store and headquarters in Seattle, and operates a group of more than 65 branch stores across the country.

In turn, some of the major department store chains are themselves owned by another, larger company. As you recall from the Chapter 3 Spotlight on a Business, The May Company owns Foley's, Lord & Taylor, Hecht's, Kaufmann's, Robinson's, Famous-Barr, and Filene's, among others. Similarly, Federated Department Stores Inc. is the parent company of retailers including Bloomingdale's, F & R Lazarus,

Table 13-1 Top 10 U. S. Department Store Companies

Store	Sales Volume (1992—in millions)
J. C. Penney Dallas, TX	$13,460
May Department Stores St. Louis, MO	$8681
Federated Department Stores Cincinnati, OH	$7080
R. H. Macy New York, NY	$6449
Dillard Little Rock, AK	$4714
Dayton Hudson Dept. Stores Minneapolis, MN	$3024
Mercantile Stores Fairfield, OH	$2732
Carter Hawley Hale Los Angeles, CA	$2138
Belk Stores Charlotte, NC	$1845
P. A. Bergner Milwaukee, WI	$1155

(Adapted from *Stores*, July 1993)

Abraham & Straus, Rich's, Burdine's, Jordan Marsh, and The Bon. In general, these larger companies allow each department store to set its own merchandising policies and establish and maintain its own image. Yet by being part of a larger group, each store gains additional clout in its dealings with manufacturers, and it can take advantage of special programs including private label and import programs, created for all the stores in the company.

General Merchandise Chains. Up until the mid-1980s, three major retailers—Sears, J. C. Penney, and Montgomery Ward—were known as the "Big Three" national general merchandise chains. Like traditional department stores, the three companies carried a broad mix of product categories including men's, women's, and children's apparel and accessories, furniture and home furnishings, along with an even broader selection that encompassed such classifications as paint and hardware, major appliances, and automotive products. Unlike department stores, these national chains concentrated almost exclusively on their own private label merchandise, offering virtually no nationally branded goods. Furthermore, they had no flagship store, instead creating a fairly standard look and layout for all stores; and they controlled all their operations, includ-

ing buying, merchandising, advertising, and so on, from a central headquarters. In addition to their nationwide network of stores, the "Big Three" retailers also conducted a significant mail-order business through their respective catalog operations.

Today, however, while all three companies are still major forces on the retail scene, they have all attempted in recent years and to varying degrees to move away from the traditional general merchandise chain format. By the early 1980s, all had added some popular national brands to their merchandise mix. Then, most dramatically, J. C. Penney undertook a complete repositioning of its merchandising and marketing strategy to become accepted as a national department store. Sears and Montgomery Ward have gone somewhat in the opposite direction, working to take advantage of strengths in certain product categories to pursue specialty businesses within the general merchandise arena. While many in the industry still consider these two to be general merchandise chains, that delineation—particularly for Montgomery Ward, which has been initially more successful in its conversions than Sears—may well be outdated before the end of the decade. In fact, back in mid-1990, a J. C. Penney executive was quoted as saying, "The term 'national chain' as we've known it has become obsolete, as the 'Big Three' have moved in different directions."[6]

Montgomery Ward, for instance, began in 1985 to reorganize its mass merchandising retail operations into what it calls a "chain of value-driven specialty stores." Four basic specialties form the focus for the retailer, including The Apparel Store (also encompassing Kids Store and Gold 'n Gems fine jewelry), Electric Avenue (appliances/electronics), Home Ideas (home furnishings and accessories), and Auto Express (tires, batteries, parts, and service). In some cases, Montgomery Ward has opened these specialty stores on an individual, freestanding basis; in other cases, all are grouped together under one roof, almost like the company's own minimall. In addition, at some locations, Montgomery Ward has leased in-store space to other specialty stores that offer merchandise complementing but not competing with the company's own lines, such as Toys "R" Us and Gart Brothers Sporting Goods. What's more, in the early 1990s the company re-entered the mail-order business, which it had abandoned in 1985. This time, however, instead of a single, huge catalog containing merchandise from all categories, it is concentrating on specialty catalogs in a variety of niches.

Similarly, Sears' strategy has been to develop what it calls "power formats" within its traditional merchandise assortment. By "verticalizing" different businesses and strengthening their presentation within the traditional Sears outlets, the retailer has created "stores within a store" for a number of broad product categories. While the company in the early 1990s was completing its implementation of this quasi-specialty strategy more slowly than Montgomery Ward, some of the areas it had targeted for power formats were children's apparel (called Kids & More), appliances and electronics (called Brand Central), as well as men's and women's apparel, home fashions, and home improvement. To further streamline the organization, early in 1993 Sears ended its long reign as a leading mail-order retailer, discontinuing its money-losing catalog business to concentrate wholly on its retail stores.

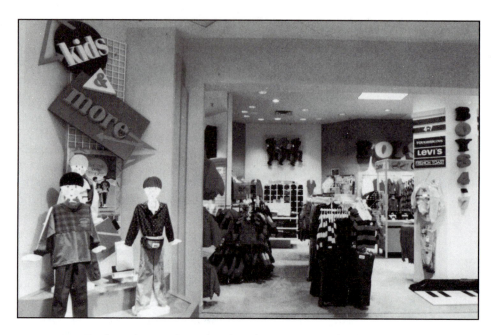

Figure 13-5. Traditional general merchandise chains Sears, Roebuck and Co. and Montgomery Ward have developed new specialty business strategies, as illustrated by Sears' Kids & More departments. (Courtesy Sears, Roebuck and Co.)

Discount and Mass Merchandise Stores. Retail stores that carry a large assortment of general merchandise, that is, both hard and soft goods, and sell them at a low mark-up, are generally referred to as **discount stores** or **mass merchandise stores**— or simply "discounters" and "mass merchants." Within this category are included stores that were originally variety or five-and-dime stores, such as Woolworth, as well as Wal-Mart, K mart, Target, Meijer, Ames, Bradlees, and Fred Meyer.

Although discount stores have generally been fashion followers, rather than fashion leaders, in recent years many of these retailers have made an effort to be more current in their fashion offerings. By doing so, and combining more up-to-date apparel looks with discounted prices, they have been successful in luring price-conscious consumers away from the more expensive department and specialty stores, at least for some categories of merchandise. This strategy was illustrated perfectly by an advertising campaign run a few years ago by Target, the discount division of Dayton Hudson Corporation, which undertook an upgrading of its image in the late 1980s. In the ads, the retailer gave tips such as "What to wear with a $175 Adrienne Vittadini sweater" or "How to top a $170 Maxima suede skirt"—with the answers being, "Target stirrup pants, $19.99," and "Target hooded sweater, $29.99," respectively.

Aside from many discounters' working to achieve a more upscale image in their fashion merchandise, their success in attracting customers has been underscored in the 1990s by the general economic mood of the country. For the most part,

American consumers have cut back on their lavish spending habits of the 1980s, and are seeking good values in their purchases. This trend helped push sales at the country's leading discount chain—and top-ranking retailer of any type—Wal-Mart, to nearly $55 billion in 1992. It has also fueled Wal-Mart's rapid expansion in the number and geographic spread of its stores far beyond its home base in Arkansas, to more than 2100 stores nationwide.

Specialty Stores

Just as its name sounds, a **specialty store** is one that specializes in a particular line of merchandise, whether that merchandise is women's, men's, or children's apparel, jewelry, consumer electronics, books, or anything else. Under this broad banner, specialty stores can range from tiny family-owned and operated shops or boutiques—known as "mom-and-pop" stores—up to huge, supermarket-style stores carrying virtually every brand and style available at low prices, sometimes called superstores or "category killers." Examples of the latter are Toys "R" Us and Circuit City.

Independent Retailers. By far the largest number of specialty stores are small, independently owned shops known as **mom-and-pop specialty stores.** These independent retailers most often consist of a single store in a locality, although owners of a successful shop may open one or more additional branches, usually in a different area of the same town or relatively nearby in a neighboring town. In the fashion arena, mom-and-pop specialty stores may specialize in such categories as jewelry, shoes, legwear and bodywear, or a particular type of apparel, such as active sportswear, wedding apparel, maternity clothes, men's tailored clothing, hand-made garments, or any other targeted niche.

Specialty Chains. Larger specialty stores are frequently part of a chain operating multiple branches within a region of the country or nationally. For instance, The Limited, which operates specialty stores under The Limited name as well as Victoria's Secret, Express, Lane Bryant, Henri Bendel, Lerner, and Abercrombie & Fitch, has more than 4000 branches all over the country. Kinney and Footlocker, both specialty store divisions of Woolworth Corporation, also have thousands of stores across the United States.

The number and variety of specialty stores have grown dramatically over the past decade or so for all types of merchandise, including fashion goods. And as with all retailers, in order to set themselves apart from the competition and win customer loyalty, specialty stores strive to create a unique image and effective merchandising policies. In some cases, this means finding a need in the marketplace that is not being addressed sufficiently and filling that particular niche. A prime example is stores that specialize in large or small sizes, such as Lane Bryant or August Max for large-size women's apparel, Petite Sophisticate for petite women's apparel, and Big & Tall Shoppes for large men's apparel.

In other cases, specialty stores draw customers by emphasizing an unusually broad and deep assortment within a particular category. For instance, Claire's Stores

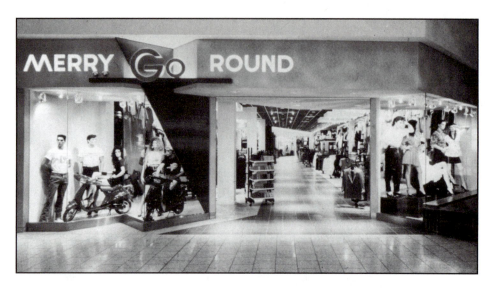

Figure 13-6. Merry-Go-Round men's apparel specialty stores are part of Merry-Go-Round Enterprises, which also operates specialty chains including Dejaiz, Attivo, Cignal, and Silverman's. (Courtesy *Stores*)

offer plenty of stock in a vast array of fashion jewelry and accessories; and Footlocker has a wide variety of athletic footwear generally available in any size. Yet other specialty stores create a unique image by offering exclusive merchandise tailored to the perceived wants and needs of their customers. The Gap and The Limited are perfect examples of specialty stores that have been very successful in continuously adapting to the changing needs of their customer base, and creating apparel for their customers that incorporates the right quality and degree of fashion at the right price.

Discount Specialty Stores. A discount specialty store could be considered something of a hybrid between a specialty store and a discounter. The two main types, both of which are growing in popularity, are off-price stores and outlet stores. Both specialize in a particular line of merchandise—in the case of an outlet store, usually from a single manufacturer or designer—and both generally offer their merchandise at deeply discounted prices.

Off-Price Stores. The term **off-price retailing** refers to a specific type of fashion discount operation in which well-known brand- or designer-name merchandise is sold at prices significantly below the regular department or specialty store price. While off-price retailing really began to blossom in the 1980s, the concept actually dates back to the 1920s, with a little store in the New York City borough of Brooklyn called Loehmann's. By promising to cut out the labels so that manufacturers would not be compromised with their department store customers, Loehmann's was able to obtain better lines of women's apparel and sell them to customers at a significant discount. This first off-price retailer is still in operation today, with more than 70 stores

Table 13-2 Top 10 U.S. Specialty Apparel Chains

Store	Sales Volume (1992—in millions)
The Limited Columbus, OH	$6944
Melville Apparel Rye, NY	$3486
Nordstrom Seattle, WA	$3422
TJX Cos. Framingham, MA	$3261
The Gap San Francisco, CA	$2960
Petrie Stores Secaucus, NJ	$1438
Saks Fifth Avenue New York, NY	$1350
U. S. Shoe Apparel Cincinnati, OH	$1262
Charming Shoppes Bensalem, PA	$1179
Kohls Menomonee Falls, WI	$1097

(Adapted from *Stores*, July 1993)

around the country. Plus, it has been joined by a growing number of other retailers selling top quality brand-name and designer apparel for less than traditional department and specialty store prices.

Some of today's roster of off-price stores are owned by larger retail organizations, companies that recognized the desire of consumers to purchase their favorite designers and labels for less money. Marshall's, for instance, which offers women's, men's, and children's apparel off-price, is owned by Melville Corporation, which also owns such retail companies as Thom McAn shoe stores, Wilson's leather specialty shops, Chess King men's apparel, and Kay-Bee Toys. Similarly, TJX Companies is the parent of two off-price apparel chains: T. J. Maxx, and Hit or Miss, as well as the discount mail-order firm Chadwick's of Boston.

Outlet Stores and Malls. A close cousin of off-price stores, **outlet stores** were originally set up as a method by which manufacturers could rid themselves of their own unsold or unsellable merchandise. Located near the factory, the stores were decorated sparsely, if at all, and offered customers either seconds and irregulars, or closeouts and overruns; that is, excess merchandise that had been produced over and above the demand by regular retail customers.

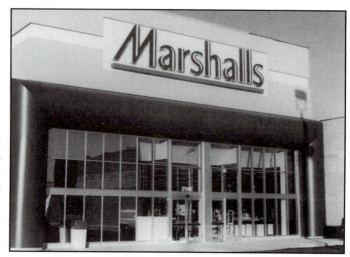

Figure 13-7. Off-price stores feature brand-name and designer labels at discount prices, usually in a no-frills, self-service setting. (Courtesy Marshall's)

Today, outlet stores still serve the same basic purpose for manufacturers, but they have sprung up in increasing numbers around the country, feeding the hunger of consumers for quality, name-brand merchandise at a bargain. Many designers and manufacturers actually operate chains of outlet stores themselves, and in some cases, they produce extra garments specifically for sale in their outlets, using the stores as a testing ground for new designs or new merchandising techniques. This trend has been so popular in recent years that the number of shopping malls specializing in outlet stores grew from just 32 in 1982 to close to 300 just 10 years later,[7] generating annual sales of some $8 billion.

Some traditional retailers operate special outlet stores as well. For instance, in 1993 Barney's New York formed an outlet division and opened its first outlet store, designed in part to serve as a clearance center for end-of-season merchandise. Other retailers that have entered the outlet business in recent years include Nordstrom, Lord & Taylor, and Sears.

In general, outlet stores sell merchandise for anywhere from 25 to 70 percent off regular retail prices. When groups of outlet stores are combined in one mall, the drawing power for consumers can be enormous. The Reading, Pennsylvania, area, for instance, is home to six outlet store complexes, and attracts some eight million visitors a year, many of them arriving by busload from the New York metropolitan area.[8] There, and at other outlet malls across the country, the list of stores often reads like a "Who's Who" of the fashion world, featuring such names as Donna Karan, Ralph Lauren, Adrienne Vittadini, Anne Klein, Calvin Klein, Carole Little, Ellen Tracy, Etienne Aigner, Joan & David, Bill Blass, Van Heusen, Bass, Jones New York, Leslie Fay, Bali, and Maidenform, just to name a few.

Other Fashion Retailers

While the majority of fashion merchandise sold through stores is sold by the types of retailers previously described, there are other kinds of stores that carry a certain amount of fashion apparel or accessories. Jewelry, in particular, is an important cate-

gory for retailers known as **catalog showrooms.** These stores are set up to display samples of a wide variety of merchandise mirroring that found in their published catalogs. Customers at the stores can make a selection by browsing either through the catalog or around the sales floor, and then request the actual item from a sales associate, who submits the order to a backroom storage area for the customer to retrieve at a designated pick-up area. Some of the largest catalog showroom operations include Service Merchandise and Consumers.

Another type of retailer that has been growing in popularity is the **warehouse club.** An offshoot of the discount store business, warehouse clubs buy merchandise in bulk, obtaining volume discounts from manufacturers, and display the goods in a warehouse style, no-frills setting, keeping costs even lower for customers. These retailers are open only to "members," who must pay an annual fee, but who, in exchange, can purchase a variety of merchandise, including clothing and fashion accessories, at or near wholesale prices. Three of the most prominent warehouse clubs are Pace Membership Warehouse, Price Club, and Sam's Wholesale Club, a division of Wal-Mart.

Still other retail outlets for fashion merchandise include flea markets, whose vendors frequently include sellers of specially purchased new or previously owned apparel and accessories, as well as one-of-a-kind hand-crafted goods; and resale or consignment shops, which buy and resell previously worn garments, and which are enjoying a new surge of popularity due to consumers' interest in both value for their money and recycling.

Non-Store Retailing

Leaving the house and going downtown or to the mall to shop is an American pastime that will probably never lose its appeal. Yet there are times when, for convenience, consumers like to select merchandise and make their purchases from the comfort of their own homes. To meet this need, enterprising retailers have developed a variety of options in non-store retailing, including new versions of the classic catalog, as well as several types of electronic shopping. In addition, direct selling to consumers also plays a minor role in the fashion industry, both through door-to-door operations, such as Avon, and in-home party plan retailing, identified most immediately with Tupperware housewares but also employed by some cosmetics, jewelry, and lingerie firms, in particular.

Catalogs

According to the Direct Marketing Association, more than half of the adult population of the United States shops by phone or mail. For many of these shoppers, the merchandise they order comes from one of more than 13 billion catalogs mailed to American households each year.[9]

Catalog retailing has come a long way from the early Montgomery Ward and Sears, Roebuck and Co. publications at the turn of the century. While those pioneering mail-order books were designed to get merchandise into the hands of consumers who might not have access to a store, today's catalogs serve a far different purpose. Since virtually everyone in America lives within a relatively easy distance of

a store or shopping area, catalogs in the 1990s are designed either to offer unique merchandise that is not available in a store or to offer goods in a time-saving, convenient way for customers who may not have time to shop.

Indeed, during the 1980s, as an ever increasing number of women joined the workforce—many of them juggling careers with families, and therefore losing the luxury of time to browse in stores—the estimated number of catalogs mailed to consumers nearly tripled.[10] This increase came not only from entrepreneurial retailers jumping into the business with a new idea, but also from established catalog retailers creating smaller, focused publications aiming at a specific segment of the marketplace.

This type of target marketing or niche marketing could be considered the catalog equivalent of specialty store retailing. For instance, giant department store chain J. C. Penney, which entered the general merchandise catalog business in 1962, still produces two general catalogs or "big books" each year, for fall/winter and spring/summer, featuring an array of fashions and merchandise for the entire family and the home. But the company also produces some 50 seasonal, promotional and specialty catalogs each year, including special mailings specifically targeting markets for large-sized women, tall/ultra tall women, petites, big men's/extra tall, bridal, maternity, and workwear. In fall 1992, Penney's added yet another specialty catalog; this one high-lighting minority artists and designers who look to Africa for inspiration, featuring Afrocentric merchandise including clothing made of traditional "kente" material.

Giant catalog retailer Spiegel, which has been selling merchandise by mail order since 1865, also adopted the strategy of specialization by launching a specialty catalog division in 1983. Among the nearly 25 different catalogs it mails each year are "For You," featuring fashions for women sizes 14 and up, "Real Life Dressing," with apparel designed to blur the line between weekday and weekend dressing, and "Agenda," consisting of easy knits and wardrobe basics for women.[11] But Spiegel has also taken a different approach more recently by combining the equivalent of a dozen or so specialty

Figure 13-8. Catalogs are a major force in retailing as witnessed by the great variety of them overflowing in mailboxes. (Courtesy Ellen Diamond)

catalogs back into one big catalog. The company's goal was to provide the convenience of merchandise grouped by category, such as ready-to-wear, designer fashions, juvenile clothing, furniture, and home textiles, but in a more substantial format that would make the catalog stand out among others in consumers' homes. Making an analogy to store retailing, Spiegel described its catalog as "putting the mall in the mail."[12]

While postal and shipping cost increases periodically put a damper on catalog mailings and sales, the popularity of this method of shopping for millions of consumers is not expected to wane. It may, however, be facing its biggest hurdle since, in the early 1990s, a movement was underway to try to force mail-order retailers to collect sales tax from customers even in states where the business had no physical presence. Should such legislation be passed, it will surely affect some consumers' willingness to purchase goods by mail, and will have a significant impact on profitability, especially for smaller catalog retailers.

In addition to companies doing retail business strictly by mail order, a tremendous number of traditional store retailers also use catalogs and other direct mail vehicles, such as circulars and billing inserts, to attract customers' attention at home. In many cases, a toll-free telephone number and/or mail order form are included, allowing customers to order regular store merchandise without going to the store. At other times, the catalog is designed simply to generate excitement about a new line of merchandise or a sales event, and to draw customers into the store to buy.

Electronic Retailing

As technology has advanced and permeated the American way of life, it is not surprising that it has also affected retailing, by creating yet more new ways for consumers to shop. As long as a consumer has a credit card and a telephone, he or she can not only sit at home and order merchandise from a catalog, but can do so just as easily from a television or a computer.

Television shopping has actually been around since 1982, when the Home Shopping Network (HSN) first joined the airwaves to compete for consumers' viewing attention. The arena burgeoned rapidly with up to 30 shopping channels in 1986, but many quickly failed and were discontinued. J. C. Penney, for instance, launched its own J. C. Penney Television Shopping Channel in the late 1980s, but canceled the venture in 1992, leaving the industry dominated by two major channels: HSN and QVC Network, which in mid-1993 were negotiating to merge. Although there are fewer channels, the popularity of television shopping has grown tremendously, with at least one shopping channel available to virtually all 47 million cable subscribers in the United States. Sales from the channels, which barely reached $1 million in 1985, were estimated at $3 billion in 1993.[13]

Television shopping has also attracted the attention of some leading designers, who view the medium as another viable outlet for their fashions. For example, when Diane Von Furstenberg debuted her "silk assets" collection of all-silk fashions on QVC in November, 1992, the entire collection sold out in less than two hours, totaling revenues of $1.2 million.[14]

J. C. Penney was not the only traditional retailer to have thrown its hat into the electronic retailing ring. In 1990, Sears launched on a national scale a venture called

Prodigy, which it had tested regionally for two years in partnership with computer manufacturing giant IBM. A family-oriented service, Prodigy links users of personal computers by modem with a wide range of services and information, including shopping, banking, news, and weather. Subscribers to the service pay a nominal monthly or yearly fee in exchange for access to all the service's features, which includes the ability to browse through "electronic catalogs" and place orders for merchandise not only from Sears, but from other participating companies, as well. In less than a year after the system's national introduction, it had attracted more than one million subscribers.

Just as technology in general changes with sometimes dizzying speed, technologies that add even more dimensions to the electronic home shopping experience are sure to be introduced in the years to come. Already, the specialty retailing division of Hartmarx Corp. has experimented with a video catalog. And at least one company was planning to introduce a satellite-based system that would allow consumers to order merchandise from a television shopping channel simply by pointing a remote control device at the product on the screen.[15] With wonders of modern technology as yet undreamed of, the approach of the next century is sure to be an exciting time for retailing!

Future Trends in Retailing

Because so much of retailing is fashion driven, and because fashion is constantly changing, retailing must also constantly change. It is equally as important for retailers to keep their finger on the pulse of their customers' needs and wants as it is for manufacturers and designers. As any social, political, or economic trends affect the lifestyle or attitudes of their customer base, retailers must adapt themselves and their merchandising policies as best they can to those changes. Leslie H. Wexner, chairman of The Limited Inc., put it succinctly when he wrote:

> In fashion retailing, we're only as good as what we can deliver to the customer tomorrow; it doesn't matter what we did yesterday or even today. If we ever think we've got things really figured out, we will be steering our business away from our customers and right off a cliff. But when we're asking questions, finding answers, acting on them—that's when we know we're thinking. And there's a good chance we're finding another way to be faster and smarter.[16]

Indeed, the next decade will reflect the dramatic changes that have taken place in the past 10 years or so, not only in the retail sector, but in the economy and society, in general. Looking ahead, some of the trends that are sure to shape retailing as the twenty-first century approaches are a continued restructuring of the industry, a value-seeking mentality of consumers, improved customer service, technological innovations, and the development of new retail formats and environments.

Restructuring of the Industry

The middle to late 1980s saw some of the nation's largest and oldest department stores being acquired by other parent organizations, merged with other stores, forced into

bankruptcy proceedings, or even closed altogether. For instance, Dillard's went on a buying spree that expanded its store base through the acquisition of such former chains as D. H. Holmes, Diamond's, Stix, Baer & Fuller, Joske's, Higbee, and Ivey's; and Dayton Hudson Corporation added Marshall Field's to its department store roster. By contrast, Federated Department Stores, which successfully emerged from a Chapter 11 re-organization bankruptcy in early 1992, did so in part by saving costs and improving efficiencies. For instance, it merged the operations of some of its chains into one. For example, first it merged Jordan Marsh Florida with Maas Brothers, and then Maas Brothers/Jordan Marsh with Burdine's. Along with Federated, Macy's was another of a number of stores in recent years that used a reorganization plan under the country's bankruptcy laws to try to get its financial strength back and continue operations on sounder footing. Other department stores were not so fortunate, with once-venerable names like Gimbel's and B. Altman closing their doors forever in the 1980s.

Value-Seeking Consumers

Because of all the recent upheaval in the retail marketplace, much of it compounded by the economic recession the country was enduring at the beginning of the 1990s, most experts believe the future of retailing must be dramatically different from the past. A major reason for this is that consumers' values and priorities have changed dramatically. Most consumers today are interested in quickly finding the item they need, purchasing it, and leaving the store, rather than spending a lot of time simply browsing. They are also seeking, more than ever before, true value in their purchases; that is, good quality merchandise at a fair price. These factors will continue to affect the how, where, and way consumers shop. For instance, recent research shows a 20 percent decrease in the amount of time consumers now spend shopping for clothes. It also shows that almost as many women shop off-price and factory outlets as they do department stores; and almost six in ten shoppers wait for sales to make their purchases.[17]

The end result of all the changes in the marketplace is hard to predict, since change never stops; but several general trends are certain to continue shaping the retail industry well into the next century. One is consumers' quest for value, which should mean ongoing growth and success for retailers like off-price stores, outlet stores, and upscale discounters that offer quality, brand-name and designer merchandise at lower prices. Plus, as a reflection of this desire for fashionable yet affordable clothing, department stores are expected to place heavier emphasis on lower-priced lines and designers' bridge collections,[18] while maintaining a top-of-the-line assortment for their most affluent, fashion-forward customers.

Improved Customer Service

In the coming years, retailers will also need to address the issue of making the shopping experience easier and more efficient for time-pressed consumers. For discounters and other retailers based on customer self-service, this may mean redesigning the layout of the store to make it faster and easier for customers to find the merchandise

they are looking for, pay for it, and leave. It may also involve offering special amenities to certain target groups of customers. Woolworth stores, for instance, designate one day a week to give a 10 percent discount on purchases made by senior citizens. For department and specialty stores, improving the shopping experience could mean increasing the amount and types of services they offer. Nordstrom, for example, has long been considered the epitome of excellent customer service, and other department stores have striven to achieve that retailer's high level of service and customer satisfaction. Among the specialized services currently offered by some retailers are personal shopping assistance by appointment and special offers or bonuses made to their charge card customers.

Advances in Retail Technology

Yet another way retailers of the 1990s are working to meet customers' needs is through the use of increasingly sophisticated technology. One of the most important aspects of this involves close cooperation with their vendors. Each year, a growing number of retailers are entering into Quick Response (QR) and other "partnership" programs with manufacturers to ensure that their stores are stocked with desired merchandise in a timely manner. Plus, as technology improves and becomes more widely accessible, more retailers are taking the next step of employing Electronic Data Interchange (EDI), whereby information on sales of specific merchandise may be transmitted directly from a computer at the store's checkout to the manufacturer of the goods, and a replenishment order for the store initiated automatically.

Information about sales transactions, which can be gathered electronically and analyzed on a day-by-day basis, is being used increasingly at the store management level, as well. By knowing the styles, their sizes, and colors that were sold yesterday—

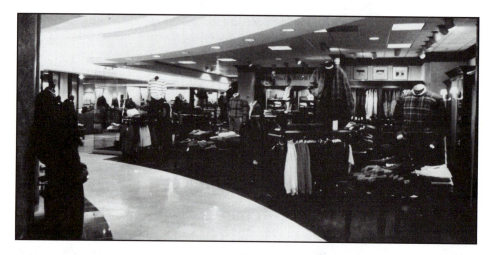

Figure 13-9. Successful retailers of the '90s are constantly working to make shopping easier and more pleasant for their customers through convenient floor layouts, good merchandise selection, and customer services. (Courtesy Belk's)

and to whom they were sold—retailers are not only planning their assortments better, but are able to develop detailed databases that allow the implementation of *micro-marketing* programs. These are ultra-targeted efforts whereby special promotions or announcements can be sent only to customers who purchased, for example, Estée Lauder cosmetics within the last three months, or who spent more than $1000 on Liz Claiborne apparel the previous year.

New Retail Formats

Despite all the mergers, acquisitions, and store closings that have already taken place in recent years, it is likely that the retail industry will continue, at least to some degree, to restructure itself in the years ahead. The proliferation of new stores over the past three decades has led to what many call the "overstoring" of America. Indeed, the number of shopping centers and malls across the country grew from 3680 in 1960 to 36,650 in 1990,[19] a pace that has slowed drastically in the 1990s. Yet, while there will surely be an ongoing cycle of stores that fall by the wayside, there will always be new and entrepreneurial retailers springing up with new assortments of merchandise, new methods and new environments in which consumers can shop for fashion. Some will be more successful than others, but all will help to keep the business of retailing fresh and dynamic.

For instance, many shopping centers and malls, some of which were built 15 or 20 years earlier, have undergone renovation and "facelifts" to revitalize their image and appeal. Plus, despite the slowdown in the number of new shopping centers and malls being built, 1992 brought with it the grand opening of the country's largest shopping/entertainment complex ever built, the Mall of America. Located in Bloomington, Minnesota, a suburb of Minneapolis/St. Paul, the 4.2 million-square-foot center houses: four anchor stores

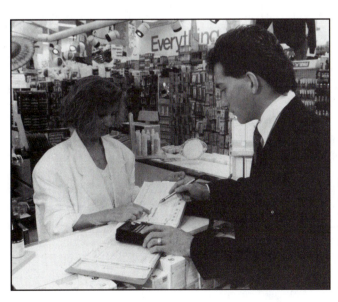

Figure 13-10. The rapid ordering technology system starts at this cosmetic counter as the supplier electronically reorders the items the retailer wants. (Courtesy *Marketing News*)

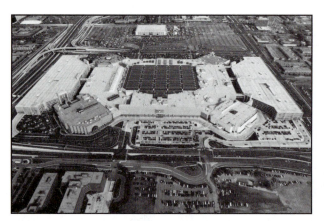

Figures 13-11a and b. New retail environments, such as the Mall of America with its seven-acre amusement park, help keep the shopping experience fresh and fun for consumers. (Courtesy Mall of America)

(Bloomingdale's, Macy's, Nordstrom, and Sears) and 400 specialty shops; a seven-acre Camp Snoopy amusement park, a miniature golf course, a 5000-square-foot Lego Imagination Center, and a 19-foot animated lumberjack; plus restaurants, five nightclubs, and a 14-screen movie theater. While the mall's long-term strength in drawing consumers remains to be seen, its initial appeal was overwhelming, with more than one million shoppers and fun-seekers having visited the complex in just the first week it was open.

In contrast, another "big" idea that was expected to make it on the retail scene in the 1980s fizzled out by the early 1990s. Borrowing on a retail format popular in Europe, several major U. S. retail companies began experimenting with *hypermarkets,* enormous stores designed for one-stop shopping that housed everything from apparel to groceries to general merchandise and services all under one roof. Entering such ventures in the late '80s were Wal-Mart with four Hypermart USA stores and K mart with three American Fare stores, both of which discontinued their programs when it became clear that the concept was not viable. Instead, however, both of these major retailers turned their attention to scaled down versions of the hypermarket format called superstores, which would consist of more traditional discount stores with a grocery store added on. K mart was planning to build at least six such stores by the end of 1993, while Wal-Mart had 40 of them on the drawing board, to be built near the company's headquarters in Bentonville, Arkansas.[20]

All of which simply goes to show that those in retailing, like those in fashion, have to be creative and dynamic, and always willing to change. And in the end, the ones that succeed best will follow the simple motto set forth by Marshall Field himself over 100 years ago: "Give the lady what she wants."

Summary

1. Over the last century, the retail industry in America has followed closely the movements of consumers, providing for the needs of early remote settlers through peddlers, general stores, and catalogs, of city dwellers through the one-stop shopping concept of department stores, and later of suburbanites through convenient, nearby shopping malls.

2. Individual retailers differentiate themselves through the establishment of a merchandising policy, which takes into account the basic elements of fashion cycle emphasis, quality, price ranges, depth and breadth of assortment, brand policies, and exclusivity.

3. Most fashion merchandise is sold through department stores, general merchandise chains, independent or chain specialty stores, discount or mass merchandise stores, off-price stores, or outlet stores. Each type differs in the assortment of merchandise it offers and its pricing policy; and individual stores within each category differ by way of their own specific merchandising policies.

4. Catalogs account for the largest segment of sales for non-store retailers, but the relatively new category of electronic retailing, including television shopping and shopping by computer, is growing rapidly as technology increases.

5. Retailers of the future must continue to follow closely and adapt to consumer trends in order to be successful. Value, ease of shopping, and service are three of the major consumer wants that retailers of the 1990s are striving to address.

Fashion Vocabulary

Explain each of the following terms; then use each term in a sentence.

branch stores

broad and shallow assortment

catalog showrooms

department store

discount store/mass merchandise store

exclusivity

flagship store

general merchandise retailer

mark-up

merchandising policies

mom-and-pop specialty stores

narrow and deep assortment

off-price retailing

outlet stores

retailing

specialty stores

target customer base

television shopping

warehouse club

wholesale cost

Fashion Review

1. Name some of the early methods of retailing in the United States and explain how they were adapted to meet the needs of consumers.

2. List the six basic elements that make up a retailer's merchandising policy, and give two or three examples of the difference in those policies among different types of stores.

3. Explain the differences among department stores, specialty stores, and discount stores, and give two or three examples of each kind.
4. Explain the concept of off-price retailers and outlet stores, and tell how the two types are alike and how they are different.
5. Identify three major trends in non-store retailing.

Fashion Activities

1. Thinking of retailers in your own community, analyze what changes are occurring on the local retail scene. What stores have opened recently? What types of merchandise do they offer and what makes them different from others selling similar goods? Have any stores gone out of business? What factors may have contributed to their closing? How many different types of fashion retailers are operating in the area? How many are part of chain organizations? Are there any specialty categories that you think are not covered and in which a new store might be successful?
2. Imagine you are an entrepreneur ready to open your own specialty store. Choose a category of merchandise in which you would like to specialize and chart out what you would select as your basic merchandising policy in the six key elements. Be prepared to explain why you made the choices you did.

Endnotes

1. Maxwell Sroge, *Inside the Leading Mail Order Houses,* Maxwell Sroge Publishing, Colorado Springs, CO, 1982, p. 325.
2. Lynn Schnurnberger, *Let There Be Clothes,* Workman Publishing, New York, 1991, p. 400.
3. "Retailing: Driving the Economy," The National Retail Institute, Washington, D.C.
4. Definition per *Stores* Magazine for its annual listing of the "Top 100 Department Stores."
5. "Merchandising & Operating Results of Retail Stores in 1990," National Retail Federation, New York, 1991.
6. Barbara Solomon, "Ward's 'Destination Stores' Find Home," *HFD,* August 20, 1990, p. 48.
7. Kevin Helliker, "Thriving Factory Outlets Anger Retailers as Store Suppliers Turn Into Competitors," *Wall Street Journal,* October 8, 1991, p. B1.
8. "For the Bargain Hunter, Ample Outlets," *New York Times,* December 15, 1991, p. 71.
9. Estimated figures from Direct Marketing Association Inc., 11 W. 42nd Street, New York, NY 10036.
10. Ibid.
11. Penny Gill, "Lifestages: New Spiegel Strategy," *Stores,* July 1990, p. 52.
12. Deborah C. Kelt, "Spiegel Puts 'Mall in Mail,'" *HFD,* April 6, 1992, p. 14.
13. Elizabeth M. Cosin, "From the Mall to Catalogs to Cable," *Insight,* May 7, 1990, p. 51.
14. Annie Flanders, "Couch Couture," *TV Guide,* January 9, 1993, p. 20.
15. Bart Ziegler, "Firm Tunes in Shop-from-Home TV System," Gannett Suburban Newspapers, September 11, 1991, p. D1.
16. Annual Report, The Limited Inc.
17. "Industry Restructuring: Pitfalls and Promises," speech given by Walter K. Levy, chairman, Walter K. Levy & Robert E. Kerson Associates, Inc., New York, to the 81st Annual Retail Convention of the National Retail Federation, January 13, 1992.
18. Isadore Barmash, "Down the Scale with the Major Store Chains," *New York Times,* February 2, 1992, p. F5.
19. "Customer Driven Marketplace: New Challenges, New Opportunities, New Roles," speech given by Jeffrey J. Hallet, futurist and principal, The Presentfutures Group, Falls Church, VA, to the 81st Annual Retail Convention of the National Retail Federation, January 14, 1992.
20. Laurie M. Grossman, "Hypermarkets: A Sure-Fire Hit Bombs," *Wall Street Journal,* June 25, 1992, p. B1.

Fashion Promotion

Objectives

After completing this chapter, you should be able to:

1. Define the term *fashion promotion activities* and explain how they are used by manufacturers and retailers.

2. Compare advertising and public relations and be able to describe their similarities and differences.

3. Define *sales promotion activities* and explain why sales promotion receives a greater share of promotional dollars than advertising.

4. Describe why visual merchandising is essential to the retailer and cite three or four elements that are considered when planning a good visual design.

5. Explain why special events are important to the retailer.

The auditorium is dark, except for flickering candles on each table. A slight murmur rises from the crowd as waiters deftly move in and out removing plates. Suddenly a spotlight shines, catching a speaker in its beam. With enthusiasm and verve, the commentator welcomes and thanks the audience for attending this memorable evening, the seventh annual Beggar's Ball fashion show.

On cue, the stage is awash with light, and the air filled with pulsating music, as groups of long-legged models converge on stage in wave after wave of new fashion looks.

A mixed source of envy and admiration, these models represent the epitome of style, modelling with poise and panache this season's favorite fashions.

Behind the scenes the line-up coordinator, who sends the models on stage, anxiously runs her eye down the model list, checking the sequence in which the models are to appear. In a panic, she runs back to the dressing room, calling for the missing model whose absence on stage will be noticed.

Unknown to the public, behind the facade of fashion cool and glamour is an orchestrated frenzy. Models barely making changes, broken zippers, and lost gloves, can jeopardize the carefully planned production.

Despite all the possible glitches that threaten this live performance, it all comes together to produce a night to remember, an image that impresses, tantalizes, and leaves audiences yearning for more.

Fashion means something different to everyone. But for most people, it represents a wonderland of gorgeous models, exquisite Parisian originals, high visibility, and a lifestyle few can afford.

With a reputation for fame, fortune, and immortality is it any wonder that fashion holds such widespread allure for women and men of all ages?

This chapter explains the role of promotion in the fashion marketing process and its use by both manufacturers and retailers.

Promotion Activities Defined

Promotions

An element of marketing, *promotion* includes all the nonpersonal and personal marketing activities necessary to inform, persuade, or motivate an individual or business to react favorably to a product or an idea.

Nonpersonal promotion is selling indirectly to the customer. Promotion activities that fit into this category include advertising, sales promotion, public relations, and publicity.

The fashion show described earlier is an example of nonpersonal fashion promotion. In a gloriously entertaining manner, the audience is given an opportunity to examine merchandise available for sale. The models promote the outfit by modelling the garment. The store owner, designer, or manufacturer—to further the image of the business and generate sales—romances audiences by producing a show with models, theme, music, and apparel that appeals to their fashion senses. The show becomes the sales promotion vehicle promoting the merchandise and the image of the business.

Personal promotion is face-to-face or over-the-phone selling. Three areas of personal promotion cover field, over-the-counter, and telephone sales.[1] Examples of personal promotion include: the salesperson representing a designer or a manufacturer who visits prospective stores; the sales associates selling in a store; and the manufacturer's representative taking a merchandise reorder over the telephone.

Nonpersonal Promotion

Advertising

One of the oldest and most familiar forms of nonpersonal promotion is **advertising,** a sales message appearing in the media and paid for by an identifiable sponsor.

Figure 14-1. Ads are one of the most popular methods used to introduce merchandise to customers. (Courtesy Bloomingdale's)

Media are the channels of communication used to reach various audiences. Examples of media are newspapers, magazines, television, and radio.

The air time or print space used for an advertisement is paid for by an identifiable source called a **sponsor.** Because the sponsor buys the advertisement, the sponsor has total control over its content, appearance, and timing.

To promote recognition, sponsors use **logos,** which are stylized print or symbols that identify the advertiser and product. The logo is a very important part of the image-building process. Companies spend much money on determining just the right look to set their logo apart from others. The type size, style, and placement of the logo are meant to portray and promote the company's image.

Types of Advertising

One way to classify fashion advertisements is through their objective. Two basic types of advertisements are product advertisements and institutional advertisements.

Product advertisements promote specific merchandise. By including pertinent information necessary to make a buying decision like price, item, and availability, product advertisements attempt to motivate consumers to make a buying decision. Most fashion advertisements are product advertisements.[2]

Unlike product advertisements, **institutional advertisements** stress the image of a particular organization or individual. Instead of trying to elicit an immediate response from the consumer, institutional advertisements are part of a long-term

Figure 14-2. Customers are most familiar with product ads, which are also called promotional ads and feature merchandise. (Courtesy Dayton Hudson Corporation)

public awareness campaign to enhance the overall image of a business and encourage and maintain customer loyalty.[3] Both product and institutional advertisements appear in various advertising media.

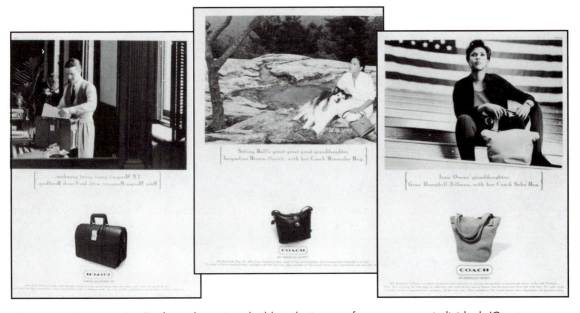

Figures 14-3a, b, and c. Product ads continue building the image of a company or individual. (Courtesy Coach)

Newspapers. Both manufacturers and retailers widely use newspapers as a means of advertising fashion goods. However, it is retailers who rely most heavily on the newspaper as their primary source to reach their locally based clientele.

The advantages newspaper advertising offers are many. Newspaper ads can be targeted to a local market; for example, a retail store's immediate customers.

Newspaper advertising is quicker than other media as it requires less lead or advance time to place an ad. Advertisers can also measure the response to an advertisement the day it runs by checking the volume of sales for that day.

Newspaper advertising also permits the advertiser to tie in with national advertising as well. **National advertising** is advertising sponsored by a producer or manufacturer and is directed toward the consumer. An example of national advertising is a Levi Strauss advertisement for western wear appearing in newspapers across the country. Another example is the Wool Bureau's television commercial featuring singer Lena Horne extolling the virtues of products made of wool.

Magazines. A traditional means of advertising for the fashion industry, magazines offer superb color and detail. Catering to a select audience, magazines are used by fabric producers, apparel manufacturers, and large retail organizations with sufficient promotional budgets, such as Saks, Nordstrom, and The Gap.

Advertising in magazines is advantageous since the color reproduction is tremendous and accurate. Depending on the magazine selected, the advertisement is targeted to reach the desired audience. Although more expensive than newspaper advertising, magazines offer fashion trend information and highly creative and beau-

Figure 14-4. This fashion trend news on Hue Hosiery seen in *Elle* magazine reaches a large audience to promote a product and the company behind the product with informative, insightful copy. (Courtesy *Elle*).

tifully executed advertisements of the latest fashions. They also have a longer circulation life than newspapers.

The only real drawback to magazine advertising is the longer lead time it takes for the advertisement to be produced. Both capital and merchandise can be tied up. Plus, apparel featured in the advertisement ideally should be in the stores when the ad is run.

Television. Television is the rising star—attractive to fiber producers, manufacturers and designers, and retailers of all sizes. Manufacturers and designers such as Monsanto, Du Pont, and Anne Klein rely on television to advertise their fashion products nationally. Retailers, such as J. C. Penney, Sears, and K mart, also rely on television to reach vast numbers of people. Even small retail stores advertise locally on cable television. Television is particularly attractive to the advertiser because products can be shown and demonstrated.

As cable television has become more widespread, and with the introduction of home shopping programs, television promotion is the wave of the future. Although home shopping programs have not all been successful, now channels such as Home Shopping Network (HSN) in Florida, and QVC in Pennsylvania are considered ventures whose time is fast-approaching. The sales of just one program, the Home Shopping Club, climbed from $160 million in 1986 to $1 billion in 1991. The day is not far off when, with interactive television, customers will be able to look at video fashion catalogs and order from the television network.[4] The $3 billion television shopping industry is just at its infancy. At this writing, QVC is working to acquire HSN and also to create a fashion channel called Q2.

Unlike television, video advertising has not been as successful as originally hoped. Videos were set up both in showrooms and in store departments adjacent to promoted merchandise to attract passing customers. They are still used by retailers in some fashion departments, such as juniors or even designer fashions, to attract attention with sound and movement.

Because the videos did not attract the anticipated large audiences, they have not been the most effective promotional tool. However, they are an effective teaching aid. Producers, manufacturers, and retailers use videos to inform and educate their sales personnel on the latest selling techniques and newest product information. Videotapes are also cost-effective, since they can be played repeatedly and referred to at a later date. Videotapes can be purchased in a wide range of topics or produced to order. For example, a store hires a video production crew to tape its employee fashion training seminar and shows the video later at the branch stores, too. Video has helped reshape the industry by creating new jobs, such as fashion video producers.

Radio. Although radio is rarely used by the fashion industry as a means of promotion, it does have certain advantages. Radio advertising is cheaper than television advertising. And ads played during the drive times, morning or evening rush hours, will probably reach their targeted market. Although radio is effective for airing announcements about sales, special events, and celebrity appearances, it does not lend itself to fashion advertising. Ordinarily most customers need to see and feel a garment before deciding whether to purchase it.

In order for promotional activities to be effective, the right media must be selected to carry the message to the right target customer. Depending on the overall image of the business, its long- and short-term objectives, available resources, and targeted customers, the media and volume of advertising are determined.

Sales Promotion

Sales promotion includes promotional activities other than advertising, public relations, and personal selling that influence or persuade a person, or business, to accept and buy an idea, service, or product.

Each year businesses spend more money on sales promotion activities than on advertising, yet actual sales results are harder to measure than advertising. Used to back up the overall promotional effort, sales promotion activities include: fashion shows by designers, manufacturers, and retailers; sampling; coupons; contests; and displays.

Fashion Shows. Fashion shows are one of the most popular ways of introducing the latest collections available for purchase. Fun, exciting, and immediate, a **fashion show** is a planned sequential procession of models on a designated stage area. The "stage area" could be a raised platform or specific area on the selling floor. Used by all levels of the fashion industry, the fashion show is a source of prestige, information, and entertainment for all participants.

To reflect the overall image or projected personality of the sponsor, and to attract the desired clientele, fashion show producers give careful attention to the selection of music, theme, models, staging, and merchandise. A great image enhancer, and a draw for free media coverage or publicity, the fashion show is an important promotional tool. If planned correctly, the viewing audience is persuaded to buy the featured merchandise. However, the escalating costs of producing a show have made the cost prohibitive for some businesses.

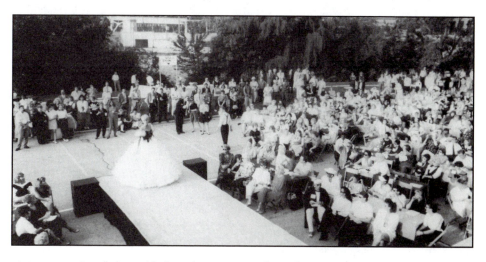

Figure 14-5. A well-planned fashion show is an excellent sales promotion activity favored by designers and retailers alike. (Courtesy Chicago Apparel Center, 1990. Photo by Robert F. Carr)

Sampling. One of the most effective means of introducing new products is by **sampling;** that is, the retailer gives customers a complimentary sample of the manufacturer's promoted product. For example, the cosmetics salesperson includes a small vial of a manufacturer's new fragrance when a customer purchases other products. The resulting sales typically justify the expenditure.

The cosmetics industry has even more elaborate sales promotion strategies typically involving sampling. As described in Chapter 10, Intimate Apparel and Cosmetics, these are known as gift-with-purchase (gwp) and purchase-with-purchase (pwp). In both instances, when consumers purchase a manufacturer's products at certain times, they may be offered either a gift, usually several samples of the manufacturer's products, or the opportunity to purchase certain additional products at a lower price.

Coupons. Coupons are also another popular sales promotion technique. *Coupons,* flyers or cut-outs that offers a price discount, may appear in catalogs, newspapers, or as separate letters to customers. The discount is offered when the customer redeems the coupon at the participating store.

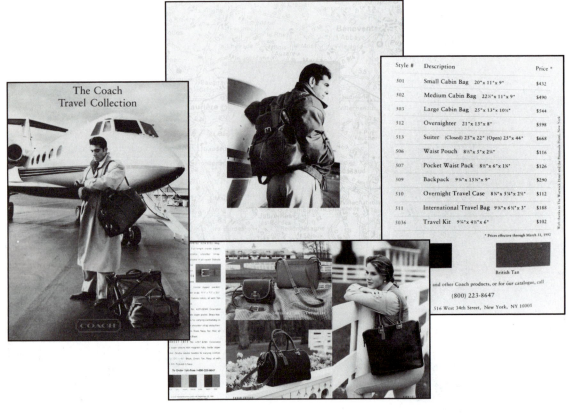

Figure 14-6. To create the right image and ensure that their product is receiving proper representation, manufacturers send appropriate promotional literature to customers and to retailers for in-store displays. (Courtesy Coach)

Contests. Contests are special events where the customer competes with other participants to win a prize. The customer in a *contest* may have to fulfill certain requirements or provide information. By contract, in a *sweepstakes* or giveaway, people fill out entry blanks and a winning name is drawn. Companies also hold contents internally to motivate sales associates and sales representatives to sell. Retailers and producers alike set quotas or projected sales that associates and representatives are motivated to reach. Prizes are awarded, from dinners for two to gift certificates to trophies.

Displays. The promotional arrangements and materials that are featured in the selling department at the point of purchase are **displays**. Manufacturers furnish appropriate promotional literature, such as brochures and inserts, that tell the customer about the product. Display materials, such as cardboard backdrops or photos of celebrities, may also be furnished to help sell the product.

Public Relations

Unlike advertising and sales promotion, which are intended for customers, public relations attempts to reach a wider audience. This audience may include—in addition to customers—employees, suppliers, competitors, the government, and the general public. **Public relations** are continuous and flexible programs developed to position the entire image of a company or an individual, such as a designer or a political candidate. Depending on the needs and desired image of the client, the public relations program aims to keep or improve that image. In either case, an effective public relations program continuously informs the appropriate target audience of the client's activities.

To achieve the desired image, executives in charge of public relations develop goals for their programs that complement company objectives. Then they turn over the job of creating the activities to a publicist, who may be within the company or an outside consultant.

Before being able to develop a concrete plan of action, the publicist must first determine if a company's projected image matches the public's perception. If there is a discrepancy, it must be addressed. Upper management is advised to make internal changes and take positive action to correct it. If the image matches, then a program to sustain the current image is put into effect.

Good public relations programs are sensitive to the changing needs of a client. To attract attention and generate publicity or free media coverage, special events like press parties and seminars are made consistent with the desired image of the company or individual. Since public relations is an overall conditioning process, activities are also held to inform, educate, and foster good will with the targeted internal and external publics. Stockholders, employees, and upper management are kept informed through annual reports, memos, and meetings, while the outside public relies on well-placed news stories, seminars, and special events to learn about the company's progress.

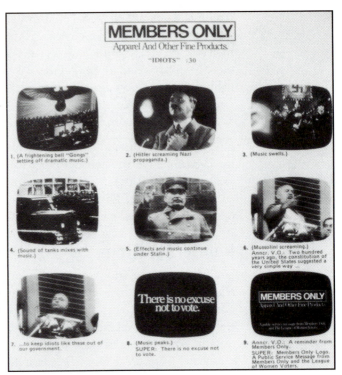

Figure 14-7. This television storyboard for Members Only promotes the overall company image, while at the same time offering a public service message. (Courtesy American Marketing Association)

Publicity

Publicity occurs when the media voluntarily use information prepared to influence various publics in the press or on the air. Free media coverage can be quite desirable as the heightened exposure results in greater recognition.

To gain publicity, publicists either submit newsworthy information to the media or create special events or activities worthy of media attention. For instance, to celebrate the grand opening of its Oak Brook, Illinois store, Nordstrom held a benefit party to honor the area's Junior League, a well-known organization of young women who support a range of worthy charities and causes. Before and after the benefit, Nordstrom was the talk of the town, attracting much media attention. The store acquired extensive publicity coverage for its opening.

Unlike advertising, publicity is not a sure promotion. It can be quite costly, time-consuming, and frustrating to plan and stage an event that attracts no media coverage. What compounds the problem is that what the media considers newsworthy may not be compatible with the company's promotional needs. "Newsworthy" means information that is timely, has a local angle, and is of interest to the audience that the media must satisfy. Proceeds from the Nordstrom opening benefit went to deserving local service organizations, creating a newsworthy public event.

One of the most popular ways used by designers, manufacturers, and retailers to convey information to the media is the **press kit,** a portfolio containing an assortment of different news releases and photographs.

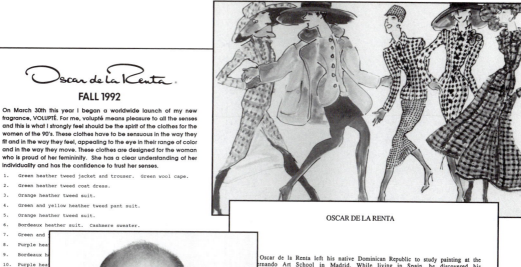

FALL 1992

On March 30th this year I began a worldwide launch of my new fragrance, VOLUPTÉ. For me, volupté means pleasure to all the senses and this is what I strongly feel should be the spirit of the clothes for the women of the 90's. These clothes have to be sensuous in the way they fit and in the way they feel, appealing to the eye in their range of color and in the way they move. These clothes are designed for the woman who is proud of her femininity. She has a clear understanding of her individuality and has the confidence to trust her senses.

1. Green heather tweed jacket and trouser. Green wool cape.
2. Green heather tweed coat dress.
3. Orange heather tweed suit.
4. Green and yellow heather tweed pant suit.
5. Orange heather tweed suit.
6. Bordeaux heather suit. Cashmere sweater.
7. Green and
8. Purple hea
9. Bordeaux h
10. Purple hea
11. Orange hea
12. Turquoise
13. Tomato cas
14. Olive wool
15. Camel cash
16. Camel cash
17. Beige cash
18. Camel cashm
19. Olive cashm
20. Multi-stri

OSCAR DE LA RENTA

Oscar de la Renta left his native Dominican Republic to study painting at the ernando Art School in Madrid. While living in Spain, he discovered his for fashion, and began sketching for leading Spanish fashion houses, soon led to an apprenticeship with Spain's most revered couturier, Cristobal ga. Later, Oscar de la Renta left Spain to join Antonio Castillo as a couture t at the house of Lanvin in Paris.

, Oscar de la Renta came to New York to design the couture collections for h Arden. In 1965, he joined the Jane Derby Company, as a partner with Ben nd his son Gerald Shaw. In 1966, the label was changed to carry the Oscar de a signature. By 1974, Oscar de la Renta, along with Gerald Shaw, took full hip of the company, which has since expanded to include Europe, the and South America, in addition to North America.

de la Renta has initiated many international fashion trends. For example, his and Gypsy fashion themes, were instantly acknowledged as pacesetters for nic fashion period, that eventually swept the world during the 1970's. Oscar Renta's talents have received frequent international recognition. Among ther honors, Oscar de la Renta is a two-time winner of the Coty American Critic's Award, and was inducted into the Coty Hall of Fame in 1973. From 1976, and most recently from 1986 to 1988, Oscar de la Renta served as nt of the Council of Fashion Designers of America. In February, 1990 he nored with the CFDA Lifetime Achievement Award.

ominican Republic has also honored its best-known native son, as one of its istinguished citizens, with the order al Merito de Juan Pablo Duarte, and the f Cristobal Colon. Behind the international man of fashion is also Oscar de la the committed patriot, whose funding and participation have helped build a needed school and day-care center in the Dominican Republic for some 350 en.

de la Renta is a patron of the arts, and is currently on the boards of the olitan Opera and Carnegie Hall. He is also on the Board of Directors of the as Society and the Spanish Institute.

de la Renta, Limited, headquarters for both Oscar de la Renta "Signature" and the Oscar de la Renta "Studio" women's wear collections, is based in New York.

Figure 14-8. The press kit, with its ready-to-use photos and information, provides the media with an overview of the subject. (Courtesy Oscar de la Renta)

News or Press Releases. One or two pages in length, a **news** or **press release** contains newsworthy information concerning an organization and/or its leaders. Typically news releases are written in a journalistic style called the inverted pyramid. The most important information is in the first paragraph, or lead, and less important information follows—the idea being that if the news story was too long, the last couple of paragraphs could be eliminated without destroying the story's content. This format also permits the editor to quickly scan the news release and determine its news value.

The public relations industry and the media depend on each other. Public relations and publicity departments use the media as an outlet for their news while the media depend on them as a source of news ideas and information.[5]

Figure 14-9. News releases have release dates to let the media know when the information can be used. The contact name and phone number is also indicated for follow-up information. Depending on the source of the news release, there will be stylistic variations on format. (Courtesy Dayton Hudson Corporation)

Newspapers, whether they like to admit it or not, rely on the public relations industry as the *de facto* assignment editors for much of their content. Press releases may be the source of as much as 40 percent of the typical newspaper, according to one study by the University of Georgia School of Journalism.[6]

Factual accuracy then becomes an issue since some of these releases are printed word-for-word.

Press Conferences. Press conferences are also a successful means of attracting media coverage. A *press conference* is a prearranged meeting with the media. A designer may hold a press conference to introduce a new line as Donna Karan did when first presenting the DKNY line. However, the press conference must cover a topic that justifies the attendance of media representatives and needs to be scheduled to accommodate their deadlines.

Personal Selling

As discussed earlier in this chapter, **personal selling** is selling directly to the consumer. "Nothing happens until a sale is made" is a well-known business fact, for the success of any business and all of its personnel. Both depend first on the volume of sales. To help sales personnel do a more effective job, both manufacturers and retailers hold sales training and product information seminars.

Personal selling occurs at every level of the fashion industry, from fiber and fabric producers to retailers, as well as the apparel manufacturers and wholesalers in between. Personal selling is the motivator that keeps the industry moving.

The better informed the sales representatives in all areas of the fashion industry, the better equipped they are to deal with today's more discerning customers.

SPOTLIGHT ON A FIRM

ESPRIT DE CORP

When the popular apparel firm Esprit de Corp aired its innovative "What Would You Do?" television spots, which provided a forum for teens to speak out on social issues, some retailers were offended.

Dubbed by some as "anti-fashion," the spots were perceived as a big departure from the fun, free-spirited, energetic ads that Esprit had been known for over the last 20 years.

But for people familiar with founder Susie Tompkins and Esprit's history, they were viewed as just one more progressive step in a company that prides itself on being "revolutionary in management" and "evolutionary in vision."

Since Esprit's inception in 1968, the company has always mirrored the philosophical bent of its owners. Founders Doug and Susie Tompkins were products of the '60s—free spirits who reveled in the laid back, carefree southern California lifestyle. Their image, fashions, and marketing all worked together to create a culture that captivated the imagination and dollars of juniors in 35 countries.

Just as attractive as the free-spirited lifestyle

ESPRIT

promise in the ads was the corporation's fabled San Francisco headquarters, where employees were promised a work environment that fostered personal growth and fulfillment. Unheard-of perks, such as free backpacking in the Grand Canyon, rafting in Africa, foreign language lessons, and access to the gym, earned the 10-acre headquarters the name "Little Utopia."

For over 20 years Susie Tompkins' fun, carefree casual wear was complemented by Doug Tompkins' innovative advertising campaigns. Their ads, which featured at first the fresh-faced energetic Esprit employees and later photographs of "real people," were unheard-of advertising techniques that revolutionized the fashion advertising industry.

Profits continued to soar until 1987, when an unexpected recession took its toll. Esprit, like many other manufacturing and retailing organizations, was unable to weather the sudden profit loss incurred by the changing customer buying habits and escalating costs.

In an industry where survival depends on the ability to change, Esprit, once the company to watch, was out of step with the times.

Doug Tompkins wanted to continue servicing the dwindling junior population, while Susie Tompkins, sensing the winds of change, wanted to design for the growing number of women 25 and older.

Due to irreconcilable differences between Susie and Doug Tompkins, a board of directors was appointed to run the company. One of the first acts of this group was to remove Susie Tompkins from the day-to-day company operations. During her two-year hiatus, she acquired a new perspective and maturity. With the financial backing of venture capitalist, Isaac Stein;

continued

Esprit Far East Chairman, Michael Ying; and former owner and founder of Rockport shoes, Bruce Katz, she returned to Esprit in 1990 and bought out Doug Tompkins' interests in the company for $325 million, less then the face value of the stock. (Doug Tompkins, however, still has some overseas business interests.)

Although determined to recoup both financial and fashion ground lost to more aggressive companies, such as The Limited and The Gap, Susie Tompkins is equally determined not to do it at the expense of the environment or people.

Whether or not Susie can achieve fiscal solvency and be corporately responsible remains to be seen.

Unlike many entrepreneurs, neither Susie nor Doug Tompkins had ever been motivated primarily by "bottom line" thinking. However, her current partners are business people first, who examine activities and plans in light of results. This difference in perspective has created a few conflicts between the partners, but represents a necessary change in thinking if the company is to survive.

Since regaining corporate control, Susie Tompkins has reorganized Esprit. In an effort to regain control of the junior market, the entire junior collection was replaced by the newer Esprit look of bright colors and lively prints interpreted in more sophisticated styling.

In the hopes of capturing new markets, new lines have been launched like the "Susie Tompkins" signature collection for the former Esprit customer over 25 years of age, as well as "Ecollection."

Promoted as an ecologically sound collection from the design concept to the manufacturing process, Ecollection is a sample of what is to come. From the organically grown colored cotton to the hand-carved and painted buttons, the line demonstrates Esprit's commitment to the environment and social good.

Besides revamping its lines, Esprit has also re-examined its image. In a continued effort to rekindle Esprit's luster and bring it back into focus, new faces like former Barney's marketing director, Neil Kraft, were hired. With a well-deserved reputation for innovation, Kraft is continuing Esprit's history of trend-setting advertising with his "What Would You Do?" campaign.

Other changes to bring Esprit into the 1990s include replacing its once-familiar high-energy teeny-bopper-like ads with soft-focused colored photography reminiscent of photographer, Ansel Adams. In keeping with this new spirit, the copy now reflects the thoughts of such writers as Ralph Waldo Emerson.

Completing this new look are the naturally-colored recycled paper bags and boxes, replacing the old brightly colored plastic bags Esprit was known for.

Although employee perks remain, the emphasis has shifted. Gone are the rafting trips in Africa, only to be replaced by new opportunities for employee growth. Reflecting Esprit's commitment to social causes, employees can now volunteer 10 hours of paid company time to the approved charity of their choice. Programs such as this distinguish the new Esprit from the old one. Yet, they are also a reminder that Esprit is truly a company created in the image and likeness of its founders. Esprit was once a force to be reckoned with in the 1980s; and that spirit continues in the 1990s.

Questions for Discussion. What three or four kinds of promotion activities attracted attention to Esprit apparel? How did these promotions reflect the company's image?

Sources. 1. "Wife Buys Out Husband at Esprit," *Fortune,* July 16, 1990, p. 109; 2. Steve Ginsberg, "Getting Serious," *Los Angeles Times,* March 6, 1992, p. E10; 3. Michael Marlow, "Susie's Esprit: New Look, New Outlook," *Women's Wear Daily,* Sept. 1990, p. 1; 4. Heidi Benson, "Rejuvenating Esprit," *San Francisco Focus,* February 1991, p. 41; 5. Laura Zinn with Michael Oneal, "Will Politically Correct Sell Sweaters," *Business Week,* March 16, 1992, p. 60; 6. Ellen Rapp, "The War of the Bosses," *Working Women,* June 1990, p. 57; 7. Edward Giltenan, "Post-Nuptial Agreement," *Forbes,* July 9, 1990.

Promotional Activities of Manufacturers

Manufacturers use *trade promotion* to influence members of the fashion industry to buy their products. Aimed within the industry, trade promotion is directed at fashion businesses. Trade promotion activities include advertising, publicity, fashion shows, and merchandise displays.

Advertising

Geared to the wants and needs of the trade customer, most trade advertising stresses two points: how well the product performs and projected profits if purchased.

Trade ads appear in such publications as *Women's Wear Daily, Stores,* and *Accessories* magazines.

Another way manufacturers promote their names and expand their advertising budgets is through cooperative advertising. A manufacturer or designer using **cooperative advertising** may co-sponsor advertising with a retailer in a local newspaper, for instance, each paying a portion of the costs. In exchange for co-funding the advertising, the manufacturer's name is featured prominently in an advertisement produced by the retailer. They enjoy a shared prestige, and the manufacturer has an opportunity to reach a market already favorably conditioned to the retailer. The promise of shared advertising costs not only saves both manufacturers and retailers money, but enables them to produce some promotions that might otherwise be financially impossible.

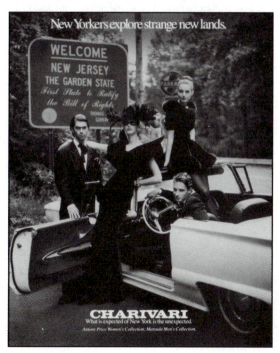

Figure 14-10. The shared expense and prestige make cooperative advertising very appealing to both manufacturers and retailers. This one promotes Anthony Price Women's Collection and Matsuda Men's Collection sold at Charivari, an upscale New York City clothing store. Ad created by Kirshenbaum & Bond, New York. (Courtesy Kirshenbaum & Bond)

Other methods used by designers and manufacturers to convey brand-name recognition include national promotion and national advertising. *National promotion* occurs when producers, manufacturers, or designers work to establish brand-name recognition for their products by promoting directly to the consumer.

Through national advertising manufacturers and designers attempt to create a demand by preselling to consumers through television and magazine advertisements. The aim is to encourage consumers to visit their favorite retailers and ask for the merchandise by name. If enough requests are made, the retailer will try to obtain the merchandise to please the customer.

Fashion Shows, Trunk Shows, and Informal Modelling

The **fashion show**, a dynamic mixture of fun, fashion, and flair, is still favored by designers as the best way to introduce buyers, trade media, and regional working media to their latest fashion collections.

The fashion show has come a long way from the stationary doll exhibits of the past to the live extravaganza it is today. However, between the wax and wooden fashion dolls of previous centuries and their contemporary living counterparts, the model is still the accepted courier of fashion news.[7]

Although designers such as Worth had used live models to show their creations to their clientele, it was not until the 1900s that the first organized show using live models came into being. A by-product of the emerging ready-to-wear market and regional Mid-west markets, live models by 1911 were accepted as a regular part of promotion in the United States for both manufacturer and retailer. By 1913, most retailers used the fashion show to introduce their season's styles.[8]

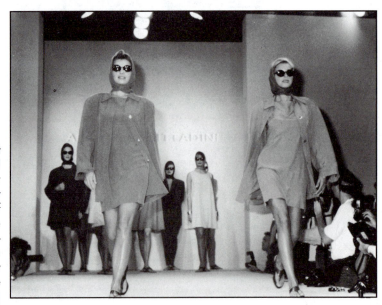

Figure 14-11. It is not unusual for designer shows to cost thousands of dollars, but the resultant publicity can be worth it. (Courtesy Adrienne Vittadini)

Today the fashion show is the accepted and expected way for designers to unveil their latest collections. From the haute couture showings in Paris to the Broadway-style textile shows, each is eagerly awaited as a source of fashion and promotional ideas.[9]

Fashion shows can be classified by use and sponsor. They run the gamut from the designer show, charity benefit, trunk show, and co-op show to taped or televised productions.[10]

Designer Fashion Shows. Publicity is generated by these exciting *designer fashion shows* as both trade and general media preview the latest seasonal collections introduced by designers in New York, Paris, and Milan. Commentated or uncommentated, designer shows can be as short as 15 minutes or as long as it takes to see the entire line. Media representatives attend to gather trend information and offer their opinion and interpretation of the latest offerings to their fashion conscious readers and viewers; buyers and fashion directors come to place orders for the upcoming season.

To keep the media informed of their latest collections or technological advancements, designers and manufacturers send out press kits. Recently, the cost of designer shows has skyrocketed, due in part to rising production costs and superstar models' fees. It is not uncommon for a designer to spend $1 million on a season's fashion showings.

Charity Shows. Held to raise money for not-for-profit organizations, *charity shows* or *benefit shows* are frequently co-sponsored, such as the annual St. Luke's fashion show in Chicago, which benefits a hospital. Since the goal is to make money, members of the organization may act as models along with professional models and celebrities. Usually a big publicity draw, charity shows can attract big designer names or stores to participate. The only drawbacks are making sure the event saves rather than spends money and the use of amateur talent may require more direction and time.

Trunk Shows. One of the least expensive, easiest, and potentially profitable shows to produce is the designer's or manufacturer's trunk fashion show. Called the **trunk show,** an entire line is assembled for travel to different stores, accompanied by a designer or company representative. The retailer only has to provide models, space, and promotion. Designers find a trunk show hard work but beneficial. They have a firsthand chance to observe consumer reactions and make necessary adjustments for future collections. Retailers and consumers also have a chance to see the entire line accessorized the way the designer envisioned it. Customers can also place orders for items not available for purchase at the store.

Televised Fashion Shows. *Taped* or *televised fashion shows* like "Style with Elsa Klensch" are here to stay and promise to grow in popularity as a marketing tool. (See Chapter 15 Career Portrait.) As time goes by, television will eventually change the nature of fashion promotion. Televised fashion shows broaden the horizons of the average fashion consumer who can now see highlights from the couture shows. Television's immediacy and freshness influence fashion by propelling the latest looks through the fashion cycle more quickly than in the past.

Figures 14-12a and b. In-store fashion shows and trunk shows promote a new line and gain from immediate customer reaction. (Courtesy Scarboro Fair and Famous Barr)

Informal Modelling. Informal modelling is not a fashion show. Instead of an organized procession of models, merchandise is informally shown by the models. For varying lengths of time, customers and buyers are shown merchandise on a one-to-one basis. Both manufacturers and designers rely on informal modelling to show their apparel in their showrooms to interested buyers. Not only can buyers see how the garment moves on a real person, but they have a better look at the construction of the garment as well. Informal modelling is sometimes used after a trunk show, too. Models mingle with the customers and discuss the features and price of the outfit. It can be a very effective selling technique.

Merchandise Displays

Creating merchandise displays, known as visual merchandising, is used by industry people in showrooms to promote the latest designer collections and to attract the appropriate buyers.

Since image is essential to the promotion of fashion, it takes on even greater significance when marketing designer lines. Retailers expect to pay more for the privilege of carrying designer merchandise, therefore they expect more from the product and its image. Showrooms must reflect the anticipated image and offer an appropriate atmosphere to showcase the merchandise.

To ensure correct representation of the merchandise and to promote sales, manufacturers and designers supply retailers with promotional materials and literature.

Positioned to attract consumers and encourage impulse buying, merchandise displays in retail stores are located near the merchandise lines being promoted, or by the cash register or in the aisle. Promotional literature to inform and educate the consumer as to the nature of the product and its correct use may be attached to the cardboard or plastic display. Samples of the product may also be available for testing.

Manufacturers of brands like Clinique provide stores, such as Lord and Taylor and Neiman Marcus, with brochures and information about their latest products. If

interested, consumers can take pamphlets from the counter displays and learn more about the product.

In some cases, promotional literature furnishes the customer with sufficient information to make a buying decision. Promotional literature is usually more effective when supplemented by an informed sales associate or when the customer is presold through exposure to national promotion.

Other promotional pieces sent by designers and manufacturers for display include blown-up photos of the promoted product or designer to be attached to full-sheet signs, which are simply oversized display signs that are positioned in high-traffic areas of a store. To attract the customer's attention, mounted product photos are set on the counter near the displayed merchandise, such as Monet or Trifari jewelry.

Informative Literature

Each season, manufacturers and designers prepare and disseminate fashion forecasts and product information to buyers and retailers about their latest fashion collections or innovations.

Brochures, pamphlets, and videotapes outline the latest fashion trends in colors, silhouettes, fabrics, and sizes based on each designer's interpretation of the season. By dispensing timely product information, designers and manufacturers keep buyers attuned to the latest fashion trends and how to present and sell their lines most effectively. Last season's blushing plum becomes this season's ripened berry. Using the latest fashion vocabulary, product attributes are discussed as to how they benefit the consumer.

Supplementing promotional literature are videotapes used to educate both consumers and employees. Product information tapes provide sales personnel with more detailed information to sell the product successfully, while other tapes introduce customers to the latest looks or demonstrate the correct technique for applying make-up. Manufacturers of brands such as Jones New York or Evan-Picone send representatives to stores to present information on new lines to salespeople at Saturday morning training meetings or all-day clinics.

Promotional Activities of Retailers

Retail promotion is promotion by a store to consumers. In large retailing organizations, the advertising, public relations, publicity, special events, and visual merchandising departments work together under the direction of the sales promotion manager to promote a uniform fashion image that is reflected in all of the company's promotional activities. Their combined efforts not only reinforce their projected image, but increase store traffic, foster good will, and sell merchandise.

Since retailers have direct contact with the consumer, successful ones know they must be attuned to the needs and wants of the customer. The type, frequency, and combination of promotion activities retailers select reflect this sensitivity.

However, with a broader selection of promotion activities and fewer promotional dollars, retailers are more selective, carefully scrutinizing the outcome of every promotional effort. If an ad or special event does not work as expected, it is eliminated.

Advertising and Publicity

Able to produce a tangible and measurable return, advertising corners a major share of promotional monies. An ad is said to "pull" when the sales from an ad equal or exceed the money spent to produce it.

As previously discussed, retailers use both product and institutional advertising to promote their merchandise and image. More money is spent on fashion product advertising than promoting just the company itself.

Since the retailer's customer is locally based, and retail advertising budgets are more modest, newspaper advertising has traditionally been favored over other media. However, television advertising, with its ability to reach vast numbers of people, is being allocated a greater percentage of the retailer's advertising budget than in the past.

Concerned with presenting a certain image, most large fashion retailing organizations maintain a public relations department. Acting as a liaison with the media, the retailer's publicist works to plant news stories that demonstrate the store's continued fashion leadership.

One way of enhancing or affirming a store or designer's fashion status is by submitting fashion merchandise to the fashion editors for editorial consideration. Fashion editors periodically request samples of merchandise from designers and retailers to illustrate their fashion news articles. If the merchandise is used, ordinarily the source of the submitted merchandise is identified. This mentioning of the store or designer name is called an **editorial credit**. The resulting publicity or pictorial spread accompanied by descriptive copy is called a **fashion editorial**.

During the year, the fashion media feature special fashion sections, which report the latest fashion news. One of the most famous of these is the *New York Times Magazine's* "Fashions of the Times," a fashion supplement appearing twice a year with separate editions for women and men. Participation in fashion sections such as these is highly prized by fashion-forward designers/manufacturers and retailers who appreciate the opportunity to promote their image and merchandise. The most sought after seasonal fashion sections are fall/winter and spring/summer as they introduce customers to the upcoming fashion season. Participation in these sections also reaffirms a designer or store's fashion stature as their inclusion represents an indirect endorsement by a reliable fashion authority, the fashion media.

Publicity is also generated through special events that run the gamut from special appearances to week-long theme promotions.

Sales Training

Most department stores hold periodic fashion seminars for employees to introduce the latest fall/winter and spring/summer fashions that have been purchased. Incoming

fashion merchandise is previewed and interpreted in light of the forthcoming trends. The store's buyer, a fashion coordinator, or a manufacturer's representative demonstrate how the merchandise should be coordinated and presented to the customer.

Additional seminars may be held to further educate sales personnel on the best way to approach customers and complete a sale. Increased competition, both home and abroad, has underscored the importance of customer service for the survival of any business.

There is a growing awareness that whether a company perceives its sales team as a vital key to its success or merely as salesclerks affects its levels of customer service and employee turnover. Poor attitudes have been known to contribute to poor customer service. Stores have also learned that employee turnover is quite costly, since each new person must be trained. With the future forecasting an emphasis on customer service, keeping well-educated and informed sales associates is a top priority for retailers. Discerning fashion companies are both consumer and employee oriented. Engraved trophies, watches, dinners for two as a reward for exceptional sales personnel and other employees may be appreciated, but wise managers know they are no substitute for better salaries, benefits, promotions, and tuition reimbursement plans.

Special Events

Special events are image-building, sales-enhancing promotional vehicles that add pizzazz, prestige, and theatrical ambiance to a promoted product.

They are used extensively by retailers, primarily department stores. Special events encompass a wide range of activities from celebrity guest appearances, entertainment, demonstrations, exhibits, sampling, parties, marathons, and theme promotions, to fashion shows.

Whatever special events mix is selected, it mirrors a retailer's long- and short-term goals, image, budget, and customer.

In a world where many retailers offer similar merchandise at similar prices, store distinctions can blur. Special events can help a store to establish a separate identity or perceived difference in the minds of its customers.

Celebrity Appearances. Celebrity appearances are personal appearances by prominent people in the news such as actors, sports figures, or experts from various fields. Through special arrangements with manufacturers, celebrities promote products. For example, basketball star Michael Jordan promotes Nike shoes. Movie star Elizabeth Taylor promotes her fragrances and makes exclusive appearances at designated stores, as she did when introducing her "White Diamonds" fragrance at stores such as Macy's and Marshall Field's. These appearances typically generate publicity and appear on the local television news and in the newspapers.

Celebrities may also agree to make personal appearances to help promote an organization they may represent or support. For example, designers Bill Blass, Ralph Lauren, and others support a number of charities.

Figure 14-13. Models are often committee members, but charity fashion shows are still great publicity draws and foster better community relations. (Courtesy Dayton Hudson Corporation)

Demonstrations. One of the easiest special events to arrange is a demonstration. In a *demonstration,* an expert is sent from the manufacturer to inform customers and show them how to use the latest product. For instance, an Estée Lauder or Elizabeth Arden representative conducts a make-over seminar demonstrating to customers how to use the latest products correctly.

Parties. Promotional galas are gatherings held to introduce, launch, promote, or serve as an appreciation of a service, benefit, or business. Depending on the overall goal, the cost of producing it usually does not exceed the anticipated gain, unless it is an exercise of good will.

Fashion Shows. Ever popular, fashion shows are frequently scheduled by department stores. They are held to increase store traffic, enhance and foster their fashion image, maintain customer loyalty, and build sales. As promotional budgets are usually tight for retailers, the type of fashion show produced is a reflection of the sponsor, promotional goals, projected image, targeted audience, and finances.

Fashion shows do run the gamut from specialty shows, such as bridal shows, which require extensive planning, to the traditional seasonal fashion show where customers are introduced to the latest fashions. Individual department or specialty stores also may hold charity shows to raise money for non-profit organizations. The aim is twofold: to make money for the charity and to foster good will.

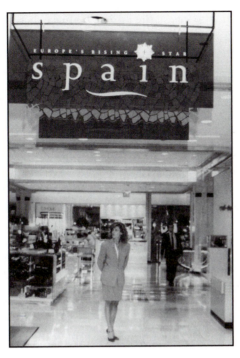

Figure 14-14. The jewel of special events: The theme promotion ties different, promoted merchandise together under one roof. Here is Bloomingdale's salute to Spain. (Courtesy Bloomingdale's)

Entertainment. Entertainment represents a wide range of theatrical talent: musicians, dancers, jugglers, magicians, singers, and clowns. Artistic talent, just like models, is often hired to enhance a promotion. Their performances add atmosphere and pizzazz. Many up-and-coming young performers are eager for the chance to break into the fashion industry.

Theme Promotions. The jewel of special events is the extended theme promotion. Organized under an umbrella theme, related special events are selected and implemented. For instance, a retailer may plan a week-long promotion to introduce and promote new apparel, cosmetics, jewelry, home furnishings, and food from the Southwest. Inspired by the merchandise, a theme is developed. To build interest, for each day of the week different activities and talent are scheduled from mini-fashion shows to exciting jewelry-making demonstrations. To pull these related activities together into a central theme, the week is given a name such as "Santa Fe Feeling."

Theme promotions are usually co-sponsored and can take much planning; but, they often result in increased traffic, sales, and prestige.

Visual Merchandising

In the world of **visual merchandising,** apparel is shown to its best advantage and in the most appropriate setting to influence sales activity.

Good displays pack pizzazz. They grab a customer's attention. If effectively designed, a customer within a limited amount of time should be able to interpret a dis-

play and decide whether or not to investigate further. To make that decision, a customer must be able to tell from the display what merchandise is being promoted and the store's image. People are often attracted to merchandise that affirms a desired image. If a display features merchandise shown in a way consistent with the customer's perceived image, the customer may shop at the store. A display is really a non-verbal way for a store to tell its customers who it is and for whom the merchandise is intended.

Displays are also used to introduce the latest fashions and show people how to coordinate and wear them correctly.

Fashion displays like fashion ads can be classified into product or promotional, and institutional displays.

Types of Displays

There are two major types of merchandise displays: product displays and institutional displays. *Product* or *promotional displays* are used to educate, inform, and sell.[11] They may be found in a store's exterior windows or inside the store. Interior displays are often positioned near the promoted merchandise as a landmark. Fully accessorized mannequins are strategically placed throughout the store to show customers how an outfit should be worn.

Institutional displays promote an idea that will benefit the company and its targeted market. They also intend to foster good will, such as windows designed to honor the return of war veterans. Another example would be the ever-popular animated Christmas windows that stores install each year for the enjoyment of holiday shoppers and to foster good cheer.[12]

Elements of a Display

When developing a display, everything from the store's image to the physical limitations of the display area is considered. Themes and merchandise already may have

Figure 14-15. Anticipated by children and adults of all ages, the traditional mechanical Christmas windows elicit joy and foster good will. (Courtesy Dayton Hudson Corporation)

Figure 14-16. Visual merchandising is a non-verbal way to convey a store's image and persuade a customer to buy the featured items. Displays are often positioned in high traffic areas to attract and direct consumers. (Courtesy The Limited, Inc.)

been planned by upper management, who have long- and short-term goals in mind. The actual work, however, is done by the visual merchandiser.

Working within a framework, the designer must consider the nature of the product and why it is being promoted. Ideas are sought for creative ways of reinterpreting the merchandise consistent with the store's image and market.

A display is like a theatrical production. It begins with an overall design or plan for the display. There must be one "star" or merchandise concept that is showcased by a supporting cast of judiciously used props, lights, mannequins, forms, and colors.[14]

Lighting is important in a display since it not only illuminates but highlights as well. Dramatic uses of light create theatrical ambiance and capture customers' attention.

Props, borrowed from the theatre term "properties," include anything that can be used to help the customer understand the concept of the promoted product. For instance, leopard-patterned sportswear is on sale. To illustrate the point, a jungle background with pretend palm trees and slinky leopards as props would enhance the mood.

Visual designers play an association game studying the color, shape, and texture of a product. Once they understand the nature of the product, images come to mind that can be used as props to help the consumer understand the product and underlying idea.

Using *color* is the fastest way to get a reaction from a customer. People buy items frequently just because of the color. An understanding of the psychological reaction to different colors is imperative when deciding on a color theme for a display. For instance, bright red means different things to different people. Some people see red

GRACE MIRABELLA

When media mogul, Rupert Murdoch, to offset $8.2 million in accrued debts, originally offered nine of his publications for sale, insiders wondered who would buy *Mirabella*.

The young magazine with its emphasis on style, rather than trend, has often been compared to the men's fashion magazine, *Esquire*.

A logical buyer for *Mirabella* would have appeared to be the Condé Nast group, except that Grace Mirabella ran the publication. Though she had over 37 years of fashion journalistic experience, an excellent reputation, and had enhanced the value of her signature publication, Grace Mirabella's former affiliation with *Vogue* guaranteed that Condé Nast would not be interested since owner S. I. Newhouse had previously fired her as *Vogue's* editor-in-chief.

In the end, *Mirabella* was not sold for a number of reasons. One was that the "start-up" publication was still losing rather than making money.

Others speculated that Murdoch was also trying to keep his promise to Grace Mirabella and kept it because he believed in the publication's money-making potential.

> *"The 'doyenne of fashion,' Mirabella has left her mark on the fashion industry . . . a legacy of good taste, quality, and panache."*

Since its inception in 1989, *Mirabella* has had an impact on the magazine industry. Competitors have been forced to once again re-evaluate their formats and editorial content, in much the same way as when *Elle* arrived on the scene in 1985. Then it was Grace Mirabella, editor-in-chief of *Vogue,* who was under the gun.

Mirabella, who had spent most of her adult life at *Vogue,* suddenly found her job in jeopardy. In her early 20s, the Skidmore College graduate joined the magazine as a proof editor. Intelligent, creative and hard working, she worked her way up from Sportswear Editor to Assistant to the Editor-in-Chief of *Vogue;* at the time it was Diana Vreeland.

It was a perfect partnership. Grace Mirabella's direct, down-to-earth personality balanced the larger-than-life flamboyant personality of Vreeland. Mirabella worked as Vreeland's assistant until 1971 when she replaced Vreeland as Editor-in-Chief. Under her direction, the magazine's circulation rose and the 97-year-old *Vogue* continued as the undisputed arbiter of fashion until 1985, when Murdoch and Hachette publications

introduced the Americanized version of the 44-year-old French magazine, *Elle*.

Although directed at a younger readership, *Elle* with its hot layouts and sharp copy captured a major share of the market.

By comparison, *Vogue* looked staid. Shaken by the unexpected success of *Elle* the trendsetting *Vogue* became instead the follower, trying to emulate the success of *Elle*.

As circulation and advertising dropped, rumors began to fly of an impending shake-up at *Vogue*. Concerned about the security of her position, Grace Mirabella conferred with the top officials at *Vogue*.

Despite assurances to the contrary, Mirabella was fired in 1988. She learned of her "sudden departure" when her husband called her at work to inform her that columnist Liz Smith had reported her dismissal from *Vogue* on television. A call to S. I. Newhouse, owner of *Vogue*, confirmed the story.

She was replaced by 38-year-old Anna Wintour, former *British Vogue* editor. Wintour, an alumna of the same "Fleet Street" school of journalism that produced Tina Brown of *Vanity Fair* fame, was brought in to rejuvenate the ailing publication and give it a younger and more "with it" look. However, her first cover issue, which featured Madonna, instead of the usual high fashion cover story, drew mixed reviews.

While reconsidering her life choices, Grace Mirabella was approached by Murdoch and offered the job of developing a new magazine. Named after herself, as suggested by Murdoch, *Mirabella* would fill that 30 and older niche of women who wanted an intelligent fashion magazine. Like Grace Mirabella, these women would not be slaves to fashion but appreciate quality, panache, and style.

Since its inception in 1989, the magazine's circulation has risen from 250,000 to around 500,000 in 1993.

Although the recipient of much well-deserved praise and industry accolades, as a start-up publication it is still costing rather then making money. In May of 1991, the British edition of *Mirabella* folded. Despite this unfortunate circumstance, Grace Mirabella still believes the American edition will prosper. Some insiders wonder if whether, after Grace Mirabella's contract expires in 1993, it will still be on the newsstands.

In either case, "the doyenne of fashion" Mirabella has left her mark on the fashion industry, leaving a legacy of good taste, quality, and panache.

Question for Discussion. Who are the target customers of *Mirabella* magazine and in what way is Grace Mirabella striving to meet their fashion needs?

Sources. 1. John Crudele, "Murdoch Mags Sale Is a Long Way From Being a Done Deal," *New York Post,* May 3, 1991; 2. "The Incredible Shrinking Mirabella," *Media Week,* April 8, 1991; 3. "British Mirabella to End," *The New York Times,* May 1, 1991; 4. "Murdoch Keeps Ties to Eight Magazines," *The New York Times,* Friday, May 17, 1991; 5. "Magazines Murdoch Is Selling and One He Is Not," *The New York Times,* Saturday, April 27, 1991; 6. "Working the Mirabella Magic," *Skidmore Voice,* Skidmore College Alumni Magazine, Spring/Summer 1991; 7. Maggie Mahar, "Mirabella (The Woman)," *Barron's,* December 18, 1989; 8. Mary Cronin, "A Fresh Take on Fashion," *Time,* April, 1991.

and visualize anger, warmth, or passion. Each reaction depends on personal interpretation of the color and its use.

Line and composition are design elements that influence the way a display is perceived. The *line* of a display means the visual direction. Lines can be vertical, curved, horizontal, and diagonal. Each illusion of line creates a different visual effect. Using a column to create a vertical line may convey a sense of elegance and strength. A diagonal line may create a feeling of action or raw energy.[14]

Composition is like a puzzle: the arrangement of lines, shapes, colors, and forms direct the eye and create a whole.[15] Composition involves the use of balance, contrast, proportion, rhythm, and repetition to form an exciting display.

Reflecting the underlying merchandise concept and store image, *mannequins* are the ultimate "sales associate." Often mirroring the age, sex, and image of the targeted customer, they demonstrate how the merchandise should be worn. Currently, there is a large selection of mannequins from which to choose based on quality and style.

Visual merchandising is important to any business since it creates the ambiance necessary to bring the customer into the store and show off the merchandise to its best advantage.

Promotional Materials

To keep customers aware of the services available, many stores, such as The May Company, Dillard's, and Bloomingdale's, periodically mail flyers, brochures, catalogs, coupons, and promotional letters to their customers.

These mailing pieces may herald the arrival of new merchandise, coming sales, promotional offers, special events, or whatever innovations have been implemented to make life easier for their customers. They are often very effective promotional tools.

Summary

1. Fashion is an image-based industry. Everyone in the fashion industry relies on fashion promotion to define and promote the fashion image and merchandise to their targeted markets. Promotion includes both nonpersonal and personal selling activities necessary to inform, persuade, or motivate customers to react favorably to a product or an idea.

2. Nonpersonal promotion is selling indirectly to the customer using advertising, public relations, and sales promotion activities, such as fashion shows or celebrity appearances. Personal promotion is direct selling, whether over the phone or face-to-face. Examples include the telemarketing field, and in-store selling.

3. Advertising is a message paid for by an identifiable sponsor and placed in the media. Advertising is a more reliable promotion than publicity. Since an ad is paid for, the sponsor is guaranteed that it will appear as indicated. All segments of the fashion industry rely on advertising to promote both their product and fashion images.

4. The media selected depend on a given company's desired image, budget, goals, and targeted audience. Television, although expensive, is a popular and effective advertising outlet, since the product can be shown in color and demonstrated. Newspaper advertising is favored by retailers to reach their locally based target market. Magazines, the traditional fashion advertising

outlet, offer advertisers excellent color reproduction, an enhanced fashion image by appearing in a prestigious fashion publication, and a longer circulation period.

5. Trade promotion is directed toward people in the fashion business. National promotion is used by designers and manufacturers to promote brand-name recognition directly to the consumer. Retail promotion is promotion directed by the retailer to the consumer.

6. Public relations programs are on-going efforts to position the image of a client. Depending on the perceptions of the targeted audience, the public relations program is adjusted to maintain or upgrade the client's image as the need arises. A by-product of public relations, publicity is free media coverage and desired by all. Its major drawback is that the company has no control over its use. But as an unsolicited endorsement, publicity has more credibility than an ad, which is viewed as biased.

7. Special events and visual merchandising are used primarily by retailers aiming to establish and convey certain images to attract targeted customers. Displays are multi-purposed. They enhance a store's image and show merchandise in a manner consistent with that image.

Fashion Vocabulary

Explain each of the following terms; then use them in a sentence.

advertising	media	sales promotion
cooperative advertising	national advertising	sampling
displays	news (or press) release	special events
editorial credit	personal selling	sponsor
fashion editorial	press kit	trunk show
fashion show(s)	product advertisements	visual merchandising
institutional advertisements	publicity	
logos	public relations	

Fashion Review

1. Cite three or four fashion promotion activities and explain how they help create and promote a manufacturer's and retailer's fashion identity and merchandise.
2. Why is advertising one of the most popular forms of promotion?
3. Why is publicity so greatly desired and how does it relate to public relations?
4. Both manufacturers and retailers rely on visual merchandising. But why is it considered an essential promotional activity for a retailer?
5. What roles do the fashion show and informal modelling play in fashion promotion?

Fashion Activities

1. Using three of four local stores in your area, discuss in class the fashion image they seem to project. Remember to consider their advertising, publicity, visual merchandising, types of special events (if any), type and price of apparel, and personnel.
2. Bring to class three or four samples of fashion advertisements, including both product and institutional advertisements. Explain the difference.
3. Choose an apparel manufacturer or retailer and report on its promotion activities, including newspaper and television advertising, and special events. Explain the organization's promotional goals as you perceive them.

Endnotes

1. Arthur A. Wintours and Stanley Goodman, *Fashion Advertising and Promotion*, p. 79.
2. *Ibid.*, p. 107.
3. *Ibid.*
4. Peter Carlin, "The Jackpot in Television's Future," *The New York Times Magazine*, Section 6, February 28, 1993, pp. 36-41.
5. John Strahinich, "That Flack Magic," *Boston Magazine*, July 1988, p. 119.
6. *Ibid.*
7. Mary Ellen Diehl, *How To Produce A Fashion Show*, p. 2.
8. *Ibid.*, p. 7.
9. *Ibid.*, p. 11.
10. *Ibid.*, p. 23.
11. Martin M. Peeler, *Visual Merchandising and Design*, p. 2.
12. *Ibid.*, p. 105.
13. *Ibid.*, p. 7.
14. *Ibid.*, p. 45.
15. *Ibid.*, p. 46.

Auxiliary Fashion Services

Objectives

After completing this chapter, you should be able to:

1. Describe the two main types of fashion research and list various kinds of firms that offer fashion research services.

2. Define the role of a buying office and describe how this role has evolved over the years.

3. Describe the different types of publications that report on fashion and explain how they differ.

4. Explain the role of a trade association and cite some of the common services that these associations provide.

I*t was about eight o'clock in the evening when Martha Daniels settled into her seat on the plane and kicked her shoes off, resting her feet in anticipation of three days of walking around the National Retail Federation's annual convention in New York City. As merchandise manager in charge of women's ready-to-wear for a small midwest department store, Martha had made the same trip many times before; yet she still got excited about the thought of attending seminars where she could learn from and share ideas with some of the most illustrious names connected with the retail and fashion industries.*

As the plane began taxiing toward the runway, Martha decided to catch up on some reading before what would be a whirlwind 72 hours at the convention. She pulled a stack of materials out of her briefcase. On top was that morning's edition of Women's Wear Daily, *which she quickly scanned for any industry news and features*

pertinent to her store. Next she began studying the quarterly color forecast that had arrived that morning in the mail from one of the leading fashion information services to which her store subscribed. After making a few notes in the margins, she tucked the forecast into the smaller portfolio that she would carry to the show, so she could discuss it the next day at her lunch appointment with an old friend who now worked for one of the New York-based fashion magazines.

As the flight attendant served her juice and a light snack, Martha turned her attention to results of a research study conducted by a resident buying office of which her store was a member. The research analyzed and compared the profit results of various merchandise categories based on sales at member stores and offered some updated guidelines for merchandise planning, which Martha decided she would like to discuss with her vice president upon returning to the store. Then, with an hour still left in the flight, she put away her briefcase and slipped the airline's in-flight magazine out of the pocket of the seat in front of her, thinking she would relax with some articles about exotic locales and maybe a crossword puzzle. The first page to catch her eye as she flipped through the issue, however, was a profile of an up-and-coming designer she had been hearing a lot about, with photos of models wearing some of his most recent creations. Eagerly, she began reading the article, as the plane continued its journey toward New York.

As you already know, the fashion business extends far beyond the field's most visible players; that is, the designers, manufacturers, and retailers of apparel and accessories. In addition to those involved in promotion, which you learned about in Chapter 14, there are numerous companies and organizations that provide other auxiliary, or related, services to the industry. Many of those services revolve around the dissemination of fashion information to different audiences.

For instance, both apparel manufacturers and retailers like Martha Daniels need to know what colors, fabrics, and styles are predicted to be popular in coming seasons. Retailers also need to be constantly aware of new sources for merchandise, as well as new systems and technologies that will make their store operations more efficient and effective. And the consuming public needs and wants to know about the latest fashion trends that will affect their wardrobe planning and purchasing, and where they can buy them. In this chapter, you will learn about some of the auxiliary fashion information services that fulfill all these needs, and more.

Fashion Research

Although they may not be considered professionals in the research field, all fashion retailers, to some degree, are constantly involved in fashion research. Whether it is the owner of a small mom-and-pop specialty store spending time on the sales floor talking to customers about their likes and dislikes or a giant chain like Sears conducting formal focus group sessions with mothers about a new children's wear strategy, obtaining knowledge about their target market and the marketplace is an ongoing task for merchandisers of fashion.

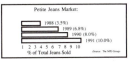
Figure 15-1. Jeanswear Communications, operating under the auspices of the Men's Fashion Association, reports on fashion, fabric marketing, merchandising and general business trends, statistical data and historical material on jeans. (Courtesy Men's Fashion Association)

Because there are so many diverse influences on the direction of both fashion and fashion consumption, however, retailers must supplement their own research efforts with information gleaned from a variety of sources. Some of this information focuses on broad, general trends in such areas as the population and the economy, while some zeroes in on specific trends and forecasts in areas such as fashion colors, fabrics, and silhouettes.

Market Research

As you recall from Chapter 2, fashion businesses use demographic and psychographic information, along with other analyses of the consuming public, to help in their market segmentation. Providing this type of data are numerous firms that conduct ongoing market research studies, many relating specifically to fashion retailing or retailing in general. In some cases, these firms specialize in market research; in other cases, market research is just one element of a broader range of services offered. For example, firms including The NPD Group, Market Research Corp. of America (MRCA) Information Services, and Find/SVP specialize in providing clients with general and customized market research in a wide range of categories. At the same time, diverse organizations including management consulting firms, fashion consultants, fashion information services, major accounting firms, brokerage houses, trade associations, and buying offices also conduct and produce studies on market trends

from a retail or consumer perspective. Among the largest and best-known companies that offer specialized market research (and other services) to the retail and apparel industries are two management consulting firms, Kurt Salmon Associates (KSA) and Management Horizons, a division of Price Waterhouse.

While basic demographic information comes in large part from the U. S. government's Bureau of the Census, many research organizations use this data as a starting point for further, more detailed analysis of the population. Specific age or lifestyle groups that are seen to be growing in numbers or purchasing power can then be targeted for in-depth studies with a particular marketing implication in mind. For instance, the management consulting group of Marketing Corporation of America, a marketing services firm, recently conducted a study entitled "Lifestyle Pulse," designed to track the shopping behavior, needs and perceptions of upscale, professional women. Similarly, among the recent research undertaken by Coopers & Lybrand, a major accounting firm, was a series of focus group sessions to examine the buying behavior of children ages 5 to 12, who have been estimated by other market research to spend almost $4.5 billion annually![1]

The results of different market research studies are made available to fashion businesses in a variety of ways. In some cases, manufacturing or retail organizations may commission a research firm to conduct a particular survey just for them, and the results then belong to the manufacturer or retailer to do with them as it pleases. In other cases, a firm conducting research will make results available for a fee, or will offer the information only to member or subscribing businesses. Occasionally, results of a key research study will be announced and generally disseminated to businesses and the media, with newspapers, trade magazines, or other publications printing highlights for the edification of their readership. For example, results of a major consumer behavior study on "Changing Shopping Patterns," sponsored by Mastercard International for the National Retail Federation, were announced in a session of NRF's annual convention in January, 1993. Subsequently, a report on the study was published as a special supplement to *Stores* magazine.

Trend Forecasting

While market research is necessarily based upon information gleaned from current demographic and psychographic data, its ultimate goal is to provide insight into how present conditions might evolve in the future. Frequently, researchers will supplement the results of a study with an analysis and opinion of what those results imply for the coming years; in other cases, research is conducted with the sole purpose of predicting future trends. This specialized area of research, involving analyzing relevant trend information that is available today and predicting the direction a particular trend will take tomorrow—or at some future time—is known as **forecasting.**

If you read the newspaper or watch the evening news on television, you are bound to hear government officials or advisors offering frequent economic forecasts for the country, which can affect all kinds of businesses. Equally important for fash-

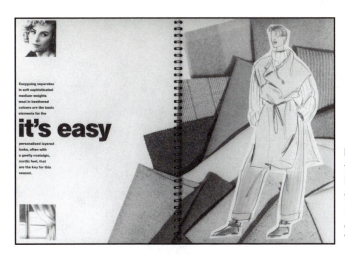

Figure 15-2. Organizations like The Wool Bureau, Inc. offer seasonal trend forecasts emphasizing fabric, weight, texture, and style. (Courtesy The Wool Bureau, Inc.)

ion businesses are specialized forecasts of fashion trends, which are available from a variety of sources.

For fashion marketers, forecasts are an invaluable aid in planning and developing product lines and assortments for upcoming seasons. These forecasts include what are expected to be the major trends in color, fiber and fabrics, silhouettes, as well as general fashion directions for a particular season, and are produced anywhere from 15 months to two years in advance of that season. Based on research in both foreign and domestic markets, the information may be presented in a number of ways, including color or fabric swatch cards, special publications or illustrated reports, audio/visual presentations, sample garments, or runway presentations.

Certain organizations offer fashion forecasting services free of charge. These include the major textile and fiber producers, such as Du Pont, Fiber Industries, and Milliken & Co.; trade associations such as Cotton Incorporated, The Fashion Association of America, Polyester Council, and The Wool Bureau; and fashion magazines such as *Glamour, Harper's Bazaar, Seventeen,* and *Vogue.* Other organizations charge a fee for their forecasts, including a number of firms that specialize in color trends, such as Color Association of the United States (CAUS), Color Box, Color Center International, Color Projections, and Huepoint.

Yet other companies offer fashion-trend forecasts as part of their broader scope of services. These companies include *fashion consultants* and **fashion information services,** which provide both general and personalized information and expertise on a fee basis to clients that include textile firms, apparel manufacturers, and retailers. The oldest of these consulting/information companies is New York-based Tobé Associates, founded in 1927. Through its weekly publication, *The Tobé Report,* the firm evaluates and analyzes all facets of the women's and children's apparel and accessories markets, and reports on changing fashion trends and merchandising strategies. Its client retailers can also benefit from personal consultations with the company's

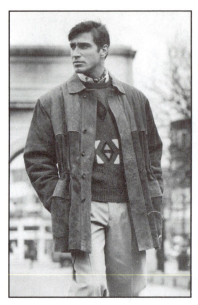
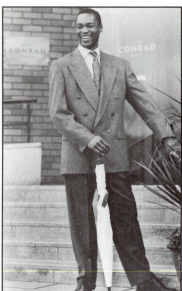

Figures 15-3a and b. Through trade associations like the Men's Fashion Association, the fashion industry is kept up-to-date on what the men's wear manufacturers are offering each season. (Courtesy Men's Fashion Association)

experts regarding all aspects of their business, from identifying customers, to merchandising and private label strategies, to targeting potential growth categories.

A number of other firms also offer trend forecasting along with additional fashion information services. The Fashion Service, for instance, offers a quarterly "Womenswear Forecast" package, as well as "Colour Snips" forecasts, and a "Womenswear Infoflash," featuring news and in-depth studies of fashion collections. Another company, Here & There, provides subscribers with 19 yearly publications covering international fashion activity and forecasts, and also offers consultations, cinema presentations, a yarn library, and film library of all designer collections. Other forecasting and fashion information services firms include Nigel French Enterprises, Promostyl, and Fashion Works.

Figure 15-4. Color-forecasting services report on each season's hot new color trends. (Courtesy Huepoint)

SPOTLIGHT ON A FIRM

THE DONEGER GROUP

Back in 1946, when Henry Doneger launched a New York-based retail buying office under the name Henry Doneger Associates, the state of the country and its retail industry was dramatically different from today. The United States was just emerging from a devastating world war and about to enter a long period of peace and prosperity; a television set in every living room was a virtually undreamed-of possibility; and suburban shopping malls were not yet a gleam in a forward-thinking developer's eye.

Little could anyone have known a half-century ago that retailing in the 1990s would lack some of the business's most venerable names, like B. Altman and Gimbel's, and that concepts such as super specialists, warehouse clubs, off-price stores, and factory outlets would be major forces on the retail scene. No one could have known

either that stalwart buying offices like Felix Lilienthal would also fall by the wayside—and that a start-up firm like Henry Doneger Associates would grow to be one of the most significant players in the field, known today as The Doneger

Group, and boasting a roster of clients that range from Wal-Mart to Nordstrom.

A main factor in The Doneger Group's longevity and success has been its willingness and ability to keep pace with the changes in its retail client base and in the way Americans shop. The most dramatic changes have taken place in the last 10 to 15 years, and Doneger met the challenges by expanding, enhancing, and evolving its services, in many cases through the acquisition and incorporation of other

well-known and specialized buying offices under the Doneger Group umbrella.

For instance, in 1984, seeing the opportunity to develop a women's large-size business, the company formed a special division

called Doneger Buying Connection; it then increased the scope of the business by acquiring Steinberg-Kass in 1986. In 1987, in order to develop Doneger's business in the better price range, it acquired the Jerry Bernstein buying office. Also in 1987, the firm addressed the growing issue of off-price buying by adding Estelle Shomer Associates, and forming its Price Point Buying Division in 1988. Other significant additions to the company's roster of holdings were Independent Retailers Syndicate, Atlas Buying

continued

Corporation, Thompson/Auer Newsletter, and VBW Associates.

The end result is a powerful and respected company comprised of highly specialized and individually staffed divisions that meet a variety of retail needs. What's more, all divisions are supported by a wide range of services accessible to the buying group's clients. The company's Fashion Department, for instance, keeps clients abreast of upcoming trends in color, silhouette, and fabric, with research specialists who analyze and report on various fashion directions. The Planning and Research Department investigates and reports changes in lifestyles and consumer trends beyond the fashion and retail arenas, offering suggestions on how retailers can profit from those changing trends.

Helping clients to build store image, increase sales and profits, and provide unique merchandising opportunities is the goal of The Doneger Group's Product Development/Private Label/Incentive Buying program. Having extensive knowledge of all markets, combined with the buying strength of its entire organization, the company provides retailers with substantial cost savings on all private label merchandise.

In addition, its Reporting Service offers accessibility to the marketplace on a daily basis, via a professional staff of buyers and merchandisers who provide clients with timely, in-depth information relating to market developments, merchandising directions, and how to anticipate retail trends. Professionally produced catalogs, focusing on specific merchandise categories, price points, or target customer groups, are also available to clients, and can be personalized with the retailer's own name. Going beyond merchandising, The Doneger Group even offers its clients information on resources for store supplies, such as mannequins and display fixtures, as well as assistance with travel and hotel reservations.

All of these services come into play within each of The Doneger Group's specialized divisions. The cornerstone division, Henry Doneger Associates, is the foundation of the company, and provides retailers with extensive market coverage, information, services, and programs in all segments of women's apparel and accessories. Doneger Buying Connection, as previously noted, specializes in the women's large-size business, including sportswear, dresses, outerwear, and intimate apparel in all price ranges.

Doneger Kids services retailers in all areas of children's wear, including infants, toddlers, sportswear, dresses, outerwear, accessories/novelties, and boy's wear. Similarly, Doneger Menswear operates as a full-service men's wear buying office, covering all price ranges of men's and young men's clothing, sportswear, outerwear, and furnishings. The Catherine Hall International Ltd. division is devoted to the development of imported merchandise for clients; and Price Point Buying, the off-price buying division, directs clients toward timely purchases that are attractively discounted. In addition, the company maintains a Doneger Home Connection division, specializing in a broad range of home furnishings.

The newest division of The Doneger Group is D³ (for Doneger Design Direction), a color and trend forecasting service that offers women's wear fashion and color forecasts, slide presentations, personalized consultations, and information files. Called by the company "the fashion forecast system for the Nineties," the program is designed to go beyond the traditional simple forecasts offered by other services. Among the enhancements of the program is a follow-up by Doneger to see how member clients actually utilize the forecast information. In addition, the program feeds back information to retailers about which resources are producing the season's trend merchandise as forecasted by D³, so stores can get the message and move the merchandise to their customers. An annual membership in the service includes three color forecasts, three fashion forecasts, 12 file bulletins, six slide shows, personalized consultations, two collections workbooks, inclusion in

source sheets, and use of the company's slide and sample library.

When taken in conjunction with the various divisions' seasonal planning guides, seasonal sketch books, Market Review and Market Focus memos, and other frequent and timely publications, it adds up to an invaluable package of information for retailers—most of whom could not begin to accumulate such a wealth of data on their own. And it is a major part of how The Doneger Group has maintained its position as "the most professionally staffed, service oriented, comprehensive and diverse buying office group in the industry."

Question for Discussion. What are some of the ways in which The Doneger Group has kept pace with the changing needs of its retail clients?

Sources. Company brochures, sample reports, and sample catalogs from The Doneger Group, 463 Seventh Avenue, New York, NY 10018.

Buying Offices

In the days before traveling across the country was as fast and easy as it is today, retailers in stores far from the fashion center of New York had difficulty learning about the latest styles and fashion news. Buying trips were, necessarily, few and far between; yet merchants wanted to be able to offer their customers new looks on a timely basis. The result was the birth of a new kind of fashion service that would be based in the fashion center of New York and would act as a representative for distant stores, shopping the various lines and placing orders for its client retailers. The organizations offering this service were called resident buying offices, or simply **buying offices.**

Today, with the current speed and ease of both travel and communication, the role of the buying office has evolved and expanded. In the 1990s, buying offices in New York and other major market centers worldwide still help locate and alert stores to new merchandise, but rarely place actual orders for their client or member stores. Yet they do fulfill a variety of other important functions, including acting as information sources on new lines and new trends, conducting market research, forecasting trends, scouting and negotiating new sources of merchandise, developing private label programs, offering sales promotion assistance, and much more, depending on the current and future needs of their retail base. By pooling the purchasing power of all the client stores together, buying offices are also able to negotiate special purchases at prices that the individual stores would never be able to obtain on their own.

In most cases, the merchandising divisions of buying offices follow an organization similar to that of their client stores. **General merchandise managers (GMMs)** are responsible for one or more broad merchandise areas, such as ready-to-wear or men's wear, and oversee **divisional merchandise managers (DMMs)** who are responsible for a specific category or categories, such as juniors or men's sportswear. In turn, the DMMs each supervise a group of **market representatives,** or specialists in particular classifications of merchandise, mirroring those of the buyers at the client stores,

such as junior jeans or men's sweaters. These market representatives cover the market daily and report back to buyers about trends, prices, resources, and other pertinent information. Although they do not actually place orders, market representatives are called "buyers" by many buying offices. They are also referred to as *market specialists* or *merchandise analysts* by some firms.

Just as the last decade has seen dramatic changes in the retail ranks, including mergers, acquisitions, and bankruptcies of some of the once-leading retail names, recent years have also seen consolidations, restructuring, and some disappearances within the roster of buying offices. Firms that were once among the leaders, such as Felix Lilienthal, no longer exist. Others have merged their operations with former competitors, such as Van Buren/Carr Associates and Burns-Winkler/Innovator, which several years ago joined to become VBW Associates, and then in 1991 were acquired by The Doneger Group. There remain, however, three main types of buying offices today: independent offices, store-owned or cooperative buying offices, and corporate buying offices.

Independent Buying Offices

By far, the largest number of buying offices are **independent buying offices;** that is, those that are independently owned and charge a fee to client stores for their services, usually a specified percentage of each store's annual sales volume. For that reason, they are sometimes also known as **fee offices** or salaried offices. In exchange for this fee, the buying office provides such services as in-depth market coverage, identification of key classifications of merchandise, price negotiations with vendors, planning assistance for merchandise assortments and inventory levels, promotional packages, and more. In most cases, the clients of independent offices are themselves independently owned specialty or department stores, usually located in smaller markets.

As specialization in retailing has increased in recent years, independent buying offices have kept pace by offering specialized market coverage in a variety of categories and price levels. Some of the larger independent offices, such as The Doneger Group (see Spotlight on a Firm) and Certified Fashion Guild, for example—both of which cover the men's, women's, and children's apparel and accessories markets—have added divisions specifically to handle off-price apparel. Some offices also focus on other segments of the market with separate divisions or programs, such as the Youth Fashion Guild and CFG Menswear divisions of Certified Fashion Guild. Still other, smaller independent buying offices devote their entire business to a specific, narrow category of merchandise. For instance, the Betty Cantor office focuses strictly on accessories; the Pam Roth office concentrates on bridal and eveningwear; while Virginia Specialty Stores covers only large-size women's clothing.[2]

Store-Owned or Cooperative Buying Offices

A buying office that is jointly owned by its group of member stores, which act as both shareholders and principal clients, is called a store-owned or **cooperative buy-**

Figure 15-5. Buying offices offer members important information on new lines, trends, sources, as well as sales promotion assistance and financial planning. (Courtesy Ellen Diamond)

ing office. There are two significant offices of this type today, both of which are headquartered in New York: Associated Merchandising Corporation, known as AMC, and Frederick Atkins Inc. Each boasts a roster of member stores from across the country; but since sales figures are frequently shared among members for comparison, a stipulation of membership is that no two directly competing stores with overlapping trading areas may be part of the cooperative.

Like all buying offices, the services offered by AMC and Frederick Atkins have evolved to such a great degree that neither company refers to itself anymore as a buying office, despite the general industry tendency to maintain that designation. Instead, Atkins calls itself "a store-owned merchandising and product development organization;"[3] while AMC identifies itself as "the world's oldest and largest retail merchandising, marketing and consulting organization."[4] For both companies, development of merchandise programs exclusive to their member stores has become a cornerstone of their business. In addition, both offer extensive market research and merchandising information services, management information and merchandise counseling, as well as support in such areas as sales promotion and direct mail.

Because of the unprecedented challenges facing the retail industry in the early 1990s, both AMC and Frederick Atkins have faced challenges of their own, and have sought ways to enhance services to their members while improving their efficiency and profitability. Atkins, for instance, whose 28 department and specialty store members include Dillard's, Gottschalk's, Hess's, Liberty House, and Younker's, announced it was seeking to increase its private label program from $400 million in wholesale prices in 1992 to $1 billion by 1997. The program includes about two dozen labels in women's ready-to-wear and sportswear alone, including the Silvercord, Allison Smith, and Danielle Martin names. Plus, Atkins was enjoying strong acceptance of its Clean Clothes private label line of all-cotton basics packaged with biodegradable materials, introduced in 1991. The organization also planned to take advantage of the North

America Free Trade Agreement by opening an export office in Mexico. Among the products Atkins envisions importing from Mexico are handbags, shoes, men's suits, and women's sportswear and dresses.[5]

At the same time, AMC announced in mid-1992 that it was reorganizing into two divisions and reshaping its product development program in response to the country's difficult economic condition at the time. One division now handles product development, while the other handles the organization's worldwide sourcing and delivery services. As part of the reorganization, the firm discontinued some of its less profitable private label categories, including dresses, body fashions, and shoes, in order to concentrate on its stronger areas, which include misses' and juniors' moderate knitwear and active casual wear. Plus, within the product development division, AMC restructured itself into five teams or "clusters," each of which is assigned to a specific store or group of stores from its 46 retail members. One cluster, for instance, works for The Dayton Hudson Corporation alone; another works only for Parisian and Woodward & Lothrop. In this way, AMC hopes to be able to focus more clearly on the product needs of each individual store, as well as achieve cost savings for the entire cooperative.[6]

Corporate Buying Offices

The third major type of buying office is the **corporate buying office,** which is maintained solely for the benefit of stores belonging to a parent corporation, such as The May Company, Federated Department Stores, Belk Stores, Carter Hawley Hale, and Mercantile Stores. Corporate buying offices serve much the same function as other buying offices, providing their stores with private label, import, or other merchandise programs, as well as information exchange, merchandising assistance, and sales promotion and marketing packages.

In recent years, as a number of retail corporations have responded to economic pressures by merging the operations of some of their store divisions, there has also been a trend toward centralizing additional functions through the corporate offices. Federated Department Stores, for example, which successfully emerged from Chapter 11 bankruptcy proceedings in early 1992, eliminated separate data centers for each of its divisions and merged them into one main center. Then, by installing a new data processing system, the company was able to begin tracking sales and inventory, thus allowing the divisions to share data and benefit from each other's successes and failures. In addition, Federated established a new team buying strategy among all its divisions, with merchandise executives and buyers from various stores making up teams to handle categories such as ready-to-wear and men's wear. Each team puts together an overall strategy, including defining the assortments and suggesting presentation, but each store has the freedom to adjust the mix by up to 30 percent to meet the needs of its individual customer base in its own markets.[7]

Fashion Publications

As you learned in Chapter 14, advertising and public relations play a key role in helping fashion marketers and merchandisers inform and entice their customers with new lines. Both these methods of promotion rely tremendously on the wide range of publications

that report news and events on the fashion scene. The readers of these publications are sometimes designers' and manufacturers' retail customers; sometimes they are general consumers seeking up-to-date fashion information. In any case, fashion publications serve an invaluable function, particularly in today's fast-paced, global fashion environment.

Trade Magazines

When designers or manufacturers need to alert retailers to the introduction of a new line, an upcoming promotion, or any other pertinent happening, they often turn to **trade magazines,** or the **trade press,** to publish their news. Trade magazines are specialized business publications that serve a particular field or segment within a field. With rare exceptions, they are not available on the newsstand; and because they focus on a targeted area of business, their circulation, or readership, is usually far lower than that of general interest magazines. However, no matter how small the circulation list, every one of the readers is intensely interested in and involved with the subject of each of these publications, which means marketers are reaching a ready-made target audience with their news.

There are literally hundreds of trade magazines in publication today, covering virtually everything from apparel production, to fashion and other product merchandising, to general retailing. Some publications target a "vertical" audience; that is, they cover one particular merchandise category, providing news of interest to readers involved at various levels of that category. For instance, *Bobbin* is written primarily for apparel manufacturers, with news of new fabrics, machinery, distribution systems, and other information of interest to that group. *Body Fashions/Intimate Apparel* contains news and information for retailers and others involved in the marketing and merchandising of intimate apparel; while *Earnshaw's Review* covers the children's wear market. On the other hand, "horizontal" trade publications cut across a range of merchandise categories with business information of interest to a broader readership. Retailing trade magazines, such as *Chain Store Age, Discount Store News,* and *Stores,* which target retail executives with news of trends in retail technologies, systems, promotions, and other management and merchandising areas, are examples of horizontal publications.

Undoubtedly the best-known publisher of trade publications in the fashion field is Fairchild Publications, which publishes the "bible" of women's apparel, *Women's Wear Daily* (known as *WWD*), and its counterpart for the men's wear and textiles markets, *Daily News Record* (known as *DNR*), among other publications. Reporters and editors for these two newspapers are out in the market virtually every day, covering important industry events and searching out trends and stories of interest to the broad base of designers, manufacturers, retailers, and others who read the papers religiously.

A relatively recent offshoot of the trade press is the field of fashion videos, designed to convey news and information about the fashion world via an audio/visual presentation. New York-based Videofashion, Inc., for instance, produces several editions of "Videofashion News" each season; and the National Association of Men's Sportswear Buyers (NAMSB) creates a "Men's Fashions" video on a seasonal basis twice a year. These videos are available on a fee or subscription basis to retailers and others in the field.

Consumer Fashion Magazines

While disseminating news and information within the industry is the purpose of trade magazines, getting pertinent fashion information into the hands of consumers is the goal of fashion magazines. Hardly a new concept, the first American fashion magazine, *Godey's Lady's Book*, actually debuted back in 1830, and was published until 1898. Today, there are four leading magazines that are devoted almost exclusively to women's fashion: Conde Nast Publications' *Vogue* and Hearst Publications' *Harper's Bazaar*, both of which are more than a century old, plus *Elle* and *Mirabella* (see Career Portrait, Chapter 14), both of which were launched in the 1980s. *Gentlemen's Quarterly* (known as *GQ*) and *Esquire* are the most prominent magazines covering men's fashions.

As noted in the previous chapter, fashion magazines not only receive announcements of new lines and collections from designers and manufacturers, but seek out—and even forecast—fashion news and trends themselves. Top editors from the leading publications are usually conspicuously seated in the front row at runway shows, and regularly attend key social events, where they can obtain a firsthand view of what the fashion-forward, trend-setting social set is wearing. What's more, the magazines' role as purveyors of fashion information is carried beyond their printed pages, through special marketing programs that benefit both readers and fashion marketers. *Harper's Bazaar*, for instance, which gained a new editor and underwent an elegant facelift in the fall of 1992, offers its advertisers special beauty products sampling programs, image marketing seminars, target marketing programs, and an advisory board compiled from a cross-section of 2000 readers.[8]

Figures 15-6a and b. Fashion magazines, like *Harper's Bazaar*, are the purveyors of fashion information, reporting on everything from designer runway shows to new beauty products. (Courtesy Cox Landey and Partners for *Harper's Bazaar*, a Hearst Magazines publication)

In addition to the key women's fashion magazines, there are numerous other publications that report fashion news and trends, often within a broader editorial context. Almost all the "women's interest" publications, such as *Mademoiselle, Glamour, Self, Redbook,* and *Good Housekeeping,* cover fashion news on a regular basis, along with a variety of other topics ranging from health, to parenting, to careers and entertainment. Bridal magazines write about fashion, as well, not only in terms of wedding apparel, but also relating to honeymoon or trousseau wardrobes. Plus, since fashion reflects and is reflected by all aspects of life, even dedicated fashion magazines incorporate articles on subjects such as travel, health, and popular culture, while maintaining their primary focus on the fashion world.

Other Fashion Reporting

Because of the pervasiveness of fashion, it is not unusual for news of trends to be reported by a wide variety of media that might not normally be considered fashion information outlets. Magazines that are considered general interest or people-oriented, such as *People* or *New York Magazine,* and even news magazines including *Newsweek* and *Time,* may write from time to time about a growing fad on the fashion front or a newly prominent designer. Virtually all daily newspapers across the country also feature fashion news on either a regular or periodic basis. Sometimes, particularly in the larger cities, newspapers maintain their own fashion editor or department; others may pick up fashion-related stories from the larger papers' syndicates or national news services. Some, such as *The New York Times,* even publish periodic fashion supplements in the form of a glossy, full-color magazine.

In recent years, fashion reporting has gained yet another media outlet with the launch of television shows on fashion, most notably Cable News Network's "Style with Elsa Klensch," which debuted in 1981. Klensch, who generally covers the high fashion scene—interviewing fashion establishment notables such as Bill Blass and Ralph Lauren—is considered the pioneer and doyenne of television fashion reporting, with a weekly audience of nearly two-and-a-half million viewers in the United States and millions more around the world. (See Career Portrait.)

In the late 1980s, Klensch began facing competition for younger viewers with the launch of MTV's "House of Style," hosted by supermodel Cindy Crawford. Targeting a different audience from Klensch, Crawford talks primarily to younger trendsetters and designers like Anna Sui and Gordon Henderson, and is said to draw as many as 4.8 million viewers for her broadcast, which airs six times a year.[9] In addition, since 1985, cable network VH1 has offered "FT—Fashion Television," a weekly round-up produced by City-TV in Toronto and viewed by some 230,000 fashion watchers in the United States.[10] Something of a cross between the straight-forward, fashion establishment reporting of Klensch and the hip, street-fashion tone of "House of Style," "FT" combines behind-the-scenes footage and interviews with a jazzy, music-video type flair.

While the three main television fashion programs vary dramatically in tone and format, together they have served the purpose of altering the way the industry views

fashion reporting. Realizing that their runway show could well be televised to millions, designers may take a closer look at everything from the lighting scheme to the collection itself. What's more, according to Klensch, some designers have even taken television training courses to improve their interview presentation, and some European designers have brushed up their English to better converse in television interviews.[11]

Trade Associations

Another important source of information for the fashion industry is the variety of trade associations related to the fashion and retailing fields. Usually comprising a membership of similar companies or individuals—such as men's sportswear buyers, or mass merchandise retailers—**trade associations** serve many functions, not the least of which is to provide a particular industry segment with a unified voice when addressing the government, the media, or the general public.

Each trade association has its own specific agenda and range of services, depending on its stated purpose, size and structure, and members' needs. Some serve primarily as lobbying organizations, representing members in communication with the government regarding pertinent issues and legislation. Others may offer a broader scope of services, ranging from market research, to public relations, to financial, and management matters. In some cases, an association sponsors and organizes seminars, conferences, and exhibitions for its field. For instance, the National Retail Federation (NRF), the nation's largest retail trade organization, states its mission as being "to represent and advance the interests of the retail industry to enhance opportunities

Figure 15-7. The National Retail Federation represents the retail industry through a number of activities, including the annual retail convention and exhibition held in New York each January. (Courtesy National Retail Federation)

ELSA KLENSCH

Most casual observers of fashion lack the credentials or connections that it takes to land a front-row seat at a prestigious designer fashion show. But this does not mean that the average Jill or John cannot get a front-and-center view of the runway at the unveiling of major collections—thanks to the wonders of television . . . and Elsa Klensch.

As fashion editor for Cable News Network (CNN), Klensch brings the glamorous world of fashion into the living rooms of millions of households each week. Her daily news features are carried on CNN at intervals throughout the 24-hour news day, and combined—often with additional material—for the half-hour "Style with Elsa Klensch" program, which the cable network airs twice on Saturdays and again Sunday mornings.

A native of Australia, Klensch began her career as a journalist, working in Sydney, London, and Hong Kong before moving to New York City in 1966 with her American husband, Charles Klensch. Once in the States, she began developing a close professional rapport with the stars of the fashion world by working as a reporter and

> *"I don't care about personalities. Personalities are so overexposed they're boring.* **People** *magazine can take care of that."*
> *Elsa Klensch*

editor with *Women's Wear Daily, Vogue, W,* and *Harper's Bazaar.* Then, in 1980, she joined the fledgling CNN team as fashion editor—and the field of fashion reporting has not been the same ever since.

As Klensch pitched the idea to CNN, her new show would be a sort of video *Vogue,* but better than a traditional fashion magazine because she would be able to present an entire collection, not just a few photos, and present it in motion, the way it was meant to be worn. It was a novel idea, considering the fact that until that time, less than a handful of television programs had attempted in any serious manner to cover the fashion scene. And even though other programming, such as MTV's "House of Style" with Cindy Crawford, has more recently begun reporting fashion news, Elsa Klensch remains indisputably the doyenne of the medium.

Contributing mightily to Klensch's position of authority is her well-earned reputation for straightforward, unbiased reporting. She still thinks of herself as a print journalist; and she works long hours writing, producing

continued

and anchoring every segment of every show. Her main criterion when considering coverage of a collection is whether the clothes are well designed, and she never indulges in backstage gossip or digging into designers' personal lives. In fact, she once told a *House & Garden* reporter, "I don't care about personalities. Personalities are so overexposed they're boring. *People* magazine can take care of that. Karl Lagerfeld could kill his mother, and I'd just ask him about the design of his clothes."

Indeed, Klensch has cultivated much respect for her ability to maintain an air of enthusiastic impartiality. Rather than criticize, if she feels a collection is not well designed, she simply does not run it on her show. And when she does feature a collection or designer, she never gushes, but simply draws out the designer as to the important colors, skirt lengths, silhouettes, and textures of the season.

The result is a very classy show, right down to the strains of classical baroque music used as its theme. The elegant tone is reinforced further by the fact that Klensch tends to focus on high fashion and the most influential, established designers. Taking one recent half-hour program as an example, she gave viewers a front-row seat at the new fall collections of Sonia Rykiel, Gianni Versace, Anne Klein, and the house of Salvatore Ferragamo, as well as spotlighting a new candy-inspired accessories collection by designer Isabel Canovas.

Her quest for the latest trends in international fashion take Klensch around the world—she regularly spends three months a year touring such fashion capitals as Paris, Milan, London, Rome, and Tokyo. Her subjects can range from the traditional elegance of Bill Blass, to the avant-garde designs of Claude Montana, to the trend-setting styles of Japanese designers like Rei Kawakubo.

No matter where she is or with whom she is conducting an interview, Klensch takes her role as a fashion reporter very seriously, and meticulously avoids projecting personal opinions into her work. Instead, she strives to clarify for viewers the various elements that go into the hard-to-define essence of style. And she does so in a way that is not esoteric or condescending to the interviewee or the viewer. "You have to be *absorbed* in an interview,"

Klensch told the reporter from *House & Garden.* "And even if you're not, you should look as though you are."

Her ability to convey the essence of style to a vast television audience has, not surprisingly, won Klensch kudos from a number of fashion industry and related groups. The Council of Fashion Designers of America (CFDA), the professional organization of the leading U. S. designers, honored her in 1987 with an award for "consistently bringing international fashion to the largest audience in the history of television, and for consistently getting the story first and getting it right." The International Fine Arts College in Miami, in awarding her an honorary doctor of fine arts in 1990, cited her "outstanding contribution to the international fashion, style, design and beauty communities in the field of communications, and her continuing inspiration for the students of IFAC."

In addition, "Style with Elsa Klensch" was voted the top fashion program in 1985 in the first Fashion Video Awards competition, in recognition of Klensch's pioneering accomplishments in television reporting. From a personal perspective, Klensch did a stint as an international vice president of The Fashion Group, and has served on numerous fashion industry awards committees.

All of which further confirms her status as one of the country's—and the world's—best-known observers and reporters of fashion news. It is a position that she enjoys, right down to the signing of autographs for fans who meet her in the street. However, she noted in one interview, that kind of recognition has taught her "never to go out unless I have make-up on, unless I'm dressed up."

Question for Discussion. How has Elsa Klensch changed the way the general public is able to learn about the latest fashion trends?

Sources. 1. Press release and biography from Cable News Network, New York, NY; 2. Maura Sheehy, "No-Frills, Meet Fash Dancer," *New York Times,* July 19, 1992; 3. Steve Weinstein, "Eye Candy: Cable Shows Find Fashion a Lure," *Los Angeles Times,* August 26, 1992; 4. Charles Gandee, "Elsa Klensch Has Style," *House & Garden,* March 1991; 5. Mayer Rus, "The Klenscher," *Out,* Summer 1992.

for profitability, encourage an advantageous business climate, and provide a vision for the future.[12] To fulfill this mission, the NRF conducts activities that include tracking of a variety of retail statistics and trends; holding some two dozen conferences and seminars each year, including the industry's most important Annual Retail Convention and Exhibition held in New York each January; representing members on legislative and regulatory issues; and informing the public and media about industry trends and issues. The NRF also publishes a variety of newsletters, reports and other publications, including the monthly *Stores* magazine.

Among the other key trade associations in the fashion and related industries are the Fashion Footwear Association of America, Jewelry Industry Council, National Fashion Accessories Association, American Apparel Manufacturers Association, Men's Apparel Guild in California (MAGIC), National Association of Men's Sportswear Buyers (NAMSB), National Knitwear & Sportswear Association, and United Infant's & Children's Wear Association.

Serving a similar informational role are a number of bureaus or councils relating to a specific niche of the industry, and often consisting of a cooperative of firms doing business within that segment. These include Cotton Incorporated, Council of Fashion Designers of America (CFDA), Crafted With Pride in the USA, New York Fashion Council, Polyester Council, and The Wool Bureau, Inc.

The Fashion Group International

A final auxiliary fashion information service important to mention here is an organization called **The Fashion Group International,** which is made up of executive women—and a few men—from all areas of the fashion and related industries. The group's beginnings trace back to 1928, when Marcia Connor, an editor at *Vogue,* came up with the idea of creating a network that would enhance opportunities for women in the various fashion fields. The first session was attended by such illustrious names as Helena Rubinstein, Eleanor Roosevelt, Claire McCardell, Elizabeth Arden, Tobé Coller Davis (founder of Tobé Associates), and Dorothy Shaver (second-in-command at Lord & Taylor at the time).

The association was formally launched in February 1931;[13] and more than six decades later, the organization has grown to include more than 6000 members in 10 countries, with 33 separate chapters in the United States alone. While the vast majority are women, a few men have been admitted as affiliate members in the Los Angeles and San Francisco chapters.

The group continues to serve its original networking and educational role through a broad-based program of formal and informal meetings and seminars, exclusive fashion shows, publications, career counseling and workshops, special events, and other activities. Scholarships, fashion education projects, and community service programs are also an integral aspect, under the auspices of The Fashion Group Foundation, whose recently re-established advisory board features some of

Figure 15-8. The Wool Bureau, Inc. offers specific support to the fashion industry on fabric trends. (Courtesy The Wool Bureau, Inc.)

the leading names in the fashion business. In fact, to maintain its high level of clout, new candidates for membership in The Fashion Group must be sponsored by current members, who today include corporate presidents, retailers, editors of major publications, and owners of advertising, marketing, and manufacturing businesses.

Summary

1. Fashion marketers and merchandisers rely on market research and trend forecasting to obtain knowledge of their target market and marketplace. A wide variety of firms, ranging from management consultants to fashion consultants to buying offices, provide research data to the industry.

2. Buying offices offer client or member stores a broad range of services, including product development, sourcing, sales promotion, trend forecasting, and more. The three types of buying offices are independent or fee offices, store-owned or cooperative offices, and corporate buying offices.

3. Fashion news and trends are disseminated to the industry through trade magazines, and to consumers through fashion magazines and other publications that report on the fashion scene. Television is also a growing medium for fashion reporting.

4. Trade associations serve specific segments of the fashion and related industries by offering to members services that include government lobbying, public relations, educational programs, and trade shows.

Fashion Vocabulary

Explain each of the following terms; then use each term in a sentence:

buying office

cooperative buying office

corporate buying office

divisional merchandise manager (DMM)

The Fashion Group International

fashion information services

fee offices

forecasting

general merchandise manager (GMM)

independent buying offices

market representative

National Retail Federation (NRF)

trade associations

trade magazines

trade press

Fashion Review

1. Explain the difference between market research and trend forecasting, and give an example of an aspect of fashion that each might focus on.
2. Name the three major types of buying offices that exist today and give an example of a company from each type.
3. Describe the job of buying office market representatives and explain how they provide a link between manufacturers and client retailers.
4. Explain the difference between a trade magazine and a fashion magazine, and give two or three examples of each kind.
5. Describe the importance of trade associations and name some of the services an association might offer its members.

Fashion Activities

1. At the newsstand or library, gather copies of three different fashion magazines from the same month and compare how they cover the fashion scene. Are there any specific topics or events that are reported in more than one of the three magazines? If so, how do details of the articles compare? What trends are identified by each issue? How does each magazine illustrate those trends? Make a chart comparing what topics or events were featured and how many pages each magazine devoted to articles on different topics including all apparel categories, accessories, and cosmetics.

2. Assume you are a market representative for a buying office. Using as your source an apparel or accessories advertisement from a fashion magazine, prepare a memo for your client store buyers on the style featured. Include a description of the item or outfit, its price, size and color ranges, and state when it will be available. Then write a note to your Divisional Merchandise Manager explaining why you selected this item for the member stores.

Endnotes

1. Robert M. Zimmerman, "Today's Children Make Shopping More Than Child's Play," *Retail Control,* January 1992, p. 21.
2. Amy Holman Edelman, *The Fashion Resource Directory,* Fairchild Publications, New York, 1990, pp. 7–14.
3. From Frederick Atkins brochure, "The Organization of Frederick Atkins Inc.," March 1992.
4. From AMC, "Vendor Reference Manual," 1988.
5. David Moin, "Atkins Targets Mexican Goods, Private Label," *Women's Wear Daily,* August 24, 1992, p. 1.
6. David Moin, "AMC Tailors New Strategy," *Women's Wear Daily,* July 23, 1992, p. 1.
7. Susan Reda, "Staying in Tune: Allen Questrom, Chairman and CEO, Federated Dept. Stores," *Stores,* September 1992, p. 19.
8. From a promotional brochure published by *Harper's Bazaar.*
9. Maura Sheehy, "No-Frills, Meet Fash Dancer," *The New York Times,* July 19, 1992, p. V5.
10. Steve Weinstein, "Eye Candy: Cable Shows Find Fashion a Lure," *The Los Angeles Times,* August 26, 1992.
11. Ibid.
12. "Fact Sheet," National Retail Federation, 100 W. 31st Street, New York, NY 10001.
13. Samuel Feinberg, "Fashion Group Still Growing at 60," *Women's Wear Daily,* May 21, 1991, p. 15.

UNIT Four

Project

Analyzing Selected Retailing Practices

The purpose of this project is to analyze the information you have obtained on retailing, determine selected fashion merchandising practices of various retailers, and to ascertain the impact on the consumer of these various retail organizations. Proceed as indicated below; your final report will take the form indicated by your instructor.

1. Select three different types of retail fashion organizations, as follows:
 - one locally owned or chain specialty store
 - one department store
 - one of any of the following kinds of retailers:
 catalog firm mass merchandiser warehouse store
 discount store off-price or outlet store
2. Determine the policies of each of the three different types of retailers in the following areas:
 - Target customer
 - Type of merchandise assortment (broad and shallow or narrow and deep)
 - Place on the fashion cycle
 - Quality level for the price
 - Percentage of domestic vs. foreign merchandise
 - Types of customer services
3. Choose one significant department (e.g., sportswear, men's suits, shoes) offered by all of the retailers that you selected in question #1. Analyze each retailer's department on the following matters:
 - Brand names offered (designer and national brands and private labels)
 - Type of advertising used. Select one or two representative ads from each department
 - Publicity and special events used by each retailer such as fashion shows, trunk shows, and charity benefits
4. Prepare a chart that compares the information for each of the retailers you selected.
5. Illustrate your chart with one or more ads from each retailer showing that retailer's merchandise.
6. Summarize the major similarities and differences in merchandising among the three organizations you selected.

14-CARROT GOLD

My room...
is where I
can be me!

unit
FIVE

Finding

Your Fashion

CAREER

Careers in the Fashion Field

CHAPTER **16**

Objectives

After completing this chapter, you should be able to:

1. Identify three entry level jobs in fashion retailing that can lead to higher levels of responsibility.

2. Name and describe three fashion retailing sales careers offering opportunities for good to excellent earnings.

3. In a typical department or chain store, describe the career paths in fashion merchandising and management, and cite three other divisions where career opportunities utilizing a fashion merchandising background may exist.

4. Explain three fashion merchandising positions in apparel wholesaling, and five in the manufacturing of apparel, fabrics, or fibers.

5. Cite three auxiliary service organizations that offer careers in fashion merchandising.

6. Explain three or four personal characteristics needed by entrepreneurs and list four different types of successful independently owned fashion businesses.

Ever since Cindy Belsario could remember, she delighted in fashion. As a little girl, she and her friends dressed their dolls in an array of costumes, carefully tying ribbons and adjusting accessories. On occasion, she would even outfit Hector, the patient family pooch, in a hat and T-shirt, which he seemed to enjoy parading around the house, the center of attention.

 Cindy maintained her interest in fashion as she grew up. In college, she realized that a career in fashion merchandising really appealed to her and so she took

as many fashion and business related courses as her schedule allowed. During vacations and holidays she worked in a local clothing store. A seminar in fashion merchandising senior year was the deciding factor for her; she analyzed the work of retail buyers and managers and realized that she had the abilities and was gaining the know-how to take on the challenges of retail merchandising.

Right after graduation Cindy landed a job with a well-known chain of women's apparel stores. She applied herself and in a year or so was appointed assistant store manager. About that time she learned that there were openings in the executive training program of a leading department store in a nearby city. Cindy applied and was accepted. As she progressed through the store's training program, she was assigned as an assistant manager to a succession of departments including children's wear, jewelry, and accessories. She moved from a branch to store headquarters where she was assistant manager in the handbag department.

From time to time Cindy would learn of openings for buyers of various departments and she would apply for each one. After three or four unsuccessful attempts, she became discouraged, thinking that her turn would never come. At last, three years after she joined the department store, a job opening as buyer of junior sportswear occurred. Cindy interviewed for it with all the determination she could muster. This time management decided the job was for her and Cindy was thrilled. She knew she had the taste, fashion sense, and expertise to do the work. For the next four years Cindy traveled to New York, Los Angeles, Seattle, Europe, and Asia, seeking out junior apparel for the department store and its more than 20 branches.

At about this time Cindy met Neil O'Connell whose work in industrial sales took him to major cities around the country. Cindy and Neil fell in love and married. When they decided to raise a family, Cindy knew that a buying career involving worldwide travel would not be in the best interests of the family and she took a leave of absence from the store. After the two boys, Mark and Doug, were old enough, Cindy returned to work, this time as an assistant branch store manager. Here she was responsible for seeing that the department managers had the merchandise and selling force that they needed, for being sure that fashion promotions and sales went smoothly, and for handling serious customer complaints. The word today about Cindy is that she may soon become a store manager herself and her career path may not stop there. In time, she may go on to manage a group of stores, or become a divisional merchandise manager, overseeing the work of several buyers. Whatever her responsibilities become, Cindy works daily with the challenge and change of fashion, matters that appeal to her intensely.

Careers in Retailing

One of the most dynamic and popular ways to begin a career in the fashion field is to gain experience in retailing. As you know, retail organizations are responsible for obtaining and offering goods and services to consumers. Seeking out a job in retailing is relatively easy because stores are everywhere, in cities, suburbs, and small towns, and they require a supply of qualified, motivated and hard-working people. Retailing

Figure 16-1. The retail environment offers a variety of positions at all levels of the business. (Courtesy Hartmarx Corporation)

needs both men and women at all levels of the business, from the receiving room to selling and supervision, and from buying and store operations to management.

Many beginning retail jobs are part-time and mesh well with a college student's schedule. While the hours are long and initial earnings low, the range of opportunities is wide and the chance to move ahead is ever present. Talented and dedicated people are always in demand. The retail environment is exciting and often glamorous, with fresh fashion goods constantly streaming in the door, and customers seeking new, interesting, and useful looks to wear.

If you enjoy working with people, anticipating and acting on the changes that come with new merchandise, like keeping good records, and are able to organize your tasks, you are already on the way to fitting into the business of retailing. Filled with drama and change, retailing offers the opportunity to work with many people and with a constant new assortment of merchandise. You may find a niche with a large specialty or chain organization, or you may want to own your own retail store some day. The challenge of retailing is that—like fashion—it is changing constantly and yet opportunities are there for businesses and individuals to do well financially, even when economic times may be slow.

Getting into Retailing

Nearly 19 million people are employed in this nation's 1.5 million retailing organizations.[1] They are responsible for nearly $2 trillion in annual retail sales.[2] Stated another way, according to the government, the average person in the United States spends around $1500 a year on apparel and related items.[3] No wonder the opportunities in retailing are plentiful!

A good way to start in retailing is by finding a part-time or summer job in a business that interests you. It may be a privately owned local specialty store, a larger department store, or general merchandise chain organization. Beginning jobs can include stock and sales work and cashiering. These tasks give you an idea of how merchandise is sold and of the retailer's routine. As you know, the work of retailers includes:

- Buying and merchandising—planning and obtaining the right assortments of goods for the store.
- Sales promotion and advertising—letting customers know about the store's merchandise.
- Store operations—making certain that everything is in order to keep the store open for business.
- Finance—getting and using funds for the business and keeping track of them.
- Human resources—finding and keeping qualified employees.

In large firms, the duties in each of these areas are handled by specialists. From time to time, however, career opportunities in some of these areas appear for people with fashion merchandising backgrounds; the most prevalent will be covered later in this chapter. In small businesses, these responsibilities are handled by one or two people.

Paths to Retail Sales Careers

Beginning jobs in retailing offer opportunities to take on essential responsibilities and to locate career paths within an organization. Three major entry level retail jobs are stockperson, cashier, and salesperson.

Stockperson. One of the most fundamental tasks in a retail organization is to be certain that the merchandise is well cared for so that it is in the best possible condition when presented to customers. Caring for merchandise is the work of a stockperson. Doing stock work gives a chance to see the movement of merchandise and the recordkeeping behind it. Stock work offers an opportunity to work with a variety of merchandise that the retailer handles. Merchandise must travel from the receiving area where it is unpacked and checked to the selling floor or back stock area, and it must be kept safe from dirt, damage, and theft. The stockperson is often responsible for overseeing this movement of goods, for transferring adequate merchandise assortments to the selling floor, and for keeping some records of quantities in stock. Stock work gives an overview of the in-store merchandising activities of the retailer.

Cashier. Many chain specialty stores and mass merchandisers whose stores feature self-selection or self-service need cashiers. The work of a cashier is to enter and total cash and charge sales on computerized cash registers and frequently to wrap or bag customer purchases. Sometimes cashiers have an opportunity to do suggestion selling, as in a shoe store when the cashier asks customers if they need hosiery, shoe polish, or laces. The ability to ring up sales quickly and accurately and to wrap merchandise swiftly are requirements for the job of cashier. For students, cashiering jobs are often excellent entry positions, because many cashiering jobs are part-time, and they are at the center of the retailer's activities. After all, nothing happens until a sale is made!

Salesperson. One of the most interesting occupations in retailing is in sales. There are some 4.5 million people employed in retail selling in stores of all sizes. Many of these are young people under the age of 25.[4] Depending on the type of selling service the retailer offers, a salesperson assists customers with their purchasing. Although beginning earnings are low, many selling jobs offer commissions, which can lead to excellent earnings. Retail sales positions may be within a store's selling department or over the telephone.

There are a number of levels of responsibility in retail sales jobs. At the entry level, the salesclerk is responsible for knowing the kinds of goods the retailer offers, where they are kept, their price, and how to operate the cash register. Beginning salesclerks usually earn close to the minimum wage paid in the area, with opportunity for raises.

The salesperson in a self-selection department, such as sportswear and other ready-to-wear is expected to assemble various fashion looks for customers, find appropriate styles and sizes, show customers into the fitting rooms, and to check with them periodically to see if another size or style is needed. Salespeople may also be responsible for handling merchandise returns and exchanges, filling in stock in the department, creating displays, and taking inventory. Earnings for salespeople in fashion departments can be very good, as they are often paid a salary and a **commission,** or a percentage of their sales. Some full-time salespeople in fashion departments earn between $18,000 and $40,000 a year.

In **salon selling,** found in the highest-priced specialty and department stores, such as Martha in Florida, Ultimo in Chicago, and the designer departments of Saks, Neiman Marcus, and similar stores, the salesperson is responsible for showing customers garments and assisting them in the fitting room. The most important part of the selling responsibility here is building rapport with customers by anticipating their needs. To do this, salon salespeople maintain client lists; that is, records of the names and addresses of customers and their size, color, and style preferences. They see that store buyers purchase goods with specific customers in mind, and they telephone customers inviting them to the store when the new merchandise arrives. Top salon salespeople in leading stores are known to have annual earnings of $50,000 and up. The work at times may be difficult and exacting, but the rewards are there.

A form of salon selling that is exacting but can also be very rewarding is the work of the bridal consultant. The salespeople who work in the bridal salon of a large department store or a bridal specialty shop are called **bridal consultants.** The work of the bridal consultant is to assist the bride and her party in selecting the bridal gown, bridesmaids' dresses, and sometimes apparel for the rest of the wedding party. Some bridal salons even offer complete wedding services from the invitations to the wedding cake.

Other sales areas that are not quite as demanding and offer opportunity for good earnings are fine jewelry, shoes, and cosmetics. The fine jewelry and shoe departments in many large stores are frequently **leased departments;** that is, store space is rented to a business specializing in that merchandise. For example, shoe departments in stores are often leased to shoe manufacturers. Leasing is done for two reasons: the inventory

Figure 16-2. Salon selling calls for a thorough knowledge of customers' fashion requirements. (Courtesy Ultimo)

or merchandise stocks can represent a big investment for the store, and the costs of specialized training needed by the salespeople are high. Salespeople in these departments are often paid an hourly amount by the store but paid a commission on sales by the leased department. They are extensively trained by the leasing organization and because the merchandise is more complicated, they have an opportunity for higher earnings than do salespeople in some other fashion departments.

Another area with special opportunities is the cosmetics field. Here salespeople are hired to sell a brand line such as Clinique or Lancôme. They are extensively trained by the cosmetics organization and usually paid a commission on their sales. For those who are adept and interested, opportunities may arise to work for the cosmetics manufacturer as a representative. In this position, a cosmetics representative has a territory or a group of stores to visit periodically, demonstrating and promoting new products to store personnel and customers.

Advancing in Merchandising

One of the most glamorous areas of retailing is buying. While the work of buyers may seem to consist of attending one new merchandise showing after another—and a great deal of it is—substantial research, planning, and recordkeeping are behind the work of a successful buyer. In small stores the owners often do the buying; in large stores, many people are responsible for buying.

No matter who does the buying, the background work is similar. Sales records are reviewed to determine what merchandise is selling well; the quantity of goods already

in the store is identified; sales volume for the coming seasons is planned; and then the **buying plan,** or the amount of new merchandise to be purchased, is set. At that point the buyer visits the manufacturers' showrooms in New York, Los Angeles, Paris, or other markets to find the goods that the store will offer customers in the coming seasons. Buying is done six months or so in advance of the selling season to give manufacturers time to produce and ship the goods to retailers. Obviously, store buyers have a great responsibility to the retail organizations employing them, for on the buyers' selections rest the income and the eventual profits of the retailer. However, experienced buyers with good merchandising judgment are well rewarded for their extensive efforts.

To reach the level of buyer, it takes time and experience. Fashion buyers today, particularly with large retail organizations, need to be college graduates. In addition, they should be alert to fashion trends and know when their customers are ready for them, and they should possess technical understanding of fabrics and garment construction. They need to be good at reaching decisions and at mathematics. Through their experience they need to recognize the problems that arise and know how to deal with them. The ability to get along well with others is also an asset. Stamina and endurance help get through a rigorous schedule.

Assistant Buyer. In many large retail organizations, promotions to the level of buyer often come from the ranks of assistant buyers. An assistant buyer is a person who has either worked up from sales, cashier, or stockperson, to become **head of stock;** that is, a person in charge of the merchandise for a given department or area. Or, an assistant buyer may have been a **buyer's clerical,** in charge of the records for the department; or even a manager, in charge of sales for a given department. In large retail organizations, an assistant buyer has also completed at least part of a training program for potential executives.

The work of an assistant buyer is to relieve the buyer of some of the more routine responsibilities. In many instances, the assistant buyer does the buying for certain basic merchandise lines. Other assistant buyer duties include verifying and following up on the buyer's purchase orders, maintaining records, and authorizing the payment of invoices. Some assistant buyers also merchandise the department and train and supervise salespeople. Many assistant buyers try to spend as much time as possible on the selling floor, working with customers to learn their likes and dislikes. The assistant buyer attends meetings with the buyer, store executives, and suppliers, and has an opportunity to learn a great deal from the buyer. When the time comes (in two to six years depending on the store) for a promotion, it may well be to buyer in another department, but the merchandising procedures for creating a profit are the same.

Department or Specialty Store Buyer. Buyers for department and large specialty stores have certain areas for which they buy. These may be fairly broad departments; for example, women's coats, suits, and dresses for a medium-sized specialty store; or they may be narrower such as junior sportswear for a department store.

A fashion goods buyer spends a great deal of time traveling to New York, or Europe and Asia, depending on the merchandise lines sought. The work is exciting

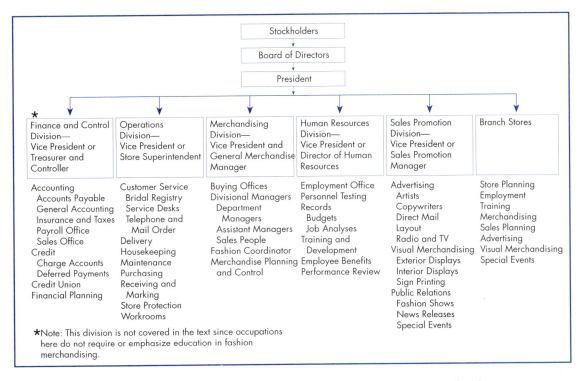

Figure 16-3. Typical department store organization chart. (Adapted from National Retail Federation)

because buyers visit interesting places and constantly see new items. Buying consists of inspecting merchandise shown by vendors to determine its suitability, and negotiating terms of the sale, including delivery dates, transportation, and final costs. When the merchandise is shipped, the buyer authorizes payment. The buyer may also introduce the goods to store executives, the advertising department, and the staff.

Some buyers go on to higher positions as group or **divisional merchandise managers,** overseeing the work of the buyers and managers of several departments such as men's tailored clothing, sportswear, and men's furnishings. A merchandise manager has had a number of years of experience as a buyer and works closely with the buyers to see that their departments are as profitable as possible. Merchandise managers control the funds of the buyers; they help new buyers plan their budgets, and review budgets with all buyers; and they confer frequently with vendors about the market and with retail management to implement plans. When a new department appears in the store, the merchandise manager has done the planning for it. Still higher on the corporate ladder is the position of **general merchandise manager,** heading up all of the divisions and often serving as a vice president of the retail organization as well. The goals of all merchandise managers and buyers are to improve the profitability of the store.

Chain Store Buyer. Many large retail chain organizations such as The Gap, Sears, and Wal-Mart, and increasingly the larger department and specialty stores, such as

Dayton Hudson department stores and Lord & Taylor, make use of a central buying office. Often located near the retailer's headquarters—for example, the buying offices for J. C. Penney are in its Dallas, Texas, home city—the **central buying office** is the center of store planning and merchandising for the entire retail chain. However, the central buying office is primarily responsible for planning and obtaining merchandise, while the responsibility for selling it is given to the retail stores.

To accomplish its tasks, the central buying office is organized as a large retail store, with general and divisional merchandise managers overseeing the work of highly specialized buyers. Instead of buying for entire departments, chain store buyers are more likely to buy specific categories or classifications of merchandise such as misses' sweaters or swimsuits. They buy these special categories in vast quantities. The buyers in central buying offices are responsible for creating a buying plan and negotiating with vendors. While they are not directly responsible for selling the goods they buy, their continued success is based on the sales results of the individual stores. The next step up for a chain store buyer is usually to buy a larger number of merchandise categories and then to progress to the level of merchandise manager.

One particularly interesting aspect of the chain store buyer's work (and some specialty and department store buyers also) is specification buying. A type of private label buying, **specification buying** occurs when a retailer negotiates to have a vendor

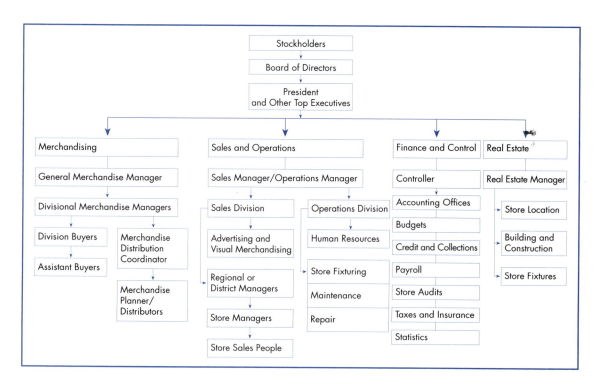

Figure 16-4. Typical apparel chain store organization chart. (Adapted from National Retail Federation)

produce goods based on the retailer's specifications. The merchandise of The Gap and J. Crew, for example, is mainly obtained through specification buying, and Mast Industries produces apparel for The Limited stores this way. The experienced buyer has an opportunity to create and order new products through specification buying.

A position related both to specification buying and to fashion design (an area outside of the scope of this chapter since the preparation for design careers differs substantially in content from merchandising) is that of product development trainee, working in the central buying office of a large retail chain. A product development trainee needs to have a knowledge of garment construction and apparel manufacturing as well as fashion merchandising and sketching ability. Early work may include gathering fashion trend information and handling order follow-up details, while more complex duties include working with product development managers and buyers to coordinate styles, locating resources, approving samples, and negotiating deliveries.

Entry level positions for a buying career in a central buying office begin with merchandise planner/distributor or buyer's clerical. these occupations require both a four-year college degree in business or merchandising, plus a knowledge of fashion trends and strong skills in mathematics and data analysis. The work of the **merchandise planner/distributor** is to determine how the goods the buyer has purchased will be distributed to each retail store in the chain. To do this, the merchandise planner/distributor does breakdowns of each style into the sizes and colors sent to every store, and maintains records of these breakdowns. A buyer's clerical handles routine details to free up the assistant buyer to work with the buyer. The assistant buyer in the central buying office aids the buyer by keeping records, handling reorders, and assuming other duties that the buyer requests.

Advancing in Retail Management

Another path to the executive ranks, and one that holds a variety of career positions along the way, is retail management. Retail managers at various levels are the people and their assistants in charge of departments, stores, and divisions. Many large department and specialty retailers require their executives to gain experience in both merchandising and management jobs as they move upward in their careers. The R. H. Macy merchandise management career path chart shown below (see Figure 16-5) is an example of the way one retail organization charts a typical route upward.

Traditionally, any good business wants to recognize and reward outstanding performance by promoting from within. Many company CEOs in organizations as large as Sears, Roebuck and Co., and J. C. Penney started their careers in entry level jobs. More often, when small- and medium-sized retailers find a talented salesperson or head of stock ready for promotion, they give that person management responsibilities. These may include merchandising a department, planning and implementing a display theme, and scheduling employees. The entire need for young executives cannot be filled this way, however, and so large retail organizations have developed executive training programs to attract potential managers and executives.

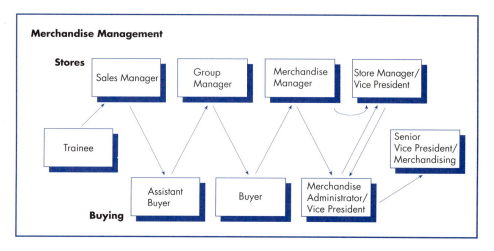

Merchandise Management

Stores

- Sales Manager
- Group Manager
- Merchandise Manager
- Store Manager/ Vice President

- Trainee

- Senior Vice President/ Merchandising

Buying

- Assistant Buyer
- Buyer
- Merchandise Administrator/ Vice President

Figure 16-5. The fashion merchandising career path for Macy's calls for experience in both management and buying. (Adapted from R. H. Macy's)

Executive Training Programs. For college graduates, the fast track into retail management is through an executive training program. A retailer's executive training program is designed to combine classroom sessions with practical on-the-job experience. Large specialty chain and department stores and mass merchandisers offer executive training programs, lasting anywhere from six months to two years, to provide the organization with a supply of qualified people for management positions as the need arises. Class sessions deal with the kinds of situations and problems that executives encounter routinely. Note the range of topics that Macy's includes in its training program for buyers and managers:

> Merchandising training covers such topics as supervising and motivating a sales staff, selling techniques, customer service, merchandise classification and presentation, sales promotion, operations and control, pricing, reports and statistical analysis, and time management.[5]

Typically, a recent graduate hired as a trainee may expect to work in a variety of selling and nonselling jobs while also attending training meetings covering topics important to managers, such as reducing costs. At the end of the training program, the trainee is usually placed in a department as an assistant department manager.

Assistant Department Manager. The work of the assistant department manager in retailing is to help the department manager run the area smoothly. Duties of the assistant department manager may include: merchandising the selling floor, taking markdowns and transferring merchandise, training department personnel, and other responsibilities designated by the department manager. Many assistant managers try to spend as much time as possible on the selling floor to determine customer preferences. The next step up is to department manager.

CAREER OPPORTUNITIES

Clothestime specializes in...people and career opportunities!

Clothestime's success and g___ ___ll continue steadily resulting in 1000 stores, in th___ ___ar future.

_____r growth___ ___s opportunities for mature top notch people ___ ___ving success for themselves.

___s for bright professionals whose succe___ ___gree, along with retail management ___

___s directly to the Vice President o___ ___ to 80 stores and the supervis___ ___anagers. Requires minimum ___experience.

___tly to the Regional Ma___ ___e supervision and d___ ___of four years retail ___

___e District Ma___ ___mizing sales___ ___handising,___ ___ilities. Su___ ___Requir___

___S___

What could be better than being in fashion?

Getting paid for it.

We're gaining ground fast. If you're interested in getting ahead fast, consider a career at Clothestime. We're experiencing phenomenal growth within the fashion ___ Which means we can put you in ___ up quickly.

Clothestime
5325 E. Hunter Ave.
Anaheim, CA 92807

Clothest___
Executive ___
5325 E. H___
Anaheim___

Figure 16-6. Informative recruitment material offers direction on making career choices. (Courtesy Clothestime, Inc.)

Department Manager. The department manager is the eyes and ears of the buyer for the local store. While the department manager has responsibility for selling the merchandise the buyer has purchased, the manager is not responsible for buying it. The department manager must see to it that the goods are on the selling floor, that the merchandise counts are accurate, and that goods are reordered when it is appropriate to do so. In addition, the department manager plans the work schedule for employees, assigns job duties, and merchandises the department to coordinate with sales promotions and advertising efforts. The department manager may be promoted to group manager, overseeing several departments, or to assistant buyer.

Assistant Store Manager. In large specialty and department stores, an assistant store manager has usually had several years' successful buying experience. For one reason or another, however, the appeal of reporting to one location, as opposed to extensive and strenuous travel, often brings seasoned buyers into retail management. In smaller chain and independent stores, assistant store managers are often promoted from the ranks of department managers or even outstanding salespeople. The assistant store manager is responsible—as directed by the store manager—for overseeing the various selling and nonselling departments, making certain that merchandise is appealingly

presented, departments are adequately staffed, customer complaints are handled, and the appropriate records are collected and transmitted to headquarters. After several years' experience, the assistant store manager may be assigned a store to manage.

Store Manager. The store manager organizes and directs through subordinate managers all the activities of the store. The store manager implements pricing policies determined by management and coordinates the activities of the non-merchandising departments—such as store operations, finance, and human resources—to keep the store running efficiently. The store manager oversees sales and expense records and provides promotional support to increase sales and move stock. Another responsibility is negotiating contracts for services such as security and maintenance. Some store managers also hire employees. Successful store managers are promoted to positions of greater responsibility. For example, in the specialty chain organization Clothestime, merchandise buying experience is not necessary for store managers; the route upward from store manager is to district manager, responsible for 6 to 12 stores. The next step is to regional manager, reporting directly to the corporation's vice president of store operations, and being responsible for up to 80 stores.[6]

Opportunities in Related Areas

In addition to the many opportunities in merchandising and management, from time to time openings occur in other areas of a retail organization. For people with fashion merchandising background, these opportunities most often include: store operations; human resources; and sales promotion, including visual merchandising and fashion coordination.

Store Operations. The various activities that keep the store open and running smoothly are performed by people in the operations division of a store. These activities include: organizing the flow of traffic through the store, both on the selling floor and behind the scenes; assuring that goods reach the departments in a timely manner; and keeping the store in good condition. When a new boutique or a seasonal department such as a "Trim-the-Christmas-Tree" shop is opened, the preparation is part of store operations. In large department and specialty stores, various managers assume responsibility in each of these areas; in smaller stores, the store manager oversees all of these endeavors. Employees selected for openings or promotion into the operations division are frequently those with proven experience in sales or stock work.

Some larger retail organizations have managers in charge of the receiving room whose responsibility it is to see that incoming merchandise is accurately counted, priced, and sent to the appropriate department; other managers may oversee the selling floor, including point-of-sale cash register and wrapping desks; customer services such as exchanges, returns, and deliveries; and behind-the-scenes mail and telephone order operations. Restaurant, housekeeping, and security staff are also part of the operations divisions of many stores.

For some retailers—usually among those offering higher-priced merchandise—the operations division also includes the personal shopping service. Personal shoppers, expe-

THE HSMU CURRICULUM

Store Management Business Plan Product

Image CUSTOMER RETENTION Sales Skills

Clientele Building **Fitting Skills** Service Skills

BUSINESS PLAN
- How to create a plan
- Focus on behavior
- How to use, monitor, and measure goals

PRODUCT
- Construction
- Piece goods
- Features vs. benefits
- Custom box
- Direction and trends

SALES SKILLS
- Effective greeting
- Determine needs
- Professional presentation
- Handling objections and questions
- Multiple selling
- Customer profiles

FITTING SKILLS
- Proper tools and etiquette
- How to measure
- Relationship of model and body type
- Technical instruction

IMAGE
- Looking the part
- Visual display
- Floor planning

SERVICE SKILLS
- A perspective
- Types of service
- Communication skills
- Personal attention ideas

STORE MANAGEMENT
- Steps to a service culture
- Management of styles and personalities
- Motivating others
- Planning and goals
- Profit impact of market strategy

CLIENTELE BUILDING
- "How to" system
- Maximize the phone
- Prospecting

Figure 16-7. Manufacturers' training programs for salespeople help them serve customers better and build business. (Adapted from Hartmarx, Inc.)

rienced retail salespeople familiar with the store's total selection of goods and adept at discerning customer needs, shop at customers' requests for business and personal gifts.

Human Resources. The work of the human resources division of any organization is concerned with locating, training, and keeping the best qualified people for the business. In a small retail firm, the owner or manager takes on all of these functions. In a larger organization, the work is done under the direction of a vice president of human resources. The major areas of a human resources division include: recruitment and selection; training and development; performance appraisal; and employee earnings and benefits.

Entry level jobs include office and clerical recordkeeping in all of these areas. Jobs with greater responsibility include recruiting and interviewing prospective employees, both in the office and at college campuses and job fairs. Advancement could lead to the position of employment manager, responsible for finding employees for all divisions of the organization. Other human resources opportunities include training for both sales and nonselling employees; that is, offering classes in a variety of subjects from cash register operation to sales technique and customer service. Some organizations offer fashion training through the human resources division. Here a background in fashion merchandising is highly useful. The position of

training director would be the next step up. College graduates with preparation in psychology and human resources are prime candidates for a retailer's human resources division; however, others with allied interests, such as fashion merchandising and human relations, are also considered.

Sales Promotion. All of the activities outside of personal selling that promote the retailer's merchandise and the store's good will are included in sales promotion. For example, the sales promotion division of a large department store typically contains the visual merchandising, advertising and public relations departments of the company, and sometimes the fashion office.

Visual Merchandising. The display windows, mannequins, interior wall and counter displays and vignettes, all comprise the retailer's visual merchandising efforts. The display director and staff are responsible for planning the merchandise themes and displays for the year and staying within an established budget. Sometimes the visual merchandising is all handled within the store's own visual merchandising department, as is the case with Marshall Field's department stores. Many smaller retailers do their own visual merchandising. Still others contract with freelance visual merchandisers to have the store windows and interiors decorated on a regular basis. Large chain organizations draw up merchandise display plans at central headquarters and send these plans with instructions to local store managers for implementation by their staff.

People who have a sense of color, line, and design, supplemented with schooling in the principles and practice of visual merchandising, and who enjoy creating new ideas and translating them into merchandise displays can often find rewarding careers in visual merchandising. They may start out in a retailer's display department, progress within that organization, move on to greater responsibility in another, or open their own visual merchandising service.

Retail Advertising. The part of the sales promotion division responsible for creating the retailer's advertisements is the advertising department. Many retailers have their own advertising departments because the alternative, using an advertising agency, is an added cost, and the store can obtain similar prices from the media. Under the direction of the advertising manager, artists, photographers, and copywriters are among those who create the retailer's advertisements. Also, these specialized services and others may be purchased by the store from independent organizations; some careers here for people with fashion merchandising preparation are covered later in the section called Owning Your Own Business.

Public Relations. The public relations department of a large retail firm is responsible for news releases, fashion shows, and special events. In a chain organization, these activities are planned by the headquarters' public relations department and coordinated with the local stores when appropriate. Small stores handle their own public relations activities. Some retailers such as Filene's Basement or the Henri Bendel division of The Limited hire independent public relations agencies to provide fanfare and excitement for important events like new store openings. Public relations activities are covered in Chapter 14, Fashion Promotion.

Figure 16-8. Buyers and merchandise managers review merchandise samples and an upcoming merchandise line. (Courtesy J. C. Penney Co. Inc.)

Fashion Coordination. Promoting new fashions and coordinating fashion shows and other fashion-related special events is the work of fashion coordination. In some retail organizations, fashion coordination is incorporated into the sales promotion division, with emphasis on creating fashion events—experience in fashion show production is necessary. In other firms, fashion coordination is part of the merchandising division, with emphasis on analyzing available resources and building a consistent fashion image for all departments; in this situation, buying expertise is necessary. In still other organizations, the **fashion director,** head of a retailer's fashion coordination efforts, is a vice president, reporting directly to top management and most likely has both promotion and merchandising responsibilities. In small retail stores, the fashion director is also the owner and manager.

People who do fashion coordination assume a variety of duties and titles, including fashion consultant, fashion stylist, and fashion coordinator. In some stores, a fashion consultant is actually a wardrobe consultant to customers or clients, informing them of new fashions and assisting them with merchandise selections. Other fashion coordination responsibilities may include, as the managers of Casual Corner stores are known to do, presenting a fashion seminar to office employees on how to assemble a useful career wardrobe.

To research fashion trends, the fashion director and staff study fashion journals and other trade information sources. They visit market centers regularly to gather information from fiber and fabric producers, apparel manufacturers, buying offices, and fashion advisory services. Then they work with the buyers to coordinate the appropriate fashion look for the store's customers. The fashion director also works with the retailer's public relations and visual merchandising departments in developing various theme promotions and fashion shows. Many fashion directors also produce fashion shows, both for store personnel and for customers. The work of the fashion director for Saks Fifth Avenue stores includes visiting the couture shows in Milan, London, and Paris, reporting to the store executives important looks for the

EUGENIA ULASEWICZ

Former President, Galeries Lafayette, New York

When the venerable French department store, Galeries Lafayette, decided to reach many of its foreign customers at home as well as in Paris, management settled right in on New York's Fifth Avenue, selecting a glamorous location opening into the upscale shopping delights of Trump Tower. Venturing into other countries was not new to Galeries Lafayette; the desire to give consumers access to French fashions and accessories had already caused the firm to open some 20 stores in western Europe and Singapore. Coming to New York was a different matter, however.

> *"Our aim is to interpret and translate French and international fashion trends. . . . I feel French by osmosis! We have been spending at least a week each month in Paris. The advantage is that we bring back the best of the culture, as well as many of the lesser-known amenities to show our sales staff." Eugenia Ulasewicz*

Many people look to Paris as the creative home of women's fashions; fashion merchandisers and consumers alike turn to Paris for apparel inspiration, not just to see what is new among the designers but often to copy the French way of dress. When a French retailer dares to open a store in New York, perhaps the most competitive apparel environment anywhere, a major management challenge could well be, "Who would run it?"

For Galeries Lafayette, the choice seemed a natural: Eugenia (Jean) Ulasewicz. Her qualifications include extensive merchandising and management experience in the New York fashion world, shored up by a background in international retailing. Brought up in southern New Jersey, she studied at the University of Massachusetts at Amherst. Developing an early interest in consumer advocacy, Eugenia Ulasewicz hoped to study consumerism as preparation for joining the consumer advocacy group founded by Ralph Nader. She studied fashion marketing with the idea of pursuing a consumer advocacy major; soon, however, she realized she had a talent for marketing and retailing. Participating in an international exchange program, she had an opportunity in London to learn firsthand the retailing methods of major stores such as Harrod's and Selfridge's.

Wanting to test her fashion marketing skills on returning home, Eugenia Ulasewicz entered the executive training program of Bloomingdale's, working also as an

assistant buyer in the handbag department. Over the next 15 years she moved upward to department manager, buyer, and then to store manager. Her most recent Bloomingdale's responsibilities were as a regional vice president over four leading Bloomingdale's stores.

When selected as president of Galeries Lafayette New York to open the Fifth Avenue store in 1991, some of Eugenia Ulasewicz's first responsibilities included visiting Paris to determine the lines to be carried—only women's wear originally in the small (40,000 square feet selling space) Manhattan store—and working with architects, buyers, and fashion designers to create a distinct style for the first U. S. branch.

Long-range strategies included developing the right merchandise lines of better, bridge, and designer price lines, and seeking out new design talent by featuring their lines in a special department called "Laboratoire." Training the employees in the elements of French style and learning the language herself were other areas of concentration for Ms. Ulasewicz. Making the New York store totally French for customers is a continuing challenge, but one based on research. Early surveys of some 3000 Trump

Tower shoppers and visit[...] eager to have a store sellin[...]

While in 1993 Eug[...] become a senior vice pre[...] there should be no questio[...] Lafayette proved invaluable[...] next stage of her still-rising ca[...]

Question for Discussion. [...] ...e back-ground of Eugenia Ulasewicz made her a logical candidate for the position of President of Galeries Lafayette New York?

Sources. 1. Penny Gill, "Galleries Lafayette: French Department Store Takes Bold Step with New York City Opening," *Stores*, September, 1991, pp. 25–29; 2. Mary Krienke, "Accent on Paris: French Chain Takes Plunge into New York Retail Waters," *Op. cit.*, p. 30; 3. Isadore Barmash, "A Store on Fifth Avenue Will Be 'Totally French'," *New York Times*, May 30, 1991, p. 2; 4. Eugenia Ulasewicz Biography, Loving & Weintraub Public Relations, 655 Madison Avenue, New York, New York 10021.

Saks customer, and then making certain that the store's buyers are buying these looks. Manufacturers also employ fashion coordinators and directors; these careers are covered later in the section on careers in manufacturing.

Careers in Wholesaling

Retail store buyers seek out the appropriate goods for their stores by visiting the showrooms of suppliers, or vendors, who offer merchandise from throughout the world. Some specialize in imported merchandise. Many vendors' showrooms are operated by large apparel manufacturers. For example, Oshkosh B'Gosh, Carter's, Danskin, and Leslie Fay have showrooms in market centers across the country such as Chicago, Dallas, and Los Angeles, as well as in New York. In general, the people in these showrooms are employees of the manufacturer; Esprit is one that hires employees for its various showrooms. The work of the manufacturer's representative and other fashion merchandising occupations with manufacturers are covered in the following sections.

Other showrooms are occupied by **manufacturers' agents;** that is, independent wholesale businesses representing a group of similar but noncompeting lines. Manufacturers' agents specialize in men's, women's, or children's wear, intimate apparel, or accessories of approximately the same price range; that is, at bridge and

better, moderate or budget levels. While some wholesalers do take possession of manufacturers' goods and take a mark-up when selling them, most do not own the goods but are paid a commission on orders delivered to the stores.

Showroom Assistant

A popular way of getting into wholesaling is by working in a showroom in a major market center. To gain access, some students work part-time or periodically during market weeks. At this hectic time, everyone in the showroom pitches in to unpack and press new samples and to ready the showroom for visiting buyers. A successful stint during market weeks may lead to a job as showroom assistant. The duties of a showroom assistant are to complete the tasks assigned by the showroom manager such as hanging and displaying merchandise samples, telephoning retail stores to inform the buyers of new merchandise, following up orders for delivery to stores, and eventually showing the lines to store buyers.

Field Sales Representative

The work of the **field sales representative** is to represent vendors to stores in a designated territory or geographical area. An experienced showroom assistant may become a field sales representative; that is, be assigned a group of stores to call on between markets for a variety of purposes. A trunk show may be scheduled in the store and the field sales representative accompanies or represents the designer and brings in the entire line for the promotion. Also, new merchandise from manufacturers may become available or there may be reordering possibilities. The field sales representative also visits stores to learn more about their customers in order to work more effectively with the buyer.

Showroom Manager

The work of a showroom manager, whether an employee or an independent business person, is to operate the showroom as effectively as possible, coordinating the

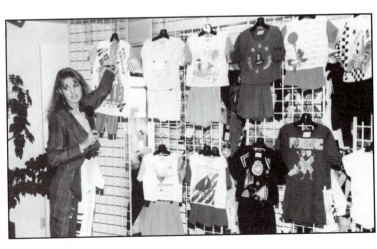

Figure 16-9. A showroom manager presents a current line of merchandise to customers. (Courtesy Ellen Diamond)

flow of merchandise between the manufacturers and the retail stores, in an effort to build sales volume and profitability each season. An independent manufacturer's agent seeks continually to identify and work with new designers and manufacturers with appropriate lines for store buyers and to locate and cultivate a larger and more profitable base of suitable stores as customers. Showroom managers have come up through the ranks of assistants and field sales representatives, and in small showrooms they perform some of those responsibilities, too. Managing a showroom is highly competitive and demanding but when successful can be profitable.

Careers with Apparel, Fabric, and Textile Fiber Manufacturers

The manufacturers of apparel such as Levi Strauss or Hartmarx, fabrics such as J. P. Stevens or Milliken, and fiber producers such as Du Pont or Celanese, offer occupations for people with fashion merchandising backgrounds. The actual jobs, however, are not as numerous as those in retailing and they are often located in New York City or the headquarters of the individual manufacturer.

The work of a manufacturer of fashion goods such as apparel, fabrics, and fibers includes these activities:
- Managing and operating the business.
- Planning and merchandising the lines.
- Designing the individual items for each line.
- Purchasing the raw materials.
- Producing the goods.
- Marketing and promoting the finished lines.

While all of these areas are well served by a knowledge of fashion merchandising, many call for specific preparation in technical areas such as design and production. Certainly, opportunities arise for people with fashion merchandising education combined with technical know-how and advanced training. They may move upward into management positions or horizontally into purchasing occupations, and there be responsible for obtaining the materials the factory uses to create its output; for example, buying fabric, laces, buttons, and other fastenings for a dress manufacturer.

Opportunities Combining Marketing and Fashion Merchandising

For people with a strong marketing background combined with fashion merchandising and technical knowledge, there are varied opportunities with apparel, fiber, and fabric manufacturers, often beginning with sales responsibilities, heading upward toward becoming account executives. An **account executive** is assigned by the manufacturer to work with specific customers in determining their needs and planning and providing products to suit those needs. For example, account executives in the separates division of Oxford Industries, a men's wear manufacturer, are responsible for

developing and transmitting to the merchandising division customer specification sheets citing styles, fabrics, and delivery dates. They then follow through on fabric selection, production schedules, and finished inventory to meet the delivery dates.

Their immediate superior is the product manager, a college business graduate who may also have an advanced degree; the product managers for Oxford Industries supervise the work of several account executives.[7] Depending on the nature of their assignments, **product managers** may work with suppliers, set prices, coordinate promotional activities and advertising, and work with the sales representatives, giving them new product information and gathering customer feedback. The product manager for sweaters for Mast Industries, the major supplier to The Limited, works with manufacturers overseas, seeking out producers for various types of sweaters and locating the appropriate yarns. The manager learns what kinds of sweaters The Limited buyers want and then travels to Europe and Pacific Rim locations such as South Korea and Hong Kong, following up on production. Product managers, depending on the extent of their responsibilities and the size of the company, earn upward of $30,000 annually; the product manager just described earns in the neighborhood of $40,000 annually.[8]

The product manager reports to the marketing manager. It is the responsibility of the **marketing manager** to plan and direct the marketing endeavors of the manufacturer to be certain that customer needs are anticipated and met effectively. The marketing manager also develops new product concepts, utilizes marketing research to determine customer needs, and oversees the promotional programs for the product lines. Marketing managers gather extensive experience in their field. They need the ability to anticipate changes in fashion, organize resources and communicate new ideas to top executives and subordinates. Marketing managers frequently hold a Master's of Business Administration (MBA) degree.

The three most popular career opportunities with manufacturers that call for fashion merchandising expertise include manufacturer's representative, merchandise coordinator, and fashion director.

Manufacturer's Representative

A manufacturer's representative is the manufacturer's local contact for the buyers in a given area. The apparel manufacturer's representative is responsible for contacting local stores to inform them of new merchandise, showing the goods to store buyers and obtaining their orders, and following up on promises of delivery. The apparel manufacturer's representative often manages or assists in the showroom during market weeks and in between is out visiting stores to build the customer base, obtain feedback on customer style preferences for next season, and present trunk shows for the manufacturer in customer stores as the agents do for the manufacturers or designers they represent.

The entry position for manufacturer's representative is that of showroom assistant for the manufacturer, with duties similar to those of the wholesaler's showroom assistant. Concerning earnings, a full-time showroom assistant can expect an income of from $13,000 to begin with and may earn up to $20,000 annually; a showroom

manager who does not go on the road, up to $30,000; and an experienced field or road sales manufacturer's representative up to $75,000 in a good territory.[9] For people who can readily discern customer preferences, like the excitement of presenting new merchandise each season, and who enjoy extensive travel, the career of manufacturer's representative can be stimulating and rewarding.

The textile and fiber industries also need sales representatives, selling fabric to apparel manufacturers; sheets, towels, and blankets to retailers; upholstery materials to furniture manufacturers; greige goods to converters; and yarns and fibers to textile manufacturers. These occupations are found across the country and can lead to good incomes and rewarding careers. Promotions lead to the positions of district manager, sales manager, and vice president. In addition to technical, marketing, and fashion merchandising knowledge, these sales occupations require human relations skills, high energy, and commitment to travel.

Merchandise Coordinator

A fairly new position among some larger apparel manufacturers, such as Guess and Esprit, is that of merchandise or visual coordinator. The work of the **merchandise coordinator** is to be certain that the manufacturer's merchandise is presented as effectively as possible within the retail stores.

For example, the job of the merchandise coordinator for The Designer Group, including Arrow, Van Heusen, and Geoffrey Beene shirts for men, is to work with 50 or so customer stores in a given area to make certain that the location and space in the stores and the inventory are presented in the best way possible. To accomplish these goals, the merchandise coordinator visits the stores to help set up effective merchandise presentations, gives seminars on product information, and follows up on problem-solving. The merchandise coordinator also travels to New York four times a year for market.[10]

Although the merchandise coordinator does not have the high earnings of the road sales representative, but in an annual range around $25,000, the work is less stressful and demanding and yet still highly varied. Since the merchandise coordinator's role involves promotion and problem solving, experience in retail management and/or showroom operation is typically a requirement. A possible promotional path is to director of field services in charge of a group of merchandise coordinators.

Fashion Director

Most large fiber and fabric manufacturers, such as Du Pont and Monsanto, as well as apparel manufacturers, such as Liz Claiborne, require extensive fashion information and also need to get the company's fashion messages to employees and customers alike. The expertise of the fashion director is vital here. For example, the fashion director of Du Pont fiber producers holds a fashion workshop for apparel designers and retailers, showing how the textures and colors of fabrics, such as nylon, spandex, and Lycra made from Du Pont fibers, may be used in a variety of styles.[11]

A fashion director in the fabric industry researches the weave and color trends and advises the mill on the best possible combinations for the season. The emphasis of the apparel manufacturer's fashion director's work is on informing the company's own sales representatives about the new season's merchandise lines. Fashion directors produce meetings and shows for the sales representatives, providing fashion and product knowledge that equips the selling force to work more effectively with store buyers. Some fashion directors may also develop presentations to the media, buying offices, and retailers.

The number of fashion director's jobs is limited compared to other opportunities in sales and merchandising, and the work requires extensive fashion merchandising training and experience, but the fashion director has an opportunity to work creatively and influence the entire industry.

The Home Sewing Industry

Closely related to apparel and fabric manufacturing is the home sewing industry. An estimated 50 million people in the United States are home sewers, enough for the three major pattern companies—Simplicity, McCall's, and Butterick—to provide a stream of fashion magazines and the latest patterns, some with designer names. The annual sales of patterns for home sewing amounts to around $50 million.[12] For individuals with sewing skill combined with fashion merchandising preparation and a four-year college degree, the home sewing field may yield a rewarding and interesting career.

Merchandising jobs include fashion merchandising or research assistants whose work is to gather market information on customers in order to determine their needs, and to report to the merchandising director who develops anticipated sales plans. Other jobs include: fashion copywriters, who provide press releases and publicity for the media; and editors and editorial assistants, who create home sewing fashion magazines, catalogs, and counter books for the fabric stores. The promotion director works with fabric and fiber companies and retailers to create promotions such as fashion shows featuring garments made from the company's patterns. The fashion stylist assists the promotion director, particularly in fitting and accessorizing models for the fashion shows. The educational director prepares educational materials for schools and 4-H groups and supervises the work of traveling stylists and local company representatives who put on fashion shows for schools and community organizations.[13]

Careers with Auxiliary Service Organizations

The many kinds of auxiliary organizations that encourage and facilitate the flow of apparel and accessories from manufacturers to consumers can be sources of challenging careers for people with fashion merchandising expertise. Although the number of job opportunities in these organizations does not come close to the number found in retail merchandising and management, opportunities can open up for those who persevere. Among the most popular specialized career areas calling for education in fashion merchandising are those found with buying organizations, in fashion promotion, and in teaching.

Buying Organizations—Domestic and International

Located in market centers such as New York, Los Angeles, Paris, or Milan, a resident buying office, either store-owned or independently owned, makes buying easier for retailers. (See Chapter 15, Auxiliary Fashion Services.) Organized like a retail store with a merchandising division that includes a general merchandise manager and divisionals, the resident buying office concentrates on specific classifications of merchandise.

Reporting to the divisionals are market representatives and their assistants who explore the marketplace by calling on vendors' showrooms to seek out new merchandise lines and new sources for retail buyers. While their main responsibility is to research the market and relay their fashion findings to retail stores, they may also buy for retailers when asked. Other responsibilities include following up on store orders, both domestic and overseas. Market representatives need good research skills, as well as the ability to communicate effectively, since they work both with vendors and store buyers. The entry level job is assistant representative. The work responsibilities include helping the market representative maintain records and assisting with other assigned duties. A four-year college degree in fashion merchandising, business, or liberal arts is also required. Market representatives in foreign cities are more effective when they can communicate in the language of the country.

Large buying organizations also have fashion coordinators whose role is to build the fashion image of local stores. Their work is to research the market, including vendors, fashion reporting services, and the media, and to create for the retailers an interpretation of the season's fashion trends. Then the fashion coordinator plans fashion shows for store promotion personnel and buyers, and creates promotional materials for the stores. The entry level job is that of assistant fashion coordinator. A working knowledge of the fashion industry plus a strong sense of fashion are basic requirements for these occupations.

Fashion Promotion Careers

Popular fashion promotion careers include fashion writing, illustration, and photography for advertising and public relations. In the area of writing, jobs calling for fashion expertise can be found with retailers including catalog houses, large manufacturers, and sometimes with advertising agencies and fashion information services, as well as the media.

A beginning job is that of *copywriter,* responsible for the wording of advertisements and for other writing tasks. A four-year college degree with a strong communications background and fashion sense are requirements for copywriters. Depending on the organization, the path upward may lead to advertising manager or editor. Fashion illustrators and photographers work for these organizations, among others, and in addition to fashion backgrounds need training and expertise in art or photography.

Working in public relations generally requires a background in copywriting and deals with creating and implementing newsworthy events that can involve celebrities and the media. For more on fashion promotion careers, see the following section, Owning Your Own Business.

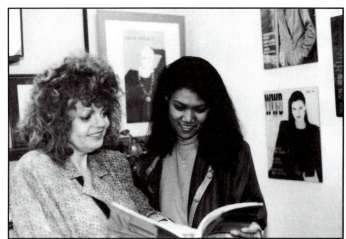

Figure 16-10.
Teaching fashion merchandising is a challenging and interesting career.

Teaching

The opportunity to teach courses in fashion merchandising and related subjects can be a personally rewarding career, although it may not pay as well as equally demanding fashion merchandising jobs. Fashion merchandising courses are offered in a number of high schools, community colleges and vocational schools, and four-year colleges and universities. Depending on the school, fashion courses are found in fashion merchandising departments or in the home economics or business management departments of the school.

To teach fashion courses in high school where they are often in the home economics department, a four-year college degree including preparation for teaching is a requirement in most states. Vocational schools typically require work experience in the field taught. Two- and four-year colleges look for teachers with Master's degrees, and many high schools prefer them. Universities require Doctorate degrees in an appropriate field.

The rewards of teaching include: the opportunity to work with many people and to help them learn; to see individual students grow and succeed; to conduct research and deepen your own understanding of a field of great interest; and when possible, to contribute to the expansion of knowledge in that field. Also, some teaching jobs can be done on a part-time basis and coordinate smoothly with other work or family obligations. Considering the drawbacks, like all other fashion-related occupations, teaching fashion is demanding and requires a great deal of energy in order to be done well. Earnings for equivalent work in private industry are often higher.

Owning Your Own Business

The greatest number of opportunities in fashion merchandising exist in owning a business. People who own and operate their own businesses are called **entrepreneurs.** The tradition and popularity of entrepreneurship in this country extend back to its

very first days, and for good reasons. Certainly, the rewards of business ownership are significant: being in charge, empowered to make decisions, and accountable to yourself; implementing changes swiftly; and most important, receiving the profit for your efforts. Business ownership is not without drawbacks, however: long hours and all kinds of hard work; reliance on yourself for all of the decisions, not a few of which could be fatal to the business; and no guarantee of a profit after all. Nevertheless, today most businesses in the United States are small, providing job opportunities and many very good incomes for a variety of people. (For a review of the forms of business ownership, see Chapter 4, Creating and Marketing Fashion.)

In addition to gaining an education, most business owners also recommend that before venturing into your own business, it is wise to obtain experience with another related company. The opportunity to work with an established organization lets a potential business owner see how things are done and later either put to use what she or he has learned or set up more profitable ways of doing things. For potential retail store owners, working for another retailer gives an opportunity to use established procedures and may include buying practice using someone else's money!

Three major areas of business ownership of particular interest to fashion merchandisers include retailing, wholesaling, and service organizations.

Retail

There are a variety of retail fashion organizations popular among entrepreneurs, including a wide range of apparel and accessories stores for men, women, and children, as well as catalogs and other direct mail operations. Schools and libraries can provide information about these businesses and many colleges offer courses covering topics such as retail organization, store operation, and direct mail. If one or more of these retail operations appeals to you, find out all you can about them, starting at school, talking with your teachers, and visiting the library to collect information; for example, on successful apparel stores.

To learn more about retail, or any other type of business operation, you may contact the nearest branch of the Small Business Administration (SBA), an agency of the federal government, to gather information. When your planning is much farther along, you may return to the SBA with a plan for your business and have it reviewed by an experienced volunteer business person. When you can, meet and talk with retail business owners about the advantages and disadvantages of owning a business.

When it comes to opening a business, particularly a retail business, you may have one of three choices. You may decide: to buy an existing independent business; to tie into a franchise organization; or to start from the very beginning. Each choice has its advantages and disadvantages.

The advantage of buying an existing business is that business is established and has a customer base; the disadvantage is that it may be hard to change if it is not as profitable as you believe it could be. The advantage of tying into a franchise—if the franchisor is reliable and has integrity—is that customers know the name and the

product such as Polo/Ralph Lauren. Also, the franchisor may help in matters such as site selection and store fixturing, executive training, and financing. (One note: Hiring an attorney to interpret for you any franchise agreement is essential to your eventual success and is well worth the investment.) The disadvantage of a franchise is its cost and the fact that earnings must be shared with the franchisor.

The advantage of starting a business from the very beginning is that it is your idea; you are responsible for its growth and success and stand to reap the eventual gains. The disadvantage is that you must create plans and guidelines on your own, without the resources available in either an established business or franchise. Many people, however, have their own original goals and by working hard realize them. (See the Business Spotlight on The Body Shop, founded by Anita Roddick, Chapter 10.)

Wholesale

There are two major categories of wholesale organizations: *agent wholesalers,* those who do not take title to or possession of the goods they sell; and *merchant wholesalers,* those who generally own the goods and sell them from a central location.

The work of agent wholesalers was described in the earlier section on wholesaling. Essentially, agent wholesalers (known also as manufacturers' agents) are independent business owners who sell the merchandise of noncompeting manufacturers to retail store customers in a certain geographic area, for example, six to eight dress lines in the same price range. Agents usually start out working in a showroom, progressing to field sales representative with a territory. Their challenge is to identify and keep profitable retail store customers and seek out and represent the best merchandise lines for those customers. The work is exciting, for each season brings new fashions and it can be highly rewarding financially; however, it is demanding, strenuous, and takes time to build the business.

A merchant wholesaler buys goods from a variety of manufacturers and markets them to retail store customers. These wholesale businesses are usually small and independently owned. Wholesalers of both types can specialize in domestic goods or imports and exports.

Service Businesses

There are many service businesses in fashion merchandising and with patience and persistence, they can be profitable. Often they may start as individual free-lancers (self-employed) with part-time assignments, but with success and persistence, they may grow into full-time businesses. For people with fashion merchandising interests, these service businesses are generally found in two major areas: promotion and merchandising. Popular opportunities in promotion include fashion styling, fashion show production, and visual merchandising. Opportunities in merchandising exist in buying and merchandising consulting.

SPOTLIGHT ON A FIRM

K MART CORPORATION

Who would have thought that today K mart Corporation stores—offspring of a variety store, the S. S. Kresge Company—would be realizing nearly half of their sales from apparel and fashion merchandise? Among the oldest of the nationwide discount organizations, K mart originally established its name for household and hardware items such as window shades, waste baskets, and drain stoppers.

While still selling a vast quantity of hard lines, today over 40 percent of each store's sales comes from apparel and other fashion goods. Total sales for the K mart Corporation, among them K mart stores, PACE membership warehouse stores, Pay Less Drug Stores, Waldenbooks, and the Sports Authority, amount to over $40 billion annually. The trend to fashion merchandise did not happen by chance.

Under the direction of Joseph E. Antonini, K mart's chairman, CEO, and president, K mart's fashion image and other changes have evolved. A company veteran of some 30 years' experience, Joseph Antonini, just out of college, joined K mart as a management trainee in Uniontown, Pennsylvania. Gaining 20 years' experience in store management and operations, he became president of the apparel division in 1984. Three years later he was promoted to head the corporation. Some of the recent changes and movement toward fashion forged by Antonini include:

- *Complete store renovation.* Early in the 1990s, K mart started on a six-year $3 billion store renovation program to modernize and enlarge its more than 2300 stores. The goals are to provide a brighter look and better merchandising layout, including faster checkout lanes, some equipped with Checkout Channel TV monitors featuring CNN news for customers in line. According to research, in the 1990s larger stores, from 70,000 to 148,000 square feet and capable of generating $250 in sales per-square-foot, are able to compete more effectively than the smaller traditional stores.

- *Electronics to speed communications.* Installing POS computerized cash registers, computer ordering systems such as QR, and a warehouse replenishment system facilitates inventory control and central buying, lowering costs to customers. With POS, authorizing customer credit takes seven seconds. A satellite communications system between headquarters and all stores permits Mr. Antonini to speak directly to employees. Other uses of the satellite system are to provide stores with a variety of information from the latest company financial data to training videos.

- *More emphasis on fashion.* There is a strong movement toward fashion with the K mart image; that is, colorful, casual apparel offering value for the money. Examples include increasing the Jaclyn Smith collection perhaps as much as 20 percent, expand-

continued

ing it to include in addition to day wear, intimate apparel and accessories such as handbags, jewelry, and sunglasses. Also, the fashion emphasis means adding more national brands in apparel, supplementing the lines already offered such as Brittania, Gitano, L. A. Gear, and L'Eggs. Another effort is to develop private labels selectively, for example. B. E. (standing for K mart's "Basic Editions" label), successful in women's casual sportswear including shorts and T-shirts, is now offered in men's, children's, and infant's wear.

By moving in these directions, many retailers believe that Joseph Antonini is responsible for bringing K mart out of the "Dark Ages" to face head-on the competition of discount heavy-hitters such as Wal-Mart and Target.

Question for Discussion. In what ways could Mr. Antonini's background and experience with K mart contribute to the corporate decision to emphasize fashion in the 1990s?

Sources. 1. David Moin, "K mart Sets a $3B Facelift," *WWD,* March 30, 1992, pp. 1, 6, and 7; 2. Isadore Barmash, "Down the Scale with the Major Chains," *The New York Times,* February 2, 1992, p. F 5; 3. Bill Saporito, "Is Wal-Mart Unstoppable?" *Fortune,* May 6, 1991, pp. 50–59; 4. Gary Robbins, "K mart Refines Format," *Stores,* September 1991, pp. 32–33; 5. Iris S. Rosenberg, "K mart Renewal Program on Track," *Op. cit.,* April 1991, pp. 18–21; 6. *K mart Annual Report 1990,* K mart Corporation, 3100 West Big Beaver Road, Troy, Michigan 48084.

Fashion Styling. Presenting the right fashion image in promotion is the work of the fashion stylist. The fashion stylist frequently works on a free-lance basis with advertising agencies and photographers to select, fit, and coordinate fashions for commercial advertisements for television or magazines. The stylist needs a background in fashion merchandising, an understanding of the advertiser's target audience, and an ability to bring together apparel and accessories to accomplish the goals of the advertisement. Some fashion stylists specialize as photo stylists and may be employed to work in a photographer's studio.

Fashion Show Production. Some businesses specialize in producing fashion shows for manufacturers and others who are interested in reaching a certain target market. Often both fashion show producers and stylists have gained fashion merchandising experience early on as models, an arduous but highly rewarding career for those people fortunate enough to meet fashion's rigid requirements. Fashion show producers assemble the garments and accessories to be shown, book the models, and choreograph and coordinate the fashion show. Their work is glamorous but calls for rapid-fire decision making and the ability to create the right effect.

Visual Merchandising. The work of visual merchandisers was described in this chapter's section on retailing. While some people in visual merchandising choose to stay with a large retail organization, others decide to strike out on their own. They may gather several medium- or small-sized retail stores as clients and work on a contractual basis to decorate the store windows and interiors at regular intervals. With luck and hard work, the visual merchandiser's client base grows.

Merchandising Consulting. Some successful fashion merchandisers go into business for themselves as consultants to other businesses. Consider, for example, the former women's ready-to-wear merchandise manager and the former accessories buyer for a medium-sized apparel store. These two women each had left retailing to raise their separate families, but as the children of each grew, the women sought to resume their careers. They both taught fashion merchandising and buying part-time at a local business college, and the business people around began asking them for advice. Soon they started a consulting service, helping store owners with buying plans and merchandising layouts. Before long, demand grew for their services and their business was on a solid footing.

Summary

1. People interested in fashion merchandising can find rewarding careers in a variety of organizations including retailing, wholesaling, manufacturing, auxiliary organizations, and in their own businesses. Popular entry jobs in retailing include stockperson, cashier, and salesperson. Some financially rewarding careers in retail sales can be found in salon selling, as a bridal consultant, or in the fine jewelry, shoe, and cosmetics departments.

2. Careers in retail merchandising as buyers are reached by working upward from jobs as head of stock, buyer's clerical, and assistant buyer. Department store and some specialty store buyers buy merchandise for specific departments such as coats and suits; they report to divisional merchandise managers who oversee the work of several buyers and who report to the general merchandise manager. Chain store buyers work from a central buying office and buy merchandise not by department but by category, such as sweaters or swimsuits. The entry jobs are merchandise planner/distributor, buyer's clerical, and assistant buyer. For potential merchandisers and managers alike (and the paths regularly cross) the retailer's executive training program for college graduates offers preparation and experience in both areas. Management jobs include assistant department manager, department manager, assistant store manager, and store manager. The related organizational divisions of store operations, human resources, and promotion, which includes visual merchandising, may hold opportunities to utilize fashion merchandising skills.

3. Careers in wholesaling include showroom assistant, field sales representative, and showroom manager. Opportunities with apparel, fabric, and fiber manufacturers include marketing positions such as account executive and product manager who work with customers and suppliers to provide the most suitable products, and marketing manager who oversees these efforts. Other careers include: manufacturer's representatives who sell to retailers; some apparel manufacturers also employ merchandise coordinators who work

with local retailers to be certain that the merchandise is effectively presented; and fashion directors who gather fashion information and develop fashion promotions for the manufacturer. The home sewing industry offers fashion-related careers in merchandising, promotion, and education.

4. Auxiliary organizations include buying offices, fashion promotion firms, and educational institutions. In buying organizations market representatives scout the suppliers to locate merchandise for store buyers, and fashion coordinators identify and promote fashion trends useful to local stores. Advertising and public relations call for communication skills as well as a fashion background. Teaching fashion merchandising requires a college degree and can be a satisfying although not a particularly financially rewarding career.

5. Owning one's own fashion business takes certain personal qualities beyond a fashion background; these include vision, steadfastness, and the ability to take risks. An individual may choose to buy and existing business, enter into a franchise agreement, or start up from the beginning. Many independent retail, wholesale, and service businesses are functioning successfully today; some of these are: fashion goods stores of all kinds; manufacturer's agents; fashion stylists; fashion show producers; visual merchandisers; and merchandising consultants.

Fashion Vocabulary

Explain each of the following terms; then use each term in a sentence.

account executive	entrepreneur	marketing manager
bridal consultant	fashion director	merchandise coordinator
buyer's clerical	field sales representative	merchandise planner/
buying plan	general merchandise	distributor
central buying office	manager	product managers
commission	head of stock	salon selling
divisional merchandise	leased departments	specification buying
managers	manufacturers' agent	

Fashion Review

1. Trace the career paths to general merchandise manager in retailing through three job levels in retail merchandising and three in management.
2. In wholesale apparel marketing, describe the work of the showroom assistant, field sales representative, and showroom manager.
3. In what three ways is the work of a fashion director for a retail organization similar to that of the fashion director for a manufacturer? How does it differ?
4. Explain three careers with auxiliary fashion organizations and describe the preparation necessary for each.

5. Describe three different kinds of fashion businesses that are independently owned. What are three or four personal qualities needed by entrepreneurs?

Fashion Activities

1. You have a good sense of fashion, strong persuasive skills, enjoy working with people, and are considering a career in sales. At this point you are deciding whether to aim for a sales position with a retail organization, a manufacturer, or to own your own sales organization as a manufacturer's agent. For each of these sales occupations, describe the work and state its advantages and disadvantages as they apply to you.
2. You are thinking that some day you may want to own your own fashion business. Explain the type of fashion business you would like to own. Then trace the preparation you would need in school and through work in other organizations. Draw a chart indicating the ideal progression of jobs you would like to take and the experience to be gleaned from each that would best equip you to run your own business.

Endnotes

1. *U.S. Statistical Abstract of 1991,* 111th edition, Bureau of the Census, U. S. Department of Commerce, Washington, D.C., 1991, Table 658, p. 401.
2. *Ibid.,* Table 1355, p. 770.
3. *Ibid.,* Table 719, p. 448.
4. *Occupational Outlook Handbook, 1990–91 edition,* U. S. Department of Labor, Bureau of Labor Statistics, Washington, D.C., 1990, p. 236.
5. *Macy's Careers, Portraits of Success,* R. H. Macy & Company, New York.
6. "Career Opportunities," Executive Recruitment Press Kit, Clothestime, 5325 East Hunter Avenue, Anaheim, CA 92807.
7. Oxford Industries Career Booklet, Oxford Industries, Atlanta, Georgia.
8. "Apparel Firm Can Be a Source of Satisfaction," *The Chicago Tribune,* Sunday, August 12, 1990, Section 8, p. 1.
9. Discussion with Jim Axelrad, Principal, Pakula Jewelry, Chicago, IL, March 4, 1992.
10. Job Description, Merchandise Coordinator, The Designer Group, 1290 Avenue of the Americas, New York, New York 10104.
11. Margaret Mazzaraco, "Du Pont: On the Sensuous Side," *Women's Wear Daily,* February 25, 1992, p. 14.
12. Stephanie Strom, "In the Grey '90's, Women Are Heading Back to the Bobbin," *The New York Times,* March 29, 1992, p. F10.
13. Nancy McCarthy Folse and Marilyn Henrion, *Careers in the Fashion Industry, What the Jobs Are and How to Get Them,* Harper & Row, New York, 1976, p. 63.

How to Start Building Your Career in Fashion

Objectives

After completing this chapter, you should be able to:

1. Assess your skills, abilities, motivations, interests, values, temperaments, experience, accomplishments, and work style.

2. Gather information about jobs and careers.

3. Develop career goals and objectives that are realistic and right for you.

4. Narrow your alternatives to specific job targeting.

5. Implement your career plans in ways that are realistic and rewarding.

6. Successfully manage the direction and timing of your career activities.

Jennifer Edmonds was born in New York City but moved to Massachusetts when she was 16 years old. She didn't want to move. She knew she would miss the Broadway shows, the wonderful shops on Fifth Avenue, and the unique art galleries in the Village, but she reasoned that she could always visit.

Following in her father's footsteps, she attended law school. Jennifer continued to visit her friends in New York City on the weekends. Upon graduating from law school, Jennifer took a job within her father's law firm. Her

starting salary was not bad for an entry level position. Her father gave her a raise every year, and by the third year, she was doing well financially. Jennifer had a good job, but something was missing; she felt a void in her life.

Jennifer felt trapped in her father's law firm, and so she decided to quit and return to New York.

Jennifer Edmonds had no idea what she wanted to do, so her friends helped her to set up some job interviews. After a few interviews, she took a job as a sales associate for a major department store. She reasoned that she could do tax preparation at home to supplement her income until she could find something better. After six months, she was promoted to department manager in children's wear.

The divisional merchandise manager noticed Jennifer's strong analytical skills, and soon promoted her to assistant buyer in domestics. There she learned how to fold towels and drape valances. Most of her day was spent on the floor straightening stock or up in the stockroom opening boxes of merchandise to take down to the main floor. Jennifer remained in that position for a year until she was finally promoted to buyer for the accessories department.

With an annual budget of about $24 million, Jennifer was very busy, selecting merchandise, writing and following up on orders, and negotiating with vendors. Her responsibilities also included developing ads for the store catalog, reading sales reports, and visiting manufacturers' showrooms. Jennifer worked long hours and was on her feet all day. By the end of the day she was exhausted. Twelve-hour work days made her put her social life on hold. Jennifer was feeling trapped again. She felt that her life was filled with disappointments. Jennifer had a good education, a good job, a wonderful salary, job security, and status, but something was wrong. Why wasn't she happy? Was this success? At this point in her life, Jennifer felt very dissatisfied. What went wrong?

Jennifer Edmonds never thought about the most important job in the world: career planning. A friend suggested that she meet with a career counselor. After a few counseling sessions, Jennifer was well on her way toward planning a career path. A year later, Jennifer was working with a manufacturing firm exporting fashion goods, a place where she could fully utilize her fashion knowledge and legal background. At last she had a career that she found satisfying and rewarding!

Introduction to Career Planning

Good jobs rarely, if ever, just fall out of the sky. At first Jennifer failed to realize the three P's of finding the right job: planning, perseverance, and patience. She failed to follow the necessary steps, which make the process of finding the right job easier and more rewarding. These factors are true whether you are looking for your first job, re-entering the labor market, trying to get a new job, or planning a mid-career change.

A career in fashion merchandising has become the goal of an increasingly large number of people of all ages.

In this changing and dynamic industry, there has been a rise and decline of many manufacturing and retailing organizations.

During slow times, companies cut operating costs and as a result employment opportunities are limited. The competition for retail management and executive positions is very intense.

In this highly competitive field, it is extremely important to compare personal attributes to job requirements to determine where the match is for your intended career.

The Role of Education in Determining Career Goals and Objectives

The best admission into fashion merchandising occupations is a combination of formal education and work experience. Some high schools offer vocational programs that can provide training and work experience.

Various colleges offer two-year and four-year programs. These programs feature preparatory curriculums and provide broad-based skills relating to research, analysis, and communication.

As a student, you will spend many hours preparing yourself to pursue a career in fashion. You have selected courses that you need for your degree and you have a faculty advisor who helps you plan your class schedule each term to ensure that you complete the appropriate course of study within a specific time.

Figures 17-1a, b, c, and d. College fashion students are offered a variety of design and merchandising programs in order to select the right career choice.

You have developed and implemented an educational plan, but what about career planning? Have you mapped out the details of what you want to do, how, where, and when you want to do it? Few people can answer these questions affirmatively. If you can, that's great. Unfortunately, most people can only say that they want to get a good job and when asked how they plan to go about getting a specific position, they're unable to give clear details. They may have short-term and long-term goals, but no specific plan of action.

Career planning is long-term, and not as simple as educational planning, which is usually a short-term process. No one can give you a clearly defined map that shows the specific paths that will absolutely guarantee success. Instead, people look at their careers in terms of dreams and desires. They dream about the glamour, money, and travel that a fashion career can offer and hope that everything will just magically happen. This is the greatest mistake made by many first-time job seekers. They give little thought to the actual position sought, the future of the position, and the meshing of their personal needs with those offered by a position or employer. Their actions lead to disappointment, and oftentimes to being fired. Or, like Jennifer, they find themselves changing jobs frequently, creating a negative impression in the eyes of potential employers.

This chapter focuses on career planning, a subject that concerns 70 percent of your life, your identity as a person, your physical and mental health, and quite literally your survival. It focuses specifically on planning your fashion career in today's challenging economy and job market. It is designed to serve as your guide to the process of finding a job in an exciting but competitive business.

It starts off with the basics of conducting a self-analysis to determine who you are and what you want out of life. The purpose is to encourage you to think seriously about what you like to do. Knowing what you want will help you define your career goals. A **career goal** is your occupational aim or objective in life and it may be expected to change through your various work experiences and aspirations. Planning for your career goal takes you through a number of steps that will help you work out a strategy to achieve your objective. It will also suggest ways that you can take advantage of resources and opportunities, which can help you achieve your goals.

You will learn how to plan and build a career in fashion merchandising aimed to make work a happier, better, and more rewarding experience for you. By developing a map or plan of action, you will find the joy that comes with the sure feeling that you are doing all that you can to identify and pursue a career in fashion merchandising.

Career Planning

What is a career? How is it different from an occupation or a job? A **career** is one's professional progress or course through life; one's total life's work. It involves finding an occupation in a field that uses skills you enjoy, in ways that fit and express your personality, and in jobs and surroundings you find exciting, satisfying, and rewarding. It is a blend of you and your work.

Taking charge of your fashion merchandising career is an exciting process of making choices that will continue throughout your life. A career may completely

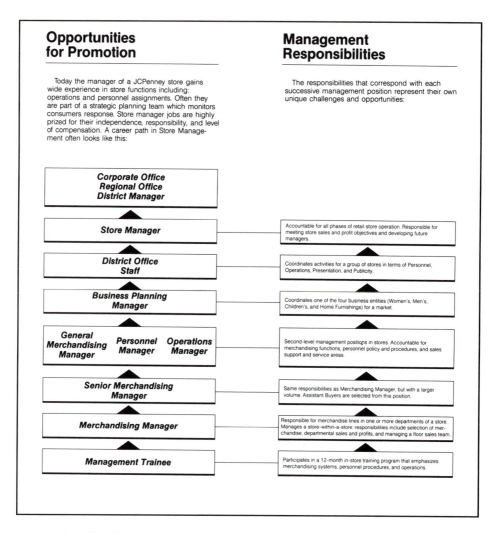

Opportunities for Promotion

Today the manager of a JCPenney store gains wide experience in store functions including: operations and personnel assignments. Often they are part of a strategic planning team which monitors consumers response. Store manager jobs are highly prized for their independence, responsibility, and level of compensation. A career path in Store Management often looks like this:

- **Corporate Office / Regional Office / District Manager**
- **Store Manager**
- **District Office Staff**
- **Business Planning Manager**
- **General Merchandising Manager / Personnel Manager / Operations Manager**
- **Senior Merchandising Manager**
- **Merchandising Manager**
- **Management Trainee**

Management Responsibilities

The responsibilities that correspond with each successive management position represent their own unique challenges and opportunities:

- Accountable for all phases of retail store operation. Responsible for meeting store sales and profit objectives and developing future managers.
- Coordinates activities for a group of stores in terms of Personnel, Operations, Presentation, and Publicity.
- Coordinates one of the four business entities (Women's, Men's, Children's, and Home Furnishings) for a market.
- Second-level management positions in stores. Accountable for merchandising functions, personnel policy and procedures, and sales support and service areas.
- Same responsibilities as Merchandising Manager, but with a larger volume. Assistant Buyers are selected from this position.
- Responsible for merchandise lines in one or more departments of a store. Manages a store-within-a-store: responsibilities include selection of merchandise, departmental sales and profits, and managing a floor sales team.
- Participates in a 12-month in-store training program that emphasizes merchandising systems, personnel procedures, and operations.

Figure 17-2. This chart shows a career path in retail store management. (Courtesy J. C. Penney, Inc.)

unfold within one organization, or with different types of work and various employers. Thus, a career spans a working life that may involve one occupation or several, in which a person can hold one or a sequence of jobs. For example, there are many opportunities within a retailing organization.

What is **career planning?** It is planning or mapping out your professional progress through life. It involves planning a career path that is the way of advancement within a given occupational field. Like a map, it gives you a sense of direction. Like a quarterback in a big football game, you will have to plan some long-term strategies in order to score well. It involves developing a plan of action or strategy of what you want to do, how you want to do it, and where you want to do it. Career planning is quite different from choosing an occupation or job.

An **occupation** is one's principal livelihood or vocation. More people today change occupations during their working lives than ever before. Individuals usually identify themselves in occupational terms: student, teacher, doctor, lawyer, engineer, and manager. In fact, there are over 20,000 occupational titles. A **job** is a position of employment within an occupation involving related tasks or duties. It is a particular kind of work in a given occupation. A person will probably have a succession of jobs within the same occupation. An example of an occupation is fashion buying. Specific fashion buying jobs include assistant buyer and buyer.

A **position** is made up of the different duties and responsibilities performed by only one person.[1] Classified advertisements and position announcements usually describe the duties and responsibilities of various positions.

Before you begin your job search, you must realize that there is no one ultimately perfect job for you. Real success can be measured by having an enjoyable job that works for you and one that meets your needs.

One of the mistakes that individuals make in their search for employment within the fashion industry is that they automatically seek out a particular job title that fits how they ultimately view themselves. They may turn down a position because of its title when the position may actually be more satisfying and rewarding for them.

There are many misconceptions about certain jobs within the industry. For example, many students want to be a fashion buyer, for say misses' sportswear, but they may not have an accurate picture of the realities of the position, what values it holds for them, and what its costs are. They may have pursued the field because it was attractive, glamorous, or popular at the time. They don't realize that a buyer has to be analytical, independent, and good with numbers. Buyers also deal with a tremendous amount of paper work.

After working long hours under intense pressure they may wake up one day and ask themselves, "What on earth am I doing here? This is not what I really wanted!" After working for a period of time in the position, they may feel that it is too late in their career to make a change. With bills to pay, they continue to work in a job that bores them, and they fail to realize that it is not too late to make a change.

Figure 17-3. Fashion buying positions are a popular career choice. Before pursuing any fashion career, know every facet of the position and how it fits with your goals.

No job title is ever going to describe who you really are, therefore you are not, nor will you ever be, your job title.[2] As you begin your career, and periodically throughout your career, you will need to conduct a self-analysis to determine just who you are and what you have to offer a potential employer. A self-analysis of your skills, motivations, and abilities will help you become a realistic rather than unrealistic job seeker.

Conducting a Self-Analysis

Ask yourself the following questions:
- Who are you?
- What do you like to do?
- Do you like to help people?
- Do you enjoy working with computers?
- Can you handle numbers and other facts?
- Can you plan, organize, and control the work of others?

An essential part of career planning is self-exploration. Self-exploration means acquiring self-knowledge. Your first task in developing your career is to gain a better understanding of yourself. To acquire self-knowledge, you have to evaluate yourself and determine who you really are and what your needs are. You have to take a close look at your interests, skills, and values so that you can make suitable and satisfying career choices. You have to determine your personality characteristics: your distinctive individual qualities considered collectively. You have to begin by gathering as much information about yourself as you can.

By doing so, you can match your strong points with an employer's requirements. This will also enable you to explore, as well as eliminate, job possibilities before you make your final choices. Like any other career, your chances of success in fashion merchandising are only good if fashion merchandising is good for you.

In addition to enabling you to make wise career choices, understanding yourself will allow you to present the best side of yourself to an employer. You will also be in a better position to market your skills to a prospective employer. It would be very difficult to convey your strengths to an employer without thoroughly understanding your own strong points. You know more about yourself than anyone else does and therefore you are the most qualified to market your skills and abilities. So ask yourself, "Who am I and what do I have to offer?"

Making an honest self-analysis is challenging and one of the most difficult things you will do in life. It is only by making an honest assessment of yourself that you can make accurate judgments about your occupational prospects. Self-knowledge will therefore help you to begin to make the best possible choices in planning your fashion merchandising career. Like an artist choosing and mixing colors from a palette, you can choose from the data on the following pages to create your own self-portrait.

Assessing Your Skills and Abilities

Skills are the talents, gifts, aptitudes, and abilities that you use in the workplace, as well as your personal life. Specific skills will help you to accomplish specific tasks.

They are the most basic unit of your life in the world of work. In order to develop a career plan, you must first identify your skills. Skills can be organized into two groups, soft skills and hard skills.

Soft Skills. Functional skills that are transferable from one occupation to another are called **soft skills.** Associated with numerous job settings, soft skills are mainly acquired through experience rather than formal training, and can be communicated through a general vocabulary.[3] Soft skills have become increasingly valuable in today's job market. Many career experts agree that the job market is moving from the specialist who is soon obsolete to the generalists who can adapt.[4]

Some authorities feel that you need to have a specialty to get a good job, but if you're a specialist you run the risk of obsolescence. **Obsolescence** on the job means being out-of-date and behind the times. The way to avoid obsolescence is to continue upgrading your specialty. Keep an eye on what is happening in the field, and where the growth and changes are happening. One way you can keep expanding your knowledge is by reading trade journals and books.[5]

Another way is through work-sponsored meetings and programs. Employers often provide training programs to help refine general skills such as organizing, managing, and communicating. Some companies offer training and development programs that cover the following areas: basic leadership skills, such as management style, presentation skills, analysis, and planning; interpersonal and communication skills; and mentoring and coaching techniques.

Hard Skills. Work-content skills that may not transfer totally from one occupation to another are known as **hard skills.** More technical in nature, hard skills are often identified as qualifications for specific jobs. They usually require formal training and are therefore the subject of most educational and training programs. They are critical for entering and advancing within certain occupations and include:

- typing/word processing
- bookkeeping
- shorthand/steno
- computer skills
- artistic/graphic skills
- machine operation skills
- accounting skills
- physical strength/energy

Skill Categories Classified. In addition, many businesses and the government classify job skills according to three major categories. For example, *The Dictionary of Occupational Titles,* a government publication, is based on the premise that "Every job requires a worker to function in relation to data, people, and things in varying degrees."[6]

Different sets of skills are made up of these three elements:

1. working with people
2. working with information or data
3. working with things

Most jobs call for combining all three elements.

For example, management involves the management of resources (things), procedures (data), and employees (people). Table 17-1 shows some specific positions and their involvement with these three major categories.

Table 17-1 Requirements of Selected Positions in the Fashion Field

Assistant Store Manager

Data—high interest. Managers use facts and figures to make many decisions each day. To reach these decisions, they spend much time studying data.

People—medium interest. Managers work with people to get the facts and figures they need. They also direct people who carry out their work plans.

Things—low interest. Managers do not have much time to check, report on, or work with things. They must count on other people to do this work.

Assistant Buyer Trainee

People—average interest. Good communication skills are important. Schedules appointments; may involve a lot of telephone work.

Data—high interest. Keeps unit control records; places reorders; follows up on shipments. Requires excellent clerical and computer skills, a solid math aptitude, and ability to analyze data and make sound business judgments.

Things—low interest. May accompany buyer to market, and do follow-up tasks with buyer.

Showroom Sales Trainee

People—high interest. Reception, greets and sells the line to clients, deals with buyers in person and on the phone, previous sales experience most helpful.

Data—high interest. Keeps sales records, faxes, follows up on deliveries, writes up orders.

Things—average interest. May be responsible for showing or modelling the line.

Personal Planning

Another side of planning is personal planning, which deals with your career in terms of financial needs, social expectations, place of employment, and the benefits that you require. It also deals with your values and the overall feelings about yourself in relation to your position. Personal planning involves assessing your personal strengths and answering the following questions:

- What types of work activities and environment appeal to me?
- Do I like to travel? Set hours?
- Do I want to work out of doors?
- Do I prefer to work by myself, on my own, or with others?
- What standard of living do I wish to maintain?
- What salary do I need to meet my financial obligations?
- Considering my financial goals and the time available, can I maintain my social life?
- What location best suits my needs?
- What benefits offered by the employer are important to me?
- What management style best suits my personality?

Self-Management Skills

The previous list of skills focuses on interaction with areas outside of you—data, people, and things. The following list focuses on the internal you—your motivations, temperament, and interests. It reflects your own style of personal management and living. By understanding yourself, you can relate your personality to various career options.

Values, another attribute of personality, are pertinent in career planning and are a critical determinant of career satisfaction. The term **values** refers to those things that you consider to be important, excellent, or desirable. They are the things, ideas, beliefs, or standards that you believe in. For example, some people may value status, recognition, or prestige while others may value free time to spend with family over a high salary. Some values that represent the various types of satisfactions obtainable from work include:

- friendship
- team work
- cooperation/competition with others
- decision making
- supervising others
- work with details
- helping others
- contributing to society
- working alone
- challenging work
- variety of assignment
- intellectual stimulation
- people/public contact
- self-expression
- status/recognition/prestige
- learning opportunities
- interesting co-workers
- advancement/achievement
- degree of risk/degree of reward
- influencing/persuading others

You may change your ideas and values as a result of the additional information that you receive through your life experiences. This ongoing list will give you more and more information to work with in evaluating potential jobs.

Work Styles and Career Environment Options

Besides skills and personality strengths, you also need to consider your preferences for work environments. By examining career environment options and identifying those you want, you gain direction for your career search. Career environment options can be:

- people oriented
- data oriented
- manual or physical
- organized or systematic
- fast/slow paced
- high/low pressured
- regular/flexible schedule
- physically active
- full-time/part-time
- traveling
- indoor/outdoor
- quiet/noisy
- stable/constantly changing environment
- urban or suburban setting
- working with hands
- working with numbers
- working with machines or equipment
- pleasant working conditions

Seems like too much work? Well, people typically resist looking very long and hard at themselves. Don't be afraid to challenge your self-image; it's well worth it. In addition, don't let your own beliefs or outside influences shortchange or undercut

yourself. Parents or friends may try to discourage you with their views of the industry, by saying it's too risky and competitive.

False expectations and misconceptions can be a roadblock between you and a successful career. For example the media, newspapers, and fashion magazines focus on the glitzy glamour of the fashion industry, not the hard work and long hours.

Developing Career Goals and Objectives

To succeed in a career you must draw a fine line between false expectations and a positive sense of possibilities. This will help you to grow, become more conscious, and will ultimately lead to success and satisfaction. There can be immense payoffs, but you have to do the work. You have got to get to know what you want and go out to get it. Identify what you do and don't like, what skills you do and don't have, and how you can make a contribution in the world of fashion. Qualities crucial to career planning include:

- commitment to your goal
- dedication in your efforts to reach that goal
- persistence in pursuing your goal

After you have committed yourself to the career planning process, the next step involves setting goals and objectives. This step will further help you to chart your own future.

Exploring Occupational Interests

Where do you want to use your skills? How do you learn about fashion merchandising occupations? In order to establish career goals, it is most helpful to gather information and learn as much as possible about this field of work. This knowledge will help you begin to make the best possible choices in planning your career. There are several resources for obtaining occupational information. These include libraries, professional trade organizations, informational interviews, and internships.

Libraries. Libraries provide an excellent source of career information about the fashion industry as a whole and about key companies and people within the industry. One of the best ways to find information is to locate recent articles published in fashion magazines and business and trade

Figure 17-4. Libraries provide an excellent source of career information. (Courtesy Fordham University)

SPOTLIGHT ON A FIRM

NORDSTROM, INC.

As shoppers browse leisurely from store to store at one end of the mall, a moving crew is busy at the other end unloading plush furniture, store fixtures, and a Steinway baby grand piano into a newly finished store.

The chatter of people assembling clothes racks, arranging furniture, and unpacking boxes of high-quality merchandise echoes throughout the lavishly decorated store.

In a nearby room, a department manager conducts an orientation session for a group of eager and bright-eyed sales trainees.

In the shoe department, a salesperson helps workers arrange 125,000 pairs of shoes in sizes 3 to 13 and AA to EE, so that everything will be ready for opening day.

A black-tie gala benefit dinner and designer fashion show the night before the grand opening is still to come. In addition, there are over 100 special events scheduled during the first two months of operation including special appearances of famous fashion designers, sports celebrities, and entertainers.

These activities make quite an impression to shoppers in the mall. They soon realize that this is not

just another store opening. . . . Nordstrom, the nearly hundred year-old Seattle-based retailer is coming to town.

How did this once-modest chain of shoe stores become such a retailing giant?

In the late 1880s, 16-year-old John W. Nordstrom left northern Sweden for the United States, with a small inheritance from his father, and his first real suit of clothes. He arrived in New York two weeks later with five dollars in his pocket, unable to speak a word of English, but with a strong desire and determination to succeed.

After laboring for two years in California mines and logging camps he settled down in Seattle, Washington, where he eagerly accepted the opportunity to go into business with Carl Wallin, a Seattle shoemaker.

Together they opened their first Seattle-based store in 1901. The first day's receipts of the shoe store came to $12.50, but profits grew quickly and in 1923, they expanded into a second outlet.

By 1933, Nordstrom's three sons took over the business and built it into the nation's largest independent shoe-store chain with 21 stores or leased departments in the Pacific Northwest states of Washington, Oregon, and Seattle.

In the 1960s, the brothers expanded into the apparel business with mergers and acquisitions,

continued

which further spread the Nordstrom name throughout West Coast malls and other shopping districts.

Today a third generation of Nordstroms, Bruce, James, and John, plus a son-in-law, Jack McMillian, and a friend, Robert Dender, run the company as it expands into major markets across the United States. Plus, the company has grown from a $30 million to a more than $3 billion operation with the same executive management leading the company. Today, Nordstrom has 63 stores in seven states, with sales in 1992 that neared $3.5 billion.

Today's Nordstrom offers a large selection of high-quality fashion apparel and shoes for men, women, and children, which includes contemporary classics to exclusive couture designs. Merchandise for women alone, found in some 28 apparel and accessories departments, accounts for 59 percent of company volume.

Although Nordstrom stocks everything from opulent evening gowns to gourmet pantry food items, there are no housewares or domestics departments. Instead, there is a major focus on huge shoe and clothing selections.

Like the earlier stores, the company continues to allocate unusually large inventories and floor space to its shoe departments. Nordstrom stocks over three-and-a-half million pairs of shoes, that if stacked in their boxes would make 33 stacks the size of Mt. Everest!

Although perceived as high-quality, Nordstrom has something for nearly everybody. For example, it offers shoes ranging in price levels from moderate to designer.

If John W. Nordstrom were here today, he would be amazed to see what his modest shoe store has become. Despite the modern and efficient business practices and buildings, the firm's success can be attributed to the founder's original philosophy: "Offer the customer the best service, selection, quality and value."

Although the size of the business has changed dramatically, many of the same operating principles set forth in the early years as a shoe store still guide the company to this day. At Nordstrom, quality goes hand in hand with value.

Decentralized buying has proven to be a major advantage for Nordstrom. Most competitors use cost-effective centralized buying systems, where all buyers are based in one location. Although decentralized buying costs more than a centralized system, Nordstrom can afford this expensive buying system because its sales average $370 per square foot versus the industry average of $160 per square foot. For example, Nordstrom's suburban store in Oak Brook, Illinois, is the only department store in the Chicago market with a locally based buying staff. In this location, buyers can respond to the sensitive needs of the marketplace. They are encour-

aged to respond immediately to customer requests and place orders with vendors directly rather than depend on a distant bureaucracy.

The average buyer spends about 20 hours a week of invaluable time working on the selling floor helping customers in order to learn what these shoppers want.

Before a new store opens, buyers and managers spend months scouting markets, determining the target customers to whom they'll be catering, and trying to learn what they want. For example, a shoe buyer may spend hours just looking at people's feet and researching what competitive stores are selling. These findings are used to make sure the new store will offer exactly what the local customers want.

What is Nordstrom's key to winning customers in new markets? The company is renowned for its extensive customer service, which has won customer loyalty and affection.

Salespersons or "Nordies" are known worldwide for their downright fanatical attention and devotion to outstanding customer service. A Nordie is trained quite differently from other salespeople. As a result, examples of "Nordie" salesperson heroics include:

- How a salesperson let a customer return a set of snow tires although the store didn't sell them.
- How the company paid for the repainting of a shopper's

car that had been scratched while she browsed in the store.

- How one shopper purchased Easter gifts and mailed them to her children in other parts of the country. The gifts did not arrive until the Monday after Easter. After she complained, Nordstrom refunded the price of the gifts and also sent her flowers to apologize.

Salespersons are encouraged to write personalized thank you notes, send flowers or candy to good customers, and to make last minute home deliveries to customers if necessary (e.g., on Christmas Eve).

Nordstrom has built its success on the belief that enthusiastic employees build sales, and the company measures its worth by the effectiveness of its sales force. Superior customer service is fostered by an aggressive sales motivation program. Salespersons are compensated on a commission basis and successful employees are awarded recognition and financial incentives.

In the future, Nordstrom is expected to continue as a major retailing giant, with 80 stores and expected sales of more than $45 billion by 1995. The company planned to open six stores in 1993 and 1994, for a total of 20 new stores in 13 states within five years.

Question for Discussion. In what ways does Nordstrom position itself to serve its targeted customers effectively?

Sources. 1. Dori Jones Yang and Laura Zinn, "Will 'The Nordstrom Way' Travel Well?," *Business Week,* Sept. 3, 1990, p. 82; 2. "Nordstrom Plans Six Units, Creates Office of President," *Women's Wear Daily,* May 21, 1991, p. 3; 3. "About the Company," Nordstrom information bulletin #0256z, Nov. 26, 1990; 4. Rita Koselka, "Fading into History," *Forbes,* August 19, 1991, p. 70; 5. "Retailing's Golden Rules," *U. S. News and World Report,* March 12, 1990, p. 19; 6. Robert Cross, "A Nice Touch," *The Chicago Tribune,* April 3, 1991, p. 5; 7. Sandra Jones, "Nordstrom Nears Midwest Debut," *WWD,* April 3, 1991, p. 19; 8. Robert Sharoff, "Oak Brook Unit Opens Friday," *WWD,* April 10, 1991, p. 24; 9. Cyndee Miller, "Labor Strife Clouds Store's Service Policy," *Marketing News,* May 28, 1990, p. 1; 10. Lisa Collins, "When Nordstrom Comes to Town," *Crain's Chicago Business,* March 11, 1991, p. 1; 11. Stephanie Della Caagna, "The Invasion of the Nordies," *New England Business,* Jan. 1990, p. 24; 12. *Nordstrom Annual Report 1989,* Nordstrom Inc., 1990, pp. 8–9.

periodicals. The *Reader's Guide to Periodical Literature* is a familiar index used for this purpose; however, most libraries now have more powerful and advanced computerized systems for uncovering published articles. The most popular system is called *InfoTrak,* which indexes tens of thousands of articles.

If you need information about a particular company, such as its name and address, phone number, and the names and titles of key top executives, there are a number of excellent reference books designed for this purpose. The most popular ones are:

Dun's Million Dollar Directory
Standard and Poor's Register
Ward's Business Directory
America's Corporate Families

Not all companies are listed in these directories. For example, *Dun's* only lists companies worth $500,000 or more. Local regions often publish their own directories for certain regions of the state.

Another reference book is called *Directories in Print,* a directory of directories. It identifies what directories exist and how to obtain them.

Some additional resources that libraries provide include:

- Encyclopedias
- Journals
- Books
- Monographs
- Audio-visual aids (films, tapes, slides, etc.)

Professional Trade Organizations. Professional trade organizations are nonprofit groups that provide knowledge and facts about a particular industry. One of the main objectives of professional trade organizations is to help spread information and knowledge about specific topics. For example, you may want to contact the National Retail Federation to find specific information on occupations within the industry, research those occupations, and then make contacts through members of that organization. (See Appendix C, Leading Trade Associations.)

Informational Interviews. One of the most valuable sources of information is people. It is important to contact people who have a knowledge of the field. This would involve speaking informally to anyone with experience, knowledge, or expertise within the field including people in the industry, preferably in the job you are researching. Other sources include business executives, teachers, authors, association staffers, industry analysts, and government personnel.

Informational interviewing will allow you to:

- Ask specific questions and obtain customized information.
- Obtain up-to-the-minute facts and information.
- Get real opinions and candid comments.

Don't be intimidated about presenting your questions, either in person or over the telephone. Time permitting, most people do not mind sharing their knowledge with those who have an interest in the field.

Internships. It is one thing to study fashion merchandising and quite another to be able to perform successfully in it.

An **internship** can serve as your first and a vital link to the professional work force. Internships help prepare you for your career and provide contacts in the field, which may lead to a full-time job offer. They also show you what the real world is like and demonstrate the skills and responsibilities required in a specific entry level job.

Many companies and organizations have structured internship programs. If you are interested in an internship, you may have to secure one through your own initiative by contacting the human resources departments of large organizations or the managers of smaller stores. Most applications require a cover letter and résumé. Many internship programs are listed in the following publications:

Career Press
62 Beverly Road, P.O. Box 34
Hawthorne, NJ 07507
1-800-CAREER-1

Peterson's Internships
202 Carnegie Center
P.O. Box 2123
Princeton, NJ 08543
1-800-225-0261

Figure 17-5. Many companies have internship programs. (Courtesy J. C. Penney, Inc.)

Internships provide a prospective employer with evidence that an applicant is acquainted with work procedures and wants to work full time in that field. A combination of successful work experience and formal education frequently enables an applicant to command a higher salary and a position of greater responsibility than people who lack these qualifications.

Implementing Your Career Plans

Richard Bolles in his popular book, *What Color Is Your Parachute?,* states, "In order to hunt for your ideal job, or even something close to your ideal job, you must have a picture of it in your head. The clearer the picture, the easier it will be to hunt for it."[7]

The previous sections of this chapter served as a guide to help you draw that picture.

Now match your strong points with those required by certain careers. For example, many students enrolled in fashion merchandising courses want to become retail buyers. If you fall into this category, you may want to determine whether you are suited to this position.

You must arrive at some tentative or definite conclusion about your career direction. Start examining your past, present, and future. Next, develop a realistic objective. Determine what you want to do and what you have to offer.

JEFFREY BANKS

"**W**hen I was 11 years old, I knew I wanted to be a designer," says Jeffrey Banks, the youngest designer ever to receive fashion's coveted Coty Award.

Jeffrey Banks became interested in fashion at an early age. He was fascinated by the fashion photographs featured in *Vogue* magazine. While in high school, his interest in art and fashion continued, and in 1967, at age 15, he started his first job as a clerk at an elegant clothier, Britches of Georgetown, Washington, D. C.

"I decided early on," says Banks, "that if I became a serious artist, I might have to wait my entire life for some recognition. Designing clothes was a way of getting instant recognition." Impressed by Banks' hard work and sense of design, the owners of Britches introduced him to Ralph Lauren, who took on Banks as his assistant in 1971, at the age of 19.

While working for his mentor, Ralph Lauren, Jeffrey Banks studied for the next four years at two prestigious design schools, Brooklyn's Pratt Institute and Manhattan's Parsons School of Design, where he graduated.

> *"I decided early on that if I became a serious artist, I might have to wait my entire life for some recognition. Designing clothes was a way of getting instant recognition."*
> *Jeffrey Banks*

Later, he started working for Calvin Klein, where the emphasis was on designing women's clothes. He soon realized that the industry was saturated with women's wear designers, so Banks began to focus his attention on men's wear. "There are more imitations [in men's wear]," he says, "but if you're good, you can make your mark."

Jeffrey Banks started to make his mark in the mid-1970s when the men's sportswear market was just beginning to boom. Banks, now working for other well-known designers, began to develop his own style, and his reputation, designing shirts, sweaters, and ties. In 1977, he won his first Coty Award for his first collection of men's furs.

In 1981, he was approached by Steve Eisendrath, Executive Vice President of Merona Sport, a fledgling Westport, Connecticut-based sportswear company with its own stores. Eisendrath asked Banks to design a new collection. This highly successful collection prompted Eisendrath to reorganize Merona into a design company, which was then sold to Oxford Industries.

Oxford Industries at the time was primarily a manufacturer of moderately priced private label goods sold at J. C. Penney, Sears, and other large chains. In 1978, Oxford picked up a license to produce Lauren's Polo sportswear for boys and was looking for other high-end licenses to boost its margins. Jeffrey Banks' men's wear line fit the bill. In 1982, he won his second Coty Award for his men's wear collection.

In 1981, he was named designer for Merona, which won him a spot on the cover of *Women's Wear Daily* and praises from fashion editors of *The New York Times*. This entrepreneurial, young, African-American designer, soon ranked third in men's wear sales only to such long-established figures as Ralph Lauren and Perry Ellis. What may have seemed like overnight success moved him right into the limelight along with top designers such as Bill Blass and John Weitz.

Besides earning revenues from Oxford for the men's wear and Merona Sport lines, in 1984 Banks earned royalties from five other licensees, including two in Japan. Jeffrey Banks, Ltd., his flourishing holding company earned an income of about $2.5 million a year.

A still young Jeffrey Banks has managed to build a strong reputation and acquire a large fortune through the men's wear industry. He is well known for his traditional, young-spirited designs that create an image of timeless elegance. His signature look combines the elements of American pop, as seen in his favorite Fred Astaire movies.

He gains inspiration for his classic yet flawless designs form his first love, fashion photography. "I've loved fashion photography ever since I was a kid growing up in Washington, D. C.," he says. "The point is, really fashionable people have their own style. Chanel had it, Cary Grant had it, Gary Cooper and Fred Astaire had it. Astaire wore pink socks and Gucci loafers in 1957, when people didn't even know what a Gucci loafer was! Now that's what I call style!"

Jeffrey Banks designer's eye for timeless fashion photography can be seen in the creation of his men's wear, but it is most apparent in his collection of over 300 black-and-white photographs, which chronicle over 50 years of fashion design. Although most of this collection focuses on fashion, a large portion of the photographs are memorable portraits of well-known film stars, writers, or fashion designers photographed in the 30s, 40s, and 50s by such masters as Steichen, Hoyningen-Huene, and Horst.

These photographs strongly influence his own designs. "Many of the clothes that you see the sitters wearing in the famous photographs have had an influence on my own designs," says Jeffrey as he views a portrait of Chanel taken by Horst. "There's a timelessness about them."

Question for Discussion. In your opinion, what personal characteristics account for Jeffrey Banks' business success in addition to his success as a designer?

Sources. 1. Stephen Kindel, "A License to Make Money," *Forbes,* December 3, 1984, pp. 153–158; 2. John Gruen, "The Designer's Eye for Timeless Fashion Photography," *Architectural Digest,* September, 1989, pp. 78–84.

Managing the Direction and Timing of Your Career

After you have set goals for yourself and have established your career plan, you have to decide on the steps necessary to achieve these goals. The next step is reaching your goals.

David McClelland, a psychologist, has identified four guidelines for reaching your goals.[8] They fall in line with these general steps.

1. Set short-term goals to reach long-term goals.
2. Study and imitate people who have reached the goal you want.

3. Think of yourself as a person who enjoys the challenge and responsibility of reaching the goal.

4. Think positively. Do not let thoughts of "I can't" stand in your way.

You must establish times when you will review your progress objectively. You should not try to plan your entire career at one time. This task would probably be so overwhelming that you would panic at the mere thought of 40 years of work. Instead, consider your career in more controllable terms. Reduce your 40-year working career into five-year terms and deal first with that current time frame.

Set goals that are realistic and achievable during this period. Review your goals and achievements at least once a year just to make sure you are still on target with your plans.

These five-year goals make up your career path in that they represent a logical progression from position to position over a period of time. As a first position, for example, you may accept a job as a sales associate in a wholesale showroom, with the short-term goal of becoming a sales representative in three years and becoming a manager in five years. With this goal in mind, you can plan your career accordingly. For example, while in school, you may work part-time in retail sales or assist in a market to get additional sales experience. You may also take additional classes to sharpen your computer skills and to acquire more transferable hard skills.

Job Targeting

Job targeting is a process in which you look at all of your personal purposes, goals, and capabilities, and then choose specific work areas that will best satisfy them. Establish a particular job target that will reflect who you are and what you seek. With self-understanding, you now have a "wish list" in mind for your fashion career.

Planning Alternatives

As your personality and environment continue to change, your job or occupation may also change. For example, you may get married later on in your life and an occupation in a high level of management may be so demanding that very little time is left to nurture family relationships. Therefore, you may need to change your occupation if you want to spend more time with your family, or you may want to move out of state and seek another position. You must therefore generate alternatives by developing a list of other occupational and job prospects.

Do not feel that there is only one occupation that is right for you. There are always several directions you might take that would lead to a satisfying career.

Also, do not think that once you get your dream job that career planning is over. Your ideal job is only valuable in terms of the sense of direction that it provides. It is important to periodically (at least annually) take a fresh look at your job, update your credentials, check how you are doing against a career plan, analyze the direction and values of your employer, and stay in touch with colleagues in other firms.

Chapter 18 will focus on developing skills that are necessary for conducting a job search.

Summary

1. A career is different from an occupation or job in that a career is your total life's work. Like a map, it gives you a sense of direction. A career is long-term and may completely unfold in one organization or with different types of jobs with various employers.

2. Career planning involves finding an exciting, satisfying, and rewarding occupation that you enjoy and that utilizes skills in a way that fits your personality.

3. An occupation is one's business, vocation, or trade. Occupational interests are attractions you have toward a particular line of work. Individuals usually change occupations during their career and are typically identified by their occupational title (e.g., buyer, store manager, etc.).

4. A job is a particular kind of work within an occupation. A person will probably have a succession of jobs within the same occupation and may change jobs more frequently.

5. Acquiring self-knowledge plays an important role in career planning. It involves assessing your skills, abilities, motivations, interests, values, temperament, experience, accomplishments, and work style or environment.

6. Acquiring information about occupations is essential in career planning. Sources of occupational information include libraries, professional trade organizations, informational interviews, and internships or on-the-job training.

7. You can draw some conclusions about your career direction by analyzing all of the information that you have obtained about yourself and your occupational prospects. These conclusions will help you to set goals for yourself.

8. Goals can be short-term or long-term. Career goals tend to be long-term; educational goals, more short-term in nature. Short-term goals can help you reach long-term goals. People who usually succeed in their careers have set realistic, challenging, but achievable long- and short-term goals for themselves.

Fashion Vocabulary

Explain each of the following terms; then use each term in a sentence.

career goal	job	position
career planning	job targeting	skills
hard skills	obsolescence	soft skills
internships	occupation	values

Fashion Review

1. What is career planning and why is it important?
2. Explain the differences between a career, an occupation, and a job. Cite an example of each.

3. Discuss three common misconceptions about fashion merchandising careers.
4. What is a self-analysis and why is it important in career planning?
5. Name and describe three ways that you can learn about occupations and jobs in fashion merchandising.
6. Cite four examples each of short-term and long-term goals.

Fashion Activities

1. Write five activities or major accomplishments from various periods of your life that have made you happy or proud of yourself. Identify the skills employed in each accomplishment. Organize your skills according to involvement with people, data, or things.

Skills	Accomplishments
People	
Data	
Things	

2. To better understand yourself, select 10 personal values that are important to you. Rate each value according to the following scale.

 Rating

1	most desirable
2	desirable
3	acceptable
4	undesirable
5	unacceptable

Endnotes

1. Arthur W. Sherman, Jr. and Bohlander, *Managing Human Resources,* ninth edition, South-Western Publishing Company, Cincinnati, OH, 1992, p. 110.
2. Tom Jackson, *Guerrilla Tactics in the New Job Market,* Bantam Books Division of Doubleday, Inc. New York, 1991, p. 41.
3. Ronald L. Krannich, PhD, *Careering and Re-Careering for the 1990's,* second edition, Impact Publishers, Virginia, 1991, p. 136–137.
4. Tom Jackson, *Op Cit.,* p. 45
5. Ibid., p. 46.
6. *Dictionary of Occupational Titles,* U. S. Government Printing Office, Washington, DC, 1991.
7. Richard Bolles, *What Color Is Your Parachute?,* Ten Speed Press, Berkeley, CA, 1989, p. 203.
8. Warren R. Plunkett and Attner, *Introduction to Management,* fifth edition, Wadsworth Publishing Co., Belmont, CA, 1994, pp. 397-398.

Conducting a Job Search

Objectives

After completing this chapter, you should be able to:

1. Draft a résumé and letter of introduction.

2. Explain the different avenues available for developing job leads.

3. Demonstrate how to handle a job interview.

4. Describe what preparation is necessary for conducting a job search.

5. State how the librarian can be an asset to conducting a job search.

6. Explain how trade associations and professional organizations can be instrumental in getting a job.

7. Cite and describe examples of the impact that current employment trends are having on job searches in the fashion field.

8. State how to determine whether a résumé or letter of introduction would be more appropriate for a given occasion.

F*rom the time Lee Anne was 12, she knew she had a gift for dressing with a sense of pizzazz. Family members and friends all sought her advice on how to put together that total look.*

After taking an introduction to fashion merchandising class she knew she wanted to be either a fashion coordinator or a visual merchandiser. Both fields peaked her interest. Knowing what she wanted to do helped Lee Anne put her

life goals in focus. Acting upon the advice of her counselor, she took classes that would help her acquire the knowledge and skills necessary for her chosen field. A part-time job in a local boutique gave her the hands-on visual merchandising experience she needed to learn if she really had the temperament and desire to be a visual merchandiser. Upon graduation, she attended a college that offered visual merchandising and display courses and continued working part-time at the boutique. Senior year, her college counselor helped Lee Anne put together a dynamic résumé that highlighted both her work credentials and education. Unlike many of her classmates, Lee Anne began to conduct her job search in the fall, rather than waiting until spring when everyone would be graduating and flooding the job market. That year gave Lee Anne an opportunity to hone her job-hunting skills and further refine her résumé. By the time her fellow graduates were conducting job searches, she was guaranteed full-time employment upon graduation. Ideally, all college graduates should be so lucky.

Introduction to Job Searching

Whether your career aspirations are domestic or international in scope, in order to find that perfect job you must take certain steps.

Finding your career path and exploring your potential requires work. Few are fortunate enough to know exactly what they want—and fortunate are the few who do. Most of us learn through research and experience where we fit in.

To eliminate some of the guess work and clarify your career goals, the quest for the perfect job starts with a long hard look at yourself.

This chapter discusses what you need to know about conducting a job search, from developing career leads to handling job interviews.

Predicting a Fashion Future

It used to be that you could anticipate three or four different careers in a lifetime. But the fashion industry has been severely hurt by ever-changing economic tides, continuous technological advancements, and the rapidly changing needs and wants of consumers.

Traditionally considered an important indicator gauging the health of an economy, the fashion industry has had more than its share of ups and downs. Responding to the recent rash of take-overs, mergers, and acquisitions, some companies such as Montgomery Ward & Co., have reverted to private ownership. This means that their stock is privately owned and not for sale. Therefore, outside investors cannot purchase majority shares of their stock and assume control of their business. It also means that the company owners can run the company as they please, without consulting outside shareholders. (For further explanation, see Chapter 4, Creating and Marketing Fashion.)

As an aspiring fashion merchandiser you must also be aware that you are entering an era where the "apparent excesses" of the 1980s, such as indiscriminate spending, are out-of-date, as both individuals and companies are tightening their belts and doing more with less.

This retrenchment means that there are fewer management positions available and correspondingly smaller staffs to carry out the work. There is the horizontal or **lateral promotion,** rather then the traditional **vertical** or upwardly bound **promotion** to maintain prestige and salary advancements.[1]

To compete in today's job market requires a realistic appraisal of the economy, job market, international and domestic political situation, and your own abilities.

As new technology eliminates old jobs, new positions are created.

Although the face of fashion is changing domestically, the opportunities abroad are just starting to be realized. The unification of the European markets; the new accessibility to Eastern Europe, the Soviet Republics, and parts of Asia; and the increased trading with Canada and Mexico, all augur well for the spirited entrepreneur who is able to read a future in the rumblings of changing nations.

While retailers face escalating operating costs and shifting fortunes, many specialty and department stores are on the rise. Stores that survive the challenge of a tightened economy and more discerning and demanding clientele are proving to be more accurate at predicting and satisfying the needs of their customers.[2]

Upon graduation, you are faced with negotiating this perpetually changing job market and need to equip yourself to adapt to evolving employment needs and economic times. One of your greatest strengths lies in the fact that there are fewer of you in the 20s age bracket than in previous generations. Although these smaller numbers mean it should be a buyer's market and recent graduates should have an edge over previous generations, it is not a guaranteed manifesto of employment. A well thought-out, organized job search is still your best plan of action.

Planning the Campaign

Once a career goal is selected, you should thoroughly research it. Information empowers job seekers and helps them to clarify their goals. Knowing where you want to go helps build your confidence in your search and in subsequent interviews.

The Letter of Introduction

In order to get that interview, a résumé or letter of introduction is your ticket for admission to a job interview.

Some experts believe that a letter of introduction is more effective than a résumé in getting that first job interview. A **letter of introduction** introduces you to a prospective employer and briefly outlines your academic and work experience. (See sample in Figure 18-1.) A letter of introduction does not take the place of a résumé, nor is it a **cover letter,** the letter that accompanies and introduces the résumé.[3]

A **résumé** is a complete outline of your academic and professional work experience. It is like leaving a business card and acts as a memory aid and point of reference for the interviewer.[4]

Both the letter of introduction and résumé can be written in different formats and styles depending on your situation and experience.

JAMES MANSOUR

President, James Mansour, Ltd.

Has success spoiled James Mansour? His associates at The Limited, Inc., didn't think so. They have nothing but rave reviews for the young, innovative former Vice President of Design and Presentation. For such outstanding achievements as clearly characterizing a store's image through the use of fine antiques and commissioned pieces, Mansour was awarded such prizes as Visual Merchandiser of the Year for 1989 by the nationwide organization of retailers now known as the National Retail Federation (NRF).

Yet Mansour seems unaffected by his success. Appreciative of his good fortune, Mansour not only shares his honors but also his talent by teaching art to underprivileged children.

Not bad for a kid from Flint, Michigan, whose parents, although supportive, were somewhat concerned about their son's uncertain future. But Mansour wanted to be an artist. His passion for art blossomed in high school. He excelled in all his art classes, but had a passing interest in other subjects.

His parents owned a grocery store chain, and allowed Mansour and his brother to operate a roadside

> *"James Mansour, Ltd. serves an international clientele as consultants on store design, visual merchandising, product development, and strategic imaging."*

produce stand. Mansour quickly saw the value of display when trying to catch the eye of passing motorists.

He acquired additional display experience when he did some window display work for Dayton Hudson.

Although he attended college, he never graduated. Eager to pursue a career as an artist, he moved to Colorado where he showed his work in galleries and taught adult education classes.

Eventually, he and a friend founded a multi-media theatrical company called "Air Theater." Since it was an alternative theatrical company, they felt it would "play" better in unfinished space, such as construction sites, rather than a traditional theater. During the 1970s, they played throughout the United States and Europe.

When they ended up at the site of the San Francisco Embarcadero Center, the troupe began to disband, as cast members got better offers. As set and costume designer, Mansour soon found himself unemployed. Determined to refinance Air Theater, he once again began doing windows. Impressed with his reputation, he was contacted by then president of The Limited, Robert Grayson, to do

some display work for him. Although he knew nothing about the store, he agreed. His girlfriend, a fashion designer, was able to fill him in.

Months passed before Grayson got in touch again. He wanted Mansour to work on the Beverly Hills Store, which was nearing completion. This time it was Mansour who was impressed, as The Limited, Inc., was innovative, progressive, and way beyond the competition.

One day while Mansour was working on a display, he overheard a man in a pinstriped suit talking with Grayson about his work. The man said although he did not understand the display, he still really liked it. Later on Mansour discovered the man in the suit was none other than Leslie H. Wexner, founder of The Limited, Inc. Wexner, pleased with the caliber of Mansour's work, eventually hired him as a full-time member of his "ensemble." Mansour's business, although successful, was costing him more than he was earning, as he had to hire additional talent to complete his obligations. By the time Wexner hired him in 1978, Mansour was more than ready, in his words "to learn the principles of business."

From the start Wexner was wonderful to James Mansour. He listened to his ideas, guided him, and acted as his mentor. He never shut him down but encouraged him and provided him with an environment where he could grow professionally.

In an effort to learn what motivates people to buy, Mansour worked in the store in every capacity from unloading trucks to ringing sales. Although he no longer "works" in the store, the lessons learned there keep him very much attuned to what works and what doesn't.

When Mansour joined the company, he reported directly to upper management. Since then, The Limited, Inc., has grown to include a number of companies. (See Spotlight on a Firm, this chapter.) Each group of stores is an independent entity with its own management, distinct image, and clientele.

From the start, it was Mansour's responsibility to help distinguish each division by creating unique and separate identities that are reflected memorably in each store's design. From the sumptuous luxury of Victoria's Secret to the cosmopolitan air of the Compagnie Internationale Express, each store conveys a very distinct, yet memorable image that meets and often exceeds the targeted customer's expectations.

For Mansour and his associates, learning how to create distinctions among the stores was problematic, until they learned to rely on the customer's anticipated perception of each store.

Once a store is established, it is periodically critiqued to ensure that the appropriate image is maintained. Displays change with fashion, but always within the parameters of the established image. From window design and store interiors to selection of music, one theme unites it all.

Pivotal to the success of establishing the right ambiance was the selection of fine antiques complemented by commissioned works of art. Just as exclusive resources were sought and developed to furnish stores with distinctive merchandise unavailable elsewhere, Mansour also shunned the traditional trade shows, which are universally attended, preferring to pick his own resources for materials and furnishings as well. Budgets for display exceeded those usually found in specialty stores; however, the furnishings are perceived as long-term investments and the resultant business worth the added expense.

In this way, he defined the identities of The Limited's various stores from Lerner New York to Henri Bendel. Mansour's designs for these stores established a "benchmark" for other visual merchandisers and store designers.

After more than a dozen years with The Limited, Inc., James Mansour formed his own design company, James Mansour, Ltd., specializing in what he calls environmental marketing. His goal is to design an atmosphere of enticement around a store's merchandise. James Mansour, Ltd. serves an international clientele as consultants on store design, visual merchandising, product development, and strategic imaging. A recent example of his work is the Warner Bros. Studio Store at Fifth Avenue and 57th Street in New York City.

continued

Question for Discussion. In what ways did James Mansour's activities as a young man help him identify and proceed toward his career goal?

Sources. 1. Marita Thomas, "Mansour of The Limited," *Stores,* January 1990, p. 154; 2. Marianne Wilson, "Bendel's Fifth Avenue Renaissance," *Chain Store Age Executive,* April 1991, p. 76; 3. Julie V. Iovine, "Design's Hidden Persuader," *Metropolitan Home,* September 1990, p. 114; 4. Jean Godfrey-June, "A Ladies Paradise," *Contract Design,* July 1991, p. 34; 5. "Faces to Watch," *Chain Store Executive,* June 1990, p. 21; 6. Phyllis Greensley phone interview with James Mansour March 1992; 7. The Limited, Inc., Annual Report 1990.

Letters of introduction can be adapted to cover everything from a mutual acquaintance referral to a cold call inquiry. For example, with a mutual acquaintance referral, the acquaintance's name is mentioned in the first paragraph of the letter to establish rapport with the reader. Then you may go on to explain why you are writing.

In the second paragraph, you stress what you have to offer the company; that is, the academic and work-related experience and qualifications that would make you an asset to the company. (Caution: Do not stress what you are hoping the company can do for you.)

(MUTUAL ACQUAINTANCE INQUIRY LETTER)

2024 Avenue Z
Dallas, TX 46520
March 12, 199–

Ms. Susan Farrell
Fashion Director
Manning Department Stores
Dallas, Texas 46521

Dear Ms. Farrell:

Mr. Jay Lund, Director of Lindy Promotion Company, suggested I contact you. I am very interested in meeting with the top people in the fashion industry, and Mr. Lund mentioned your position at Manning Department Store.

For the last three years I have produced fashion shows for all the major malls in the Dallas community. Currently, I am working with five other coordinators on the annual fall extravaganza, "Parade of Fashion", for the Houston Galleria Mall.

After attending my "Beggar's Ball" fashion show in October, Mr. Lund said that I should meet with you as I have experience in producing fashion extrava-ganzas. Mr. Lund also mentioned that your store is upgrading its fashion image, and that you are revising your existing fashion schedule to include more shows of this nature.

Although I do not know if your plans are set, I look forward to the chance of meeting with you and discussing how I can be an asset to your company. I will be calling you in the next few days to set up an appointment.

Sincerely,

Michelle Lionel

Michelle Lionel

Figure 18-1.

At the close of the letter, state that you would like to meet to discuss how you can benefit the company. Instead of waiting for the company to call, state that you will be calling to arrange an appointment.

A variation on this same idea is the cold call inquiry, where you send letters and perhaps résumés out at random to companies not actively seeking employees. Regardless of the type of inquiry made, you must research the targeted firm and compose a letter that will garner a response.

To learn about a prospective company that is publicly owned, you can send away for the company's **annual report,** which explains the organization's philosophy, objectives, future plans, and current economic health. (See Figure 18-2.)

An annual report gives information that can be useful in a job interview as well. Most employers find it flattering when a prospective employee can talk intelligently about their company. It also demonstrates initiative—a quality prized in any employee.

If time is of the essence, a quick trip to the library and a chat with the reference librarian can enable you to rapidly tap the right resources. The annual reports of many publicly held corporations are on file in most libraries. Also, the *Reader's Guide to Periodical Literature,* with subject listings, or the computerized *InfoTrak* can help you obtain timely information that could be of use.

Figure 18-2. An annual report will give you pertinent background information about a company that you are interested in as a prospective employer. (Courtesy Merry-Go-Round Enterprises, Inc.)

Once you have the information, you are able to draft an intelligent letter of inquiry. In the first paragraph, to establish rapport, you can explain how you have been tracking the company with interest and why you are writing this letter.

In the second paragraph, include information that proves you know something about the company. Information briefly outlining your academic and work experience should also be included.

In the close, once again you should state that you will be calling to arrange an appointment.[5]

The most common letter of introduction is used in response to classified want ads. Because hundreds of people may be responding to the same ad, your letter has to stand out. Being able to respond to the ad and to furnish information that demonstrates that you have done your homework can make a difference.

In the first paragraph, you create a connection by stating you are answering the ad and why you are interested in the company. Present your academic and work qualifications consistent with the order presented in the ad. Once again, include information that proves you have researched the company and believe you can be an asset if hired.

(WANT AD INQUIRY LETTER)

1234 Sacramento Street
Raleigh, NC 50545
September 21, 199–

Mr Richard Reinhart
Director of Photography
Lamont Stores, Inc.
1413 S. Belmont
Raleigh, North Carolina 50545

Dear Mr Reinhart:

I am writing in response to your want ad for a photographer's assistant. It is my understanding that the ideal candidate should have at least two years of college and one year's experience as a photographer's assistant. You also apparently need someone who can follow directions, be a team player, and do whatever is needed to get the job done.

For the last two years I have been attending the Academy of Arts where I am studying to be a fashion photographer. To augment my studies, I have been working since June of 1991 as a photographer's assistant at Logan's Photo Studio. As you may be aware, Logan's works with most of the major department stores in the city. Their client list includes such stores as Dillard's, Nordstrom, and Dayton Hudson.

In my current capacity, I have acquired experience working with different personalities from models to advertising directors. I have become well acquainted with our clients' needs and markets. I also understand the importance of being able to take direction and follow through on whatever assignments I have been given. During this year, I have done everything from ironing clothes to processing film to whatever it took to get the job done on budget and on time.

For years I have followed your store's progress. I am extremely impressed with your store's commitment to fashion and your plans to expand your current fashion photography division.

I look forward to discussing with you your current plans for expansion of your photography division, and how my experience can contribute to its success. I can be reached at 1-200-456-2345.

Sincerely,

Mark Moran

Mark Moran

Figure 18-3.

Although the company is actively pursuing applicants, it is still wise to state that you will be calling shortly to arrange an interview.[6]

For more information on writing letters of introduction refer to Madeleine and Robert Swain's book, *Out the Organization.* The Swains are founders of Swain and Swain, reputedly one of the oldest placement firms in the United States.[7]

The Résumé

Résumés are probably one of the most common means of presenting your qualifications to a prospective employer. Although opinions vary as to which format draws the best response, everyone seems to agree that all résumés should stress your strengths and assets. A typical résumé includes your name, address, phone number, availability, sometimes a career objective, and a chronological listing of education and work experience, with the most recent appearing first.

One form of résumé is the functional résumé which highlights your areas of specialization. (See Figure 18-5.) For someone re-entering the work force with too little or too much experience, the functional résumé highlights transferable skills and past accomplishments that demonstrate your capabilities.

(CHRONOLOGICAL RESUME)

JAMES WINTERS
4504 N. Kedzie
San Jose, California 45606
(212) 433-5643

JOB OBJECTIVE: Visual merchandising position with a large fashion forward department store.

EXPERIENCE: January 1992 to present
Visual Merchandising Trainee
Lewis Department Store
Columbus, Ohio
Reported directly to the visual merchandising director. Responsible for assisting visual merchandising in all phases of work from researching fashion trends to planning and to implementing design concepts for interior and exterior windows.

RESULTS: Worked with visual merchandising director to develop better communications with Advertising, Public Relations, and Merchandise Managers. New procedure reduced interdepartmental misunderstandings significantly.
Worked with visual merchandising director to upgrade the store's fashion image by developing more sophisticated and fashion forward displays.

January 1991 to January 1992
Visual Merchandising Director's Assistant
Lazarus Stores
Columbus, Ohio
Primary role to provide clerical support to visual merchandising director and offer additional assistance to the visual merchandising staff when necessary.

James Winters . . .

June 1989 to January 1991
Sales Associate — Menswear Department
J. C. Penney, Inc.
Columbus, Ohio
Coordinated and sold menswear. Also assisted with re-merchandising the department and maintaining it. Participated in price changes and inventory.

RESULTS: Developed a strong customer following and was awarded top in sales four times.

EDUCATION: BA, FINE ARTS
Northern Illinois University
Dekalb, Illinois
June 1989.

HONORS: Talented Student Scholarship

Figure 18-4.

Melissa Bjorn
2000 N. Wendell
Glenbrook, Indiana 45632
(212) 423-9445

OBJECTIVE: Fashion Promotion Manager position with a dynamic fashion foward specialty store in the Colorado area.

HIGHLIGHTS OF QUALIFICATIONS

- Over eight years experience in developing and producing image enhancing and sales producing events.
- Dynamic and innovative fashion director who can anticipate trends before competition.
- Highly organized, yet flexible, and can work within a budget or deadlines.
- Excellent communicator, negotiator, and diplomat

PROFESSIONAL EXPERIENCE

PROMOTION & PUBLIC RELATIONS

- Successfully developed campaign to upgrade a prominent specialty fashion boutique's fashion image.
- Created the "Parade of Fashions" October fashion show series to showcase the talents of struggling new designers for the city of San Diego. It was so successful, it became a yearly event.
- Spent two years coordinating civic and fashion organizations to co-sponsor the first "Beggars Ball" fashion show with proceeds each year earmarked for different worthy charities.
- Changed community public opinion regarding a new clothing store by creating a program where students had an opportunity to intern there for fashion related occupations.
- Attended New York Market and presented trend reports to executives. Also produced multi-media training fashion seminar for sales associates, buyers, and sales promotion department.

Management

- Develop newsworthy special events to generate publicity, enhance store image, increase store traffic, foster community good will, and sell merchandise.

Bjorn Con't . . .

- Delegate responsibilities to staff members and evaluate performance.
- Bi-annually develop promotion budget and calendar schedule of activities.

SALES

- Contacted outside companies to attend complimentary fashion shows to stimulate business.
- Invited outside firms to co-sponsor activities to enhance prestige and attract media coverage.

EMPLOYMENT HISTORY

1991–1992	**Public Relations Director**	Rollands Department Store Bath, Maine
1988–1991	**Special Events Manager**	J. C. Penney's Department Store Columbus, Ohio
1983–1986	**Fashion Coordinator**	Dillards Store San Jose, California
1981–1983	**Fashion and Special Events Coordinator**	Free Lance - San Jose area

EDUCATION

Associates Degree – International Academy of Merchandising and Design – Chicago, Illinois – 1981

Figure 18-5.

A résumé is an excellent way of taking stock of past accomplishments. Before writing a résumé, it is necessary to review your past experience. Take note of when, where, and what you did. For example, in citing work experience include relevant positions that pertain to your goal, such as sales associate or cashier. List both part-time and full-time employment. Also, when detailing all your academic accomplishments, include the name and address of schools attended as well as the years you matriculated. For instance, you may have attended Montgomery High School, 9400 S. Sacramento Street in Evergreen Park, Illinois, from 1990 to 1994. Not all of this information will fit on your résumé, but it is necessary for job applications, which most companies require in addition to a résumé. Academic history may include grammar school through college and beyond. Honors awarded or scholarships received should also be noted. Any pertinent volunteer work that can demonstrate leadership qualities, creativity, organizational skills, initiative, or problem-solving abilities, should be listed as well.

Because of the fluctuating economy and perpetually evolving job market, jobs that are "in" today could be "out" tomorrow. So it is imperative to be flexible. Acquire a diversified background so you have the capabilities to "re-invent" yourself and market yourself accordingly. Examples of successful "chameleons" who have managed to stay on top and anticipate and weather the turbulence of their times are

David Bowie, Calvin Klein, Madonna, Leslie H. Wexner, and Oprah Winfrey. They have taken the art of change and turned it into a science. This is especially important for career changers, who may have no actual experience in their designated career paths, but do not want to lose total credit or money for what they have already achieved. Areas of special expertise should be noted, as well as opportunities where money was saved and more sales accrued because of your stewardship. Transferable skills of leadership, initiative, and most notably team work are qualities all employers prize. The information you select and how you present it will influence the reader. Experts advise the use of **buzz words;** that is, the dynamic verbs that create an impression of action, leadership, strength, and creativity that can enhance your image. Key buzz words to use include: design, create, conduct, delegate, motivate, appoint, supervise, and develop. You do not always have to lead; projects or accomplishments that reflect a cooperative team spirit are also the way of the future. (Consider that most entry level jobs are assistant positions, where qualities like the ability to follow direction, a pleasant disposition, follow through, a positive attitude, perseverance, and team spirit are more appreciated.)[8]

Although a résumé cannot guarantee employment, it is a reflection of you. If to some employers it really is a momento of a brief encounter with you then, it must, after all the other applicants have come and gone, leave a favorable, indelible impression that you are the best candidate of all.

So, if it takes five, six, or even seven drafts to achieve the right look for your résumé, it is time well spent. And to achieve the desired results, the résumé needs to be professionally typed, printed and reproduced on professional-looking paper.

Developing Career Leads

Once you have focused on a career goal, it eliminates confusion. Instead of answering every available want ad, you zero in on ads that pertain to your goal. Remember, the résumé and cover letter must be slanted to support your career objective. Depending on the position sought, job openings will differ. Glamorous positions, such as fashion director or fashion photographer, are not as plentiful and the competition is severe. The jobs also require special talents, training, and years of experience. Your career goals may have to be temporarily adjusted to be realistically met. Therefore, if you want to be a fashion photographer, you may have to start out as a photographer's assistant or secretary and work your way up. Entry level salaries in these "glamour jobs" often do not match expectations. But it is called **paying one's dues;** that is, working at minimum wages to begin, and there is usually no way to avoid it. Salaries usually improve as performance and responsibilities increase. But how do you find a job? Where do you look? What sources are available?

The Want Ads

Most job seekers check the larger metropolitan Sunday newspapers for job leads in the want ads: Look under the position you are interested in and under related occu-

Figure 18-6. The classified section of a newspaper lists a variety of jobs in the fashion industry.

pations. For instance, you look under "B" for buyer, but also check "F" for fashion and "R" for retail and consider other related titles.

Another source of want ads are the trade publications. Magazines like *Accessories,* and newspapers, like *Women's Wear Daily* are all viable sources. If your school library or local book store does not carry these publications, check with the public library, or nearby college library.

Placement Office

Most high schools and colleges have a **placement office,** where you can obtain both part-time and full-time job leads and information. Both public and private colleges offer this service as an inducement to attract students to their college. And the more students they successfully place, the better the reputation of the school. Some private fashion colleges have excellent contacts with fashion industry professionals and encourage their students as undergraduates to take advantage of their work programs. Hands-on experiences reinforce students' academic education and provide them with opportunities to determine if they have the temperament, talent, and skills to succeed in fashion. As a student, you will also have your opportunity to pay your dues while attending school, so when you graduate you have the necessary work experience and academic credentials to qualify for a better-paying and more responsible position. Many of these schools offer lifetime placement to graduates, which means you can return to school, and at no charge receive job counseling and leads—some of these jobs are filled before they even appear in the newspaper.

Job Fairs

Ordinarily sponsored by colleges and high schools, job fairs give students an opportunity to meet prospective employers. Company representatives scouting new talent,

Figures 18-7a and b. Many companies participate in college-sponsored job fairs to scout for new talent. (Courtesy Brooks College, Long Beach, California; Lady Foot Locker; Hit or Miss)

meet students, accept résumés, and disseminate information about their companies. If properly timed, and well attended, job fairs are mutually beneficial.

Executive Search Firms

Professional employment agencies that are hired by outside firms to locate and screen higher paid employees are known technically as **executive search firms,** but are often called headhunters. Individuals seeking employment also hire headhunters. Entry-level job seekers ordinarily do not employ headhunters because they deal with higher-level positions. Usually executives and professionals in higher income brackets seek their services, since headhunters receive a percentage of the first year's earnings upon successful placement.[9]

Employment Agencies

An **employment agency** is an organization that helps individuals and businesses seeking to fill jobs. There are two types of employment agencies: public and private. A **public employment agency** is run by a state government and is a source of information about available positions in many occupations, particularly at the entry level. Public employment agency services are tax supported and therefore free. A **private employment agency** is a for-profit business whose services are paid for by the client. Companies may secure the services of an employment agency to locate potential employees or individuals to find a job. Depending on the agency, either the individual job hunter or the company is charged a fee. Many stores notify employment agencies of store openings and available positions. (On choosing a private agency, exercise care to ensure that the agency is reputable. You may check with the Better Business Bureau as to the credibility of an employment agency, but please note that the Bureau can only tell you if complaints have been lodged against the firm.)

Trade Associations and Professional Organizations

These organizations were originally formed by professionals of similar interests to solve problems that they could not resolve individually. Today, many **trade associations** and professional organizations exist for the same reason. Collectively they can be a powerful force and, for example, can lobby to promote vested interests that individually they can't achieve. Both professional organizations and trade associations can be a valuable source of career and employment information. Organizations like The Fashion Group are committed to assisting young talent and periodically offer competitions and scholarships. Most professional and trade groups are committed to improving conditions for their members and to promoting their organizations and goals. For more information about trade associations and professional groups, refer to the *National Trade and Professional Associations of America* available in most libraries. (Refer to Appendix C for a list of the more prominent fashion associations and professional groups.)

The Hidden Job Market

The hidden job market refers to job leads that ordinarily never reach the public. For example, a friend or acquaintance knows that someone retired or resigned and informs you of the job opening. **Networking** or developing contacts with people who can be influential in aiding your career is a very important part of today's job search. Some of the best jobs are the ones that people hear about through mutual friends. One of the best ways to make contacts is by volunteering, whether it is to serve on a committee or donate time. Many charities produce fashion-related activities to raise money, which may also provide credible work experience and can enhance your résumé.

Part-time or Free-lance Employment

It is sometimes difficult to obtain full-time employment in certain fields. Until an opportunity arises, either working free-lance or obtaining a part-time position can provide valid work experience and an entry into your chosen profession. If there are no openings, volunteering your services may open a door. Obviously, this approach does not work in all areas of the fashion industry; but fashion coordination, visual merchandising, photography, photo stylists, fashion illustration, advertising, fashion design, and pattern making are fields where this approach may be successful.

Phone Directory

If trade association books and directories are unavailable, the phone directory is still a good source for basic fashion information. Both in-state and out-of-state phone directories list current stores, manufacturers, showrooms, photographer studios, advertising agencies, and other fashion-related industries.

Career Centers

Most schools and local libraries have tapes, pamphlets, brochures, and books that not only describe various careers, but also suggest contacts.

Career Directories

Professional career directories usually contain an alphabetized listing of industry sources. For example, *O'Dwyer's Public Relations Directory* lists public relations agencies, while *Phelon's Directory of Women's Apparel* has an extensive listing of stores. Names, titles, addresses, and phone numbers are included in these books, so you can call and verify information to ensure you are submitting résumés to the appropriate individual. The reason you need to check information is that some of these directories are published every two years or so and employment turnover can occur within that period. When want ads are scarce or nonexistent, these books are an invaluable source of information.

Cold Calls

Cold calls involve canvassing the city and walking into stores, showrooms, or offices, inquiring if there are openings and leaving a résumé. Some businesses do not mind unexpected drop-ins and will accept a resume and furnish an application to be filled out at home or on the spot. Other businesses have definite days and times when unsolicited applicants can make an appointment to be interviewed and receive an application.

Whatever job search approaches are used, start looking for a job prior to graduation. Do not wait till May when everyone else is out looking for work. If uncertainty is holding you back, a visit to the school placement counselor should be of help. Not only can a competent placement counselor assist with employment objectives, that person can also help you draft a workable résumé. But do not waste time—come prepared with the information necessary to write your résumé. Bring with you your social security number, accurate academic and work histories, and names and addresses of references.

Preparing for an Interview

Before setting up any interviews, work on the matters of appropriate attire, portfolio presentation, résumé, and samples of work. Although creative fields have a more lenient dress code, remember to dress in a business-like, yet stylish fashion. Stylish means in good taste, not trendy. It also means presenting a "pulled-together," polished look.

Purchase a presentable portfolio or briefcase in which to carry résumés and samples of your work—this completes your professional attire.

Before the interview, schedule time for a trip to the library and a look at any articles pertaining to the company or industry. Also, if the interview has been set up by a mutual acquaintance, call that person and discuss how to conduct yourself during the interview. Specifically, find out what the employer is looking for in an employee for this particular position. Never dissemble; that is, never pretend to possess nonexistent experience or work credentials. Work histories and educational backgrounds are checked, and misrepresenting your abilities can have serious consequences not just for yourself but for your industry references.

SPOTLIGHT ON A FIRM

THE LIMITED, INC.

continuously changing needs of a better-educated and more demanding consumer through an uncanny ability to reinvent store concepts and formats. This willingness to reposition when necessary has been

department stores. And in turn, mall owners impressed with Wexner's savvy, string of successes, and ability to pay the rent have offered him preferential treatment such as prime locations and lower rents.

Since its inception, The Limited, Inc., under the direction of founder and owner, Leslie H. Wexner, has emerged as one of the most successful specialty store chains in recent retail history.

As many once powerful department stores appear to fall victim to poor management and myopic planning, specialty stores led by such visionaries as Wexner seem more attuned to changing times. Adept at anticipating fashion and economic trends, they also seem more willing to do whatever is necessary to remain afloat and move ahead.

The Limited, Inc., seems to owe much of its success to Wexner's gift for recognizing trends before the competition, and his understanding of the industry's rapidly evolving technology. He has also perpetuated an aura of excitement and interest that appears to sate the

THE LIMITED

a winning characteristic of a corporation determined to reach a projected goal of $10 billion in profits by the mid-1990s.

The Limited, Inc., is made up of separate and autonomous divisions that reflect a wide range of tastes, prices, and markets. As of this writing, The Limited, Inc., includes The Limited, Limited Too, Cacique, Victoria's Secret, Abercrombie and Fitch, Structure, Bath and Body Works, Penhaligon's, Henri Bendel, Lane Bryant, Compagnie Internationale Express, and Lerner New York. From the very affluent Henri Bendel to the moderately priced Lerners, each store fills a particular niche and gives Wexner access to different markets and consumers. Over the years Wexner has achieved with his "cluster of stores" the power and clout traditionally reserved for

Not a big believer in the value of advertising, Wexner has spent an appreciable amount of money on store design to set the right ambiance to convey a store's image and attract the appropriate clientele. In pursuit of further expansion and increased profits, new expansive "super stores" have been opened and older stores overhauled.

Wexner's success with the super stores is based on his "cluster store" approach. Mall owners rent enough space to accommodate most of the specialty stores in one mall. This enables the company to take advantage of lower rents.

Committed to giving customers more than they expect, these stores reflect an aura of elegance and an ambiance not always equal to the cost or quality of the merchandise. Even customers making minor pur-

chases cannot help but be impressed with the "peaches and cream" format rapidly becoming Wexner signature format. Stores such as Lerner New York have been transformed into a haven of good taste and elegance with spacious surroundings ordinarily reserved for higher-priced merchandise. Oversized dressing rooms, overstuffed sofas, and sometimes even a pianist are common features.

Critics of this format, however, believe that customers may be disappointed in some cases by the discrepancy between the opulent surroundings and the quality of merchandise. (This is a problem currently being addressed by management.)

The Limited, Inc., has acquired over the years a well-deserved reputation for innovation, which has been the result in part of Wexner's roving imagination and equally fleet-of-foot staff. Wexner and his associates travel the world over searching for new store concepts, trends, and ideas for the American consumer. For instance, the piped in French music, baroque fixturing, trendy fashions, and general atmosphere that is associated with Limited Express is an interpretation of popular Paris boutiques. To keep on top and beat competi-

tors, design offices are maintained in Paris, London, and Milan. Keeping in mind the versatility and coordination possibilities, the executives concentrate on seeing that the hottest fashion trends find their way to America. Obviously, Wexner has found a way of turning "savoir faire" into hard currency.

Although most of The Limited, Inc.'s stores are doing exceptionally well, both Lerner and The Limited have experienced a dip in sales in recent years. Following Wexner's orders "to fix it," both Howard Gross, President of The Limited, and Barry Aved, President of Lerner, have reorganized their respective divisions.

Gross has reviewed and recast The Limited stores to clearly separate their identity from that of Limited Express. Fashions and price points are keyed to a more affluent and older customer who appreciates such fabrics as linen.

Aved, for his part, has also repositioned Lerner by introducing better fabrics and higher prices to attract a more fashion-conscious customer.

Since these programs have only recently been implemented, it may still be too soon to judge their effectiveness. Both stores need time for the customer to recognize what

changes have occurred and respond.

In either case, as long The Limited, Inc., is willing to do whatever it takes to remain on top, it will continue despite any setbacks to provide a source of inspiration to its competitors and blaze new trails in the industry.

Question for Discussion. How does the marketing concept contribute to the success of The Limited, Inc.?

Sources. 1. Stephen Phillips, and Amy Darken, "Is There No Limit to The Limited's Growth," *Business Week,* November 6, 1989; 2. "Top 100 Specialty Stores," *Stores,* August, 1991, pg. 25; 3. Laura Zinn, "Maybe The Limited Has Limits After All," *Business Week,* March 18, 1991, p. 128; 4. Laura Zinn, "No Off-the-Rack Solutions Here," *Business Week,* May 25, 1992, p. 116; 5. David P. Schulz, "Expansion," *Stores,* August 1991; 6. Robert Lenzer, "Limited's Wexner: He Sure Knows How to Sell Clothes," *Boston Globe,* December 17, 1989; 7. Susan Caminiti, "The New Champs of Retailing," *Fortune,* September 24, 1990, p. 90; 8. Jason Zweig, "Limited Prospects," *Forbes,* September 4, 1989.

The Interview

One of the biggest problems employers have with interviewing is the number of late applicants or no shows.

Arriving late for an interview or not showing at all will not enhance your chances of being hired. If an unexpected illness or emergency occurs, notify the company and reschedule the appointment if you can. Applicants should arrive early for the interview in case preliminary paperwork must be filled out, such as a company job application.

Before completing the job application form, do read the instructions. Many times applicants write in spaces where they are supposed to print or place information in the wrong areas.

Bring pens and pencils for filling out the application. Do not rely on the receptionist to provide you with writing implements. In a small notebook have all the necessary information available such as dates and addresses for schools, jobs, supervisor names and titles, job descriptions, and references. **References** are people whom the company will contact to check on your background and character. They cannot be relatives. The names, addresses, phone numbers, and occupations of the references and their relationship to you are usually requested.

Areas of special interest and expertise may also be indicated. It is strongly advised never to fabricate or lie on an application, since it is grounds for firing. Fill out the application as neatly and clearly as possible. Use words that people are familiar with and that you can spell correctly, or bring a pocket-size dictionary.

During the actual interview remember to be yourself, and to present a polished, professional manner.

Taking your cues from the interviewer, explain what skills you have to offer the company, not what the company can do for you. Questions concerning the job and subsequent responsibilities must be discussed in detail. During the interview you should discover the company expectations for the advertised position and whether or not it has growth potential. Obviously, questions concerning salary and possible benefits should be handled with finesse. When asked if you would like the position, answer truthfully. If the answer is no, present it in such a manner that bridges are not burned and future opportunities lost. When you're ready to leave, thank the interviewer for meeting with you to discuss the job. If you really are interested in the position, stress that you are interested in the job and that you look forward from hearing from them in the near future. Take exceptional care to be nice to everyone connected with the interview, as even the receptionist may help determine who gets hired. Also, before leaving, make sure the appropriate people have copies of your résumé and/or samples of your work.

Post Interview

After the interview, promptly send a typed letter to the employer thanking him or her for meeting with you.

221 Lee Street
Minneapolis, MN 60053
June 14, 199–

Ms. Belinda Martin
Merchandise Manager
Dayton Hudson Corporation, Inc.
700 on the Mall
Minneapolis, MN 60054

Dear Ms. Martin:

Thank you for meeting with me to discuss the available junior buyers position.

Per our discussion, I have over four years experience as an associate buyer for better juniors at Junipers Department Store. Because of this experience, I do understand and appreciate the time, energy, skill, and commitment this position demands.

I also believe my prior training in display and special events will enhance my ability to succeed in this position, as I can easily work with these departments to create image-enhancing and sales-building activities.

As you are aware, I am definitely interested in this job and look forward to the opportunity to show you what I can do.

I anticipate hearing your decision in the near future. My phone number is (422) 435-8796.

Sincerely,

Jacqueline James

Jacqueline James

Figure 18-8.

It never hurts to reinforce a good impression. A short thank you note also gives you a chance to briefly recap highlights of the interview. (See sample in Figure 18-8.)

Regardless of whether the interview appeared to be successful, continue looking for a job. It is always easier to get hired when you already have a position. So do not wait for the perfect job. Depending on your financial circumstances and the desired position, it may be necessary to get a job and then find a career. Only you and your bank account can judge.

In the past, people found jobs with a company and built their entire lives around the firm. Most current employment practices no longer support this lifestyle. Until you find your niche, there is nothing wrong with exploring different occupations. Sometimes you need to try a job to find out whether or not your talents and personality meld in that position. With restructuring and mergers commonplace today, sometimes the only way to receive a raise or be promoted is to change jobs. However, job changes should be done judiciously, not on a whim. Otherwise, your work history may appear erratic.

While looking for that perfect job, volunteer and work on projects related to what you eventually would like to do. Remember you never know when the next person you help could open the right door for you. Best wishes as you set out on your career path in the dynamic field of fashion!

Summary

1. The job market is perpetually changing. Technological advancements, shifting economies, accelerated consumer demands, and changing needs are having an impact on all phases of the fashion industry. Job seekers need to be better educated and have a diversified background that can be "reinterpreted" and marketed accordingly as the need arises. Everyone in the industry must be more attuned to not only fashion trends and changes but global concerns, as well, especially since America relies so heavily on goods manufactured abroad and exports are also growing.

2. To conduct a successful job search requires time and research. Isolating a career objective facilitates the job search. Visiting the library to learn about the industry and targeted company can enhance your chances of employment. Drafting a résumé and/or letter of introduction is the accepted "admissions ticket" to an interview. There are two basic types of résumés: chronological, an historical ordering of activities beginning with your most recent position; and functional, highlighting areas of special expertise that are supported by documented activities.

3. Avenues for job leads include want ads, phone directories, trade associations and professional groups, trade publications, placement offices, career centers, the hidden job market, networking, and job fairs. Preparation for a job interview includes choosing an appropriate outfit and portfolio, researching the company, providing samples of work when necessary, and a résumé. Bring your own pen and pencil to the interview to fill out applications and take notes. Be accurate and truthful when filling out the application.

4. Be punctual for the job interview and bring additional copies of résumés. Following the interviewer's lead, be professional and discuss the job in great detail. Stress what you can do for the company and that you would like to grow with the firm. Be diplomatic: if you do not want the position, politely decline and thank the interviewer for meeting with you. Following the interview, send a thank you note.

5. If the employer fails to contact you in two weeks, call the company and find out if the position has been filled. Continue looking for employment, even if the interview appeared successful. If time and finances are running low, any job may have to be accepted. Remember, it is always easier to get a job when you are employed. If full-time employment seems elusive, consider free-lance work, part-time jobs, or volunteering.

Fashion Vocabulary

Explain each of the following terms; then use each in a sentence.

annual report

buzz words

cold call

cover letter

employment agency

executive search firms

job fairs

lateral promotion

letter of introduction

networking

paying one's dues

placement office

private employment
 agency

public employment agency

references

résumé

trade associations

Fashion Review

1. What economic and career trends must graduates consider when searching for a fashion position? What type of training do they need to compete in today's market?
2. Where can job seekers find solid job leads? What sources are available?
3. What is the advantage of drafting a chronological résumé over a functional résumé? When would you use a letter of introduction?
4. List the steps in preparing for a job interview.
5. What is the advantage of volunteering, or getting a part-time or free-lance job while looking for full-time employment?

Fashion Activities

1. Visit the placement office at your school, interview the counselor, and learn the steps to writing a résumé. Also find out from the counselor how he or she can help you find employment. Present the report in class.
2. Visit the library and ask the reference librarian to explain what resources are available for exploring career opportunities and job leads. Using these resources, select a career, and investigate it and the possible job market.
3. In-class job preparation role play: One student acts as a career counselor and another as the student job applicant. In the role play situation, the counselor helps the student draft a résumé and a cover letter.

Endnotes

1. Amy Saltzman, "Sidestepping Your Way to the Top," *U. S. News and World Report*, September 17, 1990, p. 60.
2. "1991 Career Guide," *U. S. News and World Report*, September 17, 1990, p. 88.
3. Madeleine and Robert Swain, "How to Write Letters That Win Jobs," *Working Woman Magazine*, April 1989, p. 120.
4. *Ibid.*
5. *Ibid.,* p. 121.
6. *Ibid.,* p. 122.
7. *Ibid.,* p. 123.
8. Mary Harbaugh, "Write a Résumé that Works," *Instructor*, May 1991, p. 45.
9. "Make Me A Match," *Inc.,* April 1991, p. 116.

Project

Preparing for Your Fashion Goals—Creating a Career File

The purpose of this project is to equip you with the necessary background information and documentation to start out or advance on your career path in fashion merchandising. Its outcome is a file of information concerning your goals and plans, a completed résumé, and sample letters of application. In addition, there is an opportunity to prepare for the job interview through actual practice.

Proceed as indicated by your instructor, using the following activities as a guide:

1. Develop a career plan. Identify the career goal you plan to achieve one year from now, then in three years, five years, and if you can, 10 years. Next, create a proposed career path showing the steps to that goal and the approximate time allocated for each step.
2. Look through the classified section of a recent issue of *Women's Wear Daily, Daily News Record,* or your local newspaper. Select a want ad for a job that relates to your career plan.
3. Prepare a letter of introduction in response to that want ad. (See Chapter 18, Conducting a Job Search.)
4. Create a résumé showing your education and work experience. Include your career goal.
5. Place completed items 1–4 above in a career file with your name and submit the file to your instructor, keeping a copy for yourself.
6. Prepare for a job interview as indicated by your instructor. Rehearse an interview in response to the want ad or for one of the jobs on your career path.
7. Role play an employment interview as indicated by your instructor. In the interview be certain to give the interviewer a copy of your résumé and to stress the experience and education you have had as well as your personal qualifications for this position.
8. Evaluate the interview using criteria established in your class.

Glossary of Fashion Terms

absolute quotas A form of import quota that bans further imports for a given time period when the limit is reached.

account executive Person assigned by the manufacturer to work with specific customers in determining their needs, and planning and providing products to suit those needs.

acquisition The act of one company purchasing (acquiring) another company.

acrylic A non-cellulosic petroleum-based manufactured fiber.

adaptations Copies of a garment incorporating one or two features of the original.

advertising A form of nonpersonal promotion in which a sales message appears in the media, paid for by an identified sponsor.

agent wholesalers Wholesale organizations that do not take title to or possession of the goods they sell.

alta moda Italian high fashion.

Amalgamated Clothing and Textile Workers' Union (ACTWU) The union in the men's wear and textile workers industry.

annual report A company report produced annually explaining the organization's philosophy, objectives, and current economic health.

apparel marts Buying locations where retail store buyers may do their purchasing, e.g., Dallas Market Center.

assistant buyer A person who relieves the buyer of some of the more routine responsibilities of the job.

auxiliary services Organizations assisting the movement of fashion goods to consumers. Auxiliary organizations include: advertising agencies, fashion consultants, the media, buying offices, research organizations, and others.

balance of trade The difference between the value of a nation's exports and its imports.

benefit shows Fashion shows held to raise money for a not-for-profit organizations. Also called charity shows.

birth rate The ratio between newborns and other individuals in a given population.

Bobbin A trade magazine written primarily for apparel manufacturers, with news of fabrics, machinery, distribution systems, etc.

Body Fashions/Intimate Apparel A trade magazine containing news and information for retailers and others involved in the marketing and merchandising of intimate apparel.

bones Strips of whalebone, metal, or wood used to reinforce corsets.

boutique A small shop often featuring a designer's ready-to-wear and accessories.

boys' sizes Ranges from 8 to 20, although sizes 14 to 20 are usually produced by the men's wear industry.

branch stores All the stores, other than the flagship store, in a chain.

brand name A product bearing a distinctive name that is marketed broadly, and which customers may obtain in a variety of places.

bridal consultants Salespersons who work in the bridal salon of a large department store or in a bridal specialty shop.

bridge jewelry Jewelry that is priced between costume jewelry and fine jewelry.

broad and shallow assortment A variety of styles are available to customers but only in limited colors and sizes.

bustier A deep-waisted garment consisting of a bra and camisole, originally an item of underwear.

bustle A rounded cage form or pad that causes the skirt to protrude only in back; popular in late 1800s.

buyer An individual employed by a retail organization to purchase goods for resale.

buyer's clerical Individual in charge of keeping records for an individual department.

buying behavior The way people act in the market place.

buying offices Fashion services based in major fashion centers to act as representatives for distant stores, shopping the various lines, and providing fashion information to client retailers.

buying plan The amount of new merchandise to be purchased.

buzz words In image enhancement, the use of dynamic verbs that create an impression of action, leadership, strength, and creativity.

campagus Open-toed boot worn by ancient Romans.

career One's professional course through life; one's total life's work.

career goal One's occupational aim or objective in life. Career goals may be expected to change through education and one's work experience.

career planning Planning or mapping out the professional progress through life, involving planning a career path, which is the way of advancement within a given occupational field.

Caribbean Basin Initiative (CBI) An initiative passed in 1983 with the goal of building export industries in the Caribbean and Central America, and also protecting U. S. manufacturers. Makes all kinds of manufactured goods from these areas exempt from U. S. quotas, provided they meet certain requirements.

cashier The person whose responsibility it is to enter and total cash and charge sales on computerized cash registers and to bag the customer's purchases.

catalog showrooms Stores set up to display samples of a wide variety of merchandise mirroring that found in their published catalogs.

caution The fee paid by trade buyers to attend a couture showing, either in money or an agreement to buy a certain number of items.

cellulosic fibers Manufactured fibers containing natural cellulose material, such as wood pulp or cotton linters; transformed into usable fibers by applying chemicals. Examples are rayon and acetate.

central buying office The center of store planning and merchandising for the entire retail organization.

chain organization A multi-unit general merchandise or specialty retail firm operating from a central headquarters. Wal-Mart, The Gap, and Sears, Roebuck, and Co. are all examples of retail chains.

Chambre Syndicale Chambre Syndicale de la Couture Parisienne. The governing organization of the French fashion industry.

channel of distribution The path of ownership of fashion goods from the producer to the consumer.

character licensing The granting by the owner of certain cartoon and toy characters the right to use those names on apparel and other products.

children's sizes Refers to apparel for girls and boys, ages 3 to 6, with sizes ranging from 3 to 6X for girls, and from 4 to 7 for boys.

classics Styles that remain in fashion for a long time.

The Clothing Manufacturers' Association (CMA) The oldest trade association in the men's wear industry. The CMA was organized to negotiate with the unions; it also is a major lobbying organization for the men's wear field.

cognitive dissonance The doubt a customer may experience after making a purchase; also called "buyer's remorse."

cold call 1. The act of sending letters and resumes out at random to companies not actively seeking employees; or 2. Canvassing the city and walking into stores, showrooms, or offices, inquiring about job openings.

collection 1. A couturier's line for a given season; 2. The highest-priced ready-to-wear line of a designer.

color cosmetics Makeup.

commission A percentage of the sales paid to a salesperson.

commissionaire An independent agent in a foreign market center who, for a fee, helps retailers find the merchandise they want, and follows up on the shipment of goods.

composition The arrangement of lines, shapes, colors, and forms to create a whole.

Computer-Aided Design (CAD) Computer technology used to create designs, choose among alternatives, and create patterns.

Computer-Aided Manufacturing (CAM) Using computers to produce goods, e.g., computerized cutting.

conglomerate A group of unrelated businesses in one organization.

conservative styles Styles for the person who resists change.

consumer One who uses (consumes) purchased goods.

consumer publications Fashion magazines geared to the general public and, specifically, the manufacturer's target customers, e.g., *Vogue* or *GQ*.

contest Events in which customers compete with other participants to win a prize.

contract tanneries Businesses that convert animal skins and hides into leather for other firms, but are not involved in the final sale of the finished product.

contractors Organizations and/or persons who specialize in sewing garments; they are contracted by manufacturers and jobbers as outside shops to sew their garments.

converters 1. Businesses that buy greige goods from the mills, have the fabric dyed, printed, and finished, then sell the finished fabric; 2. Businesses that buy hides and skins, and contract with tanners to process these products, then sell the finished leather; also called dealers.

cooperative advertising Retail advertising whose costs are shared by the retailer and the manufacturer.

cooperative buying office A buying office that is jointly owned by its group of member stores, which act as both shareholders and principal clients. Also called store-owned buying office, e.g., Associated Merchandising Corporation (AMC).

copywriter Person responsible for the wording of advertisements and for other writing tasks.

corporate buying office A buying office that is maintained solely for the benefit of stores belonging to a parent corporation such as The May Company.

corporate licensing The right to use a company symbol or logo on a given item; popular in children's wear, e.g., Coca-Cola or Nike T-shirts.

corporation A business organization owned by its stockholders; it has the right to buy and sell property and may sue and be sued.

cosmetics Skincare and beauty products.

costume (or fashion) jewelry Trendy, inexpensive jewelry made from a variety of nonprecious materials.

cotton A soft, durable, natural fiber grown from the cotton plant.

coupons A sales promotion technique that is an offer of a price discount upon redemption of the coupon at the participating store; may appear in catalogs, newspapers, or as a separate letter to customers.

couturier, couturière The designer of haute couture: couturier, if male; couturière, if female.

cover letter A letter that accompanies and introduces a résumé.

créateurs Designers of higher-price fashion-oriented ready-to-wear in the French fashion industry.

crinoline A full, stiff underskirt often sewn into a steel cage hoop structure to achieve the bell shape silhouette.

custom-tailored Describes clothing created for individuals according to their measurements.

customer An individual who buys goods for personal or business use.

Daily News Record (DNR) In men's wear and textile markets, the trade newspaper counterpart of *Women's Wear Daily;* also published by Fairchild Publications..

dashiki A traditional African shirt.

daywear Intimate apparel, other than foundations, meant to be worn beneath outer layers of clothing. Includes slips, camisoles, teddies, etc.

demographics The study of people based on measurable statistical information, such as income, occupation, and geographic location.

demonstration An arrangement in which an expert is sent from the manufacturer to inform customers and show them how to use the latest product.

department store A retailer with a fashion orientation and full mark-up policy, which carries an assortment of branded merchandise, including apparel for men, women, and children, and home furnishings, and operates in stores large enough to be shopping center anchors. Examples are Dayton's, Macy's, and Dillard's.

depth and breadth of assortment Refers to the number of different styles (breadth) and how many pieces of each style (depth) carried by the retailer.

design A certain version of a style.

designer licensing The granting by a designer the right to use his or her name on apparel and other products.

details The finished characteristics of a garment including: 1. the type of neckline, sleeve treatment, skirt and pant length and width; and 2. trimmings, embroidery or other embellishments.

The Dictionary of Occupational Titles A government publication based on the premise that every job requires a worker to function in relation to data, people, and things in varying degrees.

directional merchandise Merchandise for a buyer wishing to project a current image.

Directories in Print A directory of directories.

discount specialty store A hybrid between a specialty store and a discounter; includes both off-price stores (e.g., Marshall's) and outlet stores (e.g., Calvin Klein Outlet Store).

discount stores Retail stores that carry a large assortment of general merchandise, both hard and soft goods, and sell them at a low mark-up. Also called mass merchandise stores, e.g., Target and Wal-Mart.

discretionary income The amount of income remaining after paying for the necessities of life.

displays Promotional arrangements and materials that are featured in the selling department at the point-of-purchase.

disposable income The amount of money people have left after paying taxes.

diversion Process by which a manufacturer sells products to a wholesaler, who in turn sells to any retailer who wishes to buy.

divisional merchandise manager (DMM) Person responsible for specific categories of merchandise such as junior's or men's sportswear. The DMM oversees the work of the buyers and managers of several departments.

downward-flow theory Also called trickle-down theory. Holds that new fashions are first worn by the top echelons of society.

dual distribution A vertical marketing system in which a manufacturer sells through the company's own stores and to others as well. Example: Ralph Lauren merchandise is sold to many exclusive retailers and is also offered in Polo/Ralph Lauren Stores.

dye houses Factories that dye or print fabric; also called print houses.

dyeing The process of adding color to fabric or leather. After tanning for almost all leather, the dyeing process uses natural wood dyes, acid dyes, and aniline dyes.

Earnshaw's Review A trade magazine covering the children's wear market. (Full title: *Earnshaw's Infants-Girls-Boys Wear Review.*)

editorial credit Mention of a store or designer name by fashion editors.

electroplating Process in which an inexpensive base metal is passed through a gold or silver "bath" with an electric current, to give it a shiny finish.

emotional buying motives Motives based on feelings and emotions.

employment agency A public or private organization that helps individuals looking for work and businesses seeking to fill jobs.

entrepreneur A person who owns and operates his or her own business.

exclusivity Refers to how much of a retailer's assortment the customer will be able to find only at that store.

executive search firms Professional employment agencies which are hired by outside firms to locate and screen executives and other highly-paid employees. May also be hired by individuals seeking employment. Also known as "headhunters."

exports Apparel made in a given country to sell in other countries.

fads Fashion trends that last a short time, often a season or less.

Fall I Transition; one of the four or five seasons in women's wear manufacturing.

Fall II Holiday, cruise, or resort; one of the four or five seasons in women's wear manufacturing.

fashion A look or style that is popular at a given time.

fashion coordinator An individual employed by a manufacturer, retailer, or other business organization to present the firm's fashion image.

fashion director The retailer's top fashion authority; may be a vice president.

fashion cycle emphasis The decision of a retailer whether to present fashion goods to its customers earlier or later in the rise or decline of their cycle.

fashion editorial Publicity or pictorial spread accompanied by descriptive copy.

fashion followers People who wait to see if a fashion will be a success before adopting it.

fashion influencers Those people in an environment who are considered knowledgeable and whose advice about fashion is sought.

fashion innovators Those who seek out new looks and are the first to wear a new fashion.

fashion information service Organization providing general and personalized information to clients on a fee basis. Also known as fashion consultants.

The Fashion Group International An international professional organization consisting mainly of women fashion executives.

fashion leaders The people who wear and influence the direction of fashion; those persons concerned with fashion trends. They fall into 2 categories: innovators and influencers.

fashion life cycle The length of time a given look is popular; comprised of 4 parts: introduction, rise, peak, decline and obsolescence.

fashion merchandising The planning involved in marketing the right merchandise at the right place, in the right quantities, and at the right price.

fashion shows Planned, sequential processions of models in a designated area.

fashion trends 1. Looks that are timely and coming into fashion popularity; 2. the direction in which fashions are moving.

fee office's Buying offices that are independently owned and charge a fee to client stores for their services, usually a specified percentage of each store's annual sales volume. Also called independent offices.

fiber A fine, hair-like structure that can be spun into yarn and made into a textile product.

field sales representative Represents manufacturers or vendors to stores in a designated territory or geographical area.

filling In weaving, the crosswise yarn on a loom.

findings Fabrics produced by textile mills for use in garments, including linings, interfacings, trims, labels, etc.

fine jewelry Expensive jewelry made from precious metals and gemstones, e.g., a platinum necklace with diamonds.

flagship store The main store in a department or specialty store chain, often the largest and where the executive offices are located.

The Flammable Fabrics Act (1953) An act regulating the sale of highly flammable apparel fabrics, prohibiting the sale of hazardous fabrics.

flax A stiff, absorbent vegetable fiber, the source of linen fabric.

Food, Drug, and Cosmetic Act (1938) and subsequent amendments regulate the ingredients used in the manufacture of cosmetics.

forecasting Predicting the direction of fashion trends.

foundations Intimate apparel items that either support or control, such as bras and girdles.

franchise An agreement between an individual who wants to own a local retail business and a well-known manufacturer who wants to be represented in that area.

free trade The policy permitting the free exchange of goods among nations.

fur The soft, hairy coat of a mammal that can be processed into a pelt and used to make apparel and accessories.

General Agreement on Tariffs and Trade (GATT) Organization set up with the goals of negotiating trade restrictions among nations throughout the world.

general merchandise manager (GMM) Person responsible for broad areas of merchandise, often heading up all of the merchandise divisions; frequently a vice president of the retail organization.

general merchandise retailer A store that sells merchandise from a variety of different product categories, usually including a mix of hard lines (non-textile products) and soft goods (including apparel). Example: Montgomery Ward & Co.

generic name The family name, in this instance, of a group of fibers having similar chemical composition, as established by the Federal Trade Commission, e.g., nylon.

geographic segmentation Dividing a market into different locations on the theory that people living in a similar location will have similar needs.

gift-with-purchase (gwp) The bonus received as a gift by a customer when buying a certain minimum from a particular line of cosmetics.

girls' sizes From size 7 to 14; designed for the older female child.

global sourcing The purchase of goods from producers or vendors throughout the world.

Godey's Lady's Book The first American Fashion magazine, which debuted in 1830 and was published until 1898.

gold-filled A jewelry-making process in which a less expensive base metal is coated with a heavy layer of gold, always identified as such, e.g., 10KGF.

greige goods Unfinished fabrics coming directly from a loom or knitting machine; unbleached, undyed, unprinted at this stage. (Pronounced "grey" goods.)

hard skills Work content skills that do not transfer well from one occupation to another; usually technical in nature and identified as qualifications for a specific job.

haute couture A business whose designers create an original collection of garments that may then be made-to-order for individual clients.

head of stock An individual in charge of the retail stock for a given department or area.

headhunters See executive search firms.

hidden job market Job leads that never reach the public. Many of the best job openings appear only in the hidden job market.

hide An animal skin weighing over 25 pounds.

high fashion Most often custom-made or couture clothes created by famous designers; may refer to an expensive new look.

horizontal adoption theory States that fashions are adopted locally among similar or homogeneous groups, such as school, office, or community, not necessarily in a downward flow pattern.

horizontal publications Trade magazines, such as *Chain Store Age, Discount Store News,* and *Stores,* that target one level of an industry, in this instance retail executives with news of trends in retail technologies, systems, promotions, and other management and merchandising areas.

hypermarkets Enormous stores designed for one-stop shopping that house everything from apparel to groceries to general merchandise, all under one roof.

import fair A fair that brings domestic buyers in contact with groups of foreign suppliers. Example: New York's Prêt à Porter shows.

import quota Limits the amount of certain kinds of goods from foreign countries, setting the specific quantity of each item that may be brought into the country for a given time, usually a year. There are two types of import quotas: tariff-rate quotas and absolute quotas.

imports Goods manufactured in other countries.

impulse item An item that consumers purchase without advance planning. Fashion impulse items often include earrings, scarves, and other accessories.

independent (or fee) buying office See salaried office.

inflation A rise in prices caused by a rise in costs, an increase in the supply of money, or both.

infants' wear Size 0 to 24 months, intended for newborns and babies up to one year old.

informal modelling An informal show of merchandise by models, as opposed to an organized procession of models.

InfoTrak A computerized system for locating published articles; available in many libraries.

innovative styles Trendy, youthful styles.

inside shop A manufacturing facility within a given organization. Apparel produced within the manufacturer's own plant.

internships A paid or unpaid learning opportunity in a given organization or business often for a certain specified time such as six months or a year.

institutional advertising Advertisement stressing the image of a particular organization or individual in order to enhance overall image and maintain customer loyalty.

institutional displays Displays that promote an idea benefiting the company and its targeted market.

International Ladies' Garment Workers' Union (ILGWU) The garment workers' union governing the manufacture of women's wear.

intimate apparel Undergarments, or body fashions. Intimate apparel includes: 1. foundations, 2. lingerie, and 3. robes and loungewear.

job A position of employment within an occupation involving related tasks or duties. A particular kind of work in a given occupation.

job fairs Events sponsored by high schools and colleges, giving students an opportunity to meet prospective employers. Attended by company representatives who meet with students, accept résumés, and disseminate information.

job targeting A process in which individuals look at all of their personal purposes, goals, and capabilities, and then choose specific work areas that will best satisfy them.

jobbers 1. Intermediaries between the mill and various retailers and apparel manufacturers; 2. an apparel jobber is also a form of manufacturer that may do everything but the sewing; creates patterns, cuts fabric.

karats Refers to the amount of gold in an alloy. A karat is equivalent to ¹/₂₄ of the total, based on the fact that pure gold is 24 karats, or 24K.

keystone markup The retail price-setting practice of doubling the cost that the retailer pays for an item to establish its retail price.

kips Animal hides weighing from 15 to 25 pounds.

kipskins The skin of oversized calves.

knitting Constructing fabric by the interlooping of a single yarn or a set of yarns using needles.

kohl A dark eye make-up preparation used in ancient times.

last A foot-shaped form of wood, metal, or fiberglass, used for stretching leather in the making of shoes.

lateral promotion A horizontal move, rather than vertical, or upwardly bound.

learning The way consumers acquire knowledge on which to base a buying decision.

leased departments Store spaces in a large store that are rented to a business specializing in the merchandise sold in that area such as space in a shoe department being rented to a shoe manufacturer.

leave paper The apparel industry's term for writing orders.

letter of introduction A letter introducing a job applicant to a prospective employer, briefly outlining academic and work experience.

licensing Granting of the right to a manufacturer to produce and market a product bearing a famous name or image by the owner of that name.

limited liability A form of liability in which the owners of a company have no further financial obligation to the company beyond their original stock purchases.

limiting factors The factors that keep consumers from reaching a certain decision to buy such as price, time, and place.

line A design element that influences the way a display is perceived. Line (direction) may be vertical, curved, horizontal, and diagonal.

line-for-line copies A copy of a garment that is the exact duplicate of the original designer garment.

linen A fabric made from flax fiber grown from the flax plant; known for its strength and beauty.

lines New designs or interpretations of the goods that manufacturers offer; also called merchandise lines.

lingerie Intimate apparel comprised of daywear and sleepwear.

logos Stylized print or symbols that identify both the advertiser and the product in the advertising.

loungewear Also called leisurewear; comprised of a variety of garments designed for at-home, leisure-time comfort.

manufactured fibers Fibers made from wood pulp, cotton linters, or petrochemicals.

manufacturer A business that mass produces goods, for example apparel and accessories.

manufacturer's agent An independent business representing a group of similar but noncompeting lines.

mark-up The amount meant to cover expenses and profit that is added to the wholesale cost to establish the retail price. May be expressed in dollars and in percentages.

market Location where manufacturers and their representatives show and sell their goods or lines to retail buyers, e.g., the New York market.

market centers Cities where fashions are created and marketed.

market directory A showroom guidebook published by each apparel mart and given to all buyers at market. It lists all representatives and showrooms and the merchandise lines they carry, by size.

market representative An individual in a buying office whose job is to work with store buyers by seeking out the most suitable merchandise sources and informing client stores.

market segmentation Dividing the total population into smaller, more similar groupings, or market segments.

market week An event held periodically in each market center to introduce the coming season's lines to store buyers.

marketer A business offering goods and/or services; includes retailers, wholesalers, and auxiliary organizations.

marketing The process of planning and executing the conception, pricing, promotion and distribution of goods and services to create exchanges that satisfy individual and organizational objectives. (American Marketing Association)

marketing concept Determining customers' needs and what the company can best provide at a profit.

marketing manager Plans and directs the marketing endeavors of the manufacturer to be certain that customer needs are anticipated and met; develops new product concepts, utilizes marketing research

to determine customer needs, and oversees the promotional programs for the product lines.

mass fashion Styles that are popular and produced in large quantities at a wide range of prices. Also known as volume fashion.

mass market cosmetic lines Cosmetics lines offered by discount and other volume retailers.

mass merchandise stores Retail stores including general merchandise and discounters that carry a large assortment of general merchandise, both hard and soft goods, and sell them at a low mark-up. Example: Sears, Roebuck, and Co.

media The channels of communication used to reach various audiences. Includes newspapers, magazines, television, radio, and outdoor advertising.

men's clothing Generally refers to men's outerwear such as suits and coats, work clothing, slacks, and sportswear.

men's furnishings Refers to all articles of clothing that are worn with men's outerwear. Examples: ties, belts, hosiery.

merchandise coordinator The person responsible for seeing that the manufacturer's merchandise is presented as effectively as possible within the retail stores.

merchandise lines Designs or interpretations of the goods that manufacturers offer; also called lines.

merchandise planner/distributor In a retail chain organization, determines how the goods the buyer has purchased will be distributed to each store in the chain.

merchandiser A major executive of the manufacturing organization who determines the fashion direction the business will take.

merchandising The planning necessary to have the right kind and assortment of merchandise for customers when they want it.

merchandising policies Guidelines that help determine what merchandise the retailer will carry.

merchant wholesaler A wholesale organization that owns the goods sold and sells them from a central location.

merger The joining of two companies to form a single company.

micro-marketing Ultra-targeted marketing efforts whereby special promotions or announcements might be sent only to customers who purchased a particular brand of product within a particular time period.

millinery Hats.

mom-and-pop specialty stores Among retailers, a type of small, independently owned specialty store.

monopolistic competition A type of competition in which there are many competing sellers and buyers of all sizes, yet the product may be unique enough for each seller to have some control over its price. Monopolistic competition occurs in retailing and in the fashion industry.

monopoly The situation that occurs when one business dominates an industry and can set whatever prices it chooses. Unregulated monopolies are illegal in the United States.

motive An internal need to be satisfied.

narrow and deep assortment A limited number of different styles are available to customers, but they are available in many sizes and/or colors.

national advertising Advertising sponsored by a producer or manufacturer and directed to the consumer.

National Association of Men's Sportswear Buyers (NAMSB) A trade association that sponsors men's sportswear markets several times a year.

national promotion The attempt to establish brand name recognition for products by promoting directly to the consumer.

National Retail Federation (NRF) The nation's largest retail trade association. Consists of major department and chain store retailers throughout the United States. Publishes *Stores* magazine.

natural fibers Fibers from animal, plant, or mineral sources.

net income The money brought home in a pay check.

networking Developing contacts with people who can be influential in aiding your career advancement.

news or press release See press release.

niche marketing The practice by a business of identifying and closely targeting a specific market segment and gearing operations to serve that segment.

non-cellulosic fibers Fibers made from molecules containing various combinations of carbon, hydrogen, nitrogen, and oxygen, and derived from petroleum, natural gas, air, and water. Examples are nylon, acrylic, polyester, and spandex.

nonpersonal promotion Sending a sales message to customers by advertising, sales promotion, public relations, and publicity.

North American Free Trade Agreement (NAFTA) An agreement designed to lower trade barriers among the Unites States, Mexico, and Canada, eventually creating a single North American market without trade barriers; aims for an economic climate similar to that of the European Community (EC).

nylon A petroleum-based manufactured fiber introduced in the mid-1930s.

obsolescence The state of being out-of-date and behind the times.

occupation One's work or profession.

off-price retailing A specific type of fashion discount operation in which well-known brands or designer-name merchandise is sold at prices significantly below the regular department or specialty store price. Examples include Loehmann's and Filene's Basement.

offshore contracting Working with independently owned foreign producers to manufacture garments.

offshore production The manufacturing of apparel and other goods in foreign countries.

oligopoly The domination of an industry by a few major businesses. Examples include breakfast cereals and light bulbs.

outlet stores A retailer originally set up as a method by which manufacturers could rid themselves of unsold or unsellable merchandise. Example: Jones New York outlet store.

outside shop Manufacturing done other than in the manufacturer's own plant.

partnership A legal agreement among two or more individuals to enter into a business arrangement as owners.

patent leather Highly polished leather produced by applying successive coats of heavy oil varnish at the end of the finishing process, giving the leather a high, durable gloss.

patronage motives Motives for buying from a certain retailer.

paying one's dues Starting at the bottom and working up.

Peacock Revolution An era featuring a wide variety of new looks that started in the 1960s on Carnaby Street in London.

perceived difference A distinguishing feature of a product or business that allows it to stand out from others, in reality or in the mind of the customer.

perception The way individuals accept and organize external stimuli to obtain a view of the world.

Permanent Care Labeling Act An act passed in 1972 requiring that all clothing at the retail level be labeled with specific information regarding its care.

personal promotion Selling face-to-face or over the phone.

personal selling Selling directly to the consumer.

piece goods Fabrics that are produced in textile mills to be cut and assembled into garments.

placement office An office in a high school or college, where one can obtain part-time and full-time job leads and information.

position A duty or responsibility performed by only one person.

polyester A petroleum-based manufactured fiber introduced after WWII.

press conference A prearranged meeting with the media, the purpose of which justifies the media's attendance and is scheduled to accommodate their headlines.

press kit A portfolio containing an assortment of different news releases and photographs; used by designers, manufacturers, and retailers to convey information to the media.

press release Newsworthy information, one to two pages in length, concerning an organization and/or its leaders.

prestige lines Cosmetics enjoying a limited distribution and exposure through a carefully controlled number of higher-priced stores.

prêt-à-porter Ready-to-wear created by designers at approximately one-third of their couture prices.

pretanning A stage in the leather tanning process in which hides are cleaned and cured.

preteen sizes From sizes 6 to 14, providing more refined styling than children's wear, similar to the junior size range.

principals Business owners.

print houses Factories that dye or print fabric; also called dye houses.

private employment agency A for-profit business whose services are paid for by the client. May be used either by companies for locating personnel or by individuals seeking employment.

private label A label placed by retail stores on goods available only in that store.

product advertisements Advertisements promoting specific merchandise.

product managers Depending on the nature of the assignment, product managers work with suppliers, set prices, coordinate promotional activities and advertising, and work with sales representatives, giving them new product information and gathering customer feedback.

product motives Motives for buying a certain product that stem from the qualities or image of a product.

profit What a business has left from its income after paying its bills.

promotion An element of marketing that includes all the nonpersonal and personal marketing activities necessary to inform, persuade, or motivate an individual or business to react favorably to a product or idea.

prophetic fashions Styles identified early on as destined to be widely successful in many price ranges.

props Anything that can be used to help the customer understand the concept of the promoted product. Example: adding seashells to a swimsuit display.

protectionism Steps taken by the government to limit or exclude competing imports.

psychographics The study of consumers' attitudes and lifestyles.

public employment agency A free, tax-supported employment agency run by the state government; a source of information about available positions in many occupations, particularly at the entry level.

public relations A continuous, flexible program developed to promote the entire image of a company or individual.

publicity The use of prepared information by the media in the press or on the air to influence various publics.

purchase-with-purchase (pwp) The bonus received by a customer for a small additional cost when buying a certain minimum. Pwps are particularly popular in marketing cosmetics.

pure competition The condition that exists when there are many manufacturers and many customers, and no single manufacturer is able to control the price of goods.

Quick Response (QR) A computerized inventory system between retailers and major suppliers; enables stores to be continually supplied with a full range of basic merchandise.

quota Limit on the amount of certain specified goods that may be brought into a country.

rational buying motives Motives based on rational behavior, such as logical thinking and decision-making.

rayon A cellulosic fiber first produced in 1910.

The Reader's Guide to Periodical Literature A listing of the articles appearing in magazines, and in trade and business periodicals.

ready-to-wear Mass-produced garments in standardized sizes.

recession A general slow down of business activity.

references Names of people provided by the applicant that a prospective employer may contact to check on an applicant's background and character.

response An action taken in reaction to a stimulus.

résumé An outline of one's academic and work experience.

retailer A marketing organization offering goods to ultimate consumers.

retailing Selling goods and services to the ultimate consumer.

retailing trade magazines Trade magazines, such as *Chain Store Age, Discount Store News,* and *Stores,* which target retail executives with news of trends in retail technologies, systems, promotions, and other management and merchandising areas. Also called horizontal publications.

salaried office A buying office that is independently owned and charges a fee to client stores for its services, usually a specified percentage of each store's annual sales volume. Also called fee offices.

sales promotion Promotional activities other than advertising, public relations, and personal selling that influence or persuade a person or business to accept or buy an idea, service or product. Examples of sales promotion activities include: contests, coupons, and fashion shows.

sales representative An employee of a manufacturer or wholesaler who shows store buyers the new line of merchandise, takes orders, and sees that the goods are shipped on time.

salesperson A salesperson is employed to sell goods and/or services to customers.

salon selling Personalized selling service utilized by high-priced stores; the salesperson shows merchandise to customers and assists them in the fitting room.

sample hand An expert sewer who, working from a sketch or muslin, sews a complete garment in muslin, or an original sample in the actual fabric.

sampling The practice of giving a small sample of a product—usually a new product—to a potential customer, allowing the customer to try out a product before purchasing it.

season A selling period with new merchandise introduced at the beginning of each season.

secondary lines Lower-priced lines produced by designers to reach a wider customer base.

Section 807 Section 807 and 807A of the U. S. Tariff Schedule reduce or eliminate tariffs and quotas on goods partially produced in developing countries.

selective discrimination The act of patronizing stores at various price levels.

Seventh Avenue New York's famous garment district, commonly called "SA," bordered by 41st Street to the north and 33rd Street to the south.

shopping centers Centers for shopping created by real estate developers, giving customers access to the many types of stores found in the city. Initially created in the 1950s as single-level, open-air groupings or strips of stores, featuring ample parking for shoppers.

shopping mall An enclosed shopping center, containing one to several levels of small shops specializing in specific categories of merchandise, and usually "anchored" by two or three major department or chain stores.

showings Industry fashion shows sponsored by designers and their representatives or by the apparel mart sponsoring the market week.

showroom A manufacturer's or representative's local sales office.

skills The talents, gifts, aptitudes, and abilities that individuals possess and bring to the workplace.

skins Animal skins that weigh 15 pounds or less.

silhouette The shape of a garment.

silk A fine, continuous fiber produced by the silkworm and used in fabrics.

sleepwear Pajamas, nightgowns, and other apparel designed for sleeping.

slop shops Retail establishments that sold low-quality, ready-made clothes during the 1800s.

soft skills Functional skills that are transferable from one occupation to another; usually acquired through experience rather than formal training.

sole proprietorship A form of business that is owned and operated by one person, sometimes in cooperation with family members.

sourcing Seeking out suppliers (manufacturers and wholesalers) of merchandise. A task of store buyers and buying offices.

special events Image-building sales-enhancing promotional vehicles that add pizzazz, prestige, and theatrical ambiance to a promoted product. Examples include celebrity appearances and themed promotions.

specialty chain A group of larger specialty stores that form multiple branches either nationally or within a region of the country.

specialty store A retailer that specializes in a particular line of merchandise. Examples: The Limited and The Gap.

specification buying A type of private label buying that occurs when a retailer negotiates to have a vendor produce goods based on the retailer's designs or specifications.

spinning The process of twisting fibers into a long cohesive structure.

splits Layers of animal skin, other than top grain leather. They usually have a rougher, coarser appearance, and are less durable and less costly than top grain leather.

sponsor An identifiable source who pays for the air time or print space used for an advertisement.

sports figure licensing The granting of the right to use the name of a sports celebrity on apparel.

Spring I One of the four or five seasons in women's wear manufacturing.

Spring II Summer; one of the four or five seasons in women's wear manufacturing.

standardized sizes A method of matching clothing to figure type.

stimulus The agent triggering the buying motive, or desire to act.

stockperson The person responsible for seeing that merchandise is moved from the receiving area to the selling floor and for recording quantities in stock.

stomacher A decorative pasteboard worn by women during the Middle Ages; it covered and flattened the chest.

store-owned buying office A buying office that is jointly owned by its group of member stores, which act as both shareholders and principal clients. Also called cooperative buying office.

style A combination of features that make an item unique and distinct.

suede leather The bottom, or flesh layer, of an animal skin.

sumptuary laws Laws regulating what various groups of people may wear based on religious or moral reasons.

sweat shops Early factories which employed workers under unfair, unsanitary, and often dangerous conditions.

sweepstakes A give-away in which entry blanks are filled out and a name is drawn as winner from among the entries.

tailored apparel Men's wear items with firm construction and crisp detailing such as suits and topcoats, which require highly skilled labor.

tanneries Businesses that convert animal skins and hides into leather to sell as finished products.

tapered Gradually narrowed toward one end.

target customer base The type of people a retailer wants to attract, based on factors such as income level, age, geographic location, and lifestyle.

target marketing The practice of identifying and closely targeting a specific market segment and gearing operations to serve that segment.

tariff-rate quotas A form of import quota that raises the tariff on an item after a certain limit is reached.

tariffs Import taxes, or duties; the taxes on imported items.

television shopping A newly popular form of retailing whereby viewers may purchase goods shown and promoted on television. Example: QVC.

The Textile Fiber Products Identification Act (1958) Requires that all clothing and most furnishings have a label showing the fiber content by percentage.

texture The way a garment feels, due to the fiber or the method used in constructing the fabric.

toddlers' sizes From 2 Toddler (2T) to 4 Toddler (4T).

top grain leather The top layer of animal skin with the grain intact.

trade associations Organizations created to serve their members' interests. Many fashion industry trade associations, among other duties, act as a liaison between producers and retailers, hold trade shows in various regions of the United States throughout the year, and also represent members' interests to government organizations..

trade magazines Specialized business publications that serve a particular field or segment within a field; usually not available on newsstands. Example: *Stores* magazine.

trade paper Newspaper created for the women's fashion industry, the most famous being *Women's Wear Daily.*

trade press Specialized business publications that serve a particular field or segment within a field; usually not available on newsstands. Also called trade magazines.

trade promotion Advertising, publicity, fashion shows, and display/visual merchandising aimed within the industry to influence members of the fashion industry to buy their products.

trade show A temporary exhibit lasting from three to ten days, whose purpose is for manufacturers and their representatives to show new merchandise to business customers.

transshipping Sending goods through other nations to their final destination in order to evade quota restrictions and have the goods be treated as imports from the nation through which they are shipped.

trunk show A promotion in which a designer or representative of the manufacturer brings an entire line to a local store where customers may see and buy it.

unlimited liability A form of liability in which creditors may put a claim on the personal assets of the business owner if the obligations of the business are not met.

upward-flow theory The theory that fashions begin in the lower levels of society and move upward.

values The beliefs that individuals consider important.

vendor A supplier of merchandise to retailers; may be a manufacturer or a wholesaler.

vermeil A composite of gold over sterling silver.

vertical integration The organization of a business so that it controls other levels of the manufacturing and marketing process of the product.

vertical marketing systems More efficient ways of marketing merchandise by establishing ownership or formal agreements along the product's journey from manufacturer to customer. Example: the shoe wholesaler Fisher-Camuto owns 9West shoe stores as well as shoe factories.

vertical publications Publications aimed for an entire industry on all levels, such as a trade paper intended for fiber and fabric producers, as well as apparel manufacturers and retailers.

visual merchandising A situation in which merchandise is shown to its best advantage and in the most appropriate setting to influence customers to buy.

volume (or mass) fashion Styles that are popular and produced in large quantities at a wide range of prices.

warehouse club A retailer buying merchandise in bulk, obtaining volume discounts from manufacturers, and displaying the goods in a warehouse-style, no-frills setting, keeping costs even lower for customers. Often open only to members, who pay an annual fee. Example: Sam's Club or Price Club.

warp In weaving, the lengthwise yarn on a loom.

weaving The process of forming a fabric on a loom by interlacing the lengthwise yarns (warp), and the crosswise yarns (filling or weft) over and under each other. The three basic weave types are: plain, twill, and satin.

weft In weaving, the crosswise yarn on a loom.

wholesale cost The amount retailers pay manufacturers for goods.

Women's Wear Daily (WWD) The "Bible" of the women's apparel field. A trade newspaper published 5 times a week by Fairchild Publications.

wool An animal fiber obtained by trimming sheep; also obtained from goats, camels, llamas,and vicuna.

The Wool Products Labeling Act (1939) Provides that all garments made of wool have a label telling the percentage and kind of wool used.

Appendix A: The World's Leading Fashion Designers

ABBOUD. Joseph Abboud. See Career Portrait, Chapter 3.

ADOLFO. Sardina Adolfo, known as Adolfo, was born in Cuba in 1933. Through the graces of his influential aunt, Adolfo was able to apprentice in the venerable House of Balençiaga, one of the twentieth century's supreme designers. He returned to New York as a milliner and later founded his own apparel business. Known for his Chanel-influenced suits, Adolfo has won a number of fashion honors such as the Coty Award. In 1993, he closed his designer apparel business, preferring to concentrate on licensing agreements.

ALAIA. Azzedine Alaïa was originally from Tunisia but has lived in Paris for more than 30 years. He studied under fashion's famous "bad boy" Thierry Mugler. Alaïa is known for designing close-fitting black apparel often shown with industrial zippers. Alaïa garbs himself in black silk jackets and trousers and his work has a group of followers who seek out his campy look.

ALLARD. Linda Allard is the chief designer for the Ellen Tracy Company. (There is no Ellen Tracy; when the company started 45 years ago, the name was created.) Over 30 years ago Allard came to New York with a Fine Arts degree from Kent State University in Ohio, and great determination to be a designer. That determination landed her a job with the Ellen Tracy organization, known for producing women's blouses. Linda Allard soon added pants and jackets. Today, the company offers a signature line of career apparel known as Linda Allard for Ellen Tracy; Ellen Tracy Dresses; and a line of sportswear, Company by Ellen Tracy. One line of rain forest prints devotes a portion of its sales to preserving the environment, for Linda Allard is a conservationist.

ARMANI. Giorgio Armani. See Spotlight on a Firm, Chapter 12.

ASHLEY. Laura Ashley was British and lived from 1926 to 1985, but her designs are still popular worldwide. Known for its romantic appearance, the Laura Ashley look features a British heritage with small flowered prints and lace, strongly influenced by the past. Since her death, the company has gone on to expand worldwide and offers home furnishings as well as more tailored apparel for women and children.

BALENÇIAGA. (bal en see ya´ ga). Cristobal Balençiaga was born in Spain in 1895 and died there in 1972. He was a major designer of the era; many experts rank him as the leading designer of the twentieth century. His garments were original. He invented the stand-away collar and the pillbox hat among other designs. The cut was superb and the tailoring unmatched. It is said he did not release a garment to a client until he was absolutely satisfied with it. Although not easy to work with, Balençiaga trained and influenced the later work of designers Hubert de Givenchy, Emmanuel Ungaro, and Andre Courrèges.

BANKS. Jeffrey Banks. See Career Portrait, Chapter 17.

BEENE. Geoffrey Beene was born in Louisiana in 1927. He started a career in medicine but abandoned that to study at the Traphagen School of Design in New York. He then went to Paris to study at the Ecole de la Chambre Syndicale and also to work for the designer Edward Molyneux.

Returning to New York, before long he was working for the women's apparel manufacturer Teal Traina and his name began to appear on the line. He opened his own business in 1963, and in the ensuing years added a boutique line, "Beene Bag," men's wear, sportswear, jewelry, and shoes. Geoffrey Beene is known for a relaxed elegant look with a superb cut and beautiful fabrics. He has received a number of fashion awards including several Coty Awards.

BLASS. Bill Blass was born in Indiana in 1922. He attended the Parsons School of Design in New York, and also did sketches for the David Crystal sportswear organization. After returning from World War II, where he served in the army, he worked with the Maurice Rentner apparel firm and, in 1970, organized Bill Blass, Ltd. Best known for his elegant apparel for rich and famous clients, Bill Blass also designs men's wear and a secondary line called Blassport. In addition, he holds a number of licenses for fashion goods from hosiery to car interiors. Throughout his career, Blass has earned a variety of fashion awards including the various Coty Fashion Critics Awards and awards for men's fashion design.

BUCHMAN. Dana Buchman's name is on the label of the Liz Claiborne, Inc., bridge lines of career-oriented sportswear, dresses, coats, and knitwear in misses and petite sizes. Buchman, a vice president of the division bearing her name, shares design responsibilities with Karen Harman.

CARDIN. The most famous name worldwide in licensed fashion goods—with products bearing his name and found in 125 countries—Pierre Cardin was born in Italy of French parents in 1922. He was educated in France and worked for the houses of Paquin, Schiaparelli, and Dior at the time of the designer's "New Look," shortly after World War II. In the early 1950s, Cardin established his own house and presented his first couture collection. Designing for men as well as women, Cardin was one of the first to develop "unisex" apparel, with space-age appeal. His licensed products range from small leather goods to car interiors, in addition to a variety of sleek and modern clothing for women, men, and children. In 1992, France's Academie des Beaux Arts honored him with membership, placing him with other world-famous honorees including musician Yehudi Menuhin and actor Peter Ustinov.

CASTELBAJAC. Born in Morocco in 1950, Jean Charles de Castelbajac was brought up in France. Although preparing to be a lawyer, he left school to join his mother, the owner of a small apparel manufacturing plant. Designing for her organization and others, Castelbajac also worked in Italy. He designs apparel for men and women and works with several organizations. Castelbajac is known for the rugged looks of his designs, which often incorporate quilted cotton, canvas, and plaids.

CERRUTI. Nino Cerruti was born in 1930, in the town of Biella, in a region of Italy famous for its woolens. The family owned a woolen mill and Nino Cerruti assumed control of it when he was only 20 years old. Beginning with men's wear, Cerruti called attention to fashion by producing plays that needed many costume changes—costumes which he designed. He began a knitwear firm and opened a boutique in Paris. He then started manufacturing women's wear. Known for classic sportswear, Nino Cerruti designs are licensed worldwide.

CHANEL. (sha nel´). Gabrielle "Coco" Chanel, a world-renowned name in fashion, was born in France in 1883—part of her early life was spent in an orphanage. Having run a clothing store and a milliner's shop in smaller towns, Chanel was determined to open a shop in Paris, which she did after the end of World War I. She knew her clients wanted a relaxed and comfortable look, thus her designs were instantly popular and remained so throughout time. A typical Chanel look is a straight-skirted suit with braid trimming the jacket and sleeves. Multiple long strands of pearls or gold chains and perhaps a gold chain belt complete the outfit. Today the legendary Karl Lagerfeld designs for the house of Chanel and for other labels.

CLAIBORNE. Liz Claiborne. See Spotlight on a Firm, Chapter 11.

COMME DES GARCONS. (come day gar son´) Rei Kawakubo, the founder of Comme des Garçons, was born in Tokyo, Japan, in 1942. Starting out in the field of advertising, she also worked as a freelance stylist designer. She first designed women's wear and then turned to men's wear. Her work reflects the Japanese traditions of high drama, draping the body with asymmetrical emphasis.

CONRAN. Jasper Conran was born in London in 1959. He went to New York briefly to study at the Parsons School of Design, and later he worked for Fiorucci there. On returning to Britain, he showed his first line in 1978. He contributes bright and youthful looks to the British fashion industry.

COURREGES. (coo rej´). André Courrèges was born in France in 1923. Starting out to study engineering, he went on to study fashion design in Paris. Fortunate enough to land a job as a cutter with Balençiaga, Courrèges perfected the skill of fine tailoring. His designs, typified by straight-cut sleeveless shirts with short skirts and white boots, became a widely accepted look of the 1960s, and were copied everywhere.

DE LA RENTA. Oscar de la Renta was born in Santo Domingo in 1932, of Spanish parents. He studied in Madrid to become a painter but was designing fashions for friends. One of his designs happened to be a ball gown, which made the cover of *Life* magazine, and de la Renta decided to change careers. He apprenticed with several couturiers including Balençiaga and Lanvin. He then moved to New York as the designer for Elizabeth Arden. In the 1960s he opened his own firm and his reputation for glamorous and rich-looking women's wear grew. Today he designs men's and women's wear collections under his own name plus the couture collection and Ivoire line of ready-to-wear for the house of Pierre Balmain in Paris. De la Renta also has licensing agreements for fragrances and home furnishings. Oscar de la Renta has received a number of fashion awards including the Neiman Marcus Award and the Coty Hall of Fame.

DELL'OLIO. Louis dell'Olio was born in New York in 1948. He studied at The Parsons School of Design and worked as a freelance designer. In 1974, he was working for Anne Klein when the designer died and dell'Olio and Donna Karan were appointed the company's design team. Here they developed updated classic looks for the line. When Donna Karan left to form her own firm, Louis dell'Olio continued with Anne Klein as the company expanded, overseeing the Anne Klein designer lines. In 1993, he left to form his own company.

DIOR. (dee or´). Christian Dior was born in France in 1905, and died in Italy in 1957. His parents wanted him to enter government service while he hoped to be an architect. His early life was one of political activism; he went to Russia in the 1930s but was disillusioned by what he saw. Back in France he studied weaving and began selling designs for millinery when World War II broke out. After the war, he found work with couturiers Lucien Lelong and later Pierre Balmain. With the help of the textile baron, Marcel Boussac, Dior was able to launch his own line in 1947, and his "new look" was an immediate success. Characterized by soft curves, a narrow waist, and full skirt, its appeal was just right after the straight boxy looks of the war years. Other looks, such as the "A" and "H" looks, Dior added later as his collections grew more sophisticated and elegant. When Dior died, he had already groomed a successor: a young man named Yves Saint Laurent.

DOLCE and GABBANA. The Dolce and Gabbana design team consists of Domenico Dolce, born in Sicily in 1959, and Stefano Gabbana, born in Venice in 1963. The two met in Milan while both were working for an Italian designer. They later formed their own organization and began showing Sicilian-influenced fashions, many in black. Celebrities such as Warren Beatty, Mick Jagger, and Madonna became interested in their work. For example, the lingerie look popularized by Madonna featured designs by Domenico Dolce and Stefano Gabbana. More recent collections echoing the designers' passion for freedom, show fashion-forward looks in prints and bright colors. The Dolce and Gabbana collections for men and women are offered in stores throughout the world. The team also designs the Complice line for the Italian firm Genny; licenses knitwear, lingerie, accessories, and has a signature fragrance.

ELLIS. Perry Ellis was born in Virginia in 1940 and died in New York in 1986. Upon graduating from the University of Virginia with a major in retailing, Perry Ellis went to work for the department store organization Miller & Rhoads. Working as a sportswear buyer, he began to realize he could design better apparel than that in the market. He went to work for the John Meyer sportswear manufacturer and when it folded, for the Vera organization. A little later he began designing his own line called "Portfolio." It was an immediate hit and Manhattan Industries agreed to produce his label. His garments started to sell throughout the country. Known for his ability to create wearable sports-

wear using fabrics of natural fibers, Ellis added high-fashion pizzazz to classic looks. Recognized as a fashion leader, he was given the Neiman Marcus and Coty awards. After Ellis' death, his designer looks were perpetuated by designer Marc Jacobs until 1993, when that portion of the company closed down.

FENDI. The Fendi organization was founded in 1918, by Adele Fendi, and is run today by her five daughters (Paola, Anna, Franca, Carla, and Alda) with input from designer Karl Lagerfeld in designing furs. Famous for excellent workmanship, the Fendi organization is headquartered in Rome but participates in the Milan ready-to-wear shows. Known for unique and creative handling of furs, the Fendi sisters also produce expensive ready-to-wear and handbags.

FERRE. (fer ay´). Born in Italy in 1945, Gianfranco Ferre was educated as an architect. He started his career in the studio of a furniture company. Then his interests turned to designing gold jewelry and next accessories, including handbags, shoes, and scarves. He next designed a striped T-shirt that was widely copied. Established as a free-lance designer, Ferre went on to create sportswear and coats. He developed his own label and began showing ready-to-wear collections in 1974. By the 1980s he was recognized as a leading designer in Italy, along with Giorgio Armani and Gianni Versace. Ferre's apparel is known for its architectural look, clean lines, and complex and well-defined construction. Ferre designs for the house of Dior as well as under his own name.

FEZZA. Born in 1956, Andrew Fezza graduated from Boston College preparing to study dentistry. Instead, with a change of mind, he entered New York's Fashion Institute of Technology and began designing women's sportswear. Fezza started his first men's collection in 1979, and since then has been termed by some "the Armani of America," for his clean, relaxed designs. In addition to his signature line, Andrew Fezza's lower-priced lines are called "Assets" for suits, and "Fez" for sportswear and active wear.

GAULTIER. (go tee yay´). Jean Paul Gaultier was born in France in 1952. He went to work for Pierre Cardin at age 17, and later worked for the house of Jean Patou. He began to do freelance designs in 1976. Today, Gaultier is known for his avant-garde and controversial designs for men and women. He obtains many of his ideas from street fashions, advocated the "punk look" in its time, and delights in startling fashion audiences with new and daring creations.

GIVENCHY. (ghee von´ she). Born in France in 1927, Hubert de Givenchy was strongly influenced by the work of Balençiaga. Of noble demeanor, Givenchy is a hard-working couturier, best known perhaps for his most famous client, Audrey Hepburn. Givenchy started his career in the couture house of Lucien Lelong, and later worked with Jacques Fath and Elsa Schiaparelli. In 1952, Givenchy opened his own salon. Known for refined elegance and impeccable construction, the Givenchy ball gowns are opulent, while his daywear is restrained. In addition, Givenchy designs a line of ready-to-wear that is marketed throughout the world.

HERMES. (air mes´). In 1837, in Paris, a saddle shop was opened by Thierry Hermès. Over the years, the company grew to produce boots, riding accessories, and scarves, some so beautifully designed that they are framed as wall hangings. Each year a new theme, such as carriages, birds, or Asian boats, is designed for the scarves and offered in a range of colors. In the 1920s, Hermès began offering luggage and other leather goods. The Kelly handbag, made famous by Grace Kelly in films, is one of its best-known leather products. Today Hermès shops and other prestigious stores in cities around the world offer the company's exclusive scarves, ties, accessories, apparel, fragrances, and gifts.

HERRERA. Born in 1940, in Venezuela, Carolina Herrera has been developing her sense of style in New York for more than a decade. Following in the tradition of Balençiaga, Herrera is known for her elegant evening gowns and little black dresses. She creates two collections, her signature line, and her lower-priced CH line. Her apparel has been offered by Saks for more than 10 years. Herrera licenses include jewelry and fragrances.

ISANI. Soyon and Jun Kim, the brother and sister team who create the Isani label, were born in Korea in 1968 and 1966, respectively. They are known for their youthful interpretations of shirt dresses and Chanel-inspired suits.

JACOBS. Born in 1962, Marc Jacobs developed an early interest in fashion. He attended New York's

High School of Art and Design and while there also worked part-time as a salesperson at the fashionable specialty store Charivari. He went on to Parsons School of Design where he earned the Perry Ellis Golden Thimble Award for his sweaters. He and the store's co-owner had created a line of hand-knit sweaters for Charivari. After graduation he went to work for two Seventh Avenue firms before joining Perry Ellis. Here, Marc Jacobs assumed design responsibilities for the firm upon the designer's death. Strongly influenced by the French designer Madeleine Vionnet, Jacobs pays attention to fit, drape, and detail in his relaxed and creative designs. In 1993, Perry Ellis International closed down its designer division and offered to back Marc Jacobs in his own business.

JOHNSON. Betsey Johnson was born in Connecticut in 1942. Her interest in fashion began early on. After studying fine arts at Syracuse University, she served a stint as an editor for *Mademoiselle* magazine. She also designed sweaters for friends and then began designing under contract. Known for her original and even anti-establishment approach to fashion, Betsey Johnson's designs attracted the attention of well-known celebrities. She soon opened a boutique, and in 1978 started her own organization to manufacture dresses and sportswear bearing her name. Betsey Johnson has received a number of honors including the Coty American Fashion Critics' "Winnie" award.

JULIAN. Alexander Julian. See Career Portrait, Chapter 8.

KAHNG. Gemma Kahng was born in Korea in 1955. She is famous for classic suits in bright colors enlivened with large jeweled buttons.

KAMALI. Norma Kamali was born in New York in 1945. She studied at the Fashion Institute of Technology to become a fashion illustrator. On graduating, however, she went to work for an airline and traveled frequently to London where she saw the work of British designers. When she married, Kamali and her husband decided to open a store in New York to offer British and French apparel. Before long she started designing her own line, which became immediately popular. When Norma Kamali and her husband divorced, she named her line "OMO," meaning "on-my-own." Known for her creativity, Kamali has developed washable disposable paper-like apparel, the "ra-ra"

skirt, and sweatshirt fashions. In 1983, she was proclaimed the Council of Fashion Designers of America outstanding designer of the year.

KARAN. Donna Karan. See Career Portrait, Chapter 4.

KENZO. Kenzo Takada was born in Kyoto, Japan, in 1940. He was one of the first Japanese designers, along with Hanae Mori, to work in Paris. Trained as an artist, Kenzo always wanted to live in Paris and moved there in 1964. He began his career by doing freelance designs for the house of Louis Feraud and others. In 1970, Kenzo opened a shop with jungle decor called Jungle Jap, where he featured his designs. The inspiration for much his work comes from traditional Japanese apparel emphasizing its uncluttered clean lines. Many garments are of quilted cotton or knitted. Kenzo designs both couture and ready-to-wear and has proved an inspiration to other Japanese designers such as Issey Miyake.

KLEIN. Anne Klein. Anne Klein was born in New York in 1923 and died there in 1974. She came from a family already established in the fashion industry, as her father was a custom tailor. Perhaps her background enabled her to get an early start in the field, for she began working as a sketcher when she was in her teens. After operating a company called Junior Sophisticates, Anne Klein and her husband started Anne Klein and Company in 1968. Known for sportswear with clearly defined lines and excellent fabrics, Anne Klein and Company developed interchangeable looks often featuring double-breasted jackets. Her organization was one of the first to use white as a year-round color. When she died, Donna Karan and Louis dell'Olio continued the lines; when Donna Karan formed her own company, dell'Olio stayed on with Anne Klein and Company until 1993. Anne Klein lines include the exclusive Anne Klein Collection, now designed by Richard Tyler; career-oriented Anne Klein II; and the more popularly-priced A Line Anne Klein.

KLEIN. Calvin Klein. See Career Portrait, Chapter 2.

KORS. Michael Kors, born in 1959, started selling his designs to a New York store at the age of 19. He follows the clean lines of Calvin Klein but adds his own imaginative touches such as cutouts at the waist line of a strapless sheath. Kors has a designer line called Michael Kors Collection, and he developed a less expensive secondary line called "Kors."

His licensing agreements include men's wear, shoes, and swimsuits.

KRIZIA. The name of a design firm, Krizia is a venerable fashion establishment in Milan, Italy, operated by Mariucca Mandelli and her husband Aldo Pinto. A teacher by profession, Mandelli also had an interest in fashion early on. Looking at apparel in Milan's stores in the 1950s, she realized that she could create better designs. Mandelli began making skirts with a friend's help, and took them around to the stores to sell; there she gathered valuable feedback from customers. Known for its creative approach—pairing unlike fabrics such as corduroy and satin, and introducing a different animal theme each year—the company has grown and presents a variety of collections of woven and knit garments annually. Krizia apparel is carried by stores throughout the world.

LACROIX. Born in southern France in 1951, Christian Lacroix studied in Paris. Through school contacts he obtained work in the fashion house of Jean Patou, where he brought new ideas such as his early success, the pouf skirt. In 1986, he formed a firm with a friend and obtained financial backing from the Financier Agache organization, the same company that owns the house of Dior. Christian Lacroix is famous for his fanciful apparel, juxtaposing plaids and prints, and for his elaborate bridal gowns. The bright colors and patterns of southern France are some of his sources of inspiration. He also designs ready-to-wear in a licensing agreement with the Italian firm Genny.

LAGERFELD. Karl Lagerfeld. See Career Portrait, Chapter 12.

LAUREN. Ralph Lauren. See Career Portrait, Chapter 1.

MACKIE. Bob Mackie was born in Los Angeles in 1940. He studied art and theater design. He worked for the famous Hollywood designer Edith Head and then became known for his own designs for television stars, particularly Cher. He has received a number of awards for his dramatic costumes. In addition, Mackie designs day wear and swimwear, all influenced by his flair for the dramatic and glamorous.

MATSUDA. Mitsuhiro Matsuda was born in Tokyo in 1934, in a family affiliated with the Japanese kimono industry. Early on Matsuda was interested in creating western apparel based on Japanese principles. He studied fashion along with designer Kenzo Takada, and later they went to Paris in 1965. Matsuda went to New York and returned to Tokyo. He founded his own organization and began producing and marketing women's wear and men's wear through his own boutiques. In the 1980s he opened boutiques in New York and Hong Kong. In addition to his own production companies, Matsuda has several boutiques and franchises.

MCFADDEN. Mary McFadden, whose father was a cotton broker, grew up in Tennessee, although she was born in New York in 1936. She earned a degree in sociology from Columbia University and along the way attended the Sorbonne in Paris and Traphagen School of Design in New York. For a while she lived in South Africa, where she was editor of South African *Vogue* magazine. In 1970, she came back to the United States to work for *Vogue*. One of her projects was to develop for the magazine some gowns using African and Chinese fabrics. When the Henri Bendel organization bought the gowns, Mary McFadden began thinking about having her own business. In 1976, she opened Mary McFadden, Inc. One of her best-known trade marks is the elegant pleated fabric she was able to have created, which resembles the unforgettable silk fabrics of Mario Fortuny, but is of synthetic fiber, packable and needing minimum care. McFadden's customers are rich women who enjoy her beautiful fabrics and low-key looks. The fashion industry has presented her with a number of awards, including the Neiman Marcus Award and election to the Coty "Hall of Fame."

MILLER. A New Yorker born in 1951, Nicole Miller is known in the fashion world for her silk print dresses, scarves, and men's ties. Some of Nicole Miller's whimsical designs include: license plates, theater ticket stubs, and restaurant logos. Miller has been in the fashion business nearly 20 years and in her own business since 1983. Her funky ties, first worn by celebrities such as Chevy Chase, brought her to the attention of the fashion conscious. Her major retail store customers include Henri Bendel, Inc. Nicole Miller also has her own stores in a variety of locations including New York, California, Montreal, and Barcelona, Spain.

MISSONI. Tai and Rosita Missoni met in London in 1948, when Tai was competing in the Olympics on the Italian team and Rosita was studying

English. At that time, he had a business producing track suits, which were the uniform of the Italian team and were growing in popularity throughout the country. In 1953, they married and, forming their own knitting company, began producing knitwear for other organizations. Before long, they decided to offer more fashionable garments, with Tai creating unique patterns and colors and Rosita developing the shapes. Their simple yet sophisticated knits have earned them many fashion honors, among them the Neiman Marcus Award.

MIYAKE. Issey Miyake was born in Hiroshima, Japan, in 1938. He studied fashion design in Japan and then in the 1960s moved to Paris where he studied at the Chambre Syndicale de la Couture Parisienne. Then, in succession, he worked as an assistant to designers Guy Laroche and Hubert de Givenchy. From there he went to New York where he designed ready-to-wear for Geoffrey Beene. In 1971, Miyake showed his first collection in both New York and Tokyo. Two years later he showed a collection in Paris, and has shown there ever since. He also presents shows in Japan. Miyake's view of fashion is of clothing as art and that traditional Paris fashions do not mesh with today's woman. Instead, Miyake offers layered and wrapped looks. He also produces lower-price lines under the labels "Plantation," "Issey Sport," and "Pleats Please." Over the years Miyake has been given a number of awards including France's Legion d'Honneur in 1993.

MIZRAHI. Isaac Mizrahi was born into the apparel business in Brooklyn in 1961. His father was a children's wear manufacturer who, when Isaac was 10 years old, gave him a sewing machine. His mother had a keen interest in fashion and wore designer apparel. Young Isaac began designing clothes at age 13, grew serious about fashion design as a career, and went on to graduate from the Parsons School of Design in 1982. His early career led him to work for Perry Ellis, Jeffrey Banks, and Calvin Klein. In 1987, Mizrahi opened his own business. Designing both women's and men's wear, Mizrahi offers original interpretations of classic looks, emphasizing relaxed ease, and fresh color and pattern combinations. He has earned a number of honors in the fashion industry, including several awards from the Council of Fashion Designers of America.

MONTANA. Claude Montana was born in Paris in 1949. His father was German and his mother, Spanish. He started designing jewelry when in London and short of funds. The jewelry made a hit when the unusual look of rhinestones and papier mâché was picked up and shown in British *Vogue*. Returning later to Paris, Montana went to work for a leather firm where he began designing strong, rugged, masculine looks. He also designs bold knitwear. Known for his outlandish forward-looking designs, along with his compatriots Thierry Mugler and Jean Paul Gaultier, Montana is looked to in Paris for original thinking. He designed for the couture house of Jeanne Lanvin for 5 years, until 1992. Montana's more recent venture is a secondary line offered by Henri Bendel, among others, and is called "State of Montana."

MUGLER. Thierry Mugler (tee air ee′ moo glay′) was born in 1946, in Strasbourg, France. Although his father was a doctor, Mugler showed interest in fashion, making some of his own clothes. He was also interested in ballet and joined the Strasbourg Ballet Company. Soon, though, he moved to Paris where he worked creating window displays for a boutique. From there he went to London for two years. In 1971, he presented a first collection in Paris, and two years later he had his own label. His designs are high in style and sexy, inspired by the earlier work of designer Mme. Alix Grès. His accessories tend to be outlandish. Mugler's followers include Azzedine Alaïa and Jean Paul Gaultier. Mugler's organization is one of the few design firms producing ready-to-wear in its own factories.

MUIR. Jean Muir was born in London in 1933. Her career in fashion began in the stockroom and in selling lingerie for London's famous Liberty stores. Next, she moved to sketching and selling in the store's custom-made department. In 1956, she went to work for the famous Jaeger apparel company where she worked as a designer for seven years. In the 1960s, she formed her own company where she mastered the art of tailoring soft apparel such as jersey and suedes for women. Her soft, tailored, classic look is her trademark, and the construction of the garments is unsurpassed. Jean Muir has been given many awards, among them the Harper's Bazaar Trophy and the Neiman Marcus award.

OLDFIELD. Born in London in 1950, Bruce Oldfield was trained as a teacher. His interests turned to art, which he studied in London for four years and then followed with a year's study of fashion design. He started out as a freelance designer in London and then produced a line of apparel for the Henri Bendel stores in the United States. In 1974, he showed his first British collection bearing his label. He developed made-to-measure apparel for a growing group of clients and also created ready-to-wear lines featured at Bendel's and other stores. Known for sophisticated young-looking apparel, Oldfield also does elegant ball gowns for his private clients, including some royalty.

OLDHAM. Todd Oldham, born in Texas in 1962, designs sophisticated and youthful ready-to-wear with a sense of humor. He uses bright colors and whimsical details; for example, buttons in the shapes of tea pots. Other sources of inspiration include African and Aztec patterns. His label, Todd Oldham Times Seven, has sportswear and evening lines, one of which he does exclusively for The Limited's Henri Bendel stores. In 1991, he was named the fashion industry's most exciting new talent by the Council of Fashion Designers of America.

QUANT. Mary Quant was born in London in 1934. She met her husband while studying art. Together they opened a shop named Bazaar in King's Road. The apparel that they featured turned King's Road into a major shopping center for the '60s generation and the fashion "hot spot" famous for the "King's Road" look. Not pleased with the merchandise offered by vendors, Mary Quant began designing her own looks and widely popularized short skirts and other apparel, terrific for the young but dreadful on anyone older. She developed a ready-to-wear line called the "Ginger Group" and began exporting to the United States. In 1973, the British Museum had a retrospective exhibit of her work and although she is not a major fashion force today, she inspired many of the changes that give today's fashions their appeal.

RHODES. Chatham, England, is the birthplace of Zandra Rhodes; she was born in 1942. Her mother worked in the famous couture house of Worth in Paris, and had been a teacher of fashion. Textile design and art were the focus of Zandra Rhodes' studies, and she graduated from the Royal College of Art in 1966. She started out to be a textile designer and set up facilities to produce her textile designs. She also opened a store to sell dresses made from her fabrics and soon started her own apparel firm. Known for her use of beautiful fabrics, such as silk, chiffon, and rich hand-printed designs, Zandra Rhodes is often inspired by history for her imaginative and romantic ball gowns. She looks at her creations as works of art. In 1991 she designed the costumes for the famous Christmas windows at Chicago's Marshall Field's, depicting the story of Cinderella.

ROTH. Christian Francis Roth was born in 1970, in New York. In his early 20s, Roth is considered a boy wonder. His designs are simple shapes using bright colors. In 1991, he was given the Council of Fashion Designers of America's award as the year's best young talent.

RYKIEL. In 1930, Sonia Rykiel was born in Paris. She is one of the best-known designers of ready-to-wear, famous for her clean-lined knit apparel—long cardigans, skirts, and pants—and often restrained color palette, dominated by black, gray, and beige. She started designing when pregnant because she could not find suitable clothes to wear. Today her lines and her fragrance are carried in her own boutiques and other well-known stores throughout the world. Her company, Sonia Rykiel, SA, which is entirely family-owned, recorded sales estimated at $70 million in 1992.

SAINT LAURENT. Born in Algeria in 1936, Yves Saint Laurent (eve san lo ran´) arrived in Paris as a teenager and grew to be one of the leading designers of the era. A student of theater, dance, history, and languages, Saint Laurent drew also from the works of Balençiaga, Chanel, and Dior for his inspiration. After studying for a year in the school of the Chambre Syndicale de la Couture Parisienne in 1954, he was hired by the highly successful firm of Christian Dior in 1955. Two years later, when Dior died, the design responsibilities for the firm went to Yves Saint Laurent when he was only 21 years old. In 1962, he opened his own firm. Renowned for creating day wear for women based on a men's wear look, featuring blazers or double-breasted jackets and straight lines, Saint Laurent is also famous for his elegant evening wear, sourcing inspiration from his native Algeria and artists such as Picasso and Mondrian. In addi-

tion to apparel, he designs costumes for theater and ballet, and many accessories and home furnishings. The Rive Gauche shops are Yves Saint Laurent boutiques. He has been granted many fashion awards and distinctions; perhaps the most notable was the Metropolitan Museum of Art's retrospective exhibit of his work. He is the only living designer to be so honored.

SANDER. Jill Sander, a German couturière working in Milan, also shows her well-cut, fluid, and timeless apparel in Paris. Among her United States customers are Bergdorf Goodman and I. Magnin. Sander is also known for the fragrances she personally creates for men and women.

SUI. Anna Sui, from her Manhattan workrooms, introduces a free-spirited avant garde approach with looks often popularized by designers in France and Italy. Her filmy dresses, and retro-'70s and grunge looks were widely copied. Born in 1955 in Detroit, of Chinese parentage, Anna Sui had always wanted to be a fashion designer. She attended the Parsons School of Design and later started her own business. Her new age, bohemian attitude also has its well-known followers, among them Madonna and model Naomi Campbell. Stores offering her lines include Henri Bendel and Macy's. In 1992, Anna Sui was given the Council of Fashion Designers of America New Talent award.

TYLER. Richard Tyler, born in Australia in 1949, was named to design the Anne Klein Collection in 1993. Tyler's own Los Angeles-based design business, Tyler-Trafficante Inc., which includes a store, was well-known on the west coast. His clients there include Julia Roberts, Susan Sarandon, and Anjelica Huston. Known for his sophisticated styling and expert tailoring, Tyler's work has been acclaimed by some experts as the way of the future.

UNDERWOOD. Patricia Underwood was born in Great Britain in 1948. She studied fashion at New York's Fashion Institute of Technology in the late 1960s, and started designing hats. Her millinery was purchased by the Henri Bendel stores and was also shown in *Vogue* magazine. She also creates hats for other design firms such as Calvin Klein and Perry Ellis. She is well known for her ability to take millinery shapes from other times, such as milkmaids' hats, and interpret them for today's styles.

UNGARO. Born in France in 1933 of Italian parentage, Emmanuel Ungaro was taught how to make men's clothes by his father, who was a tailor. In his early 20s, Ungaro went to Paris to work for a tailor. Here he met André Courrèges who was working for Balençiaga and who introduced him to the leading couturier. When Courrèges left Balençiaga, Ungaro took his place and remained there for six years. In 1965, Ungaro started his own organization and soon became known for soft apparel with great color combinations and mixing of patterns. Ungaro seems to have two passions: designing attractive apparel for women, and music. He begins his work by shaping the fabric directly on a model. In addition to his couture collection, Ungaro has several ready-to-wear lines, the pricey "Ungaro Parallèle," a less expensive "Solo Donna," and a newer secondary line called "Emmanuel." He also has some 45 licensing agreements for his fashion goods.

VALENTINO. Valentino Garavani was born in Italy in 1932, and he studied fashion in Milan and later at the Chambre Syndicale in Paris. After working several years, first in the firm of couturier Jean Dessès and later with Guy Laroche, Valentino returned to Rome in 1959. Here he opened his own firm. In 1962, he decided to show his collection in Florence where the buyers from I. Magnin placed extensive orders and his work became known in the United States. Ten years later, Valentino began designing a men's wear line. Today he also designs a ready-to-wear line, which he shows in Paris while also showing couture in Rome. Much of Valentino's inspiration is drawn from Hollywood. His elaborate ball gowns reflect the mood of the films of the 1950s. He is famous for his celebrity clients; he designed the wedding gown for Jackie Kennedy's wedding to Aristotle Onassis and more recently Elizabeth Taylor's gown for her marriage to Larry Fortensky.

VERSACE. In 1946, Gianni Versace was born in Calabria, in southern Italy. His interest in and training for fashion began early on, since Versace's mother was a dressmaker. Famous for his creativity with knits, leathers, and colorful prints, Versace has designed under a number of labels. Up to 1994, he designed ready-to-wear for the Genny group. Today, with his own labels, he is known for his innovative work with fabrics and leathers, his use of color, and the total put-together look of his outfits.

Many experts consider him the most creative among the Italian designers working today.

VITTADINI. Adrienne Vittadini. See Career Portrait, Chapter 6.

WESTWOOD. Vivienne Westwood was born in Great Britain in 1941. After starting to prepare for a teaching career, Vivienne Westwood joined forces with Malcolm McClaren, of the pop music group Sex Pistols, and opened a shop on King's Road in London, and a few years later another shop in London's West End. Featuring apparel with lots of leather and geared to punk-rock followers, the shops would move quickly with the trends. Since then, Westwood has introduced a variety of collections, each capturing the spirit of the moment with themes such as new romantics or witches. Much of her iconoclastic inspiration comes from the current pop culture scene and is similar in feeling to the work of some Japanese designers.

YAMAMOTO. Born in Japan in 1943, Yohji Yamamoto studied fashion at the Bunka College of Fashion in Tokyo. In 1972, he started his own company and shortly thereafter showed his first collection. He then began a company in France in 1981, and now shows his collection regularly in Paris. Yamamoto's view of fashion is that it is not to be considered glamorous; indeed, his designs wrap and conceal the body. He uses layers and knits extensively.

ZANG TOI. Zang Toi was born in Malaysia in 1962, and is considered one of the leading young Asian designers, along with Gemma Kahng and Isani. Zang Toi prefers bright colors and works to offer fresh looks at prices that are not exorbitant.

ZORAN. Zoran was born in Yugoslavia in 1947. With a degree in architecture from Belgrade University and an interest in fashion, he came to the United States. Through a friend, he was able to show his styles to the Henri Bendel store organization. Understanding the clean, architectural look, Bendel purchased his designs. Before long he was featured in *Women's Wear Daily,* and his name became known in the industry. Zoran's approach to design uses simple, elegant garments such as shawl-collared coats with spectacular fabrics. He developed a wardrobe of nearly a dozen pieces that pack into a small space for travel. Zoran's colors are basic: black, white, grey, and ivory. His fabrics range from cashmere to cotton knit, with satin and velvet for evening.

Appendix B: Selected Designers and Manufacturers by Industry

A number of apparel and accessories manufacturers create well-known fashion goods and provide career opportunities in fashion merchandising. A selected group of these designers and manufacturers is listed below according to the major categories of goods they produce.

Designers and Manufacturers of Women's Wear

Geoffrey Beene
550 Seventh Avenue
New York, NY 10018

Bill Blass, Ltd.
550 Seventh Avenue, 12th floor
New York, NY 10018

Bromley Coats
500 Seventh Avenue, 11th floor
New York, NY 10018

Caron, Inc.
350 West Kinzie
Chicago, IL 60610

Catalina, Inc.
6040 Bandini Boulevard
Los Angeles, CA 90040

Liz Claiborne, Inc.
1441 Broadway
New York, NY 10018

J. H. Collectibles
200 West Vogel
Milwaukee, WI 53207

I. B. Diffusion, L. P.
Suite 170
The Apparel Center
350 North Orleans Street
Chicago, IL 60654

Esprit de Corp
900 Minnesota Street
San Francisco, CA 94108

Evan Picone, Inc.
1411 Broadway, 37th floor
New York, NY 10018

Leslie Fay Companies, Inc.
1400 Broadway, 16th floor
New York, NY 10018

The Gitano Group, Inc.
1441 Broadway
New York, NY 10018

Guess? Inc.
144 South Alameda Street
Los Angeles, CA 90021

Carolina Herrera, Ltd.
19 East 57th Street
New York, NY 10022

J. G. Hook, Inc.
498 Seventh Avenue, 23rd floor
New York, NY 10018

Jones New York
1411 Broadway
New York, NY 10018

Donna Karan Company
550 Seventh Avenue
New York, NY 10018

Anne Klein and Company
550 Seventh Avenue
New York, NY 10018

Calvin Klein, Inc.
205 West 39th Street
New York, NY 10018

Jessica McClintock, Inc.
1400 16th Street
San Francisco, CA 94103

Isaac Mizrahi & Company
104 Wooster Street
New York, NY 10012

Polo/Ralph Lauren Corporation
40 West 55th Street
New York, NY 10019

Josie Natori Company
40 East 34th Street
New York, NY 10016

Ellen Tracy, Inc.
575 Seventh Avenue
New York, NY 10018

Adrienne Vittadini, Inc.
1441 Broadway, 28th floor
New York, NY 10018

Designers and Manufacturers of Men's Wear

Joseph Abboud Apparel
Corporation
650 Fifth Avenue
New York, NY 10019

Blair Corporation (and womens'
wear and accessories by direct mail)
Warren, PA 16366

Farah, Incorporated
P. O. Box 9519
El Paso, TX 79985

L. A. Gear (apparel and accessories
for men and women)
4221 Redwood Avenue
Los Angeles, CA 90066

Hartmarx Corporation (and
women's wear)
101 North Wacker Drive
Chicago, IL 60606

Tommy Hilfiger Corporation
25 West 39th Street
New York, NY 10018

Levi Strauss & Company (and
women's and children's wear)
1155 Battery Street
San Francisco, CA 94120

Nike, Inc.
3900 S. W. Murray Boulevard
Beaverton, OR 97005

Ocean Pacific
13889 South Figuera Street
Los Angeles, CA 90061

Oxford Industries, Inc. (and
women's wear)
P. O. Box 54600
Atlanta, GA 30308

Phillips-Van Heusen Corporation
(and women's wear and shoes)
1290 Avenue of the Americas
New York, NY 10104

Polo/Ralph Lauren Corporation
(and women's and childrens' wear)
40 West 55th Street
New York, NY 10019

Reebok International
100 Technology Center
Stoughton, MA 02072

VF Corporation (and women's
wear and intimate apparel)
1047 North Park Road
Wyomissing, PA 19610

Manufacturers of Children's Wear

William Carter Company
1590 Adamson Parkway, Suite 400
Morrow, GA 30260

Gerber Children's Wear, Inc.
531 South Main Street
Box 3010
Greenville, SC 29602

Healthtex
2303 West Meadowview
Greensboro, NC 27407

Oshkosh B'Gosh, Inc. (also men's
wear and women's wear)
112 Otter Avenue
Oshkosh, WI 54901

Appendix C: Leading Trade Associations

Below is a list of selected leading trade associations in the fashion industry.

Domestic Trade Associations

American Apparel Manufacturers'
Association
2500 Wilson Boulevard, Suite 301
Arlington, VA 22201

American Association of Exporters
and Importers
11 West 42nd Street, 30th Floor
New York, NY 10036

American Fabric Manufacturers
Association
1150 17th Street
Washington, DC 20026

American Fur Industry
363 Seventh Avenue
New York, NY 10017

American Fur Merchants
Association
363 Seventh Avenue
New York, NY 10001

American Gem Society
5901 West Third Street
Los Angeles, CA 90036

American Marketing Association
250 South Wacker Drive, Suite 200
Chicago, IL 60606

American Textile Manufacturers'
Institute, Inc.
1801 K Street NW
Washington, DC 22037

American Watchmakers Institute
Box 11011
Cincinnati, OH 45211

American Wool Council
c/o American Sheep Industry
Association
6911 South Yosemite Street
Englewood, CO 80112

American Yarn Spinners
Association
P.O. Box 99
Gastonia, NC 28053

Bureau of Wholesale Sales
Representatives
P.O. Box 30359
Atlanta, GA 30309

Childrenswear Manufacturers'
Association
2 Greentree Centre, Suite 225
P.O. Box 955
Marlton, NJ 08053

Clothing Manufacturers
Association of U.S.A
1290 Avenue of the Americas,
Suite 1061
New York, NY 10104

Color Association of the United
States
409 West 44th Street
New York, NY 10036

Color Marketing Group
4001 North 9th Street
Suite 102
Arlington, VA 22203

Cosmetic, Toiletry & Fragrance
Association
1110 Vermont Avenue NW
Washington, DC 20005

Cotton Council International
1110 Vermont Avenue NW,
Suite 430
Washington, DC 20005

Cotton, Inc.
1370 Avenue of the Americas
New York, NY 10019

Council of Fashion Designers of
America
1412 Broadway, Suite 1006
New York, NY 10018

Council of Sales Promotion
Agencies
750 Summer Street
Stamford, CT 06901

Crafted With Pride in the U.S.A.
Council
1045 Avenue of the Americas
New York, NY 10018

Direct Marketing Association
11 West 42nd Street
New York, NY 10036

The Embroidery Council of
America
8555 Tonnele Avenue
North Bergen, NJ 07047-4738

The Fashion Association
240 Madison Avenue
New York, NY 10016

Fashion Footwear Association of
America
870 Seventh Avenue
New York, NY 10019

The Fashion Group International
9 Rockefeller Plaza, 17th Floor
New York, NY 10020

Fashion Jewelry Association of
America
Regency East
One Jackson Walkway
Providence, RI 02903

Footwear Industries of America
1420 K Street NW, Suite 600
Washington, DC 20005

The Fragrance Foundation
142 East 30th Street
New York, NY 10016

International Linen Promotion
Commission
200 Lexington Avenue, Room 225
New York, NY 10016

International Silk Association,
U.S.A.
c/o Gerli & Company Inc.
1359 Broadway
New York, NY 10018

Intimate Apparel Manufacturers'
Association
475 Fifth Avenue, Suite 1908
New York, NY 10017

Jewelers of America
1271 Avenue of the Americas
New York, NY 10020

Jewelry Industry Council
8 West 19th Street, #4B
New York, NY 10011

Jewelry Manufacturers Association
475 Fifth Avenue
New York, NY 10017

Leather Industries of America
1000 Thomas Jefferson Street NW,
Suite 515
Washington, DC 20007

Manufacturing Jewelers &
Silversmiths of America
100 India Street
Providence, RI 02903

Men's Apparel Guild in California
100 Wilshire Boulevard
Santa Monica, CA 90401

National Association of Fashion
and Accessory Designers
2180 East 93rd Street
Cleveland, OH 44106

National Association of Hosiery
Manufacturers
447 South Sharon Amitty Road
Charlotte, NC 28211

National Association of Men's
Sportswear Buyers
500 Fifth Avenue, Suite 1425
New York, NY 10110

National Fashion Accessories
Association
330 Fifth Avenue
New York, NY 10001

National Retail Federation
100 West 31st Street
New York, NY 10001
and
701 Pennsylvania Avenue NW
Washington, DC 20004

National Shoe Retailers' Association
9861 Broken Land Parkway
Columbia, MD 21046

Neckwear Association of America
151 Lexington Avenue, #2F
New York, NY 10016

Public Relations Society of America
33 Irving Place, 3rd Floor
New York, NY 10003

Textile Research Institute
P.O. Box 625
Princeton, NJ 08542

Wool Bureau, Inc.
360 Lexington Avenue
New York, NY 10017

Foreign Trade Associations

Camera Nazionale della Moda
Italiana
00187 via Lombardia
Roma 44, Italy

Chambre Syndicale de la Couture
Parisienne
100 Rue de St. Honore
Paris 75008, France

Clothing Export Council of Great
Britain
54 Grosvener Street
London, WIXODB
Great Britain

Federation Francaise des Industries
de Prêt-à-Porter Feminin
69 Rue de Richelieu
Paris 75002, France

Appendix D: Selected Consumer and Trade Publications

Below are lists of some of the leading consumer and trade publications in the fashion industry.

Consumer Publications

Allure
Condé Nast Publications
350 Madison Avenue
New York, NY 10017

BBW: Big Beautiful Woman
BBW Publishing Company
9171 Wilshire Boulevard
Beverly Hills, CA 90210

Details for Men
Condé Nast Publications
(For address see *Allure.*)

Ebony Man
Johnson Publishing Company, Inc.
820 South Michigan Avenue
Chicago, IL 60605

Elle
Elle Publishing
1633 Broadway, 42nd floor
New York, NY 10019-6741

Esquire
Hearst Corporation
1790 Broadway
New York, NY 10019

Essence
Essence
1500 Broadway
New York, NY 10036

Glamour Magazine
Condé Nast Publications
(For address see *Allure.*)

GQ (Gentlemen's Quarterly)
Condé Nast Publications
(For address see *Allure.*)

Harper's Bazaar
Hearst Corporation
(For address see *Esquire.*)

Harper's Bazaar en español
Editorial America, S.A.
6355 NW 36th Street
Virginia Gardens, FL 33166

Lear's
Lear's Publishing, Inc.
55 Madison Avenue
New York, NY 10021-8043

Mademoiselle
Condé Nast Publications
(For address see *Glamour.*)

McCall's
New York Times Magazine Group
110 Fifth Avenue
New York, NY 10011-5601

Mirabella
200 Madison Avenue
New York, NY 10016

Seventeen
Murdoch Magazines
850 3rd Avenue
New York, NY 10022

Town and Country
Hearst Corporation
(For address see *Esquire.*)

Vogue Magazine
Condé Nast Publications
(For address see *Glamour.*)

W
Fairchild Publications
7 East 12th Street
New York, NY 10003

Working Woman
Lang Communications
230 Park Avenue, 7th floor
New York, NY 10169-0005

Trade Publications

Accessories Magazine
50 Day Street
Norwalk, CT 06430

America's Textiles
106 East Stone Avenue
P. O. Box 88
Greenville, SC 29602

Apparel Import Digest
American Apparel Manufacturers
Association
1611 North Kent Street
Arlington, VA 22209

Apparel World
425 Park Avenue
New York, NY 10022

Bobbin
1110 Shop Road
Columbia, SC 29201

Body Fashions/Intimate Apparel
270 Madison Avenue
New York, NY 10016

Chain Store Age
425 Park Avenue
New York, NY 10022

Children's Business
Fairchild Publications
7 West 34th Stret
New York, NY 10016

Daily News Record
(For address see *Children's Business.*)

DCI Drug & Cosmetic Industry
270 Madison Avenue
New York, NY 10016

Discount Store News
425 Park Avenue
New York, NY 10022

*Earnshaw's Infants-Girls-Boys-Wear
Review*
225 West 34th Street
New York, NY 10122

Fashion Accessories Magazine
65 West Main Street
Bergenfield, NJ 07621

Footwear News
Fairchild Publications
(For address see *Children's Business.*)

Intimate Fashion News
309 Fifth Avenue
New York, NY 10001

Jewelers' Circular-Keystone
Chilton Way
Randor, PA 19089

Kid's Fashions
71 West 35th Street
New York, NY 10001

Knitting Times
51 Madison Avenue
New York, NY 10018

Leather Today
19 West 21st Street
New York, NY 10017

Modern Jeweler
7950 College Boulevard
Overland Park, KS 66210

National Jeweler
1515 Broadway
New York, NY 10036

*National Shoe Retailer Association
Newsletter*
200 Madison Avenue
New York, NY 10006

*Sales and Marketing Management
Magazine*
633 Third Avenue
New York, NY 10022

Stores Magazine
100 West 31st Street
New York, NY 10001

Teens and Boys Magazine
210 Boyleston Street
Chestnut Hill, MA 01267

Textile World
4170 Ashford-Dunwoody Road
Atlanta, GA 30319

*VM & SD (Visual Merchandising &
Store Design)*
407 Gilbert Avenue
Cincinnati, OH 45202

Women's Wear Daily
Fairchild Publications
(For address see *Children's Business.*)

Index